Die Kunst der Abstrakten Fotografie
The Art of Abstract Photography

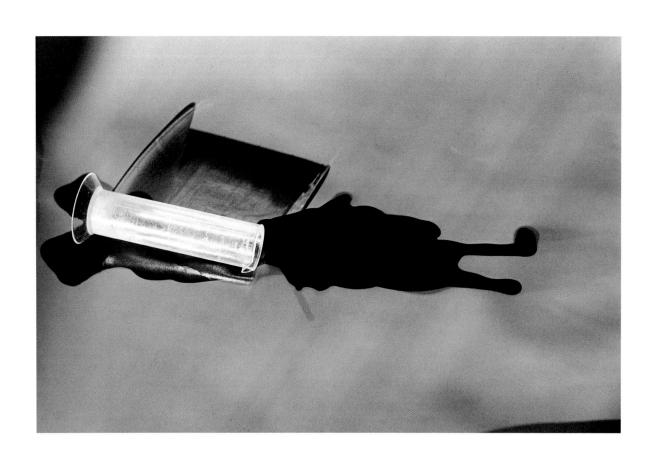

Gottfried Jäger (ed.)

Vladimír Birgus
Martin Roman Deppner
Claudia Fährenkemper
Michael Köhler
Rolf H. Krauss
Lambert Wiesing

Die Kunst der Abstrakten Fotografie
The Art of Abstract Photography

ARNOLDSCHE
Art Publishers

For June.

Die Deutsche Bibliothek – CIP-Einheitsaufnahme
Die Kunst der Abstrakten Fotografie/Gottfried Jäger (Hg.). Mit Beitr. von Vladimír
Birgus, Martin Roman Deppner, Claudia Fährenkemper, Gottfried Jäger, Michael
Köhler, Rolf H. Krauss, Lambert Wiesing - Stuttgart: ARNOLDSCHE, 2002
ISBN 3-89790-015-7

Redaktion Editorial Work Gottfried Jäger
Übersetzungen Translations Ariane Kossack, Minden (Vorwort des Herausge-
bers, Beiträge Martin Roman Deppner, Claudia Fährenkemper, Podiumsdiskussion,
Glossar); Jean Säfken, Rastede (Beiträge Gottfried Jäger, Lambert Wiesing,
Rolf H. Krauss); Susan Bollans, München (Beitrag Michael Köhler); Deborah Fideli,
Bielefeld (Beitrag Vladimír Birgus aus dem Englischen ins Deutsche nach der
Übersetzung aus dem Tschechischen ins Englische)
Typografie Typography Gerd Fleischmann, Bielefeld, und Stefan Klink, Bielefeld
Titel Cover Gottfried Jäger: Punktum, 2000. Fotobasierter, computergenerierter
Tintenstrahldruck Photo-based computer-generated inkjet print, 130 x 130 cm.
Rückseite Back René Mächler: Schwarzer Kreis, halbseitig strahlend, 1977.
Kombiniertes Überstrahlungs-Luminogramm. Unikat auf selengetontem Silber-
gelatine-PE-Papier Combined irradiated luminogram. Unique selenium protected
gelatin silver RC-paper print, 34.5 x 34.5 cm. Courtesy of the artist
Frontispiz Frontispiece Ralf Filges: Ohne Titel (Untitled), 1990. Fotoaktion
(WV 589-8/90). Mensur, Entwickler, Tageslicht, Silbergelatine-Barytpapier. Aus
der Werkgruppe Rettungsversuche zur Fotografie, interaktive Fotoinstallationen
Photo action. Measure, developer, daylight, gelatin silver baryta paper. From the
work group Rettungsversuche zur Fotografie (Rescue Attempts of Photography),
interactive photo installations, 1984-1993. Courtesy of the artist
Offset-Reproduktionen Offset Reproductions Stefan Klink, Bielefeld, Grafische
Werkstätten des Fachbereichs Gestaltung der Fachhochschule Bielefeld;
Brune Digital, Halle/Westfalen
Druck Printed by Rung Druck, Göppingen
Gedruckt auf 100% chlorfrei gebleichtem Papier, entsprechend dem TCF-Standard
Printed on paper that is 100% free of chlorine bleach in conformity with TCF
standards
Eingetragene Warenzeichen werden im Text ohne das Zeichen ® verwendet.
In the text, registered trademarks appear without ®.
Made in Europe, 2002

Inhalt Content

Vorwort Preface 7
Gottfried Jäger

Gottfried Jäger Die Kunst der Abstrakten Fotografie The Art of Abstract Photography 11

Lambert Wiesing Abstrakte Fotografie: Denkmöglichkeiten What Could Abstract Photography Be? 73

Rolf H. Krauss Das Geistige in der Fotografie, oder: Der fotografische Weg in die Abstraktion
 The Spiritual in Photography, or: The Photographic Path to Abstraction 103

Vladimír Birgus Die Tschechische Avantgarde-Fotografie zwischen den zwei Weltkriegen
 Czech Avant-garde Photography between the Two World Wars 139

Martin Roman Deppner Coburn meets Pound. Abstraktion und Vortizismus in der englischen Ästhetik der Moderne
 Coburn Meets Pound. Abstraction and Vorticism in the English Aesthetics of Modernism 163

Claudia Fährenkemper Bilder aus dem Mikrokosmos Images from the Microcosm 195

Michael Köhler Das ungegenständliche Lichtbild heute. Zeitgenössische Positionen
 Non-Objective Photography Today. Contemporary Representatives 214

 Diskussion: Was ist Abstrakte Fotografie?
 Discussion: What is Abstract Photography? 259
 Gottfried Jäger
 Thomas Kellein
 Reinhold Mißelbeck
 Herbert Molderings

 Anhang Appendix
 Glossar Glossary 286
 Zeittafel Timeline 298
 Bibliografie Bibliography 300
 Sachregister Subject Index 304
 Personenverzeichnis Index of Names 313
 Vitae Notes on Authors and Podium Discussion Participants 317
 Bildnachweis Photo Credits 318

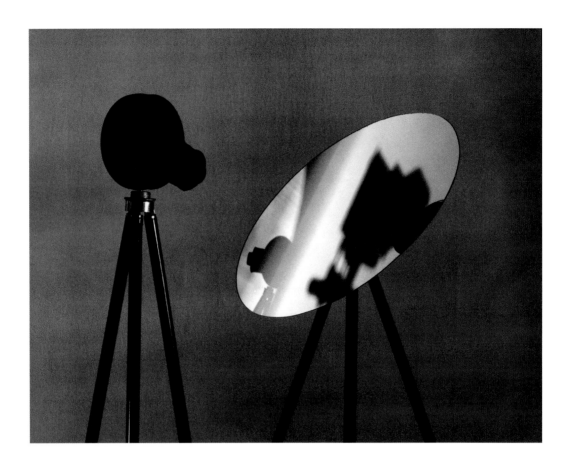

Jacob Mattner: *Camera*, 1988
Stativ, Blech und Ruß (Tripod,
sheet metal and soot)
Installation, ca. 120 x 50 x 50 cm
Kestner-Gesellschaft, Hanover 1988
Photograph: H. Klappert, Berlin

Gottfried Jäger

Vorwort Preface

Was ist Abstrakte Fotografie? Was könnte Abstrakte Fotografie sein? Gibt es Abstrakte Fotografie überhaupt?
Diesen Fragestellungen widmet sich die vorliegende Publikation. Sie ist ein Ergebnis des 21. Bielefelder Sympo-
siums über Fotografie und Medien an der Fachhochschule Bielefeld, das unter dem Titel *Abstrakte Fotografie:
Die Sichtbarkeit des Bildes* im Dezember 2000 stattfand. Parallel dazu zeigte die Kunsthalle Bielefeld die erste
umfassende Ausstellung zum Thema mit über 200 Werken von Künstlerinnen und Künstlern des 19. und 20. Jahr-
hunderts. Ergänzt wurden die Aktivitäten durch Einzelausstellungen und Vorträge an diesem Standort, der sich in
den vergangenen dreißig Jahren der Auseinandersetzung mit dieser Bildgattung besonders gewidmet hat. Trotz-
dem bleibt die Eingangsfrage weiterhin bestehen: Was ist Abstrakte Fotografie? Wie stellt sich ihre Bildrealität, ihr
Bildbegriff heute dar? In den Beiträgen der vorliegenden Publikation werden dazu durchaus unterschiedliche Stand-
punkte vorgetragen. ■ Dennoch wird niemand, der den vorliegenden Band zur Hand nimmt, die Existenz abstrak-
ter Fotografien ernsthaft in Frage stellen wollen. Sondern er wird feststellen, daß sich das ursprünglich ganz und
gar gegenständlich ausgerichtete Medium stets auch nicht-gegenständlich artikuliert hat; es hat abstrakte Bilder
hervorgebracht, die allerdings von Kunstwissenschaft und Kunstpublizistik bisher kaum angemessen wahrgenom-
men worden sind. So enthält keines der zahlreichen Überblickswerke zur abstrakten Kunst im 20. Jahrhundert
nennenswerte Beispiele und Darstellungen zu entsprechenden Aktivitäten in der Fotografie. Abstrakte Malerei,
Grafik, Skulptur, auch der abstrakte Film: Ja! Abstrakte Fotografie: Fehlanzeige. Und erst jetzt, mehr als achtzig
Jahre, nachdem der Fotograf Alvin Langdon Coburn den Begriff geprägt hat, wurde seine Vision Realität. Der 1916
von ihm vorgeschlagene Ausstellungstitel *Abstrakte Fotografie* wurde nicht durch ihn und nicht zu seiner Zeit,
sondern erst heute und nachdem der Begriff eine eigene Geschichte gebildet hat, verwirklicht. ■ Insofern muß

What is Abstract Photography? What could Abstract Photography be? Does Abstract Photography, as such, exist?
This publication focuses on questions like these. It is a result of the 21st Bielefeld Symposium on Photography and
Media held under the title *Abstract Photography: The Visibility of the Image* at the Fachhochschule Bielefeld—Uni-
versity of Applied Sciences—in December 2000. In conjunction with this symposium, the Kunsthalle Bielefeld pre-
sented the first comprehensive art historical exhibition on Abstract Photography with over 200 works by artists of
the nineteenth and twentieth century. This program was complemented by a number of solo exhibitions and lec-
tures in Bielefeld, a place which for the past thirty years has devoted itself to the dialogue on this artistic genre.
Nonetheless, the introductory question—namely, "What is Abstract Photography?"—still remains valid. How is its
pictorial reality, its pictorial terminology seen today? Indeed, the participants of the panel discussion—printed in
the final section of the book—have advocated different points of view on this subject. ■ However, nobody who
reads the present publication would seriously want to question the existence of an abstract tendency in photogra-
phy. The reader will, rather, come to realize that the originally figurative medium invariably also spoke in a non-figu-
rative manner; it created abstract images which, up to now, have hardly been properly acknowledged in the field of
art and art history. Thus, none of the numerous 'histories' of Abstract Art include noteworthy examples and por-
trayals of such work in the domain of photography. Abstract painting, abstract prints, abstract sculpture and
abstract cinema: Yes! Abstract Photography: No go! And only today, more than eighty years after Alvin Langdon
Coburn first mentioned the term has his vision become a reality. The exhibition title, *Abstract Photography*, recom-
mended by Coburn in 1916, did not find realization for him and in his time, but only today and after it made history.

man den Begriff sowohl mit einem Ausrufungszeichen als auch mit einem Fragezeichen versehen: Ist nicht jedes Foto abstrakt? Was ist überhaupt ein Foto, was abstrakt? Bekanntlich gibt es kein Bild, das nicht täuscht. Die Bildskepsis der Wissenschaften ist bekannt. Allerdings bahnt sich gerade hier ein Anschauungswandel an: Das Bild wird längst nicht mehr ausschließlich als Realität vermittelndes, sondern als Realität schaffendes Phänomen erkannt. Es hat nicht nur dienende Funktion als Medium für Kommunikation und Erkenntnisgewinn, sondern ist selbst objektiver Bestandteil des täglichen Lebens und führt Verhältnisse eigener Art herbei. Damit wird es zum Gegenstand eines neuen Wissenschaftsgebietes, das diese Verhältnisse auf seine Weise betrachtet und reflektiert: Bildtheorie, Bildforschung, Bildwissenschaft, mit Spezialdisziplinen wie Visualisierung und Visualistik, sind die Begriffe dazu, unter denen entsprechende Fragestellungen heute umfassender und grundlegender als bisher behandelt werden. Kunstgeschichte und Kunsttheorie sind dabei Teile eines Ganzen, das diese Teile in sich ein schließt und interdisziplinär vernetzt. So ist es möglich, daß auch ein Gebiet wie die Abstrakte Fotografie neu gesehen und bewertet wird. Es wird dabei vielleicht weniger historisch-ideologisch – wie bisher – als vielmehr phänomenologisch und von seinen tatsächlichen Gegebenheiten und Erscheinungen her wahrgenommen und begründet. Fragen beziehen sich auf seinen Wert, auf die Bewertung seiner Bildleistungen wie auch seiner allgemeinen gesellschaftlichen Bedeutung und Funktion. ■ Erklärtes Ziel dieser Publikation ist es daher, entsprechende Fragestellungen zu behandeln und zugleich die bildnerischen Potentiale der Kunst der Abstrakten Fotografie, ihre Ästhetik, ihre faszinierenden Facetten und ihr reiches Formvokabular zu zeigen. Dabei steht nicht, wie schon so häufig diskutiert, Fotografie als Medium im Mittelpunkt. Es geht weniger darum, was und wie das Foto etwas sichtbar macht, sondern vor allem darum, was es sichtbar *ist*: Um »Die Sichtbarkeit des Bildes«, wie es Lambert Wiesing

■ And so we should put both an exclamation mark, as well as a question mark behind the term: Is not every photo abstract? What, indeed, is a 'photo' and what is 'abstract'? Does not every image deceive? The scepticism of academia towards the image is known. Admittedly, a change in attitude is taking place right here: The image is no longer seen as one transporting 'reality', but as a phenomenon creating 'reality'. The image not only functions as a medium for communication and cognitive gains, but, as an objective part of everyday life, it creates its own conditions. Thus, the image has become the subject of a new branch of science that studies and reflects upon these conditions in its own way—something which is increasingly taking place today: The theory of the image, the research of the image, the science of the image, including specialized disciplines such as visualization and visualistics. These categories create subjects which help us examine the relevant questions more closely and more deeply than before. The history and theory of art are thereby only parts of a whole which includes and connects the aforementioned categories in an interdisciplinary manner. Thus, it is possible that a domain like that of Abstract Photography will be viewed and assessed in a novel way. Perhaps it will subsequently be perceived and interpreted less historically and ideologically, but phenomenologically and from its true conditions and appearances instead. Our questions should refer to its value, its pictorial capacity, as well as to its overall social meaning and function. ■ It is the purpose of the present publication to discuss all questions pertaining to this subject and, likewise, to draw attention to the pictorial potential of the art of Abstract Photography, to its aesthetics, its many aspects and its rich vocabulary. The focus of the discussion is for once not photography as a medium. It is not a question of what and how the photograph is able to make visible. It is, rather, a matter of what it visibly *is*: It has to do with "the visibility of the image"—

formuliert. ■ Eine Publikation wie diese und die ihr vorausgehenden Aktivitäten sind ohne vielfache persönliche Unterstützung und institutionelle Förderung nicht zu realisieren. Ich danke daher allen an dieser Publikation Beteiligten für fachlichen Rat und tätige Hilfe. Besonders danke ich meinem Kollegen Prof. Gerd Fleischmann für die exzellente Buchgestaltung und meinem Mitarbeiter Dipl.-Des. Stefan Klink für die kompetente gestalterische und technische Umsetzung. Ohne die dankenswerte Förderung des Gesamtvorhabens durch die Fachhochschule Bielefeld und in besonderer Weise durch das Deutsche Bundesministerium für Bildung und Forschung wäre das Vorhaben in diesem Umfang nicht durchführbar gewesen. Schließlich danke ich der ARNOLDSCHEN Verlagsanstalt in Stuttgart für ihr Engagement, dieses bisher weithin unbeachtete Thema in so großzügiger Ausstattung herauszugeben.

Gottfried Jäger, im Januar 2002

as Lambert Wiesing so aptly put it. ■ A publication like this and the events preceding it could not have been realized without extensive personal and institutional support. I would, therefore, like to thank all those who helped with this publication for their expert advice and their active assistance. I am particularly indebted to my colleague Prof. Gerd Fleischmann for his excellent book design and to my assistant Dipl.-Des. Stefan Klink for his competent layout and technical execution. Special gratitude should be extended to the Fachhochschule Bielefeld – University of Applied Sciences, and, in particular, to the German Federal Ministry of Education and Research whose commendable support made the whole project possible. Finally, I would like to thank the publisher for their commitment to undertake the publication of such a lavish book on a subject virtually unheeded to date.

Gottfried Jäger, January 2002

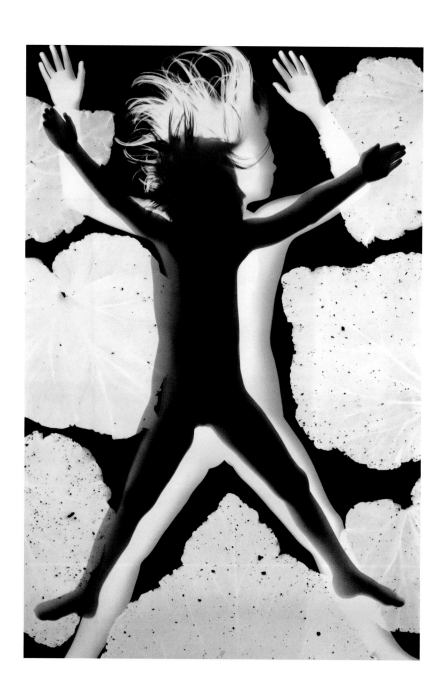

Martha Madigan: *Geneta Mana*, 2000
Solar photogram. Unique gelatin silver
print, 147 x 101.5 cm
Courtesy of the artist and Michael
Rosenfeld Gallery, New York

Gottfried Jäger

Die Kunst der Abstrakten Fotografie The Art of Abstract Photography

Der Beitrag beschreibt in Umrissen eine Kunstform des 20. Jahrhunderts, bei der die gegenständliche fotografische Abbildung zu Gunsten nicht-gegenständlicher fotografischer Bildstrukturen in den Hintergrund tritt. Im Vordergrund steht die Veranschaulichung einer (abstrakten) Idee, die unter bewußter Vernachlässigung von Aspekten der Gegenständlichkeit und Wiedererkennbarkeit fotografisch realisiert wird. Dies führt zu Bildaussagen, die die gegenständlich-abbildende Fotografie nicht ermöglicht oder die deren Grenzen übersteigen. Trotz ihrer bedeutenden Bildleistungen fand diese Richtung in der Kunst- und Mediengeschichte bisher nur selten die ihr gebührende Beachtung. ■ ■ **Stationen** Die Frühzeit der Fotografie war durch das Motiv der Abbildungstreue bestimmt.[1] Es richtete sich in erster Linie auf die Wiedergabe der ›äußeren Wirklichkeit‹ durch einen technischen Apparat, der seine Bilder mit »fast mathematischer Genauigkeit« und dabei weitestgehend automatisch und willentlich ohne die Hand eines Künstlers entstehen ließ.[2] Das Verfahren bedeutete eine entscheidende Wende für die bis dahin geltenden Regeln jeglicher Bildproduktion: So war die Abbildungsqualität nicht länger an manuelle Fähigkeiten gebunden. Details und Perspektive des Bildes entstanden in einem einzigen kurzen Moment, »mit einem Mal«. (Abb. S. 14, oben) Nur auf die Farbigkeit mußte anfangs noch verzichtet werden. ■ Doch die rasch einsetzende Popularisierung des neuen Verfahrens um die Mitte des neunzehnten Jahrhunderts rief auch prominente Gegner auf den Plan. Das eigentlich Neue, sein technischer Charakter, wurde als kunstfremd erkannt und in der bald einsetzenden Debatte um die geistigen Potentiale des Mediums eher zu dessen Verhängnis. Fotografie sollte der Kunst dienen, nicht Kunst hervorbringen. So warnte Charles Baudelaire (1821–1867) 1859 eindringlich: »Wenn es ihr [der Fotografie; G. J.] erlaubt wird, sich auf die Domäne des Geistes und der Phantasie auszuweiten, auf all das, was nur durch die Seele des Menschen lebt, dann wehe uns!«[3] Die Geschichte ist weithin bekannt, und

This article outlines a form of art of the twentieth century which gradually breaks with the photographic representation of real objects and turns to non-objective photographic image structures. The central issue involved here is the visualization of an (abstract) idea which is captured by the camera, deliberately ignoring aspects of object reproduction and any claim to recognition as such, aiming at presentational statements that object-bound, reproductive photography cannot achieve, and thus transcending the latter's limits. Despite remarkable achievements with regard to pictorial creativity, this development in the history of art and media has hitherto rarely received its deserved recognition. ■ ■ **Stages** The early days of photography were determined by the motif 'fidelity to reproduction' (*Abbildungstreue*).[1] Photography was primarily concerned with reproduction and documentation of an 'external reality' using a technical apparatus that produced pictures with "almost mathematical precision", almost completely automatically, indeed, deliberately foregoing the hand of the artist.[2] The technique was a decisive change in the rules of picture production that had been hitherto valid: Thus the quality of reproduction was no longer bound by manual ability. Details and perspectives of a picture appeared in one, brief moment, "all at once" (fig. p. 14, top). It was only color that initially played no part. ■ But the growing popularity of the new technique around the middle of the 19th century also evoked eminent opposition. What was actually new about it,—its technical qualities—was claimed to be alien to art, and in the ensuing debate about the spiritual potential of the medium it was this very technical aspect that threatened to become its downfall. Photography was to serve art, not produce it. Thus in 1859 Charles Baudelaire (1821–1867) warned in no uncertain terms: "If it [photography; G. J.] is allowed to spread into the fields of the intellect and fantasy, into all that is suffused only by the human soul, then woe

1 Jäger, Gottfried: Abbildungstreue. Fotografie als Visualisierung: Zwischen Bilderfahrung und Bilderfindung. In: Dress, Andreas; Jäger, Gottfried (eds.): *Visualisierung in Mathematik, Technik und Kunst. Grundlagen und Anwendungen.* Braunschweig, Wiesbaden 1999, pp. 137–150.

2 Baier, Wolfgang: Die Entdeckung der Fotografie. In: Baier, Wolfgang: *Quellendarstellungen zur Geschichte der Fotografie.* Halle an der Saale 1964, pp. 47ff.

3 Baudelaire, Charles: Die Fotografie und das moderne Publikum (1859). In: Kemp, Wolfgang (ed.): *Theorie der Fotografie Vol. I, 1839–1912.* München 1980, p. 111.

auch ihr Ergebnis. Die künstlerische Antwort auf die Ablehnung bestand in der Anpassung an die vorherrschenden ästhetischen Normen der Zeit. Eine bildmäßige, piktoralistische Fotografie entstand. Sie suchte das vermeintliche Manko durch sinnstiftende Themen und bildgebende Verfahren auszugleichen. Gestellte, symbolisch aufgeladene Szenen, verbunden mit der Manipulation des technischen Prozesses, mit Fotoübermalungen und Fotomontagen, waren die Folge. Die allegorischen Inszenierungen von Henry Peach Robinson (1830 – 1901) sind dafür ein Beispiel, so seine Fotocollage *Fading Away* von 1858 (Abb. S. 14, unten), sowie später die breite Bewegung der Kunstfotografie um 1900 mit ihren Ausläufern bis weit in das 20. Jahrhundert hinein. Die Entwicklung war auch verbunden mit einer Fülle von Erfindungen neuer Bildtechniken, den sogenannten Edeldruckverfahren. Sie sind Zeugnisse der vielfältigen und lange anhaltenden Bemühungen, das fotografische Bild im damaligen Sinne künstlerisch zu nobilitieren. ■ Damit trat das erste Leitmotiv der Fotografie, das der Abbilder, zu Gunsten eines zweiten Motivs, dem der Sinnbilder, zurück. Es ging nicht um die einfache Wiedergabe konkreter Objekte, sondern um eine sinnerfüllte Darstellung und Komposition. Die Gegenstände wurden dabei zum Genre, etwa zur ›Landschaft‹, und sie erschienen dabei oft nur als Anlaß für eine über den Gegenstand hinausweisende, symbolische Gestaltung (Abb. S. 15, oben). Begriffe wie Piktoralismus, Symbolismus und die erwähnte Kunstfotografie um 1900 sind Synonyme dieser Tendenz.[4] ■ Eine dritte Richtung, die der tatsächlich ungegenständlichen Strukturbilder[5], setzt nach der Jahrhundertwende ein. Sie stellt eine andere Fotografie vor, indem sie weder auf die vordergründige Welt der beobachteten Objekte (objektive Fotografie) noch auf die hintergründige Welt der beobachtenden Subjekte (subjektive Fotografie), sondern nurmehr auf sich selbst verweist. Eine neue Idee von Fotografie entsteht, die sich selbst verwirklicht und zum Gegenstand erhebt: Eine Fotografie der Fotografie. ■ Ihr geht es

betide!"[3] This story is well known, and so are its consequences. The artistic response to this degradation was to comply with the prevalent aesthetic norms of the times. A picture-like pictorial kind of photography was the result. It tried to compensate the assumed shortcomings with subject-matter that was recognizable, using reproductive techniques. Stilted, symbolically overcharged scenes, combined with manipulation of the technical process, attempts at retouché and photo montages,—all these were the result. The allegorical installations of Henry Peach Robinson (1830–1901) are an example of this, for one his photo collage *Fading Away* of 1858 (fig. p. 14, bottom), and also later the widespread movement of Art Photography of 1900, with its offshoots reaching far into the 20th century. The development also produced a whole variety of inventions of new picture techniques, the so-called high-grade printing technique. They bear witness to the multifarious and lasting efforts to ennoble the photographic picture in the artistic sense of the times. ■ Thus the first leitmotif of photography, that of icons, gave way to a second motif, that of symbols. The issue in hand was not so much the representation of a reality as the presentation of an idea. The concrete photo objects became a general genre, as it were, a 'landscape', and as such often appeared simply as an excuse for a fitting form. The design elements of the picture were the essential thing (fig. p. 15, top). Terms like Pictoralism, Symbolism and the previously mentioned Art Photography of 1900 are synonymous for this tendency.[4] ■ A third tendency—that of actual non-object structures[5]—presents itself at the turn of the century. It introduces a different form of photography, one that refers neither to the superficially visible world of observed objects (objective photography), nor to the obscure invisible world of observing subjects (subjective photography), but that refers first and foremost to itself: The self production of the medium. A new idea of photo-

4 Kaufhold, Enno: *Bilder des Übergangs. Zur Mediengeschichte von Fotografie und Malerei in Deutschland um 1900.* Marburg 1986.

5 Zum Ursprung des Begriffs vergl. For the origin of this term cf.: Schmoll gen. Eisenwerth, J. A.: *Zum Spektrum der Fotografie: Abbild, Sinn-Bild und Bildstruktur.* In: Schmoll gen. Eisenwerth, J. A.: *Vom Sinn der Fotografie. Texte aus den Jahren 1952–1980.* München 1980, pp. 236 ff.

um den Eigenwert ihrer Bilder und um deren besondere Atmosphäre, um das reine Foto – ohne daß dieses durch die Erkennbarkeit vertrauter Gegenstände gestört würde. Ihr Thema ist die Innenwelt des Apparates, der nun nicht mehr der Bildaufnahme, sondern der Bilderzeugung dient. Das bedeutet ein Absehen von bisherigen Gepflogenheiten und eine Umkehrung bisheriger Verhältnisse. Indem sie von ihren bisherigen Motiven abstrahiert, beginnt die Fotografie, die ihr zu Grunde liegenden Elemente und Strukturen in den Blick zu nehmen, zu erkennen, sie offenzulegen und auf neue Art anzuwenden. Sie wird sich damit auch ihres eigenen konstruktiven Charakters bewußt und wandelt sich von einer foto*grafischen*, bild*aufzeichnenden*, zu einer foto*genen*, bild*erzeugenden* Kunstform.[6] ■ Seitdem kann man von einer Konkreten oder auch Absoluten Fotografie sprechen.[7] Ihre Ergebnisse sind der weitestgehende Ausdruck menschlichen Abstraktionsdranges in der Kunst der Fotografie zu Beginn des 20. Jahrhunderts. Wilhelm Worringer (1881–1965) hat das Phänomen 1908 in seinem grundlegenden Werk *Abstraktion und Einfühlung* als universale Erscheinung erkannt und den Drang zur Einfühlung in die Welt der Objekte dem Drang zur Abstraktion komplementär gegenübergestellt: »Als diesen Gegenpol betrachten wir eine Ästhetik, die, anstatt vom Einfühlungsdrang des Menschen auszugehen, vom Abstraktionsdrang des Menschen ausgeht. Wie der Einfühlungsdrang als Voraussetzung des ästhetischen Empfindens seine Befriedigung in der Schönheit des Organischen findet, so findet der Abstraktionsdrang seine Schönheit im lebensverneinenden Anorganischen, im Kristallinischen, allgemein gesprochen, in aller abstrakten Gesetzmäßigkeit und Notwendigkeit.«[8] ■ Neben dem ewigen Wunsch, die wahrgenommene Welt wiederzugeben und zu interpretieren, existiert der ewige Wunsch, sie zu verändern und eine neue Welt zu schaffen. Das gilt auch für die Fotografie, und ihre Entwicklungsgeschichte ist geradezu ein Modellfall für den Vollzug beider Bestrebungen. Fotografie ist danach nicht länger

graphy is born, one that presents its own immanent reality and makes itself the object: A photograph of the photograph. ■ The main point of interest here is the intrinsic value of the picture itself and its special kind of atmosphere; we are dealing with the pure photo, the photo that renounces any need to recognize familiar objects. Its subject is the inner world of the apparatus, which no longer serves the picture as an end-product, but the process of picture-producing. This means disregarding traditional practices and reversing traditional prerequisites. By conceptualizing traditional motifs, photography begins to discern and reveal its basic elements and structures, and apply them in a new way. It also involves discerning its very own particular constructive nature. It transforms itself from a form of art that is photographic, image taking – to one that is photogenic, image giving.[6] ■ In this sense one can talk of a concrete, even absolute form of photography.[7] Its results are the most extreme expression of man's aspiration to abstraction in the art of photography at the beginning of the 20th century. Wilhelm Worringer (1881–1965) recognized this in 1908 in his fundamental work *Abstraktion und Einfühlung* (Abstraction and Empathy) as an universal phenomenon, seeing the need for empathy with the world of objects as complementary to the need for abstraction: "The opposite pole that presents itself here is an aesthetic approach that instead of presupposing the need of man for empathy, plays to his need for abstraction. As the need for empathy is a prerequisite for the kind of aesthetic satisfaction to be found in the beauty of the organic, so the need for abstraction finds its realization of beauty in life-negating inorganic elements, in crystalline structures, that is, generally speaking, in every abstract regularity and necessity."[8] ■ In addition to the eternal desire to present and interpret the perceived world, there is the eternal desire to change it and create a new world. This is true for photography too, and its history of development reflects

6 Jäger, Gottfried: *Bildgebende Fotografie. Fotografik-Lichtgrafik-Lichtmalerei. Ursprünge, Konzepte und Spezifika einer Kunstform.* Köln 1988; Jäger, Gottfried: Fotogene Kunst. Von der Experimentellen zur Bildgebenden Fotografie. In: Hülsewig-Johnen, Jutta; Jäger, Gottfried; Schmoll gen. Eisenwerth, J. A.: *Das Foto als autonomes Bild. Experimentelle Gestaltung 1839–1989.* Ausstellungskatalog Exhibition catalog. Kunsthalle Bielefeld/ Bayerische Akademie der Schönen Künste, München. Stuttgart 1989, pp. 37ff.

7 Jäger, Gottfried: Konkrete Fotografie und konstruktive Konzepte. In: Jäger, Gottfried: *Fotoästhetik. Zur Theorie der Fotografie. Texte aus den Jahren 1965 bis 1990.* München 1991, pp. 91ff.

8 Worringer, Wilhelm: *Abstraktion und Einfühlung. Ein Beitrag zur Stilpsychologie.* Amsterdam 1996, pp. 36–37 (Erstausgabe first published München 1908).

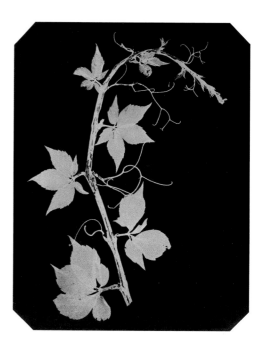

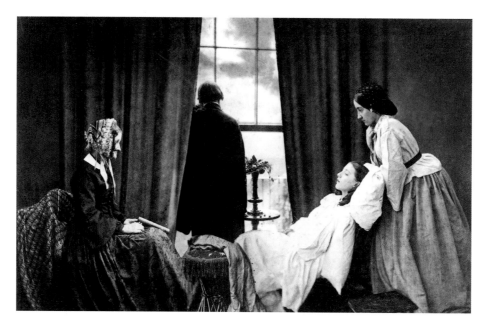

William Henry Fox Talbot: *Photogenic Drawing of a Plant*. From one of Fox Talbot's own albums, dated 1835–1839, Lacock Abbey Collection (top)

Henry Peach Robinson: *Fading Away*, 1858 Photocollage The Royal Photographic Society, Bath/ Great Britain (bottom)

Gottfried Jäger

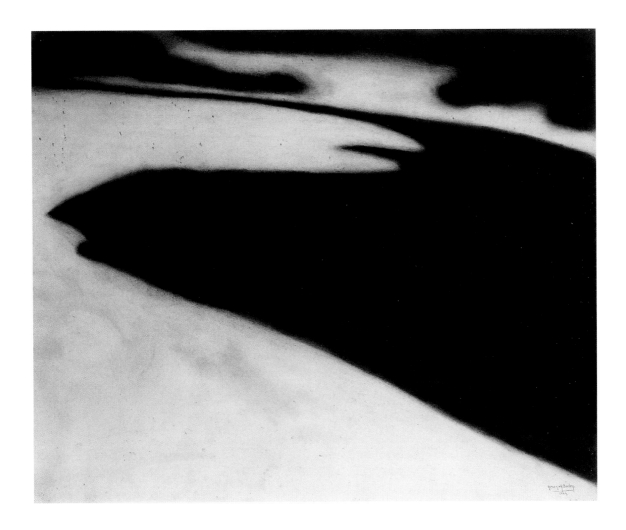

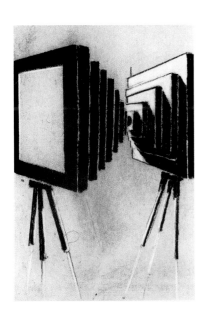

George H. Seeley: *Winter Landscape*, 1909
Two-color gum platinum print, 43.7 x 53.8 cm
Gilman Paper Company Collection (top)

Jacob Mattner: *Wie die Bilder die Camera
sehen* (How Images View the Camera), 1987
Crayon drawing, 24 x 15.5 cm
Courtesy of the artist (bottom)

nur Mittel der Darstellung – Medium –, sondern wird selbst zum Gegenstand – zum Objekt. Sie ist nicht mehr *Repräsentat* und bildet nicht nur etwas ab oder stellt es dar, sondern sie ist, was sie ist: *Präsentat*. Zwar können abstrakte Fotografien auch als visuelle Zeichen - als Anzeichen, Hinweise, Indizes oder Symptome - gelesen werden, so etwa für den Schöpfungstrieb des Menschen im Umgang mit einem primär auf Reproduktion hin angelegten Apparat. Im Augenblick ihrer Entstehung aber sind sie lediglich Objekte. Objekte ihrer selbst, mehr nicht. Aber sie sind auch nicht nichts. Fotografien dieser Art sind Gegenbilder, Kontravisionen.[9] Sie entfernen sich von ihrem ursprünglich medialen Charakter und nehmen Objektcharakter an. Und sie nehmen sich die Freiheit, ihren Apparat umzuwandeln und etwas Anderes aus ihm zu machen. Sie spielen bewußt gegen ihn, wie es Vilém Flusser (1920 –1991) später treffend formuliert.[10] ■ Im Unterschied zu den piktoralistischen Tendenzen des 19. Jahrhunderts, die die Technizität des fotografischen Verfahrens leugnen, wird diese hier bejaht. Der Blick der Kamera wendet sich dabei auf sich selbst. Auf einem hohen abstrakten Niveau spiegelt das System seine eigenen inneren Verhältnisse und bildet sie ab. Mit anderen Worten: »Es hat Kategorien wie Information und Verantwortung abgeworfen und ist zu sich selbst gekommen«.[11] Nach dem ersten fotografischen Motiv, dem Abbild, und dem zweiten, dem Sinnbild, entsteht jetzt ein drittes: Das Selbstbild des Systems (Abb. S. 15, unten). Seine ersten Ergebnisse können als frühe Zeugnisse fotografischer Selbsterkundung angesehen werden. Ihr Konzept ist in den 1910er Jahren in Umrissen erkennbar und wächst in den 1920er Jahren zu einem eigenen Gebiet, der Experimentalfotografie, heran. Es entwickelt sich nach dem Zweiten Weltkrieg vor allem in Westdeutschland fort und erfährt eine gewisse Vollendung in Theorie und Praxis seiner generativen[12] und analytischen[13] Tendenzen in den 1960er und 1970er Jahren, ehe es danach in post-fotografischen Konzepten aufgeht. ■ Die erste programmatische Mani-

in an exemplary manner the fulfilment of both endeavours. Photography is thus no longer merely a means of presentation, a medium; it becomes the goal itself, the object. It is no longer merely a means of reproduction, it no longer reproduces or presents—it is a presentation in its own right. Abstract photographs can, of course, be interpreted as visual signs, as indicators, pointers, indices or symptoms, for example, for the creative need of man when using his apparatus primarily for the purpose of reproduction. But as soon as they appear these signs are simply objects. Objects of themselves, nothing more. In this respect photographs of this kind are counter-pictures, as it were contra-visions.[9] They gradually lose their original medial character and assume the characteristics of objects. Indeed, they take the liberty of re-modelling the function of their apparatus and making it into something different. They deliberately challenge it, as Vilém Flusser (1920 –1991) later fittingly put it.[10] ■ In contrast to the pictoralistic tendencies of the 19th century that disavow the technical nature of the photographic process, the present-day tendency embraces it. The sights of the camera are here directed at itself. On a high abstract level the system reflects its own internal prerequisites. In other words, "It has thrown overboard such categories as information and responsibility, and has introverted itself."[11] After the first photographic motif, i. e. reproduction, and the second, the allegorical picture, there is now a third: The introspective self-portrayal of the system itself (fig. p. 15, bottom). Its first results can be regarded as early documents of photographic self-introspection. Its concept is already in part evident in the 1910s and develops in the 1920s to a discipline in its own right, i. e. experimental photography. It continues to develop after the Second World War, especially in West Germany, and reaches, as it were, its pinnacle in theory and practice in its generative[12] and analytical[13] tendencies in the Sixties and Seventies before becoming subsumed

9 Fontcuberta, Joan: *Kontravisionen/ Countervisions. Das Auge von Zeiss gegen das Auge von Zeus*. In: *European Photography* No. 28/1986, pp. 14 – 33.

10 Flusser, Vilém: *Für eine Philosophie der Fotografie*. Göttingen 1983, p. 55. English edition: *Towards a Philosophy of Photography*. Göttingen 1984.

11 Wiesing, Lambert: *Die Sichtbarkeit des Bildes. Geschichte und Perspektiven der formalen Ästhetik*. Reinbek bei Hamburg 1997, p. 174.

12 Jäger, Gottfried; Holzhäuser, Karl Martin: *Generative Fotografie. Theoretische Grundlegung, Kompendium und Beispiele einer fotografischen Bildgestaltung*. Ravensburg 1975.

13 Gerke, Hans: *Demonstrative Fotografie*. Ausstellungskatalog exhibition catalog. Heidelberger Kunstverein 1974; Neusüss, Floris M.: *Medium Fotografie. Experimentelle Medienreflexion. Kenneth Josephson: Die Illusion der Bilder*. Ausstellungskatalog exhibition catalog. Fotoforum Kassel 1978.

festation für eine Abstrakte Fotografie ist dem gebürtigen Amerikaner Alvin Langdon Coburn (1882–1966) zu verdanken, der den Begriff 1916 u. W. erstmals zur Diskussion stellte und niederschrieb – und zwar als Idee für eine Ausstellung, die nicht von ihm, sondern erst in jüngster Zeit möglich wurde. Coburn regte an, eine Ausstellung zum Thema Abstrakte Fotografie zu realisieren und dabei keine Arbeit anzunehmen, »in der das Interesse am Bild-gegenstand das Gefühl für außergewöhnliche Aspekte übersteigt. Ein Gefühl für Form und Struktur ist vor allem von Bedeutung, und man sollte die Gelegenheit nutzen, um unterdrückter und unerwarteter Originalität zum Aus-druck zu verhelfen.«[14] ■ Person und Werk Coburns werden in den Beiträgen von Rolf H. Krauss und Martin Roman Deppner im Rahmen dieser Publikation eingehend dargestellt. Die Ausstellung mit dem von Coburn vorgeschla-genen Titel wurde erst durch die Ausstellung *Abstrakte Fotografie* der Kunsthalle Bielefeld mit mehr als zwei-hundert Originalen aus dem ausgehenden 19. und dem 20. Jahrhundert realisiert.[15] Hier waren unter anderem auch sechs der berühmten *Vortographs* von Coburn zu sehen, prismatisch vielfach gebrochene, geometrisch-ungegenständliche Lichtmuster auf Fotopapier (Abb. S. 126f.). Sie gaben seinem Programm erste konkrete Form, indem Coburn die elementaren fotografischen Bildmittel – Licht, Optik, lichtempfindliches Material – zum eigent-lichen Bildgegenstand erhob. Es handelt sich um reine Fotokompositionen ohne vordergründig abbildende Merk-male; sie sind etwas Besonderes, Einmaliges, »Bilder reiner Sichtbarkeit«, wie Lambert Wiesing es in seinem Bei-trag ausdrückt.[16] Sie stellen nach meiner Überzeugung ästhetisch auch etwas Anderes dar als die anerkannt abstrakten Bildkompositionen der Maler jener Zeit, wie die von Picasso, Léger, Kupka, Robert und Sonia Delaunay, Kandinsky, Balla und anderen ab 1910. Die Vortografien von Coburn besitzen eine eigene ästhetische Qualität. Sie entstanden aus dem Geist der Zeit. Aber sie sind nicht Imitate der Malerei, sondern sie sind eigenständige

in post-photographic concepts. ■ The first programmatic statement concerning Abstract Photography can be attri-buted to the American-born photographer, Alvin Langdon Coburn (1882–1966) who presumably introduced and used the term in 1916 — in connection with the idea for an exhibition which he did not organise himself. Coburn's idea was to initiate an exhibition on the subject of Abstract Photography and to reject any work "in which the interest in the object of the picture goes beyond any feeling for exceptional aspects. It is, above all, a feeling for form and struc-ture that is especially important, and one should take advantage of the opportunity to promote the expression of suppressed and unexpected originality."[14] ■ The people, their work and their relationship to abstract photography were to be later analysed in detail in articles by Rolf H. Krauss and Martin Roman Deppner. There was a comprehen-sive presentation, using the title that Coburn coined, more than 80 years later at the exhibition *Abstrakte Foto-grafie* (Abstract Photography) at the Kunsthalle Bielefeld, where more than 200 original works from the 19th and 20th centuries were shown.[15] Amongst the exhibits were six of the famous Vortographs by Coburn, — prismatically, multiply fragmented, geometrical, non-object light patterns on photo paper (figs. pp. 126f). They gave his program their first specific form. Coburn succeeded in making elementary photographic pictorial means — light, optics, light-sensitive material — the object of the picture. They are pure, photographic compositions without superficially visible reproductive characteristics, something special, unique, "pictures of pure visibility", as Lambert Wiesing later expressed it.[16] In my view they are different in aesthetic terms from the acclaimed abstract picture compositions of the painters of the time, as, for example, of Picasso, Léger, Kupka, Robert and Sonia Delaunay, Kandinsky, Balla and others after 1910. Coburn's Vortographs have their own aesthetic quality. They are products of the spirit of the

14 Coburn, Alvin Langdon: Die Zukunft der bildmäßigen Fotografie. In: Kemp, Wolfgang (ed.): *Theorie der Fotografie Bd. II, 1912–1945.* München 1979, pp. 55ff.

15 Kellein, Thomas; Lampe, Angela (ed.): *Abstrakte Fotografie.* Ausstellungskatalog exhibition catalog. Kunsthalle Bielefeld. Ostfildern-Ruit 2000.

16 Vgl. auch cf. Wiesing, Lambert: *Die Sicht-barkeit des Bildes.* A. a. O. op. cit., p. 154ff.

Bildleistungen eines Einzelgängers, eine These, die sich durch die folgenden Beiträge erhärten läßt. Auch die Kölner Coburn-Tagung im Herbst 1998 hat dazu deutliche Hinweise erbracht.[17] ■ Das schöpferische Spiel mit dem Apparat, verbunden mit dem Wunsch nach Überwindung seiner Zwänge und nach Erweiterung seiner Ausdrucksfähigkeiten – dies scheinen die wesentlichen Motive für das Auftauchen abstrakter Fotografien zu Beginn des 20. Jahrhunderts zu sein. Dafür gibt es in Europa und den USA deutliche Anzeichen, wie es die Beiträge in dieser Publikation belegen. ■ ■ **Experimentelle Fotografie** Aber auch der Wunsch, tiefer in die Welt von Natur und Technik und damit in organische und anorganische Lebens- und Realitätszusammenhänge einzudringen, bilden ein wesentliches Motiv für das Aufkommen zunehmend abstrakter werdender Fotografien Ende des 19. Jahrhunderts. Dies vor allem unter wissenschaftlichen Vorzeichen. Ihre Bildergebnisse entfernen sich mehr und mehr von den natürlichen Seherfahrungen. Aber sie erschließen demgegenüber eine völlig neue Bildwelt, denken wir an die Fotografie schneller und schnellster Bewegungen, an die Kurzzeit- und Strobofotografie, die Mikrofotografie, die Thermo- und Schlierenfotografie usw. Neue bildgebende Verfahren lassen neue Inhalte und Sehweisen entstehen. Das führt zu einem erhöhten Interesse an diesen Verfahren und an den bildnerischen Mitteln. Die künstlerische Avantgarde jener Zeit nimmt sie begierig auf, löst sie aus ihrem ursprünglichen fotografischen Kontext und führt sie neuen Bedeutungen zu. Zu denken ist an den Pointillismus in der Folge von Farbtheorien und optischen Experimenten zur aufkommenden Farbfotografie.[18] Zu denken ist auch an die vielfältigen Versuche zur fotografischen Bewegungsdarstellung als Vorstufe zur Kinematografie und zum Film mit ihren ästhetisch überraschenden Effekten kontinuierlicher und intermittierender Lichtspuren (Abb S. 36). Sie werden von der Kunst des italienischen Futurismus[19] und des englischen Vortizismus[20] aufgenommen und bilden eine wichtige Grundlage für neue und

times. But they are not imitations of painting. On the contrary, they are individual, pictorial achievements of an individualist, a thesis supported by the following articles. The Coburn conference in Cologne in the autumn of 1998 also bears witness to this.[17] ■ Creative experimentation with the apparatus, combined with the desire to overcome its constraints and develop its forms of expression,— all this seems to me to be the basic reason for the emergence of abstract photography at the beginning of the 20th century. There are clear indications of this in Europe and the USA, as the articles in this publication excellently demonstrate. ■ ■ **Experimental Photography** But it is also the desire to penetrate deeper into the world of nature and technology, and thus into organic and inorganic elements of life and reality that is also an important reason for the emergence of increasingly abstract photographs at the end of the 19th century. They depart more and more from natural perceptions of the eye. But they also open up a completely new world of images, as, for example, the photographs depicting fast or extremely fast movement, the high-speed photography, stroboscope photography, photomicrography, thermo photography, Schlieren photography etc. New, picture-creating techniques produce new contents and perspectives. This promotes increased interest in these techniques and in the means. Avant-garde art of the times assimilates them with eagerness; extracts them from their original photographic context and gives them new significance. Not to be forgotten is Pointillism as a consequence of the color theories and optical experiments in response to the emergence of color photography.[18] In addition, of course, there are the various attempts at photographic presentation of movement as a precursor to cinematography and the film with the surprising aesthetic effects created by unbroken and intermittent traces of light (figs. p. 36). They are assimilated by art in Italian Futurism[19] and English Vorticism[20], and create an important

17 Deutsche Gesellschaft für Photographie (DGPh), Köln, in Kooperation mit dem in cooperation with George Eastman House, Rochester, N.Y.: *Alvin Langdon Coburn.* Köln, 18. September 1998. Kongress, Ausstellung, Katalog congress, exhibition, catalog: Römisch-Germanisches Museum, Köln; Steinorth, Karl (ed.): *Alvin Langdon Coburn. Fotografien 1900–1924.* Zürich, New York 1998.

18 Koshofer, Gert: *Farbfotografie.* Vol. 1–3. München 1981.

19 Apollonio, Umbro: *Der Futurismus. Manifeste und Dokumente einer künstlerischen Revolution 1909–1918.* Köln 1972; Calvesi, Maurizio: *Futurismus. Kunst und Leben.* Köln 1987.

20 Orchard, Karin (ed.): *BLAST Vortizismus. Die erste Avantgarde in England 1914–1918.* Ausstellungskatalog exhibition catalog. Sprengel Museum Hannover, Haus der Kunst München 1996.

eigene Bildstile und Bildsprachen. ■ In der Zeit danach lassen sich zahlreiche weitere markante Stationen abstrakter Fotografie mit unterschiedlichsten Mitteln und Motiven erkennen. So die Schadografien von Christian Schad (1894–1982), 1919 in Zürich als ›spielerische Inventionen‹ unter dem Einfluß der Dada-Bewegung entstanden (Abb. S. 37)[21]; die Rayografien von Man Ray (1890–1976) unter dem Vorzeichen der surrealistischen Methode des automatischen Schreibens (Abb. S. 38)[22]; die Fotogramme, Fotomontagen und Fotoplastiken des Bauhaus-Lehrers und ›Lichtners‹ László Moholy-Nagy (1895–1946) auf der Basis konstruktivistischer Ideale ab Anfang der 1920er Jahre – um nur einige zu nennen (Abb. S. 39).[23] Das ›Photo‹ wurde dabei theoretisch und experimentell auf seine Ursprünge und Wurzeln – gestalten mit Licht – zurückgeführt und seine Aussagemöglichkeiten von hier aus erheblich erweitert. Eine wahrlich abstrakte Fotografie entstand. Sie etablierte sich als Experimentalfotografie.[24] Ihre wichtigste Technik wurde das Fotogramm, das, ohne die Optik der Kamera zu benutzen, im fotografischen Apparat selbst entsteht, in der Camera obscura, in der Dunkelkammer. Es hat sich bis heute zu einer eigenen und ergiebigen Bildgattung der Kunst des 20. Jahrhunderts entfaltet.[25] ■ Aber nicht alle Möglichkeiten abstrakter Fotografie werden im Fotogramm erfüllt. Neben ihm existieren bis heute zahlreiche weitere Mittel und Verfahren, die zu entsprechenden Ergebnissen führen. Ein Großteil von ihnen wurde 1983 in einer repräsentativen Auswahl durch das Franklin Institute Science Museum in Philadelphia unter dem Titel *Lensless Photography* erstmals umfassend und vergleichbar nebeneinander vorgestellt. Die Auswahl zeigte Werke über einen Zeitraum von mehr als 130 Jahren, so die Photogenic Drawings von Henry Fox Talbot (1800–1877) und Anna Atkins (1799–1871) der 1840er bis 1850er Jahre bis hin zu kameralosen Arbeiten der Gegenwart. Sie enthielt Arbeiten zur Camera obscura, zum Cliché verre, zur Cyanotypie, zum Chemigramm, Bilder mit Röntgenstrahlung und Laserlicht, Hochspan-

basis for new and individual pictorial styles and languages. ■ The subsequent years produce further stages in the development of abstract photography, revealing the use of quite diversified means and motifs. This applies to the Schadographs of 1919 in Zurich by Christian Schad (1894–1982), 'playful inventions' influenced by Dadaism (fig. p. 37)[21], and also to the Rayographs of Man Ray (1890–1976) (fig. p. 38), characterized by the surrealistic method of automatic writing[22], and to the photograms, photo montages and photo plastics of the Bauhaus teacher and light artist, László Moholy-Nagy (1895–1946),—works which are based on constructivist ideals dating from the 1920's (fig. p. 39)[23]—to name but a few. The photo was traced back theoretically and experimentally to its origins and roots,—using light as a creative element—and the possibilities of expression were greatly developed from here. In this way a truly abstract form of photography was born. It became established as Experimental Photography.[24] Its most important technique became the photogram, which, without using the optics of the camera, emerges as a product within the photographic apparatus itself, in the camera obscura, in the darkroom. It has developed into its very own prodigious pictorial genre of art in the 20th century.[25] ■ But not all aspirations could be fulfilled by the photogram. In addition to this, there are to date various other means and techniques which lead to corresponding results. A large number of them were exhibited next to each other, thus inviting comparison, in 1983 in a representative cross-section by the Franklin Institute Science Museum in Philadelphia under the title of *Lensless Photography*. The collection presented works covering a period of more than 130 years, for example, the Photogenic Drawings of Henry Fox Talbot (1800–1877) and Anna Atkins (1799–1871) of the 1840s and 1850s. The exhibition included works of the camera obscura, the cliché-verre, the cyanotype-print, the chemigram, pictures of laser light, high-vol-

21 Schad, Nikolaus; Auer, Anna (ed.): *Schado-graphien. Die Kraft des Lichts.* Passau 1999.

22 Ray, Man: Rayographs 1921–1928. In: Man Ray: *Photographs 1920–1934.* New York 1975, pp. 85–104; Edouard Jaguer: *Surrealistische Fotografie. Zwischen Traum und Wirklichkeit.* Köln 1982.

23 Moholy-Nagy, László: *Malerei, Photographie, Film. Bauhausbücher Band 8,* 1925. Reprint: Mainz, Berlin 1967; *László Moholy-Nagy. Fotogramme 1922–1943.* Ausstellungs-katalog exhibition catalog. Essen: Museum Folkwang 1996.

24 Jäger, Gottfried: Experimentalfotografie. In: Gottfried Jäger: *Fotoästhetik. Zur Theorie der Fotografie. Texte aus den Jahren 1965 bis 1990.* München 1991, pp. 109ff.

25 März, Roland: Die Kunst der kameralosen Fotografie. Versuch über das Fotogramm. In: *Bildende Kunst,* No. 6/1982, pp. 279–283; Neusüss, Floris M.: *Das Fotogramm in der Kunst des 20. Jahrhunderts.* Köln 1990.

nungs-Fotogramme (Abb. S. 41) usw. Sie zeigte auch zahlreiche Fotomischtechniken, so mit Flüssigemulsion licht-empfindlich gemachte Textilien (Liquid Light), Plastikmaterialien, räumliche Fotoobjekte, Fotoassemblagen usw. Eine Fülle neuer experimenteller Möglichkeiten kameraloser Fotografie, ganz unabhängig vom klassischen Foto-gramm, breitete sich aus.[26] ■ Als weitere Verfahren der experimentellen Fotografie, die sich neben dem Foto-gramm durchgesetzt haben, sind die der Fotografik zu erwähnen: Solarisation, Negativmontage, Tontrennung, Tonwertumkehrung, das Fotorelief, die Fotoplastik usw. Sie werden heute durch Computerprogramme wie z.B. Photoshop weitgehend ersetzt. Erinnert sei auch an das bildnerisch ergiebige Verfahren des Cliché verre (Abb. S. 46, 49, 86f.), das weit vor den Fotogrammen künstlerisch eine Rolle spielt und ebenfalls über eine eigene origi-nelle Geschichte verfügt.[27] Erinnert sei an die zahlreichen Experimente mit kontinuierlichen und diskontinuier-lichen Kamerabewegungen und Mehrfachbelichtungen sowie an die kinetische Gestaltung projizierter Lichtbilder in der Nähe zu Kinematografie und Performance (Abb. S. 6, 50 oben, 92f.). ■ Das Bemühen, Raum, Zeit und Bewe-gung auf neue Weise bewußt zu machen, hat eine Fülle eigenständiger fotografischer Bilder, Objekte und Installa-tionen entstehen lassen, die eine eigene abstrakte Qualität vermitteln. Keine andere Kunstform hat dies in ver-gleichbarer Weise hervorgebracht.[28] ■ Das gilt auch für die abstrakte Kamerafotografie. Sie nimmt ihren Anfang mit der Wahl ungewöhnlicher Standpunkte, insbesondere bei Aufnahmen der Welt von oben und bei ungegen-ständlich und grafisch wirkenden Motiven, wie sie bei entsprechenden Oberflächenstrukturen in Natur und Technik häufig in Erscheinung treten (Abb. S. 40). Mit zunehmender Annäherung an den fotografischen Gegenstand ent-stehen Makrofotografien mit Abbildungsmaßstäben um 1:1 mit der Wirkung zunehmender Abstraktion. Anschau-liche Beispiele dafür sind die Fotografien von Pflanzen und Pflanzenteilen von Karl Blossfeldt (1865–1932) aus

tage photograms etc. (fig. p. 41). It also showed numerous hybrid photo-techniques, e. g. light-sensitive textiles made with fluid emulsion (Liquid Light), plastic materials, spatial photo objects, photo assemblages, etc. There was large array of new experimental possibilities of cameraless photography, alongside the classical photogram.[26] ■ Other techniques in experimental photography that have become established, i.e. are those of the photo-graphics area: solarization, negative montage, tone separation, tone reversal, the photo relief, photo sculpture, etc. They are mostly being replaced nowadays by such computer programs as Photoshop. It is also worthwhile to remember the technique that is especially pictorially innovative, i.e. that of the cliché-verre (figs. pp. 46, 49, 86f.), which played an important role in photographic art long before photograms, and which has its own unusual story.[27] And not to for-get the numerous experiments with a camera that is in constant and intermittent motion, with multiple exposures; also the kinetic presentation of projected light pictures with their affinity to cinematography and performance (figs. pp. 6, 50 top, 92f.). ■ Endeavours to increase awareness of time, space and movement in a new way have unleashed a whole range of photographic images, objects and installations, all with their own individual features and all with their own particular kind of abstraction. They induce aesthetic states that are unique and that no other form of art has produced in any comparable way.[28] ■ Abstract camera photography must also be included at this point. It started off by offering a choice of unusual vistas, especially like photographs taken of the earth from a bird's eye view, or motifs that make a non-object and graphic impression, similar to the way they often appear on correspond-ing surface structures in nature and also in man-made artefacts (figs. p. 40). With increasing closeness to the photographic object itself macro-photographs begin to emerge with the ratio of 1:1, thus effecting increased

26 Davies, Thomas Landon (ed.): *Lensless Photography*. Ausstellungskatalog exhibition catalog. Philadelphia : The Franklin Institute Science Museum 1983.

27 Glassman, Elizabeth; Symmes, Marilyn F.: *Cliché-verre: Hand-Drawn, Light-Printing. A Survey of the Medium 1839 to the Present.* Ausstellungskatalog exhibition catalog. The Detroit Institute of Arts 1980.

28 Schnelle-Schneyder, Marlene: *Photogra-phie und Wahrnehmung am Beispiel der Bewe-gungsdarstellung im 19. Jahrhundert.* Marburg 1990.

den 1910er und 1920er Jahren[29] sowie die Fotografien aus dem Mikrokosmos von Carl Strüwe (1898–1988) in der Folgezeit (Abb. S. 208 ff.).[30] Ein weiteres Eindringen in die Materie ermöglicht das Rasterelektronenmikroskop, das bis in die atomaren Bereich vorstößt. Die Entwicklung dieses Gebietes unter künstlerischen Vorzeichen wird von Claudia Fährenkemper in ihrem Beitrag exemplarisch, auch mit Einbeziehung eigener Arbeiten, dargestellt. Ihre Bilder wirken abstrakt und monumental zugleich. Sie wenden das Prinzip des ›verlängerten Auges‹ an und erschließen mit Hilfe bildgebender Verfahren eine bis dahin unbekannte Welt. ■ Wichtige frühe Beispiele abstrakter Kamerafotografien entstanden ab 1916 in New York, einem bedeutenden Zentrum für die Erfindung abstrakter Fotografie, wie Thomas Kellein belegt.[31] Sie entwickelten sich aus den Aktivitäten der *New Yorker Photo Secession* ab 1902 und der Zeitschrift *Camera Work*. Ihre Hauptvertreter sind die Amerikaner Paul Strand (1890–1976), »einer der Begründer der abstrakten Fotografie« (Abb. S. 42)[32], und Alfred Stieglitz (1964–1946), der sich für eine direkte, unmanipulierte Fotografie unter dem Begriff *Straight Photography* einsetzte. Damit wendete er sich gegen die bis dahin malerisch geprägte piktoralistische Fotografie. Mit seinen kleinformatigen, suggestiv wirkenden Kamerafotografien von Wolkenbildungen, den *Songs of the Sky* von 1923 und den *Equivalents* von 1929, gelangte er mit Hilfe einfachster Kameraführung zu atmosphärischen, stimmungsvollen Abstraktionen ganz eigener Art (Abb. S. 44f.).[33] Eine Fortführung seiner Ideen lassen sich in den elementaren und experimentellen Arbeiten der Chicagoer Schule erkennen, den Nachfolgeeinrichtungen des *New Bauhaus* ab 1938 um László Moholy-Nagy, György Kepes, Nathan Lerner, vor allem aber bei Harry Callahan und Aaron Siskind (1903–1991) (Abb. S. 46f.)[34], deren Schüler das hier begonnene Spektrum erweitern. Unter ihnen sind Ray K. Metzker, Martha Madigan (Abb. S. 10), Jack Sal (Abb. S. 49) und andere Namen zu nennen, wie aus der jüngeren Generation Mike

abstraction. Visible examples for this are the photographs of plants and parts of plants by Karl Blossfeldt (1865–1932) in the 1910s and 1920s[29], and also the photographs of the micro-cosmos taken by Carl Strüwe (1898–1988) in the years following (figs. pp. 208ff.).[30] A definitely closer look at the given subject-matter is made possible with the use of the scanning electron microscope that even penetrates into nuclear strata. In her article Claudia Fährenkemper demonstrates the development of this field from the artistic point of view, using examples from her own work. Her pictures appear to be both abstract and monumental at the same time. They apply the principle of the 'extended eye' and open up a hitherto unknown vista of the world with the help of pictorial techniques. ■ Important early examples of abstract camera photography began to emerge in 1916 in New York, an important centre for the invention of Abstract Photography, as Thomas Kellein demonstrates.[31] They developed as a result of the activities of the *New York Photo Secession* after 1902, and of the magazine *Camera Work*. Their main representatives are the Americans Paul Strand (1890–1976), "one of the founders of abstract photography" (fig. p. 42)[32], and Alfred Stieglitz (1864–1946), who with the term 'Straight Photography' advocated a direct, unmanipulated style of photography; his brand of photography rejected pictoralistic, painting-orientated tendencies in photography. With his small-sized, suggestive-like camera photographs of cloud formations, the *Songs of the Sky* of 1923 and the *Equivalents* of 1929 he created abstractions with a mood and aura of a very individual kind using the simplest of camera techniques[33] (figs. pp. 44f.). His ideas were further developed in the elementary and experimental works of the Chicago School, the successors of the New Bauhaus as from 1938, with such names as László Moholy-Nagy, György Kepes, Nathan Lerner, but especially Harry Callahan and Aaron Siskind (1903–1991),

29 Blossfeldt, Karl: *Urformen der Kunst. Photographische Pflanzenbilder*. Berlin 1928.

30 Strüwe Carl: *Formen des Mikrokosmos. Gestalt und Gestaltung einer Bilderwelt*. München 1955; Jäger, Gottfried: *Carl Strüwe. Das fotografische Werk 1924–1962*. Ausstellungskatalog exhibition catalog. Bielefeld, Düsseldorf 1982.

31 Kellein, Thomas: Die Erfindung abstrakter Fotografie 1916 in New York. In: Kellein, Thomas; Lampe, Angela (eds.): *Abstrakte Fotografie*. A. a. O. op. cit., pp. 33ff.

32 Haus, Andreas: Dokumentarismus, Neue Sachlichkeit und Neues Sehen. Zur Entwicklung des Mediums Fotografie in den USA und Europa. In: *Amerikastudien*, Vol. 26, No. 3, 1981, p. 322.

33 Bry, Doris: *Alfred Stieglitz: Photographer*. Ausstellungskatalog exhibition catalog. Boston: Museum of Fine Arts 1965; Hartmann, Sada-kichi: A Plea for Straight Photography (1904). Reprint in: Bunnell, Peter C. (ed.): *A Photo-graphic vision: Pictorial Photography. 1889–1923*. Salt Lake City 1980, pp. 149ff.

34 Hahn, Peter; Engelbrecht, Lloyd C. (eds.): *50 Jahre new bauhaus. Bauhausnachfolge in Chicago*. Ausstellungskatalog exhibition catalogue. Berlin: Bauhaus-Archiv / Museum für Gestaltung 1987.

und Douglas Starn, James Welling und Adam Fuss (Abb. S. 51, 59ff.). Sie alle sind durch das Prinzip fotografischer Abstraktion untereinander verbunden – trotz sichtbar unterschiedlichster Ansätze und Ergebnisse. ■ In der Ent-wicklungsgeschichte abstrakter Fotografie tritt zeitparallel zu den amerikanischen Zentren in der ersten Hälfte des 20. Jahrhunderts vor allem die tschechische Avantgarde mit einem reichen Fundus eigenständiger Arbeiten in Erscheinung. Sie wird im Rahmen dieser Publikation von Vladimír Birgus in seinem Beitrag ausführlich vorge-stellt.[35] ■ Nach dem Zweiten Weltkrieg zeigen sich entsprechende Aktivitäten in der Schweiz, so von Théodore Bally, Roger Humbert (Abb. S. 23), René Groebli, Rolf Schroeter, und René Mächler (Abb. S. 248f.). 1960 veran-staltete das Gewerbemuseum Basel die Überblicks-Ausstellung *Ungegenständliche Photographie*, die die damals aktuelle schweizerische und europäische Szene zu diesem Thema versammelte.[36] ■ In Westdeutschland artiku-lieren sich nach 1945 abstrakte Tendenzen der Fotografie mit einer großen Anzahl neuer Methoden und Stil-begriffe. Sie belegen den ungebrochen fortdauernden Abstraktionsdrang im Umgang mit dem Technischen Bild der Zeit parallel zum breiten Strom der darstellenden und dokumentarischen Fotografie. ■ In Ostdeutschland wird die Methode des Sozialistischen Realismus zum Staatsdogma erhoben. Experimentelle und abstrakte Tendenzen der Fotografie werden dagegen als Formalismus abgetan: »Seit den 20er Jahren werden immer wieder einmal von Fotografen Versuche gemacht, die ungegenständliche Malerei nachzuahmen oder irgendwelchen Strukturaufnahmen surreale Deutungen zu geben, indessen ist ›ungegenständliche Fotografie‹ ein Widerspruch in sich«, schrieb der Leipziger Professor für Ästhetik und Theorie der Fotografie Berthold Beiler (1915–1975) 1969[37], und Friedrich Herneck, Gründungsmitglied der Zentralen Kommission Fotografie im Kulturbund der DDR: »Über eines […] kann es keinen Streit mehr geben: Darüber, daß für den Künstler – auch für den Fotokünstler – im Sozia-

(figs. pp. 46f.)[34], whose protégés continued to broaden the range begun here. Amongst them are Ray K. Metzker, Martha Madigan (fig. p. 10), Jack Sal (figs. p. 49), and to name a few of the younger generation, Mike and Douglas Starn, James Welling and Adam Fuss (figs. pp. 51, 59ff.). They are all committed to the principle of photographic abstraction—in spite of visible differences in approach and result. ■ Parallel to the historical development in Abstract Photography that was taking place in American centres in the first half of the 20th century, there was also development amongst the Czech avant-garde, which was making its own rich range of contributions. They will appear in this publication in connection with the article by Vladimír Birgus.[35] ■ After the Second World War similar activities devel-oped in Switzerland, for example, those associated with Théodore Bally , Roger Humbert (fig. p. 23), René Groebli, Rolf Schroeter and René Mächler (figs. pp. 248f). In 1960 the Gewerbemuseum in Basle initiated the comprehensive exhibition *Non-Objective Photography* which collected topical works on this subject from the Swiss and European scene at the time.[36] ■ In West Germany there was a great surge in new methods and stylistic inno-vations that marked tendencies in Abstract Photography after 1945. These document the unbroken, continuing desire for abstraction pertaining to the Technical Picture of the times, parallel to the broad spectrum of presenta-tional and documentary photography. ■ In East Germany the method of social realism was declared state dogma. Experimental and abstract tendencies in photography were rejected as being mere formalism. "Since the Twenties there have been repeated attempts by photographers to imitate non-objective painting or to give so-called structure pictures some sort of surrealistic meaning; however 'non-objective photography' is a contradiction within itself", according to Berthold Beiler (1915–1975) in 1969, Professor for Aesthetics and Theory of Photography in Leipzig[37],

35 Birgus, Vladimír (ed.): *Tschechische Avant-garde-Fotografie 1918–1948.* Ausstellungs-katalog exhibition catalog. Neue Sammlung, Staatliches Museum für angewandte Kunst, München. Stuttgart 1999; Zuckriegl, Margit (ed.): *Laterna Magica. Einblicke in eine Tsche-chische Fotografie der Zwischenkriegszeit.* Ausstellungskatalog exhibition catalog. Rupertinum Salzburg; Städtisches Museum Abteiberg, Mönchengladbach. Mönchenglad-bach 2000.

36 Hernandez, Antonio: *Ungegenständliche Fotografie.* Ausstellungskatalog exhibition catalog. Basel : Gewerbemuseum 1960.

37 Beiler, Berthold: *Die Gewalt des Augen-blicks. Gedanken zur Ästhetik der Fotografie.* Zweite erweiterte Aufl. second extended edition. Leipzig 1969, p. 280.

Gottfried Jäger

Roger Humbert: *Photogram*, 1960
Unique gelatin silver print, 24 x 24 cm
Private collection
Courtesy of the artist (top)

Théodore Bally: *Structures* (Strukturen)
Camera photographs of stencil forms (Kamera-
fotogafien von Stanzformen). Double-spread,
taken from *Théodore Bally II – Mécaniques*.
Neuchâtel/Switzerland, 1968 (bottom)

lismus nur eine einzige Schaffensmethode besteht, [...] die Methode des sozialistischen Realismus, die höchste Entwicklungsstufe der realistischen Schaffensmethode überhaupt.«[38] ■ ■ **Subjektive Fotografie** Der Kunsthistoriker J. A. Schmoll gen. Eisenwerth, bedeutendster Fürsprecher einer experimentellen, Subjektiven Fotografie in Westdeutschland nach 1945, bezeichnete deren Aktivitäten in Anspielung auf ein geflügeltes Wort deutscher Nachkriegspolitik dagegen als »vertrauensbildende Maßnahmen«.[39] Bewußt knüpfen deren Autoren an die von den Nazis als ›entartet‹ verfemte Kunst der 1920er Jahre an und setzen sie auf eigene Weise fort. Programmatische Begriffe der Zeit sind *fotoform*, verbunden mit der Gruppe Wolfgang Reisewitz, Peter Keetman, Siegfried Lauterwasser, Toni Schneiders, Ludwig Windstoßer und Otto Steinert (Abb. S. 52, 98), sowie um 1950 *subjektive fotografie*, eingeführt von Steinert und Schmoll gen. Eisenwerth[40] sowie auch von Franz Roh, dem Verfechter der Neuen Fotografie der 1920er Jahre.[41] Wegweisend für die Zeit waren auch die Publikationen *Experimentelle Fotografie* und *Lichtgrafik* von Heinz Hajek-Halke 1955 und 1964, in denen sich ihr Autor schrittweise von jeder Gegenständlichkeit löst und sich für eine eigene Materialästhetik auf fotografischer Basis entscheidet. Damit ist er der radikalste Gestalter einer Abstrakten und Konkreten Fotografie seiner Zeit (Abb. S. 53, 87).[42] ■ Rückschauend beschreibt Georg Puttnies die Situation um 1950 in einem Katalogbeitrag über die Gruppe *fotoform*: »Seit langem sind wir wieder an Orten zu Hause, die uns ein intensives Gefühl für alles vom Menschen Gemachte sichern, die aber das Empfinden kaum mehr für die ungeplante Natur schärfen. Wir können uns deshalb [heute: 1980; G. J.] nur schwer denken, wie voraussetzungslos einmal Bilder entstanden sind. Eine kurze Zeit lang, zwischen Zusammenbruch und Wiederaufbau muß es möglich gewesen sein, die Spuren im Sand und den Glanz der Regentropfen auf eine ganz unmittelbare, neuartige Weise wahrzunehmen und abzubilden. Dies war die Periode, in der sich einige

and Friedrich Herneck, founder member of the Central Commission for Photography in the Cultural Commission of the GDR: "One thing [...] is absolutely indisputable: There can be only one creative principle for the artist—including the photo artist—in Socialism, [...] the method of socialist realism, the highest level of development of the realistic creative method per se."[38] ■ ■ **Subjective Photography** J. A. Schmoll gen. Eisenwerth, art historian and most prominent supporter of experimental Subjective Photography in West Germany after 1945, described their activities, on the other hand, as "confidence-building measures", thereby coining a standard expression in post-war German politics.[39] They deliberately continue the kind of art of the Twenties that was described by the Nazis as 'degenerate' and as such banned, developing it in their specific way. Typical programmatic terms of the times are *fotoform*, associated with the names Wolfgang Reisewitz, Peter Keetman, Siegfried Lauterwasser, Toni Schneiders, Ludwig Windstoßer and Otto Steinert (figs. pp. 52, 98), and *subjektive fotografie* (Subjective Photography) in 1950, introduced by Steinert and Schmoll gen. Eisenwerth[40] and by Franz Roh, the advocate of *Neue Fotografie* (New Photography) in the 1920s.[41] The publications *Experimentelle Fotografie* (Experimental Photography) and *Lichtgrafik* (Light Graphics) by Heinz Hajek-Halke in 1955 and 1964 were also real trailblazers at the time; here the author gradually moves away from anything that is object-bound, developing his own form of material aesthetics on a photographic basis. He is thus the most progressive initiator of an abstract and concrete form of photography of his times (figs. pp. 53, 87).[42] ■ Georg Puttnies describes the situation around 1950 in retrospect in a catalog article on the group *fotoform*: "For some time now we are back to where we have a secure and intensive feeling for everything that is made by man, but where we can hardly promote our awareness any more of unplanned nature.

38 Herneck, Friedrich: *Fotografie und Wahrheit. Beiträge zur Entwicklung einer sozialistischen Fotokultur.* Leipzig 1979, p. 17.

39 Schmoll gen. Eisenwerth, J. A., Vortragszitat bei quotation from a paper held at: *Internationales László Moholy-Nagy-Symposium, 1995.* Fachhochschule Bielefeld *University of Applied Sciences*, Bielefeld, 26. Oktober 1995.

40 Steinert, Otto: *subjektive fotografie. Internationale Ausstellung moderner Fotografie.* Ausstellungskatalog exhibition catalog. Saarbrücken: Staatliche Schule für Kunst und Handwerk 1951; Steinert, Otto (ed.): *Subjektive Fotografie. Ein Bildband moderner europäischer Fotografie.* Bonn 1952.

41 Roh, Franz: *foto-auge. 76 fotos der zeit. zusammengestellt von franz roh und jan tschichold.* Stuttgart 1929.

42 Hajek-Halke, Heinz: *Experimentelle Fotografie, Lichtgrafik.* Bonn 1955; Hajek-Halke, Heinz: *Lichtgrafik.* Düsseldorf, Wien 1964.

junge Fotografen zur Gruppe fotoform zusammenschlossen. [...] Sie war die voraussetzungslose und zeitlich äußerst eng begrenzte Bewältigung einer existenziellen Erfahrung: des Kulturverlustes nach der Periode des Völkermords.«[43] ■ Die aus dieser Einstellung heraus entstandenen Bilder sind tatsächlich Abstraktionen, eng gefaßte Ausschnitte aus Raum und Zeit. Die Schwarzweißfotografie *Spiegelnde Tropfen* von Peter Keetman aus dem Jahr 1950 ist dafür besonders bezeichnend (Abb. S. 52). Die *fotoform*-Bilder sehen von den Trümmern der Vergangenheit ab, sie suchen eine eigene innere Welt zu befestigen. Später wird man sie »als Kunst der Verdrängung« und als »Blindheit zum Zweck des Überlebens« kritisieren.[44] Aber man kann sie auch als »Zeichen der Hoffnung auf eine neue Ordnung, auf einen vernunftgemäßen und zugleich humanen Lebensstil«[45] lesen, als den Versuch ihrer Autoren, sich mit Hilfe der Abstraktion – sowohl der ihrer Einstellung als auch der ihrer Bilder – ein neues existenzielles Fundament zu sichern. ■ ■ **Generative Tendenzen** Ein demgegenüber gänzlich anderer Ansatz für abstrakte und konkrete Fotografien bedeutet ab Mitte der 1960er Jahre die Einbindung naturwissenschaftlich-technischen Denkens in die künstlerische Praxis. Er bedeutet letztendlich die bildnerische Auseinandersetzung mit den »Zwei Kulturen«.[46] Mit seinem Buch *Kunst und Konstruktion, Physik und Mathematik als fotografisches Experiment* leitet Herbert W. Franke 1957 das Thema ein.[47] Er entwickelt seine Theorie unter der Bezeichnung Kybernetische Ästhetik über die folgenden Jahre fort.[48] Sie sieht von subjektiven Befindlichkeiten weithin ab und sucht geistig-künstlerische Prozesse mit Hilfe des neu aufkommenden Informationsbegriffs und der um ihn herum entstehenden Theorien zu rationalisieren. Informationsästhetik,[49] Exakte Ästhetik,[50] Numerische Ästhetik sind weitere Begriffe dieser informationsästhetischen Schule,[51] die sich in den 1960er Jahren als außerordentlich anregend erweist. Für die theoretische Grundlegung und spätere Anwendung des Computers im Bereich der Kün-

That is why it is [today: 1980; G. J.] difficult for us to imagine how pictures were once produced unconditionally. For a brief moment, between breakdown and restoration, it must have been possible to perceive and reproduce the prints in the sand and the glistening of raindrops in a completely immediate, innovative way. This was when a few young photographers got together to found the group fotoform. [...] They demonstrated how they came to terms with an existential experience,— unconditionally and within a very limited space of time: the loss of cultural identity after the period of genocide."[43] ■ The pictures that were the result of this experience are indeed abstractions, narrowly conceived extracts in time and space. The black and white photograph *Spiegelnde Tropfen* (Reflecting Drops) by Peter Keetman of 1950 is particularly characteristic here (fig. p. 52). The *fotoform* pictures turn away from the rubble of the past, they seek to secure their own inner world. Later, they were to be dubbed and criticized as "art of suppression" and as "blindness for the purpose of survival".[44] But one can also see in them a "symbol of hope for a new order, for a more rational and also humane life-style",[45] an attempt by their authors to create a new existential basis with the help of abstraction—both in that of their inner attitude and in their pictures. ■ ■ **Generative Tendencies** The mid-1960's saw, by comparison, a completely different approach to abstract and concrete photographs: it involved the integration of the innovations of the natural sciences and technology in their artistic work. Ultimately, it means the pictorial altercation between the "Two Cultures".[46] Herbert W. Franke introduces the subject in his book *Kunst und Konstruktion, Physik und Mathematik als fotografisches Experiment* in 1957.[47] In the ensuing years he continues to develop his theory, calling it Cybernetic Aesthetics.[48] It distances itself completely from subjective sensitivities and seeks to rationalise inner, creative processes using the modern concept of

43 Puttnies, Hans Georg: *fotoform.* Ausstellungskatalog exhibition catalog. Köln: Galerie Kicken 1980, p. 1.

44 Thorn-Prikker, Jan: Die Fotografie als Kunst der Verdrängung. Otto Steinert und Schüler: Polemische Anmerkungen zu einer bedeutenden Ausstellung im Museum Folkwang. In: *Frankfurter Allgemeine Zeitung*, 31. Dezember 1990, p. 27.

45 Rotzler, Willy: *Konstruktive Konzepte. Eine Geschichte der Konstruktiven Kunst vom Kubismus bis heute.* Zürich 1977.

46 Snow, Charles P.: Die zwei Kulturen. Rede lecture, 1959. In: Kreuzer, H. (ed.) *Die zwei Kulturen. Literarische und naturwissenschaftliche Intelligenz. C. P. Snows These in der Diskussion.* München 1987.

47 Franke, Herbert W.: *Kunst und Konstruktion. Physik und Mathematik als fotografisches Experiment.* München 1957.

48 Franke, Herbert W.: *Kybernetische Ästhetik. Phänomen Kunst.* München, Basel 1979.

49 Frank, Helmar: *Informationsästhetik. Grundlagenprobleme und erste Anwendungen auf die mime pure.* Quickborn 1968.

50 Titel einer Buchserie im title of a series of books published by Verlag Nadolski, Stuttgart, um ca. 1970.

51 Maser, Siegfried: Rückblick und Neubesinnung auf die Erkenntnisse, Methoden und Ziele der Informationsästhetik. In: Maser Siegfried: *Designtheorie – Ästhetik und Kommunikation.* Wuppertal: Bergische Universität Gesamthochschule Wuppertal 1994, pp. 271ff.

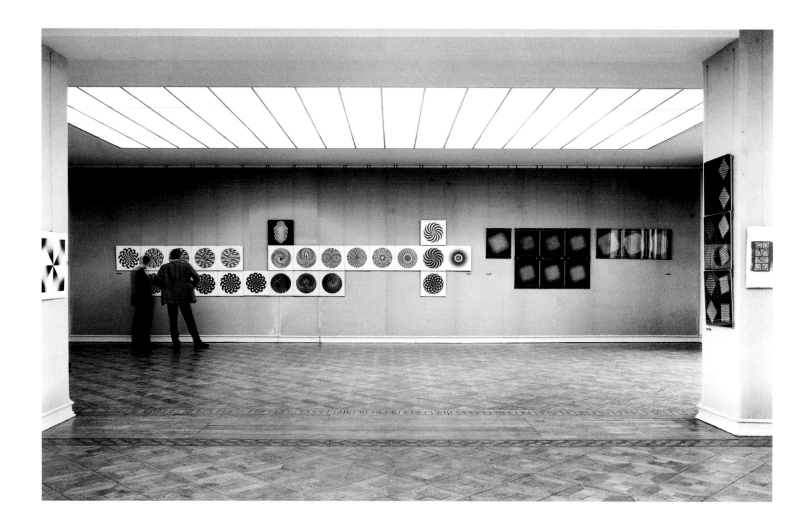

Exhibition *Generative Fotografie* (Generative Photography). Städtisches Kunsthaus, Bielefeld, 1968. Photoworks of Hein Gravenhorst (left) and Gottfried Jäger (right)
Photograph: Gottfried Jäger, 1968

ste ist sie von entscheidender Bedeutung. ■ Die daraus entstehenden Bilder werden als Ergebnisse visueller Untersuchungen aufgefaßt, dem naturwissenschaftlichen Experiment vergleichbar. Sie treten als Serien, Reihen und Sequenzen in Erscheinung und wollen so den kreativen Bildentstehungsprozeß offenlegen und zugänglich machen. In ihren entschiedensten Äußerungen vermitteln sie das abstrakte Prinzip der Gleichheit, gleicher Bedeutung und gleicher Berechtigung aller am Aufbau der Struktur beteiligten Elemente. Sie kennen keine Hierarchie, so kein Oben, kein Unten, und sie versuchen – bei aller Abstraktheit – zu objektiven, objektivierbaren Ergebnissen zu gelangen. Metaphysische Ansätze sind ihnen fremd, sie wollen aufklären, nicht verklären. ■ Insofern gehen auch die generativen Tendenzen dieser Zeit auf Überlegungen zur Konstruktiven Kunst der 1920er Jahre zurück: »Mein Wunsch war es, jenseits des Scheins in den Bereich objektiver Gültigkeit zu gelangen und dem Publikum als anonymer Agent zu dienen. [...] Meine fotografischen Experimente, speziell die Fotogramme, halfen mich zu überzeugen, daß selbst die vollständige Mechanisierung der technischen Ausführung keinerlei Bedrohung der wesentlichen Kreativität bedeutete«, schrieb László Moholy-Nagy in einem 1949 veröffentlichten Text.[52] ■ 1965 entstehen die ersten frei gestalteten Computergrafiken von Frieder Nake[53] und Georg Nees[54] auf der Grundlage der Generativen Ästhetik von Max Bense (1910–1990), der ersten Theorie für eine rechnergestützte Produktion und Programmierung des Schönen.[55] In ihrer Folge entwickelte der Verfasser dieses Beitrags Begriff und Praxis der Generativen Fotografie. Sie wird erstmals 1968 in einer Ausstellung mit Arbeiten von vier Fotografen im Städtischen Kunsthaus Bielefeld vorgestellt: Bilderzeugende Fotografien auf systematisch-konstruktiver Basis (Abb. S. 26). Ihr gemeinsames Merkmal sind Bildreihentechniken und serielle, z. T. strikt numerische Programme. Sie nehmen damit auch digitale Denk- und Arbeitsweisen in sich auf. Autoren sind Pierre Cordier mit Chemigram-

information and the theories surrounding it. Information Aesthetics,[49] Exact Aesthetics,[50] Numerical Aesthetics are further examples of this school of information aesthetics[51] which created great incentive in the 1960's. It was to be of decisive importance in laying the foundation stone and promoting the use of the computer in the field of the arts. ■ The resulting images are seen to be the products of visual research, comparable with experiments in the natural sciences. They occur as series, sequels and sequences, and as such are aimed as demonstrating the creative process of picture-production, thus making it easier to understand. In their most outspoken statements they convey the abstract principle of equality, of equal significance and equal rights of all the elements involved in creating the structure. They know no hierarchy, so there is no top or bottom, and they try—despite their abstract character— to achieve objective, or rationally understandable results. Metaphysical accoutrements are alien to them, they are aimed at enlightenment, not mystification. ■ In this respect the generative tendencies of that time also draw on Constructive Art of the Twenties: "My desire was to go beyond vanity, into the realm of objective validity, serving the public as an anonymous agent. [...] My photographic experiments, especially photograms, helped to convince me that even the complete mechanization of technics may not constitute a menace to its essential creativeness", according to László Moholy-Nagy, published 1949.[52] ■ 1965 saw the first freely designed computer graphics from Frieder Nake[53] and Georg Nees,[54] based on the Generative Aesthetics of Max Bense (1910–1990), the first theory of computer-aided production of art.[55] Based on this, the author of this article has been developing the concept and practical application of Generative Photography. Its first public presentation was at an exhibition at the Städtisches Kunsthaus Bielefeld in 1968 (fig. p. 26) involving the works of four photographers: Image-giving photographs

52 Moholy-Nagy, László: Abstract of an Artist. In: *The New Vision,* 1928. Fourth revised edition 1947. New York 1949, p. 79.

53 Nake, Frieder: *Ästhetik als Informationsverarbeitung.* Wien, New York 1974.

54 Nees, Georg: *Generative Computergraphik.* Dissertation PhD Diss. Berlin, München 1969.

55 Bense, Max: *Programmierung des Schönen. Allgemeine Texttheorie und Textästhetik. aesthetica IV.* Baden-Baden 1960; Max Bense: *Aesthetica. Einführung in die neue Ästhetik.* Baden-Baden 1965.

men (Abb. S. 55, 72), Kilian Breier mit Luminogrammen (Abb. S. 54), Hein Gravenhorst mit Fotomechanischen Transformationen (Abb. S. 56) und Gottfried Jäger mit Lochblendenstrukturen auf der Basis der Camera obscura (Abb. S. 57).[56] Ähnlich gerichtete Ausstellungen und Publikationen folgten. Beispielhaft sollen nur die Ausstellung *fotografie elementar* mit Ergebnissen aus dem Hochschulbereich im gleichen Jahr in Köln[57] sowie die ab 1970 über mehrere Jahre gezeigte internationale Wanderausstellung *Wege zur Computerkunst* erwähnt werden.[58] In den USA begann Sonja Landy Sheridan unter der Bezeichnung *Generative Systems* 1970 ein Studienprogramm am Art Institute of Chicago, das sie in den Jahren danach pädagogisch und publizistisch fortsetzte.[59] Auf dem Weg der apparativen Kunst vom Kaleidoskop zum Computer stellen generative Fotografien ein wichtiges Bindeglied an der Schnittstelle vom analogen zum digitalen Bild dar.[60] ■ ■ **Experimentelle Medienreflexion** Im weiteren Verlauf der Entwicklung fotografischer Abstraktion entstehen ab 1970 zahlreiche Projekte unter Begriffen wie Analytische Fotografie[61] und experimentelle Medienreflexion.[62] Ihre Untersuchungen richten sich vor allem auf die Kamerafotografie. Sie beziehen auch narrative Elemente ein. Zusammen mit den kompositorisch eigenwilligen Bildern von äußeren Situationen und Objekten bilden sie unter dem Begriff Visualismus eine gestalterische Gegenbewegung zur orthodoxen Dokumentarfotografie der Zeit in Westdeutschland. Visualistische Bilder wirken oft beiläufig, ihre Objekte scheinen an den Bildrand oder über ihn hinaus gedrängt zu sein. Die Leere und das Verschwinden der Gegenstände aus dem Bild werden zum eigentlichen Thema. »Das Objekt ist ihr [der visualistischen Fotografie; G. J.] ein Mittel, eine nach visualistischen Gesichtspunkten gestaltete Ordnung ins Bild zu setzen«, schreibt der Hauptvertreter dieser Richtung, Andreas Müller-Pohle, 1980 (Abb. S. 64).[63] ■ Die Fotoprojekte der künstlerischen Avantgarde dieser Zeit vermitteln ein zunehmend gebrochenes Verhältnis gegenüber den bis

created on a systematic, constructive approach. Picture sequence techniques and serial, in part, strictly numerical programs are their common features. They also assimilate modes of digital thinking and techniques. Authors to whom this applies are Pierre Cordier with his chemigrams (figs. pp. 55, 72), Kilian Breier and his luminograms (fig. p. 54), Hein Gravenhorst with his Photo-Mechanical Transformations (fig. p. 56) and Gottfried Jäger with Pinhole Structures based on the camera obscura.[56] (fig. p. 57) Exhibitions and publications on the subject were the result. May it suffice to mention just two examples of this: the exhibition *fotografie elementar* involving the results of work of some European university schools in Cologne in the same year,[57] and the international touring exhibition *Towards Computer Art* that was on tour from 1970 for several years.[58] In USA Sonja Landy Sheridan began in 1970 an ambitious study program called *Generative Systems* at the Art Institute of Chicago which was published in numerous exhibitions, lectures and articles.[59] As apparatus-induced art moved on from the kaleidoscope to the computer, Generative Photography represents an important link at the divide between the analogous and digital picture.[60] The latter fulfil the program of Abstract Photography in the widest possible sense. ■ ■ **Experimental Media Reflection** As photographic abstraction developed further there were numerous projects that started up from 1970 onwards, such as Analytical Photography[61] and Experimental Media Reflection.[62] They are especially aimed at camera photography. They also integrate narrative elements. Together with the specific compositional quality of the pictures of external situations and objects, they constitute so-called Visualism, a creative counter-movement to the orthodox documentary photography of the time in West Germany. Visualistic pictures often seem to be incidental, their objects appear to be pushed to the edge of the picture or even over and beyond the edge. Indeed, it is the lack

56 *Generative Fotografie: Kilian Breier, Pierre Cordier, Hein Gravenhorst, Gottfried Jäger.* Ausstellungskatalog exhibition catalog. Städtisches Kunsthaus Bielefeld 1968.

57 tom Moehlen, Eva (ed.): *Fotografie elementar in vier Beispielen: HfBK Hamburg, Koninklijke Akademie voor Kunst en Vormgeving s'Hertogenbosch, Werkkunstschule Bielefeld, Werkkunstschule Dortmund.* Ausstellungskatalog exhibition catalog. VHS Köln 1968.

58 Franke, Herbert W.: *Wege zur Computerkunst.* Internationale Ausstellungen der deutschen Goethe-Institute ab 1970. Ausstellungskataloge exhibition catalogs 1970ff.

59 Sheridan, Sonja Landy: Generative Systems. In: *afterimage* (USA), April 1972, pp. 2ff.; Sonja Landy Sheridan: Generative Systems Versus Copy Art: A Clarification of Terms and Ideas. In: *Leonardo* (Berkely, CA/ Oxford, GB), Vol. 16, No. 2, 1983, pp. 103–108.

60 Franke, Herbert W.; Jäger, Gottfried: *Apparative Kunst. Vom Kaleidoskop zum Computer.* Köln 1973.

61 Schmalriede, Manfred: *Bildanalytische Photographie.* In: *Timm Rautert.* Ausstellungskatalog exhibition catalog. Hanover: Spectrum Photogalerie 1973; Schmalriede, Manfred: *Analytische Fotografie. John Hilliard, Focus Works 1975/76.* Ausstellungskatalog exhibition

catalog. Karlsruhe: Badischer Kunstverein 1977; Wolf, Herta: *Timm Rautert – Bildanalytische Photographie 1968–1974.* Köln 2000.

62 Gerke, Hans: *Demonstrative Fotografie.* A. a. O. op. cit., 1974; Neusüss, Floris M.: *Medium Fotografie. Experimentelle Medienreflexion. Kenneth Josephson: Die Illusion der Bilder.* A. a. O. op. cit., 1978.

63 Müller-Pohle, Andreas: *Visualismus* (1980). In: Amelunxen, Hubertus von (ed.): *Theorie der Fotografie Vol. IV, 1980–1995.* München 2001, pp. 114ff.

Gottfried Jäger

dahin von der Fotografie als gesichert dargestellten Gegenständen. Das sorgfältig bewahrte Selbstverständnis einer realistischen, abbildungstreuen Fotografie mit Beweischarakter gerät mit Bekanntwerden und Häufung fotografischer Fälschungen in den Medien, verbunden auch mit dem Aufkommen erweiterter Möglichkeiten der elektronischen Bildbearbeitung, vollends ins Wanken. Es kommt zu künstlerischen Inspektionen und Verifikationen[64] des Mediums Fotografie. Der Begriff *Medium Fotografie* taucht erst Anfang der 1970er Jahre auf[65] – und mit ihm auch die ins Bild gesetzte Medienanalyse und Medienreflexion. Ihre Ergebnisse sind Ausdruck einer Konzeptfotografie, welche die ihr eigenen Verhältnisse von Produktion und Rezeption – ihr Konzept also – zu ihrem eigentlichen Thema macht (Abb. S. 58). ■ Die Doktrin des ›entscheidenden Augenblicks‹ von Henri Cartier-Bresson, in dem sich ein Geschehen auf seinem Höhepunkt durch ein einzelnes Foto offenbaren und mitteilen soll, scheint weitgehend erfüllt. Der Schnappschuß kann die Wiedergabe erweiterter Raum- und Zeiterfahrungen längst nicht mehr vermitteln. Es kommt zu einer regelrechten »Absage an das Einzelbild«.[66] Zu den künstlerischen Höhepunkten dieser post-fotografischen Entwicklung gehören die Fotoarbeiten der Engländer Gilbert and George, John Hilliard und David Hockney (Abb. S. 61, 186, 190f.). Sie entwickeln neue Verfahren der fotografischen Bildanalyse und Bildsynthese. Sie beleben auf diese Weise auch das Prinzip der Fotosequenz und der Fotomontage neu und stoßen zu neuen Themen vor. Ihnen gemeinsam ist – vor allem in ihren frühen Arbeiten – die Aufspaltung und Zerlegung des fotografischen Prozesses in seine einzelnen Bestandteile. Das Einzelbild wird dabei zu einem Teil des Ganzen. Es geht im Bild seines eigenen Entstehungsprozesses auf. Ergebnisse sind komplexe Bildcluster. So stellt David Hockney in seinen Fotomontagen Verbindungen von kubistischen Sehweisen und den erzählenden asiatischen Rollenbildern her, wie es Martin Roman Deppner in seinem Beitrag beschreibt. Sie berichten über Ort und

of and the disappearance of the objects from the picture that become the actual subject of the picture. "The object serves as a means [for visualistic photography; G. J.], establishing an order that is structured according to visualistic criteria", as Andreas Müller-Pohle, the main representative of this genre, put it in 1980 (fig. p. 64).[63] ■ The photographic projects of avant-garde art of the time convey an increasingly broken relationship towards the objects hitherto portrayed and unquestioned by photography. That carefully preserved sense of identity of a realistic and true form of photography with its claim to authenticity begins to falter completely as the number of photographic forgeries in the media becomes apparent and increases inexorably, — not to mention the appearance of new possibilities of electronic picture manipulation. The result is examination and evaluation[64] of the Medium Photography and the criteria of art. The term does not appear as such until the beginning of the 1970s[65] — accompanied at the same time by medium analysis and medium reflection within the picture itself. They result in so-called Conceptual Photography which concentrates on its characteristic relationship to production and reception, i. e. its concept. (figs. p. 58) ■ The doctrine of the 'decisive moment', introduced by Henri Cartier-Bresson, whereby the crucial moment of an incident is intended to become manifest and apparent within a single photograph, thus seems to have been generally fulfilled. The snap shot is no longer sufficient in any way to reproduce a broader experience of time and space. The result is a total rejection of the single picture.[66] The photographic works of the Englishmen Gilbert and George, John Hilliard and David Hockney (figs. pp. 61, 186, 190f.) become the best examples from an artistic point of view of these post-photographic developments. They develop new techniques of photographic picture analysis and synthesis. In this way they revitalize the principle of the photo sequence and the photo montage, thus paving the

64 Mulas, Ugo: *fotografo 1928 – 1973,* mit: *verifiches/verifications.* Ausstellungskatalog exhibition catalog. Musée Rath Genf, Kunsthaus Zürich 1984.

65 Wedewer, Rolf: *Medium Fotografie. Fotoarbeiten bildender Künstler von 1910 bis 1973.* Ausstellungskatalog exhibition catalog. Leverkusen : Städtisches Museum Leverkusen Schloß Morsbroich 1973.

66 Cremer, Wolfgang (ed.): *Absage an das Einzelbild. Erfahrungen mit Bildfolgen in der Fotografie der 1970er Jahre.* Ausstellungskatalog exhibition catalog. Essen: Museum Folkwang 1980.

Geschehen unter Einbeziehung des Vorgangs ihrer Entstehung. Sie verbinden Abstraktion und Konstruktion und leisten damit einen erheblichen Beitrag zur Erweiterung der bis dahin bekannten fotografischen Aussagemöglich-keiten.[67] ■ Das gilt allgemein für eine Erweiterte Fotografie, die unter diesem Begriff ab Anfang der 1980er Jahre in Erscheinung tritt.[68] Sie operiert uneingeschränkt mit fotofremden Mitteln, aber auch mit der Kamera pur. Die neue Künstlergeneration benutzt die gegenständlichen wie abstrakten Qualitäten des Mediums frei und ungebun-den und ordnet sie ihren Vorstellungen unter.[69] Die Bedeutung der konventionellen Fotografie als berichtendes Medium beginnt aus den oben genannten Gründen und auch durch die zunehmende Konkurrenz anderer, schnelle-rer Bildmedien zu verblassen. Ihre Publikationsmöglichkeiten in den Printmedien gehen zurück. Der subjektiv gefärbte und mit experimenteller Kameraführung gestaltete Fotoessay gewinnt bekenntnishafte Züge. Die Kame-ra wird zur ständigen Begleiterin. Ihr intimer Blick dringt unter die Oberfläche der Erscheinungen und deckt hin-ter der Fassade gesellschaftliche Brüche und individuelle Krisen auf – wie zugleich auch die Krise des Mediums Fotografie selbst, allerdings eher lapidar und beiläufig. Kennzeichnend dafür ist die Lomografie: Der Kult mit der Billigkamera. Sie vermittelt massenhaft Einblicke ins private Glück. Ein Vorgeschmack auf Big Brother. Einen Höhepunkt erreicht die internationale Bewegung auf einer Ausstellung mit der Präsentation tausender kleinfor-matiger Wandfotos, die tausende von Geschichten erzählen, auf der *photokina* Köln 1996. Das Einzelbild ver-schwindet vollends in dem schier endlosen Muster, dem neuen *Ornament der Masse*[70] einer All-over-Bildtapete. Auch das ist ein Aspekt abstrakter Fotografie. ■ Fotokunst und Publizistik reagieren auf ihre Weise: *Vanishing Presence* hieß eine Ausstellung in den USA[71] Ihre Bilder berichten *Vom Verschwinden der Gegenstände aus der Fotografie*, so der Titel einer ähnlich gerichteten Ausstellung im Museum moderner Kunst in Wien 1992.[72] Bald

way for new topics. All of them have in common—especially in their early works—the fact that the photographic pro-cess is split up and segmented into its integral parts. The individual picture thus becomes part of the whole. It resol-ves itself in the process of becoming a whole. The result is a complex cluster of pictorial elements. Thus, as Martin Roman Deppner points out, David Hockney integrates in his photo montages elements of cubistic perspectives and narrative Asian reel pictures. They relate place and event, including the process of the reproduction. They combine abstraction and construction, and thus contribute substantially to the hitherto known possibilities of photographic expression.[67] ■ This applies generally to Extended Photography, a term which appears at the beginning of the 1980's under this term.[68] It operates exclusively with means that are alien to the photograph, but also uses just the camera alone. The new generation of artists uses the objective and non-objective possibilities of the medium freely, with no sense of compulsion, subordinating them to their ideas.[69] The significance of conventional photography as a documentary medium begins to fade for the reasons given above and also as a result of increased competition with other, quicker picture media. The possibilities of appearing in the printing media recede, too. The photographic essay, with its subjective element, characterized by experimental camera vistas, takes on the features of a personal statement. The camera becomes a constant companion. Its intimate eye penetrates the surface of outer appearance and reveals the cracks in society and also individual crises behind the facade, and, at the same time the crisis of the medium itself, albeit succinctly and incidentally. The Lomography is typical of this: the cult of the inexpensive camera. This offers endless insights into the private sphere. A foretaste of Big Brother. The international movement comes to a climax at an exhibition at the *photokina* in Cologne 1996, showing thousands of small-sized photographs

67 Herzogenrath, Wulf; Meyer zu Eissen, Annette; Weiermair, Peter (eds.): *John Hilliard.* Ausstellungskatalog exhibition catalog. Kölnischer Kunstverein 1984; Hockney, David: *Cameraworks.* München 1984; *Gilbert & George: The Complete Pictures 1971–1985.* Ausstel-lungskatalog exhibition catalog. Bordeaux u. a. etc. München 1986.

68 Auer, Anna; Weibel, Peter: *Erweiterte Foto-grafie. 5. Internationale Biennale Fotografie.* Ausstellungskatalog exhibition catalog. Wien: Wiener Secession 1981.

69 Osterwold, Tilman (ed.): *blow up – Zeit-geschichte.* Ausstellungskatalog exhibition catalog. Stuttgart: Württembergischer Kunstverein 1987.

70 Kracauer, Siegfried: *Das Ornament der Masse. Essays.* Frankfurt am Main 1963.

darauf, 1995, spricht man von einer Fotografie nach der Fotografie[73], die ihre Gegenstände nicht mehr aufnimmt, sondern im Zusammenwirken mit digitalen Techniken regelrecht erfindet. Das Konstruierte wird das Reale, auch im Bild der Fotografie. In groß angelegten Einzelausstellungen, wie dem deutschen Beitrag auf der Biennale in Venedig 1997 mit Arbeiten von Katharina Sieverding (Abb. S. 60, unten)[74] und Sammelausstellungen wie *Das Versprechen der Fotografie* 1998[75] wird die Fotografie mit ihren gegenständlichen wie abstrakten Tendenzen ein anerkannter, selbstverständlicher Bestandteil der bildenden Kunst unserer Zeit. Ihre abstrakten Bilder sind in das Gesamtbild zeitgenössischer Kunstentwicklung eingebunden. Daneben werden sie auch als Spezifikum wahrgenommen. Publikationen und Ausstellungen zur experimentellen und abstrakten Fotografie,[76] wie die ab 1998 gezeigte Schau *Im Reich der Phantome – Fotografie des Unsichtbaren*[77], die die Entstehung abstrakter Fotografien in die Nähe des Okkulten rückt, sind dafür signifikante Beispiele. Der Beitrag von Rolf H. Krauss in dieser Publikation schildert die geistigen Grundlagen und Ergebnisse dieses Ansatzes seit Ende des 19. Jahrhunderts. ■ Künstler der Gegenwart, die ein je eigenes Konzept abstrakter Fotografie vorstellen, beschreibt gegen Ende dieser Publikation in exemplarischen Beispielen der Beitrag von Michael Köhler. Neben den dort genannten Namen sollen in diesem Zusammenhang unter vielen anderen nur einige wenige zusätzlich genannt werden. So die Amerikaner Douglas und Mike Starn (Abb. S. 59f.), Andres Serrano (Abb. S. 62), Adam Fuss (Abb. S. 51), James Welling (Abb. S. 64), die Engländerin Helen Robertson (Abb. S. 65), der Schwede Dawid (Björn Dawidsson), die Deutschen Karl Martin Holzhäuser (Abb. S. 69), Norbert Meier (Abb. S. 70), Nikolaus Koliusis, Roland Fischer (Abb. S. 67), Wolfgang Tillmans (Abb. S. 63) und die Österreicherin Ines Lombardi, der Japaner Hiroshi Sugimoto, die Koreaner Bohn-Chang Koo, Dai-Yong Jeon (Abb. S. 68) und viele mehr. Sie sorgen mit ihren Werken für eine erhöhte

telling thousands of stories. The individual picture disappears completely in this endless phenomenon, the new ornament of the masses (*Das Ornament der Masse*)[70] of an all-over picture tapestry. That, too, is an aspect of Abstract Photography. ■ Photographic art and publicity react in their own ways: *Vanishing Presence* is the name of an exhibition in the USA.[71] Its pictures tell of the disappearance of things from photography (*Vom Verschwinden der Dinge aus der Fotografie*), such being the title of an exhibition held on similar lines at the Museum of Modern Art in Vienna in 1992.[72] Soon after that, in 1995, the *Photography after Photography*[73] is the issue; it no longer captures its objects, on the contrary, it virtually creates them through the interaction of digital techniques. The construed becomes the real, within the picture of the photograph. In lavishly laid-on, individual contributions like the German one at the Venice Biennial of 1997, with works by Katharina Sieverding (fig. p. 60, bottom)[74] and collective exhibitions like *Das Versprechen der Fotografie* (The Promise of Photography), 1998[75], photography with its objective and non-objective tendencies is a recognized and natural feature of the fine arts in this day and age. Their abstract pictures are part of the overall picture of development in contemporary art. Apart from this, they are also regarded as something special. Publications and exhibitions on experimental and Abstract Photography,[76] like the presentation *Im Reich der Phantome—Fotografie des Unsichtbaren* (In the Realm of Phantoms—Photographs of the Invisible)[77] that began in 1998, which creates a link between the production of abstract photographs and the occultism, are important examples of this. In his article, Rolf H. Krauss explains the intellectual background and the importance of this approach since the end of the 19th century. ■ Michael Köhler's article towards the end of this book describes in an exemplary way contemporary artists who each present their own concept of Abstract Photography. In addition

71 Weinberg, Adam D. (ed.): *Vanishing/Presence*. Ausstellungskatalog exhibition catalog. Walker Art Center Minneapolis 1989.

72 Faber, Monika (ed.): *Vom Verschwinden der Dinge aus der Fotografie (The Disappearance of Things)*. Ausstellungskatalog exhibition catalog. Wien : Österreichisches Fotoarchiv im Museum moderner Kunst 1992.

73 Amelunxen, Hubertus von; Iglhaut, Stefan; Rötzer, Florian (eds.): *Fotografie nach der Fotografie Photography after Photography*. München/Amsterdam 1996.

74 Inboden, Gudrun (ed.): *Katharina Sieverding. Biennale di Venezia 1997*. Ausstellungskatalog exhibition catalog. Ostfildern-Ruit 1997.

75 Sabau, Luminita (ed.): *Das Versprechen der Fotografie*. Collection DG Bank. Ausstellungskatalog exhibition catalog. München, London, New York 1998.

76 De Sana, Jimmy: *Abstraction in Contemporary Photography*. Ausstellungskatalog exhibition catalog. Emerson Gallery, Hamilton College/Anderson Gallery, School of the Arts, Virginia Commonwealth University, Richmond, Virginia 1989; Köhler, Michael: Abstrakte Fotografie. In: *artis* Februar 1992, pp. 26–31;

Fotogalerie Vienna/Verein zur Förderung Künstlerischer Fotografie: *Abstrakt. Fotobuch No. 23/1999*, Wien 1999; Kellein, Thomas; Lampe, Angela (eds.): *Abstrakte Fotografie*. A. a. O. op. cit.; Photographie: Abstraite et Concrète. In: *Pratique. Reflexions sur l'art*, No. 11/2001.

77 Loers, Veit; Aigner, Carl; Stahel, Urs (eds.): *Im Reich der Phantome. Fotografie des Unsichtbaren*. Mönchengladbach/Krems/Winterthur. Ausstellungskatalog exhibition catalog. Stuttgart 1998.

Wahrnehmung abstrakter Fotografien als einer Kunstform, die von ihrer Ausstrahlung bis heute nichts verloren hat. ■ Dabei tritt das Gesamtwerk dieser Künstler nicht ausschließlich abstrakt oder gegenständlich in Erscheinung. Sondern sie bedienen sich meist beider Methoden in jeweils eigenen und unterschiedlichen Werkgruppen. Es entstehen auch hybride Bildwelten aus einer Mischung von klassischen und alternativen Gebrauchsweisen der Fotografie. Sie greifen auf fotohistorische Verfahren wie Camera obscura, Cliché verre und Edeldruckverfahren zurück und verbinden sie mit ungewöhnlichen Präsentationsformen, so der Fotoinstallation, der Fotoassemblage, der Fotoaktion sowie mit modernsten Mitteln der elektrischen und elektronischen Bildbearbeitung. Zunehmend spielt die virtuelle Kamera eine Rolle, die den ganzen komplexen Fotoprozeß in einen Binärcode zerlegt und digitalisiert und seine ästhetischen Merkmale algorithmisch simuliert. Das Foto dringt dabei in bisher unvorstellbarer Weise zu neuen Gegenständen vor, dringt in sie ein oder erzeugt sie völlig neu. Jenseits der klassischen Fotografie entsteht eine eigene Welt technischer Bilder zwischen Gegenständlichkeit, Abstraktion und Konkretion (Abb. S. 71). ■ ■

to the names mentioned here I would like to include but a few amongst many others. These are the Americans Douglas and Mike Starn (fig. p. 59f.), Andres Serrano (fig. p. 62), Adam Fuss (figs. pp. 51), James Welling (fig. p. 64), the English woman Helen Robertson (fig. p. 65), the Swede Dawid (Björn Dawidsson), the Germans Karl Martin Holzhäuser (fig. p. 69), Norbert Meier (figs. p. 70), Nikolaus Koliusis, Roland Fischer (fig. p. 67), Wolfgang Tillmans (fig. p. 63), the Austrian woman Ines Lombardi, the Japanese Hiroshi Sugimoto, the Korean Bohn-Chang Koo, Dai-Yong Jeon (fig. p. 68) and many others. They cater for an increased awareness of abstract photography and for a form of art that has lost nothing of its impact to this very day. ■ This does not mean that all of the works of these artists are solely abstract or object-orientated. They use mostly both methods in works that are grouped either separately or a mixed form. But they are also hybrid visions of the world, made of a mixture of classical and alternative methods of photography. They go back to historical photographic techniques such as the camera obscura, cliché-verre and the early fine art print techniques and combine them with unusual forms of presentation like photo installation, photo assemblage, photo action, also using the most recent electrical and electronic means available for processing pictures. The virtual camera is playing an increasingly important role, reducing the whole complex photographic process into a binary code, digitalizing it and simulating its aesthetic characteristics by applying algorithms. The photo thus advances towards new objects in a way hitherto unknown, penetrating them or re-creating them completely. Beyond the boundaries of classical photography a new world in its own right is emerging, a world of technical images, combining object-orientated, abstract and concrete features (figs. p. 71). ■ ■

Typologie Daraus kann nun ein Spektrum fotografischer Abstraktionen abgeleitet werden. Es hat sich in der Geschichte der Fotografie folgerichtig entwickelt und dabei Bildarten hervorgebracht, die sich nach Inhalt, Form und Funktion – und wie stets auch mit weichen Übergängen an ihren Grenzen – voneinander unterscheiden lassen in: ■ ■ **1. Abstraktion des Sichtbaren** Fotografien dieser Art zielen auf das ausschnitthafte, schöpferische Sehen, auf die bewußt gestaltete und verdichtete Erfassung und Darstellung des Wesentlichen eines Gegenstandes oder eines Vorgangs; sie konzentrieren sich auf formale Besonderheiten, heben deren Qualitäten und Oberflächenreize hervor, auch mit Hilfe späterer Bildbearbeitung. Sie sind im Ansatz (noch) abbildend, mimetisch, jedoch (schon) bewußt umgestaltet. Sie treten erkennbar in struktur-erzeugender Absicht auf. Eingeführte Begriffe dazu sind u. a. Gestaltende und Experimentelle Fotografie und Fotografik. Ihre Mittel sind Nahaufnahme, Tontrennung, Tonwertumkehrung, Solarisation, Verwischung, Mehrfachbelichtung u. a. m. ■ ■ **2. Visualisierung des Unsichtbaren** Fotografien dieser Art zielen auf Veranschaulichung und Darstellung des Verborgenen, das ohne optische Hilfsmittel nicht wahrnehmbar wäre. Sie entstehen unter Beteiligung bildgebender fotografischer, heute auch elektronischer Verfahren und stellen so eine Art ›verlängertes Auge‹ des Menschen dar. Entsprechende Verfahren und Methoden wurden zuerst für wissenschaftliche Zwecke entwickelt, aber auch in künstlerischen Zusammenhängen angewendet. Bekannte Beispiele dafür sind Mikro-, Röntgen-, und Thermofotografie, Kurzzeit- und Hochfrequenzfotografie, Schlierenfotografie, Falschfarbenfilm, Äquidensitendarstellungen u. a. m. ■ ■ **3. Konkretisierung reiner Sichtbarkeit** Fotografien dieser Art entstehen im freien kompositorischen Umgang mit dem fotoeigenen Material und dem Fotoprozeß. Die Mittel werden zum Gegenstand, es entstehen autonome, sich aus ihren eigenen Verhältnissen heraus selbst erzeugende, auf sich selbst verweisende, selbstreferentielle,

Typology A whole new range of photographic pictures with an increasing degree of abstraction is the result. It has steadily developed in the history of photography and has produced pictures differing in content, form and function — with the obvious deviations from classification. ■ ■ **1. Abstraction of the Visible** Pictures of this kind are aimed at segmented, creative vision, at capturing and presenting in a deliberately designed and condensed way the essential features of an object or a process; they concentrate on formal peculiarities, thus emphasising their qualities and surface features, if necessary with the help of added picture processing. To a certain extent they are (still) reproductive, mimetic, yet deliberately re-composed. They are recognisable by virtue of their structure-producing elements. They are referred to, for example, as formative and experimental photography and photo-graphics. Their means are close-ups, tone separation, tone reversal, solarization, blurring, multiple exposure, to name but a few. ■ ■ **2. Visualization of the Invisible** Pictures of this kind aim at visualising and presenting the hidden, i. e. what is not perceptible without the help of optical means. They are created by using picture-inducing photographic, and nowadays, electronic techniques, thus functioning as a kind of 'extended human eye'. Corresponding techniques and methods were initially developed for scientific purposes, but also used in art. Well-known examples of this are micro, X-ray, thermo photography, high speed and high-frequency photography, Schlieren photography, artificial color film, equidensity presentations, etc. ■ ■ **3. Materialization of Pure Visibility** Pictures of this kind are produced using photographic materials and techniques in a free and creative way. The means themselves become the object, the result are picture image structures that are autonomous, generated out of themselves through their relationship to each other, and directed at themselves, self-reflected and self-creative. They are, when it comes to it, traces

autopoietische Bildstrukturen. Letztendlich sind es Spuren des Mediums, des Apparates: Lichtspuren, Material-spuren. Eingeführte Begriffe dazu sind Konkrete, Konstruktive und Generative Fotografie. Sie realisieren sich im reinen Lichtbild, im Luminogramm, Chemigramm, Fotogramm. Ihre Untersuchungen beziehen sich auf die Eigengesetzlichkeit der Mittel, auf Einzelerscheinungen wie Schärfe-/Unschärfe-Relationen, auf Textur, Struktur, auf Syntax und Faktur des Fotografischen, auf Nachbareffekte, auf Bildstörungen wie Korn, Rauschen, Flimmern u. a. m. ■ ■ **Definition** Danach soll nun der Versuch einer Definition unternommen werden: Der Begriff Abstrak-te Fotografie bezeichnet eine besondere Spielart der Fotografie; er dient als Sammelbegriff für eine Kunstform, bei der die gegenständliche fotografische Abbildung zugunsten fotografischer Strukturbildungsprozesse in den Hintergrund tritt. Im Vordergrund steht die Veranschaulichung einer (abstrakten) Idee, die unter bewußter Ver-nachlässigung von Aspekten der Gegenständlichkeit und Wiedererkennbarkeit fotografisch realisiert wird. Dabei gelingen Bildaussagen, die die gegenständlich-abbildende Fotografie nicht ermöglicht und ihre Grenzen über-schreiten. Das Gebiet schließt die Abstraktion des Sichtbaren, die Visualisierung des Unsichtbaren und die Kon-kretisierung reiner Sichtbarkeit in sich ein. Ergebnisse abstrakter Fotografien sind nicht in erster Linie Abbilder (Ikone) und Sinnbilder (Symbole), sondern Strukturbilder (Anzeichen, Symptome, Indizes). Letztendlich sind es fotografische Objekte ihrer selbst.[78] ■ ■

of the medium, the apparatus: traces of light, traces of material. Established terms applying to them are Concrete, Constructive and Generative Photography. They find expression in the pure photographic picture, in the lumino-gram, chemigram, photogram. They focus on the intrinsic rules of the means, on specific aspects like the relation-ship of distinctness and blur, of texture, structure, on syntax and composition in the photographic process, on rela-ted effects, on picture encroachments like dust, disturbance, flickering, etc. ■ ■ **Definition** And now let us try to define Abstract Photography: The term denotes a specific variety of photography, to be regarded as a collective term for a form of art, whereby object-orientated photographic reproduction gives way to the photo processes of generating photogenic structures. The primary aim is to visualize an (abstract) idea which is translated into photo-graphic terms by deliberately omitting aspects of object identification and recognisability, thus making pictorial statements that are not possible with object-orientated, reproductive photography or that simply transcend the lat-ter's limits. This field of photography includes abstraction of visible, visualization of invisible and the materializa-tion of pure visibility. Thus it is not primarily reproductions (icons), not allegorical pictures (symbols), but structured pictures (symptoms, indices, indexical signs) that are the end-products of Abstract Photography. The photographs are thus basically photographic objects of themselves.[78] ■ ■

78 Jäger, Gottfried: Spektrum Fotografie. Bildziele – Bildarten – Bildstile. In: Jäger, Gottfried: *Fotoästhetik. Zur Theorie der Fotografie. Texte aus den Jahren 1965 bis 1990.* A. a. O. op. cit., pp. 156ff.

Schlußbemerkung Zu Beginn des 20. Jahrhunderts waren abstrakte Fotografien Bestandteil zukunftsweisender, dynamischer Konzepte, so des Vortizismus und des Futurismus. Insofern können sie als Ausdruck einer von Spiritualisierung und Fortschrittsglauben geleiteten Aufbruchstimmung in Kunst und Gesellschaft gelesen werden. In den 1920er Jahren gaben sie surrealistischen und konstruktivistischen Ideen Gestalt. Im ›Dritten Reich‹ waren sie verfemt und galten als ›entartet‹. Im westlichen Nachkriegsdeutschland wurden sie als vielversprechende Zeichen der Hoffnung und des Neubeginns gedeutet, im östlichen Deutschland als nutzloser Formalismus diskreditiert. Innerhalb der fotografischen Zunft polarisierte das abstrakte Foto zu allen Zeiten die Meinungen zwischen totaler Ablehnung und Bewunderung. Albert Renger-Patzsch, Hauptvertreter einer ›reinen‹, neusachlichen Fotografie, sprach 1960 noch von einer »zwielichtigen Gattung: weder Kunst noch Fotografie«, die entsteht, wenn man in den Fotoprozeß gestaltend eingreift und ihn mit fotofremden Elementen durchsetzt.[79] Demgegenüber spricht Vilém Flusser zwanzig Jahre später von einem Akt der Freiheit und empfiehlt, gerade so das sture Apparateprogramm zu unterlaufen und es mit immer neuen Methoden zu überlisten: »Freiheit ist, gegen den Apparat zu spielen.«[80] Ein Aspekt, der der Kunst der Abstrakten Fotografie eigenen Sinn verleiht. ■ ■

Final comment At the beginning of the 20th century abstract photographs constituted elements of future-orientated dynamic concepts, e. g. Vorticism and Futurism. To this extent they can be regarded as expression of an innovative mood in art and society, fired by a spiritualisation and a belief in progress. In the Twenties they gave expression to surrealistic and constructivist ideas. During the 'Third Reich' they were banned and looked upon as '*entartet*', degenerate. In the post-war West Germany they were seen as promising signs of hope and of a new beginning; in East Germany they were discredited as useless formalism. Within photographic circles there was always a polarization of opinions: Either total rejection or complete veneration. In 1960 Albert Renger-Patzsch, leading supporter of a "pure", real photography still spoke of a "dubious genre: neither art nor photography" that comes about when one intercepts the photographic process with compositional intention and applies elements that are alien to the photograph.[79] On the other hand, twenty years later Vilém Flusser talks of an act of freedom, and recommends counteracting that so very uninspiring apparatus program and outdoing it with constantly new techniques: "Freedom equals playing against the apparatus".[80] An aspect that gives the art of abstract photography its own sense of identity. ■ ■

79 Renger-Patzsch, Albert: *Versuch einer Einordnung der Photographie*. Rede am 30. September 1960. In: *Veröffentlichungen der Deutschen Gesellschaft für Photographie (DGPh)*, No. 4/1960, p. 6.

80 Flusser, Vilém: *Für eine Philosophie der Fotografie*. A. a. O. op.cit., p. 55.

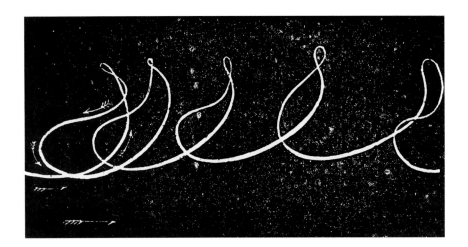

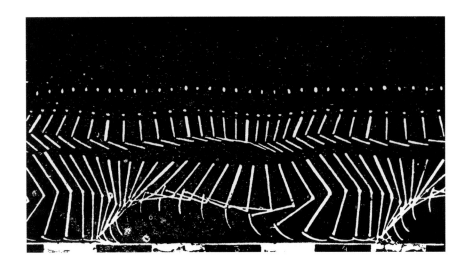

Etienne-Jules Marey: *Chronophotography,*
ca. 1893
top: Continuous exposure (Motography):
Course of movement of a crow's wing (Kon-
tinuierliche Belichtung [Motografie]:
Bewegungsbahn eines Krähenflügels)
Intermittent exposure (Strobography):
bottom: Course of movement of a runner
(Intermittierende Belichtung [Strobo-
grafie]: Bewegungsbahn eines Läufers)
Deutsches Filmmuseum, Frankfurt am Main

Gottfried Jäger

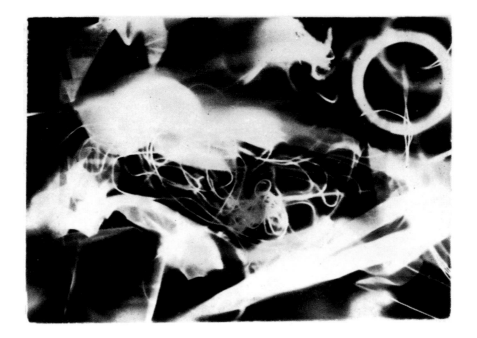

Christian Schad: *Schadografie No. 4*, 1919
Photogram. Unique gelatin silver print, 6.4 x 9 cm
The Museum of Modern Art, New York

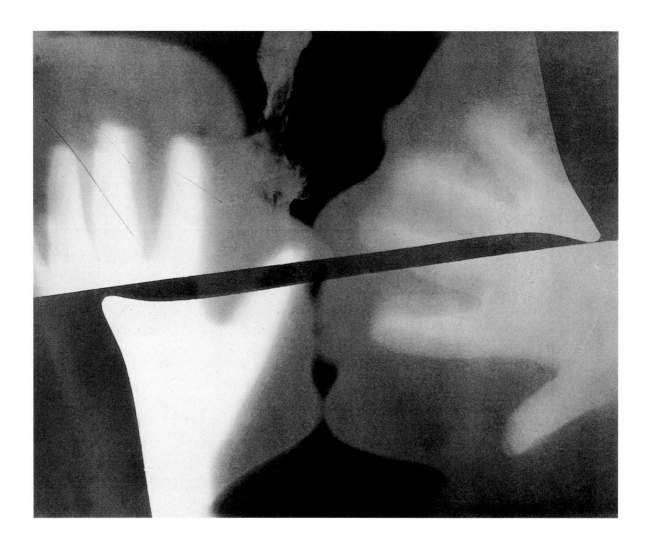

Man Ray: *Untitled*, 1922
Rayograph. Unique gelatin silver print,
23.9 x 30 cm
The Museum of Modern Art, New York,
donation James Thrall Soby

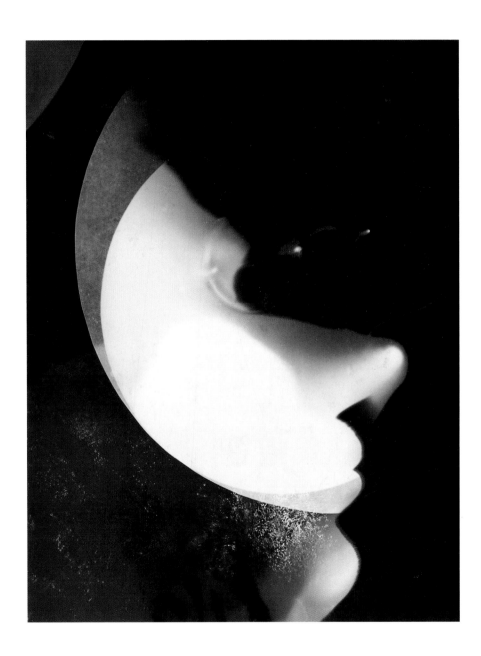

László Moholy-Nagy: *Self Portrait*, ca. 1922
Photogram. Unique gelatin silver print,
23.1 x 17.6 cm
Museum Folkwang, Essen
Courtesy of Hattula Moholy-Nagy

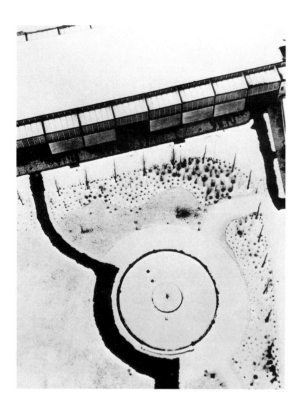

László Moholy-Nagy: *Blick vom Berliner
Funkturm im Winter* (View from Berlin
Radio Tower), 1928
Gelatin silver print, 24.8 x 19 cm
The Museum of Modern Art, New York
Courtesy of Hattula Moholy-Nagy

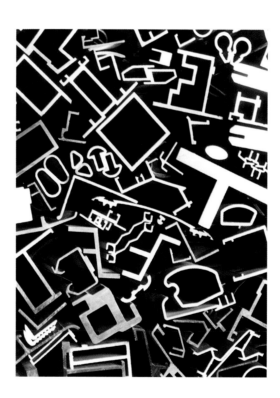

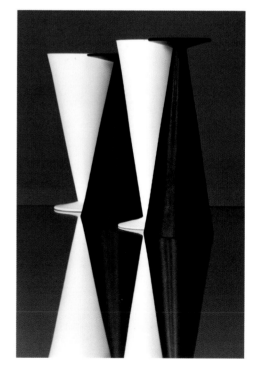

Willi Klar: *Aluminiumstangen im Querschnitt*
(Cross section of aluminium rods), 1963
Gelatin silver print, 40.2 x 30.2 cm
Collection Gottfried Jäger (bottom left)

Hansi Müller-Schorp: *Schwarz-Weiße Gläser*
(Black-and-white fine drinking glasses), 1987
Studio camera 18 x 24 cm
Gelatin silver print, 60 x 50 cm
Die Neue Sammlung, Staatliches Museum
für angewandte Kunst, Munich
Courtesy of the artist (bottom right)

Mary Jo Toles: *Recent Plant Cutbacks*
(Rückblicke: Moderne Pflanzen), 1983.
High energy (Kirlian-)photogram. High vol-
tage discharge with plants and other house-
hold items on color photo materials.
(Hochspannungs-[Kirlian-] Fotogramm.
Belichtungsmontage aus Koronaentladungen
an Blättern und Haushaltsgegenständen)
Unique Ektaprint, 20 x 24 in., with Polacolor,
8 x 10 in. (top)

Mary Jo Toles: Self-portrait of the artist and
her equipment, working in the darkroom
Courtesy of the artist (left)

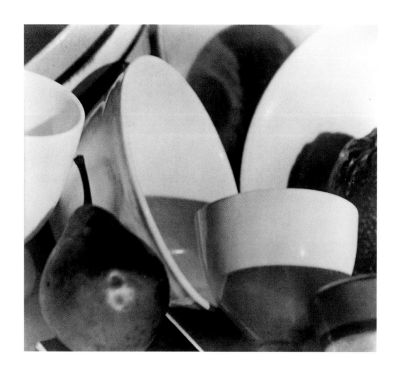

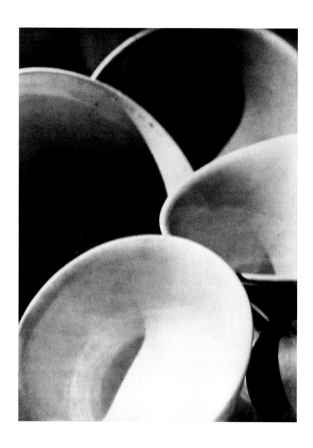

Paul Strand: *Pears and Bowls, Twin Lakes, Connecticut*, 1916
Platinum print, 25.7 x 28.8 cm
Gilman Paper Company Collection (top)

Paul Strand: *Abstraction, Bowl, Twin Lakes, Connecticut*, 1916
Photogravure, 22.7 x 16.6 cm
George Eastman House, Rochester, Museum Collection (bottom)

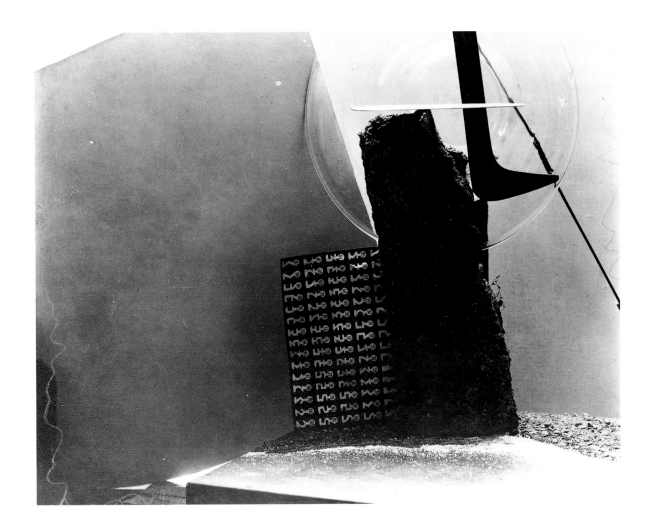

Edward Steichen: *Time-Space Continuum*,
ca. 1920
Gelatin silver print, 20 x 24.3 cm
The Metropolitan Museum, New York,
Ford Motor Company Collection

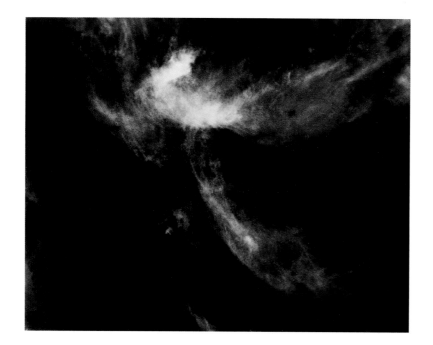

Alfred Stieglitz: *Equivalent*, 1930
Gelatin silver print, 9.3 x 11.8 cm
George Eastman House, Rochester

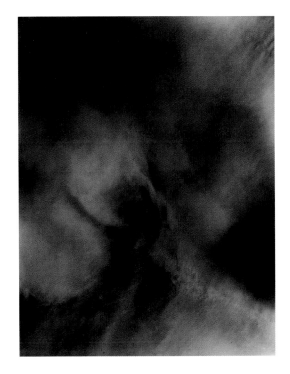

Alfred Stieglitz: *Equivalent*, 1923
Gelatin silver print, 11.6 x 9.2 cm
George Eastman House, Rochester (top)

Alfred Stieglitz: *Equivalent*, 1929
Gelatin silver print, 11.8 x 9.2 cm
George Eastman House, Rochester
(bottom)

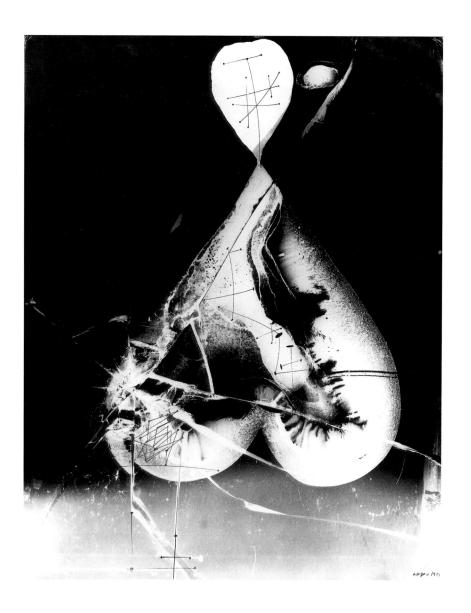

György Kepes: *Twin Hearts*, ca. 1939
Cliché verre. Gelatin silver print,
ca. 30 x 24 cm
Courtesy of the artist

Gottfried Jäger

Harry Callahan: *Weed against Sky, Detroit*, 1948
Camera photograph. Gelatin silver print,
ca. 20 x 20 cm
The Museum of Modern Art, New York

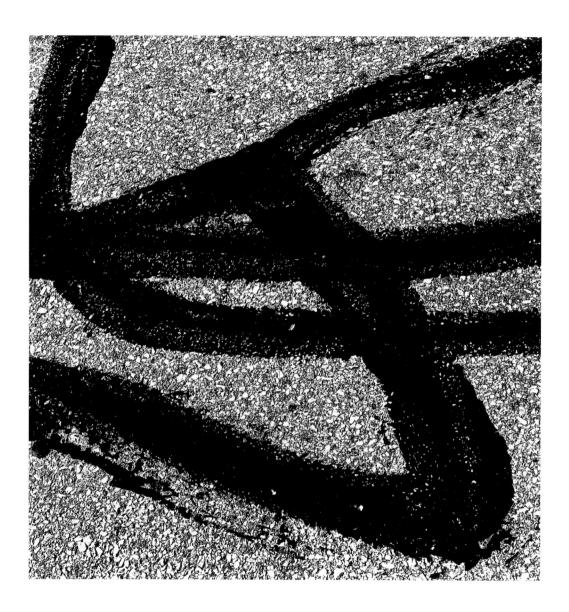

Aaron Siskind: *Providence 69*, 1986
Camera photograph. Gelatin silver print,
ca. 50 x 50 cm
The Friends of Photography, San Francisco

Gottfried Jäger

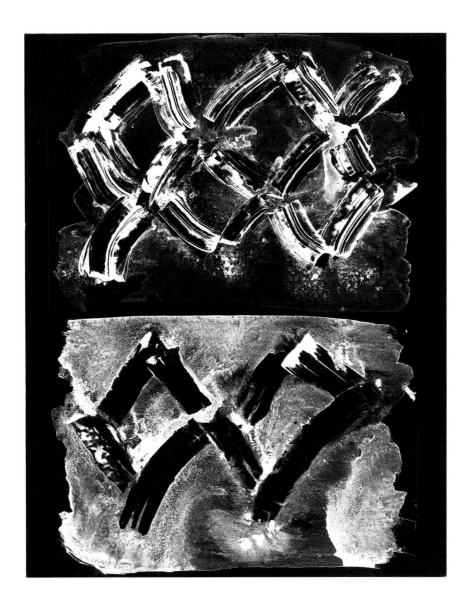

Jack Sal: *Cliché verre*, 1987
Gelatin silver print, 25.2 x 20.2 cm
Collection Gottfried Jäger
Courtesy of the artist (top)

Jack Sal: *Untitled*, 1982
Two cliché verres. Gelatin silver prints,
99 x 119 cm (left), 104.4 x 238 cm (right)
Exhibition *László Moholy-Nagy: Idee und
Wirkung. Anklänge an sein Werk in der zeit-
genössischen Kunst* (László Moholy-Nagy:
Idea and Influence. Echoes of His Work in
Contemporary Art). Kunsthalle Bielefeld,
1995 (bottom)
Photograph: Peter Nixdorf, Bielefeld

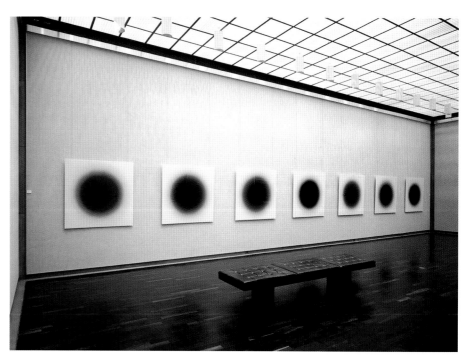

Mischa Kuball: *Projektionsraum Rotation*
(Rotation in projection room), 1995
Installation. Two slide projectors, two electro motors,
two moving glass plates (Installation. Zwei Diaprojekto-
ren, zwei Elektromotoren, zwei bewegliche Glasplatten)
Courtesy of the artist (top)

Karl Martin Holzhäuser: *Licht–Punkt–Serie I*
(Light–Point–Series I), 1995
Seven unique luminograms on chromogenic color
paper (C-prints). Diasec, each 120 x 120 cm
Exhibition *László Moholy-Nagy: Idee und Wirkung.
Anklänge an sein Werk in der zeitgenössischen Kunst*
(László Moholy-Nagy: Idea and Influence. Echoes of
his work in contemporary art).
Kunsthalle Bielefeld, 1995
Courtesy of the artist (bottom)
Photographs: Peter Nixdorf, Bielefeld

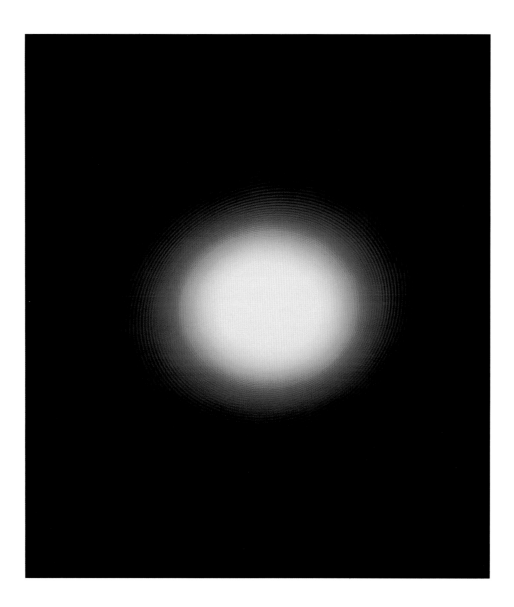

Adam Fuss: *Untitled*, 1998
Luminogram. Unique silver dye bleach print
(Cibachrome), 73.7 x 66 cm
Courtesy of Cheim & Read Gallery, New York

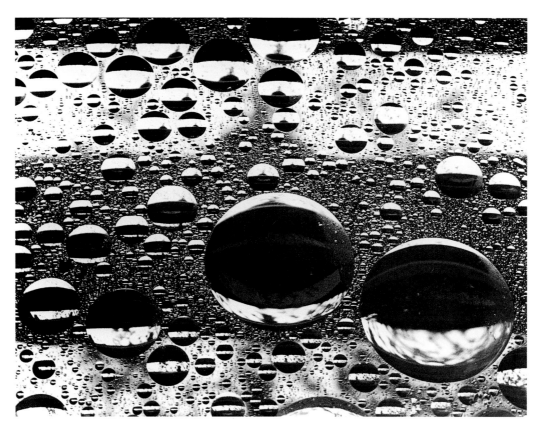

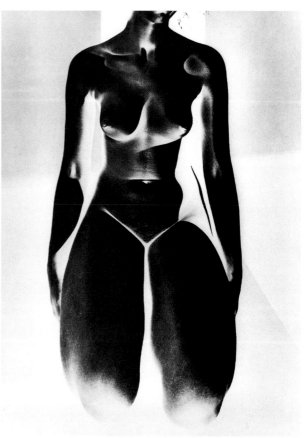

Peter Keetman: *Spiegelnde Tropfen*
(Reflecting drops), 1950
Gelatin silver print, 30.9 x 23.8 cm
Collection F. C. Gundlach, Hamburg
Courtesy of the artist (top)

Otto Steinert: *Schwarzer Akt* (Black Nude), 1958
Gelatin silver print, 60.3 x 45.6 cm
Museum Folkwang Essen
Courtesy of Stefan Steinert (bottom)

Gottfried Jäger

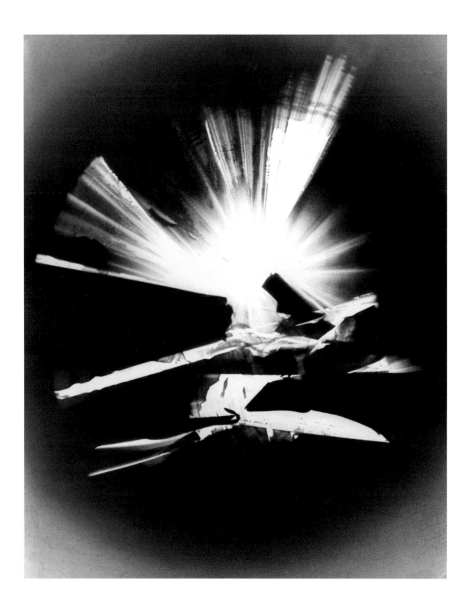

Heinz Hajek-Halke: *Untitled*, ca. 1955
Light-Graphic. Gelatin silver print,
53.5 x 42 cm
Collection Gottfried Jäger
Courtesy of Agentur Focus, Hamburg

Kilian Breier: *Knick* (Break), 1960/65
Luminogram. Unique gelatin silver print,
23.7 x 22.7 cm
Collection Gottfried Jäger
Courtesy of the artist

Pierre Cordier: *Chimigramme*, 1966
Series *Yves 16 mm*.
Unique gelatin silver print, on cardboard,
25.4 x 20 cm
Collection Gottfried Jäger
Courtesy of the artist

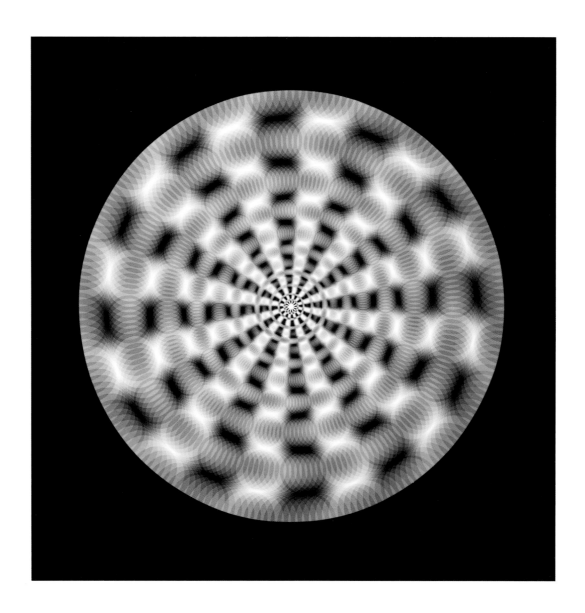

Hein Gravenhorst: *Fotomechanische
Transformation* (Photomechanical
Transformation) *No. 7/7*, 1966/67
Multiple exposure. Unique gelatin silver
print, on cardboard, 23.8 x 23.8 cm
Collection Gottfried Jäger
Courtesy of the artist

Gottfried Jäger

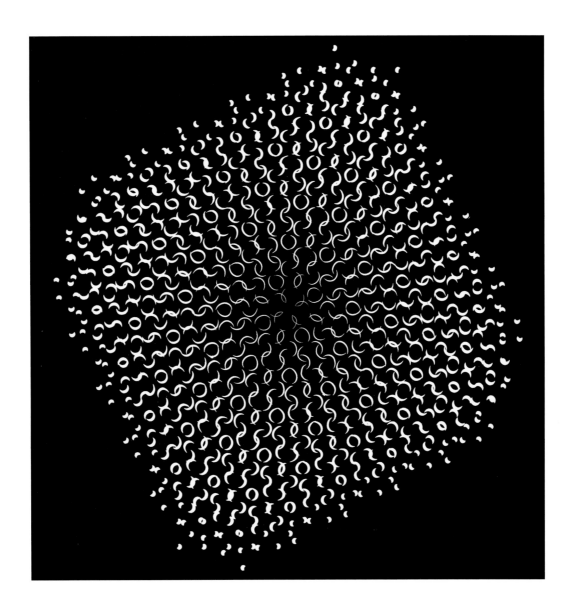

Gottfried Jäger: *Lochblendenstruktur*
(Pinhole Structure) *# 3. 8. 14 F 4. 2*, 1967
Camera obscura work. Gelatin silver print,
50 x 50 cm
Collection of the artist

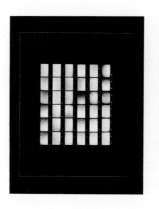

Jan Dibbets: *Untitled*, 1972
Installation, contingent on wall, according
to the artist (Wandabhängige Installation
nach Angaben des Künstlers)
Five chromogenic prints in acrylic boxes,
height 37 cm.
Collection Egidio Marzona (top)

Ugo Mulas: *Verifica 5. Die Vergrößerung:
Der Himmel für Nini* (The Enlargement:
The Sky for Nini), 1972 (bottom)
Photo tableau work. Black-and-white-photo-
graphs with maximum possible two-step
detail enlargement. "If there is something
which, under no circumstances whatsoever,
can be enlarged, then it is the sky. [...] The
dominant element is the grain, the structu-
re of the silver crystals. And one realizes
that it would be possible to attain the same
picture if one photographs a wall. Thus, it
means that the picture is reversible,
exchangeable." (Mulas)

(Foto-Tableau-Arbeit. Schwarzweiß-Foto-
grafien mit maximal möglicher Ausschnitt-
vergrößerung in zwei Stufen. »Wenn es
etwas gibt, das sich unter keinen Umstän-
den vergrößern läßt, dann ist es der Him-
mel. [...] Das vorherrschende Element ist
das Korn, die Struktur der Silberkristalle.
Und man merkt, daß es möglich wäre, das
selbe Bild zu erhalten, wenn man eine
Mauer fotografiert. Das bedeutet also, das
Bild ist reversibel, austauschbar.« [Mulas])

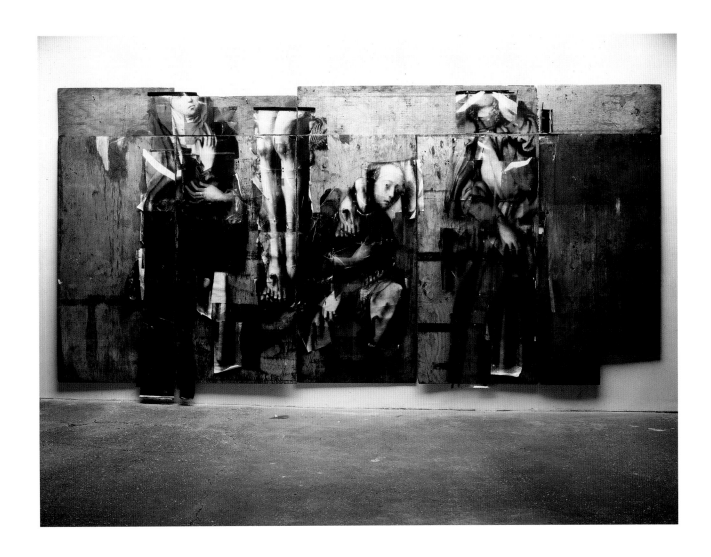

Douglas and Mike Starn: *Gothic (plywood).*
Photowork # 579, 1988–1990
Tinted orthofilm, tinted gelatin silver paper,
plywood, tape, glue, 302 x 610 cm
Exhibition Stux Gallery, New York, 1990
Courtesy of the artists

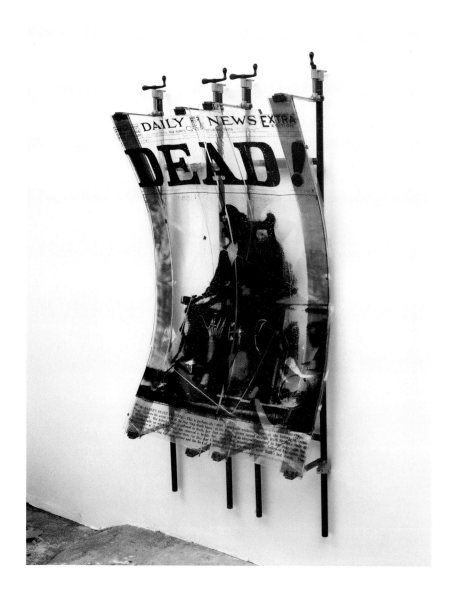

Douglas and Mike Starn: *Dead*, 1990
Wall object (Wandobjekt)
Gelatin silver film, acrylic glass, steel, silicon,
clamps, 190 x 100 x 30 cm
Courtesy of the artists (top)

Katharina Sieverding: *Steigbild III/1–3*, 1997
(left); *Steigbild II/1–3*, 1997 (right)
D-prints, acrylic glass, steel, 300 x 375 cm
Venice Biennale Exhibition, German
Pavillion XLVII (bottom)

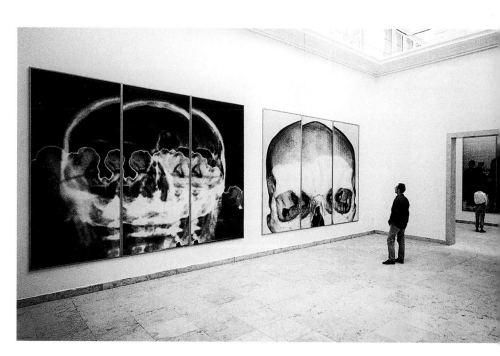

John Hilliard: *Miss Tracy*, 1994
Ink on Vinyl, 252 x 211 cm
Courtesy of the artist

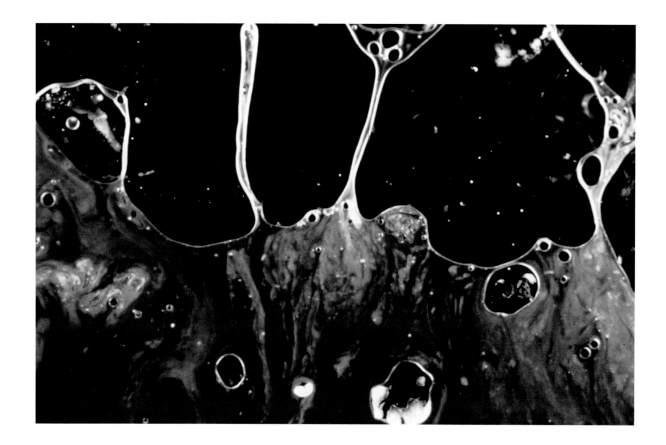

Andres Serrano: *Semen and Blood II*
(Samen und Blut II), 1990
Silver dye bleach print (Cibachrome),
silicone, acrylic glass, wood frame,
101.6 x 152.1 cm
Courtesy of Paula Cooper Gallery,
New York

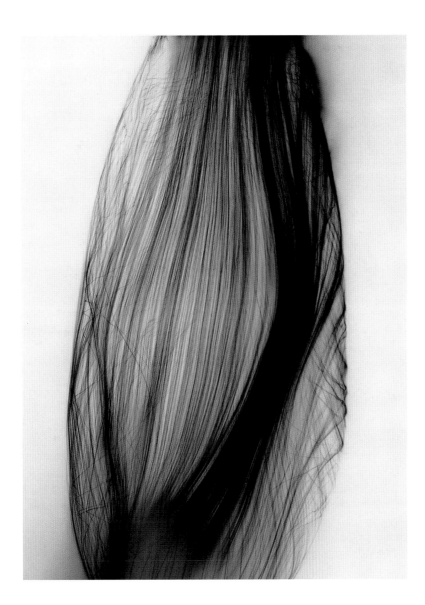

Wolfgang Tillmans: *Muskel* (Muscle), 2001
Unique chromogenic color print
40 x 30 cm
Courtesy of the artist

James Welling: *From the series New Abstractions: # 1, 1998*, 1998
Gelatin silver print, 89 x 67 cm
Sprengel Museum, Hanover
Courtesy of the artist (top)

Andreas Müller-Pohle: *Untitled*, 1978
Gelatin silver print, 40 x 30 cm
Brandenburgische Kunstsammlungen,
Cottbus
Courtesy of the artist (bottom)

Helen Robertson: *Black and White 4/1998*
Gelatin silver print, aluminium, 49 x 59 cm
"The design pattern of a fabric is photogra-
phed. Through the perceptive search of pho-
tography, the pattern returns to its quality;
but, along the way, it does not remain un-
damaged; as the fabric is streched, pulled
or creased, so photography has fixed and
transported the traces of reality on the
handicraft product. And yet the photograph
itself again becomes the model of the design
pattern. Work and artistic expression can
no longer be fixed." (Das gestaltete Muster
eines Stoffes wird fotografiert. Das Muster
findet über die Wahrnehmungssuche der
Fotografie wieder zu seiner Qualität zurück;
aber es kommt nicht unbeschadet an;
so wie der Stoff gespannt, verzogen oder
geknittert ist, so hat die Fotografie die
Spuren der Realität am kunstgewerblichen
Produkt fixiert und transportiert. Und doch
wird das Foto selbst wieder zum Vorwurf
des gestalteten Musters. Werk und künstle-
rische Setzung lassen sich dabei nicht mehr
fixieren.) Rainer Stamm, *Eikon*, 25/1998
Courtesy of Ulrich Fiedler Gallery, Cologne

Manfred Bogner: *Untitled*, 1995.
Photo sgraffito. Color photo paper, folded,
grinded. On canvas, stretcher, 50 x 40 cm
"Color photo papers are made up of several
super-imposed emulsion layers. They con-
tain a rich color potential attainable when
mechanically treating the paper (e.g. using
sand paper). Premarked folds and lines in

the paper additionally lend the object form
and structure." (Farbfotopapiere sind aus
mehreren übereinander liegenden Emulsi-
onsschichten aufgebaut. Sie enthalten ein
reiches Farbpotential, das sich bei mechani-
scher Bearbeitung des Papiers, z. B. mittels
Schleifpapier, erschließen läßt. Vorgepräg-
te Knicke und Falzlinien geben dem Objekt
zusätzlich Form und Faktur.) Bogner
Courtesy of the artist

Roland Fischer: *World Trade Center*, 1999
Camera photograph. Chromogenic color
print, 180 x 125 cm
Courtesy of Galerie von Lintel & Nusser,
New York, München

Dai-Yong Jeon: From the series *A Journey to
Find Myself* (Eine Reise, mich zu finden), 1999
Image No. 4 from eleven images.
Inkjet print on paper, 100 x 70 cm
Courtesy of the artist

Karl Martin Holzhäuser: From the series *Licht-
malerei* (Light Painting): *90. 19. 2001*, 2001
Unique gelatin silver print, 60 x 90/120 x 120 cm
Courtesy of the artist

Norbert Meier: *Neustädter Marienkirche,*
Bielefeld, 2001. Four spherical panoramic
photo projects. From the top to the bottom:
From Northtower to South (Feb. 28, 2001,
1:00–1:30 p. m.); from Northtower to North
(Feb. 28, 2001, 1:45–2:15 p.m.); from South-
tower to East (July 12, 2001, 1:00–1:30 p.m.);
from Southtower to West (July 12, 2001,
1:30–2:00 p. m.)
Each 84 laminated chromogenic color
prints, 10 x 15 cm, mounted on wood frames
70 x 180 cm
Courtesy of the artist

Gottfried Jäger

The Group Animato: *Animato*, 1995
Audio-visual paraphrases of the painting
K XVII, oil on canvas, 95 x 75 cm, 1923,
from László Moholy-Nagy. Multimedia
performance and videotape, 12 Min.
Screenshot from the electronic photo
studio in Wavefront Explore with a view
on the virtual camera and the digitalized
virtual 'object' (top)
View through the virtual camera on the
'object' with construction elements
(bottom)

(Audio-visuelle Paraphrasen über das
Gemälde *K XVII*, Öl auf Leinwand, 95 x 75 cm,
1923, von László Moholy-Nagy. Multimedia
Performance und Video, 12 Min.
Bildschirmaufnahme des elektronischen Foto-
studios in Wavefront Explore mit Blick auf
die virtuelle Kamera und auf das digitalisierte
virtuelle ›Objekt‹ [oben]
Blick durch die virtuelle Kamera auf das
›Objekt‹ mit Konstruktionselementen [unten])
Screenshots: Peter Serocka, Bielefeld
Courtesy of The Group Animato

Pierre Cordier: *Chimigramme 24/8/61 I*, 1961
Unique gelatin silver print, plywood, frame,
47 x 47 cm
Collection Gottfried Jäger.
Courtesy of the artist

Lambert Wiesing

Abstrakte Fotografie: Denkmöglichkeiten What Could Abstract Photography Be?

1 Es bestehen zwei Möglichkeiten, über das bei weitem noch nicht hinreichend erforschte Thema Abstrakte Fotografie nachzudenken. Diese Möglichkeiten unterscheiden sich durch ihre zumeist nur implizit vorhandene Fragestellung. Man kann sich dem Phänomen mit der Frage zuwenden: *Was ist Abstrakte Fotografie?*, aber auch mit der Frage: *Was könnte Abstrakte Fotografie sein?* Dies sind zwei ausgesprochen unterschiedliche Wege, die es zu differenzieren gilt. ■ **2** Die erste Frage: *Was ist Abstrakte Fotografie?* befaßt sich mit empirischen Sachverhalten. Es gibt Gegenstände, die bis heute mit dem wahrscheinlich von Alvin Langdon Coburn 1916 erstmals programmatisch verwendeten Begriff Abstrakte Fotografie zusammengefaßt werden.[1] Wer sich fragt: *Was ist Abstrakte Fotografie?*, möchte diese Gegenstände genauer erforschen, zum Beispiel ihre besonderen Eigenschaften oder ihre verschiedenen Spielarten. Er möchte wissen, wer diese Dinge wann gemacht hat und vielleicht auch noch, warum sie so bezeichnet werden, wie sie bezeichnet werden. Man merkt schnell, eine kompetente Antwort auf die Frage *Was ist Abstrakte Fotografie?* wird nur jemand geben können, der sich in der Geschichte und der aktuellen Praxis der Abstrakten Fotografie auskennt, also wahrscheinlich ein Kunst- oder Fotografiehistoriker. Das Kriterium, ob er eine richtige oder falsche, eine gute oder schlechte Antwort gibt, schaffen stets die empirischen Tatsachen. Seine Antworten werden daran gemessen, ob sie mit der Wirklichkeit – was immer man darunter versteht – übereinstimmen.[2] ■ **3** Die zweite Frage: *Was könnte Abstrakte Fotografie sein?* wird deutlich seltener gestellt; sie befaßt sich mit prinzipiellen Denkmöglichkeiten und unterscheidet sich somit kategorial von der ersten Frage. Sie wird kaum noch mit empirischem oder historischem Wissen, sondern vorrangig mit Phantasie und logischer Argumentation beantwortet. Dies ist nahe liegend, denn der Frage: *Was könnte Abstrakte Fotografie sein?* geht es nicht mehr um die Beschreibung von empirischen Realitäten, sondern um die Entdeckung

1 There are two possibilities of reflecting on Abstract Photography, a subject that still needs to be researched into more carefully. These two possibilities differ implicitly in their fundamental approach. One can approach the subject by asking either *What is Abstract Photography?*, or, equally, *What could Abstract Photography be?* These are two completely different approaches which have to be dealt with separately. ■ **2** The first question *What is Abstract Photography?* involves empirical facts. There are objects that hitherto are associated with the term Abstract Photography, a term that was probably first used in its programmatic sense by Alvin Langdon Coburn.[1] For any-body asking, *What is Abstract Photography?* there is a need to examine these objects more closely, for example, their essential characteristics or their various kinds of manifestation. For him it is necessary to know who made these things and when, and perhaps, why they are called what they are called. One quickly realises that an informed answer to the question *What is Abstract Photography?* can only be given by someone who is well versed in the history of photography and current practice of Abstract Photography: i. e. someone who is probably either an art historian or a photography historian. The criteria according to which his answer is right or wrong, good or bad, are always determined by the empirical facts. His answers will be judged by the extent to which they correspond to reality—whatever that may be.[2] ■ **3** The second question *What could Abstract Photography be?* is posed much less often: it involves principle conceptual approaches and thus differs categorically from the first question. The answer to the second question presupposes not so much knowledge of empirical or historical facts, but, first and foremost, fantasy and logical argumentation. This is obvious, since the question *What could Abstract Photography be?* no longer involves the description of empirical realities, but the discovery of new

1 Alvin Langdon Coburn: Die Zukunft der bildmäßigen Fotografie (1916). In: Kemp, Wolfgang (ed.): *Theorie der Fotografie Bd. II, 1912–1945.* München 1979, pp. 54–58.

2 In diesem Sinne einschlägige Antworten auf die Frage *Was ist Abstrakte Fotografie?* geben There are clear answers in this sense to the question *What is Abstract Photography?* by Jäger, Gottfried: *Bildgebende Fotografie. Ursprünge, Konzepte und Spezifika einer Kunstform.* Köln 1988; Neusüss, Floris M.: *Das Fotogramm in der Kunst des 20. Jahrhunderts.* Köln 1990.

denkbarer Möglichkeiten. Das Problem hat sich verschoben: Nicht was etwas ist, sondern was etwas sein könnte, steht im Vordergrund. Für dieses Thema kann die Geschichte und aktuelle Praxis der Abstrakten Fotografie allerhöchstens noch ein Hilfsmittel sein, um Möglichkeiten der Abstrakten Fotografie kennenzulernen – geleitet von dem einfachen Prinzip: Was wirklich ist, muß auch möglich sein. Doch umgekehrt – und dies ist entscheidend – findet man in der Wirklichkeit keinen Überblick über die gesamten Möglichkeiten. Denn keineswegs ist garantiert, daß alles, was möglich ist, auch verwirklicht ist. Die Empirie kann daher nicht mehr das Kriterium sein, anhand dessen entschieden wird, ob die Frage nach den denkbaren Ausgestaltungsformen der Abstrakten Fotografie richtig oder falsch, gut oder schlecht beantwortet wird. Wenn es um Möglichkeiten geht, dann entscheidet einzig die logische Schlüssigkeit, Vorstellungskraft und Vollständigkeit über den Wert der Argumentation. Man hat es daher mit einer Frage zu tun, welche nicht mehr vorrangig in der Kunstgeschichte, sondern in der Philosophie und in Künstlerprogrammen bearbeitet wird. Dies sind jedenfalls die typischen Orte, an denen Denkmöglichkeiten ausprobiert und ausformuliert werden. Daß sich die Philosophie mit Denkmöglichkeiten befaßt, ist für sie geradezu typisch. Denn wenn es um Denkmöglichkeiten geht, dann ist die Aufmerksamkeit nicht mehr auf das mit einem Begriff Gemeinte, sondern auf den Begriff selbst gelenkt. Wer fragt: *Was könnte Abstrakte Fotografie sein?* erforscht in der Tat letztlich den Sinn eines Begriffes und trifft sich daher in seinem Anliegen mit der Intention zahlreicher Künstlerästhetiken oder Künstlerprogramme. Denn der Künstler hat mit der Herangehensweise des Philosophen gemeinsam, daß er sich weniger für die vorhandenen Arbeiten seiner Kollegen als für neue, unbekannte, noch unausgearbeitete Möglichkeiten dieser Art des Fotografierens interessiert. Deshalb kann die Beantwortung der Frage: *Was könnte Abstrakte Fotografie sein?* bis ins Visionäre und Utopische gehen. ■ 4 Die Fragen: *Was*

conceptual possibilities. The problem is now a different one. We are not so much concerned with the question of what is, but of what could be. The history and current practice of abstract photography can, at the very most, be a help in this respect, offering venues for getting to know the possibilities of abstract photography—geared to the simple principle: anything that is real, must also be possible. Yet vice versa—and this is crucial—reality does not offer a complete insight into the whole range of possibilities. For there is no guarantee that everything that is possible is also realized. Empirical facts can, therefore, no longer be the criteria which determine whether the question about possible varieties of abstract photography gets a right or wrong, good or bad answer. When it comes to the question of possibilities logicality, imagination and attention to wholeness alone decide the merit of the argumentation. This is the reason the question in hand is not to be dealt with so much in terms of the history of art as from the point of view of philosophy and artists' programs. These, at any rate, are the typical areas in which new possibilities are tried out and explored. That philosophy is concerned with conceptual possibilities is not unusual. Indeed, when it comes to conceptual possibilities, it is not so much the reference to a notion that is the focus of our attention, but the notion itself. Anybody asking *What could Abstract Photography be?* is, in actual fact, exploring the meaning of the notion and in doing so, touches on the very questions that numerous theories of aesthetics or programs of artists are concerned with. The artist, indeed, shares with the philosopher the same claim: he is not so much interested in the completed works of his colleagues as in the new, unknown, and yet to be realized possibilities of this kind of photography. That is why the answer to the question *What could Abstract Photography be?* might venture into the visionary and utopian. ■ 4 The questions *What is Abstract Photography?* and *What*

Lambert Wiesing

ist Abstrakte Fotografie? und *Was könnte Abstrakte Fotografie sein?* sollten nicht gegeneinander ausgespielt werden; sie sind keine Alternativen. Keine der beiden Fragen ist die richtige oder gar die wahre. Man mag persönlich nur die Beantwortung einer der beiden Fragen für wichtig erachten, doch die Beantwortung der einen Frage kann in keinem Fall die Arbeit an der anderen ersetzen. Da insbesondere die Frage: *Was ist Abstrakte Fotografie?* im Sinne der genannten Kriterien überzeugende Antworten gefunden hat, ist es einen Versuch wert, sich auch einmal der Frage: *Was könnte Abstrakte Fotografie sein?* zuzuwenden. ■ **5** Das Adjektiv abstrakt dient in der Zusammensetzung Abstrakte Fotografie dem Zweck, eine besondere Form der Fotografie zu bestimmen. Erfreulich unstrittig ist, daß diese Bestimmung im Sinne einer Klassifikation und nicht im Sinne einer Evaluation gemeint ist. Das Adjektiv abstrakt soll nicht bewerten, sondern beschreiben. Der Begriff Abstrakte Fotografie ist also ganz anderer Natur als zum Beispiel die Begriffe politische Fotografie, schöne Fotografie oder künstlerische Fotografie. Denn was politisch, schön oder künstlerisch ist, hängt in hohem Maße von Moral-, Norm- und Wertvorstellungen ab. Man kann daher einer Fotografie keineswegs selbst ansehen, ob sie politisch, schön oder künstlerisch ist. Doch genau dies soll bei der Abstrakten Fotografie nicht der Fall sein. Das Abstrakte ist eine Klassifikation ohne jede Bewertung, welche sich auf bestimmte Eigenschaften an der Fotografie selbst richtet – und genau diese Eigenschaften gilt es zu bestimmen. ■ **6** Der Begriff Fotografie bezeichnet im weitesten Sinne die Verfahren, die mittels optischer Systeme sowie der Einwirkung von elektromagnetischen Strahlen, insbesondere von Licht, auf diesbezüglich reagierende Materialien dauerhafte Bilder herstellen. Die fotografisch hergestellten Produkte sind stets chemisch-physikalisch erklärbare Spuren. Fotografien sind das, was sie sind, aufgrund von Ursache-Wirkungs-Zusammenhängen: Nämlich das dauerhaft sichtbare Ergebnis gelenkter Strahlung – so zumindest die

could Abstract Photography be? should not be pitted against each other; they are not alternatives. None of the two approaches is the right or even true one. One might personally consider the answer to only one of the two questions to be important, yet answering the one question can in no way mean foregoing attention to the other. Since convincing answers in the sense of the above-mentioned criteria have been found especially to the question of *What is Abstract Photography?*, it is certainly worth having a closer look at the second question *What could Abstract Photography be?* ■ **5** The adjective abstract in the combination Abstract Photography serves the purpose of defining a special form of photography. There is, happily, agreement that this definition is meant in the sense of a classification and not in the sense of an evaluation. The adjective abstract is not intended to have an evaluating, but a descriptive function. The term Abstract Photography is of a completely different nature to, for example, terms like political photography, aesthetic photography, or creative photography. For what is called political, aesthetic or creative depends to a great extent on ideas of morality, norms, and values. One can, therefore, never judge by the picture itself whether it is political, aesthetic, or creative. Yet this is the very thing that does not apply to Abstract Photography. The term abstract is a classification that defies evaluation, applying to certain kinds of characteristics within the photograph itself – and it is these very characteristics which are to be determined. ■ **6** The notion photography defines in the widest sense the method which with the help of optical systems and the effect of electromagnetic rays, especially of light on materials that are sensitive to this, produces durable pictures. Such photographically produced products are always traces which can be explained in chemical and physical terms. Photographs are what they are because they embody the result of cause and effect, that is,

weite Bedeutung des Begriffes Fotografie. In einem deutlich engeren Sinne versteht man unter Fotografie das technische Herstellen von Abbildern einer Sache durch optische Transformation und Konservierung von Lichtspuren. In diesem engen Sinne von Fotografie ist diese in erster Linie durch ihren auf Ähnlichkeit basierenden Objektbezug bestimmt: Fotografie stellt berechenbare Abbilder von sichtbaren Gegenständen her. ∎ 7 Auch beim Begriff abstrakt lassen sich eine weitere und eine engere Bedeutung unterscheiden. Ganz allgemein besagt der Begriff abstrakt, daß etwas unabhängig ist, losgelöst und ohne Bezug. Die Eigenschaft, abstrakt zu sein, haben genau die Phänomene, die durch Abstraktion entstanden sind. In diesem sehr weiten Sinne von abstrakt ist nicht angegeben, was von was losgelöst ist. So nennt zum Beispiel Hegel einen Begriff abstrakt, wenn er ohne Bezug zu anderen Begriffen gedacht ist. In der deutlich engeren, aber auch gewöhnlicheren Bedeutung von abstrakt ist hingegen das, wovon abstrahiert wird, eindeutig festgelegt: Abstrakt ist etwas, das keinen Bezug zu sichtbaren, konkreten Gegenständen besitzt. Abstraktion ist dann nicht mehr ein Absehen von irgend etwas, sondern ein Absehen vom erkennbaren Gegenstandsbezug. Eine Theorie ist in diesem Sinne abstrakt, wenn sie nicht von der sichtbaren Lebenswelt handelt; ein Bild ist in diesem Sinne abstrakt, wenn kein Gegenstand auf ihm erkannt werden kann. ∎ 8 Vor dem Hintergrund dieser Überlegungen zu den Begriffen abstrakt und Fotografie wird verständlich, wieso es zumindest denkbar ist, daß die Begriffskombination Abstrakte Fotografie für eine contradictio in adjecto gehalten werden kann. Denn dies ist in der Tat der Fall, insofern die beiden Begriffe in ihrer engen Bedeutung gedacht werden: Wenn man unter Fotografie versteht, mittels Fotoapparaten sichtbare Gegenstände abzubilden, dann kann es keine Abstrakte Fotografie geben, denn diese würde verlangen, in der Fotografie von dem sichtbaren Gegenstand zu abstrahieren, den abzubilden aber nach dem engen Verständnis

the durably visible result of a directed ray—such is at least the general meaning of the term 'photograph'. In a much narrower sense the term 'photography' means the technical production of figurative pictures of an object by way of optical transformation and conservation of traces of light. In this narrow sense photography is primarily defined in terms of the similarity of the photograph to the represented object: photography creates predictable representations of visible objects. ∎ 7 The notion abstract can similarly be regarded in a narrow or general sense. Generally speaking the notion abstract means that something is independent, detached and without direct association. The quality of being abstract associated with those very phenomena that have come about by abstraction. In this very broad sense of the notion abstract there is no indication of what has become detached from what. Hegel, for example, calls a concept abstract if it is thought apart from other concepts. In the clearly narrower and also more usual sense of the term 'abstract', however, whatever has become the abstraction is clearly defined: something is abstract when it has no relationship to visible, concrete objects. Abstraction is thus not so much repudiation of something, but repudiation of visible association with a concrete object. A theory is in this sense abstract, when it has nothing to do with the "Lebenswelt"; similarly, a picture is abstract, when no visible object can been discerned in it. ∎ 8 Such reflections on the notions abstract and photography help understand why it is at least possible that the combination of the terms in Abstract Photography can be considered to be a contradictio in adjecto. This is indeed the case, if the two terms are regarded in their narrow sense: If one defines photography as the means of representing visible objects with cameras, there can be no Abstract Photography, for this would require abstracting from the visible object, the representation of which is the very essence of

Lambert Wiesing

von Fotografie gerade wesentlich für die Fotografie ist. Man kann an diesem Beispiel einen prinzipiellen Zusammenhang zwischen Abstraktion und Fotografie ableiten: Von Abstrakter Fotografie kann nur jemand sprechen, für den der Begriff Fotografie ein Phänomen mit kontingenten Eigenschaften bezeichnet. Denn Abstrahieren kann man immer nur von etwas, was für dieses etwas nicht als wesentlich erachtet wird. Wenn nichts Unwesentliches vorhanden ist, gibt es auch nichts zu abstrahieren. Deshalb ist jede gelingende Abstraktion immer auch eine Reduktion auf etwas Wesentliches; jede Abstraktion, dies ergibt sich aus dem Begriff, erfolgt aus der Intention heraus, das Augenmerk auf die als wesentlich beurteilten Merkmale einer Sache zu lenken. Genau dieser prinzipielle Zusammenhang gilt uneingeschränkt auch für den besonderen Fall der Abstraktion in der Fotografie. Wie alle Abstraktionen muß auch sie eine Reduktion auf wesentliche Aspekte sein, das heißt in diesem Fall auf wesentliche Merkmale der Fotografie. Denn wie immer abstrakte Fotografien aussehen mögen, auch sie sind nur dann denkbar – dies ist nun keine empirische, sondern eine logische Einsicht – wenn sie von etwas abstrahieren, was für die Fotografie nicht wesentlich ist: Denn würden sie von etwas Wesentlichem abstrahieren, wäre das Ergebnis keine Fotografie mehr. Wie eben das Beispiel zeigt, daß derjenige, welcher unter Fotografie das technische Herstellen von gegenständlichen Abbildern versteht, gegenstandslose Fotografie nicht als ›Fotografie‹ bezeichnen kann. Das heißt aber: Abstrakte Fotografie wird erst dann möglich, wenn der Begriff Fotografie nicht schon zuvor so reduziert ist, daß keine Abstraktion mehr möglich ist, wenn der vorausgesetzte Begriff von Fotografie noch eine Abstraktion-erlaubende Weite besitzt. ■ 9 Ein Abstraktion-zulassendes Fotografieverständnis lautet: Der Begriff Fotografie bezeichnet Verfahren, die mittels optischer Systeme (Fotoapparate) und der Einwirkung von Licht auf diesbezüglich reagierende Substanzen dauerhafte Bilder herstellen. Von diesem gewöhnlichen

photography if taken in its narrow sense. From this example one can deduce a principle connection between abstraction and photography: One can only refer to Abstract Photography, if the notion photography applies to a phenomenon with contingent qualities. For one can only make something abstract if there is something that is not regarded as being an essential part of it. If there is nothing unessential, there will be nothing to make an abstraction of. That is why every successful abstraction is also always a reduction to something essential; every abstraction—this is what the notion implies—is the result of the intention of directing attention at the essential characteristics of a thing. It is this very basic interconnection that applies without reservation to the special case of abstraction in photography. Like all abstractions this one must also be a reduction to essential aspects, that is, in this case the essential characteristics of photography. For no matter what abstract photographs look like, they can only be regarded as abstract Photographs—this is not an empirical but a logical necessity—if they can abstract from something that is not essential to photography. For if they made something essential abstract, the result would no longer be a photograph. Just as the above example shows: whoever regards photography as the technical production of figurative pictures, cannot call non-figurative photography photography. But this means: Abstract Photography is only possible if the notion photography has not been previously limited to such an extent that abstraction is no longer possible, if the presupposed notion photography still maintains a dimension allowing abstraction. ■ 9 One definition of this kind—permitting abstraction in photography—is as follows: the notion photography refers to methods which with the help of optical systems (cameras) and the effect of light on sensitive materials produce durable pictures. Beginning with this common explanation, one can continue by posing

Verständnis ausgehend, kann man nun wiederum an zwei Stellen die Fragen ansetzen: *Sind in dieser Definition unwesentliche Merkmale der Fotografie enthalten? Kann man nicht auf einen der genannten Eigenschaften der Fotografie verzichten? Was kann bei diesem üblichen Fotografieverständnis fehlen, ohne daß man aufhören muß, von Fotografie zu sprechen?* Erstens der Produktionsprozeß (also das Fotografieren) und zweitens das Produkt (also die hergestellte Fotografie) lassen sich auf unwesentliche Komponenten hin untersuchen. ■ 10 Wenn man vom Produktionsprozeß ausgeht, dann wird die Frage: *Was könnte Abstrakte Fotografie sein?* beantwortet, indem man sich Fotografiearten ausdenkt, in denen Teile des gewöhnlichen Herstellungsvorganges übergangen werden. Der in dieser Hinsicht in der Abstrakten Fotografie am meisten diskutierte, als überflüssig beurteilte Produktionsteil der Fotografie ist eindeutig das Fotoobjektiv oder gar der ganze Fotoapparat. Als Abstrakte Fotografie kann eine Fotografie gedacht werden, welche ohne komplette Fotoapparate versucht, Lichteinwirkungen auf lichtempfindliche Substanzen als sichtbare Spuren zu konservieren. Diese rein formalen Überlegungen zum Begriff der Abstrakten Fotografie decken sich – könnte es anders sein? – mit der Geschichte dieser Art der Fotografie. In der Tat bezeichnet man genau die Teile der Experimentellen Fotografie als Abstrakte Fotografie, die versuchen, mit einem reduzierten Produktionsvorgang Fotografien herzustellen. Gerade die klassischen Beispiele der Abstrakten Fotografie arbeiten bewußt ohne Kamera oder Kamerateile: Die *Vortographs* von Alvin Langdon Coburn (Abb. S. 126f.), die *Schadografien* von Christian Schad (Abb. S. 37), die *Rayogramme* von Man Ray (Abb. S. 38), die *Lochblendenstrukturen* von Gottfried Jäger (Abb. S. 57). Alle diese Beispiele sind schon allein deshalb Beispiele Abstrakter Fotografie – egal wie sie aussehen – , weil sie von Bestandteilen des Fotografierens abstrahieren. Man kann sogar sagen, daß die Geschichte der Abstrakten Fotografie in nicht geringen Teilen wie eine ständige Arbeit

the following questions on two aspects: *Are inessential characteristics of photography contained in this definition? Can one not forego one of the above-mentioned characteristics of photography? What can be omitted considering this common definition of photography without one having to stop using the notion photography?* Firstly, the production process (i.e. the taking of the photograph) and secondly, the product (i.e. the produced photograph) can be analyzed with regard to non-essential components. ■ 10 Taking the productive process as a starting point, the question *What could Abstract Photography be?* can be answered by envisaging varities of photography where certain parts of the usual production process are omitted. The part of the production process in photography which is most commonly discussed in this respect in Abstract Photography and also judged as being superfluous is clearly the photo lens and even the whole camera itself. A photograph can be thought as an abstract photograph if it tries — without using the camera as a whole — to conserve the influx of light on light-sensitive substances as visible traces. These purely formal reflections on the notion Abstract Photography coincide with — could it be otherwise? — the history of this type of photography. Indeed, one calls those aspects of Experimental Photography Abstract Photography that aim at creating photographs that involve a reduced production process. It is the classic examples of Abstract Photography that purposely forego the use of the camera or parts of it: The *Vortographs* of Alvin Langdon Coburn (figs. pp. 126f.), the *Schadographs* of Christian Schad (fig. p. 37), the *Rayograms* of Man Ray (fig. p. 38), the *Pinhole Structures* of Gottfried Jäger (fig. p. 57). All of these are examples of Abstract Photography — no matter what they look like — simply because they are an abstraction of parts of the photographic process. One can even say that the history of Abstract Photography generally seems to involve continuous work

an der Frage erscheint: Und auf was kann man bei der Herstellung eines Fotos noch verzichten? Es werden unterschiedlich radikale Antworten gegeben: Das Cliché verre (Abb. S. 46, 49, 86f.) verzichtet zwar auf einen Fotoapparat, aber nicht auf eine Art Negativ. Denn in dieser Technik wird eine Glasplatte mit Ruß oder einer ähnlich opaken Schicht belegt und anschließend wie bei einer Kaltnadelradierung eine Zeichnung eingeritzt. Danach dient diese Glasplatte als eine Art Negativ für fotografische Kopier- und Vergrößerungsprozesse. Das Cliché verre abstrahiert also von der Kamera, aber nicht vom Negativ – was den nächsten Abstraktionsschritt nahe legt: Das Fotogramm (Abb. S. 37ff., 63, 234f.). Im Fotogramm abstrahiert man auch noch vom Umweg über das Negativ und legt direkt auf das Fotopapier Gegenstände, die dann das einfallende Licht beeinflussen und entwickelbare Spuren hinterlassen. Doch auch dies läßt sich noch steigern: Im sogenannten Luminogramm (Abb. S. 86, oben; 98, 250f.) abstrahiert man dann nicht nur von der Kamera und dem Negativ, sondern auch vom Abbildungsgegenstand des Fotogramms. Im Luminogramm strahlt gelenktes und bearbeitetes Licht direkt auf das empfindliche Papier, ohne Umwege und Transformationen durch ein Objektiv, ohne Reflexionen oder Verschattungen von einem Objekt. Schaut man auf diese Reihe von denkbaren Abstraktionen, so merkt man, daß den Techniken der kameralosen Fotografie eine immanente Hierarchie eingeschrieben ist: Von der Abstraktion des Objektivs, über die ganze Kamera, über das Negativ, den Lichtgang-beeinflussenden Gegenstand hin zur radikalsten Form der Abstrakten Fotografie, die sich der Grenze zur Nicht-mehr-Fotografie deutlich annähert: Dem Chemigramm (Abb. S. 72, 92f.). Ausschließlich Kombinationen von Chemikalien auf lichtempfindlichem Papier, wie zum Beispiel Entwickler und Fixierfüssigkeit, führen bei normalen Lichtverhältnissen zur Entwicklung sichtbarer Formen. Das Chemigramm praktiziert eine Technik, bei der sich in der Tat die Frage stellt, ob nicht von einem wesentlichen Merkmal des

on the question: What else can one forego in the process of creating a photo? Various kinds of radical answers are possible: the *cliché verre* (figs. pp. 46, 49, 86f.) foregoes the use of the camera, but requires some kind of negative. This technique involves using a glass plate which has a layer of soot or any other opaque substance, and then etching a picture onto it, similar to the technique of dry-point engraving. After this the glass plate serves as a kind of negative for the photographic processes of copying and enlarging. The cliché verre, therefore, abstracts from the camera, but not from the negative—which calls to mind the next level of abstraction—the photogram (figs. pp. 38f., 63, 234f.). The photogram is a type of abstraction which avoids the negative and consists of putting objects on the photo paper which affect the influx of light on the paper, thus leaving traces on the paper that can be developed. But there is an even higher level of abstraction: The so-called luminogram (figs. pp. 86, top; 98, 250f.) abstracts not only from the camera and the negative, but also the reproduced object of the photogram. In the luminogram guided and manipulated light rays are directed onto light-sensitive paper, without the deviations or transformations produced by the lens, without reflections or shadowing produced by an object. Considering this array of possible abstractions, one cannot help noticing that there is an immanent hierarchy entrenched in the techniques of camera-less photography: from the abstraction from the lens, the whole camera, the negative or the object with is light-deflecting qualities, to the most radical type of Abstract Photography which borders very closely on the non-photograph: The chemigram (figs. pp. 72, 92f.). The exclusive use of combinations of chemicals on light-sensitive paper, for example, developer and fixing agent, under normal light conditions help to create visible forms. The chemigram uses a technique which indeed raises the question of whether there has been an abstraction

Fotografierens, nämlich von der Gestaltung und Formung des einfallenden Lichts abstrahiert wurde. Jedenfalls möchte auch Gottfried Jäger auf dieses Merkmal in seiner Definition der Fotografie nicht verzichten: »Es ist das Prinzip der Analogie zwischen Ursache und Wirkung des Lichts. Fotos kommen aufgrund gelenkter elektromagnetischer Strahlung zustande, die auf einem strahlungsempfindlichen Material fixiert wird. Diese Aussage trifft sowohl auf einfache Kamerafotografien als auch auf die abstraktesten Lichtkompositionen zu. Beide sind das direkte Ergebnis eines physikalischen Ursache-Wirkung-Wechselspiels, das sie auf ihre jeweils eigene Art und Weise abbilden.«[3] Man sieht hier erneut: Die Antwort auf die Frage: *Was könnte Abstrakte Fotografie sein?* hängt immer von der Meinung ab, was Fotografie überhaupt ist. Wenn Fotografien in der Tat »aufgrund gelenkter elektromagnetischer Strahlung zustande« kommen, wie es gerade hieß, dann ist beim Chemigramm entweder die Grenze des Abstrahierbaren überschritten oder aber eine extreme Art der Auslegung dieses Merkmales gegeben. Diese Entscheidung ist beim Chemigramm ausgesprochen schwer zu fällen: Immerhin liegen die Chemikalien selbst wie ein Objekt auf dem Fotopapier und wirken wie beim Fotogramm als lichtabsorbierendes und damit lichtlenkendes Medium. Doch wenn dieser Rest von Lichtlenkung für ein Chemigramm wesentlich sein soll, dann hätte man keine eigenständige Form der Abstrakten Fotografie, sondern nur eine Spielart des Fotogramms. Doch Fotogramme und Chemigramme lassen sich begrifflich sehr wohl unterscheiden: Die Techniken des Fotogramms beeinflussen den Weg des Lichts von der Quelle auf das lichtempfindliche Material, wohingegen die Techniken des Chemigramms die Wirkungen des Lichts auf dem lichtempfindlichen Material beeinflussen. Beim Chemigramm wird demnach ein Foto hergestellt, weil die elektromagnetische Strahlung in ihren Wirkungen vom Fotografen gelenkt und geformt wird. Man hat bei einem Chemigramm, wie bei jedem Foto, die fixierte Spur eines gesteuerten

from an essential element of photography, i. e. the forming and shaping of the influx of light. Gottfried Jäger at any rate does not wish to forego this feature in his definition of photography: "It is the principle of the analogy between cause and effect in light. Photos come about as a result of guided electro-magnetic rays which are directed at light-sensitive material. This applies both to simple camera photographs and also to the most abstract of light compositions. Both are the direct result of a physical interplay of cause and effect which they reproduce in their specific way."[3] Again one sees here: The answer to the question of *What could Abstract Photograph be?* depends on the basic concept of what photography is at all. If indeed photographs come about "as a result of guided electromagnetic rays", as mentioned above, then either the chemigram transcends the possibilities of abstraction or we are here concerned with a radical interpretation of this feature. It is extremely difficult to decide which is the case when it comes to the chemigram: At least the chemicals cover the photo-paper like an object and are, as with the photogram, like a medium which is absorbing and thus guiding light. Yet if this remnant of light-guidance is supposed to be essential for a chemigram, it would be no independent type of Abstract Photography, but a variety of the photogram. Yet there is a distinct difference in the definition of the concepts photogram and chemigram: The techniques of the photogram affect the path of light from its source onto the light-sensitive paper, whereas the techniques of the chemigram influence the effects of light on light-sensitive material. Thus the chemigram, is a photo which is produced because electromagnetic rays have their effect because the photographer directs and forms them. The chemigram, as does every photo, contains a defined line of purposeful interplay between light and light-sensitive material. It is important of remember this: The chemigram definitely does not abstract from an

3 Jäger, Gottfried: Abbildungstreue. Fotografie als Visualisierung: Zwischen Bilderfahrung und Bilderfindung. In: Dress, Andreas; Jäger, Gottfried: *Visualisierung in Mathematik, Technik und Kunst.* Braunschweig, Wiesbaden 1999, pp. 137–150.

Lambert Wiesing

Zusammenwirkens von Licht und lichtempfindlichem Material. Genau das sollte nicht übersehen werden: Man hat beim Chemigramm gerade eben nicht von einem wesentlichen Bestandteil des Fotografierens abstrahiert: nämlich von der Fixierung einer Lichtspur. Denn es läßt sich durchaus denken, daß auch auf diese Fixierung verzichtet wird, was bei sogenannten Strömungs- oder Fließbildern (Abb. Frontispiz, S. 92f.) der Fall ist. Unterschiedlich angelegte lichtempfindliche Substanzen werden einem nicht geformten Licht ausgesetzt und diesem Vorgang überlassen; man hat ein sich anhaltend entwickelndes, nicht gestopptes Chemigramm. Es mag zwar noch ein Einfluß darauf genommen worden sein, wo das Licht welche Wirkung zeigt, doch wenn man, wie es gerade hieß, von einem Foto verlangt, daß gelenkte Strahlung »auf einem strahlungsempfindlichen Material fixiert wird«, dann muß man sagen, daß diese Fixierung fehlt. Das Fließbild ist zwar denkbar, und insbesondere aus Arbeiten von Ralf Filges bekannt, fällt aber nur noch sehr zweifelhaft unter den Begriff der Fotografie. Ausschließlich die Verwendung von Fotomaterialien könnte als Begründung angeführt werden, warum das Fließbild noch eine Form der Abstrakten Fotografie ist. Die Fotografie ist in dieser Extremform der Abstraktion auf den bloßen Ablauf eines chemischen Prozesses reduziert und hat sich damit zwar nicht im chemischen Sinne, aber doch im begrifflichen Sinne aufgelöst: Die Grenze zur Objektkunst ist überschritten. ■ 11 Wenn man die kameralose Fotografie als eine Form der abstrakten Fotografie beurteilt, dann tut man gut daran, genau anzugeben, warum dies der Fall sein soll. Es sind zwei Begründungen denkbar. Erstens kann man sagen, daß die kameralose Fotografie abstrakt ist, weil sie während des Fotografierens von der Verwendung wichtiger Bestandteile des gewöhnlichen Fotografiervorganges abstrahiert. In diesem Fall führt die kameralose Fotografie notwendigerweise immer zu Ergebnissen, die als Abstrakte Fotografie bezeichnet werden können. Wenn man weiß, daß ein Foto kameralos hergestellt wurde,

essential element of photography, i. e. the fixation of a trace of light. It is indeed quite possible to imagine that this kind of fixation does not take place either, as is the case with so-called flux and fluid pictures (figs. frontispiece, p. 92f.). Light-sensitive substances, variously prepared, are subjected to unaffected light influx, and left to this process; the result is a chemigram which is continuously developing and a process which has not been stopped. There might have been an attempt to influence the extent to which where light has what effect, but if one requires of a photo—as just stated—that guided light "is directed at light-sensitive material", it has to be said that there is no fixation in this sense. The fluid picture may be conceivable, and well-known especially from Ralf Filges' work, but can only be termed photography to a very limited extent. It is only the use of photo material itself that might justify the fact that the fluid picture is a form of abstract photography. Photography, in this extreme form of abstraction, is simply reduced to mere reaction wihin a chemical process, thus dissolving not so much in the chemical, but in the terminological sense. The boundary to object art has been transcended. ■ 11 If one regards camera-less photography as a form of Abstract Photography, it is advisable to state exactly why this should be the case. There are two possible reasons. Firstly, one can say that the camera-less photograph is abstract because the process of making the photograph abstracts from important elements of the usual process of creating a photograph. In this case camera-less photography always leads to results that can be labelled Abstract Photography. If one knows that a photograph has been created without use of a camera, one necessarily knows—according to this definition—that it is abstract without having even seen the photo. This consequence is more than unsatisfactory. For, when talking about Abstract Photography it is also necessary to be aware of the characteristics of the picture. That is

weiß man nach diesem Verständnis auch, ohne das Foto gesehen zu haben, daß es abstrakt sein muß. Das ist ein mehr als unbefriedigendes Ergebnis. Denn, wenn man von Abstrakter Fotografie spricht, so sollten auch Eigenschaften der Bilder angesprochen sein. Man kann daher zweitens der Meinung sein, daß die kameralose Fotografie zu Abstrakter Fotografie führt, weil auf den Bildern keine Abbilder von Gegenständen erkennbar sind. Doch diese zweite Begründung unterscheidet sich von der ersten dadurch, daß sich mit ihr die These, kameralose Fotografie führe notwendigerweise immer und in jedem Fall zu Abstrakter Fotografie, nicht aufrecht halten läßt. Auf vielen Fotogrammen kann man klar und deutlich Gegenstände erkennen; die Ergebnisse sind nicht abstrakt. Das Cliché verre ist eine fotounterstützte grafische Technik, welche wie jede Radierung gegenständliche Fotografien erlaubt. Die Lochblendenstrukturen von Gottfried Jäger sind mit einer Apparatur hergestellt worden, die in ihren Konstruktionsprinzipien der traditionellen Camera obscura gleicht, die also auch gegenständliche Bilder hätte produzieren können. Kurzum: Wenn man nicht nur den Produktionsvorgang, sondern auch die Werke betrachten will, können die Begriffe kameralose Fotografie und Abstrakte Fotografie keineswegs gleich gesetzt werden. Die kameralose Fotografie führt in den meisten Fällen, aber eben nicht notwendigerweise zu Fotografien, die man als abstrakt bezeichnet, weil sie keinen Gegenstand zeigen. Und umgekehrt gilt es zu beachten, daß abstrakte Fotografien auch mit einer Kamera hergestellt werden können. Deshalb muß festgehalten werden, daß der Produktionsprozeß phänomenologisch-werkästhetisch betrachtet, unerheblich ist und daß vielmehr – wie angekündigt – auch das Produkt der Fotografie daraufhin untersucht werden muß, was in ihm kontingent und damit abstraktionsfähig sein kann. ■ 12 Bei einem abstrakten Foto fällt es relativ leicht zu sagen, was es *nicht* ist: Es ist kein gegenständliches Abbild. Eine abstrakte Fotografie ist ein Ding, zumeist ein Blatt Papier, welches fototech-

the reason why one can, secondly, support the view that camera-less photography implies Abstract Photography because it doesn't lead to figurative pictures as a product. But this second reason differs from the first in that the thesis connected with it, i. e. that camera-less photography necessarily and always implies Abstract Photography, cannot be upheld. Many Photograms have objects that can be clearly recognized: The results are not abstract. The *cliché verre* is a graphic technique involving photography, which, like every dry-point, permits figurative photography. The *Pinhole Structures* of Gottfried Jäger have been produced by a camera, whose construction principles are comparable with the traditional camera obscura, and as such, could have also produced figurative photographs. In short: Considering not only the production process, but also the work itself, the terms camera-less photography and Abstract Photography are not synonymous. Cameraless photography produces in most cases, but not always necessarily, photographs that are called abstract because they portray no object. But it is also a fact that abstract photographs can be produced using a camera. It is therefore important to note that the production process, seen from a phenomenological and aesthetic point of view, is of no real significance, and that, as mentioned above, the product of Abstract Photography has to be examined as to what is contingent and thus capable of abstracting from. ■ 12 When talking about an abstract photo it is relatively easy to say what it is not: It is not the figurative picture of an object. An abstract photograph is a thing, mostly a piece of paper, which has been photographically produced, on which visible forms can be seen, which the observer can either not at all or only with difficulty identify as the representation of objects. The abstract photograph is therefore not a picture that might be related to an existing or fictive object. Yet what is the use of this negative description? To say what an abstract

nisch hergestellt wurde, auf dem sich sichtbare Formen befinden, die vom Betrachter entweder überhaupt nicht oder nur sehr schwer als Abbilder von Gegenständen identifiziert werden können. Das abstrakte Foto ist daher kein Bild, welches sich auf einen existenten oder auf einen fiktiven Gegenstand beziehen könnte. Doch was hilft diese negative Beschreibung? Zu sagen, was ein abstraktes Foto nicht ist, beantwortet nicht die Frage: *Was könnten abstrakte Fotografien sein?* Das Problem der Abstrakten Fotografie ist bemerkenswerterweise nicht die simple Feststellung, daß diese keinen Gegenstand zeigt, sondern die Begründung, warum und wozu ein abstraktes Foto von der Darstellung eines Gegenstandes abstrahiert. Die Antwort hierauf hängt mit dem oben schon vorgestellten prinzipiellen Phänomen zusammen, daß jede Abstraktion geschieht, um das Augenmerk auf etwas zu lenken, was als wesentlich beurteilt wird: Wer abstrahiert, sieht von etwas ab, und zeigt damit, daß er meint, man könne hiervon absehen, womit er wiederum zeigt, daß dieses, wovon er absieht, aus seiner Sicht nicht wesentlich sein kann, da von wesentlichen Dingen prinzipiell nicht abgesehen werden kann. Deshalb führt jede Abstraktion stets zu einem Zurschaustellen des für wesentlich Erachteten; jede abstrahierende Abwendung ist mit einer sichtbarmachenden Hinwendung verbunden. Das heißt aber für die Abstrakte Fotografie, daß diese nur denkbar ist, wenn sie in ihren Werken keine erkennbaren Gegenstände abbildet, um damit etwas anderes um so deutlicher erkennbar werden zu lassen. Die Frage: *Was könnte Abstrakte Fotografie sein?* wird letztlich nicht dadurch beantwortet, daß man sagt, sie sei nicht-gegenständliche Fotografie. Das Nicht-Zeigen kann nur eine notwendige, aber keine hinreichende Eigenschaft der Abstrakten Fotografie sein, da sich Fotografien denken lassen, die keine Gegenstände zeigen und dennoch keine abstrakten Fotografien sind: Mittels fotografischer Mittel hergestelltes Geschenkpapier, auf dem schöne Formen zu sehen, aber keine Gegenstände zu erkennen sind, ist keine abstrakte

photo is not does not answer the question *What could abstract photographs be?* The problem of Abstract Photography is surprisingly enough not the simple observa-tion that it does not show an object, but the reason why and to what purpose an abstract photo abstracts from the presentation of an object. The answer to this question has something to do with the principle phenomenon, as presented above, that every abstraction serves to direct the attention towards something that is regarded as essential: Anyone using abstraction detracts from something and therefore shows that he thinks he can detract from it; thus he shows that whatever he is detracting from cannot in his view be essential, since one cannot in principle detract from essential things. That is why every abstraction necessarily reveals what is deemed essential; every detracting abstraction necessarily implies a visualizing counterpart. This means for Abstract Photography, however, that it is only possible if it does not show any recognizable objects in its works in order to make something else more clearly visible. The question of *What could Abstract Photography be?* is not to be answered by merely saying that it is non-figurative photography. Not showing can be a necessary, but not an overall sufficient characteristic of Abstract Photography, since photographs are conceivable that show no objects and yet are not Abstract Photographs: wrapping paper that has been created by photographic techniques and has patterns pleasing to the eye, but no recognisable objects, is no example of Abstract Photography because this paper does not forego showing something for the sake of another. Or imagine developing and enlarging the un-used beginning of an ordinary negative film that has been arbitrarily exposed to light: This would be no abstract photo (figs. p. 99). In fact, one must go even further: Not showing cannot really be the intent of Abstract Photography, but only a means of doing something differently and if that something — whatever

Fotografie, da dieses Papier nicht um einer anderen Sache willen auf das Zeigen einer Sache verzichtet. Oder man stelle sich vor, man würde den unbrauchbaren Anfang eines gewöhnlichen Negativfilmes entwickeln und vergrößern, der unkontrolliert Licht abbekommen hat (Abb. S. 99); man hätte kein abstraktes Foto. Man muß sogar so weit gehen: Das Nicht-Zeigen kann gar nicht das eigentliche Anliegen der Abstrakten Fotografie sein, sondern nur ein Weg, um etwas anders zu tun, und wenn dieses Andere – was immer es ist – nicht verwirklicht wird, ist die nicht-gegenständliche Fotografie keine Abstrakte Fotografie. Die Eingangsfrage: *Was könnte Abstrakte Fotografie sein?* muß präziser übersetzt werden: *Was könnten Gründe sein, Fotografien herzustellen, auf denen man keine Gegenstände erkennen kann?* Es sind mehrere Antworten denkbar; drei sollen hier vorgestellt werden. ■

13 Eine erste, nahe liegende Antwort auf die Frage: *Was könnten Gründe sein, Fotografien herzustellen, auf denen man keine Gegenstände erkennen kann?* lautet: Man möchte hiermit zeigen, daß mit dem Medium der Fotografie auf etwas anderes als nur Gegenstände verwiesen werden kann und daß dies in einem gegenständlichen Bild immer auch geschieht. Wenn die abstrakte Fotografie aus diesem Grund von der Abbildung einer Sache abstrahiert, dann ist sie eine dezidierte Selbstreflexion im Medium der Fotografie. Sie will mit den Mitteln der Fotografie die Frage beantworten, was ein Foto ist, und stellt dafür Fotografien her, die zeigen, was in gegenständlichen Bildern ein wesentlicher, allerdings gefangener, nicht selbständiger Teil ist – dieser Teil ist das Wie des Fotos, die formalen Strukturen einer Fotografie, welche ermöglichen, daß eine gegenständliche Fotografie das macht, was sie macht, nämlich einen Gegenstand zeigen. Jede Fotografie entsteht, indem auf einem Papier Lichtspuren zu sichtbaren Formen entwickelt werden. Doch diese sichtbaren Formen, ihre Gestalten und internen Relationen, dienen einem Zweck: Sie sind nicht um ihrer selbst willen da, sondern sollen etwas zeigen, was sie selbst nicht sind. Wenn

it may be—is not realized, the non-figurative result will not be Abstract Photography. The initial question *What could Abstract Photography be?* must be more clearly formulated: *What could be the reasons for creating photographs in which no objects are pictured?* Several answers are possible: Three are to be considered here. ■ **13** The question *What could be the reasons for creating photographs in which no objects are pictured?* offers a first, obvious answer: One would like to show that, with the help of the medium of photography, one can focus on something other than only visible objects, and that this is what always happens in a normal figurative picture. If Abstract Photography therefore abstracts from the representation of an object, this is tantamount to deliberate self-reflection within the medium of photography. Using the techniques and possibilities of photography it wants to offer an answer to the question of what a photo is, and therefore produces photographs that show what an essential, even if limited and not independent aspect in figurative photographs is; this aspect focuses on the how of the photo, on the formal structures of a photograph that make it possible for an figurative photograph to do what it does, i. e. to show an object. We speak of a photograph when traces of light on paper are developed into visible forms. But these visible forms and shapes and the way they relate to each others serve a purpose: They are not there for the sake of themselves, but are meant to show what they themselves are not. If one looks at a picture with a realistic content, one would not say one was looking at shapes and colours. Although the observer is aware of the shapes, he is consciously looking at the object shown in the photo, which, in phenomenological terms, is called the pictorial object. It is not the shapes and colors one is looking at, but a tree, a house etc. This pictorial object, however, is only visible because the shapes and colors are there on the paper, even if they are not per-

man sich ein gegenständliches Bild anschaut, so würde man nicht sagen, daß man sich Formen und Farben anschaut. Obwohl man auf die Formen sieht, richtet sich der Blick, die intentionale Aufmerksamkeit des Betrachters auf den im Foto gezeigten Gegenstand, den die Phänomenologie Bildobjekt nennt. Man sieht eben nicht Formen und Farben, sondern einen Baum, ein Haus usw. Aber dieses Bildobjekt ist nur sichtbar, weil es Formen und Farben gibt, auch wenn diese nicht als solche in den Blick des normalen Betrachters treten. Was aber eben nicht heißt, daß sie nicht sichtbar gemacht werden können. Das ist ein Grund für Abstraktion: Das abstrakte Bild kann auf das Zeigen einer Sache verzichten, um so zu zeigen, wie ein Foto einen Gegenstand zeigt. Das Sehen des Bildobjektes verlangt ein Übersehen der Infrastruktur. Deshalb könnte ein abstraktes Foto ein Foto sein, welches versucht, diese ansonsten übersehenen Strukturen selbst zu zeigen. Etwas Übersehenes wird zum Thema. Wenn ein abstraktes Foto aus diesem Grund auf das Zeigen einer Sache verzichtet, dann sind die Formen und Farben auf dem abstrakten Foto etwas grundlegend anderes als die Formen und Farben auf einer Tapete: Sie sind dann die Formen und Farben, die dieses Medium auch zur Darstellung von Gegenständen nutzen kann. Jedes Foto – auch das gegenständliche – entsteht aus einem Strukturierungsprozeß. Eben gerade deshalb, weil dies auch bei gegenständlichen Fotografien der Fall ist, ist die Abstraktion von der Gegenständlichkeit in der Fotografie eine Reduktion des Bildes auf den Aspekt, der für Fotografie insgesamt wesentlich ist, weil auf ihn keine Art der Fotografie verzichten kann: Man kann kein Foto schaffen, welches nicht sichtbare Strukturen entwickelt. Die Strukturen und Formen, die man in der Abstrakten Fotografie sieht, sind also nach diesem Verständnis die Strukturen und Formen, die etwas zeigen könnten, aber nichts zeigen. Man kann auch sagen: Das abstrakte Foto tritt wie ein potentielles gegenständliches Fotos auf, denn es verhält sich zum gegenständlichen Bild wie ein unvollständiger Teil zum Ganzen. Dies ist

ceived as such by the eye of the ordinary observer. But that does not mean that they cannot be made visible. This is one reason for abstraction: the abstract picture can forego showing an object in order to show how a figurative photo shows an object. Seeing the pictorial object necessarily involves overlooking the infrastructure of the picture surface. That is why an abstract photo could be a photo that is trying to show the very structures that are normally overlooked. The overlooked becomes the new theme of the abstract photo. If an abstract photo therefore foregoes showing an object, the shapes and colours presented in the abstract photo are fundamentally different from the shapes and colours on wallpaper: They are then the very shapes and colours which this medium can also use for representing objects. Every photo—even the one with objects—is the result of a process of creating structures. And because this is also the case with photographs containing objects, the abstraction from the mere repres-entation of objects in the photograph is a reduction of the picture to an aspect that is essential to photography as a whole, because no kind of photography can do without it: One cannot create a photo which does not develop visible structures. The structures and shapes which are visible in Abstract Photography are therefore the structures and shapes which could show something, but, in fact, show nothing. In other words: The abstract photo manifests itself as a potential figurative photo because it is related to a photo showing an object as an incomplete part to the whole. This is at least an interpretation which does not only apply to Abstract Photography but also abstract pictures generally from the point of view of phenomenology. Roman Ingarden, an exponent of phenomenology, underlines this explicitly: "I merely think it is important to realise that every picture representing something contains within its composition a non-figurative picture, as it were, which constitutes an indispensable

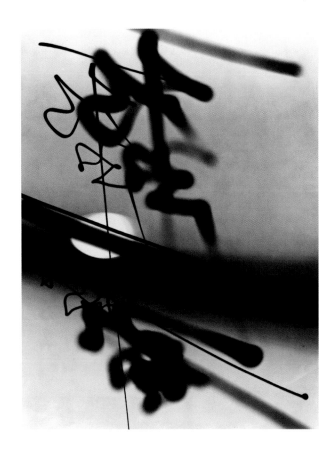

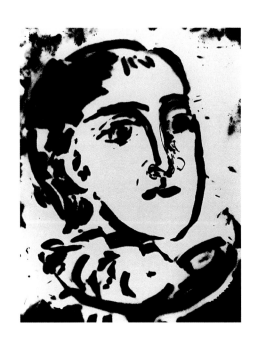 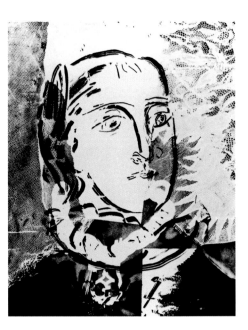

György Kepes: *Calligraphic Light Play*
(Kalligrafisches Lichtspiel), Cambridge, 1948
Luminogram. Unique gelatin silver print,
ca. 30 x 24 cm
Courtesy of the artist (top)

Pablo Picasso: *Portrait D. M.* (Dora Maar)
Two cliché-verre versions from one motif
with different photo-specific effects.
Taken from *Cahiers d'Art* 12, 6–7, Paris, 1938
(bottom)

Lambert Wiesing

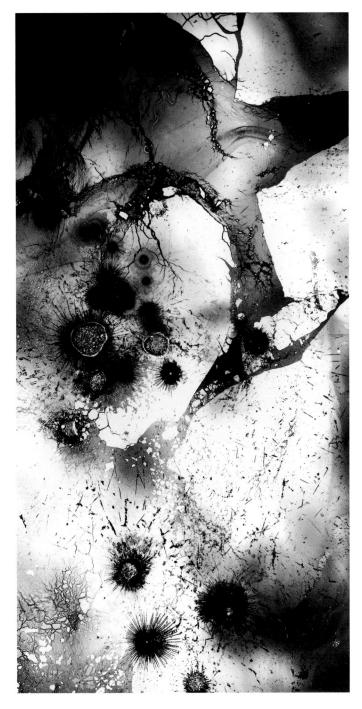

Heinz Hajek-Halke: *Untitled,* 1965
Light-Graphic (Soot lucidogram). Gelatin
silver print, 28.2 x 14.4 cm
Collection Gottfried Jäger
Courtesy of Agentur Focus, Hamburg

zumindest eine Interpretation, welche nicht nur für abstrakte Fotografie, sondern aus der Sicht der Phänomenologie für abstrakte Bilder generell zutrifft. So unterstreicht jedenfalls der Phänomenologe Roman Ingarden explizit: »Es kommt mir lediglich darauf an, uns zum Bewußtsein zu bringen, daß in den Aufbau eines jeden darstellenden Bildes ein sozusagen nichtdarstellendes Bild als sein unentbehrlicher Bestandteil eingeht.«[4] In jedem gegenständlichen Bild sind die Strukturen vorhanden, welche im abstrakten Bild freigestellt sind, was bedeutet, daß das abstrakte Foto eine Art Experiment zu der Frage ist: Was ermöglicht eine Fotografie? Zu diesem quasi-medienwissenschaftlichen Selbstverständnis passen die schon erwähnten Verfahren, den konventionellen Produktionsvorgang zu reduzieren; hierzu paßt aber auch die abstrakte Kamerafotografie, die sich radikal auf Makro- und Mikrostrukturen konzentriert (wie zum Beispiel Carl Strüwe, Abb. S. 206f.). Im letzten Fall werden sogar fast wörtlich die Strukturen der Fotografie mittels der Fotografie selbst unter die Lupe genommen; es wird also das gemacht, was metaphorisch das Anliegen der Abstrakten Fotografie insgesamt ist: nämlich eine Isolierung und Emanzipierung von fotografischen Oberflächenstrukturen. Das heißt aber auch, und dies ist entscheidend, daß die Strukturen auf einem so verstandenen abstrakten Foto keine bloß ornamentalen Formen sein können, weil sie eben eine Bedeutung haben: Sie verweisen zwar nicht auf Gegenstände, aber doch auf die Strukturen anderer möglicher Fotografien, welche Gegenstände zeigen. Die Abstrakte Fotografie ist so gesehen, wie Gottfried Jäger treffend formuliert, eine »Fotografie der Fotografie«: »Der Fotoprozeß wird dabei in seine Elemente, Bestandteile und Strukturen zerlegt. [...] Nicht mehr das Was oder das Wer, sondern das Wie steht im Mittelpunkt des Interesses.«[5] ■ 14 Eine zweite, nicht mehr ganz so nahe liegende, aber dafür radikalere Antwort auf die Frage: *Was könnten Gründe sein, Fotografien herzustellen, auf denen man keine Gegenstände erkennen kann?* lautet: Man

element in it."[4] In every picture with a figurative content there are structures which are left undefined in the abstract picture; that means that the abstract photo is a kind of experiment about the question: *What makes a photograph possible?* The methods mentioned above, which reduce the conventional production process, bear out this self-definition which appears to be, as it were, rooted in media science approaches; this also applies to abstract camera photography which concentrates radically on macro- and microstructures (as, for example, in Carl Strüwe's work, figs. pp. 208f.). In the latter case the structures of the photograph are literally scrutinized using the techniques of photography itself: the purpose of Abstract Photography as a whole manifests itself here, i.e. an isolation and emancipation of photographic surface structures. But this also means,—and this is crucial—that the structures in an abstract photograph thus defined cannot be merely ornamental forms, because they have a significance: they do not point to objects, but to the internal structures of other possible photographs which show objects. Abstract Photography is thus, as Gottfried Jäger fittingly remarks, a "photograph of photograph". "The photographic process is thus split up into its elements, parts and structures. [...] It is no longer what or who but how that is the focus of our interest."[5] ■ 14 A second, not quite so obvious, but all the more radical answer to the question *What could be the reasons for creating photographs in which no objects are pictured?* is: One would like to demonstrate here that photographs can be pictures that do not necessarily have to denote anything at all. This thesis can be put in a different way: Abstract Photography demonstrates that photographs can be pictures without any symbolic character. Anything that points to something else is a symbol or sign. When we contemplate the first answer the structures indeed point to something: they exemplify the possibilities of photographic representation.

4 Ingarden, Roman: *Untersuchungen zur Ontologie der Kunst. Musikwerk – Bild – Architektur – Film.* Tübingen 1962, S. 225.

5 Jäger, Gottfried: *Abbildungstreue. Fotografie als Visualisierung: Zwischen Bilderfahrung und Bilderfindung.* In: Dress, Andreas; Jäger, Gottfried: *Visualisierung in Mathematik, Technik und Kunst.* A.a.O. op. cit., S. 142.

möchte hiermit zeigen, daß Fotografien Bilder sein können, die überhaupt nicht auf irgend etwas verweisen müssen. Diese These kann man auch anders formulieren: Man möchte mit der Abstrakten Fotografie zeigen, daß Fotografien Bilder sein können, die überhaupt keine Zeichen sind. Alles, was auf etwas verweist, ist ein Zeichen, und in der ersten Antwort verweisen die Strukturen in der Tat auf etwas: Sie exemplifizieren die Möglichkeiten des fotografischen Abbildens. Die Strukturgebilde auf einer abstrakten Fotografie werden in der ersten Antwort als Zeichen verstanden: Sie stehen für Möglichkeiten, wie ein Foto zeigen kann. Doch muß dies so sein? Man kann sich in der Tat eine Steigerung denken. Muß die Abwendung vom Gegenstand eine Hinwendung zum ›Wie‹ des fotografischen Zeigens sein? Sie kann es, dies ist keine Frage. Aber kann die Abwendung vom Gegenstand nicht auch mit einer Hinwendung zu etwas anderem als dem ›Wie‹ des Zeigens verbunden werden? Diese Frage betrifft den Zeichencharakter Abstrakter Fotografie. Es ist in der Tat relativ leicht vorstellbar, daß auch ein abstraktes Foto semiotische Zwecke erfüllt. Doch erneut: Auch das Gegenteil ist zumindest denkbar. Nämlich daß ein abstraktes Foto auf das Zeigen einer Sache verzichtet, um ein Bild zu schaffen, das überhaupt kein Zeichen sein will. Diese Ansicht ist allerdings nur dann denkbar, wenn man nicht der sprachanalytischen Meinung anhängt, daß jedes Bild notwendigerweise immer ein Zeichen ist. Denn wenn man der Meinung ist, daß jede Fotografie ein Bild ist, dann ist man logisch gezwungen, jede Fotografie – auch die abstrakte – als ein Zeichen zu denken, und dann ist es wiederum prinzipiell undenkbar, daß die abstrakte Fotografie von diesem Zeichencharakter abstrahieren könnte, weil der Zeichencharakter dann eben keine kontingente Eigenschaft ist. Doch die Ausgangsthese, daß jedes Bild ein Zeichen ist, ist ausgesprochen umstritten. In der Phänomenologie werden überzeugende Argumente vorgebracht, daß der Zeichencharakter von Bildern kontingent ist. Wenn dies der Fall ist, würde es zur Folge haben, daß noch

The structural components in an abstract photograph are taken to be symbols according to the first answer. They represent ways in which a photograph can show something, but this something is not shown. *Yet, does that have to be so?* There can in fact be more to it. *Does the avoidance of an object necessarily imply that the how of showing is shown?* This can be the case, undoubtedly. *But can the avoidance of a realistic showing not also mean that there is something to show other than the how of showing?* This question has something to do with the symbolic character of Abstract Photography. Indeed, one can quite easily imagine that an abstract photo fulfils semiotic purposes. Yet again: the opposite might be possible, too. That is, an abstract photograph could forego being symbolic in order to create a picture that is not intended to be symbolic at all. This view is, however, only possible if one does not insist on a semiotic interpretation that every picture is necessarily always a symbol. For if one is of the opinion that every photograph is a picture, it then follows that every photograph—including the abstract photograph—must necessarily be regarded as a symbol. In that case, it is in principle impossible to imagine that Abstract Photography could abstract from this symbolic status because reference is from this point of view no contingent characteristic. But the original thesis that every picture is a symbol is highly controversial. Phenomenology offers convincing arguments that the symbolic character of pictures is contingent. If this is the case, it would follow that a further answer to the original question *What could Abstract Photography be?* becomes conceivable. That is why it is necessary to expound on the phenomenological position at this point.[6] ■ From a phenomenological point of view a picture is an object in which one can see something that is not present in an empirical sense of the word. One observes the pictorial object which has the quality of being only visible. In a photograph

6 Zur phänomenologischen Bildtheorie siehe
A phenomenological theory of the image is
discussed in: Wiesing, Lambert: *Phänomene
im Bild*. München 2000.

eine weitere Antwort auf die Ausgangsfrage *Was könnte: Abstrakte Fotografie sein?* denkbar wird. Man muß daher kurz auf die phänomenologische Position eingehen.[6] ■ Aus phänomenologischer Sicht ist ein Bild ein Gegenstand, auf dem man etwas sehen kann, was nicht anwesend ist. Man betrachtet das Bildobjekt, welches ausschließlich sichtbar ist. Auf einem Foto von Peter sieht man Peter, obwohl er nicht anwesend ist. Man kann diesen sichtbaren Peter nicht riechen, hören oder tasten. Gäbe es keine Bilder, so könnte der Mensch nur Dinge sehen, die anwesend sind. Selbst im Spiegel kann man nur anwesende Dinge sehen. Nur im Bild gibt es die Sichtbarkeit von Dingen, welche nicht gleichzeitig auch eine physikalische Existenz haben. Der Fotoapparat ist so gesehen eine Sichtbarkeits-isoliermaschine: Er isoliert die Möglichkeit, Peter sehen zu können, von der Präsenz Peters, konserviert sie und macht sie transportabel. Auf dem Foto kann man Peter sehen, obwohl er nicht da ist. Man hat daher keine anhängende, sondern eine reine Sichtbarkeit. Das heißt nun keineswegs, daß das Bild nicht immer auch aus einem anwesenden Trägermaterial bestehen würde. Doch dieses Material schaut man sich nicht an, wenn man sich ein Bild anschaut. Man schaut sich vielmehr die dargestellten Inhalte an, und diese – nur diese – haben keine andere Eigenschaft, als sichtbar zu sein. Deshalb kann man sagen: Ein Bild ist ein Gegenstand, auf dem man etwas sehen kann, was man ausschließlich sehen kann. Doch etwas, auf dem man etwas anderes sehen kann, muß kein Zeichen sein. Es kann als Zeichen verwendet werden; so wie jeder Gegenstand als Zeichen verwendet werden kann. Aber die reine Sichtbarkeit in einem Bild unterscheidet das Bild auch dann noch von gewöhnlichen Gegenständen, wenn man aufhört, das Bild als Zeichen zu nutzen, denn die reine Sichtbarkeit ist grundlegender als die Lesbarkeit.[7] ■ Für die Abstrakte Fotografie eröffnet dieses phänomenologische Bildverständnis die Möglichkeit, auf die Abbildung von Gegenständen zu verzichten, um stattdessen mittels der Fotografie etwas zu bauen, was nichts anderes

of Peter one can see Peter although he is not there. One cannot smell, hear or feel Peter in a picture of him. If there were no such things as pictures, people could only see things which are present. Even a mirror only reflects visible and present things. The picture alone renders things visible that do not have a physical existence. The camera is thus an apparatus that isolates visibility. It isolates the possibility of being able to see Peter from the presence of Peter, conserves it and makes it transferable. Peter can be seen in the photo; although he is not there. Only in the picture do you find a pure form of visibility. Now this does not mean that the picture does not also consist of material, for example, photo paper, that is also transferable. Yet one does not look at this material when one looks at a picture. One is much more involved in looking at the presented contents, and it is these, and only these, that have no other quality other than being visible. That is why one can say: A picture is an object in which one can see something that is a thing one can only see. Yet something on which one can see something else needn't necessarily be a symbol. It can be used as a symbol, just like every object can be used as a symbol. But the pure visibility in a picture also distinguishes the picture from ordinary objects when one stops regarding the picture as a symbol, for pure visibility is more basic than readability.[7] ■ This phenomenological interpretation of the picture makes it possible for Abstract Photography to forego reproducing objects, thereby creating with the help of photography something which is nothing other than an object of pure visibility. Every picture creates an object that can only be seen. "The artist does not want to paint a symbol on his canvas. He wants to create a thing. [...] He has no intention whatsoever of regarding colours and shades of colour as a *language*. [...] But what if the artist, you might ask, creates houses? Exactly, he *creates* them, that is, he creates the image of a house on the canvas and not the symbol of a

7 Siehe hierzu cf. Wiesing, Lambert: *Die Sichtbarkeit des Bildes. Geschichte und Perspektive der formalen Ästhetik*. Reinbek 1997.

Lambert Wiesing

als ein Gegenstand bloßer Sichtbarkeit ist. Jedes Bild baut einen Gegenstand, der nur gesehen werden kann. »Der Maler will keine Zeichen auf seine Leinwand malen, er will ein Ding schaffen. [...] Es liegt ihm also ganz fern, Farben und Töne als eine *Sprache* anzusehen. [...] Aber wenn nun der Maler, werden Sie sagen, Häuser macht? Genau, er *macht* welche, das heißt er schafft ein imaginäres Haus auf der Leinwand und nicht ein Zeichen von einem Haus.«[8] Bei einem gegenständlichen Bild baut man einen Gegenstand, dessen Sichtbarkeit man kennt: eben zum Beispiel ein nursichtbares Haus. Im abstrakten Foto geht es hingegen darum, Gegenstände aus reiner Sichtbarkeit zu bauen, die keine Ähnlichkeit mit realen Dingen haben, sondern schlicht neue Gegenstände sind, so wie man ja auch außerhalb von Bildern bekannte und neue Gegenstände bauen kann. Wenn man die Abstrakte Fotografie in diesem Sinne versteht, dann wird das Medium Fotografie nicht dazu verwendet, um etwas abzubilden oder sichtbar zu reproduzieren, sondern um etwas zu bilden und sichtbar zu produzieren. Das Medium wird zu einem Werkzeug, um einen künstlichen Gegenstand zu generieren. Dieses Verständnis vom Sinn und Zweck der Abstrakten Fotografie ist in dem Begriff der Generativen Fotografie treffend erfaßt: »Nicht eine Vorstellung realisieren, sondern eine Realität vorstellen, das ist: Fotografie.«[9] Doch aufgepaßt: Die Begriffe Generative Fotografie und Abstrakte Fotografie sind nicht identisch: Abstrakte Fotografie kann generativ sein, muß es aber nicht, wie die erste Antwort gezeigt hat. Die erste Form war eindeutig nicht-gegenständlich; es ging um die Infrastruktur des Bildes. Doch die generative Form der Abstrakten Fotografie ist selbst gegenständlich – nicht in dem Sinne, daß sie einen Gegenstand abbildet, sondern in dem Sinne, daß sie einen konkreten Gegenstand schafft – allerdings einen Gegenstand mit der einzigen Eigenschaft, sichtbar zu sein. So wird verständlich, wieso sich die Generative Fotografie zur Abstrakten Fotografie wie ein Teil zum Ganzen verhält und wieso die Generative Fotografie auch als

house."[8] A figurative picture builds up an object, the visibility of which can be recognized: For example, the house which is purely visible. But the idea of an abstract photograph, on the other hand, is to build up objects of pure visibility that have no similarity with real things, but are simply new objects, just as one can create known and new objects outside the picture. If one regards Abstract Photography in this sense, the medium of photography is not applied to reproducing something or making something not present visible, but to creating it and producing it visibly. The medium becomes a tool generating an artificial object. This definition of the sense and purpose of Abstract Photography is aptly embraced in the term Generative Photo-graphy: "It's not a question of realising a concept, but of presenting a reality, that is what photography is."[9] Note however: The terms Generative Photography and Abstract Photography are not interchangeable. Abstract Photography can be generative, but needn't necessarily be so, as the first answer showed. The first form was clearly non-object; the infrastructure of the picture being primary. The generative form of Abstract Photography is, however, itself object-orientated—not in the sense that it reproduces an object, but in the sense that it creates a concrete object—albeit an object with visibility as its sole characteristic. Thus it becomes apparent why Generative Photography is to Abstract Photography as the part is to the whole, and why Generative Photography can also be termed Concrete Photography: Something concrete is being created. Nevertheless: It is naturally not the photo paper that is meant as a concrete object in the ordinary sense but the object that becomes visible on the paper. The luminograms, as created, for example, in the Fifties by Peter Keetman (fig. p. 98), demonstrate tangibly this kind of Abstract Photography. One only needs to approach these photographs with the question: *What can one see in them?* One can see an object and describe

8 Sartre, Jean-Paul: *Was ist Literatur?* (*What is Literature?*, 1948). Übersetzt und herausgegeben von translated and edited by Traugott König. Reinbek 1981, pp. 14–15.

9 Jäger, Gottfried: *Fotoästhetik. Zur Theorie der Fotografie.* München 1991, p.13. Zum Begriff der Generativen Fotografie siehe for information about the term 'Generative Photography' see: Jäger, Gottfried; Holzhäuser, Karl Martin: *Generative Fotografie. Theoretische Grundlegung, Kompendium und Beispiele einer fotografischen Bildgestaltung.* Ravensburg 1975.

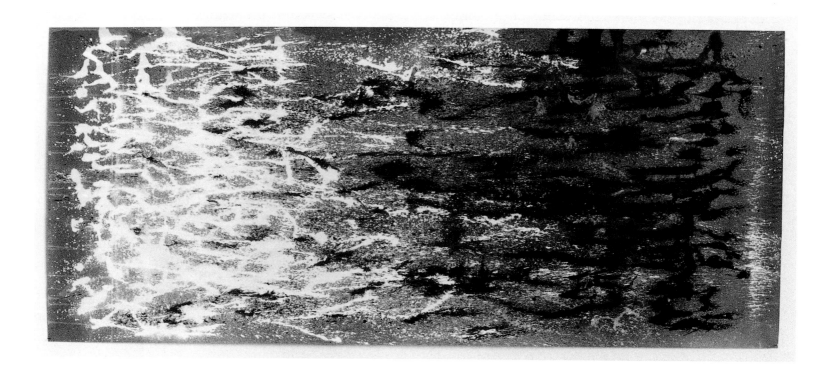

Ralf Filges: *Untitled* (WV 500-5/87/E/F), 1987
Photo action and chemigram. Unique spray image, generated by developer and fixing bath, daylight, gelatin silver RC-paper (Fotoaktion und Chemigramm. Spritzbild aus Entwickler- und Fixierflüssigkeit bei Tageslicht auf Silbergelatine PE-Papier), 129 x 300 cm.
Courtesy of the artist
Photographs: Hartwig Schwarz, Cologne

Conditions reversed: The camera does not 'take' the pictures, it rather 'gives' them; it simultaneously develops and fixes the pictures. One camera contains the developer, the other the fixer. No further treatment is involved. This allows a continuous development of the pictures, so that they take their own coloring over time. (Die Umkehrung der Verhältnisse: Die Kamera nimmt nicht Bilder auf, sondern ›gibt‹ sie; sie entwickelt und fixiert sie zugleich. Eine Kamera enthält Entwickler, die andere Fixierbad, eine weitere Behandlung findet nicht statt, so daß sich das Bild weiterentwickelt und farbig wird.) Gottfried Jäger

Lambert Wiesing

Ralf Filges: *Vorsicht lichtempfindlich!*
(Attention: Light-sensitive!), *1990*
Photo performance, November 27, 1990
(rite of initiation) and 'fluidable' photo
installation on gelatin silver RC-paper
14 x 1.10 m, from the work group *Rettungs-*
versuche zur Fotografie (Rescue Attempts
of Photography), interactive photo instal-
lations, 1984–1992 (Fotoperformance am
27. November 1990 [Initiationsritual] und
fluidable Fotoinstallation auf Silbergela-
tine PE-Papier. Aus der Werkgruppe *Ret-*
tungsversuche zur Fotografie, 1984–1992)
Hallen für die Kunst, Freiburg im Breisgau,
Germany, 1990
Courtesy of the artist
Photographs: Hartmut Schmidt, Freiburg
im Breisgau

The photograph is literally on the drip. The
life-giving tonic is the photochemical 'devel-
oper'. It is fed drop by drop onto photogra-
phic paper on the ground where it spreads
to create new patterns. (Das Foto hängt
am Tropf. Das lebensspendende Elixier
besteht aus fotochemischem ›Entwickler‹.
Er breitet sich während der Zeit der Instal-
lation tropfenweise auf dem am Boden
liegenden Fotopapier aus und läßt dabei
eigene Muster entstehen.) Gottfried Jäger

Konkrete Fotografie bezeichnet werden kann: Es wird etwas Konkretes geschaffen. Wohlgemerkt: damit ist natürlich nicht das Fotopapier als ein konkreter Gegenstand im gewöhnlichen Sinne gemeint, sondern der auf dem Papier sichtbare Gegenstand. Besonders in Luminogrammen, wie sie unter anderem in den 1950er Jahren von Peter Keetman erstellt wurden, wird diese Art der Abstrakten Fotografie greifbar. Man muß sich an derartige Fotografien nur mit der Frage wenden (Abb. S. 98): Was sieht man auf ihnen? Man sieht einen Gegenstand, dessen genaueres, eben zumeist verschlungenes Aussehen man sehr wohl präzise beschreiben kann, der aber nichts anderes als ein solches nursichtbares Aussehen hat. Die reine Sichtbarkeit ist hier zum Einzigen geworden, was vorhanden ist; man hat einen neuen Gegenstand aus reiner Sichtbarkeit, der keine Ähnlichkeit mit einem bestehenden realen Gegenstand hat, und auch gar nicht als ein realer Gegenstand gedacht werden kann. Da man einen so aussehenden Gegenstand noch nicht kannte, hat man hier in einem gleichermaßen einfachen wie aber auch fundamentalen Sinne mittels einer Fotografie einen neuen Gegenstand *sui generis* geschaffen. Wenn man es pathetisch mag, kann man sagen: Die Welt wird in der Abstrakten Fotografie nicht reicher an Schein, sondern reicher an Sein. ■

15 Eine dritte Antwort auf die Frage: *Was könnten Gründe sein, Fotografien herzustellen, auf denen man keine Gegenstände erkennen kann?* lautet: Man möchte hiermit zeigen, daß Fotografien überhaupt nicht Bilder sein müssen. Diese Antwort mag vielleicht erschrecken, denn sie abstrahiert von etwas, was weithin für sehr selbstverständlich erachtet wird, nämlich daß Fotografien stets Bilder sind. Daß dies fast immer so ist, steht außer Zweifel; fast alles, was fotografisch hergestellt wird, sind Bilder. Doch auch hier kann die entscheidende Frage nur lauten: Muß das so sein oder kann man sich dies auch anders denken? Könnte es nicht sein, daß die Verwendung der Fotografie, um Bilder herzustellen, zwar eine verbreitete, aber doch kontingente Nutzung der Fotografie ist?

it quite clearly, even if its content is often intricate, but its only characteristic is that fact that it is visible as such. Its quality of being visible has become the only thing that is there; a new object with the sole virtue of visibility has emerged, having no resemblance to an already existing real object, and not possible to conceive as a real object, anyway. Since an object of this kind has never existed before, a new object *sui generis*, in a simple, but also fundamental sense of the word has been created with the help of photography. To put it in more effusive terms: With Abstract Photography the world does not get richer in things that appear, but in things that are. ■ **15** A third answer to the question *What reasons could there be for creating photographs in which no objects are pictured?* is: To show that photographs do not have to be pictures at all. This answer might possibly be alarming since it abstracts from something that is still widely taken for granted, i.e. that photographs are always pictures. That this is almost always the case, is beyond doubt; almost everything that is produced photographically is a picture. Yet even here the decisive question must be: Is that how it has to be or are there other possibilities? Isn't it conceivable that the use of photography to produce pictures is a wide-spread, yet contingent use of photography? Most people have hair on their head, yet this is a contingent characteristic, for one can well imagine a person who is bald. Can one also imagine photographs that are not pictures? This is a question that gets to the heart of Abstract Photography. For Abstract Photography, which aims at creating photographs in which the photo abstracts from contingent characteristics of its own medium in order to emphasise the non-contingent characteristics of the medium, must consider whether, in fact, the pictorial character isn't perhaps contingent for photography as a whole. Alvin Langdon Coburn, the pioneer of Abstract Photography seems to have sensed this—as is expected of a pioneer:

Lambert Wiesing

Fast alle Menschen haben Haare auf dem Kopf, trotzdem ist dies eine kontingente Eigenschaft, denn man kann sich gut einen Menschen mit Glatze denken. Kann man sich auch Fotografien denken, die keine Bilder sind? Man hat hier eine Frage, die in das Zentrum der Abstrakten Fotografie zielt. Denn die Abstrakte Fotografie, welche sich zum Programm nimmt, Fotografien zu erstellen, in denen von kontingenten Eigenschaften des Mediums abstrahiert wird, um die nicht-kontingenten Eigenschaften zu betonen, muß sich natürlich auch fragen, ob nicht der Bildcharakter insgesamt für die Fotografie vielleicht kontingent ist. Der Ahnherr der Abstrakten Fotografie, Alvin Langdon Coburn, scheint dies – wie man es von einem Ahnherrn verlangt – geahnt zu haben: Zumindest nannte er 1916 seinen programmatischen Aufsatz zur Abstrakten Fotografie *Die Zukunft der bildmäßigen Fotografie.* Damit ist im Titel angedeutet, daß es um eine Fotografie geht, die bildmäßig sein soll und eben nicht nicht-bildmäßig. Doch wenn gar nichts anderes denkbar wäre, dann hätte er nicht explizit von bildmäßig sprechen müssen; dann wäre der Begriff bildmäßige Fotografie – der übrigens des öfteren in der Diskussion auftaucht – ein Pleonasmus. Aber es ist eben keineswegs logisch notwendig, daß die Produkte der Fotografie Bilder sind. Coburn deutet so an, daß er sich mit einer bestimmten Art der Abstrakten Fotografie befaßt. Man kann das hier angesprochene Problem auch von einer anderen Seite aufzäumen: Was ist eigentlich der nächstliegende Oberbegriff zum Begriff Abstrakte Fotografie? Es sind zwei gleichermaßen nahe liegende Kandidaten denkbar: sowohl Abstraktes Bild als auch Abstrakte Kunst. Ist die Bedeutung des Begriffes Abstrakte Fotografie in der Bedeutung des Begriffes Abstraktes Bild oder in Abstrakte Kunst oder in beiden teils teils enthalten? Wenn die Abstrakte Fotografie sich als Teil der Abstrakten Kunst versteht, dann gilt es allerdings zu beachten, daß nicht jedes Bild ein Kunstwerk und umgekehrt nicht jedes Kunstwerk ein Bild ist. Folglich ist durchaus denkbar, daß die Abstrakte Fotografie mit ihrer Abstraktion das Ziel

At least, he called his programmatic essay on Abstract Photography, written in 1916, *The Future of Pictorial Photography.* The title already indicates that we are concerned here with a kind of photography that is supposed to be pictorial and specifically not non-pictorial. If nothing else were possible, he would not have explicitly mentioned pictorial; in that case, the term pictorial photography—a term, that often crops up in discussions—would be a pleonasm. There is, however, absolutely no logical necessity for the products of photography to be pictures. Coburn thus indicates that he is concerned with a certain kind of photography. The problem in hand can also be dealt with from a different angle: What is the nearest general notion under which Abstract Photography can be classed? There are two equally obvious possibilities that spring to mind: Abstract Picture and Abstract Art. Is the meaning of the notion Abstract Photography to be found in the notion Abstract Picture or in Abstract Art or a bit in both? If Abstract Photography is seen as a part of Abstract Art, it is important to remember that not every picture is a work of art and, vice versa, not every work of art is a picture. It follows that one purpose of Abstract Photography as an abstraction can be to create objects that are photo-graphs, but not pictures. Avoidance of showing a figurative picture in the Abstract Photo can be so extreme that the result is not a picture any more. In this case the techniques of Photography are not applied to create pictures but objects, things or constituent parts of installations— this, however, occurs with the purpose of presenting possibilities that photography offers. In this sense it is possible to assume that the place of picture-oriented photography can be taken by art-oriented photography. Taken the development in art in the 20th century this step appears quite natural—the artist explores the photograph not only from the point of view of how to create artistic pictures, but also how to produce non-

verfolgen könnte, Gegenstände herzustellen, die zwar Fotografien, aber keine Bilder sind. Die Abwendung vom bildlich dargestellten Gegenstand kann also so radikal verstanden werden, daß sie zu einer Abwendung von der Bildproduktion überhaupt führt. Man nutzt dann die Techniken der Fotografie nicht, um Bilder, sondern um Gegenstände, Objekte oder Teile von Installationen herzustellen – allerdings geschieht dies wiederum mit der Absicht, auf eine Möglichkeit des Fotografierens hinzuweisen. In diesem Sinne ist denkbar, daß die Stelle der bildmäßigen Fotografie durch eine kunstmäßige Fotografie ausgefüllt wird. Angesichts der Entwicklung der Kunst im 20. Jahrhundert scheint dieser Schritt sogar ausgesprochen nahe liegend: Man untersucht die Fotografie nicht nur darauf hin, in welcher Weise mit ihr künstlerische Bilder, sondern auch nicht-bildliche Kunst geschaffen werden kann. Denn die Kunst des 20. Jahrhunderts ist in großem Maße von der Entdeckung geprägt, daß auch technisch hergestellte Gegenstände Kunststatus haben können. In der so genannten Objektkunst ist das, was als Kunst erachtet wird, kein Bild, sondern eben ein konkreter Gegenstand. Man hat hier Kunstwerke, die keine Bilder sind. Die Abstrakte Fotografie wird nun genau dann zu einem Beitrag zur Objektkunst, wenn sie die Fotografie nicht zur Bild-, sondern eben zur Objektproduktion nutzt. Auch diese Arbeiten der Abstrakten Fotografie passen noch unter den Begriff der Generativen und Konkreten Fotografie. Doch man muß sehen, daß der Begriff hier eine andere Bedeutung als die zuvor dargestellte annimmt. Denn es geht jetzt nicht mehr um die Produktion eines konkreten Gegenstandes im Bild, also um das Generieren einer Sache aus reiner Sichtbarkeit, sondern um die Produktion einer Sache, die wie jede normale Sache auch, berührt und gerochen werden kann. Die Beispiele für ein derartiges Verständnis der Abstrakten Fotografie sind zahlreich, nur eins soll genannt werden: *Graukeil* von Gottfried Jäger aus dem Jahr 1983 (Abb. S. 100f.). In dieser Arbeit findet kein Abbilden von etwas statt; es geht nicht um die

pictorial art. Art in the 20th century has to a great extent been influenced by the discovery that objects that have been technically produced can also claim to be art. In so-called Object Art it is not a picture but a concrete object that is considered to be art. Abstract Photography thus becomes a contribution towards Object Art when it uses photography to produce objects and not pictures. Works of this kind can still be defined in terms of Generative and Concrete Photography. Yet the term used here clearly has a different meaning to the one used previously. It is not so much a question of producing a concrete object in the picture, that is, of generating an object characterized by its pure visibility, but of producing a thing that like any normal thing can also be touched and smelt. There are many examples of Abstract Photography which can be interpreted in this way, but may it suffice to mention just one: *Graukeil* (Grey scale) by Gottfried Jäger, dating 1983 (figs. pp. 100f.). This work is no reproduction of anything that can be found; it does not try to produce pictorial pure visibility; the work uses the photograph in a material sense alone as a part of an installation. The photo paper which shows mostly 3-dimensional objects in a figurative photograph becomes 3-dimensional itself in *Graukeil*. The presented material takes the place of what is shown as a picture. The photo paper as a real object replaces the pictorial object, — and thus ousts the picture from a work of art.

■ 16 *What could Abstract Photography be?* Answering this question prompts at least three conceptual possibilities. Avoidance of showing things in a photo may have the intention of, firstly, showing the internal structures of possible photos, secondly, presenting pure visibility for its own sake, and, thirdly, producing Object Art. No matter what might be the history or reality of Abstract Photography, it can only be congruent with the possibilities — but it only rarely does so precisely. Anything that can and should be differentiated in conceptions, is in reality often inseparably interfused, and it is not unusual that this very quality of being interfused is a welcome attraction in its

Lambert Wiesing

Herstellung einer reinen bildlichen Sichtbarkeit, sondern einzig um die Nutzung der Fotografie im materiellen Sinne als Teil einer Installation. Das Fotopapier, welches in der gegenständlichen Fotografie zumeist dreidimensionale Dinge zeigt, wird in *Graukeil* selbst dreidimensional: An die Stelle des bildlich Gezeigten tritt das zeigende Material. Das Fotopapier verdrängt als ein realer Gegenstand das imaginäre Bildobjekt – und verdrängt damit das Bild aus einem Kunstwerk. ■ 16 *Was könnte Abstrakte Fotografie sein?* Die Beantwortung dieser Frage führt zu mindestens drei Denkmöglichkeiten. Auf das Zeigen einer Sache durch Fotografie kann man erstens um der bildimmanenten Strukturen willen, zweitens um der bloßen Sichtbarkeit willen und drittens um der Objektkunst willen verzichten. Wie immer die Geschichte und Wirklichkeit der Abstrakten Fotografie aussieht, sie kann nur den Möglichkeiten entsprechen – aber sie tut es in den seltensten Fällen eindeutig. Was im Begrifflichen klar getrennt werden kann und werden sollte, ist in der Wirklichkeit zumeist unauflösbar vermischt, und nicht selten ist die Vermischung der besondere Reiz einer Sache: Dies gilt ganz besonders für Kunstwerke, die sich zumeist nicht eindeutig in eine Schublade stecken lassen, die sich verweigern oder gleich in mehrere Schubladen passen. Doch – und dies ist ganz entscheidend – diese Widerspenstigkeit der Wirklichkeit gegenüber den klaren Typen spricht nicht gegen die Notwendigkeit, prinzipielle Denkmöglichkeiten begrifflich klar zu trennen – sie spricht nur für die Kunst. ■ ■

own right; this applies particularly to works of art which defy clear labelling, or which can be labelled in many ways. Yet the reluctance of reality—and this is very important—to clear labelling does not belie the necessity to differentiate exactly the possibilities of conceptions—it just speaks in favour of art. ■ ■

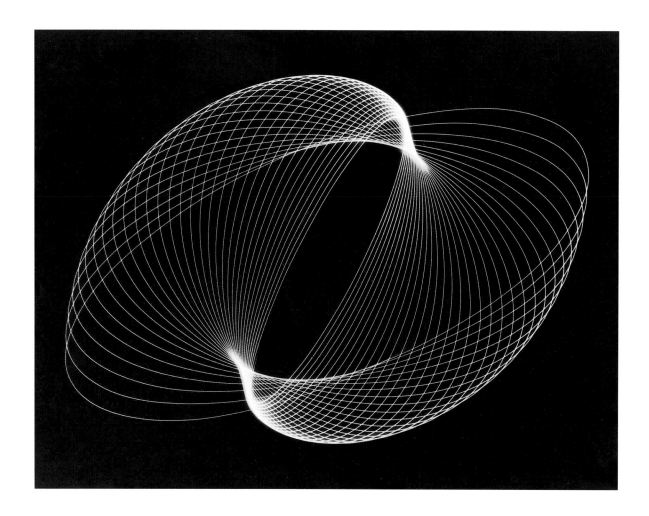

Peter Keetman: *Schwingungsfigur* (Light
Pendulum Figure) *No. 995,* 1951
Luminogram. Gelatin silver print, 17 x 23 cm
Collection Gottfried Jäger
Courtesy of the artist

Timm Ulrichs: *Landschafts-Epiphanien*
(Landscape Appearances*)*, 1972/1987
Silver dye bleach prints (Cibachrome)
from reversal film fragments.
One of three series, each nine color prints,
on cardboard, 40 x 50 cm
Staatsgalerie Stuttgart
Courtesy of the artist

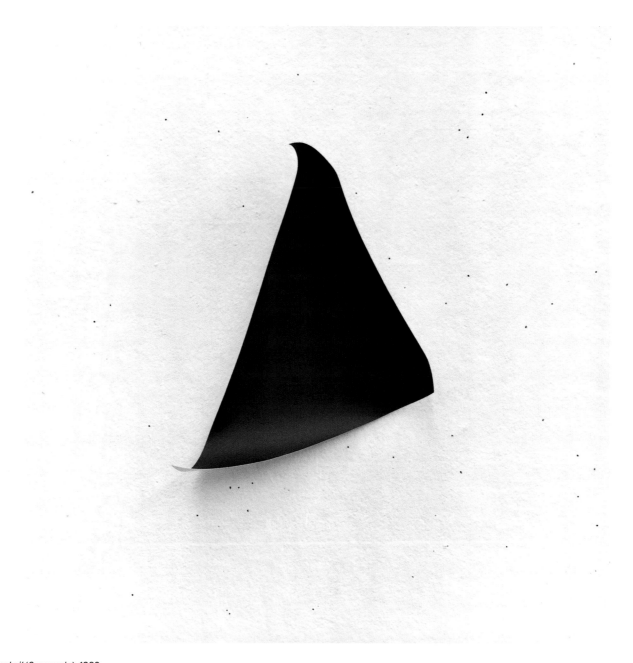

Gottfried Jäger: *Graukeil* (Grey scale), 1983
Unique gelatin silver paper, 25 x 25 cm
Studio installation

Gottfried Jäger: *Graukeil* (Grey scale), 1983
Unique gelatin silver paper, 25 x 25 cm (left);
gelatin silver print, frame, 50 x 50 cm (right)
Gallery installation, exhibition Jürgen Jesse
Gallery, Bielefeld, 1983 (top)

Gottfried Jäger: *Graukeil* (Grey scale), 1983
Installation, situation-related. April 6, 2001
National Gallery of Art, Washington D. C.
(bottom)

Alvin Langdon Coburn: *Octopus (New York),* 1912
Gelatin silver print, 30.6 x 23.2 cm, ca. 1960
Museum Ludwig, Cologne, Donation Gruber

Rolf H. Krauss

Das Geistige in der Fotografie, oder: Der fotografische Weg in die Abstraktion. Quedenfeldt – Coburn – Bruguière The Spiritual in Photography, or: The Photographic Path to Abstraction

Die Moderne ist auch ein Kind des Okkultismus. Ihre Paten heißen Theosophie, Anthroposophie, Spiritismus, Vierte Dimension, Hermetik, Kabbala, Rosenkreuzertum, Freimaurertum, Taoismus und Zen-Buddhismus. Ihre Wurzeln finden sich sowohl in westlichen als auch in östlichen Mythologien und Geheimlehren. Die historischen Avantgarden können als eine Reaktion auf die Herrschaft von Vernunft und Wissenschaft angesehen werden.[1] Der Veräußerlichung der Welt, die in Positivismus, Materialismus und Skeptizismus in der zweiten Hälfte des 19. Jahrhunderts ihren Höhepunkt erreichte, sollte eine neue Innerlichkeit entgegengesetzt werden. Alle Künste fühlten sich aufgerufen, an dieser Aufgabe mitzuwirken. Der Weg in die neuen geistigen Dimensionen führte in die Abstraktion, in der bildenden Kunst im Extrem in die Gegenstandslosigkeit. Maler, die diesen Weg beispielhaft gingen, waren Wassily Kandinsky (1866–1944), Paul Klee (1879–1940), František Kupka (1871–1957), Kasimir Malewitsch (1878–1935) und Piet Mondrian (1872–1944), um nur die wichtigsten zu nennen. Auch die Fotografie hat an diesem Aufbruch teilgenommen. Auf mindestens zwei Fotografen ist aufmerksam zu machen, auf Alvin Langdon Coburn (1882–1966) und Francis Joseph Bruguière (1879–1945), die, wie auch die Maler, über die Beschäftigung mit spirituellen Inhalten, mit Mystik und spekulativen Philosophien zur totalen Abstraktion gelangten. Ein dritter, Erwin Quedenfeldt (1869–1948), ging einen ähnlichen Weg, allerdings von einem anderen Ausgangspunkt aus. ■ ■ **Okkultismus und Moderne** Man wird sich an den Gedanken gewöhnen müssen, daß die moderne Kunst, wie sie um die Wende vom 19. zum 20. Jahrhundert entsteht, nicht nur das Ergebnis von rational nachzuverfolgenden Entwicklungsschritten ist. Die helle Welt der Formen und Farben ist unterlegt von einer Sphäre, die wir obskur zu nennen immer noch geneigt sind. Künstler, Literaten, Musiker, Theaterleute, viele kreativ Tätige waren eingebunden in ein internationales Netzwerk von esoterischen Vereinigungen, Zirkeln, Bruderschaften oder

Modernism is also a child of the occultism. Its godparents are Theosophy, Anthroposophy, Spiritualism, The Fourth Dimension, Alchemy, Cabbala, Rosicrucianism, Freemasonry, Taoism, Zen-Buddhism. Its roots are to be found both in Western and Eastern mythologies and in esoteric doctrines. The historic avant-garde movements can be regarded as a reaction to the dictate of reason and science. The superficial view of the world, which found expression and reached its climax in Positivism, Materialism and Scepticism in the second half of the 19th century, was to be countered with a new-born move to introversion.[1] All the arts felt called upon to take up this task. The path to new spiritual dimensions led to abstraction, and ultimately, in the case of the fine arts, to total absence of the object. Amongst the pioneering painters taking this path were Wassily Kandinsky (1866–1944), Paul Klee (1879–1940), František Kupka (1871–1957), Kasimir Malevitch (1878–1935) and Piet Mondrian (1872–1944). Photography, too, became involved in this new awakening. There are at least two photographers who warrant mentioning here: Alvin Langdon Coburn (1882–1966) and Francis Joseph Bruguière (1879–1945) who, like the painters, as a result of their involvement in spiritual matters, mysticism and speculative philosophies attained total abstraction. A third photographer, Erwin Quedenfeldt (1869–1948) took a similar path, but set off from another point of departure. ■ ■ **Occultism and Modernism** One will have to get used to the idea that modern art as it emerges at the turn of the 20th century, is not only the result of a process of development that can be rationally understood. The bright world of shapes and colors is to be seen before the backdrop of a sphere which we still tend to call obscure. Artists, writers, musicians, actors, anyone artistically active, all were tied into a network of esoteric societies, circles, brotherhoods or sects. Even those who did not necessarily support the teachings which the latter propagated had

1 Eine gute zeitgenössische Darstellung dieser Tendenz findet sich im Eingangskapitel Einführung in die esoterische Lehre. In: Schuré, Edouard: *Die großen Eingeweihten. Geheimlehren der Religionen.* Vorwort von Rudolf Steiner, 20. Auflage. Bern, München, Wien 1992 (erstmals erschienen 1889 unter dem Titel *Les grands initiés*; 1907 erstmals in deutscher Übersetzung).

A good contemporary presentation of this tendency can be found in the introductory chapter *Einführung in die esoterische Lehre* in: Schuré, Edouard: *Die großen Eingeweihten. Geheimlehren der Religionen.* With a preface by Rudolf Steiner. 20th edition. Bern, Munich, Vienna 1992 (first published in 1889 under the title *Les grands initiés*; first German translation 1907).

Sekten. Selbst die, die den Lehren, die diese verbreiteten, nicht anhingen, mußten sich wenigstens mit ihnen auseinandersetzen. Bücher, Pamphlete, Zeitschriftenartikel erschienen, die sich des Themas aus den verschiedensten Blickwinkeln annahmen. ■ Das Bestreben, das alte Erstarrte mit Hilfe okkulter Techniken in einen neuen Zustand reiner Geistigkeit zu überführen, hat Auswirkungen auf die praktische Arbeit. Die Künstler müssen erkennen, daß ihr Weg in der Gegenstandslosigkeit enden wird. Sie versuchen, durch Meditation und mystische Versenkung zu höheren Anregungen zu kommen. Über verschiedene Ebenen aufsteigend gelangen sie zu der höchsten, der der Wahrheit. In dieser Zone hat die Wirklichkeit keinen Platz mehr. Die in den unteren Bereichen, der materiellen Welt, vorkommenden sichtbaren Formen sind nur unerwünschte Ablenkungen. Form- und Bildfreiheit ist das höchste Ziel sowohl westlicher als auch östlicher mystischer Praktiken. Der Künstler wird daher mit fortschreitender Abstrahierung von der gegenständlichen Welt mit der Tatsache konfrontiert, daß die Gegenstände aus seinen Bildern verschwinden. ■ Was aber soll er an ihrer Stelle auf die Leinwand bringen? Wird er mit seinen Bemühungen nicht in der bloßen Ornamentik stecken bleiben, die eben noch Adolf Loos als Verbrechen bezeichnet hat?[2] Der nur abstrahierende Maler kann den Malprozeß an irgendeiner Stelle seiner Leinwand immer noch mit Hilfe eines Wirklichkeitsfragments oder auch nur mit einer Vorstellung von diesem in Gang setzen. Der gegenstandslos arbeitende braucht eine neue Theorie, einen Vorwurf, der es ihm erlaubt, seine Leinwand nur noch mit Linien, Farben und Formen zu strukturieren. Die Leere erfüllt mit Schrecken. Weder die Kubisten, noch die Expressionisten oder die Futuristen haben den endgültigen Schritt in die totale Abstraktion getan. Matisse stand mit zwei Bildern kurz davor.[3] Er hat ihn nicht gewagt und ist jedesmal in seine alte Bilderwelt zurückgekehrt. Es lag nahe, sich die Rechtfertigung für diesen Schritt aus eben der spirituellen Welt zu holen, die den Ratsuchenden in diese Situation gebracht hatte.

to get to grips with them. Books, leaflets, magazine articles were published, discussing the subject from very different points of view. ■ Efforts to transform old and rigid ideas with the help of occult techniques into a new state of pure spirituality have effects on the practical work. First of all, those artists who are really serious about it, have to accept the fact that their path will lead to abstraction. They try to gain inspiration on a higher level by meditating or becoming absorbed with mystic notions. Reaching ever higher levels, they arrive at the highest, that of truth. There is no room for reality in these spheres. The visible forms that exist on the lower levels, i.e. in the material world, are only undesired distractions. To be free of restrictions in organic form and picture is the highest aim both in Western and Eastern mystical practices. Thus by virtue of progressive abstraction from the object-orientated world, the artist finds that objects as such disappear from his pictures. ■ But what should he put on the canvas instead? Won't he in his efforts get stuck in the pure ornamentation, something that Adolf Loos only recently described as criminal?[2] The painter of solely abstract pictures can still begin the process of painting at any point on his canvas with the help of a fragment of the material world or with just a notion of this. Working without objects however the artist needs a new theory, a concept which enables him to structure his canvas with lines, colors and forms alone. An empty canvas evokes fright. Neither the Cubists, nor the Expressionists or Futurists have taken the final step to total abstraction. Matisse painted two pictures that only just stop short of abstraction.[3] He did not dare to take the step and always returned to his old pictorial world. The obvious thing to do was to find justification for this step in the very spiritual world that had brought the one searching for a solution into this situation. But even if the artist found satisfactory solutions for himself, how could he be sure that his works would

2 Vgl. cf. Loos, Adolf: Ornament und Verbrechen. In: *Sämtliche Werke Bd. 1*, Wien 1962, pp. 276–288.

3 Mit *La Moulade* von 1905 und besonders mit *Porte-fenêtre à Collioure* von 1914.
With *La Moulade* of 1905 and especially with *Porte-fenêtre à Collioure* of 1914.

Aber selbst wenn der Künstler für sich zufriedenstellende Lösungen fand, wie konnte er sicher sein, daß seine Werke dann vom Beschauer so verstanden wurden, wie sie von ihrem Autor gemeint waren? Die neue Theorie mußte also Leitlinien aufzeigen, die sowohl den Produzenten als auch den Rezipienten und ebenso das Verhältnis zwischen beiden umfassen. ■ In dem Versuch, die verschiedenen mystischen Phänomene, wie sie durch die Jahrhunderte immer wieder auftreten, in ein Ordnungsgerüst zu bringen, kommt Maurice Tuchman zu fünf Hauptgruppen. »Die fünf grundlegenden Prinzipien«, heißt es bei ihm, »innerhalb des spirituell-abstrakten Zusammenhangs – kosmische Metaphorik, Vibrationen, Synästhesie, Dualität, heilige Geometrie – sind tatsächlich fünf Strukturen, die sich auf grundlegende Denkweisen beziehen.«[4] Zwei davon lassen sich unschwer z. B. in den stark von theosophischem Gedankengut geprägten Schriften Wassily Kandinskys feststellen.[5] Die Vorstellung Kandinskys von der Verwendung geometrischer Formen läßt sich zwanglos in die fünfte Struktur, nämlich in die der Tradition der »heiligen Geometrie« einreihen und damit in ein spirituelles Umfeld stellen. ›Heilige Geometrie‹, schreibt Nigel Pennick, »ist unauflösbar verbunden mit verschiedenen mystischen Lehren [...]. So behandelt heilige Geometrie nicht nur die Proportionen üblicher, mit Lineal und Zirkel konstruierter geometrischer Figuren, sondern auch die harmonischen Verhältnisse der Teile des Menschen zueinander, die Strukturen von Pflanzen und Tieren, die Formen von Kristallen und Naturobjekten, die alle Manifestationen des universalen Zusammenhangs sind [...]. Seit Urzeiten war Geometrie unabtrennbar von der Magie.«[6] ■ Der Künstler ist grundsätzlich frei in der Wahl seiner Formen, ihr Zusammengehen muß jedoch das erzeugen, was Kandinsky den »inneren Klang« nennt, ihre Konstruktion muß einer »inneren Notwendigkeit« folgen. »Das wichtigste in der Formfrage ist das, ob die Form aus der inneren Notwendigkeit gewachsen ist oder nicht«, schreibt er.[7] Damit ist der Maler zwar nicht mehr eingebunden

be understood in the way he intended? The new theory therefore had to have guidelines that take not only the producer, but also the recipient and the relationship between the two into consideration. ■ In the attempt to structure the various mystic phenomena as they recur throughout the centuries, Maurice Tuchman identifies five groups. "The five basic principles", according to him "within the spiritual-mystical context — cosmic imagery, vibrations, synaesthesia, duality, sacred geometry — are in actual fact five structures that reflect fundamental modes of thinking."[4] Two of them can easily be found, for example, in Wassily Kandinsky's writings which contain clearly discernible theosophical ideas.[5] It is not difficult to allocate Kandinsky's notion of the use of geometrical forms to the fifth structure, i. e. to that of the tradition "sacred geometry", thus the spiritual context of which becomes apparent. "Sacred geometry", writes Nigel Pennick," is inextricably connected with various mystical teachings. [...] Thus sacred geometry deals not only with the proportions of common figures that are constructed with the ruler and a pair of compasses, but also with the harmonious relationships of parts of the human being to one each other, with the structures of plants and animals, the forms of crystals and natural objects, that are all manifestations of the universal context. [...] Since the time began geometry has been closely connected with magic."[6] ■ The artist is basically free in his choice of forms, but their interplay has to produce what Kandinsky calls "inner harmony", their construction must be subject to an "intrinsic necessity". "The most important thing about form is whether it is the result of intrinsic necessity or not", he writes.[7] Thus the artist is no longer committed to the aesthetic tradition of Western painting, but he can still feel comfortable in another world, a world that has existed since the dawn of history and that offers the discoveries of all Western and Eastern philosophies and religions as an explanation

4 Tuchman, Maurice: *Verborgene Bedeutungen in der abstrakten Kunst.* In: *Das Geistige in der Kunst. Abstrakte Malerei 1890 – 1985.* Stuttgart 1988, p. 32.

5 Kandinsky, Wassily: *Über das Geistige in der Kunst.* Mit einer Einführung von Max Bill. 10. Aufl., Bern, o. D. (erstmals erschienen im Dezember 1911, datiert 1912); Kandinsky, Wassily: Über die Formfrage. In: Kandinsky, Wassily; Marc, Franz (Hg.): *Der blaue Reiter.* Dokumentarische Neuausgabe von Klaus Lankheit. München, Zürich 1990, pp. 132 – 174 (erstmals erschienen 1912); Kandinsky, Wassily: *Punkt und Linie zu Fläche. Beitrag zur Analyse der malerischen Elemente.* Mit

einer Einführung von Max Bill. 7. Aufl., Bern-Bümplitz 1973 (erstmals erschienen 1926).
Kandinsky, Wassily: *Über das Geistige in der Kunst.* With an introduction by Max Bill. 10 th edition. Bern, undated (first edition published in December 1911, dated 1912); Kandinsky, Wassily: *Über die Formfrage.* In: Kandinsky, Wassily; Marc, Franz (ed.): *Der blaue Reiter.* A documentary edition by Klaus Lankheit, Munich, Zurich 1990, pp. 132 – 174 (first edition 1912); Kandinsky, Wassily: *Punkt und Linie zu Fläche. Beitrag zur Analyse der malerischen Elemente.* With an introduction by Max Bill. 7th edition, Bern-Bümplitz 1973 (first edition 1926).

6 Pennick, Nigel: *Sacred Geometry: Symbolism and Purpose in Religious Structures.* New York 1980, p. 8. Zit. n. quoted from: Tuchman, p. 21.

7 Kandinsky, Wassily: *Über die Formfrage.* A. a. O. op. cit., p. 142.

in die ästhetische Tradition der abendländischen Malerei, er kann sich aber doch aufgehoben fühlen in einer anderen Welt, einer Welt, die seit Anbeginn der Menschheit besteht und die die Erkenntnisse aller westlichen und östlichen Philosophien und Religionen zu ihrer Erklärung bereitstellt. Die Angst vor der Leere, der leeren Fläche der Leinwand, kann auf diese Weise überwunden, der Schritt in die totale Abstraktion kann getan werden. ■ Die Frage der angemessenen Rezeption eines solchen Kunstwerks löst Kandinsky über eine zweite von Tuchman formulierte Grundstruktur, nämlich über die der ›Vibration‹.[8] Es war besonders Sixten Ringbom, der in diesem Zusammenhang auf die Bücher der beiden Theosophen C. W. Leadbeater und Annie Besant *Der sichtbare und der unsichtbare Mensch*[9] und *Gedankenformen*[10] hingewiesen hat.[11] Sie sind 1908 auf deutsch erschienen, und es gilt als sicher, daß Kandinsky sie gekannt hat. Die Autoren entwickeln in ihnen eine Art Lehre von den Schwingungen. »Bewegung erscheint in der Materie als Schwingung«, heißt es in den *Gedankenformen*. »Jede Bewußtseins-Einheit ist in ihre besondere Hülle von Materie eingeschlossen und ist so getrennt von den übrigen Bewußtseins-Einheiten. Jede Bewußtseins-Einheit verursacht die Schwingung, die ihre Hülle dann hervorbringt. Die Schwingungen der verschiedenen Hüllen treffen sich gegenseitig, so daß jeder Bewußtseins-Einheit ständig durch ihre Hülle Schwingungen anderer Bewußtseins-Einheiten übertragen werden.«[12] Gedanken können in bestimmten Fällen auch ganz konkrete Formen annehmen. Diese Gedankenformen unterscheiden sich in Gestalt und Farbe und können von Hellsehern erkannt und beschrieben werden. Die Vorstellung von den Gedankenformen hat, wie Ringbom nachgewiesen hat, großen Einfluß auf die Malerei Kandinskys gehabt. ■ Den Untersuchungen Leadbeaters und Besants, die die Gesichte der Hellseher von kongenialen Malern zu Papier bringen ließen, gingen solche voraus, die zu diesem Zweck die Fotografie als Dokumentationsmedium einsetzten. Louis Darget (1847–1921) hatte bereits 1882, aber

of it. Fear of emptiness, the emptiness on the canvas, can be overcome in this way, the step into total abstraction can be taken. ■ Kandinsky solves the problem of an adequate reception of such a work of art using a second basic category as propounded by Tuchman, i.e. that of 'vibration'.[8] It was especially Sixten Ringbom who in this question drew attention to the books of the two theosophists C. W. Leadbeater and Annie Besant: *Der sichtbare und der unsichtbare Mensch*[9] and *Gedankenformen*[10] (Ringbom[11]). They appeared in German in 1908 and it is certain that Kandinsky knew them. The authors here develop a kind of theory of vibrations. "Motion appears in matter as vibration" according to the book *Gedankenformen*. "Every unit of consciousness is enclosed by matter in its own casing, as it were, and is thus separated from the other units of consciousness. Every unit of consciousness causes the vibration that its casing then induces. The vibrations of the various casingss touch each other so that every unit of consciousness is continually transferred via its casing to other units of consciousness."[12] Thoughts can also in certain instances take on very concrete forms. These thought forms differ in shape and color and can be identified and described by clairvoyants. The notion of thought forms had, as Ringbom has shown, tremendous influence on Kandinsky's painting. ■ Before the investigations of Leadbeater and Besant, that let kindred artists put the insights of the clairvoyants to paper, there were attempts to use photography as a means of documentation for this same purpose. Louis Darget (1847–1921) had already experimented in 1882, but especially after 1896, with the production of thought photographs. Thus he put photographic plates on the foreheads of his test subjects and, after an exposure of several minutes and the subsequent development, got amorphous forms which he attributed to particular emotions (figs. p. 108 top). "If the soul is vehemently roused by love, hate, anger, etc." he wrote, "it

8 Es gibt noch eine dritte Kategorie, die bei Kandinsky eine bedeutende Rolle spielt, nämlich die der Synästhesie oder *Audition colorée* (farbiges Hören). Die Erfahrung, daß man Farben hören, Musik sehen oder riechen kann usw., ist von großem Einfluß. So heißt es z. B. bei ihm: Es muß »möglich werden, die ganze Welt, so wie sie ist, ohne gegenständliche Interpretation **hören** zu können« (*Über die Formfrage*, A. a. O., p. 155; Hervorhebung R. H. K.). Dieser Komplex kann hier jedoch nur angedeutet werden. There is another, third category that plays an important role with Kandinsky, i. e. that of synaesthesia or *Audition colorée* (colored hearing). The experience of being able to hear colors, see or smell music etc. is of great

influence. Thus Kandinsky says: It has to "become possible to **hear** the whole world as it is without actual interpretation" (*Über die Formfrage*, op. cit., p. 155; bold print R. H. K.). I can but briefly mention this complex here.

9 Leadbeater, C. W.: *Der sichtbare und der unsichtbare Mensch. Darstellung verschiedener Menschentypen, wie der geschulte Hellseher sie wahrnimmt.* 7. Aufl., Freiburg im Breisgau 1991 (erstmals erschienen first edition 1902 *Man visible and invisible,* first German translation 1908 erstmals in deutscher Übersetzung).

10 Leadbeater, C. W.; Besant, Annie: *Gedankenformen.* 5. Aufl., Freiburg im Breisgau 1993

(erstmals erschienen 1901 unter dem Titel *Thought-forms,* first German translation 1908 erstmals in deutscher Übersetzung).

11 Ringbom, Sixten: Kunst in der ›Zeit des Großen Geistigen‹. In: *Jahresring* 40, München 1993, pp. 36ff.

12 Leadbeater, C. W.; Besant, Annie: *Gedankenformen.* A. a. O. op. cit. , p. 15.

Rolf H. Krauss

insbesondere nach 1896 mit der Herstellung von Gedankenfotografien experimentiert. So legte er seinen Versuchspersonen z. B. fotografische Platten auf die Stirn und erhielt nach mehrminütiger Belichtung und nachfolgender Entwicklung amorphe Gebilde, die er bestimmten Gemütsbewegungen zuordnete (Abb. S. 108 oben). »Ist die Seele heftig bewegt von Liebe, Haß, Zorn usw.«, schrieb er, »so setzt sie zuerst ihr eigentliches Werkzeug, das fluidische Gehirn, in Aufruhr. Dessen starke und schnelle Vibrationen übertragen sich auf das fleischliche Gehirn, das nun den Sturm der Leidenschaften nach außen projiziert in Gestalt einer wirbelnden Masse des ätherischen Stoffes.«[13] Auch der Magnetopath und Facharzt für Nervenkrankheiten an der Salpétrière in Paris, Hippolyte Baraduc (1850–1909), beschäftigte sich mit ähnlichen Experimenten (Abb. S. 109) und verfaßte darüber sogar ein Buch.[14] Wenn Ringbom die These aufstellt, man könne die farbigen Abbildungen in den Büchern von Leadbeater und Besant »als die ersten nicht-gegenständlichen Bilder betrachten, die zehn Jahre vor Kandinskys berühmtem Aquarell von 1910 entstanden [sind]«[15], so läßt sich mit gleichem Recht behaupten, daß es sich bei den Bildern von Darget, Baraduc und anderen um die ersten abstrakten bzw. nicht-gegenständlichen Fotografien handelt. ■ ■ **Erwin Quedenfeldt und die abstrakte Lichtbildkunst** Mit den Kategorien der ›inneren Notwendigkeit‹, der ›heiligen Geometrie‹ und der ›Vibration‹ hat Kandinsky eine komplette theosophische Theorie der Produktion und Rezeption von Kunstwerken entwickelt. Fünfzehn Jahre später macht sich der promovierte Chemiker und Fotograf Erwin Quedenfeldt daran, von Kandinsky stark beeinflußt, etwas ähnliches für die Fotografie zu wagen. Mit drei fortlaufenden Textbeiträgen in der *Photographischen Korrespondenz*, beginnend am 1. November 1927, entwirft er eine Theorie der ›abstrakten Lichtbildkunst‹.[16] Dem gegenstandslosen Bild nähert er sich in mehreren Schritten. Zunächst trifft er eine Unterscheidung zwischen Fotografie und Lichtbildkunst. Die Fotografie ist für ihn »die

activates its real tool, the fluid brain, first of all. The latter's strong and quick vibrations affect the flesh of the brain that then projects the storm of passions outwards in the form of a swirling mass of ethereal substance."[13] Hippolyte Baraduc (1850–1909), magnetiser and neurologist at the Salpétrière in Paris, carried out similar experiments (fig. p. 109), too, and even wrote a book.[14] If Ringbom puts forward the theory that one can regard the color pictures in the books of Leadbeater and Besant "as the first non-objective pictures that were produced ten years before Kandinsky's famous water-color of 1910."[15] it can be equally maintained that the pictures of Darget, Baraduc and others are the first abstract, i.e. non-objective photographs. ■ ■ **Erwin Quedenfeldt and the art of abstract "Lichtbildkunst"** By introducing the categories 'intrinsic necessity', 'sacred geometry' and 'vibration' Kandinsky laid the foundations for a comprehensive theosophical theory of the production and reception of works of art. Fifteen years later, Erwin Quedenfeldt, doctor of chemistry and photographer, and much influenced by Kandinsky, set about trying something similar for the photograph. In three articles contributed to the *Photographische Korrespondenz*, the first appearing on 1st November 1927, he develops a theory of "abstract 'Lichtbildkunst'".[16] He approaches the object-free picture in several steps. First of all, he makes a difference between photography and "Lichtbildkunst". Photography is for him "the automatic and mechanical reproduction of something objectively seen [...]. Photography's task is to reproduce the world for us in such a way that, looking right through the picture, we can see that world again in the state that we are used to seeing it."[17] The vision of the artist is the complete opposite; Quedenfeldt calls it 'subjective experience'.[18] ■ Any attempt to make artistic statements with the help of photography is doomed to failure; the term 'creative photography' is in itself incorrect. "The objective, inevitable

13 Darget, Louis: Verschiedene Methoden zur Erzielung fluidomagnetischer und spiritistischer Photographien. Übersetzt von G. A. Lange. In: *Die übersinnliche Welt*, 1911, p. 124.

14 Baraduc, Hippolyt: *L'âme humaine, ses mouvements, ses lumières et l'iconographie de l'invisible fluidique*. Paris 1896.

15 Ringbom, Sixten: Kunst in der ›Zeit des Großen Geistigen‹. Okkulte Elemente in der frühen Theorie der abstrakten Malerei. In: Wyss, Beat: Mythologie der Aufklärung. Geheimlehren der Moderne. In: *Jahresring* 40, München 1993, p. 45.

16 Quedenfeldt, Erwin: Die abstrakte Lichtbildkunst. In: *Photographische Korrespondenz*. 1927, pp. 321–324; 1928, pp. 337–340 und pp. 368–374.

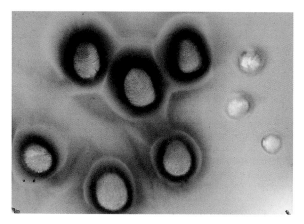

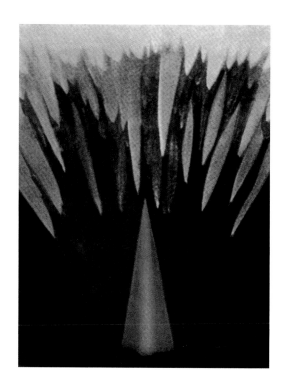

Louis Darget: *Untitled*, France, ca. 1896
Fluidal photographies (Fluidalfotografien).
Color prints, glass, ca. 6,5 x 9 cm (top);
ca. 9 x 12 cm (middle)
Institut für Grenzgebiete der Psychologie
und Psychohygiene, Freiburg im Breisgau

Anonymous: *Grant of Prayer* (Gebets-
erhörung), 1901
Taken from: C. W. Leadbeater and Anni
Besant: *Gedankenformen*. Freiburg im
Breisgau 1993 (bottom)

Rolf H. Krauss

Hippolyt Baraduc: *Iconograph of an Ecstasy
During a Prayer*, April 1894
Taken from: Rolf H. Krauss: *Jenseits von
Licht und Schatten.* Marburg 1992.

automatisch-mechanische Abbildung von objektiv Gesehenem [...]. Die Photographie soll uns die Welt so wiederge-ben, daß wir, durch das Bild hindurchsehend, die Welt wieder in ihrem uns gewohnten Zustand erblicken können.«[17] Demgegenüber steht die Vision des Künstlers, die Quedenfeldt als »subjektives Erleben«[18] bezeichnet. ■ Der Ver-such, mit Hilfe der Fotografie zu künstlerischen Aussagen zu kommen, muß scheitern; der Begriff ›künstlerische Fotografie‹ ist in sich falsch. »Das objektive, zwangsläufige Sehbild der Photographie kann nicht die subjektiv erfühlte Vision des Künstlers sein.«[19] Diese ist nur durch bewußtes Überspielen der technischen Gegebenheiten zu verwirklichen. Bemühungen in dieser Richtung bezeichnet Quedenfeldt mit ›Lichtbildkunst‹, den Ausübenden ›Lichtbildkünstler‹. »Die Grenze aller Berechenbarkeit«, heißt es bei ihm, »aller Gesetzmäßigkeit, aller wiederhol-baren Mechanik und rationalen Voraussicht ist überschritten. Es wird aus den Gründen irrationalen Lebens geschöpft und die metaphysischen Kräfte im Menschen drängen zum Ausdruck.«[20] Jetzt sollen »gewissermaßen die inneren Lichtstrahlen« eingefangen werden, »die von der geistigen Erleuchtung des Menschen ausgehen.«[21] ■ Technisch wird dieser Schritt auf einer ersten Stufe möglich mit Hilfe von Verfahren, die Quedenfeldt unter dem Begriff ›Flächenverfahren‹ zusammenfaßt. Die Fotografie, so Quedenfeldt, baut ihr Bild aus Punkten auf. Die Licht-bildkunst dagegen betont Linie und Fläche. Dies sei »im Bildaufbau stets das Mittel zur Vergeistigung und Abstrak-tion gewesen.«[22] Das mehrschichtige Gummidruckverfahren ermöglicht, ausgehend von einem Negativ, im Labor den Bildaufbau in mehreren abgestuften Tonflächen sowie den massiven Eingriff in die Bildstruktur mit Farbe und Pinsel. Flächen können konturiert, Kompositionsteile akzentuiert werden. Mit einer Verschiebungsmethode, die Quedenfeldt schon 1910 erfand, erzielt er ähnlich abstrahierende Ergebnisse. Von einem Negativ wird ein Diaposi-tiv angefertigt. Negativ und Positiv werden deckungsgleich übereinandergelegt und danach geringfügig gegenein-

perspective of photography cannot be the subjectively felt vision of the artist."[19] This can only be achieved by deli-berately covering up the technical factors. Efforts of this kind are termed 'Lichtbildkunst' by Quedenfeldt; he calls the person dealing with this the 'Lichtbildkünstler'. "The limits of all calculability", according to him, "of all rules, of all repeatable mechanical processes and rational foresight have been transcended. The artist draws on the depths of the irrational in life, and the metaphysical forces in man strive for expression."[20] It is "so to speak the inner light rays" that are now to be captured, "which emanate from man's spiritual awakening."[21] ■ On a first level this step becomes technically possible with the help of methods which Quedenfeldt sums up in the term 'Flächenverfahren' (surface methods). Photography, according to Quedenfeldt, makes its picture out of dots. 'Lichtbildkunst', on the other hand, emphasizes lines and masses. This "has always been the means to achieve sophistication and abstraction in the composition of the picture."[22] The process of combination gum bichromate printing makes it possible to construct in the darkroom from one negative the final picture out of several graded tone surfaces, and also to intervene massively in the structure of the picture with help of colors and paint brush. Masses can be given contours, compositional parts can be accentuated. By the means of a shifting technique which Quedenfeldt had already invented in 1910, he gets results that are similarly abstract. A slide is made from a negative. The negative and the slide are placed over each other and then slightly shifted. The two combined layers are then put in the enlarger and exposed on normal photo paper. The result is a picture with both dark and light contours. ■ A further possibility of duping technical factors is distortion of the perspective. This is achieved in the process of enlarge-ment by putting the ground level at an angle. Quedenfeldt draws attention to the fact that "in times of abstract

17 Quedenfeldt, Erwin: *Die abstrakte Lichtbild-kunst* (1927). A. a. O. op. cit. , p. 321.

18 Ebd. Ibid.

19 Ebd. Ibid.

20 Ebd. Ibid., p. 322.

21 Ebd. Ibid., p. 323.

22 Ebd. Ibid. Quedenfeldt ist hier sicher von Wilhelm Worringer und dessen Buch *Abstrak-tion und Einfühlung* beeinflußt. Bei Worringer heißt es u. a.: »Eine entscheidende Konsequenz eines solchen [abstrakten] Kunstwollens war einerseits die Annäherung der Darstellung an die Ebene, andererseits strenge Unterdrückung der Raumdarstellung und ausschließliche Wie-dergabe der Einzelform« (Worringer, Wilhelm: *Abstraktion und Einfühlung. Ein Beitrag zur Stilpsychologie*. München, Zürich 1987, p. 56). Quedenfeldt hat die Schrift Worringers gekannt, denn an einer Stelle heißt es bei ihm: »Einfüh-lung und Abstraktion sind die beiden Pole, zwischen denen der Entwicklungsprozeß der abendländischen Kultur verläuft«. Quedenfeldt has obviously been influenced here by Wilhelm Worringer and his book *Abstraktion und Einfüh-lung* (Abstraction and Empathy), first published in 1908. Worringer states amongst other things: "An important consequence of such an artistic objective was on the one hand the appropriat-ion of the presentation on the plane surface, on the other hand, the strict suppression of spat-ial presentation and the exclusive reproduction of the individual form". (In: Worringer, Wilhelm: *Abstraktion und Einfühlung. Ein Beitrag zur Stilpsychologie*, Munich, Zurich 1987, p. 56). Quedenfeldt was acquainted with Worringer's book, for at one stage he writes: "Empathy and abstraction are the two poles between which the process of development in the culture of the Western world takes place". (Quedenfeldt, Erwin: *Die abstrakte Lichtbildkunst* (1927). A. a. O. op. cit., p. 323).

Rolf H. Krauss

ander verschoben. Das Plattenpaket wird im Vergrößerungsgerät durchleuchtet und auf normales Fotopapier aufbelichtet. Es entstehen sowohl dunkle als auch helle Konturenbilder. ■ Eine weitere Möglichkeit der Überlistung der technischen Gegebenheiten ist die perspektivische Verzerrung. Sie wird beim Vergrößerungsprozeß durch Schiefstellen des Auffangbrettes erreicht. Quedenfeldt macht darauf aufmerksam, daß »in abstrakt denkenden Zeiten«[23] besonders die Vertikalverlängerung angewendet wurde, und verweist in diesem Zusammenhang auf die Gemälde El Grecos. Schließlich kann das Positiv auf Papier lediglich als Ausgangspunkt der künstlerischen Arbeit benutzt werden, indem man es einer Über- oder Umbearbeitung unterzieht. Die fotografische Vorlage kommt dann einer Naturskizze gleich. Die Bearbeitung kann so weit gehen, daß die Fotografie gegenüber der Zeichnung deutlich zurücktritt. ■ Auf dieser Stufe der Abstraktion ist aber immer noch die fotografierte Realität erkennbar oder wenigstens erahnbar. Erst die nächste Stufe führt in die Gegenstandslosigkeit. Quedenfeldt erwähnt in diesem Zusammenhang Man Ray und László Moholy-Nagy (Abb. S. 112, oben). Die beiden Künstler »haben versucht, durch die punktuelle Photographie ganz abstrakte Kompositionen zu geben, indem sie geometrische Gebilde in auf- und durchfallendem Lichte photographierten.«[24] Quedenfeldt ist aber mit deren Ergebnissen nicht zufrieden. Eine künstlerische Wirkung tritt für ihn erst ein, »je weniger plastisch und je flächiger die Gebilde auf der Bildfläche erscheinen. Die punktuelle Schattierung, die das Gebilde räumlich plastisch und ganz naturhaft gibt, stört die abstrakte Komposition außerordentlich.«[25] Exemplarisch erscheinen ihm hingegen die Bilder der reflektorischen Lichtspiele von Hirschfeld-Mack, »weil sie ganz abstrakte Flächenformen zeigen, die wir an keine Gegenständlichkeiten mehr hängen können.«[26] In der Tat zeigen die Aufnahmen, die Hirschfeld-Mack in den Jahren 1922–1924 von den Projektionen seiner *Farborgel* macht (Abb. S. 112 unten), nur noch verwischte Lichtspuren auf dunklem

thinking".[23] vertical extension was used, and points here to El Greco's paintings. Finally the photograph can be used only as a starting point for the creative process if it undergoes complete or partial change. The photographic blueprint is then comparable with a "natural sketch". The treatment can be such that the photograph plays only a subordinate role to the drawing. ■ On this level of abstraction the photographed extract of reality is, however, still recognizable as such or at least vaguely visible. It is, in actual fact, the next level that leads to complete abstraction. Quedenfeldt refers to Man Ray and László Moholy-Nagy here (figs. p. 112, top). Both artists "have, with the help of punctual photography ('punktuelle Fotografie') tried to create completely abstract compositions by photographing geometrical shapes in direct and penetrating light."[24] Quedenfeldt is, however, dissatisfied with their results. In his opinion, the artistic effect is only achieved "the less dimensional and the flatter the shape on the picture surface appears to be. The dotted shading which makes the shape appear spatially more dimensional and completely natural, hampers the abstract composition enormously."[25] Of exemplary value are, in his view, the pictures of the reflected light effects by Hirschfeld-Mack, "because they show abstract surface forms which can no longer be identified with any objects."[26] Indeed, the photos that Hirschfeld-Mack took of the projections of his *color organ* between 1922 and 1924 show but blurred traces of light on a dark background (fig. p. 112, bottom), quite similar to those that Bruguière made of Thomas Wilfred's *Clavilux* around the same time.[27] ■ Quedenfeldt carried out experiments like these himself at a relatively early stage. As early as 1912 he developed an ornamenting technique which he patented in the same year as a "technique for the production of symmetrical patterns from natural forms etc. with the helps of photography."[28] "He also made slides as blueprints, applying dissolved color salts like ammonium

23 Quedenfeldt, Erwin: *Die abstrakte Lichtbildkunst* (1928). A. a. O. op. cit. , p. 368.

24 Ebd. Ibid., S. 372.

25 Ebd. Ibid. Quedenfeldt ist sich in der Ablehnung des Fotogramms mit Jaromír Funke einig, der u. a. schreibt: »[Das Fotogramm] stirbt an Schönheit und Naivität; es erfüllte seine Sendung und zeigte, was man durch Spiel des Lichts herauszaubern kann, dem sich in den Weg stellen: Netz, Bindfaden, Klammer, menschliche Hand, Finger, verschiedenartig geformte Watte, Glas in verschiedenen Formen usw., usw.« Quedenfeldt rejects, as does Jaromír Funke, the photogram, the latter writing, among

other things: "[The photogram] is dying of beauty and innocence; it fulfilled its mission and showed what one can conjure up with the help of the play of light, when something is put in its path: a net, string, clip, human hand, finger, cotton wool formed into different shapes, glass in various shapes, etc., etc." (Funke, Jaromír: Vom Fotogramm zur Emotion. In : *Jaromír Funke, 1896–1945. Fotografie.* Museum Bochum 1977).

26 Quedenfeldt, Erwin : *Die abstrakte Lichtbildkunst (1928).* A. a. O. op. cit. , p. 372. Ludwig Hirschfeld-Mack (1893–1965) studierte an der Kunstakademie Stuttgart bei Adolf Hölzel und von 1920 bis 1925 am Bauhaus. Von 1926 bis 1927 war er Leiter des Vorkurses an der

Bauhochschule Weimar, 1940 ging er als Kunsterzieher nach Australien. In seinen ersten Jahren am Bauhaus entwickelte er, zusammen mit Kurt Schwerdtfeger reflektorische Farbenspiele, die er fotografisch im Bild festhielt. Ludwig Hirschfeld-Mack (1893–1965) studied at the Academy of Art in Stuttgart under Adolf Hölzel and from 1920 to 1925 at the Bauhaus. From 1926 to 1927 he was in charge of the preparatory course at the College for Constructional Engineering in Weimar, and in 1940 he went to Australia as an art teacher. During his first years at the Bauhaus he developed reflecting color patterns together with Kurt Schwerdtfeger, documenting them in photographs.

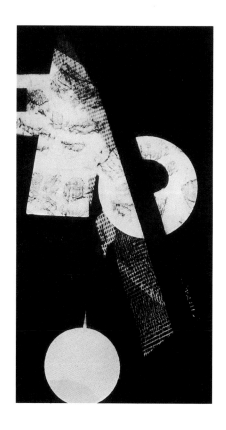

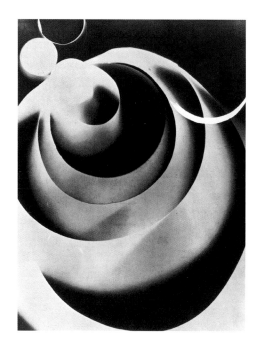

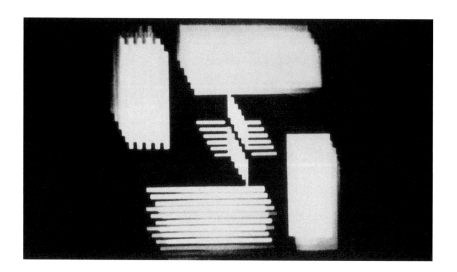

Man Ray: *Photogram.* Pl. 4 from *Champs
Délicieux. Album de photographies,* Paris, 1922
Print size 22 x 17 cm (top left)

László Moholy-Nagy: *Photogram,* 1922
Unique gelatin silver print (reproduction),
18 x 13 cm
Museum Folkwang, Essen
Courtesy of Hattula Moholy-Nagy (top right)

Ludwig Hirschfeld-Mack: Sequence from the
light game *Kreuzspiel* (Cross play), 1923
(bottom)

Rolf H. Krauss

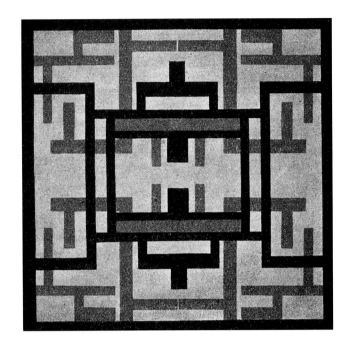

Erwin Quedenfeldt: *Ohne Titel* (Untitled),
ca. 1912
Kombinationsgummidruck nach dem Ornamen-
tierverfahren mit dem Rapportierapparat
Globus. Combined gum bichromate print,
generated by the ornamentative technique
with the repeat apparatus *Globus* **(top left)**

Erwin Quedenfeldt: *Ohne Titel* (Untitled),
ca. 1926
Komposition nach dem Ornamentierverfahren
mit dem Rapportierapparat *Globus.* Composi-
tion using the ornamentative technique with
the repeat apparatus *Globus* **(top right)**

Erwin Quedenfeldt: *Kameralose Komposition*
(Lensless composition), ca. 1927
Beispiel einer abstrakten Bildgestaltung unter
Verwendung direkter Lichtstrahlen auf Chrom-
gummifarbschichten im Kombinationsgummi-
druck. Example of an abstract image design
with direct light on gum bichromate emulsion;
combined gum bichromate print
Taken from: *Das Deutsche Lichtbild,* 1927
(bottom)

Grund, ganz ähnlich denen, die Bruguière etwa zur gleichen Zeit von Thomas Wilfreds *Clavilux* anfertigte.[27] ■ Quedenfeldt selbst hat derartige Versuche schon verhältnismäßig früh vorgenommen. Bereits 1912 entwickelte er ein Ornamentierverfahren, das er in diesem Jahr als »Verfahren zur Herstellung von symmetrischen Mustern aus Naturformen u. dgl. auf photographischem Wege« zum Patent anmeldete.[28] »Als Vorlagen fertigte er sich zum Teil Diapositive an, indem er farbige Salze, wie Ammonium- oder Kaliumbichromat gelöst auf eine Glasplatte aufbrachte, die dann in pflanzenähnlichen Formen auskristallisierten. Bild und Spiegelbild nahm er mit einer für diesen Zweck von ihm konstruierten Rapportierkassette durch Drehen und Wenden der Platte nacheinander in bis zu acht Teilsegmenten auf.«[29] Damit noch nicht genug. Um deutlich abgesetzte Grau- und Schwarzstufen zu erhalten, verwendete Quedenfeldt bei der Herstellung der Abzüge den Kombinationsgummidruck (Abb. S. 113). Derartige »absolute Kompositionen«, schreibt er, »sind durch den reinen Kopierprozeß erzeugt, es lagen also keine Kamera-Aufnahmen vor.«[30] Quedenfeldt resümiert: »Die perspektivlose Raumdarstellung ohne Kamera und Objektiv mittelst Tonflächen [...] kann als Symbol für die Anschauung in der Totalität, nach allen Seiten hin, gelten.«[31] ■ Dem Aufsatz Quedenfeldts *Die abstrakte Lichtbildkunst*, aus dem ich zitiere, sind u. a. zwei gegenstandslose Abbildungen beigegeben, von denen die erste mit Sicherheit, die zweite wahrscheinlich nicht nach diesem Verfahren entstanden ist.[32] Die erste (Abb. S. 113, oben links) zeigt zwei aus vertikalen und horizontalen Linien bestehende Gitter, die vor neutralgrauem Hintergrund in zwei deutlich voneinander unterscheidbaren Flächen, die eine dunkelgrau, die andere schwarz, übereinander gelegt sind. Die zweite (Abb. S. 113 unten) scheint eine freie Arbeit zu sein, wahrscheinlich hergestellt in einem dem Fotogramm vergleichbaren Verfahren. Die in dem Bild erkennbaren Effekte erzielt man z. B. – so die Schilderung Quedenfeldts – »wenn wir uns aus undurchlässigem Papier für unsere Kompositio-

or potassium bichromate to a glass plate, which then crystallized into plant-like shapes. He took a photo and its mirror image in up to eight sectional-segments with a repeat-action cassette especially constructed for the purpose by alternately twisting and turning the plate."[29] And not only that! In order to retain clearly offset grey and black shading, Quedenfeldt used combination gum bichromate processing to obtain prints (figs. p. 113). Such "absolute compositions" he writes "are obtained simply by using the copying process, there were therefore no camera prints."[30] Quedenfeldt sums up: "Presentation of space without a perspective and without use of camera and lens with the help of tone surfaces [...] can be regarded as the symbol for vision in its totality, from all angles."[31] ■ There are, amongst others, two non-objective picture illustrations in Quedenfeldt's essay *Die abstrakte Lichtbildkunst* from which I have been quoting of which the first is with certainty the result of this technique the second probably not.[32] The first one (fig. p. 113, top left) shows two gratings consisting of horizontal and vertical lines, set against a neutral, grey background and placed over each other on two clearly distinguishable surfaces, one dark grey, the other black. The second one (fig. p. 113, bottom) seems to be a freely created work, the result perhaps of a technique that Quedenfeldt also uses and that is similar to that of the photogram. One obtains such effects, for example, "by cutting out suitable pieces from impervious paper for our compositions and placing them on light-sensitive paper in a specific configuration and then exposing them."[33] According to Elke and Herbert Müller Quedenfeldt presented the results of his ornamenting technique and those of his shifting technique during his travels, for example, to Holland and in Düsseldorf. "The most important presentation", according to the two authors "was probably the fifteen plates *Symmetrical patterns from natural forms* at the Werkbund-Exhibition of 1914 in Cologne

27 Hirschfeld-Mack steht mit seinem Versuch, mittels geeigneter technischer Vorrichtungen musikalische Eindrücke in Farbspiele zu übersetzen, in einer langen Tradition. Vgl. z. B.: Hirschfeld-Mack's attempts to translate musical impressions into color patterns with the help of suitable technical devices, follow a long tradition. Cf. i. e.: Moritz, William: The Dream of Color Music, and Machines that Made it Possible. In: *Animation World Magazine*, 2.1, April 1997.

28 Müller, Elke und Herbert: Zum Leben und Werk von Erwin Quedenfeldt. In: *Erwin Quedenfeldt 1869–1948*. Ausstellungskatalog exhibition catalog. Essen: Fotografische Sammlung im Museum Folkwang, 1985, p. 8.

29 Ebd. Ibid.

30 Quedenfeldt, Erwin: *Die abstrakte Lichtbildkunst* (1928). A. a. O. op. cit., p. 373.

31 Ebd. Ibid., p. 374.

32 Ebd. Ibid.

nen geeignete Stücke ausschneiden und diese in bestimmter Konfiguration auf lichtempfindliches Papier auflegen und belichten.«[33] Nach Elke und Herbert Müller stellte Quedenfeldt die Ergebnisse seines Ornamentierverfahrens und die seiner Verschiebungsmethode auf Reisen u. a. in Holland und in Düsseldorf vor. »Die bedeutendste Präsentation«, so die beiden Autoren, »dürften jedoch die 15 Tafeln *Symmetrische Muster aus Naturformen* auf der durch den Ausbruch des 1. Weltkrieges vorzeitig beendeten Werkbund-Ausstellung 1914 in Köln gewesen sein.«[34] Damit wäre Erwin Quedenfeldt der erste, der gegenstandslose Fotografien auf einer Ausstellung gezeigt hat.[35] ■ Quedenfeldt war Monist und einer der führenden Mitglieder des 1906 gegründeten Monistenbundes in Düsseldorf.[36] Er war damit Anhänger einer Lehre, die von dem Naturwissenschaftler und Ordinarius für Zoologie an der Universität Jena, Ernst Haeckel (1834–1919), begründet wurde. Haeckel war ein Verfechter der Darwinschen Entwicklungstheorie und setzte sich damit massiven Angriffen der Kirche aus. In seinem hohe Auflagen erreichenden und in verschiedene Sprachen übersetzten Buch *Die Welträtsel*[37], das 1899 erstmals erschien, propagierte er die Unvereinbarkeit der Darwinschen Lehre mit dem christlichen Dogma. Den herkömmlichen dualistischen Auffassungen in Religion und Philosophie setzte er eine monistische Religion entgegen, in der es keinen persönlichen Gott gibt, der dem Menschen gegenübersteht, sondern in der Gott und Natur eine Einheit bilden. Haeckels Monismus versteht sich als eine verbindliche Ethik auf naturwissenschaftlicher Grundlage, als eine materialistische Weltanschauung und ist daher zu unterscheiden von einem mystischen Monismus, wie er sich bei Plotin oder in den Upanishaden findet. Eine solche Auffassung muß zwangsläufig zu einer extremen Gegenposition zu spirituellen Lehren und Praktiken führen. »Spiritismus und Okkultismus« werden von Haeckel in der Tat als »absurde Spuklehren«[38] bezeichnet. Die Seele »als ein immaterielles, selbständiges Wesen, welches den materiellen Körper nur zeitweise

that was prematurely closed upon the outbreak of the First World War".[34] Thus Erwin Quedenfeldt is the first person to have shown non-objective photographs at an exhibition."[35] ■ Quedenfeldt was a monist and one of the leading members of the Monist Society founded in Düsseldorf in 1906.[36] He was thus a follower of a doctrine that was initiated by Ernst Haeckel (1834–1919), natural scientist and Professor for Zoology at the University of Jena. Haeckel was a proponent of Darwin's theory of evolution and as such was the target of vehement attacks by the Church. In his book *Die Welträtsel*[37], which was first published in 1899, selling a large number of copies, and was also translated into various languages, he propagated the incompatibility of Darwin's theory with Christian teachings. He replaced the traditional dualistic approaches of religion and philosophy with a monistic religion in which there is no personal God who confronts man, but a religion in which God and Nature are one. Haeckel's monism consists of a binding ethical code based on the natural sciences; it is as such a materialistic philosophy and thus to be distinguished from the kind of mystical monism found in Plotin or the Upanishad. Such a position necessarily leads to an extreme anti-position towards spiritual teachings and practices. "Spiritism and Occultism" are indeed described by Haeckel as "absurd ghost stories".[38] According to monistic teachings there is no such thing as a soul, "as an incorporeal, independent being that only dwells in the body for a time and then leaves it."[39] On the contrary, the soul is merely "the sum of cerebral acitivity".[40] ■ In view of these observations it is remarkable that it is more Kandinsky's[41] convictions than those of Haeckel that influence Quedenfeldt's mode of speech. Thus Quedenfeldt writes, for example: "*Lichtbildkunst* is—like any art—susceptible to the convulsions of the human soul, which from time to time strive for a new presentation of the world."[42] Further: "And so *Lichtbildkunst* must also enter the

33 Ebd. Ibid.

34 Müller, Elke and Herbert: Zum Leben und Werk von Erwin Quedenfeldt. In: *Erwin Quedenfeldt 1869–1948*. A. a. O. op. cit., p. 8.

35 In dem *Jahrbuch des deutschen Werkbundes*, 1915. *Deutsche Form im Kriegsjahr. Die Ausstellung Köln 1914* (München 1915) gibt es einen Hinweis darauf, wenn es heißt: »Den Erfindern und Freunden des Ornaments suchte eine kleine Auslese von Photographien nach Naturformen zu dienen, wie sie das Mikroskop dem kunstfreundlichen Forscher erschließt«.

36 Müller, Elke and Herbert: Zum Leben und Werk von Erwin Quedenfeldt. In: *Erwin Quedenfeldt 1869–1948*. A. a. O. op. cit., p. 8.

There is evidence of this in *Jahrbuch des deutschen Werkbundes, 1915. Deutsche Form im Kriegsjahr. Die Ausstellung Köln 1914* (Munich 1915), where it says: "For the innovators and friends of the ornament there was a small selection of photographs based on natural forms, just like the microscope reveals the latter to the researcher interested in art". (Jessen, Peter: Die deutsche Werkbund-Ausstellung Köln 1914. In: Ebd. Ibid., p. 28).

37 Haeckel, Ernst: *Die Welträtsel. Gemeinverständliche Studien über monistische Philosophie*. Mit einer Einleitung von with an introduction by Iring Fetscher. Stuttgart 1984.

38 Haeckel, Ernst: *Gott-Natur (Theophysis). Studien über monistische Religion*. Leipzig 1914, p. 29.

bewohnt und ihn beim Tode verläßt«[39], gibt es nach der monistischen Lehre nicht. Die Seele ist vielmehr lediglich »eine Summe von Gehirntätigkeiten«.[40] ■ ■ Angesichts dieser Erkenntnisse ist es bemerkenswert, daß sich in Quedenfeldts Diktion eher die Überzeugungen Kandinskys[41] als die Haeckels wiederfinden. So schreibt Quedenfeldt z. B.: »Die Lichtbildkunst ist, wie alle Kunst, abhängig von den Erschütterungen der menschlichen Seele, die von Zeit zu Zeit nach einer neuen Gestaltung des Weltbilds drängen.«[42] Und weiter: »So muß auch die Lichtbildkunst in die Periode der Vergeistigung eintreten, weil sie wie jede andere Kunst aus der seelischen Konstitution des Menschen fließt.«[43] Und endlich: »Dem Künstler unserer Zeit dienen seine Werke als Mittel, um den Bau einer neuen Menschheitsordnung zu fördern. Er ist sowohl Ankläger der seichten, materialistischen Auffassung, als auch Prophet einer menschenwürdigen, sozial gerechteren und geistig vertieften Zukunft.«[44] Diese Äußerungen entsprechen der theosophischen Überzeugung Kandinskys mehr als der monistischen Haeckels, wobei der utopische Ansatz beider sichtbar wird. Kandinsky, und mit ihm die Theosophie, sieht das Heil in einer neuen Geistigkeit, Haeckel in der Überwindung von Dogmatismus und Aberglaube. Gleichzeitig wird deutlich, wie attraktiv das Modell Kandinskys für jemand immer noch ist, der wie Quedenfeldt einer Gemeinschaft angehört, die dieses in Frage stellt und bekämpft. ■ ■ Stimmt Quedenfeldt mit Kandinsky überein, was den Grundantrieb der modernen Kunst angeht, so finden sich auch Tuchmans ›heilige Geometrie‹ und ›Vibration‹ in Quedenfeldts Text wieder. Quedenfeldts Bemühungen um eine totale Abstraktion gipfeln nicht umsonst in seinem Ornamentierverfahren, mit dessen Hilfe man »abstrakt geometrische Gebilde« herstellen und »symmetrische Rhythmen«[45] erzeugen kann. »Liegt selbst in ganz gegenstandslosen Flächenkompositionen nicht starker seelischer Ausdruck?«, fragt er.[46] Die ›Vibration‹ erscheint als ›Klang‹, wenn beim Aneinanderstoßen von unterschiedlichen Flächen die »Luft durchzittert und die

period of spiritualization because, like every other form of art, it emanates from man's spiritual being."[43] And, finally: "The contemporary artist uses his works as a means to promote the construction of a new human order. He is both plaintiff of the superficial, materialistic approach, and he prophet of a more humane, socially just and spiritually profound future."[44] These thoughts correspond more to Kandinsky's theosophical convictions than to Haeckel's monistic ideas, whereby the utopian ideals of both become evident. Kandinsky, and with him theosophy, see redemption in a new spiritual perception, Haeckel finds it in overcoming dogmatism and superstition. At the same time it becomes apparent how attractive Kandinsky's model still is for someone who, like Quedenfeldt, belongs to a community that questions and fights against this. ■ ■ Whilst Quedenfeldt agrees with Kandinsky as to what the basic motivating force in modern art is, Tuchman's categories 'sacred geometry' and 'vibration' can also be found in Quedenfeldt's texts. It is no coincidence that Quedenfeldt's attempts at total abstraction culminate in his ornamenting technique with the help of which "abstract geometrical shapes" and "symmetrical rhythms"[45] can be produced. "Isn't there a strong emotional message even in surface compositions that are completely abstract?"[46], he asks. 'Vibration' appears as 'sound' when different surfaces strike each other and make "the air quiver and the soul bound in utmost ecstasy"[47] or these surfaces appear as "vibrations of grey and color sounds"[48] which rouse the observer if only he makes himself susceptible to them. ■ "We are dealing here with new forms of expression", Quedenfeldt sums up, "for which we are not emotionally prepared. In the course of art, the more or less clear presentation of object-related forms in pictures has been our guide and advisor in revealing emotional forces. These came alive solely as a result of being confronted with the real world. In non-objective art

39 Ebd. Ibid.

40 Ebd. Ibid., p. 28.

41 Quedenfeldt erwähnt Kandinsky übrigens *expressis verbis* mehrere Male. In seiner Schlußanmerkung heißt es z. B.: »Ich empfehle zur Einführung in die absolute Kunst die Werke von Kandinsky: *Das Geistige in der Kunst* und Bd. 9 der *Bauhausbücher*«. Quedenfeldt mentions him *expressis verbis* several times. In his final comments, for example, he says: "I recommend the works of Kandinsky for an introduction to pure art: *Das Geistige in der Kunst,* and Vol. 9 of the *Bauhaus books*". In: Quedenfeldt, Erwin: *Die abstrakte Lichtbildkunst* (1928). A. a. O. op. cit., p. 374.

42 Ebd. Ibid. , p. 323.

43 Ebd. Ibid.

44 Ebd. Ibid., p. 324.

45 Ebd. Ibid. , p. 373.

46 Ebd. Ibid.

47 Ebd. Ibid. , p. 338.

höchste Erregung der Seele offenbart«[47] oder als »Schwebungen der Grau- und Farbenklänge«[48], die den Beschauer erreichen, wenn er sich nur recht auf sie einstellt. ■ »Wir stehen hier vor neuen Ausdrucksmöglichkeiten«, faßt Quedenfeldt zusammen, »für die unsere seelische Sensibilität noch nicht vorbereitet ist. Wir haben im ganzen Verlauf der Kunst durch die mehr oder weniger deutliche Darstellung von Gegenständlichkeiten im Bilde einen Führer und Anleiter für die Aufschließung der seelischen Kräfte gehabt. Diese entzündeten sich erst in der Auseinandersetzung mit der realen Welt. In der absoluten Kunst fehlt dieser Führer und die Auseinandersetzung findet direkt mit den Gestaltungsmitteln statt, weil in ihrer Anwendung und Zusammenstellung direkt seelische Werte eingeschlossen liegen. Wenn sich das Organ der Seele hierfür schärft und sich auf die zartesten Schwebungen der Grau- und Farbenklänge einzustellen versteht, wird die absolute Kunst uns noch große Beglückungen schenken können. Die Aufgabe der Kunst besteht dann, wie Kandinsky so treffend sagt: ›in der inneren Wertung der äußeren Mittel‹.«[49] ■ ■ **Coburn und das kosmische Bewußtsein** Einen größeren Gegensatz als der zwischen dem deutschen Chemiker Quedenfeldt, und Coburn, dem amerikanischen Schöngeist aus reichem Hause, läßt sich kaum denken. Beide verbindet jedoch ihre Hinwendung zur Fotografie und die Tatsache, daß sie in ihrer Arbeit zur totalen Abstraktion gelangen. Der Weg dorthin wird geebnet und gelenkt von der Beschäftigung mit den Erkenntnissen einer spirituellen Welt, im Falle Quedenfeldt eher wider besseres Wissen, bei Coburn aus tiefer Überzeugung. Coburn, in Boston als Sohn einer wohlhabenden Familie geboren, verbrachte den größten Teil seines Lebens in England. Schon als Achtzehnjähriger kam er 1899 zum ersten Mal nach London. 1904 begann er ein Projekt, das ihn mit den wichtigsten Persönlichkeiten der alten und der neuen Welt zusammenbrachte: Seine Bücher *Men of Mark*[50] und *More Men of Mark*[51], die 1913 bzw. 1922 mit jeweils 33 Aufnahmen von Schriftstellern, Malern, Staatsmännern,

there is no guide, and it is the means that are, in effect, the ends because emotional qualities are imbued in their application and composition. If the soul itself is sensitised by this and thus able to adjust to the most delicate vibrations of the grey and color sounds, pure art holds much pleasure in store for us. The task of art is, as Kandinsky so aptly put it: 'in the inner evaluation of the outer means'."[49] ■ ■ **Coburn and cosmic awareness** It is hardly possible to imagine a greater contrast than the one between Quedenfeldt, the German chemist, and Coburn, the American aesthete of affluent background. Yet both are united by their interest in photography and the fact that they achieve total abstraction in their work. The path leading to this is paved and directed by involvement with and perception of the spiritual world, in the case of Quedenfeldt more against his better judgement, and in the case of Coburn out of a deep conviction. Coburn, born in Boston as a son in a well-to-do family, spent most of his life in England. He already arrived in England for the first time when he was 18 years old in 1899. In 1904 he began a project that introduced him to the most important personalities of the old and new world: his books *Men of Mark*[50] and *More Men of Mark*[51], which were published in 1913 and 1922 respectively with 33 photos each of writers, painters, statesmen, philosophers etc. ■ In his autobiography[52] of 1966 Coburn writes in retrospect that he had got made a habit of becoming acquainted with the works of anyone he portrayed before their visit. He had, as he maintains, read a few years before books by Edward Carpenter (1844 – 1929), the English writer and social reformer, whom he photographed in 1905. "The book of Carpenter's, however", writes Coburn, "which had the most influence upon me at the time of our meeting was *The art of creation* [...]. The time at which a book is read is, of course, very important, for we are respective to certain influences at certain phases of our mind's development, but it certainly made

48 Ebd. Ibid., p. 374.

49 Ebd. Ibid.

50 Coburn, Alvin Langdon: *Men of Mark*. London, New York 1913.

51 Coburn. Alvin Langdon: *More Men of Mark*. London, New York 1922.

Philosophen usw. erschienen. ■ In seiner Autobiografie[52] von 1966 schreibt Coburn rückblickend, daß er es sich zur Angewohnheit gemacht hatte, vor jedem Besuch eines zu Porträtierenden, sich mit dessen Werken vertraut zu machen. Von dem englischen Schriftsteller und Sozialreformer Edward Carpenter (1844 – 1929), den er 1905 fotografierte, hatte Coburn schon einige Jahre vorher Schriften gelesen. »Das Buch von Carpenter jedoch«, schreibt Coburn, »das den größten Einfluß auf mich zu der Zeit unseres Zusammentreffens hatte, war *The Art of Creation* [...]. Es ist klar, daß der Zeitpunkt, an dem ein Buch gelesen wird, sehr wichtig ist, denn wir sind in bestimmten Phasen unserer geistigen Entwicklung offen für ganz bestimmte Einflüsse. Dieses Buch machte im Jahr 1905 einen tiefen Eindruck auf mich.«[53] Coburn war damals dreiundzwanzig Jahre alt. ■ Carpenter entwickelt in *The Art of Creation*,[54] das 1904 in London erschien, eine Stufenlehre des Bewußtseins. Die erste Stufe ist die des einfachen Bewußtseins, welches man in der Tierwelt findet. Sie ist gekennzeichnet durch den Instinkt. Auf der zweiten Stufe, der des Selbstbewußtseins, befindet sich nach Carpenter die Menschheit jetzt. Das Selbst trennt sich von den Gegenständen. »Das Subjekt und das Objekt des Wissens driften weiter und weiter auseinander. Das Selbst findet sich im Angesicht einer toten und sinnlosen Welt.«[55] Wenn diese Trennung und Selbstisolierung unerträglich wird, eröffnet sich für den Menschen die Möglichkeit, auf die dritte Stufe zu gelangen. »Die dritte Form des Bewußtseins dämmert herauf, oder offenbart sich ihm wie ein Blitz, die Form, die man kosmisches oder universelles Bewußtsein genannt hat. Plötzlich kann das Objekt als eins mit dem Selbst gesehen, gefühlt werden [...]. Der lange Prozeß der Trennung kommt zu seinem Ende.«[56] Diese dritte Stufe kann nicht gedacht, sie kann lediglich gefühlt werden. ■ Ein solches Modell ist nur funktionsfähig, wenn Bewußtsein nicht nur als Bewußtsein des einzelnen gemeint ist, sondern eine Eigenschaft ist, die alle Menschen miteinander verbindet. Carpenter stellt sich vor, daß sich die

a deep impression upon me in 1905."[53] Coburn was at the time 23 years old. ■ Carpenter develops in *The art of creation*[54] which was published in London in 1904, a theory of the different levels of consciousness. The first one is that of the simple consciousness that is to be found in the world of animals. It is characterised by instinct. The second level, the one of self-awareness, is the one where mankind is at the moment. The self is separated from the objects. "Subject and object, perceived as such, drift further and further apart. The self finds itself face to face with a dead and senseless world."[55] If this separation and self-isolation becomes intolerable, one has the possibility of reaching the third level. "The third form of consciousness dawns on one or reveals itself in a flash; its form has been named cosmic or universal awareness. Suddenly the object can be perceived, felt as being one with the self [...]. The long process of separation comes to an end."[56] This third level is not something that can be thought, it can only be felt. ■ Such a concept is only able to work if awareness of this kind is not only understood as the awareness of a single person, but as a characteristic that unites everyone. Carpenter has the vision that people's thoughts unite with the forces that constantly form nature around us, and keep it alive to create a "universal soul, 'a sense sublime'."[57] The thoughts of people materialize initially in the objects that they create. We communicate via these with other fellow human beings. However, direct contacts are possible, avoiding any deviation. In this connection Carpenter mentions telepathy that "with the help of careful and scientific techniques has proven rather conclusively that pictures can be sent out by the brain and be seen or heard by others over big distances."[58] Pictures of this kind, for example, can also be transmitted in spiritualistic seances by mediums in a trance. "We who live", writes Carpenter, "in the middle of what we call civilization, live encompassed by the thoughts of others. We see, hear and

52 Coburn, Alvin Langdon: *Alvin Langdon Coburn, Photographer. An Autobiography.* Herausgegeben von edited by Helmut und Alison Gernsheim, mit einer neuen Einleitung von with a new introduction by Helmut Gernsheim. New York 1978.

53 Ebd. Ibid., p. 34.

54 Carpenter, Edward: *The Art of Creation. Essays on the Self and Its Powers.* London 1904.

55 Ebd. Ibid., p. 50.

56 Ebd. Ibid., p. 51.

Gedanken der Menschen mit den Kräften, die die uns umgebende Natur ständig formen und am Leben halten, zu einer »universalen Seele – ›a sense sublime‹«[57] zusammenschließen. Die Gedanken der Menschen realisieren sich zunächst in den Objekten, die der Mensch erschafft. Über sie kommunizieren wir mit unseren Mitmenschen. Aber auch direkte Kontakte ohne diesen Umweg sind möglich. Carpenter erwähnt in diesem Zusammenhang die Telepathie, die »mit Hilfe sorgfältiger und wissenschaftlicher Methoden, ziemlich schlüssig bewiesen hat, daß Bilder von einem Hirn ausgesandt und von anderen über Entfernungen hinweg gesehen oder gefühlt werden können.«[58] Auch können derartige Bilder z. B. in spritistischen Sitzungen von Medien in Trance übermittelt werden. »Wir«, schreibt Carpenter, »die wir inmitten dessen leben, was wir Zivilisation nennen, leben eingebettet in die Gedanken anderer Menschen. Wir sehen, hören und berühren diese Gedanken und sie sind, für uns, unsere Welt.«[59] Wie das Licht, der Ton oder die Elektrizität verbreiten sich die Gedanken mit großer Schnelligkeit in Form von Wellen. »Die Vibrationen, von denen wir ständig umgeben sind und die laufend von jedem bekannten Objekt sowohl ausgestrahlt als auch empfangen werden, sind gleichzeitig Botschaften eines unendlichen Bedeutens und Fühlens.«[60] ■ Auf zwei der fünf Kategorien, die sich bei Tuchman finden, habe ich damit hingewiesen. Zunächst auf die der ›kosmischen Metaphorik‹, und dann die der ›Vibration‹. Die Vorstellungen Carpenters sind, wie die Haeckels, monistisch. Bei Haeckel jedoch ist der Mensch ein Produkt seines Körpers; die Seele ist ein Teil von diesem. Bei Carpenter stellt sich die Einheit auf einer höheren, kosmischen Ebene her. Beide Kategorien finden ihre Anwendung, wenn es um die Rolle der Kunst in Carpenters System geht. Der Mensch kann die dritte Stufe, die des kosmischen Bewußtseins, ohne Hilfe nicht erreichen. Eines dieser Hilfsmittel ist die Kunst. »Jeder [...]«, schreibt Carpenter, »muß schon einmal in der Poesie, in der Musik, in der Kunst allgemein und in all den Fällen, wo das Gefühl für Schönheit ganz innen

touch these thoughts and they constitute, for us, our world."[59] Like light, sound or electricity thoughts spread out at great speed like waves. "The vibrations we are constantly subject to and that are constantly both emitted and received by every known object, are also messages of infinite significance and emotion."[60] ■ I have thus dealt with two of the five categories which Truman refers to. First of all, that of 'cosmic imagery', and then that of 'vibration'. Carpenter's ideas, like those of Haeckel, are monistic. Haeckel, however, believes that man is a product of his body; the soul is a part of it. For Carpenter this unity is on a higher, cosmic level. Both categories can be applied to illustrate the part played by art in Carpenter's system. Man cannot reach the third level, i. e. that of cosmic awareness, without help. One of these means of help is art. "Everyone [...]", writes Carpenter "must have felt at one time or another that strange sen-sation in poetry, in music, in art in general, and in all those cases where a sense of beauty within oneself has been touched, a sensation that transports one into another world of awareness where associations captivate and inspire the soul, and the distinction between subject and object disappears."[61] ■ Carpenter presents the concept of vibration as an explanation for the connection between the production and reception of non-objective art, in contrast to Kandinsky, using music as an example. The idea behind a piece of music, according to Carpenter, determines the interplay and the structure of the emotions generated by the music. Each of these emotions determines the necessary musical phrase. The harmonies and melodies which are necessary to present this phrase, determine the relationship of the different notes to each other "and, finally, the individual notes determine the number of air-vibrations which are necessary for the production. This, then, is how the whole complex of mechanical vibrations is produced and determined by a single idea, by the feeling for beauty in the mind of the

57 Ebd. Ibid., p. 31.

58 Ebd. Ibid., p. 23.

59 Ebd. Ibid., p. 25.

60 Ebd. Ibid., p. 34.

angesprochen wird, jene seltsame Empfindung gespürt haben, die einen in eine andere Welt des Bewußtseins hinüberführt, wo Bedeutungen eindringen und die Seele erleuchten, und der ›Unterschied zwischen Subjekt und Objekt‹ verschwindet.«[61] ■ Das Vibrationsmodell, als Begründung für den Zusammenhang zwischen Produktion und Rezeption gegenstandsloser Kunst, wird bei Carpenter, anders als bei Kandinsky, am Beispiel der Musik abgehandelt. Die Idee für ein Musikstück, so Carpenter, legt das Zusammenspiel und die Struktur der Gefühle für das Stück fest. Jedes dieser Gefühle bestimmt die dafür notwendige musikalische Phrase. Die Harmonien und Melodien, die gebraucht werden, diese Phrase darzustellen, bestimmen das Verhältnis der verschiedenen Noten zueinander, »und schließlich bestimmen die einzelnen Noten die Anzahl der Luftschwingungen [air-vibrations], die für deren Produktion notwendig sind. So wird der ganze Komplex der mechanischen Luftschwingungen erzeugt und festgelegt durch eine einzige Idee, durch das Gefühl für Schönheit im Geist des Komponisten. Und vice versa. Die Zuhörer, die den Komplex der Luftschwingungen in sich aufnehmen, werden Schritt für Schritt hinaufgeführt zur Realisation von und zur Teilnahme an der ursprünglichen Idee, die von Anfang an verantwortlich war für das, was von ihr ausging.«[62] ■ Da die Stufe des kosmischen Bewußtseins nicht gedacht, sondern nur gefühlt, geglaubt werden kann, sind Zeugnisse notwendig, die geeignet sind, diesen Glauben zu stärken. Carpenter beruft sich, ähnlich wie die Theosophen, auf die verschiedensten östlichen und westlichen Religionen und Philosophien, auf Buddha und Plato ebenso wie auf Jesus und Paulus, auf Plotin und auf die Gnosis, auf die mystischen Lehren des europäischen 14. Jahrhunderts bis zu Spinoza, Kant, Hegel und Schopenhauer. Insbesondere aber bezieht sich Carpenter auf die Upanishaden, alt-indische theologisch-philosophische Texte, die sich, nach Carpenter, ganz auf die Vorstellung einer kosmischen Einheit stützen. Aber keine Lehre, keine Theorie, keine Religion ist in der Lage, die Erfahrung zu

composer. And vice versa. The listeners who assimilate the complex of air-vibrations are guided step by step towards the realisation of and participation in the original idea which was responsible right from the beginning for what emanated from it."[62] ■ Since the level of cosmic awareness cannot be rationally conceived but only felt or believed, it is necessary to provide evidence to support this view. Carpenter, like the theosophists, refers to various Eastern and Western religions and philosophies, to Buddha and Plato, to Jesus and Paul, to Plotin and Agnosticism, to the mystic teachings of the European 14th century up to Spinoza, Kant, Hegel and Schopenhauer. In particular, how-ever, Carpenter refers to the Upanishad, the ancient Indian theological-philosophical texts, which, according to Carpenter, are based on the concept of cosmic unity. But no teaching, no theory, no religion can replace experience. It follows, therefore, that Carpenter, like all eastern teachers, recommends meditation. ■ Coburn's preoccupation with Carpenter's writings — "I have, I believe, a complete collection of his books"[63], as he himself said — was the beginning of a lifelong preoccupation with the occult. "I have over five thousand books", states Coburn at the end of his life, "mostly on mystical subjects and Freemasonry. These books are great friends and I would not be without them."[64] As a photographer he got to know many well-known members of the international spiritual network that embraced the western world in the first decades of the twentieth century. In 1919 Coburn became a freemason, in 1922 he joined the rosicrucians, in 1928 he became a druid. In 1923 he met the man "who influenced my life more profoundly and changed it more completely than any other person I have ever known."[65] Through him he became a member of a group which, already founded in 1911 as the *Hermetic Truth Society and the Order of Ancient Wisdom*, called itself the *Universal Order*. This was an anonymous group of people who devoted themselves to the

61 Ebd. Ibid., p. 59.

62 Ebd. Ibid., p. 111.

ersetzen. So ruft auch Carpenter, wie alle östlichen Lehrer, zur Meditation auf. ■ Coburns Lektüre der Carpenterschen Schriften – »Ich glaube, ich habe eine komplette Sammlung seiner Bücher«[63], sagt er selbst – stand wohl am Anfang einer lebenslangen Beschäftigung mit dem Okkulten. »Ich besitze über fünftausend Bücher«, stellt Coburn am Ende seines Lebens fest, »die meisten behandeln mystische Gegenstände oder Themen über Freimaurerei. Diese Bücher sind echte Freunde und ich möchte sie nicht missen.«[64] Als Fotograf lernte er viele prominente Angehörige des internationalen spirituellen Netzwerks, das in den ersten Jahrzehnten des 20. Jahrhunderts die westliche Welt umspannte, kennen. 1919 wurde Coburn Freimaurer, 1922 trat er den Rosenkreuzern bei, 1928 wurde er Druide. Im Jahr 1923 traf er jenen Mann, »der mein Leben tiefer beeinflußte und es gründlicher veränderte, als irgend eine andere Person, die ich jemals gekannt hatte.«[65] Durch ihn wurde er Mitglied in einer Gruppe, die sich, bereits 1911 als *Hermetic Truth Society and the Order of Ancient Wisdom* gegründet, *Universal Order* nannte. Es handelte sich um eine anonyme Vereinigung von Personen, die sich dem Studium der verschiedensten heiligen Texte hingaben, die in einem *Shrine of Wisdom*, so auch der Titel ihrer Zeitschrift, zusammengefaßt waren. ■ Dieser Beitritt markiert den Abschied Coburns von der Fotografie. Von da an widmet er sich nur noch dem Studium der geistigen Welt. Er fotografiert zwar noch, aber ohne Ambition. »Ich habe nichts von meiner Liebe zur Photographie verloren«, schreibt Coburn darüber, »sie hat sich nur geändert, sie ist emporgehoben und in eine andere, spirituellere Richtung gelenkt worden. Alle Kunst gehört der gleichen großen Realität an, aber sie ist eine aufsteigende Leiter, mit irdischer Schönheit auf ihrer untersten Stufe, göttlicher Schönheit als krönende Herrlichkeit und dazwischen eine aufsteigende Folge in vollkommener Symmetrie und Ordnung.«[66] ■ Man kann Coburns Leben als ein fortdauerndes Streben nach dem kosmischen Bewußtsein ansehen. Coburn ist vierundachtzig Jahre alt geworden.

study of various sacred texts which were compiled in a *Shrine of Wisdom*, also the title of their magazine. ■ This membership marks the end of Coburn's activities as a photographer. From now on he devotes himself solely to the study of the spiritual world. He still takes photographs, but without professional ambition. "I had lost nothing of my devotion to photography", Coburn writes here, "it just had been changed, lifted up and orientated into another and more spiritual channel. All art belongs to the same great Reality, but it is an ascending ladder, with earthly beauty at its lowest rung and Divine Beauty as its Crowning Glory, and in between them a sequence of ascent in perfect symmetry and order".[66] ■ One could regard Coburn's life as a continual striving for cosmic awareness. Coburn lived until the age of 84. If one takes into account that he began his photographic activities at the age of eight when he received his first camera on his birthday, and that this came to an end in 1923, Coburn's interest encompassed 33 years in which he was preoccupied with what he himself called his "adventure in photography".[67] The work of Coburn the photographer, with which we are normally concerned with, was part of the person called Coburn, the man looking for a higher level of knowledge, for only a relatively short period. Coburn's photographic work was involved with the above-quoted "sequence of ascent in perfect symmetry and order" for a limited period. It is logical that it led to non-object presentation, and it is logical that Coburn had done with it when he reached the highest level of abstraction, that of non-object presentation. ■ Information about the life and work of Coburn, the photographer, can be found, for example, in Nancy Newhall's essay of 1962[68] which has recently become available in German translation[69], and in the book by Mike Weaver, which was published in 1986.[70] I would just briefly like to draw attention to a few of the stages along the path to non-objective presentation which Coburn himself referred

63 Coburn, Alvin Langdon: *Alvin Langdon Coburn*. A. a. O. op. cit. , p. 34.

64 Ebd. Ibid., p. 128.

65 Ebd. Ibid., p. 120.

66 Ebd. Ibid.

Wenn man als den Beginn seiner fotografischen Tätigkeit seinen achten Geburtstag ansetzt, an dem er seine erste Kamera geschenkt bekam, und als ihr Ende eben jenes Jahr 1923, so kommt man auf eine Zeitspanne von dreiunddreißig Jahren, in der Coburn sich mit dem beschäftigt hat, was er selbst als sein »Abenteuer Photographie«[67] bezeichnet. Das Werk des Fotografen Coburn, mit dem wir uns normalerweise beschäftigen, hat den nach höherer Weisheit suchenden Menschen Coburn nur eine verhältnismäßig kleine Strecke seines Lebens begleitet. Coburns fotografische Arbeit hat an der eben zitierten »aufsteigenden Folge in vollkommener Symmetrie und Ordnung« eine Zeit lang teilgenommen. Es ist folgerichtig, daß sie in die Gegenstandslosigkeit mündete, und es ist ebenso folgerichtig, daß sie dort ihr Ende fand, und daß Coburn sie hinter sich ließ, als er die höchste Stufe der Abstraktion, die Gegenstandslosigkeit, erreicht hatte. ■ Über Leben und Werk des Fotografen Coburn kann man sich z. B. in Nancy Newhalls Essay aus dem Jahr 1962,[68] der seit kurzem in deutscher Sprache nachzulesen ist[69], und in dem Buch von Mike Weaver, das 1986 erschienen ist,[70] kundig machen. Ich möchte nur kurz einige Stationen auf dem Weg in die Gegenstandslosigkeit herausarbeiten, auf die Coburn in seiner Autobiografie selbst hingewiesen hat.[71] 1912 machte der Fotograf von Hochhäusern aus Aufnahmen der Stadt New York. Die bekannteste davon betitelte er mit *Octopus* (Abb. S. 102). Auf die Frage, was sie bedeute, geht er in seiner Autobiografie wie folgt ein: »Die Antwort ist, daß sie eine Komposition oder eine Übung darstellt, wie man eine rechteckige Fläche mit Kurven und Massen füllt.«[72] Sie handelt »mehr von Strukturen als von Gegenständen«.[73] ■ Im Katalog seiner Ausstellung im Jahr 1913 in der Goupil Gallery in London, hält er fest: »Warum sollte der Kamerakünstler sich nicht von den verbrauchten Konventionen lösen, die selbst in ihrem verhältnismäßig kurzen Dasein begonnen haben, sein Medium einzuengen und zu beschränken, und Freiheit des Ausdrucks fordern, die jede Kunst haben muß, um zu existie-

to in his autobiography.[71] In 1912 the photographer took photographs of multi-storeyed buildings in New York City. He gave the most famous photograph of them all the title of *Octopus*. (fig. p. 102) When asked what it meant he answered as follows in his autobiography: "The answer is that it is a composition or exercise in filling a rectangular space with curves and masses."[72] It does more "upon pattern than upon subject matter."[73] ■ As early as in 1913, in the catalogue on his exhibition at the Goupil Gallery in London, he observes: "But why should not the camera artist break away from the worn-out conventions, that even in its comparatively short existence have begun to cramp and restrict his medium, and claim the freedom of expression which any art must have to be alive?"[74] ■ In 1916 in an essay entitled *The Future of Pictorial Photography*, he continued: "Why should not the camera also throw off the shackles of conventional representation and attempt something fresh and untried? Why should not its subtle rapidity be utilized to study movement? Why not repeated successive exposures of an object in motion on the same plate? Why should not perspective be studied from angles hitherto neglected or unobserved? Why, I ask you earnestly, need we go on making commonplace little exposures of subjects that may be sorted into groups of landscapes, portraits, and figure studies? Think of the joy of doing something which it would be impossible to classify, or to tell which was the top and which the bottom!". As a consequence Coburn suggests "that an exhibition be organised of Abstract Photography"[75], which, however, never materialized. ■ Amongst other things Coburn had suggested in his text "the use of prisms for the splitting of images into segments."[76] In the same year he took up the idea and devised an apparatus that was to make this possible. "I did not see", he states, "why my own medium should lag behind modern art trends, so I aspired to make abstract pictures with the camera."[77] ■

67 Ebd. Ibid., p. 12.

68 Newhall, Nancy: *Introduction*. In: *Alvin Langdon Coburn. A Portfolio of Sixteen Photographs*. Rochester, N. Y. 1962.

69 Newhall, Nancy: *Alvin Langdon Coburn. Der jüngste Stern*. In: *Alvin Langdon Coburn, Fotografien 1900–1924*. Thalwil / Zürich 1998, pp. 23–46.

70 Weaver, Mike: *Alvin Langdon Coburn. Symbolist Photographer 1882–1966. Beyond the Craft*. Rochester, N. Y. 1986.

71 Mike Weaver erscheint Coburns Autobiografie als »ein außerordentlich naives Doku-

ment« (ebd., p. 52), und Estelle Jussim bezeichnet in einer Kritik von Weavers Buch Coburns Aufzeichnungen als »diffus« (Jussim, Estelle, in: *History of Photography*, Jahrg. 11, Nr. 3, Juli–September 1987, p. 255). Damit stehen beide in einer Tradition, die eher geringschätzig auf Selbstzeugnisse von Künstlern herab blickt. Ich bin der Meinung, daß diese immer noch die verläßlichste Grundlage für die Beurteilung eines Werkes und, wie hier, eines Lebens bilden; daß sie im Zweifel als erste herangezogen werden sollten, und die Aussagekraft jeder Sekundärliteratur übertreffen.

Mike Weaver rates Coburn's autobiography as "an extraordinarily naive document" (Ibid., p. 52), and Estelle Jussim in a review of Weaver's book describes Coburn's writings as

"diffuse" (Jussim, Estelle, in: *History of Photography*, Vol. 11, No. 3, July–September 1987, p. 225). Thus both follow a tradition that looks with disdain on personal testimonials from artists. I think that these are still the most reliable basis for an assessment of a work, and as such, as here, of a life, and in doubtful cases should be referred to first, and that surpasses the claims of any secondary literature.

72 Mit der Bezeichnung ›Kurven und Massen‹ (*curves and masses*) nimmt Coburn Bilduntterschriften auf, die der englische Fotograf Malcolm Arbuthnot (1874–1967) bereits 1908 einigen seiner abstrahierenden Aufnahmen gegeben hatte. Er betitelte sie z. B. mit *A Study in Lines and Masses* oder *A Study in Curves*

Rolf H. Krauss

ren?«[74] Um dann 1916 in einem Aufsatz, überschrieben mit *The Future of Pictorial Photography*, fortzufahren: »Warum sollte nicht auch die Kamera die Fesseln konventioneller Darstellungskunst abstreifen und etwas Frisches, bisher nicht Erprobtes wagen? Warum sollte nicht ihre subtile Geschwindigkeit benützt werden, um die Bewegung zu studieren? Warum nicht Mehrfachbelichtungen einer Platte, um einen bewegten Gegenstand aufzunehmen? Warum sollten nicht Perspektiven von bisher vernachlässigten oder nicht wahrgenommenen Blickwinkeln aus versucht werden? Warum, so frage ich allen Ernstes, sollten wir weiter kleine, alltägliche Aufnahmen machen von Gegenständen, die in die Fächer Landschaften, Porträts und Figurenstudien einsortiert werden? Man denke an das Vergnügen, etwas zu machen, das nicht klassifiziert werden kann, das man nach Oben und Unten nicht unterscheiden kann.« Dann schlägt Coburn vor, »eine Ausstellung zum Thema Abstrakte Photographie zu veranstalten«[75], die damals allerdings nicht zustande gekommen ist. ■ Unter anderem hatte Coburn in seinem Text den »Gebrauch von Prismen, um segmentierte Bilder zu erzeugen«, vorgeschlagen.[76] Noch im gleichen Jahr griff er diese Idee auf und konstruierte ein Gerät, das ihm dies ermöglichen sollte. »Ich sah nicht ein«, postuliert er, »warum mein eigenes Medium hinter der Entwicklung der modernen Kunst nachhinken sollte und so strebte ich danach, abstrakte Bilder mit der Kamera zu machen.«[77] Das Gerät setzte sich aus drei Spiegeln zusammen, die in Form eines Dreiecks montiert waren, und erinnerte entfernt an ein Kaleidoskop. Es diente in der Tat als eine Art Prisma, das das aufzunehmende Objekt in einzelne Segmente zerlegte. Fotografiert wurden kleine Holzstücke oder Kristalle, in einem Fall aber auch ein Gesicht.[78] Es ist bemerkenswert, daß es offenbar massiver Anstrengungen bedarf, die auf Gegenständliches fixierte Kamera zu überlisten und ihr auch den letzten Rest von Wirklichkeit auszutreiben. Es sind dazu mehr oder weniger komplizierte technische Vorrichtungen notwendig, bei Quedenfeldt war

The apparatus that ensued consisted of three mirrors mounted in the shape of a triangle, and was vaguely reminiscent of a kaleidoscope. It served, indeed, as a kind of prism which dissected the object to be photographed into individual segments. Small pieces of wood or crystals were photographed, in one case even a face.[78] It is interesting that tremendous efforts are apparently necessary to trick the camera fixated on objects, and to expel the last remnants of reality. To do this more or less complicated technical devices are necessary; Quedenfeldt used the cassette which he developed in connection with his ornamenting technique, and Coburn used the vortoscope described above. ■ The name vortoscope was given to the apparatus by Ezra Pound (1885–1972), the American poet and critic, he called the pictures taken by it—there are about forty of them in existence, and Coburn exhibited eighteen of them in early 1917 at the *Camera Club* in London—*vortographs* (figs. pp. 126f.). Both were derived from the term vorticism, the name which Pound had given to a group of English avant-garde artists, which had been set up by Wyndham Lewis (1882–1957), the painter, in 1914 and which broke up again after only three years. In the course of his portrait project Coburn had photographed a few members of the group, Ezra Pound in 1913, and between 1914 and 1916 Wyndham Lewis and Edward Wadsworth (1889–1949), both with their vorticist paintings in the background, and Jacob Epstein (1880–1959). Coburn had, however, never become a member of the group. His paintings were not good enough and photography was not recognised as a medium of art. Pound, however, used the vortographs to draw attention to the vorticist movement, which was about to forego its significance. ■ Coburn's strong desire to go for total abstraction was not determined by vorticist convictions. He was on the look-out for ideas and he found them in the abstract paintings of the vorticists, familiar to him through his photographic

and Angles. By using the term 'curves and masses' Coburn refers to the subtitles of pictures which Malcolm Arbuthnot, the English photographer (1874–1967) had named as such as early as 1908 in some of his abstract photographs. He called them, for example: *A Study in Lines and Masses* or *A study in Curves and Angles*.

73 Coburn, Alvin Langdon: *Alvin Langdon Coburn*. A. a. O. op. cit., p. 84.

74 Zit. n. quoted from: Ebd. Ibid., pp. 84ff.

75 Coburn, Alvin Langdon: The Future of Pictorial Photography. In: *Photograms of the Year 1916*, pp. 23ff.

76 Ebd. Ibid., p. 24.

77 Coburn, Alvin Langdon: *Alvin Langdon Coburn*. A. a. O. op. cit., p. 102.

78 Das Gesicht von Ezra Pound. The face of Ezra Pound.

es die Rapportierkassette, die er im Zusammenhang mit seinem Ornamentierverfahren entwickelte, bei Coburn ist es das eben beschriebene Vortoskop. ■ Die Bezeichnung Vortoscope wurde dem Gerät von dem amerikanischen Dichter und Kritiker Ezra Pound (1885–1972) gegeben, die Bilder, die damit erzeugt wurden – es sind etwa vierzig von ihnen bekannt, achtzehn stellte Coburn Anfang 1917 im *Camera Club* in London aus –, nannte er *Vortographs* (Abb. S. 126f.). Beides wurde abgeleitet von dem Begriff Vorticism, dem Namen, den Pound einer Gruppe von englischen Avantgardekünstlern verliehen hatte, die von dem Maler Wyndham Lewis (1882–1957) 1914 ins Leben gerufen worden war, sich aber bereits drei Jahre später wieder auflöste. Coburn hatte im Rahmen seines Porträtprojekts einige Mitglieder der Gruppe fotografiert, Ezra Pound 1913, und zwischen 1914 und 1916 Wyndham Lewis und Edward Wadsworth (1889–1949), beide vor ihren vortizistischen Gemälden im Hintergrund, und Jacob Epstein (1880–1959). Der Fotograf war jedoch nie Mitglied der Vereinigung geworden. Seine Gemälde waren nicht gut genug und die Fotografie wurde als künstlerisches Medium nicht anerkannt. Pound brauchte die Vortografien jedoch, um noch einmal auf die vortizistische Bewegung aufmerksam zu machen, die im Begriff war, ihre Bedeutung einzubüßen. ■ Coburns Drang in die totale Abstraktion war nicht von vortizistischen Überzeugungen geprägt. Er war auf der Suche nach Anregungen, und die fand er offenbar in den abstrakten Gemälden der Vortizisten, vertraut, wie sie ihm durch seine fotografischen Kontakte waren. In der Tat finden sich, besonders in deren total gegenstandslosen Werken, jene scharfkantigen, aufgesplitterten, kristallinen Formen, die in den Prismen des Kaleidoskops aufscheinen.[79] Coburns Ergebnisse jedoch standen im Widerspruch zu den Prinzipien der Vortizisten. »Paradox genug«, schreibt Cork, »je mehr Coburns Bilder sich dem ungegenständlichen Ideal des Vortizismus näherten, um so weniger spiegelten sie das bildnerische Vokabular der Gruppe wider. Sie wurden fast formlos, indem sie sich

contacts. Indeed, there are especially in their totally non-object works those sharp-edged, segmented, crystalline shapes which appear in the prisms of the kaleidoscope.[79] Coburn's results, however, contradicted entirely the principles of the vorticists. "Paradoxical enough", writes Cork, "the more Coburn's images approached the non-representational ideal of Vorticism, the less they succeeded in echoing the movement's actual pictorial vocabulary. They became almost formless, concentrating of the bewildering play of light and dissolving everything in their field of vision into gossamer."[80] ■ Coburn went his own way in photography to the very end, independent of the ideas of the Vorticists.[81] His desire to attain total abstraction was inevitable. The Vortographs are the logical consequence of an intellectual development. They do not, however, represent the final stage, but rather one step along Coburn's path to cosmic awareness. ■ ■ **Bruguière and the secret of the golden flower** Photographers are tied much more than artists to the everyday world because of the specific characteristics of their medium. Photography is not, like painting, originally a creative medium. Any photographer wanting to become creatively active beyond his profession, must be able to afford it. Up until recently there was no or hardly any market for so-called fine art photography. Attempts to emulate artists, therefore, presuppose idealism or financial independence, or specific incentives arising from professional preconditions. In Quedenfeldt's case it was an idealistic approach, combined however with the necessity to secure his livelihood with corresponding 'inventions', that led him to his deliberations and his creative activities. Coburn never had any financial worries during his life. Throughout his preoccupation with photography he represented the type of ambitious amateur who could devote himself entirely to the activities of an artistic photographer. Bruguière, like Coburn, an American, born into a rich family, was able to work with the kind of

79 Ein vorzüglicher Überblick über die vortizistische Bewegung und die Rolle, die Coburn an ihrem Rand spielte, findet sich in dem zweibändigen, reichbebilderten Werk: Cork, Richard: *Vorticism. An Abstract Art in the First Machine Age*, Bd. 1: *Origins and Development*, Bd. 2: *Synthesis and Decline*. London 1976. An excellent description of the vorticist movement and the role that Coburn marginally played can be found in the two-volume work, richly illustrated: Cork, Richard: *Vorticism. An Abstract Art in the First Machine Age*. Vol. 1: *Origins and Development*. Vol. 2: *Synthesis and Decline*. London 1976.

auf das verwirrende Spiel des Lichts verdichteten und alles in ihrem Blickfeld in die zarten Fäden eines Altweiber-sommers auflösten.«[80] Coburn ging, unabhängig von den Vorstellungen der Vortizisten, seinen eigenen fotografi-schen Weg bis zum Ende.[81] Sein Streben nach der totalen Abstraktion war zwangsläufig. Die Vortografien sind die logische Folge einer geistigen Entwicklung. Allerdings markierten sie auch keine End-, sondern lediglich eine Durchgangsstation auf Coburns Weg zum kosmischen Bewußtsein. ■ ■ **Bruguière und das Geheimnis der golde-nen Blüte** Viel stärker als andere Künstler sind die Fotografen durch die spezifischen Eigenschaften ihres Medi-ums an die Alltagswelt gebunden. Fotografie ist nicht, wie die Malerei, von Hause aus ein künstlerisches Medium. Wer als Fotograf über seinen Beruf hinaus kreativ tätig sein will, muß es sich leisten können. Bis vor kurzem gab es keinen oder nur einen äußerst begrenzten Markt für die sogenannte künstlerische Fotografie. Bestrebungen, es den Künstlern gleich zu tun, setzen daher entweder Idealismus oder finanzielle Unabhängigkeit oder spezielle Anregungen aus dem beruflichen Umfeld voraus. Im Falle von Quedenfeldt war es eine idealistische Grundhaltung, allerdings verbunden mit dem Zwang, durch entsprechende ›Erfindungen‹ seinen Lebensunterhalt zu sichern, die ihn zu seinen Überlegungen und zu seinem künstlerischen Schaffen führten. Coburn war Zeit seines Lebens ohne Geldsorgen. Er repräsentierte während seiner fotografischen Zeit den Typ des ambitionierten Amateurs, der sich der Tätigkeit eines Kunstfotografen ohne Abstriche widmen konnte. Der, wie Coburn, aus einem reichen Haus stammende Amerikaner Bruguière konnte sich zunächst gleichfalls mit einer Fotografie beschäftigen, die Kunst-anspruch erhob, ohne sich um das tägliche Brot kümmern zu müssen. Erst 1919 verlor seine Familie ihr Vermögen, und der jetzt Vierzigjährige mußte sich seinen Lebensunterhalt selbst verdienen. Seine gegenstandslosen Foto-grafien entstanden aus der Tätigkeit als Theaterfotograf heraus. ■ Was alle drei Fotografen verband, war die Hin-

photography that had artistic aspirations, without having to bother about his daily livelihood. It wasn't until 1919 that his family lost their fortune and the now forty-year-old Bruguière had to earn his own living. His non-objective photographs were the result of his job as theatre photographer. ■ What all three photographers had in common was that each developed his own specific philosophy that in itself offered practical help to cope with his life, but that also offered the spiritual basis that facilitated the step into total abstraction. Their colleague, the artist Kan-dinsky, had a theosophical, and Quedenfeldt a monistic-materialistic background. Coburn was ultimately inspired by the Indian Upanishad. Bruguière, on the other hand, is influenced by the Taoist ideas of the Chinese, and by the theories of C. G. Jung which also drew on the latter. James Enyart, Bruguière's biographer, writes: "His [Bru-guière's] multiple exposures and his abstract images utilized the psychology of C. G. Jung and Eastern philosophies as reinforcement for his tenuous beliefs. The abstract and surreal qualities of his images paralleled the intangible tenets of Jung's studies of man's inner experience and the Chinese Taoist's use of meditation as a divine (psychic) experience."[82] ■ As early as 1912 Bruguière began experimenting with new technical possibilities. His multiple exposures united different pictures on one plate. They thus predated Coburn's multiple exposure of Ezra Pound's face (fig. p. 162) by four years. Bruguière used this technique until well into the Twenties. With its help he made, amongst other things, a series of surrealistic stills for a film called *The Way* that was planned at the time.[83] He worked towards the abscence of objects in his pictures via experimentation with light. Bruguière was the official photographer for the *Theatre Guild* in New York between 1919 and 1927. In this capacity he did portraits of actors and photographed stage sets. To do the latter made it especially necessary to make the different lighting-effects

80 Ebd. Ibid., pp. 501ff.

81 Frank DiFederico kommt nach einer länge-ren Untersuchung zu einem ähnlichen Ergebnis: »Ich habe in keiner Weise die Absicht, Coburns Interesse am Modernismus oder den Einfluß der modernen Kunst auf die Vortografien abzu-leugnen. Dennoch glaube ich, darauf hinweisen zu müssen, daß obwohl sich Coburn moderni-stische Haltungen und Formen für die Vorto-grafien zu eigen machte, er sie dennoch in seine eigene Bildsprache einbettete. Das Vokabular dieser Sprache war festgelegt, bevor Coburn begann, Vortografien zu machen« (DiFederico, Frank: Alvin Langdon Coburn and the Genesis of Vortographs. In: *History of Photography*, Jahrg. 11, Nr. 4, Oktober–Dezember, 1987, pp. 292ff.).

Frank DiFederico comes to a similar conclu-sion after a long analysis: "I do not mean in any way", he writes at the end of his essay 'Alvin Langdon Coburn and the Genesis of Vortographs', "to deny Coburn's interest in modernism or the influence of modern art on the Vortographs. But I do mean to suggest that though Coburn adopted modernist atti-tudes and forms for the Vortographs, he continued to couch them in his own visual language. The vocabulary of that language was fixed before Coburn began to make Vorto-graphs." (DiFederico, Frank: Alvin Langdon Coburn and the Genesis of Vortographs. In: *History of Photography*, Vol. 11, No. 4, Octo-ber– December, 1987, pp. 292ff.).

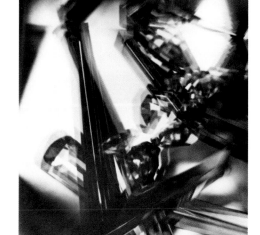

Alvin Langdon Coburn: *Vortograph,* 1917
Gelatin silver print, 28.3 x 21.4 cm
George Eastman House, Rochester (top left)

Alvin Langdon Coburn: *Vortograph,* 1917
Gelatin silver print, 27.6 x 20.7 cm
George Eastman House, Rochester (top right)

Alvin Langdon Coburn: *Vortograph,* 1917
Gelatin silver print, 47.5 x 36.4 cm
George Eastman House, Rochester (bottom)

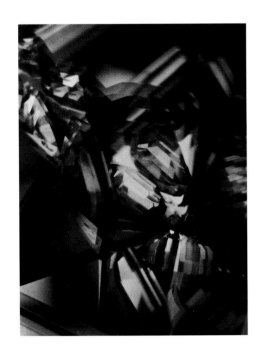

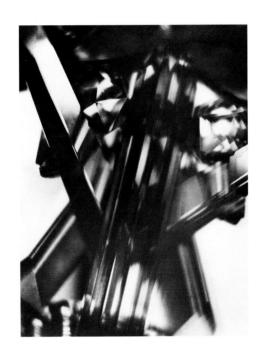

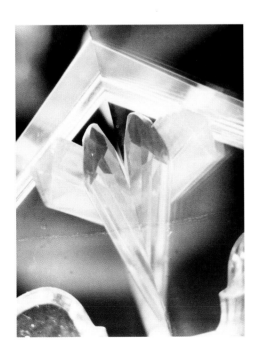

Alvin Langdon Coburn: *Vortograph,* ca. 1917
Gelatin silver print, 46.2 x 34.6 cm
George Eastman House, Rochester (top left)

Alvin Langdon Coburn: *Vortograph,* 1917
Gelatin silver print, 44.6 x 34 cm
George Eastman House, Rochester (top right)

Alvin Langdon Coburn: *Vortograph,* 1917
Gelatin silver print, 20.7 x 15.5 cm
George Eastman House, Rochester (bottom)

wendung zu einer je eigenen Philosophie, die ihnen einerseits praktische Lebenshilfe bot, andererseits aber die spirituellen Grundlagen bereitstellte, die sie befähigten, den Schritt in die totale Abstraktion zu tun. Bei ihrem Künstlerkollegen Kandinsky war es ein theosophischer Hintergrund gewesen, bei Quedenfeldt ein monistisch-materialistischer. Coburn bezog seine Kraft letztlich aus den indischen Upanishaden. Bruguière schließlich ist beeinflußt von den taoistischen Vorstellungen der Chinesen und von den davon beeinflußten Thesen des Psychologen C. G. Jung. James Enyeart, der Biograf Bruguières, schreibt: »Seine [Bruguières] Mehrfachbelichtungen und seine abstrakten Bilder verwendeten die Psychologie C. G. Jungs und östliche Philosophien als Bekräftigung seines schwach ausgeprägten religiösen Glaubens. Die abstrakten und surrealen Eigenschaften seiner Bilder glichen den geistigen Lehren von Jungs Erkenntnissen über die inneren Erfahrungen des Menschen und dem Einsatz der Meditation als einer göttlichen (psychischen) Erfahrung durch die chinesischen Taoisten.«[82] ■ Bereits 1912 begann Bruguière mit neuen technischen Mitteln zu experimentieren. Seine Mehrfachbelichtungen vereinigten verschiedene Bilder auf einer Platte. Sie gingen damit Coburns Mehrfachbelichtung des Gesichtes von Ezra Pound (Abb. S. 162) um vier Jahre voraus. Diese Technik verwendete Bruguière bis in die zwanziger Jahre hinein. Mit ihrer Hilfe entstanden u. a. eine Serie von surrealistischen Standfotos zu einem geplanten Film, der *The Way* heißen sollte.[83] Der Gegenstandslosigkeit in seinen Bildern näherte er sich über seine Auseinandersetzung mit Licht. Bruguière war zwischen 1919 und 1927 der offizielle Fotograf für die *Theatre Guild* in New York. In dieser Eigenschaft machte er Porträts von Schauspielern und hielt Bühnendekorationen fotografisch fest. Bei den letzteren kam es besonders darauf an, die verschiedenen Beleuchtungseffekte der Bühnenbildner im fotografischen Endergebnis adäquat sichtbar zu machen. Bruguière verwendete dabei eine Technik des offenen Verschlusses. Während

in the stage sets sufficiently visible in the photographic end-product. For this purpose Bruguière used a technique of the open shutter. Whilst the photo was being taken with open shutter the spot-lights with their different colors would successively be switched off, depending on how the individual colors were reproduced on the specific negative. "The difference", as Bruguière himself said, "between the vision of the human eye and the vision of the lens, plate and paper"[84] had to be aligned. ■ Using the same technique Bruguière took photos of parts of the presentation of the *Color organ*, by the Dane Thomas Wilfred in 1921. Bruguière's photos appeared in the 1922 January edition of the magazine *Theatre Arts* as an addition to the article by Stark Young. Wilfred's *Clavilux*, as the latter called his otherwise silent instrument, looked like an organ outwardly. Instead of sounds, and with the help of filters, however, it produced color-lighting that was projected in various forms consecutively, concurrently or confluently onto a white screen. Forms and the color of the light, as also the order of their appearance could be determined by playing a keyboard. ■ Bruguière captured this play of light using an open shutter. The result was blurred traces of light that simulated movement, merely signs on a black background which point to nothing but themselves (fig. p. 130, top). By putting light on a par with form the objects disappeared from the picture. "What we really found there", Stark wrote in his article," was all abstraction [...]. Painting at times has approached this abstraction, in pure design always, in the primitive art, and again in the school of modern art. But Kandinsky [...] and the rest are bounded, forever by their medium; their canvas once done is static [...]. Mobile color does not exist in material mediums but rather in light itself."[85] ■ "The fourth dimension [...]", Bruguière continued here, "that is the effect I have long wanted to give. The effect of movement in the eye of the beholder, though the object itself

82 Enyeart, James: *Bruguière, His Photographs and His Life. Photographs by Francis Joseph Bruguière, 1879 – 1945.* With a critical and biographical narrative. New York 1977, p. 7.

83 Es ist von einigem Reiz, darauf hinzuweisen, daß die Technik der Mehrfachbelichtung zum ersten Mal prominent Verwendung fand bei der Herstellung von Geisterfotografien. Die erste derartige Fotografie stammt von William H. Mumler und ist 1861 in Boston entstanden. It may be of some interest to point out the fact that the technique of multiple exposure was first notably used in producing ghost photographs. The first photograph of

this kind was from William H. Mumler and was taken in 1861 in Boston. Vgl. cf. Krauss, Rolf H.: *Jenseits von Licht und Schatten. Die Rolle der Photographie bei bestimmten paranormalen Phänomenen. Ein historischer Abriß.* Marburg 1992; Krauss, Rolf H.: *Beyond Light and Shadow, The Role of Photography in Certain Paranormal Phenomena.* Munich 1995.

der Aufnahme wurden bei geöffnetem Verschluß die verschiedenfarbigen Scheinwerfer nach und nach ausge-
schaltet, je nach dem, wie die einzelnen Farben von dem verwendeten fotografischen Negativmaterial wiederge-
geben wurden. »Die Unterschiede«, so Bruguière selbst, »zwischen dem, was das menschlichen Auge sieht und
dem, was Objektiv, Platte und Fotopapier registrieren«,[84] mußten ausgeglichen werden. ■ Mit der gleichen Tech-
nik fotografierte Bruguière im Jahr 1921 Passagen aus einer Vorführung der *Color organ* des Dänen Thomas Wil-
fred. Bruguières Aufnahmen erschienen 1922 in der Januarausgabe der Zeitschrift *Theatre Arts* als Beigabe zu
einem Artikel von Stark Young. Wilfreds *Clavilux*, wie dieser sein, im übrigen stummes, Instrument nannte, glich
äußerlich einer normalen Orgel. Anstelle der Töne wurde mit Hilfe von Filtern farbiges Licht produziert, das in ver-
schiedenen Formen hintereinander, nebeneinander oder ineinander übergehend auf eine weiße Leinwand projiziert
wurde. Formen und Farbigkeit des Lichts sowie die Reihenfolge ihres Auftretens konnten durch Bespielen einer
Klaviatur festgelegt werden. ■ Bruguière hielt diese Lichtspiele mit offenem Verschluß fest. Dadurch ergaben sich
verwischte Lichtspuren, die Bewegung simulierten, bloße Zeichen auf schwarzem Grund, die auf nichts, als auf sich
selbst verwiesen (Abb. S. 130, oben). Mit der Gleichsetzung von Licht als Form waren die Gegenstände aus dem Bild
verschwunden. »Was wir hier vor uns hatten«, schrieb Stark in seinem Artikel, »war die totale Abstraktion [...].
Die Malerei hat sich zeitweise dieser Abstraktion angenähert, im reinen Ornament war sie immer schon da, in der
primitiven Kunst ebenfalls, und dann in den verschiedenen Richtungen der modernen Kunst. Aber Kandinsky [...]
und die anderen sind für immer an ihr Medium gefesselt; ihre Leinwand, einmal bemalt, ist statisch [...]. Beweg-
liche Farben gibt es in an die Materie gebundenen Medien nicht, sie sind eher im Licht selbst zu finden.«[85] ■
»Die vierte Dimension [...]«, schrieb Bruguière in diesem Zusammenhang, »das ist der Effekt, den ich lang zu

was absolutely stationary when photographed."[86] The term "fourth dimension" was used in three different ways at
the time Bruguiére made this statement. It was within geometry of the late 19th century that it was first of all inter-
preted as a higher dimension of space. After Albert Einstein had produced his general theory of relativity in 1916,
the category of time came to be regarded as the fourth dimension. Finally, as early as around the turn of the
century "the term had unleashed a whole variety of non-mathematical associations, amongst others, the most
important was the idealistic, philosophical interpretation as a higher reality behind three-dimensional, visible per-
ception."[87] ■ Bruguière must have acquainted with these ideas at least through a text written by Max Weber
(1881–1961), the American painter and art critic, who was born in Russia. The latter had published a short essay in
1910, entitled *The Fourth Dimension from a Plastic Point of View* in *Camera Work*,[88] a magazine that had a great
impact on Bruguière's artistic and ideological development.[89] Weber writes here, for example: "In plastic art, I
believe, there is a fourth dimension which may be described as the consciousness of a great and overwhelming
sense of space-magnitude in all directions at one time, and is brought into existance through the three known mea-
surements. It is not a physical entity or a mathematical hypothesis, nor an optical illusion. It is real, and can be
perceived and felt. It exists outside and in presence of objects, and is the space that envelopes a tree, a tower, a
mountain, or any solid; or the intervals between objects or volumes of matter [...]. It is somewhat similar to color
and depth in musical sounds. It is arouses imagination and stirs emotion. It is the immensity of all things. It is the
ideal measurements, and is therefore as great as the ideal, perceptive or imaginative faculties of the creator, archi-
tect, sculptor, or painter."[90] ■ Wilfred's Clavilux Organ can be regarded as the result of the efforts of a group of

84 Zit. n. quoted from: Enyeart, James:
Bruguière. A. a. O. op. cit, p. 25.

85 Young, Stark, in: *Theatre Arts*, Vol. 6,
No. 1, January 1922, pp. 21ff.; zit. n. quoted
from: Ebd. Ibid, p. 58.

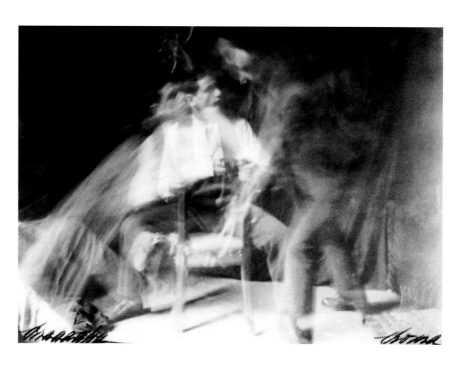

Francis Joseph Bruguière: *Sequence from
Thomas Wilfred's color organ* (Sequenz aus
Thomas Wilfreds Farborgel) *Clavilux*, 1922
(top)

Anton Giulio Bragaglia, Arturo Bragaglia:
Lo Schiaffo (Die Ohrfeige/Box on the ear), 1912
''Photodynamic' time exposure
(›fotodynamische‹ Zeitbelichtung)
Gelatin siver print, 11,8 x 15,8 cm
Collection Paul F. Walter (bottom)

erreichen versucht habe. Der Anschein der Bewegung im Auge des Betrachters, obwohl das Objekt selbst vollkommen unbeweglich im Moment der Aufnahme war.«[86] Der Begriff ›Vierte Dimension‹ wurde zur Zeit der Äußerung Bruguières in dreifacher Hinsicht verwendet. Zunächst hatte ihn die Geometrie des ausgehenden 19. Jahrhunderts einfach als höhere Dimension des Raums interpretiert. Nach der Formulierung der allgemeinen Relativitätstheorie durch Albert Einstein 1916 wurde die Kategorie der Zeit als vierte Dimension angesehen. Schließlich hatte bereits um die Jahrhundertwende »der Begriff eine Vielfalt nichtmathematischer Assoziationen angezogen, darunter als wichtigste die idealistisch-philosophische Interpretation als höhere Realität hinter der dreidimensionalen, sichtbaren Wahrnehmung.«[87] ■ Bruguière muß mit diesen Vorstellungen mindestens über einen Text des in Rußland geborenen amerikanischen Malers und Kunstschriftstellers Max Weber (1881–1961) vertraut gewesen sein. Dieser hatte 1910 einen kurzen Aufsatz mit dem Titel *The Fourth Dimension from a Plastic Point of View* in *Camera Work*[88] veröffentlicht, einer Zeitschrift, die auf die künstlerische und ideologische Entwicklung Bruguières großen Einfluß hatte.[89] Weber schreibt dort u. a.: »Ich glaube, daß es in der bildenden Kunst eine vierte Dimension gibt, die man als das Bewußtsein eines großen und überwältigenden Gefühls von Raumgröße in alle Richtungen zugleich bezeichnen könnte, und die durch die drei bekannten Dimensionen entstanden ist. Sie ist weder eine physische Größe, noch eine mathematische Hypothese, auch keine optische Illusion. Sie ist real und kann beobachtet und gefühlt werden. Sie existiert außerhalb und innerhalb der Anwesenheit von Objekten und ist der Raum, der einen Baum einhüllt, oder einen Turm, oder einen Berg, oder irgend einen anderen festen Gegenstand; oder sie ist der Raum zwischen Objekten oder den Ausdehnungen von Materie [...]. Sie hat irgendwie Ähnlichkeit mit der Farbe und Tiefe von Tönen. Sie reizt die Einbildungkraft und erregt Emotionen. Sie ist die Unermeßlichkeit aller Dinge. Sie ist das

theosophists in New York, who, thinking along such lines, researched into the possibilities of color music as from 1919. Indeed, one critic linked in a special way the language of color music with the fourth dimension when he wrote: "In the projection of this art in space I sensed a new dimension, a new direction."[91] It is feasible that whilst developing his future non-object works Bruguière was influenced by theosophical ideas on the fourth dimension. His comments in this connection on the photos of the *Color organ* had, however, more to do with time and movement. Here Bruguière coincides to a surprising degree with thoughts that the futurist Antonio Giulio Bragaglia had uttered a few years before, i.e. in his book *Fotodinamismo Futurista*,[92] published in 1913, concerning the presentation of time in space with the help of photography. ■ Antonio Bragaglia (1890–1960) had already in 1911, together with his brother Arturo, taken photographs of simple gestures like touching, smoking, greeting or movements of the head. The various actions were photographed using exposure times of one second, with the result that all that was to be seen on the photo paper was blurred traces of light depicting dematerialized movement (fig. p. 130, bottom), similar to Bruguière's Clavilux photos (or Hirschfeld-Mack's photos of his reflected play of light). Bragaglia wrote about this in his book, which was to be of great importance for the underlying theory of the futuristic movement: "**Time** is produced by us in a decisive way as a **fourth spatial dimension**, [...] when we create a work that is much more chronographical than Marey's system which is only named chronographical because it captures a few fleeting moments, i.e. the **circumstances** of a gesture."[93] Bragaglia compares chronophotography with "a clock, the hands of which only show the quarters of an hour, the cinema with a clock that also shows the minutes and photodynamism again with a third clock that not only shows the seconds, but also the **intermomentary** minutes that exist

86 Zit. n. quoted from: Ebd. Ibid.

87 Henderson, Linda Dalrymple: *Mystik, Romantik und die vierte Dimension*. In: Tuchman, Maurice; Freeman, Judi: *Das Geistige in der Kunst. Abstrakte Malerei 1890–1985*, Stuttgart 1988, p. 220.

88 Weber, Max: The Fourth Dimension from a Plastic Point of View. In: *Camera Work*, No. 31, July 1910, p. 25.

89 Über Art und Ausmaß dieses Einflusses siehe for kind and degree of this influence see: Enyeart, James: *Bruguière*. A. a. O. op. cit., pp. 14ff. Bruguière selbst veröffentlichte 1915

einen Aufsatz *What 291 Means to Me* (*Camera Work*, Nr. 47, Januar 1915) und ein Bild (*Camera Work*, Nr. 48, Oktober 1916, Abb. 7). Bruguière himself published in 1915 an essay 'What 291 Means to Me' (*Camera Work*, No. 47, January 1915) and a picture (*Camera Work*, No. 48, October 1916, Fig. 7).

ideale Maß und daher so bedeutend wie das Ideal, die Anschauung oder die Vorstellungskräfte jedes Kreativen, des Architekten, des Bildhauers oder des Malers.«[90] ■ Wilfreds Clavilux-Orgel kann als Ergebnis der Bemühungen einer Gruppe von Theosophen angesehen werden, die, ausgehend von derartigen Gedankengängen, ab 1919 in New York die Möglichkeiten der Farbmusik erforschten. In der Tat verband ein Kritiker auf besondere Weise die Sprache der Farbmusik mit der vierten Dimension, als er schrieb: »Im Entwurf dieser Kunst im Raum fühlte ich eine neue Dimension, eine neue Richtung.«[91] Es ist möglich, daß Bruguière bei der Verfolgung seiner zukünftigen gegenstandslosen Arbeiten von den theosophischen Gedankengängen zur vierten Dimension beeinflußt wurde. Seine diesbezüglichen Bemerkungen zu den Aufnahmen der Farblichtspiele waren jedoch wohl eher in Richtung Zeit und Bewegung gemeint. Damit stimmt Bruguière in erstaunlichem Maße mit Überlegungen des Futuristen Antonio Giulio Bragaglia überein, die dieser in seinem 1913 veröffentlichten Buch *Fotodinamismo Futurista,*[92] über das Übersetzen von Zeit in Raum mit Hilfe der Fotografie gemacht hatte. ■ Antonio Bragaglia (1890–1960) hatte, zusammen mit seinem Bruder Arturo, bereits 1911 Fotografien von einfachen Gesten wie Tippen, Rauchen, Grüßen oder von Kopfbewegungen angefertigt. Die jeweiligen Handlungen wurden bei Belichtungszeiten von einer Sekunde aufgenommen, mit dem Ergebnis, daß auf der Fotoplatte nur noch verwischte Lichtspuren entmaterialisierter Bewegung zu sehen waren (Abb. S. 130, unten), ganz ähnlich denen, die Bruguière bei seinen Clavilux-Aufnahmen (oder Hirschfeld-Mack bei den Aufnahmen seiner reflektorischen Lichtspiele) erhielt. Bragaglia schrieb in seinem Buch, das für die theoretische Fundierung der futuristischen Bewegung von großem Einfluß sein sollte, dazu: »**Zeit** wird in entscheidender Weise als **eine vierte räumliche Dimension** von uns hervorgebracht, [...] indem wir ein Werk schaffen, das viel chronographischer ist als Mareys System, welches nur deshalb chronographisch genannt wird,

in the spaces between the seconds. That is an almost infinitesimal calculation of movement."[94] Bruguière's (and Hirschfeld-Mack's) play-of-light photos are thus also in keeping with a futuristic tradition. ■ The experience with work using an open shutter, the use of light and perhaps also the theosophical influence of those involved in attempts at color music, is reflected in the production of *Designs in Abstract Forms of Light*, as Bruguière called his non-objective work that followed on from the Clavilux photos. Bruguière put cut-out paper shapes on a surface. By applying different lightings he achieved a play of light and shadow that with the help of multiple exposure from a static camera, ensured highlighting the contours of the paper shapes and the desired modulation in shades of white and black (figs. p. 135). "In making subjects of my own", Bruguière wrote in retrospect, "I have used papercut designs brought into low relief, and lit, generally, by one small spot lamp of 250 watts; the same lamp has been placed in different positions through a series of exposures."[95] ■ In this way non-object photos were first produced in 1922, something that had never been done before by the camera. Bruguière presented thirty of his *Designs in Abstract Forms of Light* at the exhibition that took place at the *Art Center* in New York in 1927. In 1928 most of this exhibition was shown in the gallery *Der Sturm* in Berlin. ■ Enyeart describes Bruguière as an agnostic, i. e. as someone who, disappointed by social injustice and moulded by corresponding experiences in his youth, refuses to answer questions about the meaning of life, of history or about life after death. The Taoist teachings offered him, however, an alternative to traditional religion. "Where Bruguière," writes Enyeart, "sought inner peace through his work, the Taoist scripture offered devine peace through inner awareness".[96] The book that impressed Bruguière especially, is en-titled *Das Geheimnis der goldenen Blüte* (The Secret of the Golden Flower)

90 Weber, Max: Ebd. Ibid; zit. n. quoted from:
Green, Jonathan: *Camera Work, A Critical
Anthology.* New York 1973, p. 202.

91 Cheney, Sheldon: *A Primer of Modern Art.*
New York 1924, p. 187; zit. n. quoted from:
Henderson, Linda Dalrymple: *The Fourth
Dimension and Non-Euclidean Geometry in
Modern Art.* Princeton 1983, p. 232.

92 Bragaglia, Anton Giulio: *Fotodinamismo
Futurista.* Rom 1913. Neuauflage new edition:
Turin 1980.

weil es ein paar flüchtige Augenblicke einfängt, d. h. die **Zustände** einer Geste.«[93] Bragaglia vergleicht die Chronofotografie mit »einer Uhr, deren Zeiger nur die Viertelstunden registrieren, das Kino mit einer Uhr, die auch die Minuten registriert und den Fotodynamismus wiederum mit einer dritten Uhr, die nicht nur die Sekunden, sondern auch die **intermomentanen** Minuten, die in den Zeitabschnitten zwischen den Sekunden existieren, anzeigt. Das ist fast eine Infinitesimalberechnung von Bewegung.«[94] Bruguières (und Hirschfeld-Macks) Lichtspiel-Aufnahmen stehen damit nicht zuletzt auch in einer futuristischen Tradition ■ Die Erfahrungen aus dem Arbeiten mit offenem Verschluß, der Umgang mit Licht und vielleicht auch die theosophischen Einflüsse aus dem Umfeld der Bemühungen um eine Farbmusik finden ihren Niederschlag bei der Herstellung der *Designs in Abstract Forms of Light*, wie Bruguière seine den Clavilux-Aufnahmen nachfolgenden gegenstandslosen Arbeiten nannte. Bruguière legte ausgeschnittene Papierformen auf eine Fläche. Durch unterschiedliche Beleuchtung entstand ein Spiel von Licht und Schatten, das durch mehrfache Belichtung bei feststehender Kamera für eine Herausarbeitung der Konturen der Papierformen sowie für die gewünschte Modulierung in den Weißen und Schwärzen sorgte (Abb. S. 135). »Für meine Arbeiten«, schreibt Bruguière rückblickend, »habe ich Formen aus ausgeschnittenem Papier benutzt. Diese brachte ich in ein Flachrelief und beleuchtete sie normalerweise mit einem kleinen Punktlicht von 250 Watt. Die selbe Lampe wurde in einer Reihe von Belichtungen in verschiedene Positionen gebracht.«[95] Auf diese Weise entstanden ab 1922 gegenstandslose Bilder, wie sie so vorher mit der Kamera noch nicht festgehalten worden waren. Bruguière stellte dreißig seiner *Designs in Abstract Forms of Light* in der im Jahr 1927 stattfindenden Ausstellung im *Art Center* in New York aus. 1928 wurde der größte Teil dieser Ausstellung in der Galerie *Der Sturm* in Berlin gezeigt. ■ Enyeart bezeichnet Bruguière als einen Agnostiker, als jemanden der, enttäuscht von sozialen

and was published in 1929 for the first time in the Western world, indeed in German.[97] Its contents refer to Chinese traditions, handed down by word of mouth or in writings that go back into the 8th century. The first edition dates back to the 18th century; in 1920 it was reprinted in Peking. This latest edition is the basis for the translation by the distinguished sinologist Richard Wilhelm (1873 – 1930) who published it together with C. G. Jung (1875 – 1961), the latter adding an "European commentary". ■ There was an English edition, dating 1942[98], in Bruguière's library. Bruguière therefore probably gained possession of it three years before his death. Bruguière wrote a quotation from C. G. Jung into this copy which refers to the Mandala phenomenon. It says: "A modern mandala is an involuntary confession of peculiar mental condition. There is no deity in the mandala and there is also no submission or reconciliation to a deity. The peace of the deity seems to be taken by the wholeness of man."[99] I cannot find this quotation in Jung's text of *Das Geheimnis der goldenen Blüte*, at least not in the German editions that I have. I therefore assume that Bruguière was acquainted with Jung's writings long before he came across *The Secret of the Golden Flower*. That does not mean that he didn't also know of the book before 1942, since the English translation of that was already published in 1931.[100] ■ The fact that these Chinese meditative teachings were of particular importance to Bruguière becomes apparent from the connection between his intensive preoccupation with light and their chief concern. For the *golden flower* stands for 'the cycle of light'. The light of pure 'yang' can be experienced in the peacefulness of pure 'yin' of the profound introspection of meditation. 'Yang' here means Tao, The Great One, Spirit of Heaven, etc. "When one lets light circulate", according to the book", all the forces of heaven and earth, of light and darkness crystallize."[101] This is the beginning of meditation. One directs one's thoughts

93 Ebd. Ibid. (1980), p. 33.; zit. n. quoted after: Braun, Marta: Anton Giulio Bragaglia und die Fotografie des Unsichtbaren. In: *Im Reich der Phantome. Fotografie des Unsichtbaren*. Ostfildern 1997, p. 112 (Hervorhebungen im Original bold print in the original).

94 Ebd. Ibid., p. 28 (Hervorhebung im Original bold print in the original).

95 Bruguière, Francis, Joseph: Creative Photography. In: *Modern Photography Annual*, 1935/36, p. 13.

Ungerechtigkeiten und geprägt von entsprechenden Erlebnissen in der Jugend, sich weigert, Fragen nach dem Sinn des Daseins, der Geschichte oder nach dem Fortleben nach dem Tod zu beantworten. Die taoistische Lehre bot ihm jedoch eine Alternative zur traditionellen Religion. »Wo Bruguière«, schreibt Enyeart, »inneren Frieden durch seine Arbeit gesucht hatte, gewährten ihm die taostischen Schriften himmlischen Frieden durch innere Erkenntnis.«[96] Das Buch, das Bruguière besonders beeindruckte, war *Das Geheimnis der goldenen Blüte*, das 1929 zum ersten Mal in der westlichen Welt, und zwar in deutscher Sprache, erschien.[97] Sein Inhalt geht auf mündliche handschriftliche chinesische Überlieferungen bis ins 8. Jahrhundert zurück. Der erste Druck stammt aus dem 18. Jahrhundert; 1920 wurde es in Peking neu gedruckt. Die letztere Ausgabe ist die Grundlage für die Übersetzung durch den bedeutenden Sinologen Richard Wilhelm (1873–1930), der es in Zusammenarbeit mit C. G. Jung (1875–1961), der einen »europäischen Kommentar« dazu schrieb, herausbrachte. ■ In Bruguières Bibliothek befand sich eine englische Ausgabe aus dem Jahr 1942.[98] Danach kann sie Bruguière drei Jahre vor seinem Tod erworben haben. In dieses Exemplar hat Bruguière ein Zitat von C. G. Jung hineingeschrieben, das sich auf das Mandala-Phänomen bezieht. Es lautet: »Ein modernes Mandala ist ein unfreiwilliges Bekenntnis einer bestimmten seelischen Verfassung. Es gibt keine Gottheit in den Mandalas und es gibt daher auch keine Unterwerfung unter oder eine Tröstung durch eine Gottheit. Der göttliche Frieden scheint auf die Gesamtheit der Menschheit übergegangen zu sein.«[99] Dieses Zitat kann ich in Jungs Text, zumindest in den mir vorliegenden deutschen Ausgaben von *Das Geheimnis der goldenen Blüte*, nicht finden. Ich gehe daher davon aus, daß sich Bruguière mit den Schriften von Jung befaßt hat, lange bevor er auf *The Secret of the Golden Flower* stieß. Damit ist nicht gesagt, daß er das Buch nicht ebenfalls schon vor 1942 kannte, denn eine erste englische Übersetzung erschien immerhin schon 1931.[100] ■ Daß diese

towards the space between both eyes, where light dwells. "After one hundred days a point of true fusion of light (Yang) automatically develops in the middle of the light. Suddenly the seeded pearl appears. It is like when a man and woman come together and conception takes place. One has to be very quiet then in order to nurture it [...]. The cycle of light is not only a cycle of the seeded blossom of the individual body, it is rather the cycle of true creative forces."[102] The idea of a central point and a cycle is realized in the Mandala (Mandala means circle, especially magic circle). The golden blossom is a symbol of Mandala. According to Jung this symbol belongs to the store of collective subconsciousness. It can be found not only in all old Western and Eastern cultures, but also in the drawings of Jung's patients. ■ At the beginning of this essay I drew attention to the fear that the first non-objective artists must have had when they stood before an empty surface and didn't know how to fill it. This fear disappeared in the course of time because the artists developed a vocabulary of forms and colors which their successors were able to use. Bruguière stands right at the beginning of this development with his work. He undoubtedly profits from the knowledge of those who worked with abstraction before him, but he adds new, hitherto unknown parts to this collection of devices. How both comforting and exciting must the idea of an inner, enclosed world be, in the centre of which is the Tao, the meaning of life itself. This world is without objects and it consists of light, the very driving force of photography itself. Because everybody feels this within themselves, even if subconsciously, there is a guarantee that the pictures that Bruguière makes are also understood by the observers. In this way the problem of production and reception for non-objective art, that Kandinsky clarified from a theosophical point of view, resolved in

96 Enyeart, James: *Bruguière*. A. a. O. op. cit., p. 145.

97 *Das Geheimnis der goldenen Blüte. Ein chinesisches Lebensbuch.* Übersetzt und erläutert von Richard Wilhelm. Mit einem europäischen Kommentar von C. G. Jung. München 1929.

98 *The Secret of the Golden Flower.* Translated by Richard Wilhelm, with a commentary by C. G. Jung. London 1942.

99 Zit. n. quoted from: Enyeart, James: *Bruguière*. A. a. O. op. cit., p. 146.

100 *The Secret of the Golden Flower.* A. a. O. op. cit., London 1931.

Rolf H. Krauss

Francis Joseph Bruguière: *Cut Paper
Abstraction*, ca. 1925
Gelatin silver print, 25.2 x 20 cm
George Eastman House, Rochester,
Gift of Rosalinde Fuller (top)

Francis Joseph Bruguière: *Abstract
Study*, ca. 1926
Gelatin silver print, 24.3 x 19.3 cm
George Eastman House, Rochester,
Gift of Rosalinde Fuller (bottom)

chinesische Meditationslehre von besonderer Bedeutung für Bruguière war, geht aus dem Zusammenhang zwischen dessen intensiver Beschäftigung mit Licht und deren Hauptanliegen hervor. Denn die goldene Blüte steht für den ›Lichtkreislauf‹. Das Licht des reinen ›yang‹ wird in der Stille des reinen ›yin‹, der tiefen Innenschau in der Meditation, erfahren. ›Yang‹ bedeutet dabei Tao, Das Große Eine, Geist des Himmels usw. »Wenn man das Licht im Kreis laufen läßt«, heißt es, »so kristallisieren sich alle Kräfte des Himmels und der Erde, des Lichten und des Dunkeln.«[101] Dies ist der Anfang der Meditation. Man richtet die Gedanken auf den Raum zwischen den beiden Augen, wo das Licht wohnt. »Nach hundert Tagen entsteht inmitten des Lichts von selbst ein Punkt des echten Lichtpols (Yang). Plötzlich entsteht dann die Samenperle. Es ist, wie wenn Mann und Frau sich vereinigen und eine Empfängnis statthat. Dann muß man ganz stille sein, um auf sie zu warten [...]. Der Kreislauf des Lichts ist nicht nur ein Kreislauf der Samenblüte des einzelnen Leibes, sondern es ist direkt ein Kreislauf der wahren schöpferischen Gestaltungskräfte.«[102] Die Vorstellung von Mittelpunkt und Kreislauf konkretisiert sich im Mandala (Mandala heißt Kreis, speziell magischer Kreis). Die Goldblume ist ein Mandalasymbol. Nach Jung gehört dieses Symbol zum Vorrat des kollektiven Unbewußten. Es findet sich nicht nur in allen alten westlichen und östlichen Kulturen, sondern auch in Zeichnungen von Jungs Patienten. ■ Am Anfang dieses Aufsatzes machte ich auf die Angst aufmerksam, die die ersten gegenstandslos arbeitenden Künstler befallen haben muß, wenn sie vor einer leeren Fläche standen und nicht wußten, wie sie sie füllen sollten. Diese Angst verflüchtigte sich im Lauf der Zeit, weil die Künstler nach und nach ein Formen- und Farbenvokabular erarbeiteten, auf das die Nachfolgenden zurückgreifen konnten. Bruguière steht mit seinen Arbeiten noch ganz am Anfang dieser Entwicklung. Er profitiert zwar schon von den Erkenntnissen der vor ihm abstrakt Arbeitenden, fügt diesem Instrumentarium aber neue, bis dahin unbekannte

a Taoist way. "A photograph", Bruguière writes, "can be something in itself—it can exist independently as a photograph apart from the subject; it can take on a life of its own."[103] ■ ■

101 *Das Geheimnis der goldenen Blüte.*
A. a. O. op. cit., 1929, p. 121.

102 Ebd. Ibid., pp. 122ff.

Teile zu. Wie tröstlich und ermunternd zugleich muß da die Vorstellung von einer inneren geschlossenen Welt sein, in deren Zentrum das Tao, der Sinn des Lebens selbst, sich befindet. Diese Welt ist gegenstandslos und sie besteht aus dem ureigensten Agens der Fotografie, dem Licht. Da alle Menschen sie, wenn auch unbewußt, in sich fühlen, ist Sorge dafür getragen, daß die Bilder, die Bruguière macht, von den Beschauern auch verstanden werden. Damit ist das Produktions- und Rezeptionsproblem für gegenstandslose Kunst, das Kandinsky noch theosophisch klärte, auf taoistische Weise gelöst. »Eine Photographie«, schreibt Bruguière, »kann etwas Eigenes sein – sie kann als Photographie unabhängig vom Gegenstand existieren; sie kann, neben ihrem dokumentarischen Wert, ein eigenes Leben annehmen.«[103] ■ ■

103 Bruguière, Francis Joseph: *Creative Photography.* A. a. O. op. cit., p. 11.

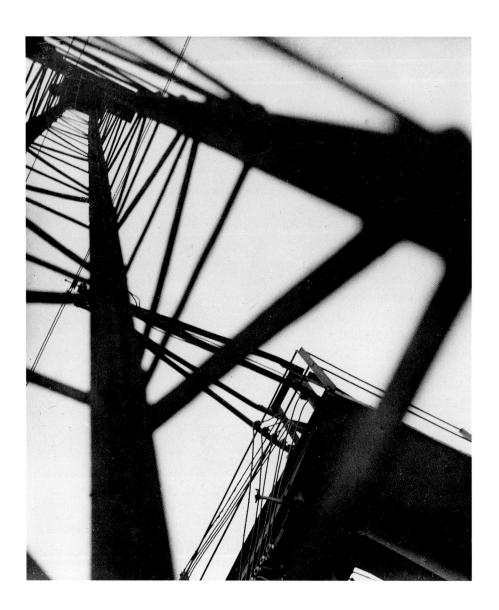

Jaroslav Rössler: *Construction*, 1928
Gelatin silver print, 37 x 29 cm
The Museum of Decorative Arts, Prague

Vladimír Birgus

Die Tschechische Avantgarde-Fotografie zwischen den zwei
Weltkriegen Czech Avant-garde Photography Between the Two World Wars

Konstruktivismus und Neue Sachlichkeit Seit 1927 und 1928 Fürsprecher und Gegner von Edeldrucken in der Prager Zeitschrift *Fotografický obzor* (Fotografischer Horizont) gegeneinander polemisierten, konnte es keinen Zweifel mehr daran geben, daß impressionistischer und sezessionistischer Piktoralismus der Vergangenheit angehörten.[1] Die Gründer der neuen Sehschule betonten die strikte Einhaltung der spezifischen Merkmale des fotografischen Mediums und lehnten romantische Motive ab. Sie gaben einer wahren Darstellung von Industrie- und Architekturmotiven Priorität. Sie waren sowohl vom Konstruktivismus als auch von der Neuen Sachlichkeit beeinflußt und machten deshalb von der dynamischen Kraft ungewöhnlicher Aufnahmewinkel aus der Vogel- oder Froschperspektive, von Diagonalkompositionen und prägnanten Detailaufnahmen Gebrauch. Die Idee der Neuen Sachlichkeit und Objektivität forderten die bestechende Schärfe der fotografischen Optik und die reiche Tonskala fotografischer Materialien geradezu heraus. ■ So stellte Karel Teige in seinem in *Život II* (Leben II) erschienenen Essay *Foto, Kino, Film* an die Fotografie zwei unabdingbare Forderungen: Rationalität und Objektivität. Jaroslav Rössler[2] wurde 1923 dank Teige als Mitglied und einziger Berufsfotograf in die Gruppe *Devětsil* aufgenommen. Rössler stellte sehr einfache Motive dar, z. B. das Oberlicht in Drtikols Studio, Gläser, Kerzen, Aschenbecher oder Ausschnitte von Teilen eines Funkempfängers, Zeugnisse seiner Faszination für alles Technische. Er verwendete deutlich konstruktivistische Perspektiven, so die Froschperspektive in den Fotografien des Petříner Aussichtsturms in Prag (Abb. S. 138) und des Eiffelturms in Paris. ■ Jaromír Funke,[3] eine weitere wichtige Persönlichkeit der neuen tschechischen Fotografie, fertigte seit 1923 ungewöhnlich minimalistische Stilleben an, in denen einfache Formen und Linien ebenso einfache Motive bildeten. Radikal wandte er in den 1920er Jahren bei einer großen Zahl von Fotografien die Prinzipien des Konstruktivismus und der Neuen Sachlichkeit an. Ein Beleg dafür ist der

Constructivism and New Objectivity When in 1927 and 1928 the supporters and adversaries of refined prints indulged in polemics in the Prague periodical *Fotografický obzor* (Photographic Horizon), it was indubitable that impressionist and Art Nouveau Pictorialism belonged to the past.[1] The founders of the new school laid emphasis on the strict preservation of the specific features of the photographic medium and rejected romantic subjects so as to give priority to a true depiction of industrial and architectural motifs. They were influenced by Constructivism as well as New Objectivity and therefore made use of the dynamism of unusual angles of shots from a bird's-eye or worm's-eye view, diagonal compositions and pronounced details. New Objectivity accented the cutting sharpness and rich tonal scale of the photographs. ■ In his essay *Foto Kino Film* (Photo Cinema Film), published in *Život II* (Life II), Karel Teige asserted photography that respects two kinds of imperatives: rationality and objectivity. Thanks to Teige Jaroslav Rössler[2] was accepted in 1923 as a member of the *Devětsil* group in which he was the only professional photographer. Rössler depicted very simple motifs, for instance, the skylight in Drtikol's studio, glasses, candles, ashtrays or details of parts of a wireless set—all this told of his fascination with technical things. He used pronounced constructivist worm's-eye views, for instance, in the photographs of the Petřín observation tower in Prague (fig. p. 138) and the Eiffel tower in Paris. ■ Since 1923 Jaromír Funke,[3] another prominent figure in Czech new photography, produced unusually minimalist still-life pictures, in which elementary shapes and lines form simple motifs. In a large number of photographs, originating in the 1920s, Funke radically applied the principles of Constructivism and New Objectivity of which there is testimony in the diagonal composition of the photograph *After the Carneval* (1924). The strong influence of these trends can also, of course, be found in Funke's later works, for instance, in the photographs

1 Sayag, Alain (ed.): *Photographes tcheques 1920–1950*. Paris, 1983; Dufek, Antonín; Eskildsen, Ute: *Tschechische Fotografie 1918–1938*. Essen 1984; Birgus, Vladimír; Bonhomme, Pierre: *Beauté moderne. Les avant-gardes photographiques tcheques 1918–1948*. Paris, Prague 1998; Birgus, Vladimír (ed.): *Tschechische Avantgarde-Fotografie 1918–1948*. Stuttgart 1999; Zuckriegl, Margit (ed.): *Laterna Magica. Einblicke in eine Tschechische Fotografie der Zwischenkriegszeit*. Salzburg 2000.

2 Birgus, Vladimír: *Jaroslav Rössler*. Prague 2001.

3 Linhart, Lubomír: *Jaromír Funke*. Prague, 1960; Souček, Ludvík: *Jaromír Funke – fotografie*. Prague 1970; Mrázková, Daniela; Remeš, Vladimír: *Jaromír Funke. Fotograf und Theoretiker*. Leipzig 1986; Dufek, Antonín: *Jaromír Funke – průkopník fotografické avant-gardy/Pioneering Avant-garde Photography*. Brno 1996.

diagonale Bildaufbau seiner Fotografie *Nach dem Karneval*, 1924. Der starke Einfluß dieses Trends findet sich auch in Funkes späterem Werk, z. B. in den Aufnahmen funktionalistischer Architektur der 1930er Jahre (Abb. S. 152 oben), in Porträts, Aktfotografien, Landschaften oder Stilleben. ■ Auch die Schüler von Jaromír Funke und Josef Ehm an der Staatlichen Grafikschule in Prag, so z. B. Gabrielová, Hatláková, Zikánová, Jílovská, Pospíšil u. a., wurden in der zweiten Hälfte der 1930er Jahre zu einer bewußten Anwendung dieser Prinzipien angeleitet. Nicht nur bei Übungen zum Thema geometrische Gegenstände im Raum, sondern auch bei ihren zahlreichen Werbefotografien. Dazu erfuhren sie überzeugende Anregungen durch die modernen Werbefotografien von Josef Sudek, Jaroslav Rössler, Alexander Hackenschmied, Bohumil Šťastný, Marie Rossmannová und anderen Fotografen. ■ Die Werke von Eugen Wiškovský,[4] er war zuerst Lehrer und später Freund von Jaromír Funke, gehören zu den originellsten Schöpfungen neuer tschechischer Fotografie. Sie stellen Gegenstände aus scheinbar unästhetischen Beton- und Metallröhren, aus Eisenstangen, Turbinen, elektrischen Isolatoren und Grammophonplatten dar, und sie extrahieren daraus künstlerisch wirkungsvolle und ausgesprochen bezaubernde Formen. Durch die Vergrößerung eines bestimmten Details, durch dessen Herauslösen aus dem Kontext, durch rhythmische Wiederholung eines gewissen Motivs und Übersetzung farbiger Realität in Schwarzweißfotografien, gelang es Wiškovský, über die konventionelle Wahrnehmung eines bestimmten Gegenstandes hinaus dessen unerwartete metaphorische Bedeutung zu entdecken. Auf diese Weise ruft seine Fotografie von Hemdkragen, später umbenannt in *Mondlandschaft* (1929), unweigerlich das Bild von Mondkratern hervor (Abb. S. 156). ■ Der Radikalismus der Kompositionen von Wiškovský übertrifft Werke anderer Autoren, die ähnliche Motive weitaus traditioneller fotografierten. Das zeigen z. B. Fotografien von dem Kaffeehaus auf der Barrandov Anhöhe in Prag von Drahomír Josef Růžička, Arnošt

of the functionalist architecture of the 1930s (fig. p. 152 top), in portraits, in nudes, landscapes or still-life photographs. ■ Also Jaromír Funke's and Josef Ehm's pupils from the State Graphic School in Prague (e. g. Gabrielová, Hatláková, Zikánová, Jílovská, Pospíšil and others) were, in the second half of the 1930s, led to a deliberate application of these principles not only in school exercises on the subject of geometrical objects in space, but also in a number of advertising shots. Here they were able to find strong inspiration in the modern advertising photographs taken by Josef Sudek, Jaroslav Rössler, Alexander Hackenschmied, Bohumil Šťastný, Marie Rossmannová and other photographers. ■ We classify the works of Eugen Wiškovský,[4] first teacher and later the friend of Jaromír Funke, among the most original creations of Czech new photography. They depict objects of seemingly quite unaesthetic concrete and metal pipes, iron bars, turbines, electrical insulators, gramophone records—and extract from them artistically effective and outright enchanting forms. By enlarging a certain detail, by taking it out of context, by the rhythmic repetition of a certain motif and the transformation of colored reality into black-and-white photographs, Wiškovský managed to completely reverse the conventional perception of a certain object and to frequently discover its unexpected metaphorical meaning. And so in the photograph *Collars*, which was later retitled *Lunar Landscape* (1929), shirt collars evoke the image of craters on the Moon (fig. p. 156). ■ The radicalism of Wiškovský's bold compositions is pre-eminent in comparison with the works of other authors who photographed the same subjects but far more classi-cally as, for instance, the coffee house on the Barrandov Terrace in Prague (Drahomír Josef Růžička, Arnošt Pikart, Jan Lauschmann or Josef Ehm) or the functionalistic power station in Kolín (Josef Sudek or Jindřich Koch, while the expressive worm's-eye views and diagonal compositions of Jaromír Funke are sometimes indistinguishable

4 Fárová, Anna: *Eugen Wiškovský*. Prague 1964; Birgus, Vladimír: *Eugen Wiškovský*. Prague 1992.

Vladimír Birgus

Pikart, Jan Lauschmann oder Josef Ehm oder auch die Fotos vom Kraftwerk in Kolín, das von mehreren Fotografen dargestellt wurde, so von Josef Sudek oder Jindřich Koch. Dagegen sind die ausdrucksstarken Fotografien aus der Froschperspektive und die diagonalen Kompositionen von Jaromír Funke manchmal nicht von Wiškovskýs Werken zu unterscheiden. Seit 1937 fotografierte Wiškovský in erster Linie Landschaften in der Umgebung von Prag. Seine metaphorischste Fotografie mit dem Titel *Katastrophe* (1939) stellt ein Getreidefeld mit dem Dach eines Bauernhauses dar, das den bildlichen Eindruck einer stürmischen See mit einem sinkenden Schiff hervorruft (Abb. S. 157). Wiškovský beschäftigte sich ursprünglich auch mit der Theorie der Fotografie, indem er seine Kenntnisse der Formpsychologie auf den Prozeß der Bildwahrnehmung anzuwenden versuchte. ■ Die Prinzipien des Konstruktivismus und der Neuen Sachlichkeit wurden auch in den Werken des informellen *Trio Aventin* von Ladislav Emil Berka, Alexander Hackenschmied und Jiří Lehovec angewendet.[5] Ebenso in vielen Fotografien der Mährischen Avantgarde-Gruppe aus Brünn und Olmütz, besonders von Karel Kapaík aus Olmütz,[6] in Fotografien von Mitgliedern der Gruppe *Linie* aus Böhmisch Budweis, so von Josef Bartuška, Oldřich Nouza, Ada Novák, Karel Valter, Karel Fleischmann u. a. sowie von Mitgliedern des deutschen Fotoklubs aus Böhmisch Budweis, dessen Mitglieder, wie Heinrich Wicpalek, Resl Chalupa oder Ferry Klein, mit der vorgenannten Gruppe zusammen arbeiteten. Gleiche Prinzipien zeigen sich auch in den Werken vieler progressiver tschechischer Amateurfotografen, z. B. bei Josef Slánský und Josef Dašek vom Klub der Amateurfotografen in Mladá Boleslav, bei Jan Lauschmann, Arnošt Pikart, Jindřich Hatlák, Josef Voříšek, Jiří Jeníček, Emil Vepřek. Auch in den Werken von Fotoreportern wie Jan Lukas, Karel Hájek, Pavel Altschul u. a. oder von Vertretern der Sozialfotografie der 1930er Jahre, wie z. B. Karel Kašpařík, Vladimír Hnízdo oder Oldřich Straka, kommen die genannten Stilprinzipen deutlich zum Ausdruck. ■ ■ **Abstrakte Tendenzen**

from the works of Wiškovský). Since 1937 Wiškovský primarily photographed landscapes in the environs of Prague. His most metaphorical photograph *Catastrophy* (1939) pictures a cornfield with a farm roof, creating the impression of a rough sea with a sinking ship (fig. p. 157). Wiškovský also originally concerned himself with the theory of photography, in which he tried to apply his knowledge of the psychology of form to the process of perception of pictures. ■ The principles of Constructivism and New Objectivity were also markedly applied in the works of the informal *Aventin Trio* of Ladislav Emil Berka, Alexander Hackenschmied and Jiří Lehovec,[5] and in many photographs done by Mora-vian avant-garde groups from Brno and Olomouc (particularly by Karel Kašpařík from Olomouc),[6] in photographs taken by the members of the Çeské Budějovice group *Linie* (Josef Bartuška, Oldřich Nouza, Ada Novák, Karel Valter, Karel Fleischmann and others) and the German Photoclub from Çeské Budějovice that cooperated with them (Heinrich Wicpalek, Resl Chalupa or Ferry Klein), as well as in the works of a number of progressive Czech amateur photographers, for instance, Josef Slánský and Josef Dašek from the Amateur Photographers' Club in Mladá Boleslav, Jan Lauschmann, Arnošt Pikart, Jindřich Hatlák, Josef Voříšek, Jiří Jeníček, Emil Vepřek, but also in the works of photo reporters (Jan Lukas, Karel Hájek, Pavel Altschul and others) or the representatives of social photography of the 1930s (e. g. Karel Kašpařík, Vladimír Hnízdo or Oldřich Straka). ■ ■ **Abstract Tendencies** Photomontages and photograms disturb the traditional 'magic' of the photograph, they evoke tension between the abstract and the concrete, between light and matter, and also represent a significant step forward in Czech avant-garde photography. At the beginning of 1923 the review *Život II* (fig. p. 152 bottom) published a *Rayograph* by Man Ray (evidently its first publication outside France), in 1925 Jaroslav Rössler created most probably the first photograms in Czechoslovakia

5 Dufek, Antonín: *Aventinské trio.* Brno 1989; Anděl, Jaroslav: *Alexander Hackenschmied.* Prague 2000.

6 Dufek, Antonín : *Avantgardní fotografie. 30. let na Moravě.* Olomouc 1981; Dufek, Antonín: *Karel Kašpařík.* Brno : Moravská galerie, 1999.

Fotomontagen und Fotogramme zerstören die herkömmliche Magie der Fotografie. Sie rufen Spannung zwischen dem Abstrakten und dem Konkreten, zwischen Licht und Materie hervor, und sie stellen damit einen bedeutenden Fortschritt in der tschechischen Avantgarde-Fotografie dar. Anfang 1923 veröffentlichte die Zeitschrift *Život II* (Abb. S. 152 unten) ein Rayogramm von Man Ray, offensichtlich seine erste Veröffentlichung außerhalb Frankreichs. 1925 kreierte Jaroslav Rössler die ersten Fotogramme in der Tschechoslowakei und Jaromír Funke folgte ihm bald nach. ■ Jaroslav Rössler ist in erster Linie als Konstruktivist anzusehen. Sein experimentelles fotografisches Werk begann er in der Zeit zwischen 1919 und 1920, fast zeitgleich also mit Werken von Alvin Langdon Coburn, Paul Strand, Man Ray, Francis Bruguière und Christian Schad. Damit zählt Rössler auch international zu den Pionieren abstrakter Tendenzen in der Fotografie. In dieser Zeit gestaltete er, noch vor seinen Fotogrammen, Studiofotografien von zwei- oder dreidimensionalen Objekten, die er aus Pappe oder anderen Materialien ausgeschnitten und für die Aufnahme geformt und zusammengestellt hatte. Gelegentlich nutzte er dabei auch Doppelbelichtungen, die es ihm ermöglichten, das Bild in einzelne Elemente aufzuteilen. So fotografierte er vielfach Teile eines Funkempfängers, ein Objekt, das ihn sein ganzes Berufsleben hindurch begleitete und faszinierte. Er schuf auch einzigartige abstrakte Kompositionen aus der Quelle reinen Lichts. Gelegentlich setzte er bei seinen avantgardistischen Fotografien auch noch die piktoralistische Technik des Bromöldruckes ein. ■ Rösslers Fotografien sind frei von literarischen Inhalten. Ihre Hauptmotive sind autonome Grundformen. Dabei zeigt er ein außergewöhnliches Talent, die abgebildete Wirklichkeit in den Hintergrund treten zu lassen und eine neue zu erzeugen. Die Gegenstände sind häufig undefinierbar und erscheinen vollkommen entmaterialisiert. Zu seinen besten Arbeiten zählen die Fotografien von scheinbar dreidimensionalen Leuchtfiguren auf schwarzen Hintergründen aus den

and he was soon followed by Jaromír Funke. ■ The experimental work of Jaroslav Rössler, who is primarily a constructivist and after or together with Alvin Langdon Coburn, Paul Strand, Man Ray, Francis Bruguière and Christian Schad the first representative of abstract tendencies in photography, began in the period between 1919 and 1920. In this period, before the mentioned photograms, he produced studio pictures of two- and three-dimensional objects carved out of cardboard or other materials. He sometimes used double exposure, which enables the picture to be split into details, he also photographed parts of a wireless set, an object that fascinated him throughout his entire life. He also photographed completely unique abstract compositions with sources of light. And he sometimes took these most extremely avant-garde pictures with the aid of the pictorialist technique of bromoil print as well. ■ Rössler was also making photographs devoid of literary content, whose main motifs he reduced to autonomous basic lines and forms. Already in these pieces he was demonstrating an extraordinary talent for reducing depicted reality and construing a new reality. The objects depicted here are often indefinable and appear utterly dematerialized. Among the best are the photographs of seemingly three-dimensional luminous figures on dark backgrounds, made in 1923–1925 (figs. pp. 153 f.), which at first glance are reminiscent of the photograms of Schad or Man Ray or Alfred Cohen's exceptional photograph, *Shadows* (c. 1920). Here, Rössler has anticipated the work of Jaromír Funke by several years. ■ Funke made his abstract-like compositions in shadow and light in the second half of the 1920s as an alternative to the Rayographs, which he, unlike Teige and so many other Czech avant-garde artists, considered a dead-end for photography. Funke worked his way to these photographs by gradually removing simple objects which had played an important role in his still lifes (objects such as starfishes, stuffed hummingbirds, bottles, panes of glass),

Vladimír Birgus

Jahren 1923 bis 1925 (Abb. S. 153 ff.). Sie erinnern an die Fotogramme von Christian Schad oder Man Ray oder an Alfred Cohens außergewöhnliche Fotografie *Shadows*, um 1920. Hierbei nahm Rössler vergleichbare Arbeiten von Jaromír Funke um einige Jahre vorweg. ■ Funke erstellte seine abstrakten Kompositionen aus Licht und Schatten in der zweiten Hälfte der 1920er Jahre als Alternative zu den Rayogrammen, die er im Gegensatz zu Teige und vielen anderen tschechischen Avantgardekünstlern für eine Sackgasse in der Fotografie hielt. Funke arbeitete sich zu seinen Fotografien vor, indem er Gegenstände, die in seinen Stilleben bis dahin eine große Rolle gespielt hatten, wie Seesterne, ausgestopfte Kolibris, Flaschen, Glasscheiben usw., nach und nach in den Hintergrund treten ließ, um sie durch ihre Schlagschatten zu ersetzen. Schatten, die von diesen Objekten selbst erzeugt wurden (Abb. S. 159). Rössler war ihm jedoch hinsichtlich des abstrakten Fotografierens weit voraus, obwohl er nur wenige direkte Vorbilder hatte, von denen er sich hätte inspirieren lassen können. Sein radikales Werk findet, im Gegensatz zu dem anderer tschechischer kubistischer Maler und Bildhauer, Parallelen fast ausschließlich im Vergleich zu ausländischen Vorbildern. Es ist sehr unwahrscheinlich, daß Rössler Anfang der 1920er Jahre das Werk Schads, Coburns, Bruguières oder Dubreuils kannte. Die beinahe abstrakten, puristischen Kompositionen von Paul Outerbridge, Margaret Watkins oder Bernard Shea Hornes waren ihm zweifellos unbekannt, wahrscheinlich sah er aber einige Beispiele von Paul Strand. Es ist anzunehmen, daß er direkt nur auf die Fotogramme von Man Ray aus dem Album *Champs délicieux* (1922) reagieren konnte, die in der tschechischen Anthologie *Život II* erschienen waren und im November 1923 in dem von *Devětsil* organisierten *Basar der Modernen Kunst* im Prager Rudolfinum ausgestellt wurden. Wir erinnern daran, daß Rössler an dieser Ausstellung nicht teilnahm und seine Fotografien bis 1926 zur dritten *Devětsil* Ausstellung, bei der sie dann allerdings neben dem Werk Man Rays hingen, nicht ausgestellt

and replacing them with shadows cast by objects (fig. p. 159). But Rössler was well ahead of him in making abstract-oriented photos, even though he had few predecessors to whom he could turn for inspiration; his radical work, unlike that of, say, Czech Cubist painters and sculptors, was made almost independently of foreign models. It is highly unlikely that in the early 1920s he would have known Schad, Coburn, Bruguière or Dobreuil's work; he undoubtedly knew nothing of the almost abstract purist compositions of Paul Outerbridge, Margaret Watkins, or Bernard Shea Horne; and he probably saw only a few examples of Strand's work. He was therefore most probably reacting directly only to Man Ray's photograms from the album *Champs délicieux* (1922), which were published in the Czech anthology *Život II* and were exhibited at the *Modern Art Bazaar* organized by *Devětsil* in the Rudolfinum, Prague, in November 1923. Rössler, we recall, did not take part in this exhibition, and his photographs were not exhibited till the third *Devětsil* exhibition, held in 1926, where they were shown near the work of Man Ray. ■ He tried to make his own photograms in the second half of the 1920s, whereas several years before he had concentrated on abstract-like photographs made with the camera. In some works, which at first appear to be photograms, he used an unfocused Tessar lens and long exposures to capture light from moving spotlights on a black background. The result is emotionally charged photographs of various blurry glowing cones, rings, lentil-shaped bodies, and curves with various shades of black, white, and gray, which at times suggest luminous substances like something seen in a delirium. Rössler was thus among the first photographers to make light itself (which plays the primary role in photography) the center of interest. Light no longer served merely to create a mood, as it had in, say, the work of the Impressionists and the Pictorialism of Art Nouveau, but now itself became the leitmotif. Therein lies Rössler's pioneering role. His original photographs of

wurden. ■ Während er sich einige Jahre zuvor auf abstrakte, mit der Kamera aufgenommene Fotografien konzentriert hatte, versuchte Jaroslav Rössler in der zweiten Hälfte der 1920er Jahre, eigene Fotogramme zu erarbeiten. In einigen Werken, die auf den ersten Blick als Fotogramme erscheinen, verwendete er ein nicht fokussiertes Tessar-Objektiv und lange Belichtungszeiten, um Licht aus sich bewegenden Scheinwerfern auf einem schwarzen Hintergrund einzufangen. Ergebnisse stellen sich als emotionsgeladene Fotografien von verschiedenen verschwommen glühenden Kegeln, Ringen, linsenartigen Körpern und Kurven mit verschiedenen Schwarz-, Weiß- und Graunuancen dar. Manchmal vermitteln sie den Eindruck leuchtender, wie im Delirium gesehener Substanzen. Damit gehört Rössler zu den ersten Fotografen, die das Licht selbst und seine dominierende Rolle in der Fotografie, in das Zentrum ihres Interesses rückten. Licht diente nun nicht mehr der Darstellung einer Stimmung, wie es in dem Werk der Impressionisten und im Piktorialismus des Jugendstils der Fall gewesen war – sondern es wurde selbst zum Leitmotiv. Darin liegt Rösslers Pioniertat. Insofern verdienen seine ersten Fotografien von einfachen Lichtfiguren aus den Jahren 1923 bis 1925 (Abb. S. 155) einen Platz an der Seite der Fotogramme Man Rays und Moholy-Nagys, die erst ein oder zwei Jahre zuvor entstanden waren. ■ In der gleichen Zeit nahm Rössler auch Fotografien von einfachen Gegenständen auf, wie z. B. von einer Kerze, einem Aschenbecher, einem Weinglas und einer Spule, und zwar vor einem Hintergrund aus schwarzer und weißer Pappe, vor verschiedenen Papiersorten und anderen, in ausdrucksvolle geometrische Figuren geschnittenen Materialien. Von mehreren Fotografien existieren eine Anzahl von Varianten unterschiedlicher Kompositionen. Auf einer Fotografie steht beispielsweise eine Kerze fast an der Kante (Abb. S. 154), während sie in einer anderen in der Mitte abgebildet ist. Schließlich fotografierte Rössler den Hintergrund frei von jedem Gegenstand. Damit wurde er zum ersten Autor, der sowohl den

simple figures of light, made in 1923–1925 (fig. p. 155), deserve a place alongside the photograms of Man Ray and Moholy-Nagy, which were made only a year or two before that. ■ In the same period Rössler was also taking photographs of simple objects (such as a candle, an ashtray, a wineglass, and a spool) against a background of black and white cardboard, different kinds of paper, and other material cut into expressive geometric figures. Several photographs exist in a number of variations with different compositions; in one, for example, a candle is almost on the edge of the photograph (fig. p. 154), whereas in another it is in the middle. Rössler ultimately photographed only the background and, similarly to František Drtikol in his Symbolist photographs of cut-out figures eight years later, was the sole author both of the photographed objects and of the photographs themselves. He was often happy simply to depict flat figures, but sometimes he tried also to capture the shadows that were cast by vertically placed fragments of cardboard lit from the side. Elsewhere, for example in the photograph *Abstraction* (1923), he employed two identical negatives placed on top of each other. Sometimes he intentionally used a slightly out-of-focus subject to dematerialize the depicted reality and to emphasize the autonomy of the photographic image, which was now almost completely independent of the reality captured in the photo. His almost abstract shots of cardboard cutouts were made well before the better known similarly constructed light abstractions of the American photographer Francis Bruguière, which also employ paper cutouts (fig. p. 135), and Rössler was definitely not influenced by them. ■ Much of this work, using elements of Cubism, Futurism, Neo-Plasticism, and Constructivism (sometimes even exhibiting certain links with the later Art Deco style), has a good deal in common with the paintings of Malevitch, Rodtchenko, Kupka, van Doesburg, Delaunay, Moholy-Nagy, and Kassák. In the photography of those days, however, Rössler has

Vladimír Birgus

Gegenstand als auch das Medium Fotografie, sein Licht, seine Schatten, in einem einzigen Bild thematisch und kompositorisch zusammenführte. Ähnlich erarbeitete acht Jahre später František Drtikol seine symbolistischen Fotografien von ausgeschnittenen Figuren. Oft begnügte sich Rössler damit, flache Figuren abzubilden. Manchmal versuchte er auch, die Schatten einzufangen, die seitlich beleuchtete hochkant gestellte Pappfragmente warfen. An anderer Stelle verwendete er zwei identisch aufeinander liegende Negative, wie z. B. in der Fotografie *Abstraktion* (1923). Er verwendete manchmal ein leicht unscharfes Sujet, um die abgebildete Realität zu entmaterialisieren und die Selbständigkeit des fotografischen Bildes, das nun von der im Foto eingefangenen Wirklichkeit beinahe völlig unabhängig war, hervorzuheben. Seine abstrakten Aufnahmen von Ausschneidefiguren aus Pappe wurden schon lange vor den bekannteren und ähnlich aufgebauten Lichtabstraktionen des amerikanischen Fotografen Francis Bruguière produziert, der ähnliche Figuren aus Papier verwendete (Abb. S. 135). Aber Rössler wurde bestimmt nicht von ihnen beeinflußt. ■ Die Arbeiten Rösslers weisen Elemente des Kubismus, Futurismus, Neoplastizismus und Konstruktivismus auf, manchmal sogar gewisse Verbindungen zum späten Art Déco-Stil. Sie haben auch vieles gemeinsam mit Gemälden von Malewitsch, Rodtschenko, Kupka, van Doesburg, Delaunay, Moholy-Nagy und Kassák. Seine Fotografie war bahnbrechend. Während die erste wichtige abstrakte Arbeit in der tschechischen Malerei vor dem Ersten Weltkrieg entstand und František Kupka zu Recht als einer ihrer ersten internationalen Pioniere bezeichnet wird, erhielt der Einfluss abstrakter Kunst in der tschechischen Fotografie seine rechte Wirkung erst durch Rösslers Fotografien von 1922 bis 1924. 1925 verwendete er einige dieser Fotografien in seinen Collagen *Fotografie*, von denen zwei (*I* und *IV*) Eigentum des Kunstgewerbemuseums in Prag sind, die anderen scheinen verloren gegangen zu sein. Er klebte die Fotografien auf ein großes Stück Papier und fügte schwarze

few counterparts. Whereas in Czech painting the first important abstract work appeared before World War I and František Kupka is rightly considered one of its international pioneers, in Czech photography the influences of abstract art were first employed with real effect in Rössler's photographs of 1922–1924. Some of these photos he used in 1925 in his collages *Fotografie*. Two of them, *I* and *IV*, are the property of the Museum of Decorative Arts, Prague (fig. p. 155), but the others seem to have gone missing. Here he pasted the photographs onto a large piece of paper and added cut-out black strips and expressive signatures. This resulted in highly effective, very early examples of the inventive linking of avant-garde photography and typography, which was being promoted in the artwork and articles of, for example, Moholy-Nagy (his book *Malerei, Fotografie, Film* was published by the Bauhaus that same year), Herbert Bayer, Alexander Rodtchenko, El Lissitsky, and Karel Teige. *Fotografie I* also employed a photomontage made of two photographs of geometric cardboard cutouts. It is a striking example of the multimedia nature of Rössler's work, a characteristic not found in the work of, say, the exclusively photographically oriented Funke. In some of the final prints of these compositions in which Rössler used the bromoil technique he may not have even realized the archaic nature of this technology, for he worked almost totally isolated from the avant-garde trends of his day. Rössler had continued his abstract photographs also in Paris between 1926 and 1935. ■ Since the middle of the 1920s František Drtikol[7] created non-figurative compositions (fig. p. 158), inspired by Cubism and at the same time by Symbolism and the Art Deco style, increasingly reflecting his philosophically religious ideas that ensued from Buddhism. In his still-life creations, in which an increasingly important role is taken over by shadows, Jaromír Funke gradually freed himself from figurative motifs and tried to synthesize direct photography with abstraction, and with

ausgeschnittene Streifen und ausdrucksvolle Signaturen hinzu. Das ergab hoch wirkungsvolle, sehr frühe Beispiele einer schöpferischen Verbindung von Avantgardefotografie und Typografie, wie sie durch Werke und Artikel von Moholy-Nagy, so in seinem Bauhausbuch *Malerei, Photographie, Film*, sowie auch von Herbert Bayer, Alexander Rodtschenko, El Lissitzky und Karel Teige propagiert wurden. Auch *Fotografie I* verwendete eine Fotomontage aus zwei Fotografien von geometrischen Ausschneidefiguren aus Pappe. Es ist ein bemerkenswertes Beispiel der multimedialen Natur von Rösslers Werk, ein Charakteristikum, das z. B. in den ausschließlich fotografisch orientierten Arbeiten von Jaromír Funke nicht zu finden ist. In einigen der endgültigen Abzüge dieser Kompositionen, bei denen Rössler die Bromöltechnik anwendete, hat er jedoch nicht die dieser Technik zu Grunde liegenden Eigenschaften angemessen umzusetzen vermocht, da er beinahe vollkommen isoliert von den avantgardistischen Trends seiner Zeit arbeitete. Rössler führte seine abstrakten Fotografien dann auch in Paris zwischen 1926 und 1935 fort. ■ Seit Mitte der 1920er Jahre kreierte František Drtikol[7] non-figurative, von Kubismus, Symbolismus und Art Déco inspirierte Kompositionen (Abb. S. 158). Sie spiegeln zunehmend seine philosophisch-religiösen Ideen wider, die sich aus dem Buddhismus herleiten. In seinen Stilleben, in denen Schatten eine zunehmend wichtige Rolle spielen, befreite sich Jaromír Funke nach und nach von figürlichen Motiven und versuchte, die direkte Fotografie mit dem Prinzip der Abstraktion zu verbinden und mit seiner Kamera Ergebnisse vergleichbar denen zu Man Rays Fotogrammen zu erzielen. Stilleben wurden zu seinem Experimentierfeld. Durch den Kubismus inspiriert, begann er Glaswürfel, geometrische Formen, Rechtecke und Quader aus Glas oder Papier zu fotografieren. In Funkes Stillebenreihe gewinnen Schlagschatten zunehmend an Form und Bedeutung, bis sich die Sujets schließlich ganz außerhalb des Bildrahmens befinden und nur noch die ungegenständlichen Schattenspiele abgebildet sind. Diese

his camera to achieve results comparable to Man Ray's photograms. The still life became an experimental workshop for him. Inspired by Cubism he began to photograph glass cubes, geometric shapes, rectangles and squares of glass or paper. In Funke's series of still lifes the role of cast shadows grows progressively, until finally the subjects are found outside the picture, and only the non-figurative shadow plays are pictured. These shadow game photographs became an important element in the history of Czech photography, but unfortunately remained practically unknown in the period when they were created, and did not influence foreign photographers. ■ In 1928 and 1929, after Rössler's, Drtikol's and Funke's isolated experiments, came the exhibitions of the Amateur Photographers' Club in Mladá Boleslav, which marked the second stage of Czech avant-garde—this became a collective movement in the 1930s. The methods of the representatives of New Objectivity became unified, many photographers of this "second avant-garde" let themselves be inspired by Surrealism. An example of the new tendency are, for instance, the experimental explorations of František Povolný from the group *f5* in Brno, who concerned himself with photographic material as such, or Miroslav Hák, who in 1937 created the expression 'strukáz' (Translator's note: Derived from the word structur). In the forties members of the post-surrealist group *Ra*, Miloš Koreček and Josef Istler, made enlargements of abstract details made of melted negatives, and figures on photographic paper with developer and fixative. This work issued from the new approach to the photographic medium as well as from the new relation to reality. ■ ■
Advertising The prosperity of Czech advertising photography is mainly due to the flourishing existence of periodical publications in the economically viable Czechoslovakia. In the second half of the 1920s, the prosperity of advertising work was attested by the numerous orders received by Josef Sudek[8] and Adolf Schneeberger,[9] both of whom

7 Birgus, Vladimír: *Fotograf František Drtikol*. Prague 1994; Birgus, Vladimír: *František Drtikol – Modernist Nudes*. San Francisco 1997; Doležal, Stanislav; Fárová, Anna; Nedoma, Petr: *František Drtikol – fotograf, malíř, mystik*. Prague 1998; Mlčoch, Jan: *František Drtikol – Fotografie 1901–1914*. Prague 1999; Birgus, Vladimír: *The Photographer František Drtikol*. Prague 2000.

Vladimír Birgus

Schattenspiel-Fotografien wurden zu einem wichtigen Element in der Geschichte der tschechischen Fotografie. In ihrer Entstehungszeit blieben sie jedoch leider nahezu unbekannt und beeinflußten ausländische Fotografen nicht. ■ Nach den isolierten Versuchen Rösslers, Drtikols und Funkes traten 1928 und 1929 die Ausstellungen des Klubs der Amateurfotografen in Mladá Boleslav in den Vordergrund. Sie kennzeichneten den zweiten Entwicklungsabschnitt tschechischer Avantgarde und wurden zu einer kollektiven Bewegung in den 1930er Jahren. Die Methoden der Vertreter der Neuen Sachlichkeit wurden vereinheitlicht, viele Fotografen dieser Zweiten Avantgarde ließen sich vom Surrealismus inspirieren. Ein Beispiel der neuen Tendenz sind die experimentellen Untersuchungen von František Povolný der Gruppe f5 in Brünn, der sich mit fotografischem Material als solchem beschäftigte, oder von Miroslav Hák, der 1937 ›strukáz‹ [Abgeleitet vom Wort Struktur, Anm. d. Übers.] erfand. In den 1940er Jahren vergrößerten Mitglieder der post-surrealistischen Gruppe *Ra*, Miloš Koreček und Josef Istler, abstrakte Details aus geschmolzenen Negativen und erzeugten mit Entwickler und Fixierbad Figuren auf Fotopapier. Diese Arbeit rührte sowohl von dem neuen Umgang mit dem fotografischen Medium, als auch von der neuen Beziehung zur Wirklichkeit her. ■ ■ **Werbung** Der Aufschwung der tschechischen Werbefotografie ist in erster Linie auf Zeitschriftenpublikationen in der ökonomisch aufstrebenden Tschechoslowakei in der zweiten Hälfte der 1920er Jahre zurückzuführen. Die Expansion der Werbung in dieser Zeit wird unter anderem durch zahlreiche Aufträge belegt, die Josef Sudek[8] und Adolf Schneeberger[9] erhielten. Ihnen war die Wirkung moderner Werbung sehr bewußt. ■ Ab 1926 arbeitete Sudek für den Verlag Drustevní práce (Kooperative Arbeit). Er wurde von dem Designer und Autor exzellenter Plakate und grafischer Layouts von Büchern und Zeitschriften, Ladislav Sutnar, geleitet. Sudek fotografierte in erster Linie einfach geformte Glas-, Metall- und Porzellangegenstände in simplen Verzierungen und ließ

thoroughly comprehended the efficacy of modern advertising trends. ■ In 1926, Sudek started working for the publishing house Družstevní práce (Cooperative Work), managed by Ladislav Sutnar, designer and author of excellent posters and graphic lay-outs of books and periodicals. Sudek primarily photographed glass, metal and porcelain objects of simple form in simple decorations, letting the outlines of objects of everyday use or of furniture stand out. These works, which were presented in 1932 within the framework of his first independent exhibition, met with considerable public success (fig. p. 161). ■ It was in these years that Karel Teige defined phototypography, a composition in which word and picture supplement each other and it is not possible to separate them formally nor their content. In the rather small but at the time significant publication *Photography in Advertising and the Neubert's Photogravure* from the year 1933, advertising is described as an autonomous production that uses large surfaces, vertical perspectives, diagonal compositions, photomontages and photocollages that address the artist, beside other, due to its functionalistic spirit.[10] ■ During extended stays in Paris between 1925 and 1926 and again from 1928 to the mid-thirties, Rössler made his living as an advertising photographer. Especially in his work of the 1930s, Rössler tried to imprint his constructivist-inspired compositions with a more commercial character. ■ The development of advertising photography is decisively influenced by the inter-war professional educational system, particularly the State Graphical School in Prague. From the middle of the 1930s, Jaromír Funke and Josef Ehm taught modern applied and advertising photography there, emphasizing perfection of depiction in accordance with the tenets of New Objectivity, as well as an effectiveness of compositional structure whose look was influenced by Constructivism. The works of the majority of students from this period are very similar, and together with the works

8 Kirschner, Zdeněk: *Josef Sudek*. Prague 1982; Fárová, Anna: *Josef Sudek – Poet of Prague*. New York 1990; Kirschner, Zdeněk: *Josef Sudek*. Tokyo, New York 1993; Fárová, Anna: *Josef Sudek*. Prague 1995; Mlčoch, Jan; Řezáč, Jan: *Růže pro Josefa Sudka/ A Rose for Josef Sudek*. Prague 1996.

9 Dufek, Antonín: *Adolf Schneeberger*. Prague 1983.

dabei die Umrisse von Alltagsgegenständen oder von Möbeln besonders hervortreten. Diese Arbeiten wurden 1932 im Rahmen seiner ersten Einzelausstellung präsentiert und hatten beachtlichen Erfolg in der Öffentlichkeit (Abb. S. 161). ■ In diesen Jahren definierte Karel Teige den Begriff Fototypografie als eine Kompositionsform, bei der sich Wort und Bild gegenseitig ergänzen, und bei der es kaum möglich ist, noch nach Form und Inhalt zu unterscheiden. Beide gehen ineinander auf. In der kleinen aber in jener Zeit einflußreichen Publikation *Fotografie in der Werbung und Neuberts Fotogravüre* aus dem Jahr 1933 wird Werbung als eigenständige produktive Tätigkeit bezeichnet, bei der konstruktive Elemente wie großformatige Flächen, vertikale Perspektiven, Diagonalkompositionen, Fotomontagen und Fotocollagen, eine bedeutende Rolle spielen und die daher auch für den ambitionierten Künstler von Interesse sein sollte, nicht zuletzt wegen ihrer funktionellen Wirkungsweise.[10] ■ Jaroslav Rössler verdiente seinen Lebensunterhalt durch Werbefotografie während ausgedehnter Aufenthalte in Paris zwischen 1925 und 1926 und wieder von 1928 bis zur Mitte der 1930er Jahre. Besonders in den Arbeiten dieser Zeit versuchte Rössler, seinen konstruktivistisch inspirierten Kompositionen auch kommerziellen Charakter zu verleihen. ■ Die Entwicklung der Werbefotografie wird entscheidend durch das Berufsbildungssystem zwischen den Weltkriegen beeinflußt, insbesondere durch die Staatliche Grafikschule in Prag. Ab Mitte der 1930er Jahren lehrten dort Jaromír Funke und Josef Ehm Werbefotografie und moderne angewandte Fotografie, und sie unterstrichen dabei sowohl die Vollkommenheit der Darstellung gemäß der Lehre der Neuen Sachlichkeit, als auch die Wirksamkeit der vom Konstruktivismus beeinflußten kompositorischen Strukturen. Die Arbeiten der meisten Studenten dieser Zeit ähneln sich sehr und tragen zusammen mit den Arbeiten der schon erwähnten Autoren bzw. Fotografen aus den Bat'a Betrieben in Zlín dazu bei, daß die Neue Fotografie der tschechischen Werbung der 1930er Jahre

of the already mentioned authors or photographers from the Bat'a plants in Zlín, contribute to the fact that new photography dominated Czech advertising in the 1930s. ■ ■ **Surrealist Photography** An extraordinary feature of the Czech avant-garde close to Man Ray and Maurice Tabard is the conjunction of rationalist tendencies, present in Constructivism, and irrationalist tendencies, represented by imaginative art and Surrealism. ■ Jaromír Funke's *Reflexes* (1929) series was already close to Surrealism and is clearly inspired by the enthusiasm of surrealists for a part of Atget's work. Funke, a supporter of direct photography, records fantasized reflections in display windows and he does not adjust the negative nor does he interfere with the development of the positive. In *The Time Persists* (1930–1934) series (fig. p. 160) he applies the principles of unusual encounters of 'objets trouvés', and thus confirms Breton's thesis that super-reality is not outside reality but within. Funke, who does not consider himself a surrealist, adduces 'emotive photography'. ■ Unlike Funke the painter Jindřich Štyrský was not interested in the photographic medium as such. For him photography was primarily a substitute for reality, which enables him to express its fetishist conception. Nevertheless, his pictures of miraculous encounters, billboards, walls, display windows, masks, artificial limbs, children's coffins and other objects from the series *The Frogman*, *The Man with Blinkers on His Eyes* and *A Paris Afternoon* from the period 1930–1934, in which the motif—the permeance of sex and death—often appears, belong to the heights of Czech as well as world surrealist photography. ■ František Vobecký, inspired by the collages of Max Ernst, did photographs of assemblages of miscellaneous objects, and a little later, of cut-out fragments of photographs (often details of female nudes), or of engravings on the background of photographs or decals. In his metaphorical photographs of metropolitan suburbs Miroslav Hák, a member of the *Group 42*, managed to join

10 Mlčoch, Jan: Avantgarde-Fotografie und Reklame. In: Birgus, Vladimír (ed.): *Tschechische Avantgarde-Fotografie 1918–1948.* Stuttgart 1999, pp. 159–174.

Vladimír Birgus

ihren Stempel aufdrückte. ■ ■ **Surrealistische Fotografie** Ein besonderes Merkmal der tschechischen Avantgarde, in der Nähe zu Man Ray und Maurice Tabard, ist die Verbindung rationaler, im Konstruktivismus angesiedelter Tendenzen, mit irrationalen, von der Imaginativen Kunst und dem Surrealismus dargestellten Tendenzen. ■ Jaromír Funkes Serie *Reflexe* (1929) war mit dem Surrealismus schon sehr nah verwandt, und sie ist deutlich von dem Enthusiasmus der Surrealisten, zu einem Teil von Eugène Atgets Werk, inspiriert. Funke, Anhänger der direkten Fotografie, nimmt phantasievoll Reflexionen in Schaufenstern auf, ohne das Negativ zu bearbeiten oder in die Entwicklung des Abzugs einzugreifen. In der Serie *Die Zeit dauert an* (1930 – 1934) (Abb. S. 160) wendet er die Prinzipien von ungewöhnlichen Begegnungen von ›objets trouvés‹ an und bestätigt somit André Bretons These, daß Super-Realität nicht außerhalb, sondern innerhalb der ›Realität‹ angesiedelt ist. Funke, der sich nicht als Surrealist bezeichnete, bevorzugt demgegenüber den Begriff ›Emotive Photography‹. ■ Anders als Funke war der Maler Jindřich Štyrský nicht an dem fotografischen Medium interessiert. Fotografie war für ihn in erster Linie ein Substitut für Realität, das ihm ermöglichte, deren fetischistische Konzeption auszudrücken. Trotzdem gehören seine Fotografien von ›wundersamen Begegnungen‹, von Anschlagbrettern, Mauern, Schaufenstern, Masken, künstlichen Gliedmaßen, Kindersärgen und anderen Objekten aus der Serie *Der Froschmann, Der Mann mit Augenklappen* und *Ein Pariser Nachmittag* aus dem Zeitraum 1934 – 1935, zu den Höhepunkten sowohl tschechischer als auch internationaler surrealistischer Fotografie. Ihnen liegt häufig das Motiv der gegenseitigen Durchdringung von Sex und Tod zugrunde. ■ Angeregt von den Collagen von Max Ernst, nahm František Vobecký Fotografien von Assemblagen diverser Objekte auf, einige Zeit später von ausgeschnittenen Fragmenten aus Fotografien, Gravüren oder Abziehbildern. Häufig finden sich Details weiblicher Aktaufnahmen. Auch Miroslav Hák, Mitglied der

irrationality and rationality. Suburbs also attracted the attention of other photographers, e. g. Jiří Sever, Václav Chochola, and Tibor Honty. The works of many other photographers also undoubtedly document the quite exceptional extent and quality of the Czech photographic avant-garde, which is one of the most important and most original elements of 20th century Czech art. ■ ■ **Social Photography** Hardly anywhere else did avant-garde authors participate in the social photography movement of the 1930s so markedly as in Czechoslovakia. The great economic crisis, which from 1929 affected a considerable part of the world, in so doing turned the attention of photographers in a number of countries to social subjects: In the USA (the photographic project *Farm Security Administration* [*FSA*], *Photo League*, etc.); in Britain (e. g. Bill Brandt and Bert Hardy); in Germany (the periodical *Arbeiter Illustrirte Zeitung* and *Arbeiter Fotograf*, the organization of Workmen's Photoreporters and others); in Hungary (the group *Sociofotó*); and in Japan. However, this did not involve direct membership in the film and photo group of the *Left front*, developing its activities in Prague since the beginning of the thirties (under the leadership of Lubomír Linhart) and in Brno (led by František Kalivoda), because only very few of the avant-garde photographers became members of the *Left front*, an organization increasingly controlled by orthodox communists. A number of avant-garde photographers, of course, participated in the identifiably propagandistically conceived international exhibitions of social photography in Prague, organized by Linhart in 1933 and 1934. Only some of them, of course, devoted themselves to social photography systematically. ■ Among them was Jaromír Funke, who moved from occasional and clichéd social pictures of the 1920s to the critical commentary of series such as *Bad Housing* and the work done in impoverished, multinational Subcarpathian Ruthenia. Also among those who engaged in social photography systematically

Gruppe 42, vermochte in seinen Fotografien von Großstadt-Vororten, Irrationalität mit Rationalität zu verbinden. Die Vorstädte zogen auch die Aufmerksamkeit weiterer Fotografen auf sich, wie Jiří Sever, Václav Chochola und Tibor Honty. Zweifellos dokumentieren sie, wie auch Arbeiten anderer Fotografen dieses Landes, die außerordentliche Qualität tschechischer Fotoavantgarde. Sie stellt damit auch eines der wichtigsten und originellsten Elemente tschechischer Kunst des 20. Jahrhunderts dar. ■ ■ **Sozialfotografie** In kaum einem anderen Land nahmen Avantgarde-Autoren an der Bewegung der sozialen Fotografie der 1930er Jahre so entschieden teil, wie in der Tschechoslowakei. Die Weltwirtschaftskrise von 1929 lenkte die Aufmerksamkeit von Fotografen in vielen Ländern auf soziale Sujets. So in den Vereinigten Staaten durch das fotografische Projekt *Farm Security Administration* (*FSA*), die *Photo League*, etc.; in Großbritannien z. B. durch die Arbeiten von Bill Brandt und Bert Hardy; in Deutschland durch die Zeitschriften *Arbeiter Illustrirte Zeitung*, *Arbeiterfotograf* und die Organisation der Arbeiter-Fotoreporter u. a.; in Ungarn durch die Gruppe *Sociofotó*. Die Entwicklung erstreckte sich bis nach Japan. ■ Das alles hatte jedoch nicht die unmittelbare Mitgliedschaft in der Film- und Fotogruppe der *Linken Front* zur Folge, einer von orthodoxen Kommunisten zunehmend kontrollierten Organisation. Seit Anfang der 1930er Jahre entwickelte sie ihre Aktivitäten unter der Leitung von Lubomír Linhart in Prag und von František Kalivoda in Brünn. Zwar beteiligten sich eine Reihe von Avantgarde-Fotografen an den erkennbar propagandistisch konzipierten und von Linhart 1933 und 1934 organisierten internationalen Ausstellungen für Sozialfotografie in Prag. Tatsächlich aber widmeten sich nur sehr wenige von ihnen engagiert und beständig dem Feld der Sozialfotografie. ■ Zu diesen gehörte Jaromír Funke. Von gelegentlichen und klischeehaften Milieuaufnahmen in den 1920er Jahren entstanden nun kritische Serien wie *Schlechte Wohnverhältnisse* und über die verarmte multiethnische Karpatenukraine.

were Karel Kašpařík (author of an excellent collection of social documents from Dolany near Olomouc), Jiří Lehovec, František Povolný and others. On the other hand though, many photographers who specialized in social documents as, for instance, Rudolf Kohn, Oldřich Straka, Vladimír Hnízdo, and Karel Poličanský, as well as then prominent photoreporters Karek Hájek or Václav Jírů, used various avant-garde arrangements in their pictures. ■ ■

Vladimír Birgus

Unter denen, die sich für die Sozialfotografie engagierten, waren auch Karel Kapaík, Autor einer exzellenten Sammlung sozialer Dokumente aus Dolany bei Olmütz, sowie Jiří Lehovec, František Povolný und andere. Viele der Fotografen, die sich auf dieses Sujet spezialisierten, wie beispielsweise Rudolf Kohn, Oldřich Straka, Vladimír Hnízdo und Karel Poličanský oder die prominenten Fotoreporter Karek Hájek oder Václav Jírů, wendeten in ihren Fotografien die Stilmittel der Avantgarde-Fotografie erfolgreich an. ■ ■

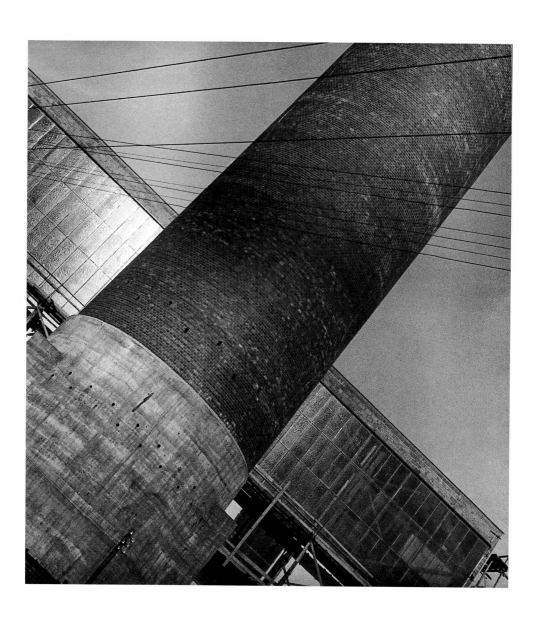

Jaromír Funke: From the series *New Archi-
tecture – Power Station Kolín*, 1932
Gelatin silver print, 40 x 30 cm
Collection Miloslava Rupesová, Prague (top)

Bedřich Feuerstein, Jaromír Krejcar, Josef
Síma, Karel Teige: Cover of the year book
Život II, 1922.
The Museum of Decorative Arts, Prague
(bottom)

Vladimír Birgus

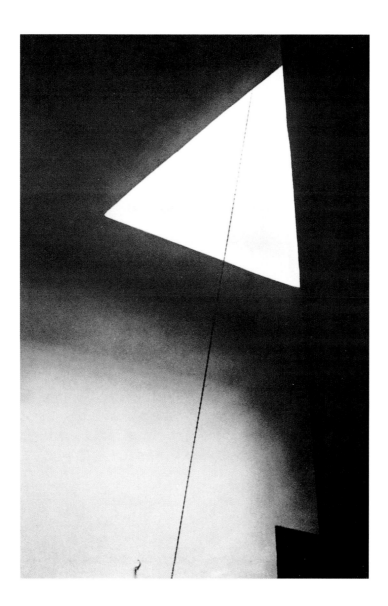

Jaroslav Rössler: *Skylight*, 1923
Gelatin silver print, 39 x 26 cm
The Museum of Decorative Arts, Prague

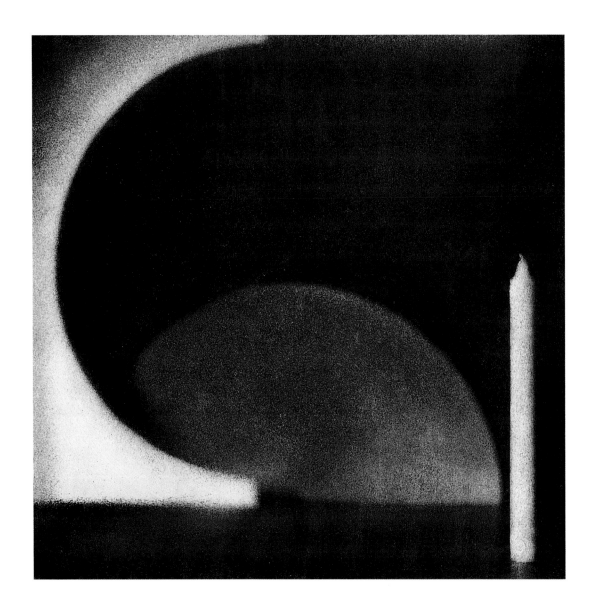

Jaroslav Rössler: *Composition with Candle*, 1923
Bromoil print, 22 x 22 cm
The Museum of Decorative Arts, Prague

Vladimír Birgus

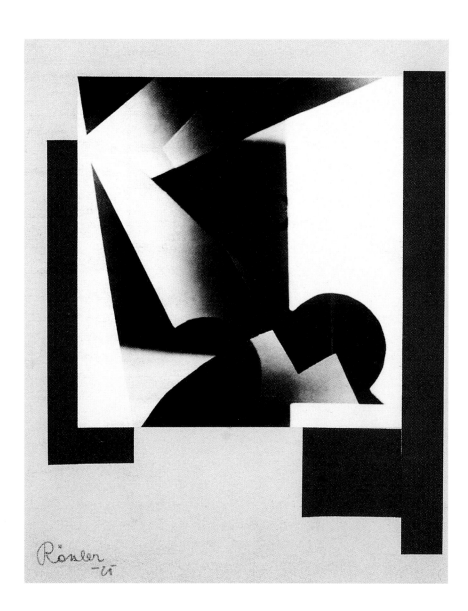

Jaroslav Rössler: *Photography I*, 1925
Gelatin silver print, 37.5 x 31 cm
The Museum of Decorative Arts, Prague

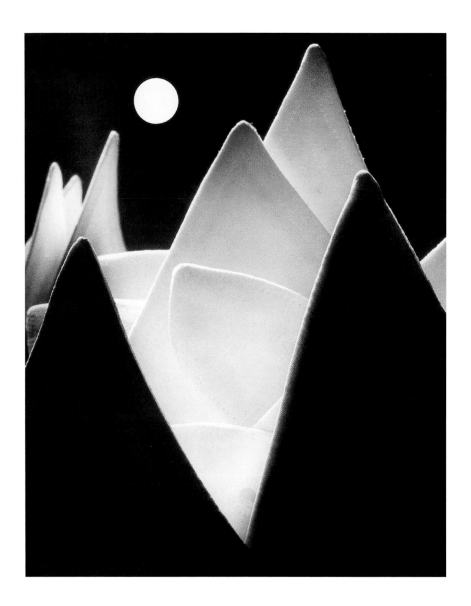

Eugen Wiškovský: *Lunar Landscape* (*Collars*)
(Mondlandschaft [Kragen]), 1929
Gelatin silver print, 29.6 x 22 cm
The Museum of Decorative Arts, Prague

Vladimír Birgus

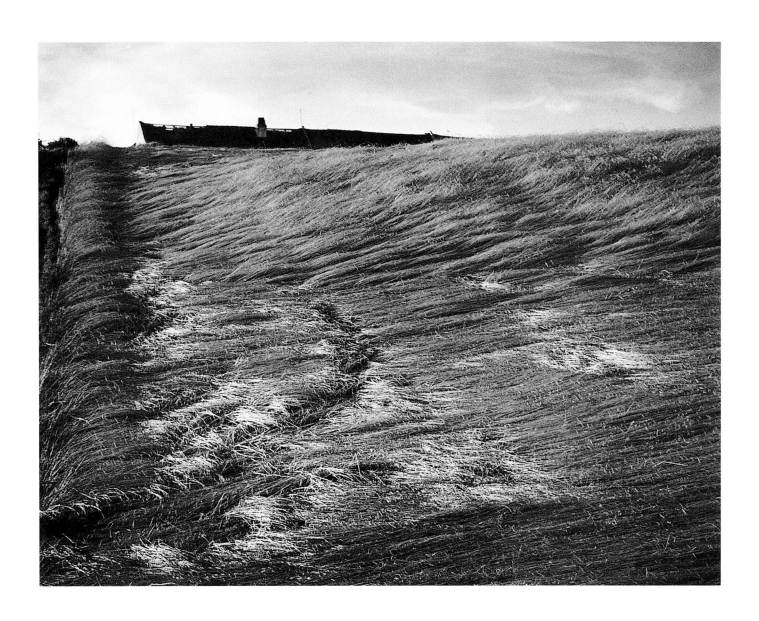

Eugen Wiškovský: *Disaster*
(Katastrophe), 1939
Gelatin silver print, 32 x 42 cm
Private collection, Prague

František Drtikol: *Nude* (Akt), 1929
Pigment print, 28 x 22.5 cm
The Museum of Decorative Arts, Prague

Vladimír Birgus

Jaromír Funke: *Exotic Still Life*
(Exotisches Stilleben), 1928/29
Gelatin silver print, 39.7 x 29.8 cm
Collection Miloslava Rupesová, Prague

Jaromír Funke: From the cycle *Time Persists*
(Aus dem Zyklus: *Die Zeit dauert an)*, 1932
Gelatin silver print, 38 x 29 cm
Collection Miloslava Rupesová, Prague

Josef Sudek: *Untitled* (Ohne Titel), 1932/36
Gelatin silver print, 12.5 x 15.5 cm
Collection Darina and Vladimír Birgus,
Prague

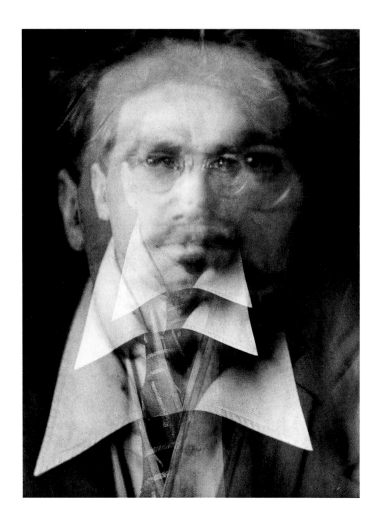

Alvin Langdon Coburn: *Portrait Ezra Pound,* 1917
Vortograph. Gelatin silver print, 20.4 x 15.3 cm
George Eastman House, Rochester

Martin Roman Deppner

Coburn meets Pound. Abstraktion und Vortizismus in der englischen Ästhetik der Moderne Coburn Meets Pound. Abstraction and Vorticism in the English Aesthetics of Modernism

Dem Vortizismus fehlt jener eigenartige Tick [des Futurismus], die Herrlichkeiten der Vergangenheit auszumerzen. The Vorticist has not this curious tic for destroying past glories.[1] **Ezra Pound**

I. Mit seinen als *Vortographs* bezeichneten Fotografien hat der 1882 in Boston geborene amerikanische Fotograf Alvin Langdon Coburn dem ebenfalls amerikanischen Poeten und Theoretiker des Vortizismus, Ezra Pound, ein zugleich fotografisches wie – so sah es jedenfalls der Fotograf selber – abstraktes Œuvre gewidmet.[2] Beide Künstler hatten sich zu Beginn des 20. Jahrhunderts nach England orientiert. Coburn besaß gleichwohl noch lange ein Atelier in New York, Pound hingegen siedelte 1909 nach London über. Im Jahre 1917 kam es zu einer intensiven Zusammenarbeit zwischen dem bereits bekannten Landschafts-, Stadt-, und Porträtfotografen einerseits und dem exzentrischen Wortführer des London-Vortex andererseits, zu deren Ergebnis u. a. achtzehn *Vortographs* gehören. Sie gelten seitdem als Meilenstein der Abstrakten Fotografie.[3] ■ Im Jahr ihrer Entstehung im Londoner *Camera Club* ausgestellt, trug auch der von Pound anonym beigesteuerte Kommentar dazu bei, daß Coburn in den Wirbel geriet, den die Vortizisten nicht nur repräsentieren wollten, sondern den sie auch für kurze Zeit im Kunstbetrieb auszulösen vermochten.[4] ■ Entsprechend finden die Vortografien in allen einschlägigen Abhandlungen zur Fotogeschichte Erwähnung, ohne daß auf die komplexen Spannungsfelder eingegangen würde, die diese Begegnung von Fotografie und Vortizismus hervorrief, eine Begegnung, die von Sympathiebekundungen, Mißverständnissen und ideologischen Querelen begleitet wurde.[5] Die fehlende Reflexion des Vortizismus und seiner Intention, »die Grenzen der herkömmlichen Einzelkünste« mit einer neuen Ästhetik »zu überwinden«[6], bei Abhandlungen über Coburns Vortografien erklärt sich u. a. daraus, daß die programmatischen Impulse der vortizistischen Bewegung weitgehend auf England beschränkt blieben und auf dem Kontinent – wenn überhaupt – vorwiegend im Kontext angelsächsischer Besonderheiten Stoff für anglistische Literaturstudien abgaben.[7] Denn die größte Wirkung erzielte der Vortizismus in der Literatur, die mit T. S. Eliot immerhin einen von Pound inspirierten Nobelpreisträger

I. With his photographs which he referred to as *Vortographs*, the American Alvin Langdon Coburn dedicated both a photographic (as seen by the photographer himself) and an abstract œuvre to Ezra Pound, the American poet and theoretician of Vorticism, who had moved to England. Coburn, born in Boston in 1882, had also focussed his interests on England as of 1899, although he still maintained a studio in New York for a long time.[2] In 1917 the already renowned landscape, urban and portrait photographer (Coburn) and the eccentric spokesman of the London Vortex (Pound) intensively collaborated, producing, among others, eighteen *Vortographs*. They are hitherto regarded as a milestone in abstract photography.[3] ■ When these Vortographs were exhibited in the London *Camera Club* in the year they were taken, Pound's anonymous commentaries also helped to pull Coburn into the maelstrom which the Vorticists not only wanted to represent, but were temporarily able to unleash in the world of art as well.[4] ■ Thus, the Vortographs are mentioned in all relevant literature on the history of photography which, however, does not sufficiently reflect on the complex tension surrounding the encounter of photography and Vorticism, namely declarations of sympathy, misunderstandings and ideological quarrels.[5] We can explain the Vorticist lack of reflection and its intention "to overcome the barriers of traditional, individual arts with a new aesthetic"[6] by the fact that the programmatic impulses of Vorticism were mostly restricted to England and, if at all, on the continent, they were predominantly the stuff of English literature studies under the heading of English 'peculiarities'.[7] For Vorticism had the greatest impact on literature: T. S. Eliot, inspired by Pound, was after all a Nobel Prize winner. In truth, Vorticism has gone by virtually unnoticed in the mainstream and theory of modern art which, until today, has led to

1 Pound, Ezra: Vortizismus. Das Programm der Moderne. In: Hesse, Eva (ed.): *Ezra Pound Lesebuch. Dichtung und Prosa*. Zürich 1985, p. 111.

2 Coburn, Alvin Langdon: *Alvin Langdon Coburn, Photographer. An Autobiography*. Edited by Helmut and Alison Gernsheim, with a new introduction by Helmut Gernsheim. New York 1978, p. 102; vgl. cf. Cork, Richard: *Vorticism and Abstract Art in the First Machine Age*. London 1976. Vol. 1, pp. 152–155, Vol. 2, pp. 348–505; vgl. cf. Coburn, Alvin Langdon: Die Zukunft der bildmäßigen Fotografie (1916). In: Kemp, Wolfgang (ed.): *Theorie der Fotografie Bd. II, 1912–1945*. München 1979, pp. 54–58.

3 Vgl. cf. Kellein, Thomas: Die Erfindung abstrakter Fotografie 1916 in New York. In: Kellein, Thomas; Lampe, Angela (eds.): *Abstrakte Fotografie*. Ausstellungskatalog exhibition catalog. Kunsthalle Bielefeld. Ostfildern-Ruit 2000, pp. 33–56.

4 Vgl. cf. Orchard, Karin: Ein Lachen wie eine Bombe. Geschichte und Ideen der Vortizisten. In: Orchard, Karin (ed.): *BLAST Vortizismus. Die erste Avantgarde in England 1914–1918*. Ausstellungskatalog exhibition catalog. Hannover: Sprengel Museum 1996, pp. 9–21.

5 Vgl. cf. Coburn, Alvin Langdon: *Alvin Langdon Coburn, Photographer*. A. a. O. op. cit., p. 102.

6 Hansen, Miriam: *Ezras Pounds frühe Poetik und Kulturkritik zwischen Aufklärung und Avantgarde*. Stuttgart 1979, p. 182.

7 Vgl. cf. Iser, Wolfgang: Image und Montage. Zur Bildkonzeption in der imagistischen Lyrik und in T. S. Eliots' Waste Land. In: Iser, Wolfgang (ed.): *Poetik und Hermeneutik. Immanente Ästhetik – Ästhetische Reflexion. Lyrik als Paradigma der Moderne*. München 1966, pp. 361–393.

aufzuweisen hat. Dem Mainstream der bildenden Künste der Moderne und ihrer Theorie ist der Vortizismus weitgehend unbekannt geblieben, was bis heute zu Mißverständnissen und zu Fehldeutungen des sich zwischen den Kontinenten bewegenden britischen Wegs innerhalb der Moderne geführt hat. Erst 1996 fand im Sprengel-Museum Hannover eine größere Retrospektive statt, die das medial umfassend argumentierende Bild- und Wort-Programm des Vortizismus in Zentraleuropa vorstellte.[8] ■ Der Reihe nach: 1916, also ein Jahr vor den eigentlichen Vortografien, generiert Coburn in der Dunkelkammer ein prismatisch anmutendes Porträt von Pound, das sich − unter Beibehaltung des Fokus in Augenhöhe − als die durch unterschiedliche Abstände verkleinerte und übereinandergelagerte Belichtung eines Negativs erweist und etwa durch die zählbaren Hemdkragen eine dreiphasige Verschiebung anschaulich werden läßt (Abb. S. 162). Unschärfen in den Zonen der Überlagerung und des Ineinandergreifens der Züge sorgen für eine Bewegungssuggestion, die an futuristische Ästhetik denken läßt, die sich ja zeitgleich mit dem Vortizismus mit weit größerer Wirkung in Italien formierte.[9] ■ Die Abstandsverschiebung um einen Fokus zeigt jedoch, daß Coburn sich durch seine Überblendungstechnik von jenen für den Futurismus bedeutsam gewordenen Chronofotografien eines Etienne-Jules Marey unterscheidet, in denen der Franzose ab 1882 den Bewegungsablauf als zeitliche Folge eines Ereignisses festhielt. (Abb. S. 166, oben links) Dies geschah mit Hilfe einer ›fotografischen Flinte‹, die auf einer runden Platte zwölf Aufnahmen in einer Sekunde ermöglichte.[10] ■ Die außerkünstlerischen Anlässe zur Reflexion der Bewegung und Zergliederung fest erscheinender Körper waren dagegen hier wie dort die gleichen; sie kündigten sich bereits in der zweiten Hälfte des 19. Jahrhunderts an: Sich rasant entwickelnde Großstädte mit Strömen von Menschen, mit Verkehr, Rädern und Turbinen, ferner Entdeckungen von Krankheitskeimen in den Mikroorganismen des Körpers, die Durchleuchtung des Körpers mit Hilfe von Röntgen-

misunderstandings and misinterpretations of Britain's position within Modernism and between the continents. It was only in 1996 that a larger retrospective held at the Sprengel Museum, Hanover, introduced to Continental Europe the 'Word and Image' programme propounded by Vorticism, a program truly embracing all media.[8] ■ In 1916, that is, a year before the Vortographs proper appeared, Coburn made a prismatic portrait of Pound in the darkroom, a portrait which, with its eye-level focus, is actually a negative of reduced varying intervals and superimposed exposures. Countable shirt collars create a three-fold displacement (fig. p. 162). Blurs in the overlapping and merging forms suggest a motion reminiscent of the aesthetics of Futurism which was founded in Italy alongside Vorticism, but with a much greater resonance.[9] ■ Interval displacements around a focal point nonetheless show that Coburn, with his technical effects of superimposition, distinguishes himself from Etienne-Jules Marey's chronophotographs (seminal for Futurism) which, from 1882 onwards, recorded motion as the temporal sequence of an event (fig. p. 166, top, left). Marey used a so-called 'photographic gun' which could take twelve shots per second on a disc.[10] ■ The non-artistic reasons to reflect on the motion and division of firm bodies were nevertheless the same in both Marey's and Coburn's age. In fact, they appeared as early as the second half of the nineteenth century: Rapidly developing cities with masses of people, with traffic, wheels and turbines, then the discovery of bacteria in the micro-organism of the body using X-rays, advancement in nuclear physics including the research of particles, electricity, daring steel constructions reaching the sky, the increasing successes in defying gravity with flying objects and, last but not least, the continuing development of war and its machinery — but this would be an entirely separate chapter.[11] ■ Before Pound, Coburn had already portrayed other contemporary personae

8 Vgl. cf. Orchard, Karin (ed.): *BLAST Vortizismus*. A. a. O. op. cit.

9 Vgl. cf. Harten, Jürgen (ed.): *Wir setzen den Betrachter mitten ins Bild. Futurismus 1909–1917*. Ausstellungskatalog exhibition catalog. Düsseldorf : Städtische Kunsthalle, 1974; vgl. cf. Moeller, Magdalena M. (ed.) : *Boccioni und Mailand*. Ausstellungskatalog exhibition catalog. Kunstmuseum Hannover mit Sammlung Sprengel. Milano 1983.

10 Vgl. cf. Paech, Joachim: Bilder von Bewegung − bewegte Bilder. Marey, Boccioni, Léger, Ruttmann. In : Deutsches Institut für Fernstudien, Universität Tübingen (ed.):

Funkkolleg Moderne Kunst. Studienbegleitbrief 5. Weinheim, Basel 1990, pp. 22 – 25. Eine genaue Analyse von Entwicklung und Technik der Chronofotografien Mareys findet sich bei an exact analysis of development and technique of Marey's chronophotography will be found in : Schnelle-Schneyder, Marlene: *Photographie und Wahrnehmung am Beispiel der Bewegungsdarstellung im 19. Jahrhundert*. Marburg 1990, pp. 112 – 142.

strahlen, die Fortschritte in der Atomphysik samt Teilchenforschung, Elektrizität, kühne, in den Himmel ragende Konstruktionen aus Stahl und zunehmende Erfolge, mittels Flugobjekten der Schwerkraft zu trotzen und – nicht zuletzt in der weiteren Entwicklung – der Krieg mit seiner Maschinerie, was ein eigenes Kapitel wäre.[11] ■ Coburn hatte vor Pound andere Persönlichkeiten der damaligen Kulturszene porträtiert, Literaten wie William Butler Yeats (Abb. S. 166, unten), Henry James, Bernhard Shaw und Gertrude Stein sowie die vortizistischen Künstler Jacop Epstein und Wyndham Lewis.[12] Auch wenn es in den Künstlerporträts darum ging, die Persönlichkeit foto-grafisch zu interpretieren, so weicht das kristalline Porträt Ezra Pounds schon allein durch den auffallend generie-renden Eingriff im Labor von den anderen Porträts – auch von den Porträts anderer Vortizisten – ab. Das heißt, die ästhetische Struktur wird hier nicht mehr unterschwellig mitgeführt; sie wird mindestens gleichbedeutend mit dem auf Wiedererkennbarkeit des äußeren Erscheinungsbildes gerichteten Porträt ins Bild gesetzt, womit zunächst ein Abrücken von der Abbildlichkeit erreicht und mithin ein Schritt zur Abstraktion vollzogen wäre.[13] Zugleich fällt auf, daß – ohne den Vortizismus zu berücksichtigen – neben den bemerkten futuristischen Bewegungssimulationen der ebenfalls zeitgleich wirkende Kubismus ins Blickfeld geraten sein könnte (Abb. S. 166, oben rechts). Das Ziel, die simultane Allansichtigkeit des Gegenstandes auf der Fläche des Bildfeldes zu erreichen, mittels dessen Zerlegung in Kuben und einer farblichen Angleichung der Kontraste, kommt durchaus auch als Anregungspotential für die von Coburn betriebene optische Zerlegung des Abbildes in Frage. ■ Mit der Anrufung dieser Kunstoffensiven zu Anfang des Jahrhunderts, denen sich dann auch die kristallin zergliederten Tierleiber Franz Marcs einfügen, ist zunächst jenes Spannungsfeld in den bildenden Künsten markiert, in dem sich – ergänzt durch Suprematismus und Konstruktivismus – die abstrakte Kunst emanzipierte, ein Spannungsfeld das – so scheint es – nicht des

from the cultural scene, literary figures such as William Butler Yeats (fig. p. 166, bottom), Henry James, Bernard Shaw, Gertrude Stein as well as, among others, the Vorticist artists Jacop Epstein and Wyndham Lewis.[12] Although he used his camera to interpret the artist's personality in his portraits, it should be said that the prismatic portrait of Ezra Pound already differs from others, also of other Vorticists, through its obvious laboratory manipulation. In other words, the aesthetic structure has become more pronounced here; it has become at least as important as the recognizability of the outer portrait. Thus, Coburn gradually distanced himself from portraiture and moved a step further towards abstraction.[13] At the same time it is noticeable that, without considering Vorticism and apart from the Futurist simulations of movement, Cubism was most probably a contemporary influence as well (fig. p. 166, top right). The Cubist aim to simultaneously view the object from all sides on the surface of the picture (by means of cubic division and a reduction in color contrasts) was definitely a source of inspiration for Coburn's optical frag-mentation of the image. ■ Referring to these avant-garde movements at the dawn of the century, in which Franz Marc's distinctive animal bodies should be included, a field of tension in the fine arts is marked whereby abstract art, together with Suprematism and Constructivism, became emancipated; it seems that this tension would have existed even without Vorticism. That is the reason why, as already mentioned, Vorticism passed unnoticed.[14] ■ Pound chastized Futurism's negative relationship with tradition. With an eye on Marinetti he wrote: "The Vorticist has not this curious tic for destroying past glories."[15] He even spoke of the Vorticists rebuilding on the banks of the river Jersey a Venice destroyed by the Futurists. His was a romantic understanding of technology upheld with great enthusiasm for technical progress, but progress interwoven with technical beauty, an approach certainly

11 Marinetti, Filippo T.: Gründung und Mani-fest des Futurismus 1909: »9. Wir wollen den Krieg verherrlichen – die einzige Hygiene der Welt –, den Militarismus, den Patriotismus, die Vernichtungstat der Anarchisten, die schönen Ideen, für die man stirbt, und die Verachtung des Weibes.« *Founding and Manifesto of Futu-rism 1909:* "9. We want to glorify war—the world's only hygiene—militarism, patriotism, the anarchist's act of destruction, beautiful ideas to die for and the contempt for women." In: Jürgen Harten (ed.): *Wir setzen den Be-trachter mitten ins Bild.* A. a. O. op. cit., o. S. Vgl. cf. Riethmüller, Albrecht: Futurismus und Tonkunst? Zu Ferruccio Busoni und Umberto Boccioni. In: Kämper, Dietrich (ed.): *Der musikalische Futurismus.* Regensburg 1999, pp. 137f.

12 Vgl. cf. Coburn, Alvin Langdon: *Alvin Langdon Coburn, Photographer.* A. a. O. op. cit., pp. 1ff.

13 Vgl. cf. Wagner, Monika: Das Problem der Abstraktion. Eine Diskussion. In: *Funkkolleg Moderne Kunst.* A. a. O. op. cit., pp. 100ff.

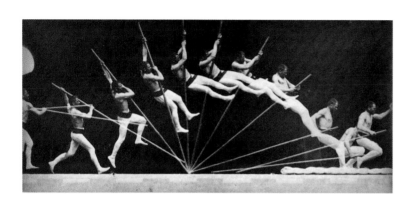

Etienne-Jules Marey: *Saut à la perche* (pole-
jump/Stabhochsprung), ca. 1890
Chronophotograph. Gelatin chlorobromide
enlargement from glass negative, 19.6 x 48.8 cm
Manfred Heiting Collection (top left)

Pablo Picasso: *L'Aficionado* (Devotee of bull-
fighting/Freund des Stierkampfes), 1912
Oil on canvas, 130 x 81 cm
Öffentliche Kunstsammlung Basel (top right)

Alvin Langdon Coburn: *William Butler Yeats,
Dublin, January 24th*, 1908
Photogravure print, 20.3 x 15.8 cm
George Eastman House, Rochester (bottom)

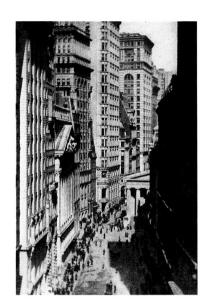

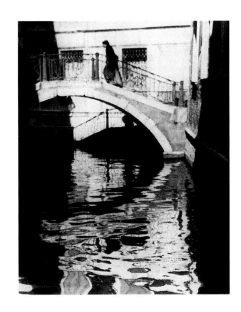

Alvin Langdon Coburn: From the series *The Stock Exchange*, ca. 1905
Photogravure print, 19.7 x 13.9 cm
George Eastman House, Rochester (top left)

Alvin Langdon Coburn: *Shadows and Reflections, Venice*, 1905
Halftone photogravure print, 20.7 x 16.5 cm
George Eastman House, Rochester (top right)

Alvin Langdon Coburn: Ink drawing for the cover of his exhibition catalogue *Vortographs and Painting* at the London Camera Club (Tuschezeichnung für den Katalogumschlag seiner Ausstellung *Vortographs and Painting* im Londoner *Camera Club*), 1917
George Eastman House, Rochester (bottom left)

First page of the *Manifest of Vorticism* (Titelblatt des *Manifestes des Vortizismus*), 1914
Taken from: *BLAST*, No. 1, 1914 (bottom right)

Vortizismus bedurft hätte. Entsprechend wurde, wie bereits erwähnt, am Vortizismus vorbeigesehen.[14] ■ Was den Futurismus betrifft, so geißelte Pound dessen negatives Verhältnis zur Tradition. Mit einem Seitenblick auf Marinetti schrieb er: »Dem Vortizismus fehlt jener eigenartige Tick, die Herrlichkeiten der Vergangenheit auszu-merzen.«[15] Er sprach sogar davon, daß die Vortizisten ein von den Futuristen zerstörtes Venedig wieder aufbaun würden. Ihm schwebte ein romantisches Technikverständnis vor, das zwar von der Technikbegeisterung getragen wird, zugleich aber die alten Schönheiten darin verweben möchte, durchaus den Stadtlandschaften Coburns ver-gleichbar, dessen Blicke auf New York und Venedig beispielsweise einer ähnlich ästhetisierenden Sehweise unter-worfen sind (Abb. S. 167, oben links). Die Dynamik jener Zeit, Mühsal und Schmutz werden auf Distanz gehalten.[16] ■ ■ II. Für die erste Ausstellung seiner Vortografien 1917 fertigte Coburn eine plakativ gehaltene Zeichnung aus Tinte an (Abb. S. 167, unten links); sie diente als Cover für die Broschüre zur Ausstellung, die auch Gemälde Coburns präsentierte.[17] Die Cover-Zeichnung Coburns führt uns noch näher an das Wechselspiel zwischen Fotograf und Denker heran, erscheint das Blatt doch auch wie eine schematische, programmatische Zuspitzung seines Ver-ständnisses von Vortizismus, dessen Titulierung Pound vom lateinischen *vortex*, d. h. ›Wirbel‹ ableitete.[18] Nun zeigt Coburns Piktogramm keinen Wirbel im engeren Sinn, aber es veranschaulicht die damit verknüpfte Energie-formel: Zuspitzung und Konzentration im Inneren bei gleichzeitiger Entladung nach außen. Die zum Zentrum spitz zulaufenden ›hard-edge‹ Flächen, begleitet von schlängelnden Linien und wegsprühenden Teilchen, simulieren zudem jene orgiastische Entladung eines phallischen Konzepts, das Pound als zusätzliche Inspiration mit dem Vortizismus verband: Pound vertrat einen »spermologischen Stil«, denn für ihn hing der schöpferische Geist aufs engste mit der männlichen Potenz zusammen. »Das tote mühsame Zusammentragen und vergleichen der toten

comparable to Coburn's cityscapes wherein New York and Venice are perceived in a similar aestheticizing way (figs. p. 167, top left). The dynamism, hardship and filth of the contemporary age are kept at a distance.[16] ■ ■ II. Coburn produced a posterlike ink drawing for the exhibition of his Vortographs in 1917 (fig. p. 167, bottom, left); this drawing served as cover for the pamphlet to the exhibition which also showed paintings by Coburn.[17] His cover illustration brings us closer still to the dialogue between the photographer and the thinker, as the drawing resem-bles a schematic, programmatic definition of how he understood Vorticism, the title Pound had derived from the Latin word *vortex*, meaning 'whirl' or 'eddy'.[18] Coburn's pictogram does not depict an eddy, as such, but it does illus-trate the force of energy accompanying it: concentration directed inwards with a simultaneous explosion outwards. Hard-edge areas pointing inwards towards the centre, together with curved lines and flying particles, are to simulate the orgiastic explosion of a phallic concept which, in connection with Vorticism, additionally inspired Pound: he advocated a so-called "spermological style", since the creative spirit was for him intimately linked with male potency. "The dead laborious compilation and comparison of other men's images", says Pound, "all this is mere labour, not the spermatozoic act of the brain."[19] ■ Another anonymous pictogram, circulated in the Vor-ticist journal *BLAST*, shows the shape of a cone suggesting centrifugal forces of acceleration (fig. p. 167, bottom right). Pound regarded the vortex as an image which brings together the pole of rest (in the centre) and movement (around the centre), a union of opposites with enduring consequences also for the textual structure of his poems to be investigated later. Many artists of the time pursued the motif of the vortex both in word and in image. The principle of the merging of periphery and centre was even adopted by typography; and the slogan for architecture

14 So finden sich Darstellungen des Vortizis-mus in Abhandlungen zur Kunstentwicklung der Moderne vorwiegend, wenn nicht aus-schließlich in englischen Publikationen. Pre-dominantly, if not exclusively, we find descrip-tions on Vorticism in texts on the aesthetic development of Modernism in English publica-tions. Vgl. cf. *Abstraction: Towards a New Art. Painting 1910–1920*. Ausstellungskatalog exhibition catalog. Tate Gallery London. London 1980; vgl. cf. Compton, Susan (ed.): *Englische Kunst im 20. Jahrhundert*. Ausstel-lungskatalog exhibition catalog. Royal Acad-emy of Arts London, Staatsgalerie Stuttgart. München 1987.

15 Pound, Ezra: Vortizismus. Das Programm der Moderne. In: Hesse, Eva (ed.): *Ezra Pound Lesebuch*. A. a. O. op. cit., p. 111.

16 Hansen, Miriam: *Ezras Pounds frühe Poetik und Kulturkritik zwischen Aufklärung und Avantgarde*. A. a. O. op. cit., pp. 40f.

17 Weaver, Mike: *Alvin Langdon Coburn. Symbolist Photographer 1882–1966. Beyond the Craft*. Rochester, N. Y. 1986, pp. 64–68.

18 Vgl. cf. Gaßner, Hubertus: *Der Vortex – Intensität als Entschleunigung*. In: Orchard, Karin (ed.): *BLAST Vortizismus. Die erste Avantgarde in England 1914–1918*. A. a. O. op. cit., pp. 22–38.

Denkbilder«, sagt Pound, »das ist bloße Plackerei, nicht der spermatozoische Akt des Gehirns.«[19] ■ Ein anderes, anonymes Piktogramm, das in der den Vortizismus begleitenden Zeitschrift *BLAST* verbreitet wurde, visualisiert die Kegelform mit der Suggestion zentrifugaler Beschleunigungsenergie (Abb. S. 167, unten rechts). Für Pound ist der Wirbel eine Denkfigur, die es erlaube, Ruhepol (im Zentrum) und Bewegung (um das Zentrum herum) zu verei-nen, eine Zusammenführung von Gegensätzen mit nachhaltigen Konsequenzen auch für die Textstruktur seiner Gedichte, wie noch zu zeigen sein wird. Diesem Denkbild sind viele bildende Künstler in jener Zeit mit Gemälden und Texten nachgegangen. Bis in die Typografie ist das Prinzip des Zusammenwirkens von Peripherie und Zentrum ver-folgt worden, um die Architektur wurde geworben mit dem Slogan: »Architects! Where is your Vortex?«[20] In der Fotografie ist Coburns Beitrag der einzige geblieben. ■ Ein Vergleich des wohl bekanntesten Gemäldes der Vorti-zisten, dem *Workshop* von Wyndham Lewis aus den Jahren 1914–1915 (Abb. S. 172, oben links), mit einer Vorto-grafie Coburns zeigt zunächst die strukturelle Übereinkunft, die gerade in der Kombination von ruhender Mitte und Bewegungssuggestion begründet liegt, die bei Coburn mittels einer kristallinen Lichtbrechung mit Fokus und labiler Kippachse erzeugt wird. Dennoch ist diese Nähe zwischen den vortizistischen Gemälden und den Vortogra-fien Coburns von Pound selbst zwiespältig aufgenommen worden. Einerseits würdigte Pound die Vortografien als Arrangements aus Blöcken von Licht und Dunkelheit (*Vortograph No. 8*) bzw. als in der Wahrnehmung einem Ton-satz von Chopin vergleichbar (*No. 3*), andererseits sah er dieselben Vortografien, nämlich *No. 8* und *3* (Abb. S. 172, oben), als Bild einer zerberstenden Muschel bzw. als Bild eines fallenden, stürzenden Zeppelins.[21] ■ Im Zusam-menhang mit seiner Abneigung gegen andere zur Zeit des Vortizismus einflußreiche Kunstrichtungen wie Natura-lismus, Impressionismus und Futurismus polemisierte Pound gegen die mimetischen Irrlichter aller Reproduk-

went, "Architects! Where is your Vortex?"[20] In photography, as it were, Coburn's contribution remains an isolated case. ■ A comparison with probably the most renowned Vorticist painting, the *Workshop* by Wyndham Lewis from 1914-1915 (fig. p. 172, top, left), and a Coburn Vortograph, would foreground the structural correspondence found in the combination of "still-centre" and the suggestion of motion (which Coburn creates through a prismatic breaking of light with a focal point and a flexible pivot). However, Pound regarded the similarity between Vorticist paintings and the Vortographs with suspicion. On the one hand, he appreciated Coburn's Vortographs as arrangements of blocks of light and darkness (*Vortograph No.8*) or as analogies of the perception of a musical phrase by Chopin (*No. 3*) but, on the other hand, he respectively saw the same Vortographs (that is, *No.8* and *No.3;* figs. p. 172, top) as images of a bursting shell or a crashing zeppelin.[21] ■ Together with his rejection of other influential art move-ments at the time of Vorticism (such as Naturalism, Impressionism and Futurism), Pound inveighed against the mimetic temptations of all reproduction techniques, and this included photography; his attitude towards motion pictures was later to change.[22] In a deliberate attempt to confront Coburn he wrote in a text for the exhibition he had organized, *Vortographs and Paintings*: "Art photography has been stuck for twenty years. During the time practically no new effects have been achieved. Art photography is stale and suburban. It has never had any part in aesthetics."[23] In a similar tenor he subordinated the Vortographs to a lower rank within Vorticism. According to Pound, "Vortography stands below the other Vorticist arts in that it is an art of the eye, not of the eye and hand together."[24] Fearing that through photography Impressionism could influence Vorticism, Pound wrote that Impressionism, being malleable, merely received impressions and was the plaything of conditions, but that

19 Pound, Ezra: Vorwort zu einer Überset-zung von Remy de Gourmonts: *Physique de l'amour: The Natural Philosophy of Love.* New York 1922, p. XVI. Zit. n. quoted from: Hesse, Eva: *Ezra Pound. Von Sinn und Wahn-sinn.* München 1978, pp. 327, 510.

20 Vgl. cf. Lewis, Wyndham: *The Caliph's Design. Architects! Where is your Vortex?* (1919). Edited by Paul Edwards. Santa Barbara, CA, 1986.

21 Vgl. cf. Weaver, Mike: *Alvin Langdon Coburn.* A. a. O. op. cit., p. 68.

tionstechniken, so auch der Fotografie; zum Film sollte sich seine Haltung später differenzieren.[22] Eine Konfrontation mit Coburn bewußt in Kauf nehmend, schrieb er begleitend zu der von ihm ansonsten unterstützten und sogar lancierten Ausstellung *Vortographs and Paintings*: »Kunstfotografie tritt seit zwanzig Jahren auf der Stelle. Während dieser Zeit sind so gut wie keine neuen Effekte erzielt worden. Kunstfotografie ist abgestanden und kleinbürgerlich. Sie hat in der Ästhetik nie eine Rolle gespielt.«[23] In demselben Tenor wird auch der Vortografie ein untergeordneter Rang innerhalb des Vortizismus zugewiesen. Pound: »Die Vortografie steht unter allen anderen vortizistischen Künsten, indem sie eine Kunst des Auges ist und nicht eine gemeinsame des Auges und der Hand.«[24] Pound fürchtete, über die Fotografie könnte der Impressionismus Einfluß auf den Vortizismus nehmen und schrieb, der Impressionismus sei »das Spielzeug der Verhältnisse, die knetbare Masse, die Eindrücke empfängt«, während der Vortizismus eine »gewisse flüssige Energie« gegen die Verhältnisse richte und, »statt nur widerzuspiegeln und zu beobachten, Neues ersinnt.«[25] Seine ambivalente Haltung zeigt sich jedoch darin, daß er den Vortografien diesen Willen zur neuen Form zubilligte: »Sie steht weit über der Fotografie, und zwar deshalb, weil der Vortograf seine Formen nach Belieben kombiniert.«[26] Insgesamt aber schränkte er ein: »Die Vortografie mag jedoch sehr wohl den gleichen Platz in der Ästhetik der Zukunft einnehmen wie ihn die anatomischen Studien der Renaissance in der Ästhetik der Akademie besaßen.«[27] ■ Die Ablehnung Pounds gegenüber der Fotografie beruht demnach auf der von ihm darin gesehenen mangelnden Verbindung von Auge und Hand, zugleich erkennt er in den Vortografien den Willen zur Form, der allerdings nur dazu genügt, daß sie künftig etwa jene Rolle in der akademischen Ausbildung einnimmt, die einst die Anatomie in der Renaissance innehatte. Worauf zielt Pounds Zweideutigkeit? Bliebe es allein bei seiner negativen Bewertung, könnte man ihm ebenso Arroganz wie Unkenntnis

Vorticism exerted a certain fluid energy on the conditions and, instead of simply reflecting or observing, rather devises things new.[25] His ambivalent attitude is nonetheless shown in the fact that he granted the Vortographs this desire for new forms: "It stands infinitely above photography in that the Vortographer combines his forms at will."[26] With reservations he conceded: "Vortography may, however, have very much the same place in the coming aesthetic that the anatomical studies of the Renaissance had in the aesthetics of the academic school."[27] ■ Pound thus rejected photography because he saw in it a lack of harmony between eye and hand; at the same time he recognized the Vortograph's desire for new forms which could, however, only take the role which anatomical studies had enjoyed in Renaissance academic education. What is the point of Pound's ambiguity? If it were for his negative commentaries alone, one could blame him for being both arrogant and ignorant. There are sufficient exemplary photographers—Coburn's friend Stieglitz ought to be mentioned—who helped advance photography formally, too.[28] Put otherwise: Why was Coburn, the well-situated photographer, so fascinated by Pound's ideas—ideas until today so positively received that Pound has become a true role model for other positions of abstract photography, such as the Generative Photography of the Bielefeld School? Retrospectively in his biography and despite all sorts of misunderstandings and confrontations (he responded to Pound in a so-called irritated postscript), Coburn saw credit given to him by Pound for the Vortographer's form-creating energy which also fuelled his future works such as the photographs of construction details of Liverpool Cathedral (fig. p. 173, top, left). He even hoped "to publish some day a little book of these abstract photographs to prove my point".[29] ■ ■ III. When examining the Vortographs more closely, the following can be said: Coburn intended, or so he said, to place photography on

22 Vgl. cf. Hansen, Miriam: *Ezras Pounds frühe Poetik und Kulturkritik zwischen Aufklärung und Avantgarde.* A.a.O. op. cit., pp. 210f.

23 Pound, Ezra: *Pavannes and Divisions.* New York 1918, p. 254. Zit. n. quoted from: Hansen, Miriam: *Ezras Pounds frühe Poetik und Kulturkritik zwischen Aufklärung und Avantgarde.* A.a.O. op. cit., p. 210 (Anmerkung annotation).

24 Ebd. ibid.

25 Pound, Ezra: A Retrospect. In: *Pavannes and Divisions.* New York 1918, p. 51. Zit. n. quoted from: Hesse, Eva: *Ezra Pound. Von Sinn und Wahnsinn.* A.a.O. op. cit., p. 112.

26 Humphreys, Richard: Demon Pantechnichon Driver: Pound in the London Vortex 1908–1920. In: *Pound's Artists. Ezra Pound and the Visual Arts in London, Paris and Italy.* Ausstellungskatalog exhibition catalog. Tate Gallery London. London 1985, p. 71.

27 Pound, Ezra: *Pavannes and Divisions.* New York 1918, p. 254. Zit. n. quoted from: Hansen, Miriam: *Ezras Pounds frühe Poetik und Kulturkritik zwischen Aufklärung und Avantgarde.* A.a.O. op. cit., p. 210 (Anmerkung annotation).

vorwerfen. Gibt es doch genügend Zeugnisse in der Fotografie – der mit Coburn befreundete Stieglitz wäre zu nennen –, die die Fotografie auch in der Form weiterentwickeln halfen.[28] Und umgekehrt gefragt: Was faszinierte den gestandenen Fotografen Coburn an den Reflexionen Pounds, deren Rezeption ihn bis heute für andere Positionen der abstrakten Fotografie – so der Generativen Fotografie der Bielefelder Schule – hat vorbildlich werden lassen? Trotz aller Mißverständnisse und Frontstellungen – Coburn antwortete Pound mit einem, wie es heißt, gereizten Postscript – bewertete Coburn rückblickend in seiner Biografie die von Pound attestierte formgebende Kraft des Vortografen als Anerkennung, die ihn auch für spätere Arbeiten, so die Fotografien von Konstruktionen der Liverpooler Kathedrale, inspirierten (Abb. S. 173, oben links). Er hoffte sogar »eines Tages ein kleines Buch mit diesen abstrakten Fotografien zu veröffentlichen, um meine Ansicht zu beweisen.«[29] ■ ■ III. Auf den Prüfstand gestellt, lassen sich die Vortografien wie folgt rekonstruieren: Die erklärte Absicht Coburns war es, es mit der Fotografie den Abstraktionen in anderen Künsten gleichzutun: »Ich sah nicht ein, weshalb mein eigenes Medium hinter den Trends der modernen Kunst zurückstehen sollte; also strebte ich danach, abstrakte Bilder mittels der Kamera zu machen. Für diesen Zweck [!] erdachte ich das Vortoskop gegen Ende 1916. Das Instrument beteht aus drei Spiegeln, die in Form eines Dreiecks miteinander befestigt sind und in gewisser Weise einem Kaleidoskop gleichen – und ich denke, daß viele von uns sich noch daran erinnern können, welchen Spaß wir mit diesem wissenschaftlichen Spielzeug hatten. Die Spiegel wirkten wie ein Prisma, welches das von dem Objektiv geschaffene Bild in Segmente aufteilte. Sollte jemand wissen wollen, wie das Vortoskop tatsächlich kostruiert ist: Ich habe das Original der Royal Photographic Society überlassen, wo es – ich habe keinen Zweifel daran – immer noch aufbewahrt wird. Die von mir fotografierten Gegenstände waren normalerweise Holzstücke und Kristalle – und im Fall

an even par with abstraction in the other arts: "I did not see why my own medium should lag behind modern art trends, so I aspired to make abstract pictures with the camera. For this purpose I devised [!] the Vortoscope late in 1916. The instrument is composed of three mirrors fastened together in the form of a triangle, and resembling to a certain extent the kaleidoscope—and I think many of us can remember the delight we experienced with this scientific toy. The mirrors acted as a prism splitting the image formed by the lens into segments. If anyone is curious as to its actual construction, I gave my original Vortoscope to the Royal Photographic Society, where I have no doubt it is still preserved. The objects I photographed were usually bits of woods and crystals—and in the case of Plate 55 [in the quoted book; G.J.] Ezra Pound himself."[30] ■ The secret of the *Vortographs* was that they were generated twice by photographic means: that is to say, on the one hand, like any photograph, with the camera, on the other hand, as a broken ray of light in the Vortoscope, since an additional self-made instrument mounted in front of the camera lens was used. The Vortoscope, as 'scientific toy', consisted of three mirrors forming a triangle which, according to another source, was born by "using bits of broken glass from Pound's old shaving mirror [...]."[31] The kaleidoscopic apparatus split the picture into prismatic segments before release of the camera. Objects used were fragments of wood and crystals or, in some works, the portrait of Pound himself. Altogether the Vortographs can be divided into three groups. ■ Mike Weaver describes the first group as "a two-dimensional set of lines with an image of Pound in silhouette. They are flat designs" (fig. p. 173, top right). In its published version one of the Vortographs was later entitled *The High Priest of Vorticism*. ■ The second group, "in which multiple exposure was added to the mirror effects, shows an increased number of overlapped diagonal lines in the manner of Lewis'

28 Vgl. cf. Kellein, Thomas: Die Erfindung abstrakter Fotografie 1916 in New York. In: Kellein, Thomas; Lampe, Angela (eds.): *Abstrakte Fotografie*. A.a.O. op. cit., pp. 33–56.

29 Coburn, Alvin Langdon: *Alvin Langdon Coburn, Photographer*. A.a.O. op. cit., p.102.

Percy Wyndham Lewis: *Workshop*
(Werkstatt), 1914/15
Oil on canvas, 76.5 x 61 cm
The Tate Gallery, London (top left)

Alvin Langdon Coburn: *The Eagle, Vortograph
No. 8* (Der Adler, Vortografie Nr. 8), 1917
(printed later, ca. 1950s)
Gelatin silver print, 20.8 x 15.6 cm
George Eastman House, Rochester (top
middle)

Alvin Langdon Coburn: *Vortograph No. 3*
(Vortografie Nr. 3), 1917 (printed later,
ca. 1950's)
Gelatin silver print, 20.8 x 15.7 cm
George Eastman House, Rochester (top
right)

Ando Hiroshige: *Ferry at Haneda* (Fähre
bei Haneda), 1858
Wood-block print. From the series: *One
Hundred Views of Famous Places in Edo*
(Holzschnitt. Aus der Serie: *Einhundert
Ansichten von berühmten Plätzen in Edo*)
George Eastman House, Rochester (bottom
left)

Alvin Langdon Coburn: *Cadiz Harbour*
(Hafen von Cadiz), 1906
Gelatin silver print, 17.9 x 15.7 cm
George Eastman House, Rochester (bottom
right)

Martin Roman Deppner

Alvin Langdon Coburn: *Liverpool, Cathedral under Construction* (Kathedrale im Bau), 1919
Gelatin silver print, 28.3 x 21.3 cm
George Eastman House, Rochester (top left)

Alvin Langdon Coburn: *Ezra Pound,* 1917
Vortograph. Gelatin silver print 20.2 x 15.5 cm, printed 1950
George Eastman House, Rochester (top right)

Katsushika Hokusai: *View of Mount Fuji from the Valley of Waves in the Sea of Kanagawa* (Ansicht des Fuji vom Wellental im offenen Meer vor Kanagawa), 1831/32. Farbiger Holzschnitt aus der Serie *Sechsunddreißig Ansichten des Fuji* (Color woodcut from the series *36 Views of Mount Fuji*) 25.4 x 36.2 cm
Institute of Arts, Minneapolis (bottom)

der Abbildung 55 [i.d. zitierten Buch; G. J.] war es Ezra Pound selbst.«[30] ■ Das Geheimnis der Vortografien bestand demzufolge darin, daß sie mit Hilfe eines selbst erfundenen Apparates, der vor das Kameraobjektiv geschaltet wurde, sozusagen doppelt apparativ generiert wurden: zum einen, wie jedes fotografische Bild, durch die Kamera, zum anderen als gebrochener Lichteinfall in den Vortoscopen. Das wissenschaftliche Spielzeug Vortoscope bestand aus drei zu einem Dreieck zusammengeführten Spiegeln, dessen Entstehung in einer anderen Quelle auch als »Verwendung von Glassplittern aus Pounds altem Rasierspiegel [...]«[31] beschrieben wird. Das kaleidoskopisch wirkende Gerät splittete das in der Kamera entstehende Bild zuvor auf in ein Prisma aus Segmenten. Als Objekte dienten bereits fragmentierte Hölzer und Kristalle bzw. in einigen Arbeiten das Porträt Pounds höchstpersönlich. Insgesamt lassen sich die Vortografien in drei Gruppen einteilen. ■ Die erste Gruppe wird von Mike Weaver beschrieben als »eine zweidimensionale Reihe von Linien mit dem Bild Pounds im Profil. Es sind flache Entwürfe« (Abb. S. 173, oben rechts). Eine Vortografie davon wurde in der publizierten Fassung später mit *The High Priest of Vorticism* betitelt. ■ Die zweite Gruppe »in der die Spiegeleffekte noch zusätzlich mehrfach belichtet worden sind, zeigt eine größere Zahl sich überschneidender Diagonalen in der Art von Lewis' *Composition* (1913)« (Vgl. *No. 3* und *8*). ■ Die dritte Gruppe »beruht visuell auf den Zeichnungen Jacop Epsteins für seinen *Rock-drill* (1913/15).«[32] ■ Allein diese Orientierungen an den Strukturen vortizistischer Kunst belegen, daß Coburn Pounds Befürchtung, der Gebrauch des Vortoscopen sei nutzlos für jemanden, der für Formen und Muster kein Auge habe, teilte. ■ Die vorwiegend kristalline Gesamtstruktur der Vortografien korrespondiert denn auch mit Pounds Vorstellung, über die Konstruktion des gedanklichen Wirbels die Heterogenität der fragmentierten Kultur wie in einem Kristall zusammenzusehen.[33] Dem Wirbel kam in diesem Bild die Funktion des energetischen Zentrums zu. Pound sah in dem Composition (1913)." (cf. *No. 3* and *No. 8*). ■ The third group "is visually derived from the drawings by Jacop Epstein for his *Rock-drill* (1913/15)."[32] ■ These attitudes towards the structure of Vorticist art alone prove that Coburn shared Pound's fear that the use of the Vortoscope was useless for someone who had no eye for forms and patterns. ■ The largely crystalline overall structure of the Vortographs is analogous to Pound's vision of the heterogeneity of a fragmented culture seen as in a crystal by means of the concept of the vortex.[33] The vortex functions as the energetic centre in this analogy. Pound saw, among other things, a simultaneity of past and future in the crystalline whirl which might also in part explain his reference to the importance of anatomy in the Renaissance compared with the role of photography in contemporary art. The leitmotival crystal in his later *Cantos*, allusive of Ovid's, likewise appears distilled into his work. Pound had in mind a crystal grid which unites the inner functioning of a lower world—like an alchemic synthesis of amorphous bedrock.[34] Pound also mentions the Greek 'phantastikon', the centre of consciousness which certain special individuals are lucky to possess. According to Pound, "their minds are [...] circumvolved about them like soap-bubbles reflecting sundry patches of the macrocosmos."[35] We might also remember that the medieval soothsayer used a crystal ball to tell fortunes. Like Pound, Coburn was also "deeply interested in Oriental art and occult ideas and it seems likely that both he and Pound saw in the 'Vortography' a formal language that also spoke of 'secret things'."[36] ■ Pound swayed between the illusory construct ("Wahngebilde", cf. Eva Hesse) of a perfect identilogical coherence in which everything would harmonize in a crystalline light, and the conclusion that "I cannot make it cohere". ■ In *Canto CXVI* (116) we read: "I have brought the great ball of crystal, / who can lift it? / Can you enter the great acorn of light? / But the beauty is not

30 **Ebd.** ibid.

31 Humphreys, Richard: Demon Pantechnichon Driver: Pound in the London Vortex 1908–1920. In: *Pound's Artists.* A. a. O. op. cit., p. 69.

32 Weaver, Mike : *Alvin Langdon Coburn.* A. a. O. op. cit., p. 68.

33 **Vgl.** cf. Hesse, Eva: *Ezra Pound. Von Sinn und Wahnsinn.* A. a. O. op. cit., pp. 108f., pp. 262f.

kristallinen Zusammenwirbeln u. a. eine Gleichzeitigkeit von Vergangenheit und Zukunft gegeben, woraus sich auch sein Hinweis auf die Bedeutung der Anatomie für die Renaissance im Vergleich mit der Fotografie hinsichtlich ihrer Bedeutung für die Gegenwartskunst z. T. erklären dürfte. Das in seinen späteren *Gesängen*, den an Ovid orientierten *Cantos*, ebenfalls als Leitmotiv fungierende Kristall erscheint in seinem Werk als Destillation. Pound dachte dabei an ein Kristallgitter, das die inneren Zusammenhänge des Unterreichs entsprechend der alchimistischen Synthese des amorphen Erdgesteins verknüpft.[34] Auch erwähnt Pound das griechische ›Phantastikon‹, jene Mitte des Bewußtseins einiger besonderer Menschen. »Ihr Sinn«, so Pound, »ist ihnen rings umgewölbt wie Seifenblasen, auf denen sich etliche Flicken des Makrokosmos spiegeln.«[35] Erinnert sei daran, daß auch dem mittelalterlichen Wahrsager die Kristallkugel als Medium des Hellsehens diente. Wie Pound war auch Coburn »zutiefst an der Kunst des Orients und an okkulten Ideen interessiert, und es erscheint möglich, daß sowohl er als auch Pound in der Vortografie eine formale Sprache sahen, die auch von ›geheimen Dingen‹ sprach.«[36] ■ Pound schwankte zwischen dem »Wahngebilde« (Eva Hesse) der fugenlosen identitätslogischen Zusammenhänge, in denen sich mit kristallinem Glanz alles zusammenfügen würde, und der Feststellung »I cannot make it cohere«. ■ In *Canto CXVI* (116) heißt es: »Die große kristallene Sphäre hab ich geholt, / wer kann sie heben? / Findest du Einlaß in die große Lichteichel? / Doch die Schönheit liegt nicht im Wahnsinn, / Ob mich auch Wrack und Irrtum umgibt. / Ich bin kein Halbgott, / es will sich mir nicht einfügen.« (*I cannot make it cohere.*)[37] ■ ■ IV. Wie Pound interessierte sich Coburn darüber hinaus für die asiatische Kunst. Einige Fotos Coburns sind direkt als ästhetischer Nachvollzug asiatischer Bildkultur zu sehen (Abb. S. 173, unten). ■ Die flächige, in den Bildraum einfallende Bildarchitektur der japanischen Kunst leitete allgemein ein anderes Bildsehen in Europa ein. Sie hat, neben weiteren Ursachen, entschieden dazu

in the madness / Though my errors and wrecks lie about me. / And I am not a demigod, / I cannot make it cohere."[37] ■ ■ IV. As already mentioned, Coburn was interested, like Pound, in Oriental and particularly Asian art. Some of Coburn's photos are to be seen as direct aesthetic replicas of the pictorial culture of Asia (figs. p. 173, bottom). ■ In general, the two-dimensional Japanese pictorial architecture introduced a new mode of perception to Europe. It considerably helped, among other things, to abolish the one-dimensional European perspective as found, for example, in the works of Vincent van Gogh and Edouard Manet.[38] ■ Due to his interest in Asian poetry, the Japanese *haiku* and the plasticity of Chinese calligraphy (with its angular structure), Pound came to associate the concept of the vortex with Asian pictorial culture. He tried to bring together an understanding of the vortex and the image, in other words, to create texts which in an unconscious way imaginatively engender an image.[39] The relationship between Vorticism and Imagism, between vortex and image, is important. This relationship alone makes it possible to comprehend the inspiration which goes beyond a narrow definition of Vorticist art, as later expressed in the work of David Hockney whom I will refer to in the second part of my paper. ■ Pound writes: "The image is itself the speech. The image is the word beyond formulated language. [...] The image is not an idea. It is a radiant node or cluster; it is what I can, and must perforce, call a VORTEX, from which, and through which, ideas are constantly rushing."[40] ■ On the basis of this reflection he set up between 1910 and 1915 a programme which he pursued (with certain adjustments) until completion of his life's work, the *Cantos*. This led to Pound's distinction between sign and symbol, according to which a sign does not exhaust its meaning as quickly as a symbol. For Pound, image and sign are synonymous terms. ■ "The symbolist's symbols have a fixed value, like numbers in arithmetic, like 1,

34 Vgl. ebd. cf. ibid., pp. 99f.

35 Pound, Ezra : *The Spirit of Romance*. London 1910, p. 92. Zit. n. quoted from : Hesse, Eva : *Ezra Pound. Von Sinn und Wahnsinn*. A. a. O. op. cit., p. 111.

36 Humphreys, Richard : Demon Pantechnichon Driver : Pound in the London Vortex 1908–1920. In : *Pound's Artists*. A. a. O. op. cit., p. 69. Vgl. cf. Weaver, Mike : *Alvin Langdon Coburn*. A. a. O. op. cit., pp. 11–21 (The Japanese Influence).

37 Pound, Ezra : *Canto CXVI/795–796*. Zit. n. quoted from : Hesse, Eva : *Ezra Pound. Von Sinn und Wahnsinn*. A. a. O. op. cit., p. 109.

beigetragen, die Eindimensionalität europäischer Perspektivkonstruktionen aufzuheben, so etwa in den Werken Vincent van Goghs und Edouard Manets.[38] ■ Die Verknüpfung von gedanklichem Wirbel und asiatischer Bildkultur ergab sich für Pound vornehmlich aufgrund seiner Beschäftigung mit der asiatischen Dichtkunst, dem japanischen Haiku und dem Bildhaften des chinesischen Schriftzeichens, das auch in der erwähnten Grafik Coburns bezüglich ihrer den Raum einwinkelnden Struktur durchscheint. Pound war darum bemüht, das Verständnis von Vortex und Image zusammenzuführen, das heißt, Texte so zu formen, daß aus diesen ein Bild förmlich imaginativ herausspringe.[39] Die Verbindung von Vortizismus und Imagismus, von Vortex und Image ist wichtig. Erst diese Verbindung ermöglicht die über die enge Auffassung von vortizistischer Kunst hinausreichende inspirierende Anregung, wie sie später u. a. bei David Hockney zur Wirkung gelangte. ■ Pound: »Das Bild selbst ist die Sprache. Das Bild ist das Wort jenseits der formulierten Sprache. […] Das Bild ist nicht eine Idee. Es ist ein strahlender Knoten oder ein Bündel; es ist, was ich nennen kann und gezwungenermaßen ein VORTEX nennen muß, aus dem und durch den Ideen ständig drängen.«[40] ■ Auf Grundlage dieser Überlegung formte er zwischen 1910 und 1915 ein Programm, das er bis zur Vollendung seines Lebenswerkes, den Cantos, mit Erweiterungen für seine eigene Praxis aufrechterhielt. Daraus resultierte auch Pounds Unterscheidung zwischen Zeichen und Symbol, derzufolge ein Zeichen seine Bedeutung nicht so schnell erschöpfe wie ein Symbol. Dabei sind ›image‹ und Zeichen für Pound synonyme Begriffe. ■ »Die Symbole der Symbolisten«, sagt Pound, »sind festgelegte Größen wie die Zahlen in der Arithmetik, wie 1, 2 und 7. Die Bilder (images) des Imagisten sind veränderliche Größen wie die Zahlen a, b und x in der Algebra.«[41] ■ Diese veränderlichen Größen hat Pound in seinen Gedichten als Überlagerung von bildhaften Eindrücken verstanden, als Zusammenschluß eines komplexen Bedeutungsgeflechts zu einem Bildnenner. »Das

2 and 7. The imagiste's images have a variable significance, like the signs a, b and x in algebra."[41] ■ In his poetry Pound understood these variable quantities to be an overlapping of pictorial expressions, as the sum of a complex web of meanings over a pictorial denominator. "The image is the poet's tool", says Pound, and "an image is that which presents an intellectual and emotional complex in an instant of time"; a centre of oscillation allowing the reader's imagination to logically complete the process of interpreta-tion. It creates "that sense of sudden liberation; that sense of freedom from time limits and space limits […]."[42] ■ Thus, according to Pound, the aesthetic of the 'image' consists of the following: tension and moment, escape from time and space, an overlap of semantic layers over a pictorial denominator and its (oscillating) transition into thought. These steps can be traced clearly, albeit upon careful analysis, in Pound's probably most famous, haiku-like 'one-image-poem' from 1914 entitled *In a Station of the Metro*. It reads: "In a Station of the Metro / The apparition of these faces in the crowd; / Petals on a wet, black bough."[43] ■ In Wolfgang Iser's interpretation, this poem is not a representational description but, rather, a mere pictorial phenomenological possibility. Pound achieves this by bringing together two opposing movements. The title still signalizes known details of the outside world, whereas the combination of a subway station and a wet, black bough, of faces in the crowd and of petals, abruptly reduces reality without any links whatsoever. The poem oscillates between what is named and what is imagined. The reader's fantasy is prompted to create an imaginary yet, in the technical sense, dysfunctional image which then initiates the imagining of further connotative pictorial sequences. Nonetheless, there is order in this abrupt, confusing synopsis. For the dark tube of the subway is analogous to the black bough. The petals and the faces have something in common, too; in their

38 Vgl. cf. Walther, Ingo; Metzger, Rainer: *Vincent van Gogh. Sämtliche Werke. Bd. I und II.* Köln 1989, pp. 291f.

39 Vgl. cf. Hansen, Miriam: *Ezras Pounds frühe Poetik und Kulturkritik zwischen Aufklärung und Avantgarde.* A. a. O. op. cit., p. 188; vgl. cf. Iser, Wolfgang : Image und Montage. Zur Bildkonzeption in der imagistischen Lyrik und in T. S. Eliots *Waste Land.* In: Iser, Wolfgang (ed.): *Poetik und Hermeneutik. Immanente Ästhetik – Ästhetische Reflexion.* A. a. O. op. cit., pp. 361–393.

40 Pound, Ezra: Vorticism. In: *Fortnightly Review, 96* (N. S.)/ 573, 1. Sept. 1914 (GB), p. 153. Zit. n. quoted from: Hansen, Miriam: *Ezra Pounds frühe Poetik und Kulturkritik zwischen Aufklärung und Avantgarde.* A. a. O. op. cit., p. 188.

41 Pound, Ezra: Vortizismus. Das Programm der Moderne. In: Hesse, Eva (ed.): *Ezra Pound Lesebuch.* A. a. O. op. cit., p. 104.

Bildhafte (*image*) ist der Werkstoff des Dichters«, sagt Pound, und: Ein »Image ist etwas, was einen intellektuellen und emotionalen Komplex innerhalb eines Augenblicks darstellt«; ein Schwingungszentrum, das den letzten logischen Schritt für eine imaginierende Leistung des Lesenden offenhält. Es erzeuge ein »Gefühl plötzlicher Befreiung und Lösung aus zeitlich und räumlichen Schranken […].«[42] ■ Komplex und Augenblick, Ausbruch aus Zeit und Raum, Übereinanderlagerung von Sinnschichten über einen Bildnenner und ihr (schwingendes) Hinübergleiten zur Denkbewegung machen demnach Pound zufolge die Ästhetik eines ›Image‹ aus. An Pounds wohl bekanntestem, 1914 verfaßten und der Haiku-Form angenäherten ›Ein-Image-Gedicht‹ mit dem Titel *In a Station of the Metro* sind diese Schritte einsichtig nachzuvollziehen, allerdings erst nach analytischer Betrachtung. Es lautet: »In einer Station der Metro / Das Erscheinen dieser Gesichter in der Menge; / Blütenblätter auf einem nassen, schwarzen Ast.«[43] ■ Der Interpretation Wolfgang Isers zufolge ergibt das Gedicht keine gegenständliche Beschreibung, sondern nur eine ins Bild gefaßte Wahrnehmungsmöglichkeit. Das erreicht Pound, indem er zwei gegenläufige Bewegungen miteinander verschränkt. Die Überschrift signalisiert noch bekannte Außenweltdaten, dagegen wirkt die Zusammenstellung von U-Bahnstation und nassem, schwarzem Ast, von Gesichtern in der Menge und Blütenblättern wie eine schroffe Reduktion der Realität, in der die Übergänge fehlen. Das Gedicht oszilliert zwischen Benennbarem und Vorstellung. Die Phantasie des Lesenden wird zu einer imaginären, gleichwohl – im technischen Sinn – funktionsuntüchtigen Bildgestalt veranlaßt, die den Anstoß zur Imaginierung ergänzender Bildfolgen auslöst. Dennoch ist die schockartige, verwirrende Zusammenschau auf eine Ordnung zurückzuführen. Eine Analogie besteht nämlich zwischen der dunklen Röhre des U-Bahnschachtes und dem schwarzen Ast. Auch die Blütenblätter und Gesichter haben etwas Gemeinsames. Beide können in dem Kontext, in den sie gestellt sind, ›aufleuchten‹

given contexts both can either 'light up' or be 'wet'. Pound avoids the random classification of a given sign by offering a combination of signifieds which provoke uncommon juxtapositions of them, thereby making possible other logical structures beyond the usual. The subway tube and the black bough should be seen together as an image with one common denominator. This denominator cannot be found in a comparable function but, rather, by factoring out the differences via a similar aesthetic suggestion of those fragments used.[44] ■ Both object descriptions, reduced in the poem to fragments, have darkness and blackness in common. By means of a cinematic superimposition, the elongated form might help create an imaginary visual relationship, a relationship that brings together the change of perceived horizons both of city and nature, thereby engendering a third image. Sergej Eisenstein, inspired by structures which also influenced Pound's poetry, appropriated a similar aesthetic: that is, the pictorial aspect of Chinese letter characters and of Japanese poetry.[45] But Pound's aim was not the montage of a divergent sequence à la Eisenstein from which would stem a certain compelling thought; but, rather, a perceptual condensation creating a picture, an 'image'. Fenollosa, the Japanologist and art historian, describes this process with the words: "The eye sees two things in one. Things in motion, motion in things."[46] A 'moving-image', as it were. ■ In his later development of the 'image' into the 'ideogram', Pound furthermore made it a method to collate quotations from various historically and culturally connoted areas and different geographical sources. In his *Cantos*, Pound particularly tried to create an effect which he likewise admired in the Japanese haiku and in the abovementioned Chinese letter characters: a plethora of simultaneous meanings, opposing all linear logic, which makes the relationships between things "more real and more significant" than "the things which link them".[47] To repeat: an understanding

42 Pound, Ezra : « *motz el son* » – *Wort und Weise. Eine Didaktik der Dichtung.* Zürich 1957, p. 51.

43 Ezra Pound, zit. n. quoted from: Iser, Wolfgang : Image und Montage. Zur Bildkonzeption in der imagistischen Lyrik und in T. S. Eliots *Waste Land.* In : Iser, Wolfgang (ed.) : *Poetik und Hermeneutik. Immanente Ästhetik – Ästhetische Reflexion.* A. a. O. op. cit., p. 368.

oder ›naß‹ sein. Pound entgeht der beliebigen Zuordnung einer Zeichensetzung durch das Angebot zur Kombination von Zeichenanteilen, das zu ungewohnten Zusammenstellungen reizt, gleichwohl über Signifikanten verfügt, die andere, Sinn machende Strukturen ermöglichen, jenseits gewohnter Bahnen. U-Bahnröhre und schwarzer Ast lassen sich über einen gemeinsamen Nenner zu einem Vorstellungsbild zusammensehen. Dieser Nenner wird nicht aufgrund einer vergleichbaren Funktion, sondern – unter Ausklammerung der Unterschiede – mittels einer ähnlichen ästhetischen Anmutung der ins Spiel gebrachten Fragmente gebildet.[44] ■ Beide im Gedicht zu Fragmenten gewordenen Gegenstandsbezeichnungen sind auf Dunkelheit und Schwärze gestimmt. Mit Hilfe einer Art filmischer Überblendung ließe sich über die längliche Form eine imaginär optische Beziehung herstellen, eine Beziehung, die den Wechsel unterschiedlicher Empfindungshorizonte von Großstadt und Naturerlebnis in eins setzt und ein drittes Bild erzeugt. Sergej Eisenstein hat sich eine vergleichbare Ästhetik zu eigen gemacht, angeregt durch Strukturen, die auch die Poesie Pounds beeinflußten: das Bildhafte der chinesischen Schriftzeichen und der japanischen Dichtung.[45] Aber keine Eisensteinsche Montage des divergierenden Nacheinander, aus der zwingend ein bestimmter Gedanke sprüht, ist das Ziel, vielmehr eine Blickverdichtung zu einem Bild, zu einem *image*. Diese beschrieb der Japanologe und Kunsthistoriker Fenollosa mit den Worten: »Das Auge sieht beides in einem. Dinge in Bewegung, Bewegung in den Dingen.«[46] Ein *moving-image* sozusagen. ■ Später hat Pound in der Erweiterung des *image* zum *ideogram* das Zusammentragen von Zitaten aus historisch und kulturell unterschiedlich konnotierten Bereichen und geografisch auseinanderliegenden Quellen zur Methode erhoben. Vor allem in den *Cantos* versuchte er damit eine Wirkung zu erreichen, die er ebenfalls am japanischen Haiku und am erwähnten chinesischen Schriftzeichen so bewunderte: eine der linearen Logik entgegenstehende Mehrgleisigkeit der Bedeutungen, die die Relationen

of the vortex helps us to link layers of meaning and pictorial worlds—separated and existing independently from one another in history and in genre—which, approaching each other through a common denominator, represent both resting pole and movement between which their true potential is released. ■ ■ **V.** With respect to every comparable source of inspiration, Coburn's later voiced opinion that Vorticism was merely derived from Cubism and Futurism[48] explains the dilemma of his relationship with Pound who, as already mentioned, rightly saw something quite original in Vorticism. Pound accordingly placed Coburn's work close to other non-Vorticist interpretations of art, a fact which might explain his ambivalent attitude. Admittedly, it must be said in this context that his expectations could not really be fulfilled by other Vorticists. Their vortex constructions did not focus on heterogeneous, moving pictorial planes, at best echoes of Byzantine mosaics could be seen in them. These emphasize the sharp contours of each mosaic piece against the other, but never any smooth transitions.[49] The generation of pop artists around David Hockney and R. B. Kitaj used a pictorial principle to turn heterogeneous motifs into oscillating picture patterns; but this is a subject deserving separate research.[50] ■ Let us then concentrate on David Hockney who, particularly with his meanwhile world-famous crystalline, prismatic photographic works, calls for a more than superficial comparison with Coburn and Pound. To begin with, his proximity to the oscillatory centres of the Vorticist aesthetic is best seen in several of his paintings. Hockney himself believes his paintings to be in close dialogue with photography. ■ The possible source of inspiration for Hockney's painting from 1968 of an American collector-couple is a photograph, or more specifically, several self-shot photographs of one motif (figs. p. 180). The painted portrait of the collector-couple is different from the photographs, due to its blurred details and the addition of

44 Vgl. ebd. cf. ibid., pp. 370–372.

45 Vgl. cf. Hesse, Eva: Ezra Pound. *Von Sinn und Wahnsinn*. A. a. O. op. cit., pp. 80f. Vgl. cf. Eisenstein, Sergej: *Vom Theater zum Film*. Zürich 1960, p. 36.

46 Fenollosa, Ernest: Zit. n. quoted from: Fischer, Walter L.: Ezra Pounds chinesische Denkstrukturen. In: Hesse, Eva (ed.): *22 Versuche über einen Dichter*. Frankfurt am Main 1967, p. 179.

zwischen den Dingen »wirklicher und bedeutungsvoller« machen »als die Dinge, die sie verknüpfen«.[47] Nochmals: Mittels eines Vortex-Verständnisses wird die Verknüpfung von historisch und gattungsmäßig getrennt voneinander existierenden Sinnebenen und Bildwelten möglich, die sich über einen gemeinsamen Nenner aufeinander zubewegen, sowohl Ruhepol und Bewegung zugleich darstellen und dazwischen ihr eigentliches Potential entfalten. ■ ■ **V.** Bei allen vergleichbaren Anregungspotentialen macht Coburns später geäußerte Ansicht, daß der Vortizismus lediglich abgeleitet sei von Kubismus und Futurismus,[48] deutlich, worin das Dilemma der Beziehung zu Pound bestand, der ja – wie wir gesehen haben – im Vortizismus zu Recht etwas ganz Eigenes erblickte. Entsprechend sah Pound in den Werken Coburns eine Nähe zu anderen, nicht vortizistischen Kunstauffassungen gegeben, was seine ambivalente Haltung begründen könnte. Daß sich seine Vorstellung ebenfalls bei den anderen Vortizisten nicht wirklich erfüllen konnte, darf dabei freilich nicht unerwähnt bleiben. Schließlich waren ihre Vortex-Konstruktionen nicht auf das sich bewegende Zusammenblenden heterogener Bildschichten gemünzt, allenfalls konnten darin Anklänge an byzantinische Mosaike gesehen werden. Diese betonen die scharfen Kanten der Steinchen, weisen aber keine fließenden Übergänge auf.[49] Das Zusammenblenden hetrogener Motive über einen Bildnenner zu oszillierenden Bildmustern war erst der Generation der Pop-Künstler um David Hockney und R. B. Kitaj vorbehalten, was einer gesonderten Untersuchung bedürfte.[50] ■ Hier konzentrieren wir uns auf David Hockney, der besonders durch seine inzwischen weltberühmten, ebenfalls kristallin und prismatisch anmutenden Fotoarbeiten mehr als nur äußerliche Vergleiche mit Coburn und Pound zuläßt. Zunächst sei seine Nähe zu den Schwingungszentren der vortizistischen Ästhetik hervorgehoben, die sich vor allem in einigen seiner Gemälde aufdecken lassen. Hockney selbst sieht seine Gemälde in einen engen Dialog mit der Fotografie verknüpft. ■ Die Inspirationsquelle

painterly intricacies, such as the linear pattern of the floor. The combination of black/white and color photography is evident in the gradual greying of the painting, with the result that the color is softened—as if controlled—and the shadows lose their fine contours. Hockney's use of acrylic paint as from 1967 helps to lessen the painting's glossy effect, giving it a frozenness reminiscent of a cold shock which, according to Werner Spies, eliminates the realism of the models.[51] ■ With the cold shock, the force of the photographic moment and its time-disrupting effect is heightened; through the arrangement of several perspectives, however, Hockney tries to bring together in one picture the "layers of time".[52] The photograph's "one-point-perspective" (Hockney) disappears or, rather, it must coexist with other perspectives. While the viewer is on the level of the collector-couple, the floor in the picture appears to be seen from an elevated point of view. We are shown each and every object equally and simultaneously. There is no falling or fading away in the picture's background. Hockney tries to level the spatial depth of the photograph.[53] ■ The same applies to Hockney's interpretation of space transforming into a modern pictorial structure the rigidity of Piero della Francesca's spatial understanding which corresponded to scientific rules of the construction of perspective. It should not be overlooked, however, that Hockney also saw 'his' America through the eyes of Edward Hopper. Hopper's paintings of expectation and isolation are artificial in color, as if taken straight out of a Hollywood film, such as his *Seawatchers* of 1952. Hockney transports these out of their local context and into a multitracked, traditional European mode of perception.[54] ■ What has been achieved on all pictorial levels— that is, the motifs, the signs and quotations, the interaction of the media and the use of color—is a dialogic interplay which makes visible and also brings together differences without totally eliminating the source of inspiration.

47 Pound, Ezra (ed.): *Ernest Fenollosa: The Chinese Written Charakter as a Medium for Poetry*. London 1936. Deutsch in: *NO – vom Genius Japans*. Zürich 1963, p. 246. Zit. n. quoted from: Hesse, Eva: *Ezra Pound. Von Sinn und Wahnsinn*. A. a. O. op. cit., p. 84.

48 Vgl. cf. Coburn, Alvin Langdon: *Alvin Langdon Coburn, Photographer*. A. a. O. op. cit., p. 102.

49 Vgl. cf. Hesse, Eva: *Ezra Pound. Von Sinn und Wahnsinn*. A. a. O. op. cit., pp. 253f.

50 Deppner, Martin Roman: *Zeichen und Bildwanderung. Zum Ausdruck des ›Nicht-Seßhaften‹ im Werk R. B. Kitajs*. Hamburg, Münster 1992, pp. 42f.

David Hockney: *American Collectors*
(Fred and Marcia Weizman), 1968
Acryl on canvas, 214 x 305 cm
Art Institute Chicago (top)

David Hockney: *Fred and Marcia Weizman,
Beverly Hills*, 1968
Black-and-white and color photographs
(bottom)

Martin Roman Deppner

für Hockneys Gemälde eines amerikanischen Sammlerpaares von 1968 etwa sind mehrere selbst geschossene Fotos von einem Motiv (Abb. S. 180). Das gemalte Porträt des Sammlerpaares unterscheidet sich von den Fotos zunächst durch die Reduktion der Detailschärfe bei gleichzeitiger Hinzufügung malerischer Einzelheiten – so das gestrichelte Muster des Bodens. Die Kombination aus Schwarzweiß- und Farbfotografie schlägt sich in der leichten Ergrauung des Gemäldes nieder, mit der Folge, daß die Farbigkeit gedämpft wird – wie kontrolliert – und die Schattenschläge ihre Schärfe verlieren. Die um 1967 von Hockney begonnene Verwendung von Acrylfarbe trägt zur Verminderung eines Hochglanzeffektes bei und gibt dem Gemälde jene Gefrorenheit, die an einen Kälteschock erinnert, in dem, so Werner Spies, der Realismus der Vorlagen ausklingt.[51] ■ In der Anmutung des Kälteschocks wirkt die Gewalt des fotografischen Augenblicks und dessen zeitunterbrechende Wirkung gesteigert fort – durch das Arrangement verschiedener Blickwinkel ist dagegen der Versuch unternommen, die »Schichten einer Zeit«[52] in einem Bild zu vereinen. Die dem Foto eigene »Ein-Punkt-Perspektive« (Hockney) verschwindet, oder besser: Sie muß sich ihre Existenz mit anderen Ansichten teilen. Während der Betrachter sich mit dem Sammlerpaar auf gleicher Höhe befindet, erscheint der Boden im Bild von einem erhöhtem Standpunkt aus gesehen. Wir werden auf jeden Gegenstand – als sei er einzeln aufgenommen – gleichwertig und gleichzeitig verwiesen. Eine Abstufung nach hinten ist nicht gegeben. Hockney ist bemüht, die Raumtiefe des fotografischen Bildes zur Fläche hin auf-zuheben.[53] ■ Das gleiche gilt bezüglich jener Räumlichkeit, an der Hockney sich maß, um ihre Strenge in eine moderne Bild-Struktur zu überführen: Die den wissenschaftlichen Regeln der Perspektivkonstruktion entsprechende Raumauffassung Piero della Francescas. Übersehen sollte man freilich auch nicht, daß Hockney sein Amerika zusätzlich mit den Augen Edward Hoppers wahrnimmt. Hoppers in künstlicher, wie aus dem Hollywoodfilm

A logical combination is just as possible as is a different work of art evoking other pictures. But in order to bring together the abundance of elements used, a centre of energy is necessary. It thereby documents something like the artist's wish to concentrate the dispersed forms, colors and signs so that they are readily available for the inquiring beholder; without a doubt, a legacy of the pole of energy found in the centre of the vortex which the Vorticists believed was a trigger for action. ■ A visual comparison with Vorticist art might not bring forward the discussion considerably, since the concentrated planes, colors and perspectives which on occasion become increasingly non-figurative and facetted, are too much focussed on a geometric-technical notion of the vortex. And yet, through the arrangement of a spiral structure and of bands or areas of color directed towards the energetic centre, we are able to draw a structural comparison. If it is true that the "characteristics of all Vorticist compositions are [...] dislocated", i. e. disassembled, displaced "forms, dispersed parts, colors and planes [...] which consolidate into new forms of the mind", as it is put in a commentary concerning the exhibition on Vorticism at the Sprengel Museum, Hanover, then this decidedly coincides with Hockney's approach. Except that the dislocated parts are swirled together by means of a more complex understanding of construction. These parts—together with a semantic, spiral-like descent into the past and numerous dispersed fragments reaching into the present—are combined via a form-content principle, a point of reference to be understood as Hockney's attempt to construct perspective. Pound regarded such a point as the centre of all energies, as the eye of the storm. As a 'still-centre' this concentration of energy functioned as a 'primary pigment', namely as a stimulatory impulse for an 'aesthetic control system' which, according to Eva Hesse, was to be developed into an archetypal characteristic in the

51 Spies, Werner: Die verzweifelte Ver-heißung. Andy Warhol im Museum of Modern Art in New York. In: Spies, Werner: *Rosarot vor Miami. Ausflüge zu Kunst und Künstlern unseres Jahrhunderts.* München 1990, p. 162.

52 Livingstone, Marco: *David Hockney.* Revised and updated edition, London 1987, p. 118 (übersetzt vom Autor).

53 Vgl. cf. Hesper, Stefan: Kristalle der Zeit. Zur Anachronie der Wahrnehmung bei David Hockney und Gilles Deleuze. In: Jürgen Stöhr (ed.): *Ästhetische Erfahrung heute.* Köln 1996, pp. 126–147.

entnommener Farbigkeit gehaltene Erwartungsbilder, so die 1952 gemalten *Seawatchers*, überführt Hockney gleichsam aus ihrer regionalen Voraussetzungslosigkeit in ein mehrgleisiges, Tradition verarbeitendes europäisches Sehen.[54] ■ Auf allen bildnerischen Ebenen – den Motiven, den Zeichen und Zitaten, den Wechselwirkungen der Medien und des Farbeinsatzes – ist ein dialogisches Wechselspiel erreicht, das die Differenzen ebenso aufzeigt wie zusammenführt, ohne die jeweilige Herkunft der Formanregungen ganz zu eliminieren. Eine sinngebende Kombinatorik ist ebenso möglich wie der Umgang mit einem interferierenden, andere Bilder evozierenden Kunstwerk. Zum Zusammenwirken der Fülle jener ins Spiel gebrachten Anteile bedarf es jedoch eines Energiezentrums. Hier dokumentiert es so etwas wie den Willen des Künstlers, die versprengten Formen, Farben und Zeichen zu verdichten, um sie für den fortleitenden Abruf des nachforschenden Betrachters bereitzuhalten. Ohne Zweifel ein Erbe des von den Vortizisten verfochtenen, Aktivierung einleitenden Kraftpols im Zentrum des Wirbels. ■ Der von der Anschauung hergeleitete Vergleich mit der bildenden Kunst des Vortizismus mag dagegen keine nennenswerten Bezugspunkte ergeben, erscheinen doch die um ein optisch wahrnehmbares Zusammenziehen konzentrierten Flächen, Farben und Winkel, denen sich zuweilen auch figurative Reduktionen und Facettierungen angliedern, zu sehr auf eine geometrisch-technische Vorstellung des Wirbels gemünzt. Und doch gelingt das so arrangierte Ineinandergreifen von Spiralstruktur und zum energetischen Zentrum hin gewinkelten Farbstreifen nebst Flächen auf eine Weise, die einen strukturellen Vergleich zuläßt. Wenn richtig ist, daß »Grundzüge aller vortizistischen Kompositionen [...] dislozierte«, d. h. auseinandergelegte, versetzte »Formen, versprengte Teile, Farben und Flächen« sind, »die sich zu neuen Gestalten des Willens verdichten«, wie es in einem Kommentar zu der Ausstellung zum Vortizismus im Sprengel Museum Hannover heißt, dann entspricht dies in einer entschiedenen Hinsicht dem *Cantos*.[55] ■ ■ **VI.** Prior to the post-structuralist and post-modern discovery of fractures, the latter had already existed when a separation of signs was combined with an undoing, so to speak, of sensorial horizons. ■ Contemporary to Vorticist ideas it was Ferdinand de Saussure's *Cours de linguistique générale* which—in its linguistic division of signs into sound and meaning, into signifiant and signifié (into signifier and signified, between sign exterior and sign interior) is to be seen as a parallel development.[56] We thereby come to understand that the communicating person transports the exterior of one thing onto another, somewhat like Ludwig Wittgenstein interpreted our perception of color: "It is as if", he writes in his *Philosophische Untersuchungen* (Philosophical Investigations), "we were to lift the impression of color like a thin skin off the object perceived."[57] Today the disassociation of signs has become the basic tool for many an aesthetic operation without, in my opinion, considering Vorticist achievements and its "dissociation of sensibility": namely, the dissolution of sensorial reflexes, displaced from their supposedly safe environment, and derived from a uniformly functioning emotional order.[58] ■ The "dissociation of sensibility"—occurring when we see separated forms, parts, colors, planes and motifs which expand our capability to build up a novel mode of perception—opens a new door for the experience potential of Modernism. Such an approach, by breaking up the unity of sensorial stimulation and everyday experience, helps conjure up another unfamiliar collage of displaced signs implied in a cultural, communicative and psychological way; with such an approach the Vorticist visions have also lent a semantic dimension to our contemporary shift of signs, deconstructivist thought included. This semantic dimension is still to be explored in the current discussion concerning reference points in a virtuality of signs, in the chain of signifiers/signifieds. It was, after all, Marshall McLuhan, the

54 Diesbezüglich sehe ich einen der wichtigsten Reibungspunkte zwischen der amerikanischen und englischen Auffassung von Moderne gegeben: Während die Amerikaner bemüht sind, sich von Europa abzunabeln mit dem Ziel, die Kunst insbesondere nach 1945 voraussetzungslos zu entwickeln (was Widerspruch hervorgerufen hat, vgl.: Guilbaut, Serge: *Wie New York die Idee der modernen Kunst gestohlen hat.* Chicago 1983; Dresden, Basel 1997), betreiben zahlreiche englische Künstler (auch im Unterschied zu den Kunstauffassungen Zentraleuropas) bis heute eine Verwirbelung des Historischen mit dem Aktuellen, was m. E. auf die Kenntnis der vortizistischen Methoden und Ziele zurückzuführen ist.

Here I see one of the most important points of friction between the American and the English interpretations of Modernism. Whereas the Americans try to free themselves from Europe with the aim to develop, particularly after 1945, an art which focusses on America alone (a fact that has aroused opposition, cf. Guilbaut, Serge: *Wie New York die Idee der modernen Kunst gestohlen hat.* Chicago 1983; Dresden, Basel 1997), many English artists (different also to continental European opinions on art) like to swirl together—even up until today— the historical with the contemporary which, in my opinion, goes back to their knowledge of the Vorticist program.

Vorgehen Hockneys. Nur sind die versprengten Teile mit Hilfe eines weiter gefaßten Konstruktionsverständnisses zusammengewirbelt. Sie sind durch einen inhaltlich gewichteten spiraligen Abstieg in die Vergangenheit einschließlich der Auflese versprengter, in die Gegenwart reichender Fragmente über einen form-inhaltlichen Nenner kombiniert, einem Bezugspunkt, der bei Hockney in diesem und in anderen Beispielen etwa als die Auseinandersetzung mit der Perspektivkonstruktion auszumachen wäre. Für Pound war ein solcher Punkt die Konzentration aller Energien, ein Zentrum im Wirbelsturm. Als *still-centre* fungierte diese Energieballung zugleich als *primary pigment*, als Anfangsimpuls für ein ›ästhetisches Regelsystem‹, das sich in den *Cantos*, so Eva Hesse, zu einem archetypischen Nenner erweitern sollte.[55] ■ ■ **VI.** Die auf dem Abspalten der Zeichen und der Auftrennung der Empfindungshorizonte basierende Kombinatorik schafft denn auch viele Brechungen, die bereits vor poststrukturalistischen und postmodernen Reflexionen zur Wirkung gelangten. ■ Der zeitgleich mit den vortizistischen Ideen geschriebene *Cours de linguistique générale* von Ferdinand de Saussure nämlich, sprachtheoretisch die Aufspaltung der Zeichen in Laut und Bedeutung, von Signifiant und Signifié begründend (von Signifikat und Signifikant, zwischen Zeichenhülle und Zeichenkern), ist als parallele Entwicklung einzustufen.[56] Damit ist die Erkenntnis verbunden, daß der kommunizierende Mensch die Hülle einer Sache auf eine andere zu übertragen versteht, etwa so, wie Ludwig Wittgenstein den Umgang mit den Farben deutete: »Es ist doch förmlich«, schreibt er in *Philosophische Untersuchungen*, »als lösten wir den Farbeindruck wie ein Häutchen von dem gesehenen Gegenstande ab.«[57] Heute ist die Dissoziation der Zeichen zum Grundwerkzeug vieler ästhetischer Operationen geworden, ohne daß m. E. die Leistungen des Vortizismus und seiner *dissociation of sensibility* dabei berücksichtigt würden – jene Auflösung von Sinnesreflexen, herausgenommen aus ihrer sicher geglaubten Verortung, zerteilt aus einer einheitlich

rediscovered author of *Understanding Media* who, during his studies at Cambridge showed interest in Pound and significantly learned from Vorticism with regard to sensorial distraction in the media world. Pop art, with its surprisingly original categories, is for example greatly indebted to him. McLuhan was particularly interested in T. S. Eliot whose most famous poem *The Waste Land* helped to develop Vorticism from its very beginnings.[59] ■ The idea that a picture is imagined as a result of a Vorticist construct or a consciously imagined—and thereby only perceivable—picture is yet another message of the great aesthetic revolution around 1914. This focus on imagination loosened the martial constraints of some Vorticists, as those of Wyndham Lewis for instance, and through a combination of displaced, exposed sensorial structures revealed other aspects of man's suffering. ■ ■ **VII.** Hockney's photographic works function, as it were, by activating our (system of) perception. In this context Hockney is referring to Werner Heisenberg's Uncertainty Principle and his statement that human perception can even change the object perceived (a realization also shared by Pound in relation, however, to magic, alchemic procedures). "The emphasis of Heisenberg's work lies in measurements", says Hockney. "We try to measure the world as if we were not in it", naturally an impossible approach, so Hockney in accord with Heisenberg. "One cannot measure without taking into account the person measuring. [...] This means with reference to pictures that through a change in perspective, the viewer—or participant, so to speak—can be drawn into the picture."[60] ■ Hockney's experiments with Polaroid photographs led him to make shots of one motif as parts of one motif. Every motif detail documents another aspect and another angle. Thus, the viewer is simultaneously guided to various levels: To the cut-up motif, to the equal, individual photos each with their own perspective and to the stabilizing raster of

55 Vgl. cf. Hesse, Eva: *Ezra Pound. Von Sinn und Wahnsinn*. A. a. O. op. cit., pp. 62f. Zum Verständnis des *primary pigment* vgl. cf. Hansen, Miriam: *Ezra Pounds frühe Poetik und Kulturkritik zwischen Aufklärung und Avantgarde*. A. a. O. op. cit., p. 184.

56 Saussure, Ferdinand de: *Grundfragen der allgemeinen Sprachwissenschaft* (1916). Berlin 1967, insbesondere especially pp. 76–127.

57 Wittgenstein, Ludwig: Philosophische Untersuchungen (1952). In: Wittgenstein, Ludwig: *Tractatus logico philosophicus / Philosophische Untersuchungen*. Leipzig 1990, p. 227.

funktionierenden Gefühlsordnung.[58] ■ Mit der *dissociation of sensibility*, die als Folge der Wahrnehmung aus-
einandergelegter Formen, Teile, Farben, Flächen und Motive die Fähigkeit zur Neukonstruktion des Empfindungs-
vermögens erweitert, ist ein neuer Zugang zum Erfahrungspotential der Moderne eröffnet. Mit der geleisteten
Einübung, nach der Auflösung der Einheit von Sinnesreiz und Alltagserfahrung eine anders und ungewohnt gewich-
tete Neumontage der aufgesprengten, kulturell, kommunikativ und auch psychologisch konnotierten Zeichen
anzuregen, haben die vortizistischen Visionen darüber hinaus den Zeichenverschiebungen unserer Zeit – einge-
denk dekonstruktivistischer Aktivitäten – eine inhaltliche Dimension gerettet. Diese ist in der aktuellen Diskussion
um die Existenz von Bezugspunkten in der Zeichenvirtualität, von Signifikantenketten ohne oder mit Referenten
noch auszuloten. Schließlich war es Marshall McLuhan, der wieder aktuelle Autor der *Magischen Kanäle*, welcher
während seiner Studien in Cambridge sich für Pound interessierte und viel bezüglich der Zerstreuung des Empfin-
dungsvermögens in medialen Zusammenhängen vom Vortizismus lernen konnte. Die Pop Art hat es ihm mit über-
raschend anderen Zuordnungen gedankt. McLuhan hat sich insbesondere für T. S. Eliot interessiert, dessen
berühmtestes Poem *The Waste Land* ja den Vortizismus der ersten Stunde weiterentwickeln half.[59] ■ Die Vor-
stellung, daß die Imaginierung eines Bildes als Resultat eines vortizistischen Konstrukts, als Ergebnis eines im
Bewußtsein sich bildenden Bildes und damit als Rezeptionsleistung sich erst erfülle, ist als eine weitere Botschaft
dieses Aufbruchs um 1914 zu werten. Dieses Hinlenken zur Imaginierung hat die martialischen Zwänge mancher
Vortizisten, so auch jene von Wyndham Lewis, überwunden und mit Hilfe der Kombination von dislozierten, offen-
gelegten Empfindungsstrukturen zu anderen Horizonten der leidenden Kreatur geführt. ■ ■ **VII.** Hockneys foto-
grafische Arbeiten sind geradezu getragen von der Aktivierung der Wahrnehmungsstruktur. Hockney beruft sich

the picture surface which, seen in isolation, resembles a template, a minimalistic 'pattern'. The exact date of
the Polaroid Collages (*Noya + Bill Brand with self portrait [although they were watching this picture being made].
Pembroke studios London 8th May 1982*) furthermore suggests that Hockney is making reference, among others,
to On Kawara's *Date Paintings*. (fig p. 186, top) Apart from the precise information given in the title, there is no cen-
tral point of reference for the viewer who is left disoriented amidst the facetting of depth. He stands in front of
a figuration which immediately falls apart in the 'all-over' of the Polaroid; the evaluating eye is directed across
the entire pictorial plane. Remaining for a moment at the borders of the raster yet without finding enough hold
there, the act of viewing becomes analogous to the movement of the camera eye scanning or screening a motif. ■
It is obvious that Hockney aims to photographically translate the multiperspectival rupture which had created ten-
sion between space and object in Cubism. Hockney animates this analogy by including another possibility, namely
to offset the viewer's one-dimensional viewpoint which is, in fact, also Jackson Pollock's way of constantly chan-
ging position by means of the 'all-over' structure of his action painting (fig. p. 186, bottom). Pollock's pictorial
structure—which introduces and connects different emotional levels (sometimes more, sometimes less dynamic,
coupled with careful reflections) and which allows the viewer himself to experience and to mentally summarize
these levels—aims towards imagination, essentially the product of an absent object. The informal structure and the
'all-over', which must be two-dimensional, transform the pictorial plane into an autonomous space-continuum
with a life unto its own.[61] Hockney achieves this not through Pollock's rigorous uncertainty but, rather, by structu-
ral means of perspective and fragmentation. ■ Though Pollock bans visible figures in his pictures, his traces of

58 Vgl. cf. Wind, Edgar: *Kunst und Anarchie*.
Frankfurt am Main 1979, pp. 25f., pp. 130f.
(Anmerkungen annotations 42, 43).

59 Vgl. cf. Moormann, Karl: *Materialien aus
der Grauzone zwischen Literaturwissenschaft
und Informationstechnologien*. Literaturwis-
senschaftliches Seminar, Universität Ham-
burg, Referateservice, 4. Folge, Juni 1992.
Hamburg 1992, pp. 17–20; vgl. cf.: Hesse, Eva:
T. S. Eliot und ›Das wüste Land‹. Frankfurt am
Main 1973; vgl. cf.: Iser, Wolfgang: Image und
Montage. Zur Bildkonzeption in der imagisti-
schen Lyrik und in T.S. Eliots *Waste Land*. In:
Iser, Wolfgang (ed. : *Poetik und Hermeneutik.
Immanente Ästhetik – Ästhetische Reflexion*.
A. a. O. op. cit., pp. 361–393.

Martin Roman Deppner

dabei auf die Unschärferelationen Werner Heisenbergs und dessen Erkenntnis, daß die menschliche Wahrnehmung sogar ihren Gegenstand verändere – eine Einsicht, die Pound ebenfalls teilte, allerdings in Berufung auf magische, alchemistische Prozeduren. »Ein Schwerpunkt der Heisenbergschen Arbeit sind Messungen«, sagt Hockney. »Wir versuchen die Welt zu vermessen, als wären wir selbst nicht auf ihr.« Was natürlich – so Hockney im Einklang mit Heisenberg – unmöglich ist. »Man kann nicht vermessen, ohne den Messenden mit einzubeziehen. [...] Auf Bilder bezogen, bedeutet das, daß mit einer Änderung der Perspektive der Betrachter, sozusagen als Teilnehmer, in das Bild einbezogen werden kann.«[60] ■ Hockneys Experimente mit Polaroidfotos führten dazu, Aufnahmen von einem Motiv als Teile eines Motivs zu geben. Jeder Motivausschnitt dokumentiert einen anderen Blickwinkel und einen anderen Abstand. Der Betrachter wird so auf verschiedene Ebenen gleichzeitig verwiesen: Auf das zerlegte Motiv, auf die einzelnen, gleichwertigen Fotos mit je eigener Perspektive und auf das die Bildfläche stabilisierende Raster, welches, isoliert betrachtet, wie eine Schablone, wie ein minimalistisches *pattern* anmutet. Die Datierung der Polaroid-Collagen auf den Tag genau (*Noya + Bill Brand with self portrait [although they were watching this picture being made]. Pembroke studios London 8th May 1982*) (Abb. S. 186, oben), läßt darüber hinaus vermuten, daß Hockney damit u. a. auf die *Date-Paintings* On Kawaras anspielt. In der heterogenen Tiefenfacettierung hin- und hergerissen, bleibt gegenüber der genauen Angabe im Titel kein zentraler Ort zur Orientierung. Dem Schauenden tritt eine Figuration gegenüber, die zugleich im *all-over* des Polaroids aufgelöst wird; Gewichtungen lenken den Blick über die ganze Bildfläche. An den Nahtstellen des Rasters für einen Augenblick haften bleibend, ohne jedoch ausreichend Halt zu finden, wird das Sehen zu jener Bewegung, die dem Abtasten des Motivs mit der Kamera entspricht. ■ Offenkundig ist, daß Hockney eine fotografische Umsetzung der im Kubismus zur Verspannung von

dripping paint are, however, witness of pulsating bodily action; the figure, in contrast, is to be found in Hockney's 'all-over' camera movement. Whereas Pollock's abolishment of one-dimensionality leads to the infinite—"an aperspectival space which immediately evokes the infinitely curved spaces of modern macrophysics"[62]—Hockney seeks a connection between finite space and infinite movement in a way adopted from microphysics. (This is proof of his knowledge of the Uncertainty Principle). Apart from the different perspectives and the constant change in spatial depth, the blurred spatial relations of the overall motifs and the procedural sequence of shots help to extend the vision beyond the given. ■ By simultaneously showing fragmentation and collation, the blurring of the figure provokes a rupture in narrative perspective which, like the transition from central to multi-perspective and like the premises of the Uncertainty Relations in particle matter between 1900 and 1925, constitutes the action of the modern novel. This brings us to the 'crystallized world' to which the reader gains access, not only through Pound's *Cantos*, but also through a reading of Marcel Proust's *Remembrance of Time Lost*, so treasured by Hockney. The reader learns from the narrator about the "evocation of the twelve spheres of memory [...] in the plurality of the *moi successifs* (the successive I, M. D.), which presuppose Marcel's journey through time." The "pluralistic mode of evocation of the refound 'worlds'" of Proust is possible, due to "two sides of one and the same time", as they appear in the separation of the narrator's perspective (the remembering I) and of Marcel's perspective (the remembered I). Moreover, this perspectival crossing leads to an "uncertainty and irreality" wherein images are created, blurring the contours of messages.[63] Obviously Hockney—particularly in his large-format photo montages ensuing the polaroid raster pictures—is also working with a "new construction of the experience

60 David Hockney in einem Interview mit in an interview with Anders Stephenson am 1. März 1988. In: *David Hockney – Neue Bilder* (Recent Paintings). Ausstellungskatalog exhibition catalog. Frankfurt am Main: Galerie Neuendorf, 1988, pp. 5, 7; vgl. cf.: Heisenberg, Werner: *Die physikalischen Prinzipien der Quantentheorie.* Leipzig 1930; vgl. cf.: Heisenberg, Werner: *Einführung in die einheitliche Feldtheorie der Elementarteilchen.* Stuttgart 1967.

David Hockney: *Noya + Bill Brand with Self Portrait (Although They Were Watching This Picture Being Made) Pembroke Studios London 8th May* (Noya und Bill Brand [indem sie die Entstehung dieses Bildes betrachten]), 1982
Polaroid collage, 62.2 x 62.2 cm
Courtesy of the artist (top)

Jackson Pollock: *No. 32,* 1950
Enamel colors on canvas, 269 x 457.5 cm
Kunstsammlung Nordrhein-Westfalen,
Dusseldorf (bottom)

Raum und Figur führenden multiperspektivischen Brechung beabsichtigt. Hockney belebt diese Entsprechung durch Einbeziehung einer anderen Möglichkeit, den eindimensionalen Betrachterstandpunkt aufzuheben: Jackson Pollocks Suggestion eines beständigen Standortwechsels, hervorgerufen durch die in Folge des *Action Paintings* entstandenen *all-over*-Strukturen (Abb. S. 186, unten). Pollocks Bildstruktur, welche die verschiedenen Grade der Emotion vorführt und verknüpft (mal mehr, mal weniger dynamische Entladung, gepaart mit zurückhaltenden Verweilungen) und die dem Betrachter erlaubt, diese Stadien nachzuvollziehen und selbst gedanklich zusammenzufassen, zielt auf Imagination, die wesentlich aus der Abwesenheit des Gegenstandes resultiert. Die informelle Struktur und das *all-over*, die ihre Voraussetzungen in der Einhaltung der Zweidimensionalität haben, machen die Fläche zu einem Raumkontinuum mit Eigenleben.[61] Dieses Eigenleben erreicht Hockney durch die an Stelle der rigorosen Unbestimmtheit Pollocks getretene Struktur der Blickwinkel und Zerteilung. ■ Während bei Pollock der sichtbare Körper aus dem Bild verbannt ist, die Spuren der Farbläufe aber von pulsierenden Körperhandlungen zeugen, holt Hockney die Figur in das *all-over* der Kamerabewegung hinein. Während bei Pollock die Aufhebung der Eindimensionalität zu einer Unendlichkeit führt, »eine aperspektivische Räumlichkeit, die unmittelbar die Vorstellung von unendlich gekrümmten Räumen der modernen Makrophysik evoziert«,[62] sucht Hockney eine Verknüpfung zwischen endlicher Räumlichkeit und unendlicher Bewegung in einer Weise, die er der Mikrophysik entnommen hat. Hier macht sich die Kenntnis der Unschärferelationen bemerkbar. Neben den unterschiedlichen Blickwinkeln und dem ständigen Wechsel der Raumtiefen sind es die in der Gesamtmotivik verunklärte Raumbeziehung sowie die in der Reihung von Aufnahmen erzeugte Prozessualität, die die Vorstellung über das Gegebene hinaustreiben. ■ Die Verunklärung der Gestalt, hervorgerufen durch die gleichzeitige Zurschaustellung von Zerteilung und Zusam-

of things" à la T. S. Eliot's *Waste Land* in which juxtaposed quotations suggest interfering images that provoke reflection. It is then merely a small step to the effects of superimposition typical of Eliot, to the creation of cinematic effects as found in *The Waste Land*.[64] ■ ■ **VIII.** With the breakthrough to the multiperspective Hockney, as we have already seen, is above all in dialogue with Picasso and translates the Cubist aim to surmount one-dimensional perception into his photographic images, an effect which Hockney, in contrast to his polaroid combinations, tries to heighten in his photo collages. He ultimately goes beyond existing limits, creating informal structures in which photographic moments and painterly gestures come together. Hockney's *Zen Garden* of 1983 is shown here in comparison to a painting by Hans Hartung of 1949 (figs. p. 190). ■ The hybridity of Hockney's art shows that he is interested in breaking up traditional habits of perception. With his shifts of the visual axis which create blurred areas and eliminate a fixing point of sight, Hockney particularly adopts Picasso's method of fragmentation and assemblage, his juxtaposition of construction and figuration.[65] He thereby makes use of photography's capacity for detail and he later also uses the motion gestures of video documentation. Also part of this process are light effects and stage props. Moreover, Hockney does not shy away from reproduction machinery which he integrates into his art, like the fax machine whose quality to transmit messages he cherishes as much as the color photocopier's capacity to copy.[66] When used in his artworks their tension is heightened, this time between that of a technical distance and a handmade closeness. As a consequence, he would not have achieved his multi-facetted prisms without the help of apparatuses, which again brings us to the genesis of Modernism. ■ Before Coburn, the use of apparatuses to explore the changing relations between viewer and picture was already considered and

61 Vgl. cf.: Verspohl, Franz-Joachim: Die Moderne auf dem Prüfstand. Pollock, Wols, Giacometti. In: *Funkkolleg Moderne Kunst.* A. a. O. op. cit., p. 27.

62 Haftmann, Werner: *Malerei im 20. Jahrhundert*. München 1965 (4. Aufl.), Bd. 1, p. 478.

menfügung, ruft jene Aufspaltung der Erzählperspektive ins Gedächtnis, die wie der Übergang von Zentralper-
spektivität zur Mehrperspektivität und die Begründung der Unschärferelation in der Teilchenmaterie zwischen
1900 und 1925 die Handlung des modernen Romans konstituiert. Sie erscheint wie die ›kristallisierte Welt‹, in die
der Leser nicht nur durch Pounds *Cantos* eingeführt wird, sondern in die er auch vermittels der von Hockney sehr
geschätzten Lektüre von Marcel Prousts *A la recherche du temps perdu* gerät. Lesend erfährt er die vom Erzähler
geleistete »Evocation der 12 Erinnerungsbereiche [...] in der Pluralität der *moi successifs* [der aufeinanderfolgen-
den Ichs, M. D.], welche die Etappen von Marcels Weg durch die Zeit bedingen.« Die »pluralistische Erscheinungs-
weise der wiedergefundenen ›Welten‹« Prousts wird möglich, durch die »zwei Aspekte ein und derselben Zeit«, wie
sie in der Trennung der Perspektive »des Erzählers (erinnerndes Ich) und der Perspektive Marcels (erinnertes Ich)«
erscheinen. Überdies geht die Verschränkung der Perspektiven über in eine »Unbestimmtheit und Unwirklichkeit«,
Bilder erzeugend, in denen die Konturen der Aussagen verschwimmen.[63] Offensichtlich operiert Hockney – ins-
besondere in seinen auf die Polaroid-Raster folgenden großformatigen Fotomontagen – auch mit einer »Neu-
konstruktion der Dingerfahrung«, die für T. S. Eliots *Waste Land* gilt, in der die montierten Zitate interferierende
Bilder suggerieren, um Reflexion zu provozieren. Zu der für Eliot typischen Überblendung, zu der Erzeugung
filmischer Effekte wie in *Waste Land* ist es nur ein kleiner Schritt.[64] ■ ■ VIII. Mit der geleisteten Aufsprengung
zur Mehrperspektivität gerät Hockney – wir haben es bereits gesehen – vor allem in einen Dialog mit Picasso und
überführt die von der kubistischen Malerei angestrebte Überwindung eindimensionaler Sehweisen ins fotogra-
fische Abbild, ein Effekt, den Hockney in seinen Fotocollagen gegenüber den Polaroid-Kombinationen zu steigern
versucht. Schließlich sprengt er die Grenzen und erzeugt informelle Strukturen, in denen fotografische Augen-

tested, yet in the context of psychological research in man's perceptive potential. The idea that man sees with two
eyes and that the camera eye, in contrast, directs and focuses the sight of one eye led to stereometric experiments
to break the vision on mirrors with the help of so-called stereoscopes (resulting in the invention of the diorama).
In other words, one tried to reflect the sight of one eye away from that of the other. Inspired by Ernst Mach's
question of why man has two eyes, the stereoscopic experiments made it possible to produce binocular pictures to
which Magritte, for instance, still liked to refer.[67] ■ As regards Magritte, he chose to break up signs whereby he
searched for the difference between sign and object and the power of the shiftings of signs; he thus juxtaposed,
among others, the well-known image of a pipe with the phrase that it was not a pipe. As a picture, the representa-
tion of the object is set apart from the object; it is free for new constructs. As these remarks should illustrate,
it was nothing else but such a superimposition of signs which lay at the basis of Pound's Vorticist thought and which
was set apart from the original object. At bottom, Coburn's apparatus of the Vortograph, deconstructing light and
image, as well as Pound's crystalline cosmos of signs energetically forced through a vortex, led to the following:
Abstractions in which art becomes a mental construct via fields of vision and phenomenological structures which
force further active imagination. And later, it was Walter Benjamin's thought as well which was described as "pris-
matic".[68] However, the fact that Pound, Coburn and Hockney made room for a manual aspect, hence for a direct
contact with the thing or object, makes us wonder whether this dimension can actually be sustained in a digital
age where everything is possible or at least constructible. ■ If the *Vortex* à la Pound made it possible to unite
pole of rest (in the centre) and movement (around the centre), to bring together past and present, primitivism and

63 Jauß, Hans Robert: *Zeit und Erinnerung
in Marcel Prousts* A la recherche du temps
perdu. *Ein Beitrag zur Theorie des Romans.*
Frankfurt am Main 1986, pp. 246f.; vgl. cf.:
Hockney, David: *David Hockney by David
Hockney. My Early Years.* London 1976, p. 40.

64 Vgl. cf. Iser, Wolfgang: Image und Monta-
ge. Zur Bildkonzeption in der imagistischen
Lyrik und in T. S. Eliots *Waste Land.* In: Iser,
Wolfgang (ed.): *Poetik und Hermeneutik.
Immanente Ästhetik – Ästhetische Reflexion.*
A. a. O. op. cit., p. 391.

blicke und malerische Gesten zusammenfallen. Hockneys *Zen Garden* von 1983 sei hier einem Gemälde Hans Hartungs aus dem Jahre 1949 gegenübergestellt (Abb. S. 190). ■ Bei den Mischformen seiner Kunst geht es Hockney folglich um eine Auflösung tradierter Sehgewohnheiten. Insbesondere Picassos Methode des Zerlegens und Zusammenfügens, das Nebeneinander von Konstruktion und Figuration, integriert Hockney in seine Verschiebungen der Sehachse, mit denen er Unschärfen konstruiert, um den festlegenden Augenpunkt aufzulösen.[65] Er benutzt dazu die Ausschnitthaftigkeit der Fotografie, später auch die bewegende Gestik der Video-Dokumentation. Lichtinszenierungen und Bühnenbilder werden ebenfalls in diesen Prozeß integriert. Ferner hat Hockney keine Scheu vor reproduzierenden Maschinen, die er in seine Kunst integriert, so das Faxgerät, dessen Übertragungsqualität er ebenso schätzt wie die Kopierleistung der Farbkopiergeräte.[66] Verwoben in die Kunstwerke erhöht dies abermals die Spannung in seinen Arbeiten, diesmal zwischen technischer Distanz und handgemachter Nähe. Ohne Apparatur wäre er folglich nicht zu seinen vielseitigen Prismen gekommen, was uns abermals auf die Entstehungsgeschichte der Moderne verweist. ■ Die Hinzuziehung apparativer Ergänzungen zur Ergründung wechselnder Beziehungen von Betrachter und Bild wurde bereits vor Coburn erwogen und erprobt, allerdings im Kontext psychologischer Erforschungen der Wahrnehmungspotentiale des Menschen. Die Überlegung, daß der Mensch mit zwei Augen sieht, das Kameraauge dagegen den Blick eines Auges leitet und fokussiert, führte dazu, stereometrische Versuche zu machen, um den Blick mit sogenannten Stereoskopen auf Spiegeln sich brechen zu lassen. Man erprobte sozusagen, den Blick des einen Auges von dem Blick des anderen wegzuspiegeln. Angeleitet durch Ernst Machs Frage, warum der Mensch zwei Augen habe, wurden die stereoskopischen Sehexperimente Anlaß, beidäugige Bilder zu produzieren, auf die noch Magritte Bezug nahm.[67] ■ Magritte leitete in diesem Zusam-

modern technology, the real and the unconscious without "destroying" the "glories of the past" (as Pound remarked, referring to Marinetti and the Futurists, see above), then Hockney's dynamic juxtapositions of the heterogeneous tread upon similar terrain. ■ Hockney's linking of time and space, of photography and painting, of history and modernity, of abstraction and figuration created pictures in the vein of Chinese scrolls from the 17th and 18th centuries—"passable pictures", so to speak, which allow the viewer to stroll from motif to motif.[69] This process, analogous to the relationship between the moving viewer and the static picture, must, however, culminate in relativity, ambivalence and the Uncertainty Relations found in the picture. ■ In a commentary on his large painting *A Visit by Christopher and Don* (fig. p. 191), Hockney emphasizes that the driving force behind this work was a synthesis of the heterogeneous which, inspired by the aesthetic of the Chinese scrolls, made possible the merging of Cubism and narrative structure, a process which Hockney in turn underpins with intensive colors and a certain artificiality; this is both a reflex of media-oriented, contemporary and omnipresent colorfulness and a rejection of such arbitrariness.[70] With reference to his oscillatory centres, neither Hockney nor his interpreters mention the achievements of Vorticism which in its turn is indebted, as shown, to the impulse given by Asian culture for a mode of perception and thought generating prismatic new pictures. It is significant, however, that the literature on Coburn as well as that on Hockney always makes reference to the same pictorial precedent, namely Hokusai's *36 Views of Fuji* (fig. p. 173, bottom).[71] ■ ■

65 Schiff, Gert: Perspektivwechsel: Hockneys Dialog mit Picasso. In: *David Hockney. Eine Retrospektive.* Ausstellungskatalog exhibition catalog. Los Angeles County Musem of Art. Köln 1988, pp. 41–53.

66 Vgl. cf. Mißelbeck, Reinhold (ed.): *David Hockney. Retrospektive Photoworks.* Ausstellungskatalog exhibition catalog. Köln: Museum Ludwig, 1998.

67 Vgl. cf. Clausberg, Karl: *Neuronale Kunstgeschichte. Selbstdarstellung als Prinzip.* Wien, New York 1999, pp. 57–79.

David Hockney: *Sitting in the Zen Garden of
the Ryoanji Temple, Kyoto, Feb. 19, 1983*
(Sitzend im Zen-Garten des Ryoanji Tempels,
Kyoto, 19. Februar 1983)
Photo collage. Ed. 4/20, 144.8 x 116.9 cm (top)
Courtesy of the artist

Hans Hartung: *T 1949–24,* 1949
Oil on canvas, 97 x 146 cm (bottom)

Martin Roman Deppner

David Hockney: *A Visit by Christopher and
Don, Santa Monica*, 1989 (Ein Besuch bei
Christopher und Don, Santa Monica, 1989)
Diptychon. Oil on canvas, 182.9 x 609.6 cm
Collection Ludwig, Cologne

menhang auch zu jenen Zeichenaufspaltungen über, die ihn nach der Differenz zwischen Zeichen und Gegenstand und nach den Potenzen der Verschiebungen der Zeichen Ausschau halten ließ, indem er u. a. das bekannte Bild einer Pfeife mit dem Satz konfrontierte, daß es sich dabei nicht um eine Pfeife handele. Als Bild ist die Darstellung eines Gegenstandes von diesem abgelöst, frei für Neukonstruktionen. Nichts anderes war – wie diese Aufzeichnungen zeigen sollten – schon den vortizistischen Überlegungen Pounds eingeschrieben, bezüglich seiner Überblendung von Zeichen, die von ihren ursprünglichen Trägern abgespalten waren. Im Kern läuft demnach die Licht und Bild zergliedernde Apparatur Coburns ebenso wie der kristalline, durch einen Wirbel energetisch getriebene Zeichenkosmos Pounds auf jene Abstraktionen hinaus, die Kunst über Sehfelder und Wahrnehmungsstruktur hindurch auch zu einem gedanklichen Konstrukt werden lassen, das auf eine aktivierende Weiterimaginierung drängt. Später wurde auch – um einen weiteren Gedanken ins Feld zu führen – das Denken Walter Benjamins als prismatisch beschrieben.[68] Daß bei Pound, Coburn und Hockney Platz für die Hand, für das Machen und damit für die unmittelbare Berührung mit den Dingen gelassen wurde, läßt danach fragen, wie wir diese Dimension in digitaler, alles konstruierender Zeit, ebenfalls aufrecht erhalten können. ■ Wenn ein ›Vortex‹ im Sinne Pounds es erlaubte, Ruhepol (im Zentrum) und Bewegung (um das Zentrum herum) zu vereinen, um Vergangenes und Gegenwärtiges, Primitivismus und moderne Technik, Reales und Unbewußtes zusammenzuwirbeln, ohne die »Herrlichkeiten der Vergangenheit«, wie Pound ja mit einem Seitenblick auf Marinetti und die Futuristen bemerkte, »auszumerzen«, dann haben u. a. Hockneys dynamische Kombinationen des Heterogenen vergleichbares Terrain beschritten. ■ Hockneys Verknüpfungen von Raum und Zeit, von Fotografie und Malerei, Geschichte und Modernität, Abstraktion und Motivstruktur haben ihn zu jenen Gemälden geführt, die – angelehnt an chinesische Bildrollen des 17. und

68 Holz, Hans Hein: Prismatisches Denken. In: *Über Walter Benjamin*. Frankfurt am Main 1968; vgl. cf.: Thierkopf, Dietrich: Nähe und Ferne. Kommentare zu Benjamis Denkverfahren. In: *Text und Kritik*. Heft 31/32, 1979, pp. 15–17 (dort ist von ‚Mosaik‘ und von ‚Kristall‘ die Rede there are used the terms ‘mosaic’ and ‘crystal’); vgl. zu cf. to Hockney: Hesper, Stefan: Kristalle der Zeit. Zur Anachronie der Wahrnehmung bei David Hockney und Gilles Deleuze. In: Jürgen Stöhr (ed.): *Ästhetische Erfahrung heute*. Köln 1996, pp. 126–147.

18. Jahrhunderts – zu ›begehbaren Bildern‹ werden und die die Betrachtenden von Motiv zu Motiv schreiten lassen.[69] Ein Verfahren, das notwendigerweise innerbildlich wie im Verhältnis von sich bewegendem Betrachter zu statischem Bild zu Relativität, Ambivalenz und Unschärferelation führen muß. ■ In einem Kommentar zu seinem großen Gemälde *A Visit by Christopher and Don*, 1984 (Abb. S. 191), hebt er hervor, daß in dieser Arbeit jene Synthese des Heterogenen Pate stand, die die Zusammenführung von Kubismus und Erzählstruktur mit Hilfe der Ästhetik chinesischer Bildrollen ermöglichte, ein Prozeß, den Hockney wiederum durch eine intensive Farbigkeit und Künstlichkeit als Aktivposten unterlegt, ein Reflex mediatisierter, gegenwärtiger und allgegenwärtiger Buntheit wie eine Absage an deren Beliebigkeit zugleich.[70] Zwar erwähnen weder Hockney noch seine Interpreten bezüglich seiner oszillierenden Schwingungszentren die diesbezügliche Vorleistung des Vortizismus, der ja auch – wie gezeigt – der asiatischen Kultur den Impuls zu einer prismatischen, neue Bilder an der Oberfläche generierenden Seh- und Denkweise verdankt. Auffallend ist jedoch, daß sich ebenso in der Literatur zu Coburn die in der zu Hockney stets die Verweise auf die gleiche Bildkultur finden, auf Hokusai und seine *36 Ansichten des Fuji* (Abb. S. 173, unten).[71] ■ ■

69 Weschler, Lawrence: Ein Besuch bei David und Stanley, Hollywood Hills 1987. In: *David Hockney. Eine Retrospektive.* A.a.O. op. cit., pp. 90 – 94.

70 Ebd. ibid.

71 Vgl. Weaver, Mike: *Alvin Langdon Coburn.* A.a.O. op. cit., pp. 11 – 21.

Claudia Fährenkemper: *Tetramorium spec.,*
Mund einer Ameise (Mouth of an Ant), 1998
Rasterelektronenmikroskop-Fotografie
(Scanning electron microscope photograph),
500:1
Gelatin silver print, 100 x 80 cm
Courtesy of the artist

Claudia Fährenkemper

Bilder aus dem Mikrokosmos Images from the Microcosm

Einleitung Fotografie ist ein Medium, das unsere Wahrnehmung sensibilisiert und immer wieder neue Sichtmöglichkeiten eröffnet. Es ist in der Lage, neue Welten zu erschließen und magische Bilder zu vermitteln. Meine Fotografien von Insekten zeigen einen Kosmos, der nur durch das Rasterelektronenmikroskop (REM) sichtbar gemacht werden kann. Im folgenden stelle ich eigene Arbeiten und meinen Weg dorthin vor. Dabei sehe ich meinen Standort als eine Position zwischen Fotografie, Kunst und Wissenschaft. ■ Mikrofotografien lösen winzige Aspekte aus der realen Welt heraus und machen sie auf diese Weise anschaulich. Sie sind durch einen mehrfachen Abstraktionsprozeß gekennzeichnet: ■ ● Es sind aus der Natur isolierte Insekten, die den Gegenstand meiner Betrachtung bilden. ■ ● Es sind tote, goldbedampfte Präparate, deren Oberflächen ich fotografiere. ■ ● Es sind durch die Mikroskopie und ein damit gekoppeltes bildgebendes Verfahren vermittelte Naturstudien. ■ ● Es sind durch die mikroskopischen Vergrößerungen aus ihrem Gesamtzusammenhang herausgelöste Formen. ■ ● Es fehlt ihnen die Farbe, da es Schwarzweißfotografien sind. ■ Meine rasterelektronenmikroskopischen Bilder entstehen nicht in einem ausschließlich fotografischen Prozeß, sondern sie sind Ergebnis eines Hybridverfahrens. Dabei entstehen zunächst die elektronisch-digital erzeugten Abbildungen des Rasterelektronenmikroskops, die dann mit einer an das Mikroskop gekoppelten Rollfilmkamera für das Format 6 x 7 cm auf Schwarzweiß-Negativfilm aufgenommen werden. Die hohe Bildauflösung und die Detailgenauigkeit des Verfahrens führen die Illusion einer Wirklichkeit herbei, welche eigentlich unsichtbar ist, in ihrer Sichtbarkeit aber den ständigen Vergleich zur empirischen Wirklichkeit herausfordert. ■ Seit 1996 fotografiere ich Insekten am Rasterelektronenmikroskop des Zoologischen Forschungsinstitutes und Museums Alexander Koenig in Bonn. Zuvor habe ich Mikrostrukturen wie Mikromotoren und Mikroturbinen mit dem Rasterelektronenmikroskop am Forschungszentrum in Karlsruhe fotografiert. Die Ergebnisse haben mich nicht

Introduction Photography is a medium which sensitizes our perception and which, again and again, opens up new ways of seeing things. Photography is able to make us enter new worlds and to convey magical images of such realms. My photography of insects reveals a cosmos which is only made visible by means of the Scanning electron microscope (SEM). In the following text, I will introduce my own work and the path leading towards it. I place myself in a position amidst photography, art and science. ■ Microphotographs disclose minuscule aspects of the real world and thereby make them visible. My microphotographs are characterised by a multi-faceted process of abstraction, namely: ■ ● They are insects, isolated from nature, which are the object of my project. ■ ● They are photographic images of the surfaces of dead, mounted specimens, dusted with vaporised gold. ■ ● They are studies of nature, transmitted by means of microscopy and an attached image-making procedure. ■ ● They are forms which are abstracted from their general context through microscopic enlargement. ■ ● They lack color, as they are black and white photographs. ■ These scanning electron microscopic images are not solely the product of a photographic process, but rather the result of a hybrid technique. Firstly, the scanning electron microscope makes electronically-digital images taken as pictures (format: 6 x 7 cm) on a black and white negative film by a roll-film camera attached to the microscope. The technique's high optical resolution and detailed precision create the illusion of a de facto invisible reality which, in its visibility, nonetheless provokes a constant comparison with empirical reality. ■ Since 1996, I have taken photographs of insects with a scanning electron microscope at the Zoologisches Forschungsinstitut und Museum Alexander Koenig, Bonn (Alexander Koenig Zoological Research Centre and Museum, Bonn). Prior to this, I took photographs of microstructures, such as micromotors and microturbines, with a scanning

zufrieden gestellt, weil die Größenverhältnisse nicht definierbar waren. Als Maßstab benutzte ich schließlich präparierte Käfer vom Zoologischen Institut in Bonn und kombinierte sie in Karlsruhe mit den Mikrostrukturen. Das Foto vom Käfer mit Mikroturbine war ein Schlüsselerlebnis für die weitere Entwicklung des Themas (Abb. S. 205, oben). ■ Die Insektenfotografien weckten mein Interesse für die verborgene Welt der filigranen und beweglichen organischen Konstruktionen und ihren Reichtum an perfekt erscheinenden morphologischen Details. Mich reizten aber auch die besonderen bildgebenden Möglichkeiten des Verfahrens, vor allem seine detailreiche dreidimensionale Formensprache. ■ Die Serie dieser Insektenfotografien habe ich *Imago* genannt. Das ist zum einen die Bezeichnung für ein erwachsenes Insekt, das alle Entwicklungsstadien durchlaufen hat. Zum anderen zielt der Begriff auf das Bild. ■ ■ **Das Rasterelektronenmikroskop** Das Prinzip des Rasterelektronenmikroskops wurde bereits 1937 erfunden, seine Technik jedoch erst nach 1965 entscheidend weiterentwickelt. Seine besonderen Fähigkeiten bei der Wiedergabe von Oberflächendetails mit einer hohen Auflösung und dreidimensionaler Wiedergabe war für die naturwissenschaftliche Forschung, besonders für Materialanalysen, von großer Bedeutung. Das REM arbeitet anders als das Lichtmikroskop. An die Stelle des sichtbaren Lichts tritt ein Elektronenstrahl, der das Objekt abtastet. Die Grenzen für Beobachtung und Abbildbarkeit werden so erheblich erweitert. Die Schärfentiefe des REM ist etwa 1.000 Mal größer als die des Lichtmikroskops. ■ Das Bild wird nicht im Ganzen erzeugt, sondern wie ein Fernsehbild Zeile für Zeile aufgebaut. In einer hochevakuierten Mikroskopsäule tastet ein durch Elektrolinsen hochgradig gebündelter Elektronenstrahl einen rechteckigen Bereich der Objektoberfläche ab. Der Elektronenstrahl löst an jeder Stelle, auf die er trifft, Sekundärelektronen aus, die auf den Detektor (Elektronenfänger) treffen und durch dessen Szintillator in Lichtblitze umgewandelt werden. Durch einen Fotomultiplier werden die Signale verstärkt und schließlich auf

electron microscope at the Forschungszentrum in Karlsruhe (Research Centre Karlsruhe). I was, however, dissatisfied with the results, since the small size made the microstructures undefinable. Eventually, I used mounted beetle specimens from the Zoological Centre in Bonn as a yardstick and combined them with the microstructures in Karlsruhe. The photograph of a beetle with microturbine was a key experience for the future development of this particular subject or theme (fig. p. 205, top). ■ The insect photographs awakened my interest for the hidden world of filigreed and mobile organic constructions and its abundance of seemingly perfect morphological details. But I was also intrigued by the particularly pictorial potential of this technique, especially its three-dimensional language of shapes, so rich in detail. ■ I called this series of insect photographs *Imago*. On the one hand, this term denotes an adult insect which has gone through all stages of development. On the other hand, the expression refers to the image. ■ ■ **The Scanning Electron Microscope** The principle of the scanning electron microscope (SEM) was invented as early as 1937, but it was only after 1965 that its technology was properly advanced. Its particular capacity to reproduce surface details both three-dimensionally and with a high resolution was of great importance for scientific research, especially for the analysis of materials. The function of the SEM differs from that of the light microscope. In the place of visible light, an electron ray scans the object. Thus, the parameters for observation and representability are widened considerably. The SEM's depth of focus is approximately 1.000 times greater than that of the light microscope. ■ The image is not produced as a whole, but is rather put together line by line, similarly to a picture on television. Within a depressurised microscope shaft, a ray, highly focussed by electron lenses, scans a rectangular area of the object's surface. Wherever and whatever the electron ray touches, it releases in so doing

einem Monitor sichtbar gemacht, wobei die Intensität des Elektronenschreibstrahls der Bildröhre und damit die Helligkeit der Bildpunkte auf dem Bildschirm gesteuert werden kann. Synchron zur Abtastung des Objektes wird ein Bild aus ca. 2.000 Zeilen aufgebaut. Jedem Abtastpunkt auf dem Objekt entspricht ein Bildpunkt auf dem Bildschirm. Das Foto wird schließlich mit einer wesentlich höheren Auflösung als auf dem Arbeitsbildschirm auf Film aufgezeichnet. Eine endgültige Beurteilung des Bildergebnisses ist erst möglich, wenn der Rollfilm entwickelt ist und kleine Abzüge davon vorliegen. ■ Der besondere dreidimensionale Eindruck der REM-Fotografien beruht auf der extremen Schärfentiefe des Verfahrens und auf seinen besonderen ›Lichtverhältnissen‹. In den Fotos sieht es so aus, als käme das ›Licht‹ aus einer bestimmten Richtung. In Wahrheit hängt der Kontrast von der Neigung der Objektoberfläche ab. Die Bereiche, die näher am Detektor der reflektierten Elektronen liegen, erscheinen heller als jene, die weiter entfernt sind. Stellen, die viele Sekundärelektronen aussenden, werden hell wiedergegeben, und umgekehrt. Mit der Neigung einer Fläche nimmt die Menge der austretenden Sekundärelektronen und damit die Helligkeit zu, bis bei streifendem Einfall des Primärstrahls die Fläche ganz hell erscheint. Auf einem vermehrten bzw. verminderten Austritt von Sekundärelektronen an Kanten und Ecken beruht der so genannte Kanteneffekt. Herausragende Strukturen erscheinen heller, tiefer liegende dagegen dunkler. Dieses Phänomen läßt bestimmte Bildpartien häufig wie solarisiert erscheinen. ■ REM-Bilder sind normalerweise monochrom. In Büchern und Magazinen treffen wir dagegen häufig farbige Reproduktionen an. Die Kolorierung ist jedoch fiktiv und wurde entweder von Hand oder mit Hilfe des Computers oder durch Fototechniken erzeugt. Zur Demonstration klarer Formen und Strukturen benutze ich ausschließlich die Schwarzweiß-Fotografie. ■ ■ **Die Präparate** Zum Teil bekomme ich die Käfer, Ameisen, Wanzen etc. von Biologen, häufig sammele ich sie aber auch selbst. Bei der anschließenden Präpa-

secondary electrons which hit the detector (electron receptor), the scintillator of which in turn transforms the secondary electrons into flashes of light. The signals are amplified by means of a photo-multiplier and finally become visible on a monitor, whereby the intensity of the picture tube's electron recording ray, hence the lightness of the scanning points, can be controlled on the monitor. An image of approximately 2.000 lines is built up synchronous to the scanning of the object. Each point scanned on the object is equivalent to a scanning point on the monitor. The photo is finally recorded on film with a much higher resolution than on the operating monitor. An ultimate analysis of the recorded image is only possible after processing the film roll and after miniature prints thereof are available. ■ The special three-dimensional character of SEM photographs lies in their extreme depth of focus and in their particular 'conditions of light'. In these photos, 'light' appears to be coming from a certain direction. But, in reality, the contrast is only due to the slant of the object's surface. The areas closer to the detector of the reflected electrons appear to be brighter than those more distant. Areas emitting many secondary electrons are rendered bright and vice versa. As the gradient of a surface area increases, so does the number of emitted secondary electrons, and consequently its brightness, until the area appears totally bright as the primary ray passes it. The so-called edge effect (Kanteneffekt) is the result of an increased and/or decreased emission of secondary electrons at edges and in corners. Protruding structures appear brighter, those lower-lying are comparatively darker. This phenomenon often makes certain parts of the picture appear to be solarized. ■ SEM images are normally monochrome. But in books and magazines one often finds reproductions in color. However, this is a fictive coloration, executed either by hand, by means of a computer, or by photographic techniques. In order to demonstrate clear

ration, die ich selbst vornehme, treffe ich unter dem Stereomikroskop mit 20-40facher Vergrößerung zunächst eine Auswahl von Insekten oder Fragmenten. Nach ihrer Reinigung in einem Ultraschallbad werden sie in einer Alkohol-reihe getrocknet und schließlich auf einem Probenteller fixiert (1 cm im Durchmesser). Abschließend werden sie hauchfein (Schichtdicke: 25–40 nm) mit Gold bedampft und damit leitfähig gemacht. Meine Insektenpräparate haben eine Gesamtgröße von etwa 3–10 mm. ■ ■ **Konkrete Abstraktion** Im Zusammenhang mit Arbeiten von Albert Renger-Patzsch bin ich auf den Begriff ›Konkrete Abstraktion‹ gestoßen, den ich auch für meine Arbeit als durchaus zutreffend erachte.[1] In Abb. S. 213 sieht man sowohl die plastische Kugelform, als auch die unzähligen klei-nen runden Hufeisenformen der Oberflächenstruktur. Sie greifen die große runde Form im Detail wieder auf und sehen wie eine Ziselierung aus. Das Foto zeigt in aller Schärfe den Käfer *Ceratocanthus spec.* in 30facher Ver-größerung. Er ist mit all seinen Details eindeutig zu definieren. Zugleich stellen sich bei der Betrachtung unvermit-telt eine Reihe von Assoziationen zu Formen im Makrokosmos ein, die mit diesem Käfer überhaupt nichts zu tun haben. Die Abstraktion ist gekoppelt mit dem gesteigert realistischen, plastisch-räumlichen Eindruck. ■ Dabei gilt mein Interesse nicht der Illustration besonderer wissenschaftlicher Beobachtungen, sondern dem sinnlichen Erleb-nis einer perfekten, komplexen, winzigen Form als Raum, Skulptur oder Landschaft. Eine wesentliche Rolle spielen die Formanalogien zur sichtbaren Welt. Die wissenschaftliche Bedeutung leitet jedoch in keiner Weise meine Aus-wahl. Meine Fotografien zeigen nicht Objekte entomologischer Forschung. Selbst wenn sie für Biologen von wissen-schaftlicher Bedeutung wären, so haben sie doch ihre eigene Welt, die offen ist für viele Interpretationen, die den Mikrokosmos mit dem Makrokosmos verbinden. Im Gegensatz zu ihrem Realismus haben diese Fotografien immer auch etwas Geheimnisvolles, Magisches und Surreales. Sie haben schließlich nichts mehr mit dem Insekt zu tun,

shapes and structures, I make exclusive use of black and white photography. ■ ■ **The Prepared Specimens** I often receive beetles, ants, bugs, etc. from biologists, although I also collect them myself frequently. When preparing them, I choose from a variety of insects and segments, magnified 20 to 40 times under the stereomicroscope. Having been cleaned in an ultrasound bath, the samples are dried in a sequence of alcohol, then mounted on a sample plate (1 cm in diameter). Finally, they are very thinly dusted with vaporised gold (25–33 nm thick) which makes them conductive. My preparations of insect specimens are approximately 3–10 mm in size. ■ ■ **Concrete Abstraction** In connection with works by Albert Renger-Patzsch, I came upon the term 'concrete abstraction' which I consider to be quite relevant for my work as well.[1] Fig. p. 213 shows both the plastic spherical shape, as well as countless small round horse shoe shapes of the surface structure. The latter, resembling engravings, pick up in detail the large round form of the former. The photograph shows the beetle *Ceratocanthus spec.* with greatest precision, magnified 30 times. It is clearly definable in all its details. Likewise, it is possible to study directly a range of associations to forms in the macrocosm, totally unrelated to this beetle. Abstraction is therefore coupled to the intensified realistic, three-dimensional impression. ■ In so doing, I am not so much interested in the illustration of particular scientific studies, but rather in the sensorial experience of a perfect, complex, minuscule form as space, sculpture or landscape. Form analogies to the visible world play an important role here. However, their scientific importance does in no way influence my choice. My photographs do not represent objects of entomological re-search. Even if they were of scientific importance to the biologist, they represent a world of their own, open to a plethora of interpretations connecting the microcosm with the macrocosm. Contrary to their realism, there is

1 Kuspit, Donald: Albert Renger-Patzsch –
A Critical-Biographical Profile. In: *Aperture*,
Vol. 131, 1993, p. 69.

Claudia Fährenkemper

sondern sind eigenständige Bildlösungen. Nicht das Insekt, sondern dessen Abbild wird bis in die Tiefen ausgelotet. ■ Folgende Vorgehensweisen und Entscheidungen sind dazu notwendig: ■ ● Fragmentieren, Isolieren und Monumentalisieren von prägnanten, konstruktiven Formen bzw. Details aus einer unbegrenzten Vielzahl potentieller Bilder innerhalb eines Präparates. ■ ● Wahl der günstigsten Perspektive, der besten Schärfentiefe und des besten Kontrastes, um den dreidimensionalen Eindruck erfahrbar zu machen. Dies setzt umfassende Kenntnisse der apparativen Bedienung voraus. ■ ● Wahl eines mikroskopischen Vergrößerungsbereiches zwischen 40- und 3.000fach, in dem die Objekte noch ihre Konkretheit behalten (Man kann mit dem REM problemlos in den atomaren Bereich gelangen, bis zu einer 100.000fachen Vergrößerung). ■ ● Wahl der geeigneten Film-Entwickler-Kombination für Schärfe und Feinkörnigkeit. ■ ● Wahl der fotografischen Vergrößerung und Präsentation. Meine Vergrößerungen auf Barytpapier haben Formate zwischen 50 x 60 und 80 x 100 cm (wissenschaftliche Bilder sind dagegen meist klein, selten größer als 9 x 12 cm und heute zunehmend Digitalprints). ■ Diese bewußten Entscheidungen machen den Unterschied meiner fotografischen Arbeit zu Wissenschaftsfotografien aus. ■ Nach der vorbereitenden Präparation ist vor allem die visuelle, betrachtende Arbeit am Mikroskop ein oft sehr langwieriger Prozeß. Er nimmt nicht selten zehn Stunden an einem einzigen winzigen Insekt in Anspruch. Dabei wird das Objekt immer wieder gekippt, gedreht und erneut fokussiert, um es aus allen möglichen Perspektiven zu betrachten. Es ist ein Herantasten an unvorhersehbare Bilder. Während dieses Beobachtungsprozesses sammelt man oft eine Reihe von Bildern als Notizen, die dann, wenn das definitive Bild gefunden ist, im weiteren fotografischen Prozeß verworfen werden. Das Ringen um das gültige Bild ist prinzipiell nicht anders als bei Fotografien der sichtbaren Welt. Neben fotografischen Kenntnissen setzt es jedoch die der mikroskopischen Technik voraus. ■ ■ **Mein Weg zur Mikrofotografie** Qualität

always something mysterious, magical or surreal in these photographs. Ultimately, they no longer have to do with the insect, but they are independent images. Not the insect, but an image of it is explored in depth. ■ For this, the following steps and decisions guide me: ■ ● To fragment, isolate and blow up characteristic, constructive shapes and details out of an unlimited number of potential pictures from a given slide preparation. ■ ● To determine the most favourable perspective, the best depth of focus and the best contrast, in order to make the three-dimensional impression perceivable. It is a prerequisite to fully understand the functioning of the apparatus. ■ ● To determine a microscopic magnification range of between 40 and 3.000 times, a range wherein the objects still show their specific shape (the SEM easily enters the atomic range with a magnification rate of up to 100.000 times). ■ ● To determine a suitable film-processing combination for sharpness and fineness of grain. ■ ● To determine photographic enlargement and presentation. The format of my enlargements on baryta paper are between 50 x 60 cm and 80 x 100 cm in size (scientific prints, in comparison, are mostly small, rarely larger than 9 x 12 cm, and are nowadays increasingly digital prints). ■ The deliberate choices outlined above set my photographic work apart from scientific photography. ■ The preparation of the samples is followed by the visual work of microscopic scrutiny, often an extremely time-consuming process. The study of one tiny single insect for up to ten hours is no exception. Because of that, the object is again and again tilted over, turned around and focussed anew, so as to examine it from all possible perspectives—it is a way of gradually approaching unimaginable images. During this process of examination, a set of images is often collected as studies, which are later discarded when the definitive photograph has been found. The difficulty of finding the perfect picture is, in principle, the same as it is with photographs of the

und Systematik ihrer Arbeitsweise sowie der streng dokumentarische und konzeptuelle Ansatz meiner Lehrer Bernd und Hilla Becher haben meine Studien an der Kunstakademie Düsseldorf wesentlich geprägt. In dieser Zeit, zwischen 1988 und 1993, fotografierte ich mit einer Großformatkamera in den Braunkohlentagebauen Deutschlands. Zunächst machte ich dabei nur Landschaftsaufnahmen, auch unter dem Eindruck ausgedehnter Canyon- und Wüstenlandschaften, die ich im Südwesten der USA zwischen 1987 und 1991 bereiste. Dabei interessierten mich vor allem die Morphologie der natürlichen Landschaft und ihre Formverwandtschaft zu den mir bekannten Industrielandschaften. ■ Von einem bestimmten Punkt an verlagerte sich mein Interesse auf die Maschinen, die beim Braunkohlenabbau eingesetzt werden und die die Landschaft über lange Zeiträume hinweg bearbeiten und gestalten. Während der letzten zehn Monate der Montage eines dieser 200 m langen und 100 m hohen Geräte am Tagebau Hambach fotografierte ich 1991 eine Serie von Details der Konstruktion dieses Baggers aus verschiedensten Perspektiven (Abb. S. 205, unten). Auf die Serie von Konstruktionsdetails folgte eine umfangreiche Dokumentation von Braunkohlentagebaugeräten, die ich über einen Zeitraum von fünf Jahren, bis 1993, in sämtlichen deutschen Tagebauen fotografierte.[2] Wesentliches Ziel war die Wiedergabe präziser morphologischer Details der industriellen Landschaft, aber auch Bilder von Konstruktionen und Funktionen ihrer riesigen beweglichen Maschinen. Ein anderer wichtiger Aspekt war das Verhältnis von Mensch, Maschine und Landschaft. Menschen fungieren in diesen Bildern oft als Maßstab. Viele der fotografierten Maschinen sind inzwischen nicht mehr im Einsatz, gesprengt, zerlegt. In den meisten der unzähligen kleinen Tagebaue im Osten Deutschlands ist der Förderbetrieb eingestellt, die Landschaft sich selbst überlassen oder sie befindet sich in einem Prozeß der Rekultivierung. Viele dieser Fotografien sind inzwischen historische Dokumente. ■ Unabhängig von diesem Projekt hatten mich schon 1992 Fotografien von

visible world. Apart from requiring photographic expertise, an understanding of the microscope's technology is a sine qua non as well. ■ ■ **My Path towards Microphotography** The high quality and systematic approach of the work of my teachers Bernd and Hilla Becher, as well as their strictly documentary and conceptual tendency, greatly influenced my studies at the Academy of Arts in Dusseldorf. During this period, between 1988 and 1993, I used a large-format camera to take pictures in the brown coal open-cast mining areas of Germany. At first I only made landscape photographs, inspired by the vast landscapes of canyons and deserts in the South West of the United States where I had travelled between 1987 and 1991. Thus, I was interested above all in the morphology of the natural landscape and in the relationship of its forms to those industrial landscapes known to me. ■ From a certain point onwards, my interest shifted to the machines used in brown coal open-cast mining and which work and shape the landscape over lengthy periods of time. In 1991, during the last ten months when one of those structures (200 m in length, 100 m in height) was assembled in the Hambach open-cast mine, I photographed a series of construction details of this excavator from different perspectives (fig. p. 205, bottom). This particular series was followed by an extensive documentation of brown coal open-cast mining equipment which I photographed in all of Germany's open-cast mines over a period of five years until 1993.[2] My principal aim was to reproduce not only precise morphological details of industrial landscapes, but also to produce images both of the construction and the function of the giant, mobile machines active in them. The relationship of man, machine and landscape played another important role. People often act as yardsticks in these pictures. In the meantime, many of the photographed machines are no longer in use—they are blown up or disassembled. Operations have ceased in most of East

2 Fährenkemper, Claudia: *Fördergeräte im Braunkohlentagebau.* Ausstellungskatalog exhibition catalog. Kreismuseum Peine 1993.

Claudia Fährenkemper

staubkorngroßen Mikrostrukturen im Wissenschaftsteil überregionaler Zeitungen neugierig gemacht, zumal sie mich an meine vielfach fotografierten Baggerdetails erinnerten. 1993 hatte ich mehrfach Gelegenheit, am Institut für Mikrostrukturtechnik des Forschungszentrums Karlsruhe Aufnahmen von solchen Mikrostrukturen zu machen. Auch meine Schwangerschaft 1994 trug dazu bei, meine Arbeit in die gegenwärtige Richtung zu führen. Ultraschall-Videoprints, die das ungeborene Kind in meinem Körper sichtbar machten, interessierten mich, und es folgte eine intensive Auseinandersetzung mit den bildgebenden Verfahren der Medizin. Ich fotografierte die auf dem Bildschirm eingefrorenen Bilder von Föten und vergrößerte sie als Porträts aus ihren Schallsegmenten. Ich setzte die Porträtserie von 16 bis 23 Wochen alten Föten mit schwangeren Frauen in einer Praxis für Pränataldiagnostik bis 1995 fort.[3] 1996 nahm ich die Arbeit am Rasterelektronenmikroskop wieder auf und setzte meine mikrofotografische Arbeit mit Insekten am Zoologischen Forschungsinstitut in Bonn fort. ■ Zu meinen Leitbildern für dieses Gebiet zählt der Zoologe Ernst Haeckel (1834-1919). Er gab 1863 eine *Radiolarienmonografie* mit etwa 3.000 Zeichnungen von Skeletten und Schalen wasserbewohnender Mikrolebewesen heraus. Zwischen 1899 und 1904 erschien seine Arbeit innerhalb der zehnbändigen Reihe *Kunstformen der Natur*.[4] Sie erfüllt bis heute hohe wissenschaftliche und ästhetische Ansprüche (Abb. S. 204). Auch Karl Blossfeldt (1865-1932) gehört mit seinem Buch *Urformen der Kunst* von 1928[5] und seinen Arbeiten dazu. Sie waren 1994 im Kunstmuseum Bonn zu sehen und beeindruckten mich in ihrer Strenge, Monumentalität und skulpturalen Qualität (Abb. S. 206f.). ■ Nennenswerte Vorbilder sehe ich auch im Werk des Bielefelder Grafikers und Fotografen Carl Strüwe (1898-1985), dessen Buch *Formen des Mikrokosmos* 1955 erschien,[6] und der darin eine eigene Systematik und Symbolssprache der Mikrofotografie entwickelte. In den elementaren Formen des Mikrokosmos sah er Symbole des Lebens und ›Urbilder‹, so für

Germany's countless, small open-cast mines, the landscape being left on its own or finding itself in the course of recultivation. Many of these photographs are historic documents today. ■ Already as early as 1992 and unrelated to this project, I found in the scientific sections of national newspapers photographs of microstructures, the size of dust particles. They aroused my curiosity, particularly since they reminded me of details of the excavator which I had so often photographed. In 1993, I had the opportunity on several occasions to take photographs of such microstructures at the Nuclear Research Centre, Karlsruhe. My pregnancy in 1994 furthermore helped push my work into the present direction. Ultrasound videoprints, showing the unborn child in my body, caught my interest and set in action an intense dialogue with the image-giving methods applied in medicine. I photographed images of the foetus frozen on the monitor and enlarged them as portraits out of their sound segments. Until 1995, I kept up work on the portrait series of foetuses (16 – 23 weeks old) with pregnant women in a clinic for prenatal diagnosis.[3] In 1996, I resumed work at the scanning electron microscope and continued my microphotographic work with insects at the Zoologisches Forschungsinstitut, Bonn. ■ The zoologist Ernst Haeckel (1834 – 1919) is one of my role models in this field. In 1863, he published his so-called *Radiolarienmonografie*, comprising approximately 3.000 illustrations of skeletons and shells of aquatic micro-organisms. Between 1899 and 1904, his work appeared in a series of ten volumes entitled *Kunstformen der Natur* (The Art Forms of Nature),[4] which, to this day, satisfies high scientific and aesthetic demands (figs. p. 204). Karl Blossfeldt (1865 – 1932) is likewise one of my mentors, with his book from 1928 called *Urformen der Kunst* (Primal Forms of Art)[5] and his works in general. In 1994, they were exhibited at the Kunstmuseum Bonn, and I was impressed by their severity, monumentality and sculptural quality (figs. pp. 206f.). ■

3 *3. Internationale Fototriennale*. Ausstellungskatalog exhibition catalog. Esslingen 1995, pp. 38ff.

4 Haeckel, Ernst: *Kunstformen der Natur*. 10 Bände. Leipzig, Wien 1899 – 1904.

5 Blossfeldt, Karl: *Urformen der Kunst. Photographische Pflanzenbilder*. Text: Karl Nierendorf. Berlin 1928.

6 Strüwe, Carl: *Formen des Mikrokosmos. Gestalt und Gestaltung einer Bilderwelt*. München 1955; Jäger, Gottfried: *Carl Strüwe. Das fotografische Werk 1924 – 1962*. Ausstellungskatalog exhibition catalogue. Kulturhistorisches Museum. Bielefeld, Düsseldorf 1982.

das Kollektiv, für das Individuum, für die Abwehr usw. (Abb. S. 208f.). ■ Zuletzt nenne ich in diesem Zusammenhang den Kölner Fotografen August Kreyenkamp (1875-1950). Auch ihm war, wie allen anderen vorher Genannten, das Werk von Haeckel bekannt. Seine Kompositionen vor allem aus den 1930er Jahren sind klar und sachlich und von einer zu damaliger Zeit ungewöhnlich kompromißlosen technischen Qualität. Form und Struktur der Kieselalgen spiegeln sich in seinen Fotografien von Harzkristallen und Mohnkapseln, wie auch in seinen aus der Vogelperspektive aufgenommenen Bildern von Regenschirmen einer Menschenmenge oder umgestürzten, ausrangierten Pferdekarren mit Speichenrädern. Verschiedene Varianten abgetrennter Insektenköpfe weisen auf eine intensive Auseinandersetzung mit der Präparation und der Perspektive hin, die meiner Arbeitsweise durchaus verwandt ist (Abb. S. 206, unten). Vereinzelt trifft man auf eine Publikation seiner Arbeit.[7]

Examples I consider worth mentioning are also to be found in the work of Carl Strüwe (1898–1985), the graphic artist and photographer from Bielefeld, whose book *Formen des Mikrokosmos* (Forms of Microcosm)[6] appeared in 1955. In it he developed his very own systematic of and symbolic language for microphotography. In the elementary forms of the microcosm, he saw symbols of life and primal images (Urbilder)—for the collective, the individual, the defence, etc. (figs. pp. 208f.). ■ Last, but not least, I should mention in this context August Kreyenkamp (1875–1950), a Cologne photographer. He too, like all the aforementioned, was acquainted with Haeckel's work. His compositions, particularly those from the 1930s, are lucid and objective and they reveal an uncompromising technical quality unusual in those days. The form and structure of diatoms are reflected in his photographs of resin crystals and poppy-heads, similar to his photographs of umbrellas in a crowd, taken from a bird's-eye view, or of overturned, dumped horse carriages with spoke-wheels. Different variations of severed insect heads indicate an intense concern for both preparation and perspective, very much related to my method of working (fig. p. 206, bottom). Sporadic one could find a publication of his work.[7]

7 Thomas, Ann: *The Search for Pattern.*
In: Ausstellungskatalog exhibition catalog.
National Gallery of Canada, Ottawa, 1997;
Thomas, Ann: *Beauty of Another Order—
Photography in Science.* New Haven, London,
Ottawa 1997, p. 106, Anmerkung annotation
no. 67.

8 D. B. (Denis Brudna): Claudia Fähren-
kemper – Imago. In: *Photonews*, Nr. 2/2001,
pp. 14–15.

■ ■ **Zusammenfassung und Dank** Meine frühere Beschäftigung mit Maschinen und mit der durch sie geprägten Landschaft hat meine aktuelle Arbeit und Wahrnehmung von Natur wesentlich beeinflußt. Anders als zu Beginn des 20. Jahrhunderts, als die Natur noch mehr von einem romantischen Standpunkt aus gesehen wurde, ist die Art und Weise, in der wir sie heute betrachten, kühler und sezierender. Die zunehmende Dominanz von Technik und Wissenschaft in unserem Leben und der damit verbundene Einfluß der wissenschaftlichen bildgebenden Instrumente auf die Wahrnehmung von Natur ist dafür mit verantwortlich. ■ Die Mikrofotografie spielt als Mittel der Bildproduktion in zeitgenössischen deutschen Fotografieausstellungen heute kaum eine Rolle – anders als in den großen Ausstellungen der ersten Hälfte unseres Jahrhunderts und auch im Gegensatz zur Rezeption solcher Fotografien in den USA und Kanada. Ich hoffe, daß ich mit meinen Fotografien einen Beitrag zu einer größeren Aufmerksamkeit für dieses faszinierende Gebiet zwischen Wissenschaft und Kunst leisten kann.[8] ■ Dem Zoologischen Forschungsinstitut und dem Museum Alexander Koenig, vor allem Dr. Michael Schmitt und Karin Ulmen, möchte ich an dieser Stelle für die großzügige Unterstützung meiner Arbeit danken. Auch dem Institut für Mikrostrukturtechnik am Forschungszentrum Karlsruhe, besonders Prof. Wolfgang Menz und Gerhard Schüler, gilt mein besonderer Dank. ■ ■

■ ■ **Summary and acknowledgements** My earlier preoccupation with machines and landscapes shaped by them considerably influenced my present work and perception of nature. In contrast to the beginning of the twentieth century, when nature was still looked at from a more romantic point of view, we tend to regard her today in a more sober, more analytical way. The increasing dominance of technology and science on our lives and the ensuing influence of scientific, pictorial instruments is responsible for our changing perception of nature as well. ■ Today, microphotography as an image-producing medium hardly plays a role in contemporary German photographic displays—different to the important exhibitions in the first half of the twentieth century and in contrast to the reception of such photographs in the United States and in Canada. With my photographs, I hope to be able to make a contribution leading to a greater acceptance of this fascinating field between science and art.[8] ■ I would like to take this opportunity to express my gratitude to the Zoologisches Forschungsinstitut und Museum Alexander Koenig, in particular Dr. Michael Schmitt and Karin Ulmen, for their generous support of my work. Furthermore I would like to thank the Institut für Mikrostrukturtechnik am Forschungszentrum Karlsruhe, in particular Prof. Wolfgang Menz and Gerhard Schüler. ■ ■

Ernst Haeckel: Pl. 4 – *Triceratium* (Diatomees) and pl. 5 – *Cyrtoidea* ('Bottle' Radiolarians) (Flaschen-Strahlinge), from Haeckel's *Kunstformen der Natur* (The Art Forms of Nature) (10 volumes), Leipzig, Vienna 1899 – 1904
Courtesy of Manfred Kage Collection, Weißenstein

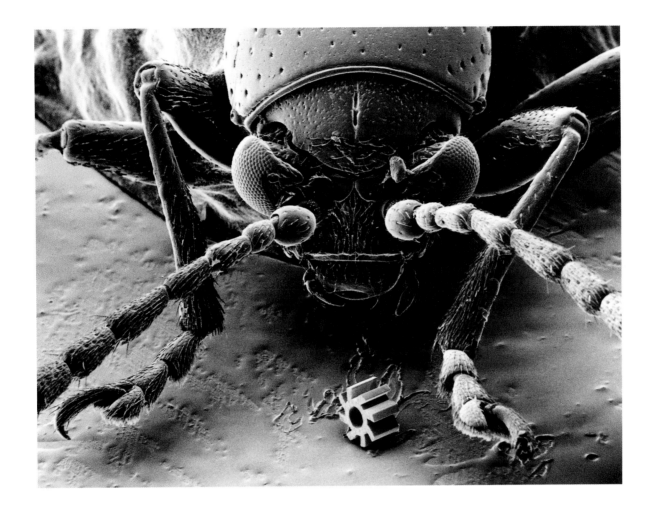

Claudia Fährenkemper: *Käfer mit Mikroturbine*
(Beetle with Microturbine), 1994
Rasterelektronenmikroskop-Fotografie
(Scanning electron microscope photograph),
80 : 1
Gelatin silver print, 48 x 58 cm
Courtesy of the artist (top)

Claudia Fährenkemper: *Schaufelrad des
Baggers 292* (Bucket Wheel of the Excavator
292), 1991
Gelatin silver print, 48 x 58 cm
Courtesy of the artist (bottom)

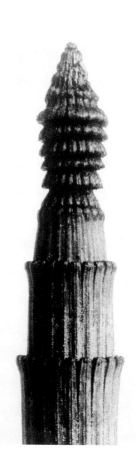

Karl Blossfeldt: *Equisetum hyemale* (Winter-schachtelhalm) (Rough horsetail), 10 : 1, 1900 – 1925
Gelatin silver prints, each 30 x 12 cm
Karl Blossfeldt Archive, Ann and Jürgen Wilde
(top)

August Kreyenkamp: *Insekt* (Insect), 1929/30
Mikrofotografie vom Kopf einer Wespe (Micro-photograph from the head of a wasp)
Reproduction from a print medium, 16.8 x 20 cm
Rheinisches Bildarchiv, Cologne (bottom)

Karl Blossfeldt: *Dipsacus laciniatus* (Weber-
distel) (Teasel), 4 : 1, 1900–1925
Gelatin silver print, 30 x 40 cm
Karl Blossfeldt Archive, Ann and Jürgen Wilde

Carl Strüwe: Aus der Serie *Die elementaren
Formen: Dreiecksform* (From the series
The Elementary Forms: Triangular), 1930
Mikrofotografie von Diatomeen (Microphoto-
graph of diatomees), 400 : 1
Gelatin silver print, 53.7 x 38.1 cm
Kunsthalle Bielefeld

Carl Strüwe: *Ein Kristall ist geboren*
(A Crystal was Born), 1946
Mikrofotografie von Asparaginsäure
(Microphotograph from acid of asparagin),
240 : 1
Gelatin silver print, 24.2 x 19.2 cm
Collection Gottfried Jäger

Manfred P. Kage: Vier Bilder aus der 24-teiligen Serie *Von der Struktur zur Gestalt* (Four pictures from the 24-parts series *From the Structure Towards Form),* ca. 1966
Mikrofotografien chemischer Gestaltung von Bernsteinsäureimid (Microphotographs of chemical modifications of succinic anhydride)
Gelatin silver prints, 38 x 29.6 cm
Als Chemiker verfügt Manfred P. Kage über Erfahrungen zur Beeinflussung der Kristallisation chemischer Verbindungen. Temperaturveränderung, Lösungsmittelkorrosion und gerichtete Luftströmungen werden als Gestaltungsmittel eingesetzt. Damit ist ein und dieselbe Substanz (z. B. Bernsteinsäureimid) willkürlich steuerbar und kann die verschiedensten Formen annehmen. Durch polarisiertes Licht und mit Hilfe des von Kage entwickelten ‚Polychromators', lassen sich Farbe, Kontrast und Helligkeit stufenlos variieren.
Manfred P. Kage, chemist, works on the basis of experiences in influencing the crystallization of chemical compounds. Changes in temperature, corrosion by solvents and directed currents of air are used as a means of composition. In this way one and the same chemical substance (e. g. succinic anhydride) can be controlled at will and assume a wide variety of forms. Coloration can be varied continuously with the help of polarized light from Kage's special apparatus, the 'Polychromator'.
Collection Gottfried Jäger
Courtesy of the artist

Claudia Fährenkemper

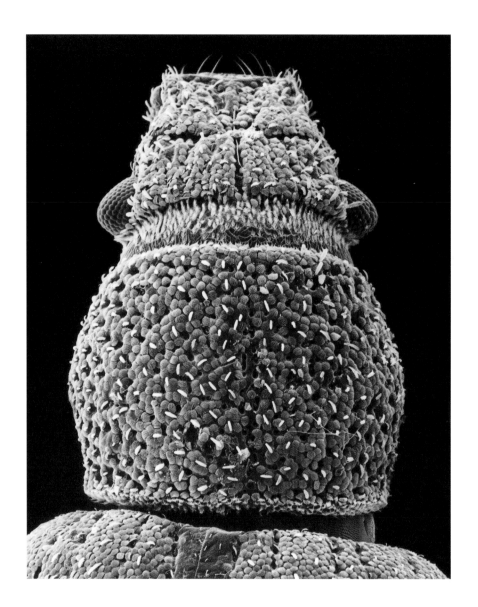

Claudia Fährenkemper: *Strophosoma melano-
grammum* (Käferkopf) (Head of a Beetle), 1996
Rasterelektronenmikroskop-Fotografie
(Scanning electron microscope photograph),
30 : 1
Gelatin silver print, 58 x 48 cm
Courtesy of the artist

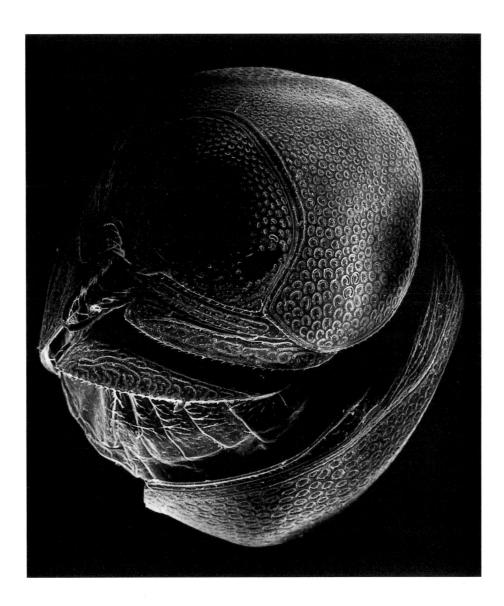

Claudia Fährenkemper: *Ceratocanthus spec.,*
(Käfer) (Beetle), 1996
Rasterelektronenmikroskop-Fotografie
(Scanning electron microscope photograph),
30 : 1
Gelatin silver print, 100 x 80 cm
Courtesy of the artist

Anmerkung:
Die den rasterelektronenmikroskopischen
Fotografien von Claudia Fährenkemper beige-
fügten Vergrößerungsangaben beziehen sich
auf die lineare Vergrößerung der Objekte bei
der fotografischen Aufnahme auf das Negativ-
format 6 x 7 cm. Die anschließende fotografi-
sche Vergrößerung ist darin nicht enthalten.

Michael Köhler

Das ungegenständliche Lichtbild heute. Zeitgenössische Positionen
Non-Objective Photography Today. Contemporary Representatives

1 Das abstrakte Bild – diese folgenreiche Erfindung moderner Kunst – hat seine Ursprünge in der Malerei. Daraufhin versuchten Künstler in Europa und den USA, Abstraktionen auch in anderen Medien zu realisieren, so in der Grafik, der Bildhauerei und (ab 1916) in der Fotografie. Mit Gründung der Künstlergruppe *Abstraction-Création* 1931 in Paris[1] wurden zwei Wege zum abstrakten Bild anerkannt: Zum einen die Reduktion des Naturvorbilds auf elementare Formen (*Abstraction*), zum anderen das Komponieren elementarer Farb- und Formkonstellationen ohne Naturvorbild (*Création*). Wegen ihrer Bindung an real existierende Motive scheint die Fotografie auf die erste Form der Abstraktion beschränkt, das Abstrahieren. Durch kameralose Lichtbilder kann sie aber auch völlig ungegenständliche Resultate erzielen. Das abstrakte Lichtbild ist dennoch eine marginale Gattung der Fotografie geblieben, wenngleich mit lückenloser Kontinuität. Künstler, die sich der Gattung heute zuwenden, sehen sich also einer gewichtigen Tradition von mittlerweile 85 Jahren Dauer gegenüber. Ihr etwas Neues hinzuzufügen, verlangt daher nicht weniger Erfindungsreichtum als das für andere Gattungen der Bildkünste gilt. Gibt es überhaupt noch Positionen abstrahierenden Fotografierens, die nicht besetzt sind; oder Strategien des ungegenständlichen Lichtbildes, die nicht ausgereizt wurden? Mit den Künstlern, die ich im folgenden vorstellen will, meine ich: Sicher, ja. ■ Um zeitgenössische Positionen handelt es sich bei den Abstraktionen dieser Künstler im doppelten Sinn: Die meisten der hier vertretenen Arbeiten sind erst in den 1990er Jahren entstanden. Zudem stammen sie von Künstlern, deren Karrieren nach 1960 begannen – also bereits in der Epoche der künstlerischen Postmoderne, die bis heute anhält. Signum dieser Epoche ist der stilistische Pluralismus, das gleichwertige Nebeneinander heterogener Bildvorstellungen auf dem Markt zeitgenössischer Kunst sowohl im Angebot einzelner Galerien als auch im Werk einzelner Künstler. Die Frontstellung der Klassischen Moderne zwischen Figurativen und Abstrakten ist eingeebnet,

1 The abstract picture—that central invention of modernist art, has its origins in painting. Subsequently artists in Europe and the United States made attempts to produce abstractions using other media. In graphic art, in sculpture and (from 1916) in photography. The artists' group *Abstraction-Créations* founded in 1931 in Paris,[1] established two ways to the abstract picture. One was the reduction of nature to elementary forms (*abstraction*), the other the composition of elementary forms and colour constellations without reference to nature (*création*). Because of its dependence on real subjects, photography would appear to be limited to the first form of abstraction. But fully non-objective results can also be achieved through light pictures produced without a camera. The abstract photo has however remained a marginal area of camera work, although one with an unbroken history. Artists who come to this area today are therefore now building on a solid tradition of 85 years' duration. To add something new to this requires no less inventiveness than in other forms of art. Are there any aspects of abstract photography that have not already been explored, or strategies for non-objective photos that have not yet been exhausted? With the artists I am now going to introduce, the answer in my opinion is: Yes. ■ The abstractions of these artists are contemporary in two senses: All the works I am showing are recent, all are from the 1990s and most of them were produced in the second half of the decade. They are also by artists who started their careers after 1960—when the present postmodern epoch had already begun. This epoch is characterized by a plurality of styles; on the contemporary art market, and even in the collections of individual galleries and the works of individual artists a heterogeneous mixture of pictures is the acceptable norm. The conflict between classic modern representatives of the figurative and the abstract has been resolved, and the differences have disappeared. The choice of one or other style is no longer

1 *Abstraction-Création, Art non-figurativ.* Internationale Künstlergruppe, gegründet 1931 in Paris. Ihre Zeitschrift *Abstraction-Création* erschien zwischen 1932 und 1936 in fünf Jahresheften und repräsentierte die wesentlichen Tendenzen dieser Kunst in der ersten Hälfte der 1930er Jahre. International group of artists, founded in Paris in 1931. Its magazine *Abstraction-Création* was published between 1932 and 1936 in five annual issues, and represents the main tendencies of this art form in the first part of the 1930s.

ihre Fehden gehören der Vergangenheit an. Philosophische oder gar weltanschauliche Positionen werden heute mit der Entscheidung für die eine oder andere Stilrichtung nicht mehr bezogen. Das Formvokabular der Moderne zwischen Abstraktion und Realismus ist zu einem Fundus geworden, aus dem sich der postmoderne Künstler ohne Vorbehalte derart bedient, daß er seine ästhetischen Prämissen von Werkblock zu Werkblock ändert oder zeitlich parallel mehrere Werkserien unterschiedlicher Stilrichtung vorantreibt. ■ ■ 2 Auch die Frage, was Arbeiten dieser Art überhaupt noch mit Fotografie zu tun haben, soll angesprochen werden. Aus fotografischer Perspektive gehören praktisch alle hier vertretenen Künstler ins Lager der Experimentellen. Sie benutzen unorthodoxe Verfahren und setzen Materialien und Apparate bisweilen kalkuliert regelwidrig ein. ■ Aber was bedeutet es heute schon, wenn man sie als Grenzgänger des Fotografischen bezeichnet? So gut wie alle Künstler, die heute mit der Kamera arbeiten, verstehen sich als Grenzgänger des Fotografischen – sogar wenn sie dokumentarisch arbeiten. ■ Die Fotografie hat im letzten Drittel des 20. Jahrhunderts und in fast all ihren Formen eine breite Akzeptanz im Kunstkontext erlebt. Diese Entwicklung hat bezeichnenderweise dazu geführt, daß der Bezugsrahmen, in dem Werke der Fotografie heute betrachtet und beurteilt werden, weniger die Fotogeschichte als vielmehr die Kunstgeschichte ist. ■ Rein fotoästhetische Beurteilungskriterien haben ausgedient. Das heißt auch, daß technische wie ikonografische Parallelen zu Vorbildern der Fotogeschichte jetzt weithin unerwähnt, weil unbekannt, bleiben. Die Kamera ist als zeitgemäßer Ersatz von Pinsel und Pigment akzeptiert. Im Bewußtsein der Kunstöffentlichkeit figurieren Fotowerke nicht länger als Grafik oder Druckgrafik. Sie konkurrieren jetzt mit anderen Großformen des Tafelbildes, denen sie sich auch in Format und Preisniveau angenähert haben. So bestehen Künstler, die sich der Kamera bedienen, häufig darauf, nicht mehr als Fotografen bezeichnet zu werden; als mit Fotografie arbeitende

defended on the basis of a particular philosophy or even world view. The form vocabulary of the modern artists, ranging from abstraction to realism, has become a source of ideas which artists who now belong to the post-modern age can exploit without scruple, changing their aesthetic approach with each series of work or pursuing various styles in parallel series of work. ■ ■ 2 Since with many of the works here it may be tempting to ask whether they have anything to do with photography at all, I would like to address this aspect in advance. From the photographic point of view, almost all the presenting artists are experimental photographers. They employ unorthodox methods, and use materials and equipment often in a manner deliberately contrary to the norm. ■ What does it signify, however, if we say their work falls somewhere between art and photography? Most artists who use a camera would put themselves in this category, even when they work in a documentary style. ■ The general acceptance of artistic status for certain forms of photography in the last third of the 20th century has had paradoxical consequences. In the art world, photos are no longer viewed and assessed in the context of photo history but in the context of art history. ■ Assessment criteria based purely on photography are no longer valid, which also means that technical and iconographic parallels to historic models are now not generally mentioned, because they are not even noticed. The camera has been accepted as the modern substitute for brushes and pigment. The art public no longer perceives photo works as graphics or prints. As a result, these now compete with paintings, which they have come to resemble in terms of format as well as price level. This is why artists who use cameras insist that they are not photographers. Sculptors, perhaps, or painters, but please not photographers or photographic artists. ■ It is thus surprising that abstract photography has such a low status on the art market—compared for example with the documentary work

Maler oder Bildhauer vielleicht, nicht aber als Fotografen oder Fotokünstler. ■ So überrascht es, wie bescheiden der Stellenwert abstrakter Fotografie im Kunstbetrieb heute ist – verglichen etwa mit dem dokumentarischer Fotokunst. Denn während ihrer ganzen Geschichte stand Abstrakte Fotografie der jeweils zeitgenössischen Kunst näher als der zeitgenössischen Fotografie. ■ Warum Abstrakte Fotografie bei Kuratoren, Kritikern und Sammlern so wenig Aufmerksamkeit genießt, ist schwer erklärlich. Vielleicht hängt es damit zusammen, daß auch die abstrakte Kunst heute an den internationalen Kunstbörsen nicht besonders stark notiert – von Stars des Kunstmarkts wie Gerhard Richter und Sigmar Polke einmal abgesehen. ■ Offenbar bilden abstrakte Malerei und abstrakte Fotografie eine Art System kommunizierender Röhren in der Hinsicht, daß Produktion und Wertschätzung abstrakter Fotografie steigen, wenn abstrakte Malerei floriert. Und umgekehrt, daß abstrakte Fotografie nur am Rande wahrgenommen wird, solange zeitgenössische Malerei von anderen als abstrakten Tendenzen geprägt wird. ■ In der Postmoderne hat es bislang nur einen relativ kurzen Moment gegeben, in dem die Öffentlichkeit für Abstrakte Fotografie empfänglich war: Gegen Ende der 1980er Jahre, als auf dem amerikanischen Kunstmarkt ein Revival abstrakter Malerei forciert wurde, das Karrieren von Künstlern wie Ross Bleckner, Peter Halley oder Philipp Taaffe etablierte. Damals gab es diverse Ausstellungen abstrakter Fotografie in New Yorker Galerien. Und – etwas zeitversetzt – im deutschsprachigen Bereich zwei Museumsausstellungen, die ich erwähnen möchte: *Anwesenheit bei Abwesenheit* (1990) in Zürich, Kurator war Walter Binder,[2] und *Vom Verschwinden der Dinge aus der Fotografie* (1992) in Wien, deren Kuratorin Monika Faber war.[3]

of the Becher students. Especially since, right from the start, abstract photography has always been much closer to the art of its day than to the photography. ■ It is therefore difficult to explain why abstract photography commands so little attention from curators, critics and collectors. Perhaps it has something to do with the fact that abstract art, too, is currently less in demand on the international art markets—with the exception of stars such as Gerhard Richter and Sigmar Polke. ■ Abstract painting and abstract photography are probably linked in this respect, so that the production and value of abstract photography increase when abstract painting is en vogue. And conversely, abstract photography is only of marginal interest when the art of a particular period tends away from the abstract. ■ In the post-modern period so far, there has only been one relatively brief period when the public was receptive to abstract photography. Namely towards the end of the 1980s, when the American art market also saw a revival of abstract painting which established the careers of artists such as Ross Bleckner, Peter Halley and Philipp Taaffe. At this time there were various exhibitions of abstract photography in New York galleries. And—somewhat later—in German-speaking countries there were two museum exhibitions I would like to mention. One was called *Anwesenheit bei Abwesenheit* (Presence in Absence) and was curated by Walter Binder,[2] the other *Vom Verschwinden der Dinge aus der Fotografie* (The Disappearance of Things from Photography), and was curated by Monika Faber.[3]

2 *Anwesenheit bei Abwesenheit. Fotogramme und die Kunst des 20. Jahrhunderts.* Ausstellungskatalog exhibition catalog. Zurich : Schweizerische Stiftung für die Photographie, Kunsthaus Zürich, 1990.

3 Faber, Monika (ed.): *Vom Verschwinden der Dinge aus der Fotografie* (*The Disappearance of Things*). Ausstellungskatalog exhibition catalog. Wien : Österreichisches Fotoarchiv im Museum moderner Kunst, Wien 1992.

■ ■ **3** Bei der Reihenfolge der hier vorgestellten dreizehn Künstlerinnen und Künstler habe ich mich am ›Ying‹ und ›Yang‹ abstrakter Kunst orientiert: Der ›biomorphen‹ Abstraktion einerseits, die ihre Wurzeln im Surrealismus hat, und der ›geometrischen‹ andererseits, wie sie zuerst bei den Künstlern des Konstruktivismus anzutreffen ist. ■ Bestimmend für die Reihenfolge war die relative Position, die die Werke zwischen den Polen rein biomorpher und rein geometrischer Abstraktion darstellen. Den Beginn machen Arbeiten, die der Tradition des ersten Prinzips stärker zuneigen. Die Auswahl der Werkbeispiele wurde mit den Künstlerinnen und Künstlern getroffen, auch die Texte wurden mit ihnen abgestimmt. ■ ■

■ ■ **3** The texts on the works of the thirteen artists presented here are ordered according to the 'Ying' and 'Yang' of abstract art: 'Biomorphic' abstraction, which has its roots in Surrealism, and 'geometric' abstraction, which was first introduced by the Constructivists. ■ The sequence of the artists is governed by the position of their works between the two extremes of purely biomorphic and purely geometric abstraction. The works in the biomorphic tradition are dealt with first. The works were selected with the participation of the artists, who also approved the following texts. ■ ■

Detlef Orlopp: *Wasserzeichen* *1937 in Elbing (D) ■ ■ Orlopps Ausstellungsbeteiligungen reichen zurück bis 1957. In jenem Jahr hingen seine Arbeiten gleich in drei Gruppenschauen: *fotografie als uitdrukkingsmiddel* (Fotografie als Ausdrucksmittel), Arnheim/Niederlande; *Images inventées* (Erfundene Bilder), Brüssel; *Abstraktes und Konkretes*, Kunstverein Darmstadt. Zusammengenommen stecken die drei Titel ziemlich genau den Begriffsrahmen ab, in dem sich Orlopps Werk seit damals bewegt. ■ Fotografie als Ausdrucksmittel: Von Anfang an hat Orlopp eine Fotografie jenseits kommerzieller Verwertbarkeit angestrebt, Kamerawerke, die ihre ästhetischen Prinzipien vielmehr aus dem Programm moderner Malerei entlehnen. ■ Erfundene Bilder: Von Fotografen, die direkt arbeiten – die also weder am aufzunehmenden Motiv, noch am belichteten Negativ wesentlich manipulieren –, heißt es üblicherweise, daß sie ihre Bilder finden, nicht erfinden. Doch Orlopp findet nur, was er sich vorher ausgedacht und dann gezielt gesucht hat: Das jeweils nächste Bild, das den Radius seines bisherigen Œuvres bereichert oder erweitert. Insofern gleicht sein Vorgehen dem des modernen Künstlers in traditionellen Medien, der seine Arbeit als systematische Erkundung eines spezifischen Formenkanons begreift. Bei Orlopp gibt es zwei Werkblöcke solcher Erkundung, meist im Format 50 x 50 cm abgezogen: *Berg-Werke* und *Seestücke.* In beiden Fällen wird ihre Perspektive und Räumlichkeit soweit negiert, daß sie im Bild als strukturierte Flächen erscheinen. ■ Abstraktes und Konkretes: Wählt Orlopp entsprechende Bildausschnitte, so verwandeln sich seine Fotos in Werke abstrakter Kunst. Und wenn seine *Seestücke* ab 1985 unter dafür optimalen Bedingungen aufgenommen wurden, erscheinen diese Lichtbilder wie zarte ungegenständliche Grafitzeichnungen, verwandelt zu Werken konkreter Kunst (Abb. S. 232f.).

Detlef Orlopp: *Wasserzeichen* (Watermarks) Born 1937 in Elbing (D) ■ ■ Orlopp has been showing his work in exhibitions since 1957. In that year his work featured in three group exhibitions: *fotografie als uitdrukkingsmiddel* (Photography as a Means of Expression), Arnhem/Netherlands; *Images inventées* (Invented Images), Brussels; *Abstraktes und Konkretes* (The Abstract and the Concrete), DarmstadtX/Germany. Together the three titles describe the framework within which Orlopp has worked ever since. ■ Photography as a means of expression: From the beginning Orlopp aimed at a type of photography beyond commercial use, camera works based on aesthetic principles derived from modern art. ■ Invented images: it is usually said of photographers who works straight, manipulating neither the motif to be photographed nor the exposed negative, that they take, and do not make their pictures. Orlopp, however, takes only what he has first envisaged and then specifically looked for—in each case the next picture that will add to or enrich his previous oeuvre. In this way his procedure is similar to that of the modern artist working with traditional media, who embarks on a systematic exploration of a specific set of formal problems ■ This type of exploration characterizes two blocks of work by Orlopp, most of them measuring 50 x 50 cm: *Berg-Werke* (Rock Pieces) and *Seestücke* (Seascapes). In both cases depth is negated to such an extent that we are left with a structured surface. ■ Abstract/concrete: when Orlopp chooses the appropriate vantage point, his photos turn into works of abstract art. And when his *Seestücke*—from 1985 on—are taken under optimal conditions, they resemble delicate, non-objective pencil drawings, thus becoming works of concrete art (figs. pp. 232f.).

Michael Köhler

Floris M. Neusüss: *Nachtstücke* *1937 in Lennep (D) ■ ■ Im Zentrum von Neusüss' Schaffen steht das Foto-gramm: »Die lichtreichen Schatten«, wie er einmal formulierte. Ihm widmet er sich als Fotohistoriker, als Hoch-schullehrer und als Künstler. Von den zahlreichen Ausstellungen, Katalogen und Büchern zur Geschichte des Foto-gramms, die er im Laufe der Jahre erarbeitet hat, sei nur das gewichtigste Buchprojekt genannt: *Das Fotogramm in der Kunst des 20. Jahrhunderts*, Köln, 1990. ■ Historische Recherche und akademische Lehre des Fotogramms sind bei Neusüss freilich nur Nebengleise. Im Vordergrund stehen bildnerische Aktivitäten. Abgesehen von einer Phase konzeptueller Fotografie in den 1970er Jahren, hat er die ästhetischen Möglichkeiten des Fotogramms seit 1960 mit immer neuen und andersartigen Werkgruppen in alle Richtungen hin ausgeleuchtet. ■ Es gibt figurative Serien (Abb. S. 234), sogar Fotogramm-Porträts, aber auch abstrakte und völlig ungegenständliche Arbeiten. Die Großformate nehmen Maße bis zweieinhalb Meter an, kleine Arbeiten, wie die *Ulos* (unbekannte Licht-Objekte) aus jüngerer Zeit, messen um 30 x 20 cm. ■ Eine der hier gezeigten Arbeiten entstammt einer Werkserie der 1980er Jahre, den *Nachtstücken,* die im Freien entstanden sind. Neusüss legt nachts Bahnen von Fotopapier mit der licht-empfindlichen Seite nach unten im Garten aus und belichtet sie teils mit dem natürlichen Licht von Mond und Gewit-ter, teils mit künstlichem Blitzlicht. ■ Gräser, Kräuter, Pflanzen, Hölzer und Steine etc. produzieren dabei einen Teppich surrealer Muster reichster Grautöne zwischen reinem Schwarz und reinem Weiß: poetisch-rätselhafte Tableaus. Die *Nachtstücke* tendieren zwar zur Abstraktion, die Beziehung zur Wirklichkeit bleibt aber noch erahn-bar (Abb. S. 235).

Floris M. Neusüss: *Nachtstücke* (Night Pieces) Born 1937 in Lennep (D) ■ ■ The focal point of Neusüss' creative work is the photogram, or, as he once described it: "light-filled shadows". He has dedicated himself to this subject as a photo historian, an art academy professor and an artist. Of the numerous exhibitions, catalogues and books on the history of the photogram that he has produced over the years, I will mention only his most significant project, the monograph *Das Fotogramm in der Kunst des 20. Jahrhunderts* (The Photogram in 20th-Century Art), Cologne, 1990. ■ Historical research and academic teaching on the subject of the photogram are however only supplementary to Neusüss' central preoccupation as an artist with light-filled shadows. Aside from a phase of conceptual photography in the 1970s, he has been exploiting the various aesthetic possibilities of the photogram since 1960, constantly pro-ducing new and different series of work. ■ There are figurative series (fig. p. 234), and even photogram portraits, but also abstract and fully non-objective series. The large formats can be up to two-and-a-half metres high and the small ones, such as the most recent *Ulos* (unidentified light objects) a mere 30 x 20 cm. ■ One of the works shown here comes from a series produced in the 1980s, *Nachtstücke* (Night Pieces), with formats from 50 x 50 cm to 30 x 40 cm. They were produced outdoors. Neusüss laid out sheets of photographic paper in his garden with the light-sensitive side face down and illuminated them with artificial flashes. ■ A carpet of surreal patterns in every shade from pure black to pure white was obtained from the grasses, herbs, plants, twigs and stones etc. The overall effect is both poetic and mysterious, since the *Nachtstücke* tend towards abstraction, but still retain a relationship to reality (fig. p. 235).

Marco Breuer: *Tremors* *1966 in Landshut (D) ■ ■ Marco Breuer erhielt seine Ausbildung 1988–1992 beim Lette-Verein in Berlin, dann an der Fachhochschule Darmstadt. Aber schon damals haben ihn die traditionellen Fototechniken, die man ihn dort lehrte, wenig gereizt. Heute lebt und arbeitet Breuer als freier Künstler in New York, und seine Technik hat sich zu einer Gratwanderung im Grenzgebiet von Fotografie und Zeichnung entwickelt. ■ Für die Werkgruppe *Tremors* wählte der Künstler als Ausgangsmaterial handelsübliches Silbergelatinepapier, das klassische Fotomaterial für Schwarzweißabzüge, im Format 40 x 50 cm. Diesem Bildgrund rückte er in der Dunkelkammer mit diversen Haushaltsgeräten zu Leibe, mit einer Heizplatte etwa, einer elektrischen Pfanne und dergleichen mehr. ■ In erhitztem Zustand zog er diese Objekte unter wechselndem Druck der Hand über das Papier. Wird das bearbeitete Blatt in der herkömmlichen Weise entwickelt, so zeigen sich die Versengungen der Fotoemulsion und des Papiers in reichem Kolorit von Dunkelbraun über gebrannte Siena-Erde bis hin zu Holzkohle-Schwarz. ■ »Zentral für diesen Werkblock«, schreibt der Künstler, »ist die gezielte Mißhandlung sowohl der Werkzeuge, die ihre Spuren hinterlassen, wie des Papiers, das die Spuren bewahrt. Beim einzelnen Werk aber dominiert das Unvorhersehbare – als die Resultante aus sperrigem Werkzeug, nicht vollkommen kontrollierbarer Hand und der Eigenreaktion des Materials.« ■ Dazu schreibt James Elkins: »Wenn man den Zufall sorgfältig lenkt, wie Breuer es tut, entsteht ein viel stärkerer Realitätseffekt als jeder, der sich mit traditionellen Darstellungstechniken erzielen ließe. Und das heißt: Mimesis ist ein Irrweg, da wirkliche Ähnlichkeit von den Dingen selbst bewirkt wird.«[1] (Abb. S. 236f.)

Marco Breuer: *Tremors* Born 1966 in Landshut (D) ■ ■ Marco Breuer lives and works in New York City. He studied photography at the Lette-Verein in Berlin 1988–1992 and, later, at the Fachhochschule Darmstadt, University of Applied Sciences. Since the beginning of his studies Breuer has looked for ways to expand the definition of photography. ■ Today his process is walking a fine line between drawing and photography: Working mostly with commercially available black-and-white photo paper, he subjects the paper itself to a range of erosive treatments. ■ In 2000 Breuer worked on the *Tremors* series: Working in the darkroom, he employed an assortment of household tools, a hot-plate, an electric pan etc., moving them with varying pressure across photographic paper, registering their movement as a type of irregular, seismographic trace. The paper responds to the heat from the tool by recording a latent image which, once developed, turns the emulsion a range of colors from deep umber to burnt sienna and charcoal black. ■ "Essential to this body of work", Breuer writes, "is the deliberate misuse of both the tools which leave their impressions and the photographic paper recording the evidence. The process constitutes a negotiation between the awkwardness of the tool, the tremors of the hand, and the material's response." ■ As James Elkins states: "When chance is well-managed, as it is in Breuer's new work, it creates a reality effect much stronger than anything that could be achieved by ordinary representation—it says, in essence: Mimesis is misguided, because real resemblance comes out of the objects themselves."[1] (figs. pp. 236f.)

1 James Elkins: Renouncing Representation. In: Marco Breuer: *Tremors, Ephemera,* New York, 2000.

Stephan Reusse: *Thermovisionen* *1985 in Pinneberg (D) ■ ■ Neben den *Pissflowers* und den Künstlerporträts bilden die *Thermovisionen* im fotografischen Werk von Stephan Reusse einen der drei kontinuierlich erweiterten Werkblöcke. Die frühesten *Thermovisionen* stammen noch aus Reusses Studienzeit zu Beginn der 1980er Jahre. Anfangs wurden die Motive in Schwarzweiß abgezogen. Ab 1986 gibt es dann nur noch Cibachrome-Prints in Formaten um 180 x 220 cm. ■ Im Entstehungsprozeß der Thermovisionen verbinden sich Fotografie und Thermografie. Die Thermografie ist ein der Fotografie analoges Verfahren. Während die Kamera Lichtwellen aufzeichnet, bildet der Thermograf Wärmedifferenzen ab. Das Gerät besteht aus einem Wärmesensor mit angeschlossenem Rechner. Dieser wandelt die Daten des Sensors in ein sichtbares Bild um, das man auf dem Monitor des Rechners betrachten kann. ■ Das Monitorbild fotografiert Reusse mit einer Kamera, um ein Negativ zu erhalten, von dem er Cibachrome-Prints herstellen läßt. Formen mit niedrigen Temperaturen erscheinen auf dem Bildschirm des Thermografen in bläulichen Farben, hohe Temperaturen in Farbtönen zwischen Orange und Weiß. Damit der Thermograf etwas abbildet, muß ein Objekt nicht mehr körperlich anwesend sein. Es reicht, wenn es eine Wärme-Aura hinterlassen hat. Das gilt auch für von vornherein unsichtbare Phänomene, wie z. B. für Atemluft oder einen Furz. ■ Fotohistoriker werden einen Gutteil der Thermovisionen deshalb zur Gattung der Phantombilder rechnen, während Kunsthistoriker sie vermutlich im Kontext der Spurensicherung ansiedeln dürften (Abb. S. 238f.).

Stephan Reusse: *Thermovisionen* (Thermovisions) Born 1985 in Pinneberg (D) ■ ■ In the photographic oeuvre of Stephan Reusse, his *Thermovisions* are one of three blocks of work to which he has added on a continuous basis—the others being the *Pissflowers* and artists' portraits. The earliest Thermovisions date from Reusse's student days in the early 1980s. At the beginning his motifs were in black-and-white, but from 1986 he produced only cibachrome prints measuring 180 x 220 cm. ■ The Thermovisions are created by combining photography and thermography. The two processes are analogous: While the camera records light waves, the thermograph registers heat differences. The apparatus consists of a heat sensor connected to a computer. This converts the sensor data into an image that can be seen on the computer screen. ■ Reusse photographs the screen picture with a camera to obtain a negative from which his cibachromes can be printed. Forms with low temperatures appear on the screen in bluish colors, while high temperatures result in a range of colors from orange to white. An object does not necessarily have to be present for the thermograph to produce an image. It is sufficient if something has created an aura of heat. And this also applies to phenomena that are invisible by nature such as breath or a fart. ■ Photo historians will thus classify most of the Thermovisions as phantom pictures, while art historians will probably see them as *Spurensicherung* (securing of evidence) (figs. pp. 238f.).

Winfried Evers: *Konstruktionen* *1954 in Haarlem (NL) ■ ■ Die Fotoarbeiten des Niederländers Winfred Evers sind vom Beginn seiner Karriere 1977 an arrangiert und konstruiert. Seit dieser Zeit entwickelte und änderte sich seine Arbeitsweise langsam und schrittweise. ■ So fand die Bildmontage bei ihm bis 1980 allein vor der Kamera statt. Erst dann nutzte er die Techniken der Montage innerhalb der Kamera, wenn er verschiedene Teile des Negativs maskierte und getrennt belichtete. Und erst am Ende der 1980er Jahre ging er dazu über, auch von den Möglichkeiten der Negativ-Manipulation Gebrauch zu machen. ■ Bis 1986 arbeitete Evers ausschließlich in Schwarzweiß, danach für etwa zehn Jahre nur in Farbe, jetzt wieder nur in Schwarzweiß. Das hat weniger ästhetische als technische Gründe, denn mittlerweile sind Evers' Konstruktionen hybrider Natur: Zuerst tritt die Aufnahmekamera in Funktion, dann werden deren Ergebnisse am Computer komplett überarbeitet. Und das läßt sich bei großen Dateien in Schwarzweiß leichter bewerkstelligen. ■ Bei den Gründervätern der Abstraktion, wie Kandinsky, Kupka, Malewitsch und Mondrian, war der Vorstoß in ungegenständliche Bildwelten durch einen gewissen Mystizismus motiviert. Die Aufgabe des Gegenstands wurde nicht als Verlust empfunden, sondern als notwendige Voraussetzung einer Vergeistigung der Kunst gesehen, als Bedingung ihrer Distanzierung vom Materialismus der Moderne. ■ Dem Zeitgeist der Postmoderne gegenüber wirkt eine weltanschauliche Fundierung von Kunst nurmehr lächerlich. So war Evers der bislang einzige Künstler, auf den ich während meiner Recherchen zur Foto-Abstraktion der letzten zwanzig Jahre stieß, der es nicht ablehnte, in seinen neuesten Arbeiten den Versuch zu sehen, Ikonen zu schaffen; Bilder zur Kontemplation und Introspektion; Sinnbilder von metaphysischer Symbolik mit Bezug zu östlichen Weisheitslehren (Abb. S. 240f.).

Winfred Evers: *Konstruktionen* (Constructions) Born 1954 in Haarlem (NL) ■ ■ The Dutchman Winfred Evers has been arranging and constructing his photographic works since the beginning of his career in 1977. All his changes of method have evolved slowly and gradually. ■ Up until 1980, his montage work took place solely in front of the camera. It was only then that he started to carry out montage inside the camera itself, masking various parts of the negative and exposing them separately. And it was not until the end of the 1980s that he finally began exploring the possibilities of negative manipulation. ■ Up until 1986 Evers worked only in black-and-white, and for the next ten years after that only in color. He has now gone back to black-and-white, less for aesthetic than for technical reasons, as Evers' constructions have taken on a hybrid form: The images he first records with a camera are then processed in the computer, and this is easier to do in black-and-white. ■ With the founding fathers of abstraction such as Kandinsky, Kupka, Malevitch and Mondrian, the venture into non-objective image worlds was motivated by a certain mysticism. Giving up the object was seen not as a loss, but as a necessary prerequisite for the spiritualization of art, as a condition for distancing it from the materialism of the modern age. ■ Given the nature of postmodernism, it seems a little ridiculous to justify art from the standpoint of a particular world view. Evers is the only artist I found in my research into the abstract photography of the last twenty years who would not reject out of hand any interpretation of his work as an attempt to create "icons", in other words pictures for contemplation and introspection, or symbolic associations with Eastern doctrines of wisdom (figs. pp. 240f.).

Michael Köhler

Steffen Kluge: *Lichtgrafiken* *1964 in Wolfsburg (D) ■ ■ Steffen Kluges *Lichtgrafiken* sind das Produkt ›reiner Lichtgestaltung‹ im Sinne von László Moholy-Nagy. Die Formen, die sie uns zeigen, sind völlig immateriell, bloße Lichtreflexe. ■ Komplexe Lichtmodulation, wie sie von Kluge angewendet wird und die weit über das hinausgeht, was Moholy-Nagy einst beschrieb, setzt eine genaue Kenntnis der physikalischen Grundlagen von Lichtbeugung, -brechung und -spiegelung voraus. Hinzu kommt ein komplexes System unterschiedlicher Gerätschaften. ■ Die Farben entstehen durch Spektralzerlegung weißen Lichtes mittels optischer Prismen. Spiegel selektieren einzelne Farben aus dem Spektrum, mischen sie neu und leiten das Licht durch den Raum. Für Formen und Konturen in der Projektion sorgen Masken und Linsensysteme. Meist wird jede Farbe eines Bildes einzeln gemischt, geformt und präzis in die Gesamtkomposition plaziert. ■ Kluges Kamera hält also nur fest, was von ihm vorher bis ins letzte Detail ausgetüftelt wurde. Sie fügt dem auch nichts mehr hinzu, da das Fotografieren hier nur den Zweck verfolgt, ein Negativ zu erhalten, von dem die Abzüge hergestellt werden können – meist in moderaten Formaten von 60 x 90 cm. ■ Vom ihrem relativ mühsamen Entstehungsprozeß ist in den fertigen Arbeiten nichts mehr zu spüren. Denn im Gegensatz zum gewählten Werkverfahren entwickelt sich Kluges kompositorische Phantasie offenbar weniger methodisch als spontan und intuitiv und dabei frei von technischen Einschränkungen (Abb. S. 242f.). ■ Bildfindungen Moholy-Nagys klingen nach, sind aber nirgends prägendes Vorbild. Daher sollte man bei Kluge auch nicht von einem Werk in direkter Nachfolge Moholy-Nagys sprechen; eher von einer initialen Inspiration durch diesen Klassiker des fotografischen Experiments.

Steffen Kluge: *Lichtgrafiken* **(Light Graphics)** Born 1964 in Wolfsburg (D) ■ ■ Steffen Kluge's *Lichtgrafiken* (Light Graphics) are the product of 'reine Lichtgestaltung' (pure light design) in the sense in which it was introduced by László Moholy-Nagy. The forms involved are wholly immaterial—they are simply light reflections. ■ Such complex light modulation as this, which goes far beyond Moholy's practice of it, requires a precise knowledge of the physical basis of light diffraction, refraction, and reflection, as well as a whole battery of equipment. ■ The colors are produced by breaking down the spectrum of white light using optical prisms. Mirrors select individual colors from the spectrum, remix them and direct the light through space. Masks and lens systems etc. are used to create forms and contours. The individual colors of a picture are usually mixed separately, given a particular form and placed precisely in the overall composition. ■ Kluge's camera thus only records what he has already planned down to the last detail. And does not add anything, since he only photographs in order to obtain a negative from which the prints— most of them a modest 60 x 90 cm—can be produced. ■ The relatively laborious creation process is not evident at all in the finished product. By contrast with the procedure he has chosen, Kluge's approach to composition is spontaneous and intuitive rather than methodical. It is also free of technical limitations (figs. pp. 242f.). ■ Kluge's compositions may be reminiscent of works by Moholy-Nagy, but they are never directly modelled on them. It would thus be wrong to speak of Kluge as Moholy's successor and more accurate to say that this modernist master of experimental photography simply served as Kluge's initial source of inspiration.

Hubert Kretschmer: *Seismographics* *1950 in Grainau (D) ■ ■ Auf den ersten Blick scheinen Hubert Kretschmers Arbeiten digital generiert. Der Computer kommt aber erst zum Schluß ins Spiel, wenn die Aufnahmen eingescannt werden, um das Endprodukt herzustellen: Die Bearbeitung des Fotos und seine Ausgabe als Iris-Print im Format 100 x 150 cm. ■ Die Motive selbst belichtet Kretschmer mit analoger Kamera auf traditionellen Farbfilm. Nur ein Kunstgriff dabei ist unorthodox: Üblicherweise werden Fotos mit statischer Kamera aufgenommen, Kretschmer dagegen belichtet mit bewegtem Apparat. Aber nicht mit gleichmäßig bewegter Kamera – sonst könnte er seine Verwischungen auch digital erzeugen, etwa mit Hilfe eines Weichzeichner-Filters im Photoshop-Programm des Rechners und einem Befehl wie Bewegungsunschärfe. ■ Wie Kretschmer seine Kamera im Einzelfall bewegt, ist für das Bildresultat zwar entscheidend, für den Betrachter indes unerheblich. Es ist ebenso unerheblich wie die Kenntnis der genauen Pinselbewegung in Werken gestischer Malerei oder des abstrakten Expressionismus, zu denen Kretschmers Werkprozeß Parallelen aufweist. ■ Bei ihm steht das Resultat im Vordergrund, nicht der Prozeß, der zu ihm führt. Das Ergebnis sind Bilder, die sich zwischen hoher Abstraktion und vibrierender Wirklichkeit einordnen lassen. Dank Kretschmers ›seismografischem‹ Verfahren führen sie zu einer eigenartigen Konzentration vorgefundener Licht- und Farbstimmungen. ■ Ebenso nebensächlich ist auch zu wissen, wo Kretschmers Bilder aufgenommen wurden. Nur der Vollständigkeit halber sei deshalb erwähnt, daß die hier ausgewählten Motive aus der Oper in Tel Aviv stammen (Abb. S. 244f.).

Hubert Kretschmer: *Seismographics* Born 1950 in Grainau (D) ■ ■ At first glance, Hubert Kretschmer's work seems to have been generated digitally. The computer is however only used at the end of the process, when the pictures are scanned in to produce the final product: Iris prints usually measuring 100 x 150 cm ■ The motifs themselves are taken by Kretschmer with an analogue camera and conventional color film. Only one procedure is unorthodox. The classic photo is taken with a static camera, but what Kretschmer does is to move the camera. Not evenly, otherwise he could produce his blurring artificially using motion diffusion filter in the Photoshop program. ■ Although the way Kretschmer moves the camera in each individual case determines what the image looks like, this is not important for the viewer. It is as irrelevant as the precise movement of the brush in gestural painting and Abstract Expressionism, with which Kretschmer's work process has parallels. ■ It is in any case the result, not the process that is most important in Kretschmer's work. And the result is images that oscillate between abstraction and vibrant reality; in all of them, however, Kretschmer's 'seismographic' method has produced a unique record of the light and color moods of the places he photographed. ■ It is equally irrelevant where Kretschmer's pictures were taken. I will therefore only mention for the sake of completeness that all the motifs here come from the opera in Tel Aviv (figs. pp. 244f.).

Michael Köhler

Michael Wesely: *Amerikanische Landschaften* *1963 in München (D) ■ ■ Sein Werkzeug ist zu seinem Marken-zeichen geworden. Michael Wesely arbeitet mit dem einfachsten aller fotografischen Apparate: Der Lochkamera. Zuerst hat er mit ihr den Faktor Aufnahmezeit thematisiert. Üblicherweise bemißt sich diese Zeit in Minuten und Sekunden. Bei Weselys frühen Arbeiten in Stunden, Tagen, sogar Jahren. So dokumentierte er bei seiner bislang bekanntesten Arbeit – im Auftrag der DaimlerChrysler Corporation – die Entstehung des Potsdamer Platzes in Berlin in Aufnahmen mit Belichtungszeiten von jeweils zwei Jahren. ■ Zum Signum solcher Langzeitaufnahmen wird, daß alles Ephemere verschwindet und dem Konstanten Platz macht oder, wie bei der Arbeit *Potsdamer Platz,* das langsam und stetig Wachsende zum eigentlichen Bildgegenstand wird. ■ In seinen neueren Werkserien hat Wesely den Fokus seiner Arbeit gewechselt - vom Thema Zeit zum Thema Farbe. Dafür ersetzte er die Lochblende seiner Kamera durch eine Schlitzblende. Sein Sujet bilden dabei erneut Topografien. Hatte die Lochblende noch realistische, d. h. perspektivische Ansichten der fotografierten Orte geliefert, so reduziert die neue Blende das fotografierte Motiv zu vertikalen oder horizontalen Streifenmustern. ■ Die hier vorgestellten Beispiele sind Weselys jüngster Serie entnommen, *Amerikanische Landschaften,* die im Jahr 2000 bei einem mehrmonatigen Reisestipendium im Westen der USA entstanden sind. Produziert als Diasec-Prints im Format 125 x 200 cm, vermitteln sie eine Anmutung jenes non-figurativen *american sublime,* das man bislang nur von den Farbfeld-Leinwänden eines Barnett Newman oder Clyfford Still kannte (Abb. S. 246f.).

Michael Wesely: *Amerikanische Landschaften* (American Landscapes) Born 1963 in Munich (D) ■ ■ Michael Wesely's trademark is his tool: That most basic of all photographic apparatuses, the pinhole camera. He first used it to explore the factor of exposure time. ■ Exposure time is usually measured in minutes and seconds. In Wesely's early work it is measured in hours, days and even years. Thus in his best-known work, commissioned by the Daimler-Chrysler Corporation—he documented the rebuilding of the Potsdamer Platz in Berlin in photographs which each had exposure times of two years. ■ The distinguishing feature of such longtime exposures is that everything ephemeral disappears and only the constant traits remain, or, in the case of the *Potsdamer Platz,* the slow and steady growth. In his more recent series of works, Wesely has shifted the focus of his photos from time to color. For this purpose he replaced the round aperture in his camera with a slit. Once again, topography is his subject. While the round aperture provided realistic views, i. e. views in perspective, of the places he photographed, the new aperture reduces the photographed motifs to vertical or horizontal patterns of stripes. ■ The examples shown here are from Wesely's most recent series, *American Landscapes,* produced last year on a trip of several months' duration financed by a travel grant in the western part of the U.S.A. These works, produced as 125 x 200 cm cibachromes under Diasec, convey that sense of the sublime in the American setting such as is only to be found in non-objective canvases by a Barnett Newman or Clyfford Still (figs. pp. 246f.).

René Mächler: *Konstruktives Licht* *1936 in Zürich (CH) ■ ■ Von den Stilrichtungen abstrakt-ungegenständlicher Kunst hat in Mächlers Geburtsland, der Schweiz, vor allem die konkrete Kunst eine international renommierte Schule hervorgebracht. Ihr bekanntester Vertreter, insbesondere der Zürcher Konkreten, ist Max Bill. ■ Vor diesem Hintergrund mag es Mächler leichter gefallen sein, sich Mitte der 1960er Jahre auf das Wagnis eines ausschließlich ungegenständlich angelegten Foto-Œuvres einzulassen. Zudem ließen erste Theorien kybernetischer Kunst – wie Max Benses Generative Ästhetik – die Auseinandersetzung mit konkretem Formvokabular damals als verlockende Antizipation einer heraufziehenden Epoche exakt-rationaler Kunstproduktion mit Computern erscheinen. ■ Mächlers erste Werkserie ungegenständlicher Fotografie Mitte der 1960er Jahre ist an der Grenze von konkreter und konstruktiver Kunst angesiedelt. Zunächst sind es Rasterprojektionen, die quadratische Muster aus konkreten Formen methodisch auf ihre Variationsmöglichkeiten hin untersuchen. Dann, in den 1970er Jahren, reduziert Mächler sein Repertoire auf Quadrate, Dreiecke, Kreise und konzentrische Ringe und läßt sie im Verfahren seines *Überstrahlungsluminogramms* sichtbar werden (Abb. Schutzumschlag). ■ Der Werkteil *Konstruktives Licht,* wurde um 1980 begonnen. Er rekapituliert das bis dahin Erarbeitete, jedoch auf weniger systematische Weise (Abb. S. 248). Mächler eröffnet sich damit neue Freiheiten, so auch die, mit neuen Medien zu experimentieren. Ein Ergebnis dieser Arbeit stellen die *Videogramme* aus den letzten Jahren dar (Abb. S. 249).

René Mächler: *Konstruktives Licht* (Constructive Light) Born 1936 in Zurich (CH) ■ ■ Among the various styles of abstract/non-objective art, in Switzerland, Mächler's home country, it is the concrete style that has produced an internationally acclaimed school, with Max Bill as the best known representative of the *Zürcher Konkreten* (Zurich Concrete Art Group). ■ This may have made it easier for Mächler than for others to risk an exclusively non-objective photo œuvre in the mid 1960s. The first theories of cybernetic art that were appearing at the time—such as Max Bense's Generative Aesthetics—also made exploration of a concrete vocabulary of form and color particularly attractive with the new epoch of exact-rational art production using computers on the horizon. ■ Mächler's first series of non-objective photographs is on the border between concrete and constructive art. It consists of Raster Projections where grids of concrete forms are shifted in fixed increments. Then, during the 1970s, Mächler reduced the grids to single squares, triangles, circles and concentric rings, this time employing the technique of the *irradiated luminogram* (fig. cover). ■ The body of work entitled *Konstruktives Licht* (Constructive Light), begun in 1980 and still being augmented, recapitulates earlier concerns, but in a less systematic way, and thus permits Mächler new freedoms (fig. p. 248). These include experimentation with new media—such as the *Videogram* of 1993 that are shown here (fig. p. 249).

Michael Köhler

Christiane Richter: *Fotowerke* *1963 in Bielefeld (D) ■ ■ Christiane Richter arbeitet zweigleisig. Bei ihren Werken auf Papier gibt es einerseits Abstraktionen in Aquarell, zum andern die abstrakten Fotowerke, um die es hier geht. Die Ikonografie beider Werkblöcke ist ähnlich. Sie steht in der Tradition konkreter Kunst und thematisiert das, wofür Josef Albers in einer Veröffentlichung 1963 den Terminus ›Interaction of Color‹ prägte. ■ Beide Werkblöcke – Aquarelle und Fotowerke – bestehen aus kleinformatigen Arbeiten in der Größe um 40 x 40 cm und Formaten mit Abmessungen von 120 x 100 cm bis zu 120 x 240 cm. ■ In den Farbfeldern ihrer Aquarelle läßt Christiane Richter eine eigene Faktur erkennen (Abb. S. 251). Dagegen gibt es in ihren Fotowerken davon keine Spur. Richters Fotowerke sind – nach einer Bezeichnung von László Moholy-Nagy – das Resultat reiner Lichtgestaltung. Mit ihrer Kleinbildkamera fotografiert die Künstlerin vorher nicht etwa präparierte Farbtafeln, sondern weißes Licht, das seine Farbigkeit durch Filterung erhält. ■ Auch nach der Aufnahme verläuft der Werkprozeß traditionell. Die belichteten Negative werden auf Cibachrome belichtet, auf Karton montiert und mit Acrylglas laminiert (Abb. S. 250f.). Auf diese Art verfährt Christiane Richter seit Beginn ihrer künstlerischen Karriere zu Anfang der achtziger Jahre. Damit wurde sie zu einer Pionierin ungegenständlicher Fotokunst der Farbe. Vorbilder konnte sie nur aus der Malerei beziehen. Danach befragt, nennt sie die Namen Barnett Newman, Mark Rothko und Ellsworth Kelly.

Christiane Richter: *Fotowerke* (Photo Works) Born 1963 in Bielefeld (D) ■ ■ Christiane Richter operates in two different areas, producing abstract watercolors and the abstract photo-works that are presented here. The iconography of both blocks of work is similar. Following the tradition of concrete art, she explores what Josef Albers termed the 'Interaction of Color'. ■ Both watercolors and photographic works consist of small-format pictures measuring 40 x 40 cm and large-format pictures with dimensions ranging from 120 x 100 cm to 120 x 240 cm. ■ In her watercolors, Richter introduces an own factura into the color fields (figs. p. 251), but in the photographic works there is no trace of this: they are the result of pure light design as Mohol-Nagy termed it. With her 35 mm camera she does not photograph previously prepared colored surfaces, but works solely with white light, which acquires its color through filtering. ■ After the photograph has been taken, she also proceeds according to traditional methods. The exposed negatives are developed on cibachrome paper, mounted on card and laminated with acrylic glass (figs. pp. 250f.). Richter has been working in this way since the beginning of her artistic career in the early 1980s, and is thus one of the pioneers of non-objective color photography. ■ She could therefore only take her cues from painting. When asked for names of particular artists, she mentions Barnett Newman, Mark Rothko and Ellsworth Kelly.

Inge Dick: *Valeurs* *1941 in Wien (A) ■ ■ Bei flüchtigem Hinsehen wirken ihre Gemälde in Öl auf Holz monochromatisch – wie weiße Tafeln, die durch regelmäßig gereihte Spachtelspuren in Form kleiner Rechtecke strukturiert sind. Eine genauere Inspektion ergibt, daß dem Weiß minimale Spuren anderer Farben beigemischt, die Tafeln in Wahrheit polychrom sind – und zwar derart, daß sie minutiöse Farbverläufe zeigen, zarteste Übergange zwischen zwei Farbtönen, die von Bild zu Bild anders gewählt sind. ■ Das Operieren am kaum oder ohne ihre Intervention gar nicht Sichtbaren charakterisiert auch das fotografische Oeuvre von Inge Dick. Seit Anfang der 1980er Jahre ist es parallel zu ihrer Malerei entstanden. Dafür bevorzugt sie ab 1995 wegen seiner satten Farbigkeit Polaroid-Material in Formaten 60 x 50 und 244 x 113 cm. Beide Formate lassen sich jedoch nur mit Spezialkameras an den Orten Boston, New York und Prag belichten. ■ So taucht der Name der Stadt Boston im Titel in vier Werk-Serien auf: *Boston Red, Boston Blue, Boston Black* und *Boston White.* Die Farbnamen der Titel verweisen auf den Farbton, mit dem eine Fläche monochrom eingefärbt war. Sie wurde unter Kunstlicht wechselnder Intensität fotografiert. Jedes Bild innerhalb einer Serie zeigt daher einen anderen Ton der jeweiligen Grundfarbe. ■ Welch reiche Farbpalette die Interaktion von Lichtintensität und Fotomaterial erbringen kann, führt Inge Dicks bislang ambitioniertestes Projekt vor Augen: Die Arbeit *Ein Tages Licht Weiß 13. 6. 1996, 5:07 – 20:52.* Daraus sind die hier gezeigten Bildbeispiele entnommen. Dabei wurde ein rein weißes Rechteck 99 Mal zu verschiedenen Zeiten eines Tages fotografiert. Am frühen Morgen hinterließ das Tageslicht in den Bildern einen fast schwarzen Schimmer, später ein immer helleres Blau (Abb. S. 252f.), das dann zu Weiß changierte – bis sich am Abend der Farbverlauf vom Morgen in umgekehrter Reihenfolge wiederholte.

Inge Dick: *Valeurs* Born 1941 in Vienna (A) ■ ■ At first glance her paintings in oil on wood seem to be monochromatic—pure white surfaces structured with evenly arranged spatula marks in the form of small rectangles. On closer inspection the white is seen to be mixed with minimal traces of other colors: the pictures are in fact polychrome in that they contain minute color sequences, very subtle transitions between two shades of color which are different in each picture. ■ In her photographic oeuvre, which she has been producing parallel to her painting since the early 1980s, Inge Dick also operates with barely visible aspects, or aspects that are only visible with her intervention. Since 1995 she has been using Polaroid material on account of its rich color. The formats she uses, 60 x 50 and 244 x113 cm, can however only be exposed with special cameras from this company, which are located in Boston, New York and Prague. ■ The name Boston thus features in the title of four work series: *Boston Red, Boston Blue, Boston Black* and *Boston White.* For each series Dick applied the color in question to a particular surface and then photographed it using artificial light of varying intensity. Every picture in a series is thus in a different shade of the basic color. ■ The rich range of colors that can be created by the interaction between light intensity and photographic material is demonstrated by Inge Dick's most ambitious project to date: The work *Ein Tages Licht Weiß* (One Day Light White) *13. 6.1996, 5:07 – 20:52,* which involved photographing a pure white rectangle 99 times at various times of day. The pictures produced in the early morning light have an almost black shimmer, later on they become light blue (figs. pp. 252f.), fading gradually to white, until in the evening the color progression repeats that of the morning in reverse order.

Michael Köhler

Günther Selichar: *Screens, Cold* *1960 in Wien (A) ■ ■ *Who is afraid of Blue, Red and Green?* heißt eine Werk-gruppe von Günther Selichar aus den 1990er Jahren. Der Titel spielt auf eine Werkserie des amerikanischen Farb-feldmalers Barnett Newman um 1966/67 mit dem Titel *Who's afraid of Red, Yellow and Blue* an. ■ Rot, Gelb und Blau sind die Grundfarben der Malerei und die primären Farben in der Palette des Plastizismus von Piet Mondrian und *De Stijl*. Aber elementare malerische Abstraktionen sind inzwischen klassisch geworden. Selichar gab ihnen neue Bedeutung und Aktualität, indem er das Gelb in der Farbtrias durch Grün ersetzte. Denn Rot, Grün und Blau sind die Primärfarben des Lichts. Auf ihnen beruht die Technik der Farbfotografie und des Farbfernsehens. ■ In *Who is afraid of Blue, Red and Green?* ließ Selichar Farbfelder in doppeltem Sinn konkret werden: Indem er die hori-zontalen und vertikalen Farbstreifen seiner Bilder mit entsprechendem Pigment füllte und durch schmale Stege voneinander trennte. Selichars jüngste Werkgruppe, *Screens, Cold*, will einen Dialog zwischen konkreter Malerei und neuen Medien in Gang setzen, insbesondere mit den Mitteln der Monochromie. ■ *Screens, Cold* sind hier die matten Scheiben ausgeschalteter Bildschirme von Fernsehern, Computern und anderem Technogerät. Selichar rückt sie ins Licht und fotografiert sie. Die Abzüge machen sichtbar, was man bislang kaum wahrgenommen hat: Jeder Monitor besitzt eine spezifische Eigenfarbe, ein Eigenleben (Abb. S. 254f.). Dazu der Künstler: »Mich reizt das Vexierspiel der hochauflösenden, dokumentarischen Art der Fotografie, die ab einem gewissen Betrachtungs-abstand umspringt in eine sehr malerische Ästhetik im Sinne konkreter Kunst. Es ist auch eine ironische Rück-besinnung auf Marshall McLuhans Unterscheidung in ›hot und cold media‹. ›Cold‹ nannte er Medien, die hohe Par-tizipation des Betrachters verlangen, weil die dargebotenen Datenmengen so grob sind, daß sie stark ergänzt werden müssen.«

Günther Selichar: *Screens, Cold* Born 1960 in Vienna (A) ■ ■ One group of works produced by Selichar during the 1990s is entitled *Who is afraid of Blue, Red and Green?*. The title refers to a work series by the American color field painter Barnett Newman at the end of the 1960s entitled *Who is afraid of Red, Yellow and Blue?* ■ Red, yellow and blue are the basic colors of painting and the primary colors in the plasticist palette of Piet Mondrian and *De Stijl*. But times have changed. Elementary abstraction in painting has become classical, almost academic. Selichar therefore replaced the yellow in the red, yellow and blue combination with green and thus revived color field compositions. Blue, red and green are the primary colors used for television. ■ In *Who is afraid of Blue, Red and Green?*, Selichar concretized the color fields in his pictures in two ways—by filling in the horizontal and vertical stripes of color in his pictures with the corresponding pigment and by separating them with narrow bands. ■ Selichar's latest group of work, *Screens, Cold*, is an attempt to initiate a dialogue between concrete painting and new media. This time on the theme of monochromy. ■ *Screens, Cold* are the matt surfaces of switched-off screens, of TVs, computers and other technical equipment. Selichar photographs them in bright daylight and the prints reveal something that had pre-viously gone almost unnoticed: every monitor has its own particular color in the blue, green and grey range (figs. pp. 254f.). The artist comments on his work as follows: "What fascinates me is the way photographs with their high-resolution, documentary nature suddenly become painterly in the sense of concrete art when viewed from a certain distance. It is also an ironic reference to Marshall McLuhan's distinction between 'hot and cold media'. He termed media that required a high degree of participation by the observer 'cold', because the data are so rough they must be heavily complemented."

Herwig Kempinger: *Immaterielle Objekte* *1957 in Steyr (A) ■ ■ Herwig Kempinger kam auf Umwegen über die Objekt- und Installationskunst zur Fotografie. Die Wahrnehmung realer Skulpturen wird durch die Räume beeinflußt, in denen sie ausgestellt sind. Diese Räume sind künstlerischen Vorstellungen gemäß selten ideal. Kempinger begann daher, seine Skulpturen in den ›fotografischen Raum‹ zu transferieren. Er ist zwar nur zweidimensional, dafür lassen sich seine Parameter genau festlegen. ■ Die Räume in Kempingers Fotografien sind als imaginäre, nicht illusionistische Räume konstruiert; sie sind allein von Licht und Schatten bestimmt. Die Skulpturen in ihnen erscheinen ebenso imaginär, ohne Verweis auf Maßstab und Materialität – obwohl es sich um handgefertigte und anschließend im Studio ohne weitere Manipulation abgelichtete Objekte handelt. ■ Anfangs waren es Objektgruppen, gegen Ende der 1980er Jahre nurmehr einzelne elementare Volumina. Und zwar in Abzügen der Formate 70 x 100 und 120 x 210 cm unter Diasec (Abb. S. 256). Zu Beginn der 1990er Jahre vollzog sich ein Strategiewechsel: Zuerst verschwanden die Objekte aus Kempingers Bildern (Abb. S. 257), dann wurden die Bilder selbst zu Skulpturen. Kempinger fügte sie zu deckenhohen Vierkantsäulen zusammen, zu Objekten, die ihrerseits zwischen Greifbarem und Immateriellem oszillieren. Die Aufhebung des Materiellen legt den Einsatz des Computers nahe. Das Instrument kommt jedoch erst bei den jüngsten Arbeiten Kempingers zum Zuge. Sie sind temporären Volumina von Wolken gewidmet. ■ Bei den hier gezeigten Werken hatte sich der Computer noch als wenig brauchbar erwiesen: Renderings ließen Räume und Objekte allzu perfekt erscheinen: eher virtuell als imaginär. Das Imaginäre konnte mit seinen kleinen ›Fehlern‹ eher das Kamerabild produzieren. Darauf legte Kempinger besonderen Wert.

Herwig Kempinger: *Immaterielle Objekte* (Immaterial Objects) Born 1957 in Steyr (A) ■ ■ Kempinger came to photography via object and installation art. The perception of sculptures is influenced by the rooms in which they are exhibited. This bothered him because the rooms concerned were never ideal. He thus began to transfer his sculptures into rooms created by means of photography. While these are only two-dimensional, their parameters can be precisely defined. ■ The rooms in Kempinger's photography are imaginary rather than illusionistic and consist solely of light and shade. The sculptures in them have a similarly imaginary appearance, which gives no hint of their scale or material—even though they are hand-made objects photographed without manipulation in the studio. ■ At the beginning his pictures still contain groups of objects, but towards the end of the 1980s he was only presenting spacious forms, printed on cibachrome under Diasec in 70 x 100 and 120 x 210 cm formats (fig. p. 257). At the beginning of the 1990s, Kempinger changed his strategy. First the objects vanished from his pictures (fig. p. 256). Then the pictures themselves were turned into sculptures, joined together to form ceiling-high square pillars: objects, in other words, which in turn oscillate between the tangible and the immaterial. ■ With Kempinger's interest in the abolition of material aspects, the computer would seem to be an obvious production tool. However, he has only used it in his most recent works, which are devoted to the fleeting forms of clouds. ■ For the works discussed here the computer turned out to be not very useful. Rooms and objects thus produced looked too 'perfect', more virtual than imaginary. In the end, only the camera image with its minor imperfections was able to create that impression of the imaginary that Kempinger particularly values.

Michael Köhler

Detlef Orlopp
Floris M. Neusüss
Marco Breuer
Stephan Reusse
Winfried Evers
Steffen Kluge
Hubert Kretschmer
Michael Wesely
René Mächler
Christiane Richter
Inge Dick
Günther Selichar
Herwig Kempinger

Detlef Orlopp: *Seestück* (Sea Piece)
14. 9. 1977, 1977
Camera photograph. Gelatin silver print,
50 x 50 cm
Courtesy of the artist

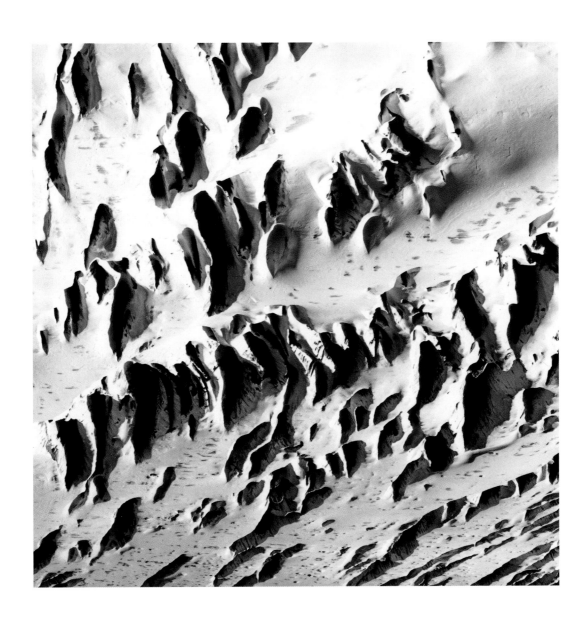

Detlef Orlopp: *Wasserzeichen* (Watermark),
4. 9. 1983, 1983
Camera photograph. Gelatin silver print,
50 x 50 cm
Courtesy of the artist

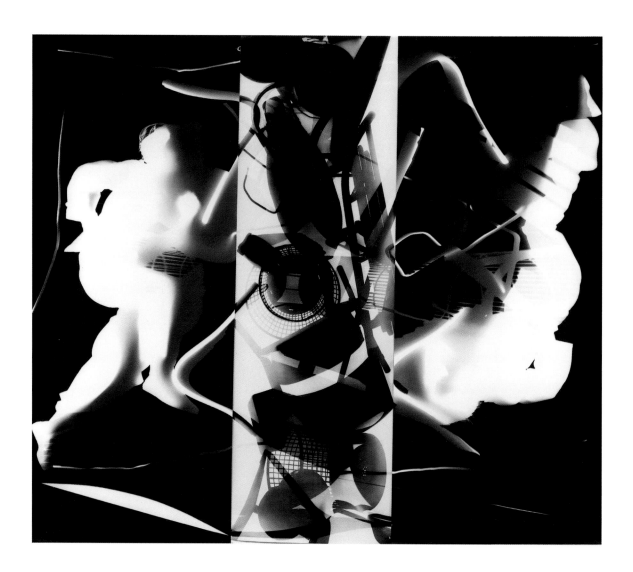

Floris M. Neusüss: *Zwei Unbekannte ent-
kommen einer Gleichung* (Two Unknowns
Escape from an Equation), 1988
Photogram. Unique gelatin silver print,
243 x 291 cm
Courtesy of the artist

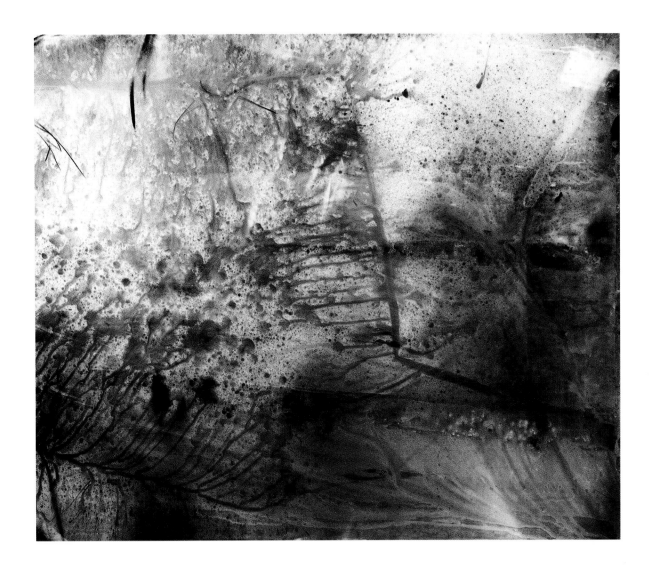

Floris M. Neusüss: *Gewitterbild* (Picture
of a Thunderstorm), 1984
Photogram. Unique gelatin silver print,
90 x 106 cm
Courtesy of the artist

Marco Breuer: From *Tremors,* 2000
Unique gelatin silver paper, 46 x 35.5 cm
Courtesy of Roth Horowitz, New York

Marco Breuer: From *Tremors*, 2000
Unique gelatin silver paper, 46 x 35.5 cm
Courtesy of Roth Horowitz, New York

Stephan Reusse: *Furz* (Tart), 1978 – 1994
Thermograph. Chromogenic color print,
Diasec, 170 x 210 cm
Exhibition Kunstverein Lingen, 1997
Courtesy of the artist
Photograph: Stephan Reusse

Stephan Reusse: *Ghost* (Gespenst), 1984
Thermograph. Chromogenic color print.
Diasec, 220 x 180 cm
Exhibition Museum Fredericianum, Kassel, 1989
Courtesy of the artist
Photograph: Anja Helbing

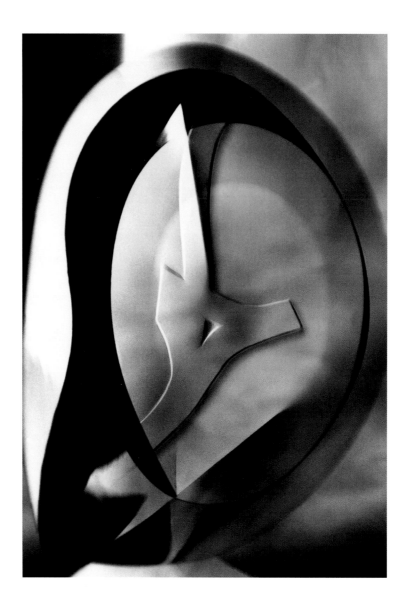

Winfried Evers: *Daily Poem*, 1998
Gelatin silver print, 40 x 25.5 cm
Courtesy of the artist

Michael Köhler

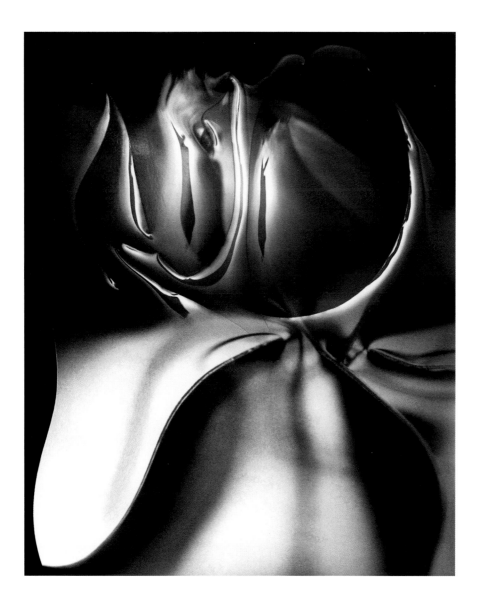

Winfried Evers: *Donna Data,* 1998
Gelatin silver print, 40 x 35.5 cm
Courtesy of the artist

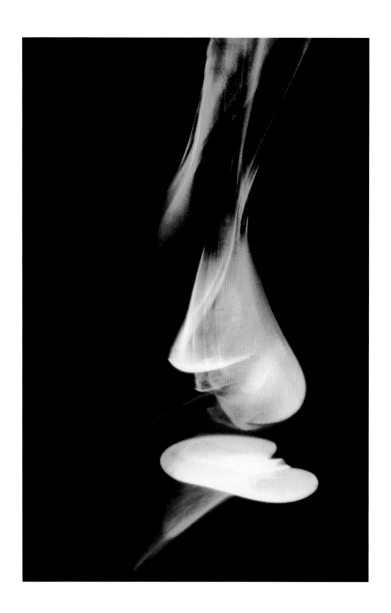

Steffen Kluge: *Lichtgrafik* (Light Graphic)
542/93, 1993
Chromogenic color print, 90 x 60 cm
Courtesy of the artist

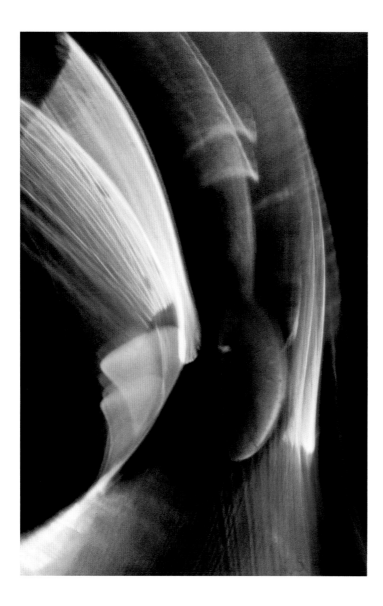

Steffen Kluge: *Lichtgrafik* (Light Graphic)
385/94, 1994
Chromogenic color print, 90 x 60 cm
Courtesy of the artist

Hubert Kretschmer: *Oper, Tel Aviv* (Opera,
Tel Aviv) (No. 125 - 31A), 1999
Inkjet print on photo paper (Iris-print),
150 x 100 cm (Original in Farbe original in color)
Courtesy of the artist

Hubert Kretschmer: *Oper, Tel Aviv* (Opera,
Tel Aviv) (No. 125-18A), 1999
Inkjet print on photo paper (Iris-print),
150 x 100 cm
Courtesy of the artist

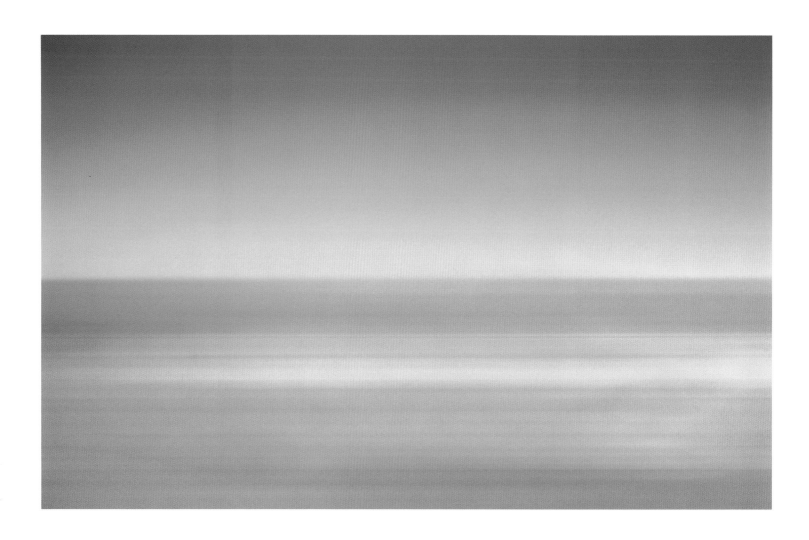

Michael Wesely: *Zabriskie Point,
Death Valley,* 1999
Unique chromogenic color print,
Diasec, metal frame, 125 x 200 cm
Paul Köser Collection, Krefeld
Courtesy of the artist

Michael Köhler

Michael Wesely: *Pacific Ocean at
La Jolla,* 2000
Unique chromogenic color print,
Diasec, metal frame, 125 x 200 cm
Collection Volpinum, Vienna
Courtesy of the artist

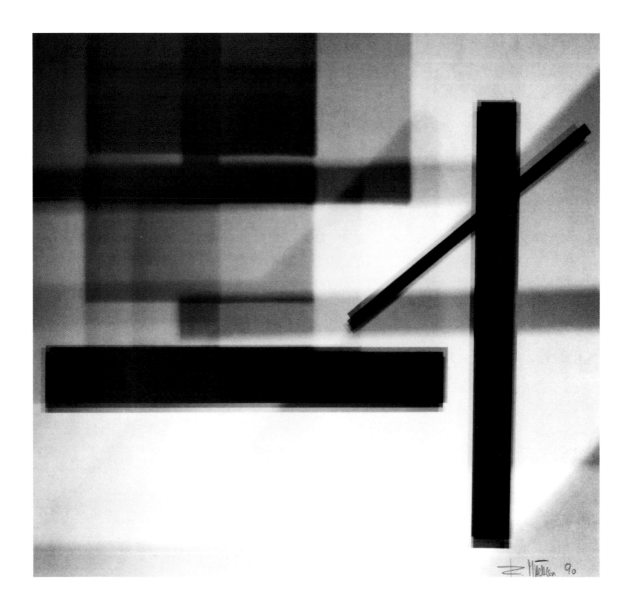

René Mächler: *Construction* (Konstruktion), 1990
Luminogram. Unique selenium protected gelatin
silver print, 28 x 29 cm
Courtesy of the artist

René Mächler: *Videogram 04/93,* 1993
Silver dye bleach print (Ilfochrome), aluminum,
70 x 70 cm
Burkhard Arnold Gallery, Cologne
Courtesy of the artist

Christiane Richter: Zwei Arbeiten *Ohne Titel*
(Two works untitled*)*, 1992
Chromogenic color prints, Diasec,
each 125 x 370 cm
Exhibition *László Moholy-Nagy : Idee und
Wirkung. Anklänge an sein Werk in der zeit-
genössischen Kunst* (László Moholy-Nagy :
Idea and Influence. Echoes of His Work in Con-
temporary Art), Kunsthalle Bielefeld, 1995
Photograph: Peter Nixdorf, Bielefeld

Christiane Richter: *4 x Papier auf Holz*
(paper on wood), *100 x 70 cm, 1998*
Double page from the exhibition catalog
Gallery Fahnemann, Berlin
Courtesy of the artist (bottom right)

Michael Köhler

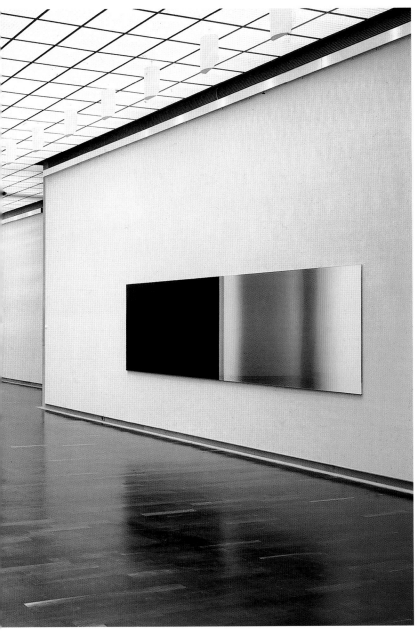

Inge Dick: Two works from the series *Ein Tages Licht Weiß* (One Day Light White) *13. 6. 1996, 5:07–20:52.* Here: *Weiß* (White) *13. 6. 1996, 10:29 hrs.* (left) and *10:32 hrs.* (right). 99 unique silver dye diffusion prints (Polaroid), each 60 x 50 cm
Courtesy of the artist and Rupert Walser Gallery, Munich

Michael Köhler

Günther Selichar: *Screen, Cold # 12,* 1997 / 2001
Color photograph. Silver dye bleach print
(Ilfochrome), Alucobond, 125 x 362 cm
Courtesy of the artist

Michael Köhler

Günther Selichar: *Screen, Cold # 22*, 1997/2001
Color photograph. Silver dye bleach print
(Ilfochrome), Alucobond, 125 x 200 cm
Courtesy of the artist

Herwig Kempinger: *Ohne Titel* (Untitled), 1991
Chromogenic color print, acryl, 202 x 115 cm
Courtesy of the artist

Michael Köhler

Herwig Kempinger: *Ohne Titel* (Untitled), 1988
Chromogenic color print, aluminum, 120 x 210 cm
Courtesy of the artist

Man Ray: *Objets mathématiques* (Mathe-
matical objects/Mathematische Objekte),
1934–1936
Gelatin silver prints, 24 x 30 / 30 x 24 cm
Centre Pompidou, Paris
Exhibition *Abstrakte Fotografie* (Abstract
Photography), Kunsthalle Bielefeld,
1 December 2000–18 February 2001.
Photograph: Gottfried Jäger, Bielefeld

Diskussion: Was ist Abstrakte Fotografie?
Discussion: What is Abstract Photography?

Podiumsdiskussion am 3. Dezember 2000 mit den Kunsthistorikern Vladimír Birgus, Reinhold Mißelbeck (†), Herbert Molderings und Gottfried Jäger. Gesprächsleitung: Thomas Kellein, Leiter der Kunsthalle Bielefeld, und, zusammen mit der Kunsthistorikerin Angela Lampe, Kurator der Ausstellung *Abstrakte Fotografie*.[1] Die Diskussionsbeiträge von Vladimír Birgus wurden durch einen technischen Defekt leider nicht aufgezeichnet. Wir verweisen daher besonders auf seinen Aufsatz zur tschechischen Avantgarde der Abstrakten Fotografie in dieser Publikation (s. S. 139ff.). Der folgende Einführungstext von Thomas Kellein ist seiner Eröffnungsrede zu der genannten Ausstellung entnommen.

Thomas Kellein: *Was ist Abstrakte Fotografie?* – Die Frage steht im Zentrum unserer Ausstellung und unserer Diskussion. Sie hat uns vom ersten Augenblick der Planungen zu dem Projekt und über das zweitägige Symposium hinweg begleitet. Die Debatte soll mit einigen Sätzen zu dieser Kunstform eröffnet werden. ■ Die Erfindung abstrakter Fotografie als Kunstform geht auf Werke zurück, die 1916 in New York durch Paul Strand, 1917 in London durch Alvin Langdon Coburn und 1918 in Zürich durch Christian Schad geschaffen wurden. Formal begann mit ihnen eine radikale Versachlichung und selbstbewußte Neustrukturierung des Bildaufbaus. Alfred Stieglitz hatte mit der New Yorker *Galerie 291*, Fifth Avenue, zwei wichtige Voraussetzungen dazu geschaffen: Den internationalen Austausch zwischen den Künstlern und dem Kunstpublikum und die Anerkennung des Kubismus. Durch seine Zeitschrift *Camera Work* machte er beispielgebende Werke von Cézanne, Rodin, Matisse und Picasso bekannt. In seinem Umkreis wurde ab 1910 nicht mehr *piktoralistisch* oder *symbolistisch*, sondern zunehmend *straight*, geradeheraus und ehrlich fotografiert. Es ging um motivische und technische Unverfälschtheit.[2] Paul Strand war 1916 im Alter von 26 Jahren der erste Fotograf, der abstrakte Stilleben aus Schalen mit Früchten schuf.

Panel discussion at December 3rd, 2000 with art historians Vladimír Birgus, Reinhold Mißelbeck (†), Herbert Molderings and Gottfried Jäger. Moderated by Thomas Kellein, director of the Kunsthalle Bielefeld, and together with Angela Lampe, art historian, the curator of the exhibition *Abstrakte Fotografie* (Abstract Photography), held at the Kunsthalle Bielefeld.[1] Due to technical reasons, Vladimír Birgus's contributions could unfortunately not be recorded. Therefore, we refer in particular to his essay on the Czech avant-garde of Abstract Photography found in this publication (see pp. 139ff.). Thomas Kellein's introductory remarks are taken from his inaugural address at the abovementioned exhibition.

Thomas Kellein: *What is Abstract Photography?* — This question is at the center of our exhibition and is the subject of this discussion. It has never left us—from the first moment of the project's inception until today. To introduce the subject, I will open the debate with a few remarks concerning the beginnings of this art form at the dawn of the twentieth century. ■ The discovery of Abstract Photography as an art form goes back to works created in New York in 1916, in London in 1917 and in Zurich in 1918. Formally, they introduced a radical objectification and a self-assured restructuring of the pictorial composition. With the *Gallery 291*, Fifth Avenue in New York, Alfred Stieglitz met two important requirements: An exchange of international ideas and the recognition of Cubism. His journal *Camera Work* acquainted the public with exemplary works by Cézanne, Rodin, Matisse and Picasso. As from 1910 he and his colleagues no longer made photographs *pictorialist* or *symbolist* in style, but increasingly *straight*, that is, in a straight-forward and honest way. It was a matter of purity, both in motif and in technology.[2] In 1916 Paul Strand, at the age of 26, was the first photographer to compose still lives of bowls with

1 Ausstellung exhibition *Abstrakte Fotografie* (Abstract Photography), Kunsthalle Bielefeld, 1. Dezember 2000 – 18. Februar 2001

2 Hartmann, Sadakichi: A Plea for Straight Photography (1904). Reprint in: Bunnell, Peter C. (ed.): *A Photographic Vision: Pictorial Photography. 1889–1923*. Salt Lake City 1980, pp. 149f.

Strand konnte und wollte damit lernen, »wie man Bilder baut, woraus ein Bild besteht, wie sich Formen zueinander verhalten, wie Formen gefüllt sind, und wie die ganze Sache zu einer Einheit finden muß«. Der Amerikaner Alvin Langdon Coburn schuf ab 1917 in London unter dem Einfluß von Ezra Pound so genannte *Vortographs,* bei denen der Gegenstand in eine Spiegelkonstruktion gelegt und dadurch in ein Formenprisma überführt wurde. Der Züricher Dadaist Christian Schad setzte ab 1918 als erster die Technik des Fotogramms ein, um Texte mit Schatten in kubistische Collagen zu verwandeln. Die Ursprünge abstrakter Fotografie hat etwas später Edward Steichen als künstlerische Suche nach universalen Symbolen bezeichnet. Die avantgardistischen Fotografen aus New York wollten ihrem Medium eigenständige, einzigartige Bilder entlocken, um die künstlerische Fotografie gegenüber der Wirklichkeit und den herkömmlichen Kunstgattungen Malerei und Skulptur zu emanzipieren. ■ In Kenntnis der amerikanischen Avantgardefotografen des Stieglitz-Kreises, der Arbeiten von Christian Schad in Zürich sowie der Pariser *Rayografien* von Man Ray entwickelten konstruktivistische Fotografen auf deutschsprachigem und sowjetischem Boden das lichtbildnerische Abstraktionsprogramm der 1920er Jahre. László Moholy-Nagy gilt als Wegweiser des Fotogramms, das er bereits Ende 1922 in Berlin, ab 1923 dann als Bauhauslehrer in Weimar und später in Dessau mit seiner Frau Lucia Schulz in Angriff nahm. Moholy-Nagys von Anbeginn stark geometrisierte Lichtbilder, die er mit Hilfe von Stangen, Rädern, Scheiben und anderen, in der Regel kaum wiedererkennbaren Gegenständen arrangierte, suggerieren Bewegung mit Licht, die aus dem Dunkel kommt. Noch ehe Moholy-Nagy seinen bedeutenden Beitrag zur abstrakten Fotografie begann, hatte er 1922 in der Zeitschrift *De Stijl* den Einsatz lichtempfindlicher Bromsilberplatten propagiert, um »Lichterscheinungen (Lichtspielmomente)« zu empfangen und zu fixieren. Ein zeitgenössischer Fotograf zeichnet sich, Moholy zufolge, durch gesteigerte Lernfähigkeit und

fruit (figs. p. 42). Strand was able and wanted to learn "how pictures are composed, of what they consist, how their forms relate to each other, how the forms are filled and how everything has to find its place in a unified whole." As from 1917 the American Alvin Langdon Coburn, influenced by Ezra Pound in London, made his so-called *Vortographs*, in which the object was put in a construction of mirrors and was thereby changed into a prism of forms. Christian Schad, the Zurich Dadaist, was the first in 1918 to introduce the technique of the photogram, in order to transform shadowed texts into Cubist collages. Edward Steichen somewhat later described the roots of Abstract Photography as an artistic quest for universal symbols. The New York avant-garde photographers wanted to make unique, original photographs, so as to emancipate artistic photography from reality and from the traditional artistic genres of painting and sculpture. ■ Constructivist photographers (German-speaking and of Soviet origin) developed the photographic program of Abstraction of the 1920s, due to their knowledge of the American avant-garde, of the photographers surrounding Stieglitz, of Christian Schad's Zurich works and of Man Ray's Parisian *Rayographs*. László Moholy-Nagy pioneered the abstract photogram with which he began in Berlin at the end of 1922, then advanced while teacher at the Bauhaus in Weimar as of 1923, and advanced further with his wife Lucia Schulz in Dessau. From the very beginning Moholy-Nagy's highly geometric photographs—which he arranged using rods, wheels, discs and other hardly recognizable objects—suggest movement with light emerging from the dark. Even before Moholy-Nagy made his most important contribution to Abstract Photography, he had in 1922 advocated in the journal *De Stijl* the use of light-sensitive silver bromide plates to receive and secure "optical phenomena (light effects)." According to Moholy, the modern photographer was keen to learn and highly aware of technology.

hohes Technologiebewußtsein aus. Er sollte »alle Elemente menschlichen Schaffens in eine Synthese« bringen. ∎ Ausgehend von Moholy-Nagy verbreiteten sich konstruktivische Foto-Texturen in Mittel- und Osteuropa ab 1924 wie ein Lauffeuer. Mit der Ausstellung *Film und Foto,* die 1929 vom Deutschen Werkbund in Stuttgart veranstaltet wurde und auf Europatournee ging, und der von Franz Roh und Jan Tschichold dazu herausgegebenen Publikation *Foto-Auge,* die ein bedeutendes Foto von El Lissitzky auf dem Umschlag zeigt, entwickelte sich abstraktes Fotografieren bis 1930 zu einem internationalen Stil. ∎ Mit dem Hochschullehrer, Sammler und Fotografen Otto Steinert fand die Avantgardefotografie der 1920er Jahre in der jungen Bundesrepublik Deutschland nach 1948 einen Garanten für ästhetische Kontinuität. Steinert rief die *Subjektive Fotografie* 1951 in Saarbrücken als Folge von Ausstellungen und Publikationen ins Leben, so daß freies kompositorisches Gestalten mit Kamerabildern und Fotogrammen weiterhin möglich schien. Die erste gleichnamige Schau wanderte nach Köln, München und an das George Eastman House in Rochester/USA. Ab 1959 lehrte Steinert an der Folkwangschule für Gestaltung in Essen und baute die bedeutende fotografische Sammlung am dortigen Folkwang Museum auf. Zu den herausragenden Vertretern abstrakten Fotografierens der 1950er Jahre in Deutschland zählen neben ihm der Kölner Chargesheimer, der Berliner Heinz Hajek-Halke, Peter Keetman sowie – rückblickend – auch der Bielefelder Mikrofotograf Carl Strüwe, dessen Arbeiten erstmals 1955 in Buchform publiziert wurden. ∎ Mit dieser historischen Voraussetzung ist das Feld der abstrakten Fotografie aber nur unzureichend definiert, denn heute, im Jahr 2000, können wir nicht mehr von gegenständlicher und ungegenständlicher, von abstrakter und figurativer Fotografie im Sinne von Gegensatzpaaren sprechen, die einander elementfremde Klassen bilden. Im Unterschied zu früher genießt die Fotografie heute eine internationale künstlerische und ungeahnte marktwirtschaftliche Anerkennung. Schon

He was "to synthesize all elements of human creativity." ∎ Influenced by Moholy-Nagy, Constructivist photo-textures spread like wildfire throughout Central and Eastern Europe as from 1924. By 1930 Abstract Photography had turned into an international style, on the one hand on account of the exhibition *Film und Foto* organized in 1929 by the German Werkbund in Stuttgart and subsequently touring Europe, on the other hand due to the publication *Foto-Auge,* edited by Franz Roh and Jan Tschichold, with an important photograph by El Lissitzky on its cover. ∎ After 1948 it was Otto Steinert—professor, collector and photographer—who assured aesthetic continuity for avant-garde photography of the 1920s in the young Federal Republic of Germany. In 1951 Steinert founded *Subjective Photography* in Saarbrücken as a result of exhibitions and publications which furthermore advocated a free compositional design with photographs and photograms. The first show under the same title went to Cologne, Munich and the George Eastman House in Rochester. From 1959 onwards Steinert taught at the Folkwang School of Design in Essen and helped build up the important photographic collection of the local Folkwang Museum. Among the most influential German representatives of Abstract Photography from the 1950s are Chargesheimer from Cologne, Heinz Hajek-Halke from Berlin, Peter Keetman and, in retrospect, Carl Strüwe, the microphotographer whose works were for the first time published in book form in 1955. ∎ This historical outline, however, cannot sufficiently define the field of Abstract Photography, because today, in the year 2000, we can no longer speak of objective and non-objective, of abstract and figurative photography in the sense of opposing pairs of dissimilar categories. Photography today, in contrast to yesterday, enjoys an international artistic and unprecedented economic success. Already in the 1960s photographers represented the object as an abstraction in minimalist

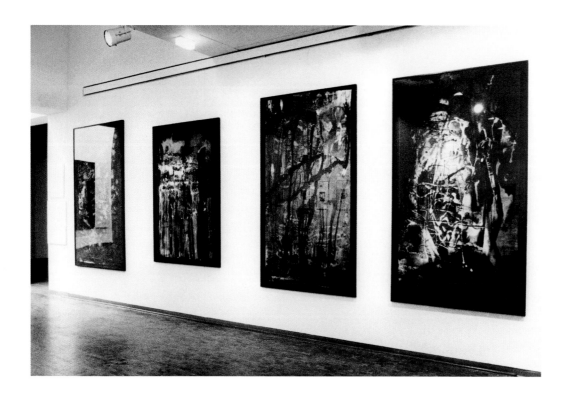

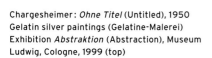
Chargesheimer: *Ohne Titel* (Untitled), 1950
Gelatin silver paintings (Gelatine-Malerei)
Exhibition *Abstraktion* (Abstraction), Museum
Ludwig, Cologne, 1999 (top)

Chargesheimer: *Ohne Titel* (Untitled), 1950
Gelatin silver painting (Gelatine-Malerei)
40.5 x 30 cm
Museum Ludwig, Cologne (bottom)

in den 1960er Jahren stellten Fotografen durch minimalistische Formen von Lichtbildnerei den Gegenstand selbst, in Form serieller Häuser oder Parkplätze, als abstrakte Größe vor. Ausgehend von dieser Wahrnehmungsänderung strukturieren heutige Fotografen das Verhältnis von Oberfläche und Tiefe, Wesen und Erscheinung grundlegend neu. Es geht bei abstrakten Fotografien folglich auch um die sich ständig ändernde Wirklichkeitswahrnehmung, um das Infragestellen dessen, was wir sehen, glauben, fühlen und hoffen. Die Abstrakte Fotografie ist in jedem Jahrzehnt etwas anderes, und folglich müssen wir sie ständig neu definieren. ■ Daher frage ich vielleicht als erstes Reinhold Mißelbeck, inwieweit für ihn Abstrakte Fotografie überhaupt ein Ausstellungsthema ist, inwieweit ist das Thema konsensfähig?

 Mißelbeck: Mein Interesse daran hat sich an der von mir betreuten Sammlung entzündet.[3] Sie beinhaltet unter anderem ein großes Konvolut des Kölner Fotografen Chargesheimer, der, als ich 1980 an die Sammlung kam, in erster Linie aufgrund seiner Bücher über Köln und das Ruhrgebiet gefeiert wurde, als ein Fotograf, der Menschen beobachtet und in der Tradition von Fotografen wie Henri Cartier-Bresson oder Brassaï gearbeitet hat. Chargesheimer hat parallel dazu aber auch ein Werk geschaffen, das er in den 1940er und 1960er Jahren intensiv vorangetrieben hat: Ein Werk, das aus *Silbergelatine-Malereien* besteht (Abb. S. 262). Diese Werkgruppe ist in den 1960er Jahren intensiv rezipiert worden. Gleichzeitig hat Chargesheimer abstrakte Skulpturen gemacht, die er *Meditationsmühlen* nannte. Sie gehen in die Richtung von Nicolas Schöffer, aber sie fanden nachher keine Beachtung mehr. Man hat − ich will das nebenbei bemerken, ohne die Namen der dafür Verantwortlichen zu nennen − als der Ankauf des Nachlasses von Chargesheimer im Museum Ludwig in den 1970er Jahren anstand, nach mehreren ziemlich einheitlich klingenden Gutachten dafür ausgesprochen, die Fotografien von Chargesheimer anzukaufen.

photography (like in series of houses or parking lots). Departing from this change in perception, contemporary photographers show in a novel way the relationship between surface and depth, between what is and what is seen. As a consequence this exhibition focuses on our constantly changing perception of reality, on the questioning of what we see, believe, feel and hope for. Every decade interprets Abstract Photography differently which is the reason why we must continually redefine it. ■ May I then perhaps ask Reinhold Mißelbeck to what extent he considers Abstract Photography a valid subject for an exhibition or to what extent there is agreement on this subject at all?

 Mißelbeck: My interest in all this stems from the collection of which I am the curator.[3] It contains, among others, a collection of works by Chargesheimer, the Cologne photographer, who, when I was put in charge of it in 1980, was celebrated principally for his books on Cologne and the Ruhr District and who was a photographer with an eye for people, working in the tradition of photographers like Henri Cartier-Bresson or Brassaï. But Chargesheimer also worked on a project which he intensely pursued in the 1940s and 1960s: A work consisting of gelatin silver paintings (figs. p. 262). These paintings were very well received in the 1960s. Chargesheimer simultaneously created abstract sculptures which he called *Meditationsmühlen* (Mills for Meditation). They go in the direction of Nicolas Schöffer, but were later disregarded. Without mentioning the names of the parties responsible, let me say that, in the 1970s, at the time when the purchase of Chargesheimer's œuvre by Museum Ludwig was under discussion, general agreement existed to acquire Chargesheimer's photographs—not, however, his gelatin silver paintings, since they were artistically uninteresting. And that's what happened. ■ Then, at the end of the 1980s, and in a second attempt with the help of private sponsors, I purchased these gelatin silver paintings from Charges-

3 Reinhold Mißelbeck: Die Erwerbungen seit 1977. In: *Photosammlung.* Ausstellungskatalog exhibition catalog. Köln: Museum Ludwig 1986, S. 8ff.

Aber unter Ausschluß der *Gelatinesilber-Malereien*, denn die seien künstlerisch nicht interessant. So geschah es. ■ Ich habe dann Ende der 1980er Jahre in einem zweiten Anlauf mit Hilfe privater Gelder diesen Teil des Nachlasses Chargesheimer von den Erben, der Familie Redlin, gekauft und der Sammlung zugeführt. Außergewöhnlich an den Arbeiten ist, daß sie ein Format haben, wie wir es in jenen Jahren eigentlich erst von Sigmar Polke kennen, Formate von etwa zweieinhalb, drei Meter Breite und einem Meter Höhe. Es sind Bildformate, die heute bei den jungen Künstlern, die mit Fotografie arbeiten, sehr wohl üblich sind. Für einen Fotografen Anfang der 1960er Jahre waren sie ausgesprochen ungewöhnlich. ■ Chargesheimer hat ja in Düsseldorf an der BIKLA-Schule gelehrt.[4] Es gab also durchaus Verbindungen, die noch nicht genauer erforscht sind. Jedenfalls war das, auch durch die Berührung mit Arbeiten von Man Ray, László Moholy-Nagy, El Lissitzky und auch Hajek-Halke, die wir im Museum haben, ein Ausgangspunkt, der mich herausgefordert und gereizt hat zu fragen: »Warum wird Abstrakte Fotografie nicht anerkannt?« ■ Man hat abstrakter Fotografie vielfach vorgeworfen, sie unternehme nichts anderes als den verzweifelten und hoffnungslosen Versuch, Tendenzen, die in der Malerei anerkannt sind, nachzuvollziehen. Das wirft man der Fotografie ohnehin gerne vor. Ich habe es gerade erneut bei Rolf H. Krauss nachgelesen, der seinerzeit festgestellt hat, daß die Fotografie bislang noch keine eigene künstlerische Bewegung in Gang gebracht hätte, die »Kunstgeschichte geschrieben« habe; daß also die Fotografie der bildenden Kunst eigentlich hinterherlaufe und deren Strömungen und Tendenzen nur nachvollziehe.[5] Das ist meines Erachtens so nicht haltbar. Wer die aktuellen Tendenzen der zeitgenössischen Kunst verfolgt, wer verfolgt, wie sehr die Fotografie heute die Kunstszene dominiert, muß zu einem anderen Urteil kommen. Diese Bewegung, die in den letzten zehn Jahren mit dieser Gewalt über uns hereinbricht, ist ja nicht aus dem Nichts entstanden. Es gibt Vorläufer, es gibt Entwicklungs-

heimer's heirs (the Redlin family) and added them to the collection. What is extraordinary about these works is that they come in a format in those days known to us only through Polke, a format of about two or three meters by about one meter. These are sizes customary for young artist-photographers nowadays, but which were most unusual for a photographer in the early 1960s. ■ Chargesheimer taught at the BIKLA school.[4] Surely there must have been points of contact which to date have not been researched more closely. This—together with the study of works by Man Ray, László Moholy-Nagy, El Lissitzky and Hajek-Halke, too, which are part of our museum collection—was the point of departure that challenged and tempted me to pursue the subject and to ask myself, "Why is Abstract Photography not being recognized?" ■ Abstract Photography has often been blamed for desperately and hopelessly trying to copy trends and tendencies accepted in the world of painting. In any case, that's what photography is accused of. Only just recently I read this again in Rolf H. Krauss, who once asserted that photography has yet to instigate an artistic movement to write art history; in other words, photography has always limped behind fine art and its currents and tendencies.[5] In my opinion, this is not plausible. Those who closely follow the trends in contemporary art, those who witness to which extent photography dominates the art scene today, have to come to a different conclusion. The movement of Abstract Photography—which, in the past ten years, has come upon us with a vengeance—did not come out of nowhere. There have been precursors, there have been growing tendencies: On the one hand, they go back to photo-artistic works of the 1920s and 1930s; on the other, they refer to how photography has been used as a document in fine art; and, in the end, simply to how influential the Becher School has been. In other words, for the first time, artists have addressed photography and have transformed pure

4 BIKLA, Abkürzung für *Bild und Klang,* eine private Schule für experimentelle Fotografie in Düsseldorf, geleitet von Anneliese Gewehr.
BIKLA, abbreviation for *Bild und Klang* (i. e. Image and Sound), a private school for experimental photography in Dusseldorf directed by Anneliese Gewehr.

5 Krauss, Rolf. H.: *Photographie als Medium. 10 Thesen zur konventionellen und konzeptionellen Photographie.* Berlin 1979 (2. Aufl. 2nd edition Stuttgart 1995).

tendenzen. Sie beruhen einerseits auf fotokünstlerischen Arbeiten der 1920er, 1930er Jahre, zum anderen auch darin, wie Fotografie als Dokument verwendet wurde für die bildende Kunst. Zum Schluß eben auch mit dem ganzen Einfluß, den die Becher-Schule hatte, daß also erstmals Künstler sich mit Fotografie befassen und ausgesprochen pure, reine fotografische Ästhetik in die Kunst umsetzen. ■ Vor diesem Hintergrund denke ich eben: Abstrakte Fotografie ist absolut ein Thema, das man untersuchen muß. Vor allem die Frage: Wird es möglich sein, das Verhältnis von bildender Kunst und Fotografie erneut beispielhaft darzustellen? Mit der Bielefelder Ausstellung wurde die Frage einen Schritt vorangetrieben. ■ Vielleicht in Kürze, was ich unter abstrakter Fotografie verstehe und wie ich den Begriff definieren würde. Ich sehe dazu drei Möglichkeiten, die auch durch Beispiele in der Ausstellung belegt sind. ■ Die erste Möglichkeit ist die *Abstraktion in der Fotografie*, insofern sie eine Abstraktion vom Gegenstand darstellt. Wenn der Fotograf immer näher an seinen Gegenstand heranrückt, ihm immer dichter auf den Pelz rückt, sozusagen, dann kommt er zu einem Punkt, an dem die Wiedererkennbarkeit des Gegenstandes umschlägt in eine Betonung von Strukturen, von geometrischen Mustern. Von hier bis zu einer abstrakten Komposition ist dann nur ein kleiner Schritt. So bei Karl Blossfeldt (Abb. S. 206f.), wobei man sagen könnte: Das ist doch eigentlich eine dokumentarische Fotografie, sie zeigt doch sehr präzise einen Gegenstand. Aber man muß auch sehen: Das Foto ist zwar dokumentarisch angelegt, aber letzten Endes ist die dahinter steckende Bildabsicht, die Dokumentation zu *überwinden*, um Strukturen aufzudecken. ■ Der zweite Punkt wäre eine Fotografie, die in den Bereich der *Selbstreflexion* hinein vorstößt. Selbstreflexion in der Fotografie ist letzten Endes das, was Gottfried Jäger mit dem Begriff *Generative Fotografie* belegt hat.[6] Dabei befaßt sich das Medium mit seinen eigenen technischen Mitteln, dem Fotoprozeß, z. B. der Fotochemie. Die *Gelatinesilber-Malereien* Chargesheimers fallen hier hinein, aber auch

photographic aesthetics into an art. ■ Therefore, with this in mind, I believe Abstract Photography is most definitely a subject to be studied: Above all, the question about whether or not it will again be possible to successfully represent the relationship between fine art and photography. To put it cautiously, let me say that this Bielefeld exhibition has advanced the question one step further. ■ Perhaps a few more words on how I understand Abstract Photography and how I would define the term. There are three points to consider, all foregrounded in the exhibition as well. ■ The first point is the *abstraction of the photograph* insofar as it represents an abstraction of the object. When the photographer approaches his object closer and closer, when he moves in on it, he reaches a point at which the object becomes unrecognizable, but whereby structures and geometric patterns are emphasized. There is only a very fine line between this and an abstract composition. Numerous works in the exhibition illustrate this border area. For example, in the case of Karl Blossfeldt (figs. pp. 206f.) where we could actually say that this is a documentary photograph, yet one which quite explicitly shows an object. But we also have to understand that, although the photo is laid out documentarily, there is nonetheless a hidden intention ultimately to transcend the documentary, in order to reveal structures. ■ The second point would be a genre of photography which enters the realm of self-reflection. *Self-reflection in photography* is in fact what Gottfried Jäger claims with his term *Generative Fotografie*[6] wherein the medium is concerned with its own technical means (e. g. with photochemistry), its own technical and esthetical process. Chargesheimer's gelatin silver paintings are as much part of this category as are Gottfried Jäger's photographs, of course (fig. p. 267, top). In total, I would say that the medium is concerned with itself, similar to what occurred in painting: painting as painting; painting which focuses on surface

6 Ausstellung exhibition *Generative Fotografie.* Städtisches Kunsthaus Bielefeld, Februar 1968. Vgl. dazu die Passage *Generative Tendenzen* im einführenden Beitrag des Herausgebers, S. 26ff. Cf. the excerpt on *Generative Tendencies* in the editor's contribution, pp. 26ff.

die Fotografien von Gottfried Jäger selbst (Abb. S. 267, oben). Das Medium befaßt sich auf ähnliche Weise mit sich selbst, wie die Malerei das gemacht hat: Malerei als Malerei; Malerei, die sich mit Oberflächenstrukturen, mit Farbpigmenten und ähnlichen Dingen befaßt und nichts anderes beinhaltet. Dies ist dann eine Abstraktion, die eigentlich schon als *Konkretion* der Malerei zu bezeichnen ist. Die Abstraktion schlägt um in *Konkrete Kunst.* ■ Das Dritte ist dann die *Abstraktion vom Medium.* Und da kommen wir z. B. zu den Arbeiten von Bernd Lintermann (Abb. S. 267, unten). Abstraktion vom Medium ist etwas, das sich im Kontext zur Digitalisierung des Bildes entwickelt. Es gibt mehr und mehr Fotoarbeiten, die aussehen wie Fotos, die aber keine mehr sind. Das beginnt schon in der Malerei bei gewissen Bildbeispielen von Gerhard Richter. Hier haben wir ein Foto, das als Zeitungsfoto gedruckt, fotografisch reproduziert und übermalt wurde, und das dann letzten Endes wieder in gedruckter Form vorliegt. Dieser Wechsel zwischen den verschiedenen Medien zeigt sich also auch schon in der bildenden Kunst. Er ist aber in der medialen Auseinandersetzung heute stärker zu verzeichnen. So *erfindet* der Computer ›Fotos‹ digital, Fotos, die virtuell sind, und die letzten Endes das, was die Fotografie ausmacht, tatsächlich nicht sind. Bei ihnen gibt es keinen Zeitpunkt, zu dem einmal der Auslöser gedrückt wurde, oder keinen Ort, an dem die Fotochemie dem Licht ausgesetzt war, keine Zeit und keinen Ort, zu denen ein einmaliges fotografisches Bild entstand. Und Lintermann gibt dazu ein Beispiel. Wer seine Bilder sieht und nicht weiß, was sie sind, denkt an das fotografische Bild, das vielleicht digital manipuliert wurde. In Wahrheit ist es ein Bild, das nie ein fotografisch-chemisches Verfahren durchlaufen hat, auf dem sich nie eine gewisse Menge von Licht auf Fotochemie niedergeschlagen hat. Es ist das Ergebnis einer Berechnung. Das Bild wird mittels Computer erzeugt und wirkt dennoch sehr fotografisch. Das sind die drei Ebenen, auf denen sich Fotografie als Abstraktion, als abstraktes Bild, heute abspielt.

structures alone, on color pigments and the like, with no other content whatsoever. It is then an abstraction, more to be called a concretion of painting. Abstraction turns into *Concrete Art.* ■ *Abstraction from the medium* is the third point. This brings us to what is shown at the end of the exhibition: Works by Bernd Lintermann (fig. p. 267, bottom). Abstraction from the medium occurs in the context of the digitalization of the image. There are more and more photographic works which resemble photos, but which are no longer any (like in painting, in Gerhard Richter's works, for instance). Here we have a photograph printed as a newspaper photo, photographically reproduced and painted over, then finally available again in printed form. This change from one medium to another is already to be witnessed in fine art. Today, however, it is more pronounced in the media world. The computer invents 'photographs' digitally, photographs which are virtual and are ultimately not that which is the very stuff of photography. There is neither a point in time when the release was actuated, nor a locus where the photochemistry was exposed to light; no time, no place in which a unique photographic image was ultimately made. Lintermann gives us an example: He who sees his pictures, and does not know what they are, thinks of a photograph which has perhaps been digitally manipulated. In truth, it is a picture which has never undergone a photographic-chemical process, a picture in which light has never met photochemistry. Instead it is a calculated picture. It is based on a numerical pattern which, with the help of a computer, creates the picture and which, as I said, nonetheless has a highly photographic effect. ■ These are, as I see it, the three ways in which photography represents abstraction or abstract pictures.

Kellein: I would now like to invite Herbert Molderings to comment upon the opening question. If one were to ask you in the street, "What is Abstract Photography?", what would be your reply?

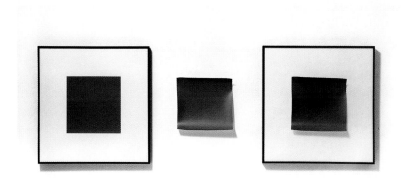

Gottfried Jäger: *Zwei Quadrate* (Two
Squares), 1983
Dreiteilige Fotoarbeit (Three-part photo
work). Two gelatin silver papers 25 x 25 cm,
one gelatin silver print 50 x 50 cm
Museum Ludwig, Cologne (top)

Bernd Lintermann: *Computergenerated
Landscape II*, 1998
Hot wax print on paper, 88.8 x 115.8 cm
Museum Ludwig, Cologne
Courtesy of the artist (bottom)

Kellein: Ich möchte jetzt Herbert Molderings bitten, die Eingangsfrage aufzugreifen. Wenn Sie gefragt würden auf der Straße: »Was ist Abstrakte Fotografie?« – Was würden Sie antworten?

Molderings: Daß ich sowohl als Kunst- wie auch als Fotohistoriker große Probleme mit diesem Begriff habe. Ich habe insbesondere Probleme mit der Definition des *Spektrums* dieses Begriffs: Röntgenfotografie, Chronofotografie von Etienne-Jules Marey, Astrofotografie, Makrofotografie, Mikrofotografie – dieses ganze Spektrum der naturwissenschaftlichen Dokumentarfotografie unter diesen Begriff zu fassen, finde ich sehr verwirrend. Ich frage mich, ob der Begriff *Abstrakte Fotografie* dann wirklich noch ein operationaler, produktiver Begriff ist, der unsere Erkenntnis dieses Phänomens erweitert – oder nicht in eine Richtung führt, die eher verschleiert, was da vor sich geht. ■ Es ging ja dieser Fotografie keineswegs darum, Formen von der Natur zu abstrahieren. Vielmehr ging es ihr darum, mit Hilfe eines technischen Prozesses tiefer in die Strukturen der Natur hineinzublicken, mit Hilfe einer Optik, die die natürliche Optik unseres Auges erweitert. Und wenn, das hat die kunsthistorische Forschung in den letzten zwanzig Jahren deutlich gemacht, dann nicht deshalb, weil es hier um abstrakte, autonome Formen ging. Sondern darum, hinter den Schleier unserer Augen zu dringen. Das heißt: Man begriff die natürliche Wahrnehmung angesichts der technisch-optischen Möglichkeiten der naturwissenschaftlichen Fotografie plötzlich nicht mehr als hinreichendes Erkenntnisorgan, sondern als ein Organ, das uns hinderte, die tiefen Strukturen der Natur zu sehen und zu begreifen. Die röntgenfotografische Sichtbarmachung unsichtbarer Strahlung wurde begriffen als positivistischer, naturwissenschaftlicher Beweis der Existenz okkulter Phänomene, die am Ende des 19. Jahrhunderts die Maler so enorm beschäftigt haben. ■ Die Zeit um 1900 markiert den Höhepunkt der Entchristianisierung der Weltanschauung, des Verlustes von Transzendenz, und diese Lücke, diese

Molderings: That I, as art historian and photo historian, have great problems with this term. In particular, I have difficulties with the definition of the spectrum of the term, which includes X-ray photography, Etienne-Jules Marey's chronophotography, astrophotography, macrophotography, microphotography, etc. To put this whole spectrum of scientific documentary photography under one and the same heading is very confusing. I wonder whether the term Abstract Photography can still be considered as a functional, productive category widening our understanding of it, or whether it is not merely mystifying what is actually happening. ■ This type of photography was not concerned with abstracting forms from nature. It rather attempted to look deeper into the structures of nature with the help of a technical process, with the help of optics widening the natural optics of our eye. And if so, as art historical research of the past twenty years has revealed, then not because it was a matter of abstract autonomous forms, but so as to get behind the retina of our eyes instead. In other words, due to the technical-optical possibilities of scientific photography, natural perception was no longer regarded as a sufficient sensorial tool for recognition but, rather, as something which kept us from seeing and understanding the deeper structures of nature. X-ray photography, by revealing invisible rays, was regarded as a positivist, scientific proof of the existence of occult phenomena which so preoccupied painters towards the end of the nineteenth century. ■ The time around 1900 marks the culmination of the dechristianization of a particular weltanschauung, of the loss of transcendence; as from 1875 onwards, this gap or void was filled with an enormous interest in theosophy, in spiritualism and in scientific spiritualism as it appeared in 1890. The painters asked themselves: What can we, as painters challenged by photographic technology, still accomplish, in order to help advance empirical perception? ■ Let us mention

Leere wurde seit 1875 durch ein enormes Interesse für die Theosophie und für den (wissenschaftlichen) Spiritismus wie er seit 1890 aufkommt, ausgefüllt. Die Maler fragten sich: Was können wir als Maler angesichts der Herausforderung durch die fotografische Technik überhaupt noch leisten, um hinter den Schleier der empirischen Wahrnehmung zu sehen? ■ Was dann geschah, es sei hier nur en passent erwähnt, war ein Rekurs auf neoplatonische Ideen, es war die Idee, daß allen Sinnesphänomenen letzten Endes Ideen zu Grunde liegen, unveränderliche, absolute Ideen. Die Malerei sollte durch das Erfinden von absoluten, autonomen Formen diese absoluten Ideen sichtbar machen. Also nicht mehr empirische Phänomene abbilden, das hatte die Malerei konkurrenzlos an die Fotografie übergeben, den Wettbewerb konnte sie nicht aufnehmen, der war längst verloren. Sondern etwas sichtbar machen, was die Fotografie nicht fotografieren kann, was sie nicht abbilden kann, nämlich Geist, Spiritualität, das war die neue Aufgabe der Maler. Und an diesem historischen Punkt hat László Moholy-Nagy zuerst den Pinsel und dann auch das Fotopapier in die Hand genommen und zu arbeiten begonnen. ■ Als ich von Ihrer Ausstellung hörte, das Konzept las und durch die Namen das Spektrum dieses Begriffs vor Augen hatte, fiel mir ein, daß, so weit ich weiß, László Moholy-Nagy, der eigentlich mit seinen Fotogrammen der Kronzeuge der Abstrakten Fotografie schlechthin sein sollte oder könnte, diesen Begriff niemals verwendet hat! Mir ist keine derartige Stelle bekannt. Wenn jemand von Ihnen in seinen Schriften auf diesen Begriff gestoßen ist, wäre ich Ihnen für einen Hinweis dankbar. Das interessiert mich sehr! Moholy-Nagy hat hunderte und aberhunderte von Seiten über das Fotogramm, über die Fotografie und über die abstrakte Kunst geschrieben. Aber er hat im Zusammenhang mit seinen Fotogrammen nie von Abstrakter Fotografie gesprochen. Seine Fotogramme wurden zwischen 1922 und 1925 *Lichtkompositionen* genannt. Das war sein Ausdruck: *Lichtkompositionen*, Kompositionen mit Licht. 1925 führt er dann diesen

in passing what then happened: It was a turning back to neo-platonic philosophy, it was the thought that all sensorial phenomena were ultimately indebted to ideas, to unchangeable, absolute ideas. Using new, absolute and autonomous forms, painting was to make these absolute ideas visible. Thus, it was no longer a matter of copying empirical phenomena—painting had readily handed this over to photography, since it could not compete with new technology; it was a lost cause. The duty of the painter was, rather, to make visible what photography could neither capture nor reproduce, namely the spirit or spirituality per se. And at this point in history, László Moholy-Nagy first picked up the paint brush, then photographic paper, and set himself to work. ■ When I heard of your exhibition, read about the concept and learned about the names included in the spectrum of Abstract Photography, I realized that, as far as I know, László Moholy-Nagy who, with his photograms, could actually be considered as the chief initiator of Abstract Photography, never even used the term! I know of no existing quotation. Should anyone of you have come across this term in his writings, I would be most grateful for the reference. It greatly interests me! Moholy-Nagy wrote hundreds and hundreds of pages on the photogram, on photography and on abstract art. But in connection with his photograms, he never once mentioned the term Abstract Photography. Between 1922 and 1925 he called his photograms *Lichtkompositionen* (compositions of light). This was his term: *Lichtkompositionen*, *Kompositionen mit Licht* (compositions of light, compositions with light). In 1925 he introduced the more general term *photogram* which he adhered to, albeit referring to both terms in his later American publications. Why did he renounce the obvious term Abstract Photography? ■ I think he did it, in order to highlight an important difference: Namely, the difference between abstract painting—which he also called absolute

generellen Begriff *Fotogramm* ein, und den behält er bei, wobei er dann später in seinen amerikanischen Büchern oft beide Ausdrücke verwendet. Warum hat er auf den naheliegenden Begriff Abstrakte Fotografie verzichtet? ■ Ich glaube, er hat es getan, um eine wichtige Differenz zu benennen: Zwischen der abstrakten Malerei – die er auch absolute Malerei nennt und deren Aufgabe darin besteht, Linien, Formen und Farben in ihrer Eigenwertigkeit zu erkunden, zu reflektieren und zu gestalten – und dem, was das Fotogramm, das lichtempfindliche Papier, leisten kann. Bei diesem geht es meines Erachtens weniger um die Autonomie, die Selbstreferentialität von Formen, sondern um das Licht. Und das Licht ist keine abstrakte Form, keine Abstraktion. Das Licht war in den 1910er und 1920er Jahren, ein philosophischer, vor allem wissenschaftsphilosophischer Schlüsselbegriff, der die Grenze zum Begriff der Materie beschrieb. Der Lichtbegriff war eng verknüpft mit der Idee der Auflösung der Materie, die damals sehr viele Künstler und Wissenschaftler beschäftigte. Er fand sich dann in dem Begriff der Energie wieder, der bei Moholy-Nagy auch immer wieder vorkommt, auch in der Verbindung von beiden Begriffen im Begriff der Licht-Energie. Und dieses Phänomen, Gegenstände – sprich: Materie – aufzulösen in Energie, in reines Licht, das konnte das Fotogramm leisten. ■ Das Fotogramm ist ja das Endprodukt eines relativ komplizierten Vorgangs. Den kennen Sie alle, aber man sollte ihn sich vielleicht noch einmal in Erinnerung rufen. Moholy-Nagy benutzte stets Gegenstände, er hat nicht mit der Taschenlampe gearbeitet, er hat also keine Lichtschriften gemacht oder so etwas. Er benutzte zum Teil ganz komplizierte, skulpturale Aufbauten, um diese Lichtkompositionen zu erzeugen. Mit anderen Worten: Er zerleuchtete die Gegenstände in seiner künstlerischen Arbeit, er löste sie auf in reine Energie (Abb. S. 273 rechts). Moholy-Nagy greift im Zusammenhang mit seinen Fotogrammen immer wieder Fragen der Raumgestaltung, der Gestaltung des Raumes durch Licht auf. Das Fotogramm visualisiert einen Raum,

painting and whose aim it was to explore, reflect and compose lines, forms and colors in their intrinsic value—and that which the photogram, the light-sensitive paper, can deliver. In my opinion, the latter is less concerned with the autonomy or self-referentiality of forms, but with light instead. And light is no abstract form, no abstraction. In the 1920s—actually it began towards the end of the 1910s—light was a philosophical and, above all, scientific-philosophical key term which described the limits of the notion of matter. Light, as a concept, was intimately linked with the idea of the dissolution of matter, an idea which at the time preoccupied many artists and scientists. It then reappeared in the concept of energy, repeatedly used by Moholy-Nagy, or as a compound such as light-energy. The photogram's achievement was to dissolve objects—i.e. matter—into energy, into pure light. ■ The photogram was, as it were, the end product of a relatively complicated process. All of you know this, but let me nonetheless recapitulate. Moholy-Nagy always used objects, he never worked with a torch, hence he did not make light-pen images or the like. He used objects—in part highly complicated, sculptural constructs—to create these compositions of light. In other words, his objects were flooded with light, dissolved into pure energy (fig. p. 273 right). With his photograms Moholy-Nagy, thus, incessantly addresses questions of spatial design or of the composition of space through light. The photogram makes a certain space visible in which the relations of dimension are unimportant. One is to go beyond geometric space; the photogram is to come closer to non-Euclidean space. So when Moholy-Nagy mentions space, he is thinking of the relation of the objects' position ("Lagebeziehung der Dinge"). This is the definition of space in topology, in non-Euclidean geometry. Neither relations of measurement nor measurements, rulers and the like are important; rather, what is important are the relations of position. Moholy-Nagy focuses on a

in dem die Maßverhältnisse keine Rolle spielen. Der geometrische Raum soll überwunden werden, das Fotogramm soll sich dem nicht-euklidischem Raum nähern. Er spricht, wenn er von Raum spricht, von der Lagebeziehung der Dinge. Das ist die Definition des Raums in der Topologie, in der nicht-euklidischen Geometrie. Maßbeziehungen spielen keine Rolle, Messungen, Lineale, all das spielt keine Rolle, sondern Lagebeziehungen. Moholy-Nagy hat eine qualitative Geometrie im Blick, keine quantitative Geometrie. Und diesen absolut neuen Raumbegriff, der so viele Künstler seiner Zeit beschäftigt hat, den, glaubte er, mit dem Fotogramm fassen zu können. Quintessenz dieses ganz fokussierten historischen Rückblicks auf die Arbeit Moholy-Nagys, eines eminent wichtigen Künstlers, wenn man von abstrakter Fotografie redet, ist: Diese gab es für Moholy-Nagy nicht. Es war ein ganz anderer Gedanken-kosmos, in dem das Fotogramm entstanden ist und praktiziert wurde. ■ Wenn Moholy-Nagy im Gegensatz zu Man Ray sehr darauf geachtet hat, daß die Gegenstände, die er zur Herstellung des Fotogramms benutzte, nicht mehr wiedererkennbar waren, dann deshalb, weil es ihm nicht darum ging, die lichtartigen Schatten von Gegen-ständen, Traumrealitäten und ähnliches zu visualisieren. Vielmehr ging es ihm um philosophische Probleme, um die Idee der Auflösung, des Verschwindens der Materie, und um die Idee eines neuen Raumes, eines nicht-euklidischen Raumes, eines reinen Lichtraumes. Moholy-Nagy hat mit den Fotogrammen großartige Werke geschaffen, die in diese komplexe Denkstruktur eingreifen und *Denkbilder* – Sie [zu Thomas Kellein gewandt] haben den Begriff für die Gegenwart benutzt – darstellen, die diese ganzen Fragen eines neuen Weltbildes, insbesondere wissenschaftli-chen Weltbildes, das die Künstler in den 1920er Jahren so sehr beschäftigte, verdichten. Deshalb kann ich mit dem Begriff Abstrakte Fotografie in diesem Zusammenhang überhaupt nichts anfangen. Er führt meine Gedanken in Regionen, die ich für aufgesetzt halte und die nichts mit der Sache und mit dem Phänomen selbst zu tun haben. ■

qualitative geometry, not a quantitative one. With his photogram he considers it possible to pinpoint this absolute-ly new concept of space with which so many artists of his time were preoccupied. The point of this historical reflec-tion on the work of Moholy-Nagy, an eminent artist in the domain of abstract photography, is that, for him, abstract photography did not exist. The photogram was the product of a totally different field of thought. ■ If, in contrast to Man Ray, Moholy-Nagy was intent on making the objects of his photograms unrecognizable, then this was so, because he was not concerned about making visible the 'lightlike' shadows of objects, dream worlds, etc. Instead, he focussed on philosophical problems, on the idea of the dissolution and disappearance of matter and on the idea of a new space, a non-Euclidean space, a pure space of light. With his photograms Moholy-Nagy created great works of art which affect this complex structure of thought representing *images of thought*—you [turning to Thomas Kel-lein] used the term in reference to today's situation—and which intensify all these questions concerning a new world view, particularly a scientific world view that had greatly interested artists of the 1920s. This is why I am at a loss about using the term Abstract Photography in this context. It sounds ostentatious and makes me think of things unrelated to the actual phenomenon. ■ Abstract photographs exist if, for example, we are talking about *Generative Photography*. I think that we [turning to Gottfried Jäger] discussed the topic for the first time in 1969. Do you still remember that I wrote on *Generative Photography* in 1969? You don't, do you?

Jäger: Yes I do: after Constance, an unforgettable conference! Somewhat outdated in the meantime, but the content is still the same.[7]

Molderings: Karol Hiller's heliogravures,[8] Francis Brugière's works, Chargesheimer's gelatin silver paint-

Es gibt abstrakte Fotografien, wenn wir z.B. über *Generative Fotografie* reden. Ich glaube, wir [zu Gottfried Jäger gewandt] haben uns 1969 das erste Mal darüber unterhalten. Wissen Sie, daß ich 1969 über *Generative Fotografie* geschrieben habe? Das wissen Sie nicht mehr!

Jäger: Doch, ich weiß es: nach Konstanz, einer unvergeßlichen Tagung! Inzwischen etwas verblichen, Ihr Text, aber der Inhalt ist noch präsent.[7]

Molderings: Auch die Heliografien eines Karol Hiller[8] oder die Arbeiten eines Francis Bruguière, Chargesheimers *Silbergelatine-Malereien*, große Teile der Fotografik der 1950er Jahre, die Mode der Lichtpendel-fotografien usw., diese Begeisterung für die strukturelle Fotografie der 1950er Jahre, ich glaube, dafür ist dieser Begriff verwendbar. Wenn wir von einer Subgeschichte der Fotografie sprechen, dann glaube ich, geht es um die Definition des Spektrums dieser Subgeschichte, und diese sehe ich nicht so weitläufig, wie Sie es in Ihrer Aus-stellung darstellen – obwohl ich alle diese Bilder gerne sehe.

Kellein: Vielen Dank für dieses zweite Statement. Ich möchte nun Gottfried Jäger das Wort mit der Frage geben: Gibt es diese Subgeschichte? Und ist es, nach dem zweitägigen Symposium und nach den Ausstellungen und neuen Erfahrungen, möglich zu sagen: Die Definition des Begriffes Abstrakte Fotografie sollte entweder enger und weiter gefaßt werden? Wie ist die Sache der Abstrakten Fotografie jetzt zu bewerten, die ja auch Ihre Sache ist von Anbeginn?

Jäger: Nun, wir haben die Aktivitäten zur Abstrakten Fotografie bisher stets als Fragestellung und These verstanden, nicht als Behauptung mit bestimmten Festlegungen. ■ Für mich ist Fotografie ein komplexes Medium, das, wenn man es vereinfacht ausdrückt, zwei Kulturen verpflichtet ist: Dem Realismus und auch der

ings, large portions of photography from the 1950s, the fashion of light-pendulum photographs, etc. I actually think, however, that the term Abstract Photography applies to a certain enthusiasm for the structural photo-graphy of the 1950s. If we choose to talk about a subhistory of photography, then I believe we must define the spectrum of this subhistory, and I don't see it as multi-faceted as shown in your exhibition—although I enjoy all these pictures.

Kellein: Many thanks for your second statement. I would now like Gottfried Jäger to continue by answer-ing the following question: Does this subhistory exist? And is it possible to say—after our two-day symposium, the exhibitions and, undoubtedly, the experiences gained—that the spectrum of Abstract Photography should either be limited or expanded? How are we to evaluate the question of Abstract Photography today, a question that has been yours from the beginning as well?

Jäger: Well, we conceived our entire conference as a questioning of Abstract Photography, not with its assertion or with a certain biased declaration. Instead, we began by questioning the concept that still has to be examined further—which we are, after all, doing right now. ■ In my eyes, photography is a very complex medium which, if one were to put it simply, is indebted to two cultures: To Realism and also to Abstraction, a visual language unrelated to physical objects. It wants to show something that just cannot be shown figuratively: some-thing included in the term Abstraction. ■ Let me tell you a short story. A few years ago I was in a restaurant with my son and a guest sitting at the table next to us noticed his box of painting utensils. The stranger asked him, "What do you do with it?" My son replied, "I paint." Next came the question, "How do you paint: figuratively or abstract?"—

7 Tagung *Fotografie und ihre Funktions-bezüge zur bildenden Kunst und Literatur* der Universität Konstanz, Oktober 1969. Erste umfassende wissenschaftliche Veranstaltung dieser Art in der Bundesrepublik Deutschland. Danach veröffentlichten Guido Boulboulé und Herbert Molderings einen Text unter dem Titel ›Orientierung auf den Klassenkampf‹, in: *tendenzen*, München 1970. 11. Jg., Nr. 65, 1970, S. 14 – 17. Den Titel hatte die Redaktion erfunden. Er lautete ursprünglich ›Kunst und Automation‹.

A reference to the symposium held at the Uni-versity of Constance, *Fotografie und ihre Funk-tionsbezüge zur bildenden Kunst und Literatur* (Photography and its Relationships to Fine Art and Literature), October 1969. It was the first comprehensive academic conference of this kind in the Federal Republic of Germany. Subsequently, Guido Boulboulé and Herbert Molderings published a text entitled *Orientie-rung auf den Klassenkampf* (Orientation on Class Conflict) in the journal *tendenzen*, Vol. 11, no. 65, 1970, pp. 14 – 17. The essay's title was chosen by the journal editors. It was originally *Kunst und Automation* (Art and Automation).

8 Karol Hiller (1891 – 1939), polnischer Maler, Fotomonteur und Fotograf. Realisierte zwischen 1930 und 1938 eine Serie von *Helio-graphischen Kompositionen*, Kontaktabzüge von im Stile der abstrakten Malerei bearbei-teten Planfilmen. Polish painter, photo mont-agiste and photographer. Between 1930 and 1938, he realized a series of *Heliographic Compositions*, contact prints from sheet film, processed in the style of abstract painting.

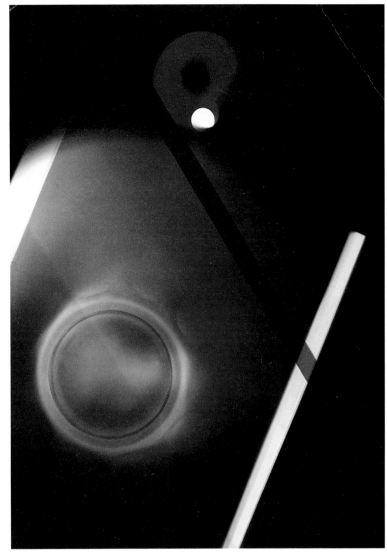

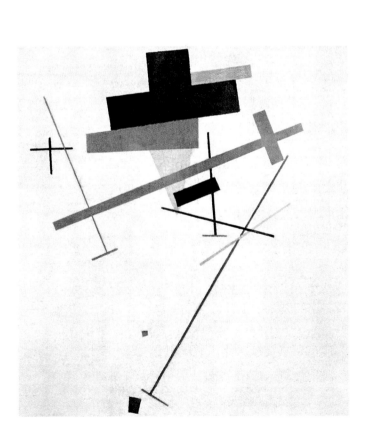

László Moholy-Nagy: *Ohne Titel* (Untitled),
1923 – 1925
Photogram. Unique gelatin silver print,
17.9 x 12.9 cm
Centre Georges Pompidou, Paris
Courtesy of Hattula Moholy-Nagy (right)

Kasimir Malevitch: *Suprematistic Com-
position,* ca. 1915 – 1916
Oil on canvas, 49 x 44 cm (left)

Abstraktion, einer nicht auf den physischen Gegenstand bezogenen Bildsprache. Sie will etwas zeigen, das mit Gegenständlichkeit nicht zu zeigen ist: Einen Bereich, den man ganz allgemein unter den Abstraktionsbegriff fassen kann. ■ Ich will dazu eine kurze Geschichte erzählen: Vor einigen Jahren saß ich mit meinem Sohn in einem Restaurant und ein Gast am Nebentisch bemerkte seinen Koffer für Malutensilien. Der Fremde fragte ihn: »Was machst du?« Mein Sohn antwortete: »Ich male«. Frage: »Wie malst Du: gegenständlich oder abstrakt?« Usw., usw. Diese einfache Fragestellung möchte ich auf die Fotografie anwenden. Auf der einen Seite existiert das Streben nach dem genauen Abbild, so in der Reportagefotografie, dem realistischen Foto, usw. Auf der anderen Seite die Bestrebung, etwas Neues zu schaffen, das vorher nicht vorhanden war, der Wunsch, etwas herzustellen, etwas zu erzeugen. ■ Und nun ist es eine akademische Frage, ob das so Konstruierte dem Begriff der Abstraktion zugehört oder nicht. Wenn man es puristisch sieht: Nein. Denn Abstraktion reduziert, Konstruktion baut etwas Neues auf. Trotzdem würde ich zunächst die Unterscheidung in gegenständlich und nichtgegenständlich bzw. in gegenständlich und abstrakt vertreten, weil man sie als – zugegeben grobe – Zuordnung gut gebrauchen kann. Man kann sie gebrauchen, um dieses zweite Phänomen, die ›zweite Kultur‹ der Fotografie, ihre nichtgegenständliche Seite, die ja Vielen noch immer unbekannt ist und ungewöhnlich erscheint, mit einem inzwischen doch geläufigen Begriff zu versehen und darauf aufmerksam zu machen. ■ Die Debatten des Symposiums haben dazu Auffassungsunterschiede erbracht, wie sie sich ähnlich auch hier artikulieren. Sie bleiben sicherlich vorerst bestehen. Als Beispiel greife ich den Hinweis von Herrn Molderings auf die *Generative Fotografie* von 1968 auf: Wir haben ja damals nicht umsonst einen neuen Begriff für unsere Arbeit gesucht und eingeführt, um deutlich zu machen, daß es hier um eine ganz spezielle Geschichte geht, nämlich darum, neue, durch Technik inspirierte Bilder hervorzubringen, etwas zu

and so on. Now, I would apply this simple question to photography. On the one hand, there is the ambition for an exact copy or representation, as in journalistic photography, realistic photography, etc. On the other hand, there is the ambition to create something that did not exist before, to produce, to construct something new. ■ And so it becomes an academic question of whether or not such constructions fall under the heading abstraction. Looking at it in a purist way: No. Abstraction reduces, construction builds something new. But for now I would advocate a distinction between the figurative and the non-figurative, i. e. between the figurative and the abstract. This admittedly rather general distinction is very useful for us to work with, so that we can draw attention to the abovementioned second phenomenon (the 'second culture' of photography, its non-figurative side, still unknown and unusual for many today) by making it a meanwhile more acceptable term. ■ The symposium debates have shown that differences of opinion exist—and will continue to exist. Let's return to Mr. Moldering's comments on the *Generative Situation* of 1968. It was not without good reason that we looked for and introduced a new term for our work in those days, so as to state clearly that we were concerned about something very specific: To produce or 'generate' new pictures inspired by technology, not to represent abstraction in the strict sense of the word. ■ For me Abstract Photography is a general term, one which requires divisions and subdivisions which, in turn, necessitate a clear differentiation among them. I would keep it at that for now.

Kellein: But I still have a question for Mr. Moldering: Provided your thesis is correct that Moholy-Nagy does not actually belong into the exhibition—that's nice, I like it—but I then need to know: What about Man Ray? Should he be eliminated, too, and what shall we do then?

generieren – und eben nicht: Abstraktion im strengen Sinne des Begriffs vorzuführen. ■ Abstrakte Fotografie ist für mich also ein Sammelbegriff; ein Begriff, der allerdings Unterteilungen braucht, Unterabteilungen, die man genauer differenzieren muß. Dabei möchte ich es hier erst einmal belassen.

Kellein: Ich habe trotzdem noch eine Frage an Herrn Molderings: Wenn ihre These richtig ist, daß Moholy-Nagy eigentlich *nicht* in diese Ausstellung gehört – ich finde das sehr schön, es gefällt mir. Ich muß aber dann wissen: Was ist mit Man Ray? Soll der auch raus, und was machen wir dann?

Molderings: Es geht ja hier um einen gewissen Anspruch. Es ist außerordentlich verdienstvoll, daß wir es hier mit einer Ausstellung zu tun haben, die das alte Ethos der Museumsausstellung aufrecht erhält und Ausstellungen noch als Rechercheprojekt, als mit der wissenschaftlichen Recherche verbundenes Projekt sieht und nicht als reines Entertainment, was ja nun heute dominiert. Die Ausstellung hat diesen Anspruch, und dabei geht es um die Einführung einer historischen Kategorie, einer ästhetischen Kategorie, und darum, inwieweit diese das Phänomen, das die Ausstellung durch zahlreiche Bilder vorstellt, auch wirklich erfaßt. Ich möchte dazu nur eines sagen: Diese Sache mit Ihrem Sohn ist sehr interessant. »Junge, wie malst Du, gegenständlich oder abstrakt?« Ja, das ist dann einfach gegenständlich oder abstrakt. Als ich zu studieren anfing, habe ich im wissenschaftlichen Diskurs eine Situation vorgefunden, die genau so funktionierte. Diese Situation war das Ergebnis einer außerordentlich reduktionistischen Kunstgeschichtsschreibung, die über Jahrzehnte erfolgt war und die in Greenbergs Schriften[9] in den 1950er, frühen 1960er Jahren ihren Höhepunkt gefunden hat. Sie reduzierte das Verständnis der abstrakten Malerei außerordentlich. Sie entzog ihr im Grunde genommen jede Spiritualität, jede Geistigkeit. Es hieß nämlich, die abstrakte Malerei sei der Endpunkt des Vorgangs des Abstrahierens von der empirischen Realität. Schließlich

Molderings: We are talking about a certain claim. It should be praised that we are looking at an exhibition that maintains the traditional ethos of a museum exhibition and still sees exhibitions as research, as scientific research—and not as pure entertainment which, as it were, is the norm today. The exhibition makes this claim, hence it is an introduction to an historic category, an aesthetic category. Thus, it is about how far the exhibition, through numerous pictures, is able to truly define the phenomenon of Abstract Photography. Let me just say one thing: This remark about your son is very interesting, "How do you paint, figuratively or abstract?" Well, that's what it's all about: Figuratively or abstract. When I began studying, I faced in scientific discourse a situation functioning just like that. The situation was the result of an extremely reductionist form of art history which had existed for decades and had reached its zenith in Greenberg's writings of the 1950s and early 1960s.[9] It reduced the understanding of abstract painting considerably. It basically rid abstract painting of any spiritual quality. It was said that abstract painting was the culmination of a process of abstracting from empirical reality. The artist had ultimately reached pure forms, colors, lines—and that was it. The painter had discovered the intrinsic value of his painterly means and on these he had to focus. An extremely reductionist discussion then evolved which accompanied the second generation of abstract painting and went alongside the transformation of the first generation of abstract painting into a school of design. From 1980 onwards, art historians no longer addressed this question. Research in art history has shown that the abstract painting of artists like Mondrian, Kandinsky, Kupka, Delaunay and Malevitch did not evolve in this way. ■ The pioneers of abstract art have left us with a genre of painting which is highly philosophical. It is saturated with spirituality. Malevitch's *Black Square* is not simply a black square on a white background.

9 Clement Greenberg, geb. 1909, New Yorker Kritikerpapst in den 1950er Jahren neben Harold Rosenberg, ist für sein Buch *Art and Culture* berühmt. In ihm wird die Moderne in einem Kantschen Sinn als Ausgeburt logischen Verstandes – im Sinne von Selbstkritik – beschrieben. Sein Aufsatz *Modern Painting* (*Art and Literature*, No. 4, Spring 1965) stellt die Flachheit und Zweidimensionalität moderner Malerei als einen Prozeß der kontinuierlichen Selbstbewußtwerdung des Mediums heraus. (Kellein)

Clement Greenberg, born 1909, the pope of criticism, together with Harold Rosenberg, in New York during the 1950s. Famous for his book *Art and Culture*. He describes modernity in a Kantian way as the invention of logical reasoning (i. e. in the self-critical sense). His Essay 'Modern Painting' (*Art and Literature*, No. 4, Spring 1965) interprets the flat, two-dimensional nature of modern painting as a sign for the way in which the medium is incessantly in the process of becoming more self-conscious. (Kellein)

sei der Künstler zu den reinen Formen, Farben, Linien vorgedrungen, und das sei es. Der Maler habe die Eigen-
wertigkeit seiner malerischen Mittel entdeckt, und darauf müsse er sich jetzt reduzieren. Es ging um eine außer-
ordentlich reduktionistische Diskussion, die dann mit der zweiten Generation der abstrakten Malerei sehr kom-
patibel war mit der Verwandlung der abstrakten Malerei der ersten Generation in eine Schule des Designs. Diese
Diskussion muß man in der Kunstgeschichte seit ca. 1980 für erledigt halten. Die kunstgeschichtliche Forschung
hat gezeigt, daß die abstrakte Malerei eines Mondrian, Kandinsky, Kupka, Delaunay, Malewitsch, so nicht entstan-
den ist. ■ Die Malerei der Pioniere der abstrakten Kunst ist in hohem Maße eine philosophische Malerei. Sie ist
gesättigt mit Spiritualität. Das *Schwarze Quadrat* von Malewitsch ist nicht einfach ein schwarzes Quadrat auf
weißem Grund. Und Mondrians Abstraktionen sind nicht einfach horizontale, vertikale und auf der Basis der drei
Grundformen beliebig zusammengefügte Beziehungen. Ich glaube, wenn man sagt: »abstrakt-gegenständlich«,
dann meint man auf der einen Seite eine Malerei der reinen Form, selbstreferenziell, und auf der anderen Seite die
Abbildung von Gegenständen. Doch die Maler, die das Projekt der abstrakten Moderne begonnen haben, haben die-
sen platten Gegensatz gar nicht im Sinn gehabt. Das ist eine Erfindung von Clement Greenberg und anderen. Ich
würde sagen, wir sollten bei der theoretischen Begriffsbildung nicht auf das Niveau »abstrakt« vs. »gegenständ-
lich« zurückgehen, nur jetzt bezogen auf die Fotografie. Sondern wir sollten an diese sehr detaillierte und komple-
xe Diskussion über das Projekt der abstrakten Moderne in der Kunstgeschichte anknüpfen, um Phänomene wie die
Chronofotografie und die Rayografie oder das Fotogramm begrifflich exakt zu fassen. Und dann, glaube ich, wird
sichtbar, daß diese fotografischen Bilder sehr viel komplexer sind, als daß dies der Begriff Abstrakte Fotografie
zum Ausdruck bringen kann. ■ Wenn wir sagen: Abstrakte Fotografie, dann rücken wir die historische Betrachtung

And Mondrian's abstractions are not simply relations among horizontal, vertical and the three basic forms arbitra-
rily arranged. I think that when we say 'abstract-figurative', we have in mind, on the one hand, a painting of pure,
self-referential forms and, on the other, the representation of objects. However, the painters who embarked on the
project of abstract modernism did not even think of this trivial contrast. This is the discovery of Clement Greenberg
and others. I would say that, in the context of photography, we should not refer to a theoretical terminology such
as "abstract or figurative". But we should, rather, begin with this highly detailed and complex discussion concern-
ing the project of abstract modernism in art history, so as to define phenomena like chronophotography, Rayo-
graph or the photogram as termini. And then it will, I believe, be obvious that these photographs are much more
complex than the term Abstract Photography can express. ■ When we say Abstract Photography, we are moving
the historical discussion of photography as a medium closer to abstract painting. In my opinion, it is more appro-
priate to include the subject in the history of the *imprint* (Abdruck). Because only then does the photograph's
dialectic—namely, the presence of the object and the absence of the object—become visible. And this is what I con-
sider so special and incomparable about the medium—that it is a dialectic image only by means of a technical pro-
cess; in other words, it is always about presence and absence. Granted, when I portray a person, this is evident. In
the photogram this tension becomes even more complex. When Moholy-Nagy floods an object or a still life with light
and breaks it up into an energy of light, and if there is then darkness where once there was light and light where
once there was darkness, then a highly complex image evolves which—for me, at least—is what makes his photo-
grams so unbelievably fascinating and far superior to those of Man Ray. But that is another matter!

der Fotografie als Medium in die Nähe der abstrakten Malerei. Es ist meines Erachtens sinnvoller, es in die Geschichte des *Abdrucks* zu integrieren. Denn nur dann wird die Dialektik dieses Bildes, nämlich stets Präsenz des Gegenstandes und Abwesenheit des Gegenstandes zu beinhalten, sichtbar. Und das finde ich das Besondere, das Unvergleichliche dieses Mediums, daß das fotografische Bild durch den technischen Prozeß ein dialektisches Bild schlechthin ist, d.h. es ist immer Präsenz und Abwesenheit zugleich. Gut, wenn ich einen Menschen abbilde, ist das klar. Im Fotogramm wird diese Komplexität noch viel verwickelter. Wenn Moholy-Nagy einen Gegenstand, ein Stilleben zerleuchtet und in Lichtenergie auflöst, und wenn dann auch noch dort, wo Licht war, Dunkelheit ist und dort, wo Dunkelheit war, Licht ist, entsteht eine so hohe Komplexität des Bildes, und die macht für mich jedenfalls die unglaubliche Faszination seiner Fotogramme aus, die meines Erachtens himmelweit denen von Man Ray überlegen sind. Aber das ist eine andere Frage!

Kellein: Wir waren uns klar darüber, daß die Clement Greenberg-Diskussion, die so genannte Abstraktion als Weltsprache, lange vorbei ist. Wir haben keinen Rechtfertigungsdruck. Wir waren nicht der Meinung, daß wir ein Gefäß öffnen, in das eine Klasse von Fotografien eingeworfen wird, und dann machen wir den Deckel drauf und sagen: Das war es jetzt. Es ist ja vielmehr so, daß in diesem Jahrzehnt eine andere Dimension von Abstraktheit geführt wird. Uns war bewußt, daß es heute – Reinhold Mißelbeck hat es mit der Digitalisierung angedeutet – unmöglich ist, die Kategorie der Abstraktion wie bisher aufrecht zu halten. Ich will damit nicht alles in Frage stellen. Aber ich denke an die Idee einer Ontologie von Abstraktion im Wandel: wahrscheinlich sehen wir in fünf Jahren schon wieder alles anders. Ich möchte Ihnen damit Offenheit anbieten. Wir hatten einen begrifflichen Ansatz und wir hatten einen künstlerischen Ansatz. Die Frage bleibt: »Was ist Abstrakte Fotografie?«

Kellein: We earlier agreed upon the fact that the Clement Greenberg discussion—on abstraction as a so-called universal language—is long over and done with. We do not have to prove the point, since we did not believe that we had opened a drawer into which was shoved a group of photographs and that we had then closed it, saying, that was it. It is, rather, that our decade has discovered another aspect of abstraction. We know today—Reinhold Mißelbeck, referring to digitalization, mentioned it—that it is impossible to maintain the hitherto known category of abstraction. Thereby, I do not want to question everything. But I am thinking of the idea of an ontology of abstraction in process: In five years we will probably see everything differently again. So I will leave the question open for discussion. We have made a beginning in terms of terminology and aesthetics. The question remains, "What is Abstract Photography"?

Mißelbeck: I have to be honest. Had I been in charge of the exhibition, I would probably have limited it much more. That would have been a way to define the problem of Abstract Photography, to present this definition via the exhibition and to prove my thesis. When Mr. Kellein and I discussed the subject, I discovered that he followed this open concept. Today I must admit that this open concept is better, especially when such an exhibition is held for the first time. Indeed, it is the first time that the subject is being addressed in a large, comprehensive exhibition. I also consider it more fruitful for the discussion not to remain within self-made parameters but, rather, to go beyond the limits which have been defined and to look at them from both sides. I believe that this open concept contributes more to the discussion and can lead more clearly to a conclusion than if one had taken a different approach.

Mißelbeck: Ich muß offen sagen: Hätte ich die Ausstellung gemacht, so hätte ich sie wahrscheinlich sehr viel stärker eingeengt. Nach der Methode, das Problem Abstrakte Fotografie zu definieren und diese Definition mittels Ausstellung darzustellen und zu beweisen. Als ich mich mit Herrn Kellein unterhalten habe, stellte ich fest, er hatte dieses offene Konzept. Ich muß heute sagen: Ich halte es für besser, gerade wenn man eine solche Ausstellung das erste Mal macht. Es ist das erste Mal, daß dieses Thema in einer großen umfassenden Ausstellung thematisiert wird. Und dann halte ich in der Diskussion für wesentlich fruchtbarer, nicht selbstgesteckte Grenzen einzuhalten, sondern die Grenzen dessen, was man zu definieren gedenkt, zu öffnen, zu überschreiten und diese Grenzen von beiden Seiten zu sehen. Dieses offene Konzept bringt für die zu führende Diskussion sehr viel mehr und kann schließlich sehr viel klarer zu einem Ergebnis führen, als wenn man es anders gemacht hätte.

Molderings: Um auf diese Debatte zurück zu kommen, von der ich glaube, daß sie schon gar keine Debatte mehr ist – sie ist eigentlich erledigt und gehört schon der Vergangenheit an, wenn ich das richtig sehe; vielleicht beschönige ich da auch die Situation aus meiner Perspektive. Zur Frage: Läuft die Fotografie der Malerei hinterher oder tut sie das nicht? ■ Gerade die naturwissenschaftliche Fotografie hat sich relativ unabhängig von den ästhetischen Standards in der Malerei in der zweiten Hälfte des 19. Jahrhunderts entwickelt, und dabei ging es um ganz andere Ziele, als um die Idealisierung von Realität, sprich: um klassizistischen Akademismus. Es ging auch um andere Ziele als in der realistischen Malerei, sprich: um Courbet und Nachfolger. Einfach deshalb, weil dieses Medium ein Instrumentarium zur Verfügung hatte, mit dem Courbet nicht mithalten konnte. So entstanden zwischen 1880 und 1910 Astrofotografie, Chronofotografie, Röntgenfotografie usw., eine Bilderwelt, die absolut überraschend war. Dann kommt im Ersten Weltkrieg die militärische Aufklärungsfotografie aus der Luft dazu, und ich

Molderings: To return to the discussion that, if I see it correctly, is apparently finished since it has been exhausted and belongs to the past (but maybe I find excuses for how I view the situation). Well, back to the question: Does photography lag behind painting or does it not? What does the history of art say? ■ In particular, scientific photography has developed quite independent from the aesthetic standards of painting in the second half of the nineteenth century. Thereby, aims were pursued different to an idealization of reality—in other words, classical academism—and different to those of realistic painting—in other words, Courbet and successors. All this simply because photography could make use of instruments with which Courbet could not compete. Thus, between 1880 and 1910, astrophotography, chronophotography, X-ray photography, etc. were developed—a truly surprising visual universe. Then, during World War I, aerial military reconnaissance photography was invented, and I would have great difficulties to put this under the heading of Abstract Photography. I mention this only as an aside, since such photography indeed had a purely documentary function. The point was to recognize structures, to identify these structures as objects and, finally, to bombard them. Steichen, for instance, took such photographs in great numbers [during his military service in World War I, editor's remark]. But returning to the relationship between painting and photography, this aerial military reconnaissance photography greatly interested Malevitch and influenced him in the development of a new axiality, a new comprehension of balance in Suprematist composition. ■ Of course you would know of Malevitch's famous demonstration panels in which he combines particular styles of painting—Futurism, Cubism, Expressionism, Suprematism—with specifically new photographic forms. You know of Suprematism which cancels the static of the picture, the system of axes in our body—the horizontal, the vertical:

hätte große Probleme, diese unter die Abstrakte Fotografie zu fassen. Das jetzt nur mal in Parenthese, weil diese Fotografie wirklich in eine ganz klare dokumentarische Funktion eingebunden war. Es ging darum, Strukturen zu erkennen, Strukturen gegenständlich zu identifizieren, um sie anschließend mit Granaten zu beschießen. Derartige Fotos hat z. B. Steichen massenweise, in der Zeit seines Militärdienstes im Ersten Weltkrieg, gemacht. Und diese, jetzt zurück zum Verhältnis von Malerei und Fotografie, diese militärische Aufklärungsfotografie aus der Luft, hat in einem ganz starken Maße Malewitsch beeindruckt, beeinflußt bei der Entwicklung einer neuen Axialität, eines neuen Gleichgewichtsverständnisses in der suprematistischen Kompositionstechnik. ■ Sie kennen ja seine berühmten Demonstrationstafeln, wo er bestimmte Stilformen in der Malerei, Futurismus, Kubismus, Expressionismus, Suprematismus, korreliert mit ganz bestimmten neuen fotografischen Formen. Sie kennen den Suprematismus, der die Statik des Bildes, das in unserem Körper eingebaute Achsenkreuz aus Horizontale und Vertikale außer Kraft setzt: Auf einem suprematistischem Bild gibt es keinen Horizont (Abb. S. 273, links). Und es gibt auch auf einer Kamerafotografie von László Moholy-Nagy nie einen Horizont. Die Aufklärungsfotografie aus der Luft gibt also die Impulse für neue Entwicklungen auf dem Gebiet der suprematistischen Technik. Der suprematistische Kompositionsbegriff gibt dann Moholy-Nagy wiederum Impulse, um in seiner Kamerafotografie eine ganz neuartige Bildform zu erfinden. Und das ist eine ständige Wechselbeziehung, und da zu sagen, wem das Primat gehört, das ist aus historischer Sicht gar nicht möglich. Es ist die Frage: Wann legen Sie den Schnitt? Legen Sie den Schnitt 1910, dann haben Sie das Primat der Fotografie. Legen Sie den Schnitt vor die ersten Fotos von Moholy 1925, dann liegt das Primat beim Suprematismus, also bei Malewitsch. Nur wenn man außer Acht läßt, an welchem historischen Schnittpunkt man diskutiert, können solche Vorurteile, die Fotografie laufe immer der Malerei

There is no horizon in a Suprematist picture (fig. p. 273, left), just like there is never a horizon in a camera photograph by László Moholy-Nagy. Aerial reconnaissance photography also fuelled new developments in the field of Suprematist art. Suprematist composition, in turn, gave Moholy-Nagy the impetus to invent entirely new pictorial forms in his camera photography. We are looking at a constant interrelation here, so we cannot ask ourselves who, from a historical point of view, is more pre-eminent. The question is: Where and when do we see the turning point? If we say it was around 1910, then we have the primacy of photography. If we name Suprematism, Malevitch and Moholy-Nagy, saying it was prior to Moholy's first photos of 1925, then Suprematism, hence Malevitch, holds the primacy. Only if we ignore which historical turning point is being discussed can such prejudices that photography is always lagging behind painting arise. ■ As for today's situation: Photography, as digital photography, is possibly facing yet another such turning point; a bundle of energy is about to be untied which will again give painting new impulses. Just the other day, I saw Jeff Koons's latest paintings in Berlin which could not exist without digital photography. Digital photography is materially, and thus physically, at the basis of the layers of paint in his works. It lies beneath them; and the oil paint is on top. This is a well-kept studio secret. But, as you know, there is a certain 'forensic fraction' in art history which will take care of this.

Audience: We were just speaking of 'cuts' and we actually have to make another cut today: The cut of zero and one. It is characterized by these two digits. They don't say anything, they don't explain anything to me. If I am given such a piece of silver (a CD), what do I get? Music, image or writing? The answer is only given when I put it into the computer. Here is a matter to reconsider.

hinterher, aufkommen. ■ Zur Situation heute: Möglicherweise steht die Fotografie mit der digitalen Fotografie wieder vor so einem Schnitt, da ist wieder so ein Energieknoten geschürzt, der dabei ist, sich zu öffnen und der Impulse abgibt in die Malerei. Ich habe letzte Woche die neuesten Gemälde von Jeff Koons in Berlin gesehen, die sind ohne digitale Fotografie nicht zu machen. Der Malschicht liegt die digitale Fotografie auch materiell, also physisch zu Grunde. Sie liegt da drunter. Und da drüber sitzt die Ölfarbe. Das ist ja ein wohlbehütetes Ateliergeheimnis. Aber Sie wissen ja, es gibt eine, wie sagt man: forensische Fraktion in der Kunstgeschichte, und die kümmert sich schon darum.

Zuhörer: Wir sprachen ja eben von ›Schnitten‹, und wir müssen heute eigentlich wieder einen Schnitt machen: Den Schnitt von Null und Eins. Er ist gekennzeichnet durch diese beiden Zahlen. Sie sagen gar nichts, sie machen mir im Grunde nichts klar. Wenn ich so einen Silberling (eine CD) kriege, was krieg ich? Musik, Bild oder Schrift? Das löst sich erst auf, wenn ich das in den Computer schiebe. Darüber wäre neu nachzudenken.

Jäger: Wir jetzt sind bei der Digitalisierung angelangt, was die Sache natürlich nochmal verkompliziert. Dabei wird Fotografie simuliert, und zwar schon auf einem erheblich hohen Niveau, wie in dem Statement von Herrn Mißelbeck erwähnt. Die Computer sind in der Lage, die Ästhetik der Fotografie, der konventionellen wie der abstrakten Fotografie, zu simulieren und ihre Ergebnisse als echte Fotos auszugeben. Plötzlich gibt es so etwas wie ›digitales Licht‹, das es ja eigentlich gar nicht geben kann – und da verlassen wir die Fotografie. ■ In dem ersten Beitrag unseres Symposiums hat Lambert Wiesing eine sehr schlüssige Definition zum Abstraktionsbegriff formuliert: daß man von einem Ding, ohne es aus dem Blick zu verlieren, sehr weitgehend abstrahieren könne – allerdings nur so weit, als man seine ›kontingenten‹, konstitutiven Eigenschaften nicht verletzt, d.h., nur bis zu der

Jäger: Well, now we have reached the topic of digitalization which complicates the subject further. Photography is hereby simulated—in fact, at a very high level, according to Mr. Mißelbeck. Computers have the capacity to simulate the aesthetics of both conventional and abstract photography; they pretend to create real photos. Suddenly we have something like 'digital light' which cannot actually exist—and at this point we leave photography behind. ■ In the first paper of our symposium, Lambert Wiesing gave a very logical definition of the term Abstraction: That we can, under certain circumstances, abstract from a given object to a great extent—however, only to the point where we do not harm its 'contingent', constitutive characteristics (cf. Wiesing, chapter 15, pp. 94ff.), in other words, to the point where we begin to encroach on its basic, intrinsic characteristics. And here we should reconsider—the decisive aim of this exhibition!—what photography, under these new circumstances, 'still' is. Using the term Abstraction and its pictorial results, we could think differently about all this: What remains if we rid photography of all its possible elements and take away that which had hitherto constituted this medium? If, for instance, we were to take from photography the camera, we would have cameraless photography, but this still remains photography. Everybody will agree up to this point. ■ But the question remains: How much more can we abstract from photography without breaking it up, destroying it? We have already gone very far, so far that the so-called medium photography is no longer a medium; instead, photography has become the object, the object photography, a self-referential object. ■ For me the question of Abstraction does not refer so much to a given object which is more or less abstractly represented through the photo. It is not a matter of an abstracting photography; the question is, rather, about an abstraction of photography. It becomes more and more 'abstract' loses in

Grenze, an der man beginnt, seine grundlegenden und bestimmenden Eigenschaften anzutasten (vgl. Wiesing, S. 94 ff.). Und hier wäre – als entscheidende Frage dieser Ausstellung! – darüber nachzudenken, was Fotografie unter den neuen Verhältnissen überhaupt ›noch‹ ist? Mit Hilfe des Begriffs der Abstraktion und seinen Bildergebnissen wäre neu darüber nachzudenken: Was bleibt übrig, wenn wir von der Fotografie alle möglichen Elemente abziehen und wegnehmen, die, landläufig gesehen, das Medium bisher begründet haben? Beispiel: Wenn wir der Fotografie die Kamera wegnehmen, kommen wir zur kameralosen Fotografie, aber es bleibt: Fotografie, usw. Bis hierher werden alle einverstanden sein. ■ Aber die Frage bleibt: Was können wir noch von der Fotografie abstrahieren, ohne sie im Kern zu treffen und aufzulösen? Wir sind dabei schon sehr weit gegangen, so weit, daß das so genannte *Medium Fotografie* gar kein Medium mehr ist, sondern zum Objekt wird, zum *Objekt Fotografie*, zu einem eigenständigen Gegenstand der Betrachtung. ■ Die Frage der Abstraktion stellt sich daher für mich also nicht so sehr im Hinblick auf irgendwelche Gegenstände, die durch das Foto mehr oder weniger abstrakt abgebildet werden, sie stellt sich nicht in Bezug auf eine abstrahierende Fotografie. Sondern sie stellt sich angesichts einer Abstraktion *der* Fotografie. Sie wird zunehmend ›abstrakt‹, verliert bei der Abbildung, gewinnt dafür aber als Objekt an bildnerischer Kraft. Mit ihrer Abstraktion wird sie selbständig, autonom, befreit sich von abbildenden Aufgaben. So verstehe ich unseren Titel. Er fordert insofern die Frage heraus: Was ist Fotografie, ihr Kern, ihre Bestimmung? Eine Idee, ein Phänomen? Gerade jetzt, in dieser Zeit, in der wir uns anschicken, Fotografie zu transformieren und sie einem Rechner zu überantworten. Wir machen ein Rechenbild daraus, ein gerechnetes Bild, bei dem überhaupt keine nachvollziehbare Analogie mehr zwischen natürlicher Ursache und natürlicher Wirkung mehr besteht.

representation, gains in pictorial power. In its abstraction it becomes independent, autonomous and frees itself from representational functions. *This* is how I interpret the title of our discussion. In this respect it challenges the question: What is photography, its essence, its purpose? An idea, a phenomenon? Particularly now, in an age where we are beginning to transform photography and to hand it over to computers. We turn it into an arithmetical image, an image arithmetically composed, whereby an analogy no longer exists between cause and effect, and so forth.

Kellein: I would say that we have reached a limit where a new type of artwork begins. Because the medium exists as hot wax on paper, there is great danger that this sort of photography is actually digging its own grave. Ultimately, we should not forget that the decision concerning the direction of Abstract Photography or of photography, in general, is nowadays neither the photographer's decision, nor that of the art historian, nor even that of the philosopher. It should simply be said: The art market decides. If these works are bought, then catalogs will be published in which essays on and critiques of these exhibitions will make sure—Mr. Molderings called this "forensics"—that such things are important. I do not intend to close the discussion on the renowned excuse of the art mafia; I do not believe in it and, if so, we all have been part of it for ages, but I believe it is dangerous to say, in reference to the ready-made, that these hot wax, computer-generated images are no photographs.

Mißelbeck: May I perhaps add a word or two on this matter. It is extremely interesting to look at these works by Bernd Lintermann in relationship to Man Ray's photographs of mathematical shapes.[10] The latter are about models of integral calculations which Man Ray transformed into photographic images, into aesthetic appearances. As far as the principle and the thought are concerned, Bernd Lintermann does just this. He uses mathe-

Kellein: Ich würde sagen, hier ist eine Grenze erreicht, an der eine neue Klasse von Kunstwerken beginnt. Weil das Medium mit Heißwachs auf das Papier gelangt ist, ist die Gefahr, daß sich diese Fotografie ihrem Selbstverständnis nach selbst ein Grab schaufelt, relativ groß. Die Entscheidung darüber, wie die Entwicklung weiter geht mit der Abstrakten Fotografie oder mit der Fotografie allgemein, ist ja in unserer heutigen Welt letzten Endes weder die Entscheidung der Fotografen noch der Kunsthistoriker noch der Philosophen, das sollten wir nicht vergessen. Sondern sehr simpel muß man sagen: Es ist die Entscheidung des Kunstmarktes. Wenn diese Werke gekauft werden, dann werden Kataloge erscheinen, in denen Aufsätze und Rezensionen dieser Ausstellungen schon dafür sorgen werden – Herr Molderings hat das Forensik genannt – daß diese Dinge ihre Bedeutung haben. Ich will nicht die Diskussion schließen mit dem berühmten Argument der Kunstmafia, an die ich nicht glaube und wenn, dann gehören wir alle längst dazu, aber ich halte es, mit Bezug auf das *Ready-made,* für sehr gefährlich zu sagen: Diese Heißwachs-computergenerierten Bilder sind keine Fotografien.

Mißelbeck: Vielleicht noch ein Wort dazu. Ich halte es für interessant, die Bernd Lintermann-Arbeiten in eine Beziehung zu setzen mit den Fotografien, die Man Ray von mathematischen Formen gemacht hat (Abb. S. 258). Bei diesen Bildern handelt es sich ja auch um Modelle von Integralrechnungen, die Man Ray in fotografische Bilder, in ästhetische Erscheinungen umgesetzt hat.[10] Bernd Lintermann macht letzten Endes vom Gedanklichen her genau dasselbe: Mathematische Logarithmen bringt er in den Computer, und der Computer druckt das aus. Der Weg ist kürzer. In jedem Fall steckt Mathematik dahinter. Man Ray mußte den Umweg gehen, eine mathematische Formel in Form eines dreidimensionalen Objektes zu fotografieren, während Bernd Lintermann die mathematischen Formeln durch den Computer unmittelbar in ein Bild übersetzt. Insofern ist dies vom Konzeptionellen her ein

matical logarithms that he feeds into the computer and the computer prints them. The way of getting there is, hence, only shorter. In each and every case, it is basically mathematics. Man Ray still had to take the detour of adapting a mathematical formula into a three-dimensional object which he photographed; an aesthetic product was the result. Bernd Lintermann, on the other hand, used the computer to directly translate these mathematical formulas into images. In this respect, there exists a direct link between the intellect and the concept. If we consider photography not only as a technical or an aesthetic manifestation, but if we also look at its intentions, then, I believe, we look at something which cannot be ignored. We cannot but remain curious as to what will evolve.

Jäger: I still hesitate to comment. The example just mentioned consists of representational computer graphics. They look like traditional photographs. But what happens when an abstract photographer uses the computer to produce images in the sense of Abstract Photography which per se is already difficult to identify? Are these images still photographs? If the computer were to simulate not the normative aesthetics of photography but, rather, its abstract form, if nowadays generated images were to be made everywhere, images that don't have anything to do with normal photographs anymore, then we shall find ourselves in a true fix. Then we will surely have to leave the world of photography and say, "here begins the digital image." Full stop. This image might, therefore, completely resemble an abstract photograph, but it is not one (cf. cover). One could possibly say: It is photobased, it comes from the idea of photography. But nothing more. ■ Then again, this question poses yet another new, intriguing dialectic, a new alternation, a new to-and-fro between the media. What is novel about it is that we have meanwhile learned to simulate and have partly learned to handle it. We have begun to get used to it. I personally find

10 Man Ray: *Objets mathematiques* (Mathematische Objekte), 1934–1936. Kamerafotografien von mathematischen Modellen. Man Ray wurde 1934/1935 von Max Ernst auf die Existenz dieser Modelle im Pariser *Institut Poincaré* hingewiesen, didaktische Objekte aus Holz, Gips und Draht, die geometrische Formeln, vor allem die vierte Dimension im nicht-euklidischen Raum veranschaulichen sollten. Vgl. Lampe, Angela: Irreale Welten: Die Fotografie Man Rays. In: *Abstrakte Fotografie.* Ausstellungskatalog Kunsthalle Bielefeld, 2000–2001, S. 57–73.

(Mathematical objects) Camera photos of mathematical models. In 1934–1935, Max Ernst drew Man Ray's attention to these models available at the *Institut Poincaré*, Paris: didactic objects made of wood, plaster and wire which were to show geometric formulas, above all, of the fourth dimension in non-Euclidean space. Cf. Lampe, Angela: *Irreale Welten: Die Fotografie Man Rays* in the catalog accompanying the discussed exhibition, *Abstrakte Fotografie,* exhibition catalog, Kunsthalle Bielefeld, 2000–2001, pp. 57–73.

ziemlich gerader Weg von dem Einen zum Anderen. Wenn wir Fotografie eben nicht nur als eine ästhetische oder technische Erscheinung ansehen, sondern sie auch unter intentionalen Aspekten betrachten, dann, denke ich, ist hier etwas entstanden, das man wirklich nicht ausschließen kann. Das kann man nur mit Neugier verfolgen.

Jäger: Hier werden gegenständliche Fotografien – Kalenderfotos – am Rechner simuliert. O. k. Aber was passiert, wenn ein abstrakter Fotogaf am Rechner Bilder im Sinne abstrakter Fotografien simuliert? Hier beginnt: Das digitale Bild. Ende. Es kann genauso aussehen wie eine abstrakte Fotografie, aber es ist keine. Es ist allenfalls ein fotobasiertes Bild: Ein fotobasiertes, computergeneriertes Image.

Mißelbeck: In gewisser Hinsicht gibt es entsprechende Aktivitäten schon. Ich weiß nicht, ob Du [zu Gottfried Jäger gewandt] die Bilder von Inge Dick kennst? Sie benutzt blaue Farbe, letzten Endes blaues Licht, und sie hat zwei parallele Versuche gemacht und zum einen Blau fotografisch, zum anderen Blau digital gespeichert und beide Images immer weiter vergrößert. Einerseits werden die Körner der fotografischen Chemie, andererseits die Pixel des Rechenbildes sichtbar gemacht; in einer mathematischen Reduktion wird in zwölf Schritten die Anzahl der Pixel reduziert, bis letzten Endes nur noch zwei blaue Rechtecke stehen bleiben. Das Ergebnis ist das Resultat einer digitalen, mathematischen Operation.[11]

Jäger: Ja, aber es ist kein Foto mehr.

Mißelbeck: Es ist ein Ilfochrome!

Jäger: Das ist der Bildträger!

Kellein: Es ist der 1. Advent und 13:04 Uhr – und damit Zeit für das Ende dieser spannenden Diskussion, die wir fortführen werden. Ich danke allen, die sich daran beteiligt haben. ■ ■

this extremely fascinating. However, the colleague who simulates figurative photographs with the computer makes digital images, and his resulting success relies on the known aesthetic basis of conventional photography. He makes calendar photographs with the computer. But it becomes particularly interesting the moment when somebody makes abstract images claimed to be photographs, which, however, they are not. Indeed, this blurs the boundaries. If at all, it is a photo-based image: A photo-based, computer-generated image. So we are far from having reached the heart of the question, "What is Abstract Photography?"

Mißelbeck: To a certain degree, there are already beginnings of particular activities. Now, I don't know if you [turning to Gottfried Jäger] are acquainted with Inge Dick's pictures? She used blue color, blue light actually, working on two parallel experiments: Firstly, the blue photographed; secondly, the blue digitally saved; and both images repeatedly enlarged. On the one hand, the grains of photographic chemistry, on the other hand, the pixels of the computer image are made visible; the number of pixels is mathematically reduced in twelve steps until eventually only two blue rectangles remain. The product is the result of a digital, mathematical operation.[11]

Jäger: Yes, but it is no longer a photo.

Mißelbeck: It is an Ilfochrome!

Jäger: That is the picture carrier!

Kellein: It is the First Advent and shortly after 1 p. m.—time, therefore, to conclude this fascinating discussion which we shall indeed continue. Thanks to all participants. ■ ■

11 Dick, Inge: *Bleu du ciel.* Ausstellungskatalog exhibition catalog **Fotogalerie Wien** u. a. et al., Vienna 1999 – 2000

Inge Dick: Two works of the project *Bleus
du ciel* (Blues of the Sky/Blau des Himmels),
1998/1999
1998/20 (links); 1998/23 (rechts)
Silver dye bleach print (Ilfochrome), acryl,
Aludibond, each 55 x 55 cm
Museum moderner Kunst, Vienna
Courtesy of the artist.

Anhang
Appendix

Glossar
Glossary

Zeittafel
Timeline

Bibliografie
Bibliography

Sachregister
Subject Index

Personenregister
Index of Names

Vitae
Notes on Authors
and Podium Discussion
Participants

Bildnachweis
Photo Credits

Glossar Kurzerläuterungen einzelner Bildtechniken, soweit sie Gegenstand dieser Publikation sind. Ausführlichere Darstellungen enthält die in der Bibliografie angegebene Fachliteratur.

1 Lichtgestaltung Licht erzeugt in der lichtempfindlichen Schicht des Films oder des Fotopapiers ein latentes Bild, das durch chemische Entwicklung sichtbar gemacht wird. So entsteht ein Lichtbild. László Moholy-Nagy begründete in den 1920er Jahren die Fotografie als reine Lichtgestaltung: »Das wesentliche Werkzeug des fotografischen Verfahrens ist nicht die Kamera, sondern die lichtempfindliche Schicht«.[1] Damit entstand eine neue Bildgattung: die kameralose Fotografie, die sich – im Rahmen dieser Publikation – durch drei Begriffe unterscheidet:

Fotogenische Zeichnung So bezeichnete William Henry Fox Talbot in seinem Bericht *Über die Kunst der fotogenischen Zeichnung* 1839 die Ergebnisse des von ihm gefundenen Verfahrens. Es waren Unikate, sie entstanden ohne Kamera, allein durch das Auflegen von Gegenständen auf das lichtempfindliche Material (Abb. S. 14, oben). Das ›fotogenische‹ Motiv, also die Erzeugung einer Bildinformation durch Licht, trat aber bereits in einer frühen Phase der Entwicklung des neuen Verfahrens gegenüber dem Motiv der Aufzeichnung in den Hintergrund. Im gleichen Jahr 1839 schrieb John F. W. Herschel an Talbot, daß er das Wort ›photographic‹ für das neue Verfahren für geeigneter halte, als ›photogenic‹.[2]

Luminogramm Ergebnis reiner Lichtgestaltung; elementarer Ausdruck einer Interaktion von Licht und lichtempfindlichem Material. Das Luminogramm entwickelt – im Unterschied zum Fotogramm – seine Form ohne jeden Gegenstand. Es ist die ursprünglichste Art kameraloser Fotografie, eine Art Selbstdarstellung des Lichts (Abb. S. 50f., 54, 98).

Fotogramm Negatives Schattenbild eines Gegenstandes auf lichtempfindlichem Material. Lichtquelle und Gegenstand können während der Belichtung ruhen (Abb. S. 37f.) oder bewegt worden sein (Abb. S. 53). Durch unterschiedliche Abstände zwischen Gegenstand und lichtempfindlichem Material lassen sich auch plastische Bildwirkungen erzielen (Abb. S. 273). Das Fotogramm mit seinen Nebenfächern stellt eine eigene Bildgattung der Fotografie und der Künste im 20. Jahrhundert dar.[3]

Glossary Brief explanations of individual photographic techniques, in so far as they are discussed in this publication. More detailed accounts can be found in relevant literature on the subject given in the bibliography.

1 Light Design In the photosensitive layer, light engenders the 'latent image', brought forth and made visible by chemical development. Hence is made an image of light. In the 1920s, László Moholy-Nagy established photography as pure light design: "The camera is not the essential tool of the photographic process; it is the photosensitive layer instead".[1] This gave rise to a new photographic genre: cameraless photography, which—within the scope of our publication—can be differentiated into three terms:

Photogenic Drawing This was the term William Henry Fox Talbot used in his report *On the Art of Photogenic Drawing* of 1839 to describe the results of the process he had invented. Photogenic drawings were unique prints, made without the help of a camera solely by placing objects onto photosensitive material (fig. p. 14, top). But already in the early developmental phase of the new photographic process, the 'photogenic' purpose (the production of visual information through light) lost in importance against the reason for recording (the photographic purpose). In the same year, 1839, John F. W. Herschel wrote to Talbot that he considered 'photographic' a more appropriate word for the new process than 'photogenic'.[2]

Luminogram The result of pure light design; the rudimentary expression of an interaction of light and photosensitive material. In contrast to the photogram, the luminogram develops its form without other objects. It is the most basic type of cameraless photography, a kind of self-representation of light (figs. pp. 50f., 54, 98).

Photogram Cameraless photography. Negative silhouette of an object on photosensitive material. During exposure, light source and object are either static (figs. pp. 37f.) or are moved (fig. p. 53). Varying intervals between object and photosensitive material also facilitate plastic pictorial effects (fig. p. 273). The photogram and its neighboring categories represent an independent pictorial genre in twentieth-century art and photography.[3]

1 Moholy-Nagy, László: fotografie ist lichtgestaltung. In: *bauhaus, zeitschrift für bau und gestaltung.* 2nd Vol., No. 1, 1928, p. 2ff.

2 Baier, 1964, p. 120

3 Neusüss, 1990

2 Fotooptische Gestaltung Optik und Kamera bilden zusammen mit dem lichtempfindlichen Material die wesentliche Grundlage der Fotografie. Das von einem Gegenstand ausgehende oder reflektierte Licht wird durch eine Optik auf einen Bildträger gelenkt, auf dem das latente Bild entsteht. Die primitivste Form einer Optik ist die Lochblende; demgegenüber existieren bekanntermaßen Objektive höchster Auflösung für allgemeine und spezielle Anwendungen vom Mikrokosmos bis zur Astrofotografie. Im Rahmen dieser Publikation spielen drei Formen fotooptischer Gestaltung eine besondere Rolle:

Camera obscura Wörtl.: dunkle Kammer. Urform der fotografischen Kamera. Ihre Funktion beruht auf dem Gesetz optischer Abbildung durch eine Lochblende. Sie bündelt die von einem Gegenstand ausgehenden Lichtstrahlen und projiziert sie in der Lochkamera kopfstehend und seitenvertauscht auf die der Lochblende gegenüberliegende Bildfläche. Lochgröße und Abbildungsschärfe stehen in einem Abhängigkeitsverhältnis. Aristoteles lieferte eine frühe Beschreibung der Lochkamera[4]; in der Renaissance wurde sie von Leonardo da Vinci und Albrecht Dürer als Zeichenhilfsgerät vor allem für die genaue Erfassung und Darstellung der geometrischen Perspektive genützt. Die Erkundung ihrer bildnerischen Möglichkeiten wird seit den 1970er Jahren unter neuen Vorzeichen vorangetrieben.[5]

Chronofotografie Sammelbezeichnung für Bildverfahren, die Zeit- und Bewegungsabläufen darstellen. Die Chronofotografie bildet eine Vorstufe zur Kinematografie und zum Film. Ihr Begründer ist der amerikanische Fotograf Eadweard Muybridge, der in der 1870er Jahren mit Hilfe von Serienkameras Bewegungsabläufe und Gangarten u. a. von Pferden festhielt. Mit Momentaufnahmen von bis zu 1/6000 Sekunde gelang es ihm, Phasen des Vogelfluges von verschiedenen Seiten zu fotografieren. Sein Buch *Animals in Motion* hat bis heute große Wirkung auf die Künste.[6] Auch der Pariser Physiologe Etienne-Jules Marey gehört zu den Pionieren dieses Gebietes. Unter anderem entwickelte er 1882 eine fotografische Flinte, mit der er schnell fliegende Vögel phasenweise erfassen und darstellen konnte. Das Gebiet teilt sich in zwei Verfahren auf:

Motografie: Kontinuierliche Belichtung Dabei wird der Bewegungsablauf als Ganzes durch eine ununterbrochene Belichtung aufgezeichnet. Die Belichtungsdauer entspricht der Dauer der Bewegung, die damit als fließender und zusammenhängender

2 Photo-Optical Design Optics and the camera, together with photosensitive material, form the necessary basis of photography. Light radiating from an object is directed through the optics onto a picture carrier which creates the latent image. The pinhole diaphragm is the most primitive form of optics compared to lenses available today with highest resolution for general and specific application in the field of micro and even astrophotography. Within the scope of this publication, three forms of photo-optical design are of importance:

Camera Obscura The dark chamber, the original form of the photographic camera. Its function is based on the law of optical reproduction by means of a pinhole diaphragm. It concentrates the light beams radiating from an object and projects them in the pinhole camera upside down and laterally inverted onto the picture surface opposite the pinhole diaphragm. The size of the diaphragm and the focal sharpness are dependent on each other. Aristotle gave an early description of the *camera obscura*[4]; and in Renaissance days, Leonardo da Vinci and Albrecht Dürer used it as a drawing aid in particular to determine and illustrate the geometric perspective correctly. Since the 1970s, new approaches have been taken to investigate further its pictorial potential.[5]

Chronophotography Collective term for photographic processes representing time and motion. Chronophotography is the pre-liminary stage to cinematography and motion pictures. Its inventor is the American photographer Eadward Muybridge who, in the 1870s and with the help of a series of cameras, captured the movement and paces of the horse, among others. With instantaneous exposures of up to 1/6000 sec., he was able to photograph phases of the flight of birds from various sides. His book entitled *Animals in Motion* has greatly influenced the arts until today.[6] The Parisian physiologist Etienne-Jules Marey is also a pioneer in this field. In 1882, he developed a photographic gun with which he could capture and portray fast-flying birds. Chronophotography can be divided into two processes:

Motography: Continuous Exposure Uninterrupted exposure records the sequence of motion as a whole. The time of exposure corresponds to that of the sequence of motion, shown as a flowing and interconnected event. The process is also known as trace photography; it serves, among others, to record work processes (figs. pp. 36, top; 130). A further variant is the cine-

4 Baier, 1964, p. 7

5 Hammond, 1981; Smith, 1985; Jäger, 1988, pp. 130ff.; Renner, 1985

6 Muybridge, Eadweard: *Animals in Motion. An Electro-Photographic Investigation of Consecutive Phases of Muscular Actions* (1872–1885). London 1907; Schnelle-Schneyder, 1990

Vorgang dargestellt wird. Das Verfahren wird auch als Spurfoto-
grafie bezeichnet, es dient u. a. der Aufzeichnung von Arbeits-
vorgängen und -abläufen (Abb. S. 36, oben, 130). Eine weitere
Form ist das Cinegramm, bekannter als Zielfotografie. Dabei
werden schnelle Bewegungsabläufe bildlich gedehnt und damit
verbessert sichtbar gemacht. Das technische Mittel dazu ist ein
Schlitz, der während der Belichtung und parallel zur Bewegung
des Gegenstandes kontinuierlich vor dem Film abläuft.

Strobofotografie: Intermittierende Belichtung

Verfahren zur
Erfassung und Darstellung von Bewegungs- und Zeitabläufen in
Phasen; es wird daher auch als Phasenfotografie bezeichnet
(Abb. S. 36, oben). Spezifische Mittel sind der stroboskopische
Verschluß in der Strobokamera, dabei rotiert eine Flügelblende
vor dem Objektiv und gibt die Öffnung nur phasenweise frei, und
die Strobobeleuchtung, z. B. mit dem Stroboblitz. Für langsam
ablaufende Bewegungen kann jede phasenweise geschaltete
Lichtquelle benutzt werden. Für schnellere Bewegungen wird
der Stroboblitz eingesetzt. Pionier dieses Gebietes ist Harold
Edgerton mit seinen Kurzzeitaufnahmen um 1933. Sie markieren
den Beginn eines neuen fotografischen Spezialgebietes: die
Hochfrequenz- oder Strobofotografie.

Mikrofotografie

Verbindung von Mikroskop und Kamera zur
Darstellung kleinster Objekte. Die Lichtmikroskopie erlaubt
Abbildungsmaßstäbe von 25:1 bis 1500:1. Objekte, die kleiner
sind als Lichtwellen, z. B. Viren, können mit dem Lichtmikroskop
nicht mehr erfaßt werden. Für sie wurden Elektronen- und
Rasterelektronenmikroskop (REM), entwickelt. Die wissen-
schaftliche Bedeutung der Mikrofotografie ist evident; die
künstlerische Arbeit mit diesem Instrument war bisher eher
randständig.[7] Dennoch gibt es auf dem Gebiet einen reichen
Fundus bedeutender Bildleistungen (s. Beitrag von Claudia
Fährenkemper, S. 195ff.).

3 Fotochemische Gestaltung

Hier geht es um Fotomaterial
und seine Bearbeitung auf fotochemischer Basis. Grundlage ist die
Lichtempfindlichkeit von Silbersalzen (Silberhalogenide). Sie stellen
eine Verbindung der (salzbildenden) Elemente Brom, Chlor und Jod
mit dem Element Silber dar und besitzen die Eigenschaft, daß sich
unter Lichteinfluß ihr molekularer Aufbau ändert. So entsteht ein
latentes Bild, das durch chemische Entwicklung sichtbar gemacht
wird. Die Silbersalze (Kristalle) sind in eine Gelatineschicht einge-

gram, better known as the picture of the finish. Fast sequences
of motion are visually stretched and can thereby be better seen
and analyzed. Its technical means is a slit, which continuously
moves in front of the film during exposure and parallel to the
movement of the object.

Strobophotography: Intermittent Exposure

Photographic
process to record and illustrate time and motion sequences in
phases; it is also referred to as phase photography (fig. p. 36,
top). Specific tools are the stroboscopic shutter of the strobo
camera, whereby a winged diaphragm rotates in front of the
lens, opening it only intermittently, and the strobo lighting,
which makes use of a strobo flash. For slow motion sequences,
any intermittent light source can be used. For faster motion
sequences the strobo flash can be applied. Harold Edgerton,
with his snap shots of 1933, is a pioneer in the field. His photo-
graphs mark the beginning of a new special area in photography:
high-frequency or strobophotography.

Microphotography

The combination of a microscope and a
camera, in order to depict minuscule objects. The light micro-
scope permits 'useful' picture scales of 25:1 up to 1500:1. For
objects smaller than the waves of light (e. g. viruses) and which
can no longer be seen under a light microscope, the electron
and the scanning electron microscope (SEM) were developed.
Although its importance for scientific purposes is readily appar-
ent, microphotography has only been marginally used for art-
istic work to date.[7] However, there exists a rich plethora of
noteworthy contributions (cf. Claudia Fährenkemper's pictorial
work and her text found in this publication, pp. 195ff.).

3 Photochemical Design

This refers to photographic material
and its photochemical processing. It is based on the photosensitiv-
ity of the silver salts (silver halide), which bring together the (salt-
creating) elements of bromine, chlorine and iodine; furthermore,
their molecular fabric is able to change under the impact of light.
A latent image is, thus, produced through chemical developing. The
silver salts (as crystals) are embedded in a gelatin layer. They—
together with other filtering, adhesive and protective layers—form

7 Reumuth, 1954; Strüwe, 1955

bettet. Zusammen mit weiteren Filter-, Haft-, und Schutzschichten bildet sie die fotografische Emulsion. Diese liegt auf dem Schichtträger (Papier, Film, Glas) auf und ist fest mit ihm verbunden. Auf dieser Basis hat die fotochemische Industrie im Laufe der Zeit eine Fülle handelsüblicher Materialien entwickelt. Für künstlerische Zwecke werden daneben oft nichtkonventionelle, ›alchimistische‹ Verfahren ausprobiert und angewendet, die eigenen Vorstellungen folgen. Eines dieser Verfahren mit künstlerischer Bedeutung ist das Chemigramm.

Chemigramm Primärform chemischer Gestaltung auf der Basis von Fotomaterial. Insofern ist es mit dem Luminogramm und Fotogramm vergleichbar und gehört wie diese zur Gruppe der kameralosen Fotografie. Ein Chemigramm entsteht grundsätzlich immer dann, wenn – auch fotofremde – Substanzen strukturbildend auf die fotografische Emulsion einwirken (Abb. S. 92). Licht ist dabei als Katalysator erforderlich, jedoch nicht bildbestimmend. Man unterscheidet das ›reine‹ Chemigramm (Abb. S. 72), dessen Bildstrukturen ausschließlich aus chemischen Reaktionen heraus entstehen, und das Fotochemigramm (Abb. S. 55), das durch Vorbelichtung auch figurative Elemente enthält. Ein Pionier und Meister des Chemigramms ist der Belgier Pierre Cordier.[8]

Schwarzweiß-Fotomaterial Die Daguerreotypie verwendete versilberte Kupferplatten, auf denen sich durch Niederschlag von Joddämpfen eine hauchdünne lichtempfindliche Schicht bildete. Die frühen Salzpapiere, wie sie Talbot verwendete, enthielten Jodsilber und Chlorsilber, die in den Papierfilz eindrangen und sich mit ihm verbanden. Ihre Lichtempfindlichkeit war gering. Daher suchte man früh nach geeigneten Mitteln, um die Silbersalze in größeren Mengen festhaftend auf eine Unterlage zu bringen. Zunächst wurde Albumin (Eiweiß), später Kollodium (Nitrozellulose) verwendet. Schichten, in die Silberkristalle eingebettet sind, nennt man Kolloide.[9]

Eine der größten Entdeckungen der Fotochemie war die Gelatine als Bindemittel für die Silbersalze durch Richard Leach Maddox 1871. Sie führte zur Trockenplatte, die das umständliche ›nasse‹ Kollodiumverfahren ablöste und mit einer erheblichen Steigerung der Lichtempfindlichkeit verbunden war. Gelatine ist in trockenem Zustand fest, in Wasser aufgeweicht und erwärmt wird sie flüssig, und dann können sich darin die Silberkristalle bilden und verteilen. Die erstarrte Masse bezeichnet man als

the photographic emulsion, which lies on top of the emulsion carrier (paper, film, glass) and is firmly joined to it. Over time the photochemical industry has developed many commercial brands on this basis. But for artistic purposes, non-conventional or 'alchemic' processes are often tested and applied, ones which follow the artist's own understanding of the matter. One of these artistically important processes is the chemigram.

Chemigram Primary form of chemical design based on photographic material. In this respect, it can be compared with the luminogram and the photogram and, like these, it belongs to the category of cameraless photography. A chemigram is generally produced when substances—also non-photographic ones— influence the texture of the photographic emulsion (fig. p. 92). Light, thereby, is a necessary catalyst, but it is not pictorially determinative. Distinction is made between the 'pure' chemigram (fig. p. 72), the pictorial structure of which is produced solely by means of chemical reactions, and the photochemigram (fig. p. 55) which, through pre-illumination, possesses figurative elements as well. A pioneer and master of the chemigram is the Belgian Pierre Cordier.[8]

Black-and-White Photographic Material The Daguerreotype used silver-plated copper plates on which vaporized iodine formed a wafer-thin, photosensitive layer. The early salt papers, as used by Talbot, contained silver iodide and silver chloride, which seeped into the paper pulp becoming one with it. Their photosensitivity was low. Therefore, suitable means were sought from early beginnings on how to firmly fix large quantities of silver salts onto a supporting material. Initially albumen (egg white), later collodion (nitrocellulose) were used. Colloids are layers in which are embedded silver crystals.[9]

In 1871, Richard Leach Maddox yielded one of the greatest discoveries in the field of photochemistry: gelatin as a binder for silver salts. It led to the dry plate, which replaced the complicated wet collodion process and considerably increased photosensitivity. In its dry state, gelatin is firm, in water it softens, and heated it becomes fluid so that silver crystals can form and spread in it. The hardened mass is referred to as silver gelatin emulsion—or in short, gelatin silver. Distinction is made between two categories:

8 Cordier, 1988

9 Schmidt, 1994

Silbergelatine-Emulsion, kurz: als Silbergelatine. Man unterscheidet sie nach zwei Kategorien:

Auskopieremulsionen Sie waren die ersten lichtempfindlichen Schichten der Fotografie und sind heute kaum mehr oder nur noch vereinzelt zu künstlerischen Zwecken in Gebrauch. Ihre Besonderheit besteht darin, daß die Emulsion (z.B. Kaliumjodid, Silbernitrat und Gallussäure) in den Papierfilz eindringt und eine papierene, oft seidige Oberfläche entsteht, die sich auch grafisch leicht weiter bearbeiten läßt. Zur Gruppe der Auskopieremulsionen zählen die Kalotypie, das älteste fotografische Kopierverfahren, 1840 von Talbot entwickelt. Es trägt daher auch seinen Namen: Talbotypie. Mit ihm wurde der fotografische Abzug und die moderne Vervielfältigbarkeit des Fotos eingeleitet. Zu den Auskopieremulsionen zählen weiter die heute noch gebräuchliche Cyanotypie, Platinotypie und Palladiotypie, sowie auch das nicht mehr angewandte Albuminkopierverfahren.[10]

Entwicklungsemulsionen Die heutige Form der Emulsionsschicht ist die Silbergelatine. Sie enthält als lichtempfindliche Substanz Brom-, Chlor- oder Jodsilber oder eine ihrer Verbindungen. Art und Zusammensetzung der Silbersalze in der Emulsion wirken sich auf den Bildton aus, was für Schwarzweiß-Papiere von Bedeutung ist. Bromsilberemulsionen zeigen in der Regel blauschwarze, Chlorsilberemulsionen braunschwarze, und Chlorbromsilberemulsionen warme, braunschwarze Bildtöne. Angaben dazu sind im Kunstkontext eher selten. Einzelne Sammler und Archive weisen aber auch darauf hin .

Schwarzweiß-Material Fotografische Werke sind meist Aufsichtsbilder auf Papier. Fotopapiere unterscheiden sich nach Art ihrer Oberfläche (glänzend, halbmatt, matt), nach ihrer Stärke (papier- oder kartonstark) und nach Art ihres Aufbaus. Das letztgenannte Merkmal trennt in Baryt- und polyäthylenbeschichtete Papiere, kurz: PE-Papiere. Im englischen Sprachraum tragen sie die Bezeichnung RC für *resin coated* (kunstharzbeschichtet); diese sind technisch leichter zu verarbeiten, kommen bei hohen Ansprüchen des ›Fine Art Prints‹ aus ästhetischen Gründen aber kaum in Betracht. Da sich Unterschiede zwischen Baryt- und PE-Papier drucktechnisch nicht vermitteln lassen, wird im Rahmen dieser Publikation auf nähere Angaben dazu verzichtet.

Printing-Out Emulsions Print-out emulsions were the first photosensitive layers in photography and, today, are only seldom used in isolated cases for artistic purposes. Their special feature is the emulsion (e. g. potassium iodide, silver nitrate and gallic acid) which seeps into the paper pulp, whereby paperlike and often matt-silken surfaces emerge, which facilitate further graphic work. The calotype belongs to the category of copy-out emulsions; it is the oldest photographic copying process, invented by Talbot in 1840, which is why it also bears the name 'Talbotype'. It paved the way for the photographic print and, hence, modern photographic duplication. Other copy-out emulsions are the cyanotype, the platinotype and the palladiotype, all still in use today; the albumen copy process is not used anymore.[10]

Developing Emulsions Gelatin silver is used as an emulsion layer today. Its photosensitive substance is silver bromide, silver chloride, silver iodide or its compounds. The type and composition of the silver salts in the emulsion influence the tone of the image, which is of importance for black-and-white paper. As a rule, silver bromide emulsions produce bluish-black tones, silver chloride emulsions, however, brownish-black ones, and silver bromic chloride emulsions produce warm, brownish-black tones. In an artistic context, it is quite rare to find such references. But certain collections and archives make mention of developing emulsions.

Black-and-White Material Photographic works are usually images seen on paper. Photographic papers are to be distinguished by the type of their surface (glossy, semi-matt, matt), by their thickness (paper, cardboard) and by their composition. The latter is grouped into baryta paper and polyethylene-coated paper — or in short, PE-paper. In English they are known under the name 'resin-coated' (RC-) papers; these are technically easier to handle but, due to aesthetic demands, they hardly satisfy the high standards of fine art prints. Because print differences between baryta and RC-paper cannot be conveyed, no further details are given within the scope of this publication.

With only a few exceptions, all of the black-and-white photographs reproduced in this publication were taken in the twentieth century. Therefore, they are invariably prints on gelatin silver baryta paper. RC-papers were introduced around 1970, hence, if at all, it would really only be necessary to make a distinction as of this date.

10 Mutter, Vol. III, 1963; Reilly, 1980; Arnow, 1982; Knodt/Pollmeier, 1989

Mit nur wenigen Ausnahmen sind alle in dieser Publikation wiedergegebenen Schwarzweiß-Fotografien im 20. Jahrhundert entstanden. Es handelt sich daher stets um Abzüge auf Silbergelatine-Barytpapier. Um 1970 kamen PE-Papiere auf, so daß erst ab diesem Zeitpunkt eine Unterscheidung in Frage kommt. Auch die Begriffe Abzug und Unikat bedürfen noch eines Kommentars. Der gebräuchliche deutsche Begriff Abzug ist im engeren Wortsinn ebenso unzutreffend wie der englische Parallelbegriff print. Denn Fotografien sind materiell weder (von etwas) abgezogen, noch (auf etwas) aufgedruckt worden. Außerdem müßte man nach Vergrößerung und Kopie, im Englischen nach enlargement und copy unterscheiden. Fotografien von Kleinbildnegativen sind in der Regel Vergrößerungen; Fotografien von größeren Negativen (so vor allem aus der Frühzeit der Fotografie) sind dagegen oft nur Kopien. Trotz ihrer begrifflichen Unschärfe werden Vergrößerungen und Kopien unter ›Abzug‹ (deutsch) bzw. ›print‹ (engl.) subsumiert. Die Termini haben sich international durchgesetzt und reichen für eine erste technische Zuordnung in der Regel aus.

Abzug bzw. print bedeuten außerdem: Vervielfältigung, Auflage. Ihr Gegenbegriff ist das Unikat, engl. unique print. Fotografische Aufnahmen werden in der Regel mehrfach von einem (Film-) Negativ abgezogen bzw. geprintet. Nur selten treten sie als Unikate auf, wie das bei Fotogrammen oder Luminogrammen die Regel ist. Allerdings verlangt der Kunstmarkt oft auch bei Abzügen bzw. Prints eine zahlenmäßige Begrenzung, die Limitierung. Im Rahmen dieser Publikation spielen Angaben dazu keine Rolle.

Mit der Angabe Abzug bzw. print wird hier jede von einem Schwarzweiß- oder Farbnegativ hergestellte Kopie bzw. Vergrößerung bezeichnet – auch wenn von dem betreffenden Bild im äußersten Fall nur ein Exemplar existieren sollte. Demgegenüber wird als Unikat ein Bild bezeichnet, dessen Technik tatsächlich und genuin nur ein Einzelstück hervorzubringen erlaubt (Abb. S. 54, 234–237).

Farbmaterial Moderne Farbfotomaterialien beruhen, kurz gesagt, auf drei grundsätzlich voneinander zu unterscheidenden technischen Verfahren: Dem der Chromogenen Entwicklung, dem Silberfarbausbleich-Verfahren und dem Silberfarbdiffusions-Verfahren. Bei der chromogenen Entwicklung werden die Farben bei der Bildentwicklung durch die in die Schicht und den Entwickler eingelagerten Farbkuppler chemisch erzeugt. Sie

The terms print and unique print also ask for an explanation. The common German term Abzug is, in the narrow sense of the word, as incorrect as its English equivalent print. For, in physical terms, photographs are neither printed (from something), nor printed (onto something). Moreover, one should distinguish between enlargement (Vergrößerung) and copy (Kopie). Photographs from 35-mm negatives are usually enlargements; in contrast, photographs from larger negatives (above all, those from the early days of photography) are often merely copies. Despite the lack in terminological precision, enlargements and copies are referred to as 'print' (in English) and 'Abzug' (in German). The terms are internationally accepted and, as a rule, should suffice for a general technical classification.

In addition, print (Abzug) means duplication or circulation. The unique print (Unikat) is its antonym. Photographs are usually printed more than once from a (film) negative. Only seldom are they unique prints, like photograms and luminograms. However, the art market often demands a limited number for prints. Within the scope of this publication, details on print limitation are unimportant and are not given except for a few isolated cases.

The term print (Abzug) means any copy or enlargement made from a black-and-white or color negative—even if, in the extreme, only one copy of the picture concerned should exist. In contrast, a unique print is a picture with a technique allowing for only one single genuine specimen (figs. pp. 54, 234–237).

Color Photographic Material In brief, modern color photographic materials are based on three technical processes each totally different from the other: The chromogenic development process, the silver dye bleach process and the internal dye diffusion transfer process. In the chromogenic development process, the colors are chemically produced by color couplers embedded in the layer and the developer. They are, however, rather unstable. This is disadvantageous for the color fastness and longevity of the photograph. Prints and enlargements of this most frequently-used color development process are simply known as C-prints. In the silver dye bleach process, pigments embedded in the layer are reduced according to their exposure to light. In their brilliance and longevity, they are unsurpassed; commercial brands are, for example, Ciba-chrome and Ilfochrome. In the internal dye diffusion transfer process, colors are generated by diffusion in the super-imposed layers of the

sind daher relativ instabil. Dies wirkt sich nachteilig auf Licht-echtheit und Haltbarkeit der Bilder aus. Abzüge und Vergröße-rungen dieses am häufigsten angewendeten Farbverfahrens werden kurz als C-Prints bezeichnet. Beim Silberfarbausbleich-Verfahren werden in die Schicht eingelagerte Farbstoffe belich-tungsbedingt reduziert. Sie sind hinsichtlich Brillianz und Haltbarkeit unübertroffen; handelsübliche Marken sind z.B. Cibachrome und Ilfochrome. Beim Silberfarbdiffusionsverfahren entstehen die Farben durch Diffusion innerhalb übereinander gelagerter Schichten im Material; eine verbreitete Marke ist z. B. Polaroid. Historisch existiert daneben eine Fülle weiterer Verfahren, die künstlerisch immer noch angewendet werden, wie z.B. das Farbeinsaugübertragungs-Verfahren, bekannter unter der Markenbezeichnung Dye Transfer.

4 Foto-Grafische Gestaltung

Dazu gehören alle zeichneri-schen, malerischen, montierenden und drucktechnischen Verfahren, die zu künstlerischen Zwecken eine Verbindung mit dem Fotopro-zeß eingehen. Das Zusammenspiel von Hand und Apparat spielt hier eine entscheidende Rolle. Damit hat sich im Laufe der Zeit ein weites Verfahrens-Spektrum entwickelt; es wird auch unter der Be-zeichnung Fotografik zusammengefaßt. Einzelne Verfahren haben sich zu eigenen Bildgattungen verselbständigt, wie die Gruppe der Edeldruckverfahren, das bereits zuvor behandelte Fotogramm oder das Luminogramm sowie die Fotomontage.[11]

Cliché verre

Primärform fotografischer Gestaltung, älteste Verbindung zwischen der Kunst der Zeichnung und der Technik der Fotografie: ein handgefertigtes Klischee auf Glas, das mit Licht ›gedruckt‹ und vervielfältigt wird. Eine Glasplatte wird mit Ruß oder einer ähnlich opaken Schicht belegt, anschließend wird mit einer Nadel eine Zeichnung eingeritzt (Abb. S. 87). Das Ver-fahren ist der Kaltnadelradierung vergleichbar. Das Glasklischee wird anschließend im Sinne eines Negativs für einen fotografi-schen Kopier- oder Vergrößerungsvorgang benutzt. Dabei tre-ten fototypische Effekte, wie z.B. Überstrahlungen, hinzu (Abb. S. 86, unten). Das Verfahren wurde bereits Mitte des 19. Jahr-hunderts angewendet. Bedeutende Maler und Grafiker haben es künstlerisch genützt. Das Cliché verre und seine Nachbarverfah-ren, wie Cliché cellophane, Diaphane Collage oder das Luzido-gramm , haben inzwischen eine eigene Geschichte gebildet.[12]

material; a well-known brand, for instance, is Polaroid. In addi-tion, seen historically, there exist a number of further develop-ment processes still used for artistic purposes, such as the dye imbibition transfer process, better known under the brand name Dye Transfer.

4 Photo-Graphic Design

This includes all processes of drawing, painting, mounting and typography which, together with the photo-graphic process, are applied for artistic purposes. Here, the inter-play of hand and apparatus plays a decisive role. Over time, a wide spectrum of processes has evolved; photo-graphic design is also known under the term photographics. Individual processes have become individual pictorial genres, such as the group of fine art print processes, the aforementioned photograms or luminograms, as well as the photomontage.[11]

Cliché Verre

The oldest combination of the art of illustration and the technique of photography: It is a hand-made stereotype plate on glass, 'to print' and duplicate with light. A glass plate is coated with soot or with a similar opaque substance, then an illustration is engraved into it with a needle. The process is com-parable to dry-point engraving (fig. p. 87). The cliché verre is subsequently used like a negative in a photographic printing or enlargement process. Thereby phototypical effects like irradia-tion often occur (figs. p. 86, bottom). The process was already used in the middle of the nineteenth century. Renowned pain-ters and graphic artists have applied it for their needs. The cliché verre and its related processes, like the cliché cellophane, the lucidogram or the diaphanous collage,[12] have meanwhile written their own history.

Photographics

A collective term for all processes in which photographic and graphic elements interact for pictorial purpo-ses. The term goes back to the German chemist and photogra-pher Erwin Quedenfeldt (cf. text by Rolf H. Krauss pp. 103ff.). He coined it in 1920 for the graphic retouching of photograms, "whereby the illustration alone, but not the photogram, should come to the fore"; it is, therefore, a procedure which is "actually neither photography, nor illustration", as a critic has commen-ted.[13] A decade or so after 1920, photographics meant "artisti-cally composed photographs shot by a camera, but skilfully manipulated by the artist to the greatest possible extent".[14] Today many of the earlier complicated photographic processes—

11 Jäger, 1988; *Das Foto als autonomes Bild*, 1989

12 Glassman/Symmes, 1994

Fotografik Sammelbegriff für alle Verfahren, bei denen fotografische und grafische Mittel bildnerisch zusammenwirken. Der Begriff geht auf den deutschen Chemiker und Fotografen Erwin Quedenfeldt zurück (s. hierzu den Beitrag von Rolf H. Krauss, S. 103ff.). Er führte ihn 1920 für die zeichnerische Überarbeitung von Fotogrammen ein, »wobei die Zeichnung allein, das Fotogramm dagegen gar nicht zur Geltung gelangen soll«; es handelte sich also um eine Arbeitsweise, die »eigentlich weder Fotografie noch Zeichnung ist«, wie ein Kritiker äußerte.[13] Zehn Jahre später faßte man unter Fotografik »künstlerisch komponierte Lichtbilder« zusammen, »die wohl aus einer Kameraaufnahme entstanden, jedoch in weitestgehendem Maße der Beeinflussung durch die Hand des Autors unterliegen«[14]. Heute lassen sich viele der zuvor komplizierten Verfahren der Fotografik, wie Solarisation, Tontrennung, Bildumkehrung, Strukturbildung, Färbung, usw. mit Hilfe von Computerprogrammen für die Bildbearbeitung, wie z.B. Photoshop, problemlos realisieren.

Lichtgrafik, Lichtmalerei Unterbegriffe der Fotografik sind Lichtgrafik, Lichtzeichnung und Lichtmalerei. Dabei wird mit einem Lichtstift (z. B. der Taschenlampe; Abb. S. 98) oder einem Lichtaggregat (Abb. S. 69) in der Dunkelkammer auf dem lichtempfindlichen Material eine Bildstruktur erzeugt. Der Überraschungseffekt spielt hier eine wesentliche Rolle, denn Arbeitsergebnisse können erst nach der Entwicklung betrachtet und überprüft werden.

Fotomontage, Fotocollage Bedeutende und eigenständige Gattungen der Fotografik. Dabei werden Foto- und Textteile, manchmal auch Materialelemente, zu einer kompositorischen Bildaussage verdichtet. Der Begriff Fotomontage wurde 1924 durch Moholy-Nagy eingeführt. Seine Ergebnisse vermitteln, zusammen mit dem ebenfalls von Moholy-Nagy propagierten *Typophoto*[15] ein typisches Bild jener Zeit. Propaganda und Werbung haben sich bis heute ihrer Mittel bedient. Bildsymbol und Textinformation wirken hier einprägsam und nachhaltig zusammen. John Heartfields politische Montagen sind herausragende Beispiele jener Zeit.[16]

Fotografische Druckverfahren Künstlerische Bildtechniken, die Fotografie und manuelle Druckgestaltung miteinander verbinden. Sie erlebten ihre Blüte um 1900, wurden aber bis in die 1930er Jahre hinein handwerklich genützt.[17] Ihr Ziel war die Veredelung des Fotos und seine Anerkennung als Kunstform.

like solarization, tonal separation, image reversal, textural formation, coloration, etc.—can be easily realized by computer software for pictorial editing, such as Photoshop.

Light Graphics, Light Painting Light graphics, light drawing and light painting are subdivisions in the field of photographics. With the help of a light stick (fig. p. 98) or a lighting set (fig. p. 69) in the darkroom, pictorial structures are produced on photosensitive material. The surprise effect plays an important role, as the results can only be seen and examined upon development.

Photomontage, Photocollage Important and independent genres of photographics in which photographic and textual elements, sometimes also pieces of material, are concentrated into a compositional pictorial statement. In 1924, Moholy-Nagy coined the term photomontage. His works, together with the *Typophoto*[15] also propagated by him, convey a typical picture of his time. To date, propaganda and advertising have made use of these genres. Both pictorial symbol and textual information can be easily remembered and leave a lasting impression. John Heartfield's political photomontages are typical examples of that time.[16]

Photographic Printing Processes Artistic techniques which bring together photography and manual print design. They experienced their heyday around 1900, but were still used by craftsmen until the 1930s.[17] Their aim was to refine photographs, in order to make the public recognize them as an art form. Most of the processes are based on a tanning of the photosensitive layer through pictorially appropriate exposure. The photosensitive substance does not consist of silver bromide, as is the case with papers used for developing but it, rather, consists of chrome or ferric nitrate compounds and a colloid such as gelatin. Exposed areas of the layer harden more than unexposed ones and, upon further handling, they serve as a printing block.

The most common processes based on chrome salts are the pigment print (fig. p. 158) with its variants such as the gum bichromate print (fig. p. 113), the carbon print, as well as the oil print and the bromoil print (fig. p. 154). The platinum print and the cyanotype are the best known processes on the basis of a ferric nitrate compound.[18]

13 Graphikus (Pseudonym): Photographik. In: *Der Photograph*, Nr. 42/1920, pp. 161f.

14 Neumann, Jan A.: Der Einfluß des Modernismus auf die Lichtbildnerei der Gegenwart. In: *Camera*, 8. Jg. Nr. 11, 1930, p. 293

15 Moholy-Nagy, László: *Malerei, Photographie, Film*, 1925; Lusk, 1980

16 Hiepe, 1969; Herzfelde, 1971; Ades, 1976

17 Kaufhold, 1986; Schmidt, 1994

Grundlage der meisten Verfahren ist die Gerbung der lichtemp-findlichen Schicht durch eine bildmäßige Belichtung. Die licht-empfindliche Substanz besteht dabei nicht aus einem Silbersalz wie bei den Entwicklungspapieren, sondern aus Chrom- oder Eisensalzverbindungen und einem Kolloid, z. B. Gelatine. Diese Schicht wird an den belichteten Stellen stärker als an den unbe-lichteten gehärtet und dient, nach weiterer Bearbeitung, als Druckstock.

Die bekanntesten Verfahren auf der Basis von Chromsalzen sind der Pigmentdruck (Abb. S. 158) mit seinen Varianten Gummi-druck (Abb. S. 113), Carbrodruck sowie Öl- und Bromöldruck (Abb. S. 154). Die bekanntesten Verfahren auf der Grundlage einer Eisensalzverbindung sind der Platindruck und die Cyanotypie.[18]

5 Fotoräumliche Gestaltung

Verbindung von Fotografie mit dreidimensionalen, raum-zeitlichen Elementen. Das Gebiet ist wenig bekannt, hat aber zu interessanten künstlerischen Ergebnissen geführt. Eine Primärform ist das Fotorelief auf der Basis der Gerb-entwicklung, auch als Druckstock für Vervielfältigungen. Das Gebiet reicht heute bis zur Fotoinstallation, Fotoinszenierung, bis Foto-performance und Fotoaktion.[19] Zu deren Vorläufern zählen die *Reflektorischen Lichtspiele* von Hirschfeld-Mack (Abb. S. 112, unten) und die kinetische Lichtskulpturen von Moholy-Nagy aus den 1920er Jahren. Bezüge zu Theater und Tanz liegen nahe.

Fotoobjekt, Fotoskulptur, Fotoplastik

Fotoobjekt: Das Foto bildet nicht ein Objekt ab, sondern es ist selbst Objekt. Seine materialen Eigenschaften sind Gegenstand der Betrachtung (Abb. S. 92f., 100f.). Fotoskulptur: Fotografisch erzeugtes, frei-stehendes dreidimensionales Objekt aus einem Material; dabei wirken fotografische, skulpturale und plastische Mittel zusam-men. Ihr Erfinder ist der französische Bildhauer François Willème, der 1860 ein Patent dazu anmeldete. Sein Ziel war der identische Abguß eines Vorbildes mit mechanisierten Mitteln, so daß auch »Arbeiter, die keine Kenntnis der Bildhauerkunst« besitzen, Fotoskulpturen ausführen könnten.[20] *Photoplastik*: So bezeichnete Moholy-Nagy seine – allerdings flächigen – Fotocollagen mit ausgeprägt plastischer Wirkung. Sie verbinden Fotofragmente mit geometrischen Elementen und stehen dem Neoplastizismus Mondrians und Theo van Doesburgs nahe.[21]

5 Photospatial Design

The interaction of photography with three-dimensional, spatiotemporal elements. The area is little known, but it has yielded interesting artistic results. A primary form is the photo relief based on tan development, also used as a printing block for duplication. Today the area includes photo installations, photo productions, as well as photo performances and photo actions,[19] the precursors of which are Hirschfeld-Mack's reflecting *Lichtspiele* ('light play') (fig. p. 112, bottom) and Moholy-Nagy's light sculptures of the 1920s. A close connection to theatre and dance is to be seen.

Photo-Object, Photosculpture, Photoplastic

Photo-object: The photograph does not show an object; it is an object proper. Its material characteristics are the subject for consideration (figs. pp. 92f., 100f.). *Photosculpture*: a free-standing, three-dimensional object photographically made of one material, in which photographic, sculptural and plastic elements interact. Its inventor is the French sculptor François Willème, who had it patented in 1860. His aim was to make an identical copy of a model using mechanical means, so that "workmen with no skills in sculpture" could execute photosculptures.[20] For Moholy-Nagy, Photoplastic meant his—albeit two-dimensional—photo-collages with a pronounced plastic effect. They bring together photographic fragments and geometric elements and are to be associated with the neo-plasticism of Mondrian and Theo van Doesburg.[21]

Photoinstallation

The incorporation of photographs into a spatial environment (fig. p. 6); characteristic is the interrelation of photograph, wall, space, even sound. In essence, the term already refers to any photograph mounted on a wall, since it is of course clear that an interaction of elements will ensue. But only in the case of an installation—which mirrors, reflects or spreads the interrelations between photographs and space—does this genre attain its special effect (fig. p. 101).

Photoproduction, Photoperformance

Stage arrangements for photographic purposes; collective term for pictorial proces-ses in which arranged scenes and constructions are made exclu-sively for the photograph. Therefore, the results are also known as 'stage photography' (figs. pp. 14, bottom; 43).[22] Its stage is the photographer's studio. Photoproduction, like photoperfor-mance and photoaction, have the character of a performance

18 Heidtmann, 1978; Knodt/Pollmeier, 1989; Münzberg, 1989

19 Jäger, 1988, p. 288ff.

20 Drost, 1986, p. 278

21 Lusk, 1980, p. 25

Fotoinstallation Einbindung von Fotografien in eine räumliche Situation (Abb. S. 6); die Wechselbeziehung zwischen Foto, Wand, Raum, zuweilen auch Klang, ist dafür bezeichnend. Im Grunde verweist der Begriff bereits auf jede an einer Wand angebrachte Fotografie, denn eine Wechselwirkung zwischen den Elementen tritt in jedem Falle ein. Aber erst durch eine Installation, die die Wechselbeziehungen zwischen Foto und Raum widerspiegelt, reflektiert oder auch kolportiert, gelangt das Verfahren zu seiner besonderen Wirkung (Abb. S. 101).

Fotoinszenierung, Fotoperformance Szenische Arrangements für fotografische Zwecke; Sammelbegriff für bildnerische Verfahren, bei denen gestaltete Szenarien und Aufbauten ausschließlich für das Foto geschaffen werden. Ihre Ergebnisse werden daher auch als inszenierte Fotografie oder ›stage photography‹ bezeichnet (Abb. S. 14, unten; 43).[22] Ihre Bühne ist das Fotostudio. Die Fotoinszenierung hat, wie Fotoperformance und Fotoaktion, Aufführungscharakter (Abb. S. 92f.). Die letztgenannten Methoden sind jedoch stärker durch die Zeitdimension und das Element der Dauer geprägt (Abb. S. 50, oben). Häufig spielen Personen und Modelle dabei eine Rolle (Abb. S. 158).

6 Fotoelektrische und -elektronische Gestaltung Bildnerische Verfahren, die auf einer Verbindung von fotografischen mit elektrischen oder elektronischen Mitteln beruhen. Das Gebiet schließt die Elektrofotografie in sich ein: Ein beschichtetes Trägermaterial wird durch eine Bildbelichtung elektrostatisch aufgeladen. Fotokopie und Xerokopie funktionieren nach diesem Prinzip. Anfänge des Gebietes sind durch das Fotogalvano nachgewiesen, das schon in Verbindung mit der Daguerreotypie zu Kopierversuchen geführt hat. Die Fotogravüre (Abb. S. 167, oben links) resultiert aus diesen Anfängen. Ein Sondergebiet, das erwähnt werden soll und die Gemüter immer wieder bewegt, ist die Korona- oder Aurafotografie (Abb. S. 41), nach ihrem Entdecker Kirlianfotografie genannt.[23] Mit ihr wird versucht, psychische Zustände durch Ladungsaustausch auf Fotomaterial darzustellen und nachzuweisen. Schließlich gehören die neuen elektronischen, rechnergestützten Verfahren für die Aufnahme, Speicherung und Bearbeitung von Fotografien mit Hilfe des Computers zu dem Gebiet, kurz: Die digitale Fotografie.[24]

Fotokopie, Xerokopie Trockenkopierverfahren, das es erlaubt, Fotografien und andere Vorlagen auf normale, nichtpräparierte Papiere zu kopieren. Das Verfahren wurde 1938

(figs. pp. 92f.). However, the latter methods are more influenced by duration and the dimension of time (fig. p. 50, top). People and models frequently play a role (fig. p. 158).

6 Photoelectric and Photoelectronic Design Pictorial processes based on a combination of photographic and electric or electronic elements. This domain includes electrophotography, in which exposure induces the electrostatic charging of a coated carrier material. Photocopy and xerocopy follow the same principle. The roots of this area are to be found in the photogalvano which, together with the daguerreotype, had already led to attempts in duplication. The photogravure (fig. p. 167, top, left) is a product of these beginnings. A special area which should be mentioned and which, again and again, arouses discussion is corona or aura photography (fig. p. 41), also known as Kirlian photography after its inventor.[23] Through an exchange in charges on photographic material, it tries to show and record psychic states. Ultimately, the new electronic processes of taking, saving and developing photographs using computers—in short, digital photography—belong to this category.[24]

Photocopy, Xerocopy Dry-copy processes, which allow photographs and other documents to be copied onto normal, untreated paper. It was the American Chester F. Carlson who invented the process in 1938 and led it to marketability. The 1970s saw a downright boom with the proclamation of its own art form: Copy art. Numerous ensuing exhibitions were held under the label of Electroworks.[25] With artistic photocopy, the circumstances are reversed: The original is no longer copied, but the copy becomes the original instead.

Digital Photography Computer-aided taking, saving, development and duplication of photographic images. The spectrum of digital photography ranges from photo-realistic images (fig. p. 267, top) to photo-based, computer-generated, abstract compositions (fig. title). The digital camera electronically saves photo-optic pictorial information, which the computer then develops and which is issued by a printer. Digital photography also includes the scanning of a pre-existing photograph; the latter is electronically copied line by line and fed into a computer. The previously analogous image structure of the photograph is converted into a digital one. The direct physical meeting of cause (object) and effect (image)—the essential characteristic of conventional photography to date—is severed here. The image

22 *'blow up' Zeitgeschichte*, 1987; *fotografia buffa*, 1987; *Das konstruierte Bild*, 1989

23 Krippner/Rubin, 1975; *Umgang mit der Aura*, 1984

24 Urbons, 1994

25 *electroworks*, 1979

durch den Amerikaner Chester F. Carlson erfunden und zur Marktreife geführt. In den 1970er Jahren kam es zu einem regelrechten Boom mit Ausrufung einer eigenen Kunstform: Der Copy Art, mit der sich zahlreiche Ausstellungen, so unter der Bezeichnung *electroworks*, beschäftigten.[25] Mit der künstlerischen Fotokopie kehren sich die Verhältnisse um: Nicht mehr ein Original wird kopiert, sondern die Kopie wird zum Original.

Digitale Fotografie Rechnergestützte Aufnahme, Speicherung, Bearbeitung und Wiedergabe fotografischer Bilder. Das Spektrum digitaler Fotografie erstreckt sich von der fotorealistischen Abbildung (Abb. S. 267, oben) bis zur fotobasierten, computergenerierten abstrakten Komposition (Titelabbildung). In der digitalen Kamera wird die fotooptisch aufgenommene Bildinformation elektronisch gespeichert, anschließend im Computer bearbeitet und durch einen Drucker ausgegeben. Zur digitalen Fotografie zählt auch das Scannen eines vorhandenen Fotos. Dabei wird es zeilenweise elektronisch abgeschrieben und in den Rechner eingelesen. Die zuvor analoge fotografische Bildstruktur wird in eine digitale übergeführt. Die direkte physische Verbindung zwischen Ursache (Objekt) und Wirkung (Bild), bisher das wesentliche Merkmal konventioneller Fotografie, reißt an dieser Stelle ab. Die Bilddaten können anschließend elektronisch weiter bearbeitet und unbeschränkt verändert, ›manipuliert‹ werden. Parallel zum Begriff der Filmanimation (Animationsfilm, Trickfilm), der tote Objekte in Bewegung versetzt, kann man hier von Fotoanimation sprechen: Das ruhende Foto (*still*) wird mittels Elektronik (neu) ›belebt‹.

Das Gebiet schließt auch die Fotosimulation in sich ein: Fotografische Bilder werden nicht aufgenommen, sondern erzeugt. Fototypische Strukturen werden algorithmisch, durch Rechenoperation, den konventionellen Fotografien gegenüber täuschend ähnlich nachgebildet (Abb. S. 267, unten). Das analog erscheinende Foto ist tatsächlich ein errechnetes Bild; es steht nicht in direkter, sondern indirekter Beziehung zur äußeren Wirklichkeit.

Viele Gründe sprechen dafür, daß die Fotografie künftig von diesen Prinzipien zunehmend stärker bestimmt sein wird. Das abbildungstreue Foto ›wirklicher‹ Realität, wird dabei zum Spezialfall. Es geht in den Kanon Technischer Bilder ein.

Digitale Druckverfahren Rechnergestützte Vervielfältigung von Aufsichtsvorlagen. Die Digitalisierung der Informationsverarbeitung führte auch zu einer forcierten Entwicklung neuer

data is subsequently processed electronically and changed or 'manipulated' in an unrestricted way. Parallel to the term film animation (animated cartoon), which sets dead objects into motion, we should refer to photo animation here: Electronics animate the still photograph.

The area also includes photosimulation: Photographic images are not taken, but are generated instead. By algorismic means using calculations, photo-typical structures are reproduced strikingly similar to conventional photographic images (fig. p. 267, bottom). In actual fact, the analogously shown photo is a calculated image; it does not have a direct, but an indirect relationship to outside reality.

There are many reasons to support the idea that the photograph of the future will be increasingly determined by this principle. Thus, mimetically faithful photographs of 'true' reality become a special case. They enter the canon of Technical Images.

Digital Printing Computer-aided duplication of a screened object. The digitalization of information processing also led to a conscious development of new systems to issue photographic images. Electronic Inkjet-Print systems using today's best quality ink by far surpass the light-fastness of conventional C-Prints. And, according to manufacturers' information, noticable changes in color are only to be seen after more than 30 years. Image data can be transferred onto (almost) any carrier material, even onto the largest of formats. The processes include, for example, the Scanachrome and the Iris Giclée Print, also called the Iris Fine Art Print (or Iris-Print in short). The term is derived from the French verb 'gicler', meaning to spray, and, like other processes, is a registered trade mark. The application of digital printing processes make use of any kind of image data and, with respect to materials and certification, they concentrate on the specific needs of the art market. Other systems, such as the Duraflex-Print (Kodak) or the Lambda Print (Durst), prefer digital exposure on photographic paper: With the help of a digitally-controlled laser light, the image data are directly transferred onto color photographic paper, which is later chromogenically developed. It is, therefore, a C-Print with all its advantages and disadvantages; the results are genuine half-tones of highest dissolution and not, as in the case of digital prints, colors made up of individual ink-jet print pixels. In due course, we can expect further interesting developments in this area.

Systeme für die Ausgabe fotografischer Bilder. Elektronische Sprühsysteme (Inkjet-Print) mit Tinten von heute höchster Qualität übertreffen die Lichtechtheit konventioneller C-Prints bei weitem. Wahrnehmbare Farbveränderungen lassen sich laut Herstellerangaben erst nach mehr als 30 Jahren feststellen. Die Bilddaten können auf (fast) jedes Trägermaterial auch größter Formate aufgebracht werden. Zu den Verfahren zählen z.B. Scanachrome und der Iris Giclée Print, auch: Iris Fine Art Print oder Iris-Print. Der Begriff ist von dem französischen Verb *gicler* (sprühen), abgeleitet und wie andere als Markenzeichen geschützt. Anwendungen gehen von jeder Art Bilddaten aus und sind hinsichtlich Materialien und Zertifizierung auf kunstmarktspezifische Belange ausgerichtet. Andere Systeme, wie z. B. Duraflex-Print (Kodak) oder Lambda-Print (Durst) favorisieren die digitale Belichtung auf Fotopapier: Die Bilddaten werden mit Hilfe eines digital gesteuerten Laserbelichters direkt auf Farbfotopapier übertragen, das anschließend chromogen entwickelt wird. Es handelt sich demnach um einen C-Print mit all seinen Vor- und Nachteilen; es entstehen echte Halbtöne mit höchster Auflösung und nicht, wie beim Digitaldruck, aus einzelnen Sprühpixeln zusammengesetzte Farben. Das Gebiet läßt in der nächsten Zeit wei-tere interessante Entwicklungen erwarten.

7 Präsentationstechnik Schließlich sollen die in dieser Publikation erwähnten Begriffe zur Bildpräsentation kurz angesprochen werden. Neben traditionellen Materialen auf der Basis von Pappe oder Holz haben sich kunststoffbeschichtete Aluminiumplatten unter Bezeichnungen wie Aludibond (kurz: Dibond) und Alucobond durchgesetzt. Der erstgenannte Typ besitzt eine Metall- und eine Kunststoffseite, der zweite Typ besteht aus zwei Metallseiten, zwischen denen sich eine Kunststoffschicht befindet. Ihre Vorteile sind völlige Planlage und hohe Stabilität. Zunehmend werden vor allem großformatige Fotografien auch hinter oder zwischen Acrylglas präsentiert, bekannt auch unter der Marken-bezeichnung *Plexiglas*. Dabei wird das Foto mit seiner Vorderseite und mit Hilfe einer hochtransparenten Siliconschicht fest haftend auf das Acrylglas aufgebracht, die Rückseite wird gleich behandelt oder mit einem anderen Material versehen. Das Verfahren ist unter der Bezeichnung Diasec bekannt. Häufig werden Fotooberflächen zum Schutz oder aus ästhetischen Gründen zusätzlich glänzend oder matt laminiert.

Gottfried Jäger

7 Methods of Presentation Finally, some remarks on the terms mentioned in this publication on the methods of presentation of photographs. Apart from traditional materials based on cardboard or wood, plastic-coated aluminum plates known under Aludibond (Dibond in short) and Alucobond have won general acceptance. The former consists of a metal and a plastic side; the latter of two metal sides with a plastic layer in between. Their advantages are complete evenness and stability. Particularly large-format photographs are increasingly presented behind or between acrylic glass (in short, acryl), better known under the trade name *Plexiglass*. Using a highly transparent silicon coating, the front of the photograph is firmly applied onto the acrylic glass; the backside is similarly treated or covered with a different material. The process is known as Diasec. For protection or for aesthetic purposes, the photo surfaces can be laminated either glossy or matt. This short summary does not claim to be comprehensive, as it merely refers to terms mentioned in this publication.

Gottfried Jäger

Zeittafel Timeline	1900	1910	1920	1930	1940

Stilistische Begriffe
Stylistic Terms

Pictorial Photography
Photo Symbolism
Kunstfotografie um 1900
Straight Photography (Hartmann, 1904)
Fotodinamismo Futurista (Bragaglia, 1911)

Abstract Photography (Coburn, 1916)

Abstract Camerawork (Strand, 1916)
Vortographs (Coburn, 1917)
Schadographs (Schad, 1919)
Experimental Photography
Concrete Photography / Constructive Photography
Surrealistic Photography
Rayographs, *Champs Délicieux* (Man Ray, 1922)
Equivalents (Stieglitz, 1922)
bauhaus (1919 – 1933) new bauhaus
Neues Sehen (Roh, 1929) (1937 – 1951)
Neue Sachlichkeit

Technische Begriffe
Technical Terms

Cyanotype Process (1842) Photogram (Moholy-Nagy, 1922) Light Box
Heliogravure/Photogravure (1880) Photocollage Light Drawing
Platinotype Process (1880) Photomontage Light Painting
Gum Bichromate Process (1894) Photoplastic Light Modulator
Bromoil Process (1907) Typophoto (1924)
Chronophoto Electronic Flash
Cinematograph Stroboscope
Time Exposure Microscope
X-Ray Solarization
 Tone Separation

Die hier genannten Begriffe sind auch in den Texten dieser
Publikation enthalten. Die entsprechenden Textstellen lassen
sich über das Sachregister auffinden. Die Jahreszahlen
verweisen auf die Zeit der Einführung des Begriffs.
The terms mentioned here are also referred to in the texts of
this publication. Page details are to be found in the subject index.
The years represent the time when the terms were introduced.

Gottfried Jäger

1950	1960	1970	1980	1990	2000

fotoform

Subjektive Fotografie (Steinert, Schmoll, 1951)

Ungegenständliche Fotografie (Hernandez, 1960)

Generative Fotografie (Jäger, 1968)

Serial Photography / Elemental Photography

Concept Art / Conceptual Photography

Analytical Photography

Copy Art / Electroworks

Altered Photo Processing Lomography

Pinhole Revival

Experimental Media Reflection (Neusüss, 1978)

Visualism in Photography (Müller-Pohle, 1980)

Extended Photography (Auer, Weibel, 1981)

Photo Recycling Photo (1982)

Autopoietic Photography

Polaroid Montages (Hockney, 1982)

Vanishing Presence (1989)

The Disappearance of Things

Photography after Photography

Chromogenic Development Process	Silver Dye Bleach Process		Photomedia	Digital Photography	Computer Photo
Dye Imbibition Transfer Process			Mixed Media	Virtual Photography	
Dye Diffusion Transfer Process	Xerocopy		Hyper-Media		Photo-based
	Photolaser			Photoanimation	Computer-generated
Luminogram	Scanning Electron Microscope			Photosimulation	Image
Lucidogram			Inkjet Print		
Chemigram		Photo Sequence	Iris Print		
		Photoperformance			
		Photoinstallation			
		Photoaction			

Bibliografie Bibliography Ausgewählte Ausstellungskataloge und Bücher zur abstrakten Fotografie Selected exhibition catalogs and books on abstract photography

1. Ausstellungskataloge Exhibition catalogs
Gruppenausstellungen in chronologischer Reihenfolge
Group exhibitions in chronological order 1951–2001

subjektive fotografie. Internationale Ausstellung moderner Foto-grafie. Curated by Otto Steinert. Catalog essays: Otto Steinert, Franz Roh, J. A. Schmoll gen. Eisenwerth. Fotografische Abteilung der Staatlichen Schule für Kunst und Hand-werk Saarbrücken, 1951
Images inventées. Exposition internationale de photographies. Organisée par la Galerie Aujourd'hui du Palais des Beaux-Arts de Bruxelles et l'École des Beaux-Arts de Sarrebruck, Directeur Prof. Dr. Otto Steinert. Catalog essays by Chris Yperman, H. van de Waal, J. A. Schmoll gen. Eisenwerth. Brussels, 1957
Fotografie als uitdrukkingsmiddel. Gemeente-museum Arnhem. Catalog essay Martien Coppens. Arnheim, 1957–1958
Ungegenständliche Photographie. Curated and catalog essay by Antonio Hernandez. Gewerbemuseum Basel, 1960
Kunstfotografie um 1900. Curated by Otto Steinert. Catalog essays: Otto Steinert, Fritz Kempe, Hermann Speer, L. Fritz Gruber, Heinrich Freytag, Heinz Spielmann. Museum Folkwang Essen, 1964
Heinz Hajek-Halke: Lichtgrafik. Curated and catalog essay by Gottfried Jäger. Werkkunstschule Bielefeld, 1965
Mikrofotografien Carl Strüwe und Manfred Kage. Curated and cata-log essay by Gottfried Jäger. Werkkunstschule Bielefeld, 1966
Elektronische Grafik: Herbert W. Franke. Curated and catalog essay by Gottfried Jäger. Werkkunstschule Bielefeld, 1968
Generative Fotografie: Kilian Breier, Pierre Cordier, Hein Graven-horst, Gottfried Jäger. Curated by Gottfried Jäger. Catalog essays: Herbert W. Franke, Gottfried Jäger. Kunsthaus Biele-feld, 1968
Foto-Grafik. Die Sammlung Clarissa. Curated by Käthe Schröder. Catalog essay: Heinz Hajek-Halke. Kestner-Museum Hannover, 1968
Fotografie elementar in vier Beispielen: HfbK Hamburg, Konink-lijke Akademie v. Kunst en Vormgeving s'Hertogenbosch, WKS Bielefeld, WKS Dortmund. Curated by Eva tom Moehlen. Catalog essays: Eva tom Moehlen, Fritz Seitz, Wim Noordhoek, Pan Walther, Gottfried Jäger. Adult College Cologne, 1968
Experimentelle Photographie. Hans Mayr, Wladimir Narbut-Lieven, Bronislaw Rogalinski, Hans-Joachim Taige. Curated and catalog essay: Wilhelm Mrazek. Kunstgewerbemuseum Köln, Cologne, 1972

Medium Fotografie. Fotoarbeiten bildender Künstler 1910–1973. Curated by Rolf Wedewer. Catalog essays: Rolf Wedewer, Lothar Romain. Städtisches Museum Leverkusen Schloß Morsbroich. Leverkusen, 1973
Fotomedia: Die Erfahrungen italienischer Künstler im Umgang mit Foto und Videotape. Catalog essays: Daniela Palzzoli, Eugen Thiemann. Museum am Ostwall, Dortmund, 1974
Demonstrative Fotografie. Curated and catalog essay by Hans Gercke. Heidelberger Kunstverein. Heidelberg, 1974
Fantastic Photography in Europe. Exhibition organization by Lorenzo Merlo, Canon Photo Gallery Amsterdam. Catalog essay by Carole Naggar. Rencontres Internationales de la Photographie, Arles (F) and other places in Europe 1976–1978. Amsterdam, 1976
Künstlerphotographien im XX. Jahrhundert. Curated by Carl-Albrecht Haenlein. Catalog essays: Carl-Albrecht Haenlein, Klaus Honnef, Werner Lippert, Schuldt. Kestner-Gesellschaft, Hanover, 1977
Fantastic Photography in the U.S.A. Exhibition organization by Lorenzo Merlo, Canon Photo Gallery Amsterdam. Catalog essay by Roman Cieslewicz. Museo Fundacio Miró, Barcelona (SP) and other places in Europe. Amsterdam, 1978
Das experimentelle Photo in Deutschland 1918–1940. Curated and catalog essay by Emilio Bertonati. Galeria Del Levante, Munich, 1978
electroworks. Curated by Marilyn McCray. George Eastman House, Rochester, N. Y., 1979
Erweiterte Fotografie / Extended Photography. 5. Internationale Biennale Wien. Curated and catalog essays by Peter Weibel, Anna Auer. Wiener Secession, Vienna, 1981
Photo recycling Photo. Curated by Floris M. Neusüss. Catalog essays: Herbert Molderings, Rolf Lobeck. Bermuda-Dreieck für Fotografie (Fotoforum), Kassel, 1982
Lensless Photography. Curated and catalog essay by Thomas Landon Davies. The Franklin Institute Science Museum, Phila-delphia (1983) and IBM Gallery of Science and Art, New York City (1984). Philadelphia, 1983
Kunst mit Photographie. Die Sammlung Dr. Rolf H. Krauss. Collected and curated by Rolf H. Krauss. Catalog essays: Rolf H. Krauss, Manfred Schmalriede, Michael Schwarz. Nationalgalerie Berlin, 1983
subjektive fotografie. Bilder der 50er Jahre. Curated by Ute Eskildsen. Catalog essays: Ute Eskildsen, Paul Vogt, Manfred Schmalriede. Folkwang Museum Essen and other places in USA, Sweden, Belgium. Essen, 1984

Umgang mit der Aura. Lichtbild Abbild Sinnbild. Curated and catalog essay by Veit Loers. Städtische Galerie Regensburg. Zurich, 1984

Behind the Eyes. Eight German Artists. Curated by Van Deren Coke. Catalog essay: Georg Jappe. San Francisco Museum of Modern Art, 1986

Positionen experimenteller Fotografie. Bielefelder Autoren: Bitter, Filges, Herter, Holzhäuser, A. Jäger, G. Jäger, Meier, Schwarz, Wächter. Curated and catalog essay by Jutta Hülsewig-Johnen. Kunsthalle Bielefeld, 1986

Reste des Authentischen. Deutsche Fotobilder der 80er Jahre. Curated and catalog essay: Ute Eskildsen. Museum Folkwang Essen, 1986

Bildschaffende Konzepte: Janzer, Holzhäuser, Kammerichs, Sal. Curated by Gottfried Jäger. Catalog essays by Gottfried Jäger, Enno Kaufhold, Marlene Schnelle-Schneyder, Städtische Galerie Leinfelden-Echterdingen, 1987

»blow up« Zeitgeschichte. Curated and catalog essays by Tilman Osterwold, Peter Weiermair, Klaus Honnef, Karl-Egon Vester, Thomas Kempas, Martin Kunz. Württembergischer Kunstverein Stuttgart and other places in Germany and Swizerland. Stuttgart, 1987

fotografia buffa. Inszenierte Fotografie. Beispiele aus den Niederlanden. Curated and catalog essay by Klaus Honnef. Rheinisches Landesmuseum, Bonn, 1987

50 Jahre New Bauhaus. Bauhaus Nachfolge in Chicago. Exhibition concept and catalog editors: Peter Hahn and Lloyd C. Engelbrecht. Catalog essays by Peter Hahn, Lloyd C. Engelbrecht, Alain Findeli, Jeannine Fiedler et al. Bauhaus Archiv, Berlin, 1987

Das Foto als autonomes Bild. Experimentelle Gestaltung 1839–1989. Curated and catalog essays by Jutta Hülsewig-Johnen, Gottfried Jäger, J. A. Schmoll gen. Eisenwerth. Kunsthalle Bielefeld, 1989; Bayerische Akademie der schönen Künste München, 1990. Stuttgart, 1989

Das konstruierte Bild. Fotografie – arrangiert und inszeniert. Curated by Michael Köhler. Catalog essays by Michael Köhler, Zdenek Felix, Andreas Vowinckel. Kunstverein München, 1989 and other places in Germany. Schaffhausen, Zürich, Frankfurt am Main, Düsseldorf, 1989.

Das Innere der Sicht. Surrealistische Fotografie der 30er und 40er Jahre. Curated by Monika Faber. Catalog essays by Monika Faber, Antonin Dufek, Alain Mousseigne, Jasna Tijardovic, Milanka Todic. Österreichisches Fotoarchiv im Museum moderner Kunst Wien, Vienna, 1989

Vanishing Presence. Curator: Adam D. Weinberg. Catalog essays by Adam D. Weinberg, Eugenia Parry Janis, Max Kozloff. Walker Art Center, Mineapolis. New York, 1989

Abstraction in Contemporary Photography. Curated by Jimmy de Sana. Catalog essays by Andy Grundberg, Jerry Saltz. Emerson Gallery, Hamilton College, 1989; Anderson Gallery, School of the Arts, Virginia Commonwealth University, Richmond, Virginia, 1990

Fotografie am Bauhaus. Überblick über eine Periode der Fotografie im 20. Jahrhundert. Conception of exhibition and catalog: Jeannine Fiedler. Catalog essays by Peter Hahn, Jeannine Fiedler, Andreas Haus, Rolf Sachsse, Herbert Molderings et al. Bauhaus Archiv, Berlin and other places in Germany, Zurich, Paris. Berlin, 1990

New Spaces of Photography. Curated and catalog conception by Romuald Kutera and Jerzy Olek; arrangement of exhibition by Lech Mrozek. Catalog essays by Mark Haworth-Booth, John Hilliard, Gottfried Jäger, Jan-Erik Lundström, Ikuo Saito. East-West Photoconference II, Wroclaw (PL), 1991

Vom Verschwinden der Dinge aus der Fotografie / The Dissapearance of Things. Curated by Monika Faber. Catalog essays by Monika Faber, Susanne Neuburger. Österreichisches Fotoarchiv im Museum moderner Kunst, Vienna, 1992

LichtStücke: Vergegenwärtigung des Lichts. Curated by Ralf Filges. Catalog essay by Gottfried Jäger. Historisches Museum Bielefeld, 1993

Künstler mit der Kamera. Photographie als Experiment. Curated and catalog essay by Barbara Auer. Kunstverein Ludwigshafen am Rhein, 1994. Mannheim, 1994

László Moholy-Nagy: Idee und Wirkung. Anklänge an sein Werk in der zeitgenössischen Kunst. Gruppe Animato, Holzhäuser, Jäger, et al. Curated and catalog essays by Jutta Hülsewig-Johnen and Gottfried Jäger. Kunsthalle Bielefeld, 1995

László Moholy-Nagy. Fotogramme 1922–1943. Conception and organization: Ute Eskildsen, Museum Folkwang, Essen, and Alain Sayag, Centre Georges Pompidou, Paris. Catalog essays by Herbert Molderings, Floris M. Neusüss and Renate Heyne. Paris, Essen, 1996

Im Reich der Phantome. Fotografie des Unsichtbaren. Curated by Andreas Fischer and Veit Loers. Catalog essays by Veit Loers, Carl Aigner, Urs Stahel, et al. Städtisches Museum Mönchengladbach (D), Kunsthalle Krems (A), Fotomuseum Winterthur (CH). Ostfildern-Ruit, 1997

Lichtseiten. Die schönsten Bilder aus der Photographischen Sammlung der Berlinischen Galerie. Curated by Janos Frecot. Catalog essays by Janos Frecot, Jörn Merkert, Viola Vahrson. Berlinische Galerie, 1998, and other places in Germany and Austria, 1999–2000. Berlin, 1998

Abstrakt I–IV: Mina Mohandes (I), Kilian Breier (II), Inge Dick (III), Herwig Kempinger (IV). Editorial and Design: Susanne Gamauf. Catalog essays by Maren Lübbke, Lisa Spalt. Fotogalerie Wien. Fotobuch Nr. 23/1999. Vienna, 1999

Fotogene. Works of Breier, Klauke, Kupelwieser, Moscouw, Neusüss. Curator Walter Ebenhofer. Kunsthalle Steyr, 1999

Abstrakte Fotografie. Curated by Thomas Kellein and Angela Lampe. Catalog essays by Thomas Kellein, Angela Lampe, Gottfried Jäger. Kunsthalle Bielefeld, 2000–2001. Ostfildern-Ruit, 2000

This is [not] a photograph. Curated by Roger Sayre. Traveling group exhibition with Ellen Carey, Adam Fuss, and others. Catalog essays by Roger Sayre, A. D. Coleman. New York, 2001

Positionen der Farbfotografie: Die Abstraktion. Curated by Longest F. Stein. Catalog essay by Enno Kaufhold. Kunst und Medienzentrum Adlershof, Berlin, 2001

2 Theorie, Geschichte, Ästhetik Theory, History, Aesthetics Monografien Books 1952–2001

Baier, Wolfgang: *Quellendarstellungen zur Geschichte der Fotografie*. Halle/Saale, 1964

Barthes, Roland: *Die helle Kammer. Bemerkung zur Photographie*. Frankfurt am Main, 1989 (First published Paris, 1980)

Bourdieu, Pierre et al.: *Eine illegitime Kunst. Die sozialen Gebrauchsweisen der Photographie*. Frankfurt am Main, 1983 (First published Paris, 1965)

Coke, Van Deren: *The Painter and the Photographer: From Delacroix to Warhol*. Albuquerque, 1964; 2nd ed. 1970

Daval, Jean-Luc: *Photography. History of an Art*. Genf, 1982

Dress, Andreas; Jäger, Gottfried (Hg.): *Visualisierung in Mathematik, Technik und Kunst. Grundlagen und Anwendungen*. Braunschweig, Wiesbaden, 1999

Flusser, Vilém: *Für eine Philosophie der Fotografie*. Gottingen, 1983

Flusser, Vilém: *Standpunkte. Texte zur Fotografie*. Gottingen, 1998

Franke, Herbert W.: *Kunst und Konstruktion. Physik und Mathematik als fotografisches Experiment*. Munich, 1957

Franke, Herbert W.; Jäger, Gottfried: *Apparative Kunst. Vom Kaleidoskop zum Computer*. Cologne, 1975

Gernsheim, Helmut: *Creative Photography. Aesthetic Trends 1839–1960*. New York, 1962

Glüher, Gerhard: *Licht – Bild – Medium: Untersuchungen zur Fotografie am Bauhaus*. Berlin, 1994

Green, Jonathan (Ed.): *Camera Work. A Critical Anthology*. New York, 1973

Haus, Andreas: *Fotografie als Spenderin ornamentaler Sehweisen. Splitter zu einem Denkmosaik*. Drensteinfurt (Vipecker Raiphan), 1984

Honnef, Klaus: *Simulierte Wirklichkeit. Inszenierte Fotografie. Bemerkungen zur Paradoxie der fotografischen Bilder in der modernen Konsumgesellschaft*. In: *Kunstforum international*, Themenhefte No. 83, 84, 1986

International Center of Photography (ICP): *Encyclopedia of Photography*. New York, 1984

Jäger, Gottfried; Holzhäuser, Karl Martin: *Generative Fotografie. Theoretische Grundlegung, Kompendium und Beispiele einer fotografischen Bildgestaltung*. Ravensburg, 1975

Jäger, Gottfried: *Bildgebende Fotografie. Fotografik Lichtgrafik Lichtmalerei. Ursprünge, Konzepte und Spezifika einer Kunstform*. Cologne, 1988

Jäger, Gottfried: *Fotoästhetik. Zur Theorie der Fotografie. Texte aus den Jahren 1965 bis 1990*. Munich, 1991

Jäger, Gottfried; Wessing, Gudrun (Hg.): *über moholy-nagy. Ergebnisse aus dem Internationalen László Moholy-Nagy-Symposium, Bielefeld, 1995. Zum 100. Geburtstag des Künstlers und Bauhauslehrers*. Bielefeld, 1997

Jäger, Gottfried (Hg.): *Fotografie denken. Über Vilém Flussers Philosophie der Medienmoderne. Ergebnisse des 7. Internationalen Vilém Flusser-Symposiums, Bielefeld 1998*. Bielefeld, 2001

Jaguer, Edouard: *Surrealistische Photographie. Zwischen Traum und Wirklichkeit*. Cologne, 1982

Kahmen, Volker: *Fotografie als Kunst*. Tubingen, 1973

Kaufhold, Enno: *Bilder des Übergangs. Zur Mediengeschichte von Fotografie und Malerei in Deutschland um 1900*. Marburg, 1986

Koschatzky, Walter: *Die Kunst der Photographie. Technik, Geschichte, Meisterwerke*. Salzburg, Vienna, 1984 (2nd Ed. Munich, 1987)

Kracauer, Siegfried: *Theorie des Films. Die Errettung der äußeren Wirklichkeit*. Special chapter: Fotografie. Frankfurt am Main, 1964. First published New York, 1960

Krauss, Rolf H.: *Photographie als Medium. Zehn Thesen zur konventionellen und konzeptionellen Photographie*. First published Berlin, 1979; second edition Ostfildern, 1995

Krauss, Rolf H.: *Walter Benjamin und der neue Blick auf die Photographie*. Ostfildern bei Stuttgart, 1998

Lusk, Irene-Charlotte: *Montage ins Blaue. László Moholy-Nagy. Fotomontagen und -collagen 1922–1945*. Berlin, 1980

Moholy-Nagy, László: *Vision in Motion*. First edition New York, 1930. C. 1947 by Sibyl Moholy-Nagy. Chicago, 1969

Moholy-Nagy, László: *Malerei, Photographie, Film*. München 1925. (Bauhausbuch 8) Reprint Mainz, Berlin, 1967

Müller-Pohle, Andreas (Hg.): Die fotografische Dimension. Zeitgenössische Strategien in der Kunst. In: *Kunstforum international*, Themenheft No. 129, 1995

Neusüss, Floris, M. (Hg.): *Fotografie als Kunst – Kunst als Fotografie. Das Medium Fotografie in der bildenden Kunst Europas ab 1968*. Cologne, 1979

Newhall, Beaumont: *Geschichte der Photographie*. Munich, 1984
 (First edition New York, 1982)
Reeve, Catharine und Sward, Marilyn: *The New Photography. A
 Guide to the New Images, Processes, and Display Techniques
 for Photographers*. Englewood Cliffs, New Jersey, 1983
Ritchin, Fred: *In Our Own Image. The Coming Revolution in Photo-
 graphy*. New York, 1990
Rotzler, Willy: *Photographie als künstlerisches Experiment: Von
 Fox Talbot zu Moholy-Nagy*. Luzern, Frankfurt am Main, 1974
Sachs-Hombach, Klaus; Rehkämper, Klaus (Hg.): *Bildgrammatik*.
 Magdeburg, 1999
Schmoll gen. Eisenwerth, J. A.: *Vom Sinn der Photographie. Essays
 aus den Jahren 1952–1980*. Munich, 1980
Sontag, Susan: *Über Fotografie*. Munich, Vienna, 1978 (First edition
 On Photography, New York, 1977)
Steinert, Otto (Hg.): *Subjektive Fotografie. Ein Bildband moderner
 europäischer Fotografie*. Bonn, 1952
Steinert, Otto (Hg.): *Subjektive Fotografie 2. Ein Bildband moderner
 Fotografie*. Munich, 1955
Stelzer, Otto: *Kunst und Photographie. Kontakte Einflüsse Wirkun-
 gen*. Munich, 1966
Szarkowski, John: *Mirrors and Windows: American Photography
 since 1960*. New York, 1978
Wick, Rainer K.: *Das neue Sehen. Von der Fotografie am Bauhaus
 zur Subjektiven Fotografie*. München, 1991

3 Technik und Spezialgebiete Techniques and Special Areas
 Monografien Books 1954–1999

Ades, Dawn: *Photomontage: Photography as Propaganda*. New York,
 1976
Arnow, Jan: *Alternative Photographic Processes*. New York, 1982
Cordier, Pierre: *Chimigramme*. Exhibition catalog. Musées Royaux
 des Beaux-Arts de Belgique, Brussels, 1988
Drost, Wolfgang: Die Herausforderung des Fortschritts an die Kunst.
 Von der ›technischen‹ zur ›kreativen‹ Photoskulptur. In: *Fort-
 schrittsglaube und Dekadenzbewußtsein im Europa des 20.
 Jahrhunderts*. Heidelberg, 1986
Glassman, Elizabeth; Symmes, Marilyn F.: *Cliché-verre: Hand-Drawn,
 Light-Printed. A Survey of the Medium 1839 to the Present*.
 Exhibition catalog. The Detroit Institute of Arts. Detroit, 1980
Hammond, John H.: *The Camera Obscura, A Cronicle*. Bristol (GB),
 1981
Heidtmann, Frank: *Kunstphotographische Edeldruckverfahren
 Heute*. Berlin, 1978
Herzfelde, Wieland: *John Heartfield. Leben und Werk*. Dresden, 1971
 (2. Auflage)

Hiepe, Richard: *Die Fotomontage. Geschichte und Wesen einer
 Kunstform*. Exhibition catalog. Kunstverein Ingolstadt, 1969
Knodt, Robert; Pollmeier, Klaus: *Verfahren der Fotografie*. Exhibiti-
 on catalog. Fotografische Sammlung im Museum Folkwang,
 Essen, 1989
Krippner, Stanley; Rubin, Daniel: *Lichtbilder der Seele. PSI sichtbar
 gemacht. Alles über Kirlians Aurafotografie*. Munich, 1975
Münzberg, Diether: *Künstlerische Techniken (IV.): Die Fotografie*.
 Exhibition catalog. Essays by Diether Münzberg, Jutta Hülsewig-
 Johnen, Gottfried Jäger. Kunsthalle Bielefeld, 1989
Mutter, Edwin: *Kompendium der Photographie Bd. I. (Grundlagen),
 Bd. II. (Negativ-, Diapositiv- und Umkehrverfahren), Bd. III.
 (Positivverfahren)*. Berlin-Borsigwalde, 1957–1963
Nadeau, Luis: *History and Practice of Oil and Bromoil Printing /
 History and Practice of Carbon Processes / History and Practice
 of Platinum Printing*. Frederictown, New Brunswick (CAN), self
 editing, o. D. (vor 1984)
Neusüss, Floris, M. (Hg.): *Das Fotogramm in der Kunst des 20. Jahr-
 hunderts. Die andere Seite der Bilder. Fotografie ohne Kamera*.
 Cologne, 1990
Reilly, James M.: *The Albumen & Salted Paper Book. The History
 and Practice of Photographic Printing 1840–1895*. Rochester,
 1980
Renner, Eric: *Pinhole Photography. Rediscovering a Historic Techni-
 que*. Boston/London, 1995
Reumuth, Horst: *Wunder der Mikrowelt*. Stuttgart, 1954
Schad, Nikolaus; Auer, Anna: *Schadographien. Die Kraft des Lichts*.
 Introduction: L. Fritz Gruber. Passau, 1999
Schnelle-Schneyder, Marlene: *Photographie und Wahrnehmung am
 Beispiel der Bewegungsdarstellung im 19. Jahrhundert*. Mar-
 burg, 1990
Schmidt, Marjen: *Fotografien in Museen, Archiven, Sammlungen.
 Konservieren, Archivieren, Präsentieren*. Special: Verfahren der
 Fotografie (Photographic techniques and processes). Munich,
 1994
Smith, Lauren: *The Visionary Pinhole*. Salt Lake City, 1985
Strüwe, Carl: *Formen des Mikrokosmos. Gestalt und Gestaltung
 einer Bilderwelt*. Munich, 1955
Urbons, Klaus: *Elektrofotografie. Analoge und digitale Bilder*. Colo-
 gne, 1994
Wade, Kent E.: *Alternative Photographic Processes. A Ressource
 Manual for the Artist, Photographer, Craftsperson*. New York,
 1978

Sachregister

Kursiv = Titel

Abbildung 11
Abbildungstreue 11
Abdruck 278
Absolute
 Fotografie 13
 Malerei 270
 Kunst 116f.
Abstraction-Création 214
Abstrahierende Fotografie 282
Abstrakte
 Fotografie 1ff., 298
 Grafik 7
 Kamerafotografie 20, 298
 Kunst 7, 95
 Malerei 216, 270, 276
 Skulptur 7
 Tendenzen 142
Abstrakter Film 7
Abstraktes Bild 214
Abstraktion 13, 26, 33, 215, 222, 266
Abstraktion
 biomorphe 216
 fotografische 22
 geometrische 216
 konkrete 198
 totale 117, 125, 128
Abstraktions-
 begriff 281
 drang 13
Abzug 291
Acrylglas 297
Ähnlichkeit 76, 94
Albumin 289f.
All-Over 185ff.
Alcubond 297
Aludibond 297
Ambivalenz 193
Ammoniumbichromat 114
Analytische
 Fotografie 28, 299
 Tendenz 16

Animationsfilm 296
Angewandte Fotografie 148
Anthroposophie 103
Anzeichen 16, 34
Apparat 11
Äquidensiten 33
Arbeiterfotograf 150
Arbeiter Illustrirte Zeitung 150
Art Déco 146
Ästhetik der Fotografie 8, 22
Ästhetik
 exakte 26
 formale 90
 futuristische 164
 generative 27
 kybernetische 26
 numerische 26
Astrofotografie 268, 279, 287
Aurafotografie 295
Auskopieremulsion 290
Automatisches Schreiben 19
Autopoiesis 34, 299

Barytpapier 4, 290
Bauhaus 19, 145, 298
Berichtende Fotografie 30
Bewegungsdarstellung 18, 164, 287f.
Bielefelder Schule 171
Bild
 digitales 284
 latentes 286f., 288
Bild-
 analyse 29
 arten 35
 aussage 11
 bearbeitung 29, 293
 begriff 7
 cluster 29
 erfahrung 11
 erfindung 11
 erzeugung 13
 forschung 8
 montage 222
 realität 7
 reihentechnik 27
 rolle 189
 skepsis 8

 stile 35
 struktur 11
 synthese 29
 theorie 8
 wissenschaft 8
 ziele 35
Bildgebende
 Fotografie 13
 Verfahren 12, 21, 33, 195, 201
Bildmäßige Fotografie 17, 95f., 163
Billigkamera 30
Belichtung
 intermittierende 36, 288
 kontinuierliche 36, 287
Bewegungsunschärfe 224
BLAST 169
Braunkohlentagebau 200
Bromöldruck 142, 146, 154, 294, 298

Camera obscura 19, 82, 287
Camera Work 21, 131, 259
Canto(s) 175, 188
Carbrodruck 294
Champs délicieux 112, 143, 298
Chemigramm 19, 34, 55, 72, 289, 299
Chicagoer Schule 21
Chromogene Entwicklung 291, 297, 299
Chronofotografie 164, 166, 133, 277, 287, 298
Cibachrome® 292
Cinegramm 288, 298
Clavilux 129, 132
Cliché
 cellophane 292
 verre 19f., 82, 86, 292
Computer-
 foto 71, 283, 299
 grafik 27
 kunst 28
Chronofotografie 164, 268, 279
Copy Art 295, 299
Cyanotypie 19, 290, 294, 298

Dada 19
Daguerreotypie 289, 295
Darstellende Fotografie 22
De Stijl 260

Subject Index

Italics = as title

Absolute
 Art 116
 Painting 269
 Photography 13
Abstract
 Art 7, 95
 Cinema 7
 Camera Photography 20, 298
 Tendencies 142
 Painting 7, 216, 269
 Photography 1ff., 298
 Sculpture 7
Abstraction 215, 222, 266
Abstraction
 Biomorphic 216
 Concrete 198
 Geometric 216
 Total 117, 124f.
Abstraction-Création 214
Acrylic glass 297
Advertising Photography 140, 146
Aesthetic Photography 75
Aesthetics
 Cybernetic 26
 Exact 27
 Generative 27, 226
 Information 27
 Numerical 27
Aesthetic of Photography 8
Agnosticism 120
Albumen Process 289f.
Alchemy 103
Alcubond 297
All-over 184f.
Aludibond 297
Ambivalence 189
Ammonium Bichromate 114
Analytical
 Photography 28, 299
 Tendency 16
Anthroposophy 103
Apparatus 11

Applied Photography 148
Art
 Absolute 116
 Abstract 7, 95
 Banned 25
 Concrete 226f.
 Constructive 27
 Degenerate 25
 Non-Objective 116, 119
 Object 96
Art
 Déco 143, 145
 Photography 12
Astrophotography 268, 279, 287
Aura-Photography 295
Automatic Writing 19
Autopoietic Photography 299

Banned Art 25
Baryta Paper 4, 290
Bauhaus 19, 145, 286, 298
Bielefeld School 170
Bird's-Eye View 202
BLAST 167
Blurring 33, 187
Bromoil Print 142, 145, 154, 294, 298
Brown coal open-cast mining 200

Cabbala 103
Calotype 290
Camera Obscura 19, 32, 82, 287
Camera Photography 20, 28, 67, 280
Camera, Virtual 32, 71
Cameraless Photography 20, 48, 82, 281, 286, 289
Camera Work 21, 129, 259
Cameraless Photography
Canto(s) 174, 182, 185
Carbon Print 294
Central Commission for Photography (GDR) 25
Champs délicieux 112, 143, 298
Chemigram 19, 28, 34, 55, 72, 289
Chicago School 21
Cinematograph 287, 298
Chinese Scrolls 189
Chromogenic (Development) Process 291, 299

Chronophotography 164, 131, 268, 279, 277, 287, 298
Cibachrome® 292
Cinegram 288
Cinematography 18, 20, 287
Clavilux 128f.
Cliché-
 Cellophan 292
 Verre 19, 32, 49, 82, 86, 292
Close up 33
Collodion Process 289
Color
 Coupler (C-)Print 291f., 296f.
 Photography 291
 Music 131
 Organ 111, 114, 128ff.
Computer-
 Aided Production 27
 Graphics 27
 Photography 299
Concept Art 299
Conceptual Photography 29, 299
Concrete
 Abstraction 198
 Art 226f.
 Painting 229
 Photography 13, 34, 96, 298
Construction 222
Constructive
 Art 27
 Photography 34, 298
Constructivism 144, 147, 216
Contemplation 222
Continuous Exposure 287
Contra-Vision 16
Conventional Photography 30
Copy Art 295, 299
Corona-Photography
Cosmic Imagery 105
Countervision 16
Creative Photography 75
Creativeness 7
Crystal 171, 174, 202
Cubism 144f., 165, 178, 184, 189, 259, 279f.
Cyanotype 19, 290, 294, 298
Cybernetic Aestetics 26

Deutsche Gesellschaft für Photographie
(DGPh) 18, 35, 317
Diagonalkomposition 148
Diaphane Collage 292
Diasec 225, 230, 238f., 246f., 250, 297,
Dibond 297
Digitale
　Fotografie 281, 295f., 299
　Druckverfahren 296
Digitales Bild 284
Digitalisierung 266, 278, 281
Dokumentarfotografie 22, 28, 265
Dokumentarismus 21
Doppelbelichtung 142
Drittes Reich 34
Druid 121
Dualität 105
Dunkelkammer 19, 164, 220
Duraflex® 297
Dye Transfer® 292, 299

Edeldruckverfahren 12, 292
Einfühlungsdrang 13
Elektrofotografie 295
Elektronenstrahl 196
Elektronische Bildbearbeitung 29
Elementarfotografie 28, 299
Entartete Kunst 25
Entscheidender Augenblick 29
Entwicklung, chromogene 291
Entwicklungsemulsion 290, 293
Equivalents 21, 298
Erweiterte Fotografie 30
Esoterik 103
Exakte Ästhetik 26
Experimentalfotografie 16
Experimentelle
　Fotografie 13, 18, 25, 33, 31
　Medienreflexion 16, 28, 299
Expressionismus 280
Expressionismus,
　abstrakter 224

Faktur 34, 227
Falschfarbenfilm 33
Farb-
　fotografie 229

fotomaterial 291
orgel 111
Farm Security Administration (FSA) 150
Film und Foto 261
Fixierflüssigkeit
Fixierung 81
Fließbild 81
Flimmern 34
Flinte, fotografische 164, 287
Fluidalfotografie 93, 108
Flüssigemulsion 20
Formale Ästhetik 90
Formalismus 22
foto-auge 25, 261
Fotochemische Gestaltung 288
Fotodinamismo Futurista 131ff., 298
fotoform 24f., 299
Fotogene Kunst 13
Fotogenische Zeichnung 286
fotografia buffa 295
Fotografie,
　abbildungstreue 29
　absolute 13, 116
　abstrahierende 282
　abstrakte 1ff.
　analytische 28, 299
　angewandte 148
　berichtende 30
　bildanalytische 28
　bildgebende 13
　bildmäßige 17, 95f.
　darstellende 22
　digitale 281, 295f., 299
　dokumentarische 22, 265
　elementare 28, 299
　emotive 149
　erweiterte 30, 299
　experimentelle 13, 18ff., 25, 31, 33
　generative 16, 26, 34, 91, 96, 171, 265,
　　274ff., 299
　gestaltende 33
　kameralose 20, 82, 282, 286, 289
　konkrete 13, 25, 34, 96, 298
　konstruktive 34, 298
　konventionelle 30
　künstlerische 75, 260
　neue 25

neusachliche 35
objektive 12
politische 75
realistische 29
reine 35
serielle 299
strukturelle 274
subjektive 12, 25, 261, 299
surrealistische 148ff., 298
ungegenständliche 22, 298
virtuelle 71, 299
wissenschaftliche 268
fotografie elementar 28, 299
Foto-
aktion 32, 92, 294f., 299
animation 296, 299
assemblage 20, 32
ästhetik 13, 91
collage 12, 188, 293f., 298
galvano 295
grafik 13, 33, 274, 292f.
gramm 7, 19, 34, 63, 112, 142f., 219,
　260, 270ff., 286, 289, 291f., 298
gravur/gravüre 166f.295, 298
installation 4, 32, 93, 294, 299
inszenierung 294f.
kopie 295
laser 299
montage 12, 19, 29, 146, 188, 292f.,
　298
multiplier 196
objekt 294
performance 92, 294f., 299
plastik 19f., 294, 298
relief 20, 294
sequenz 29, 299
simulation 283, 296, 299
sgraffito 66
skulptur 294
tableau 58
typografie 148
übermalung 12
Foto-Grafische Gestaltung 292ff.
Fotomechanische Transformation 28, 56
Fotoelektrische Gestaltung 295
Fotoelektronische Gestaltung 295
Fotooptische Gestaltung 287

Dadaism 19
Daguerreotype 289, 295
Darkroom 19, 164, 220, 287
Decisive Moment 29
Degenerate Art 25
Depth of Focus 197, 199
Developing Emulsion 290
Diagonal Composition 147
Diaphanous Collage 292
Diasec 225, 230, 238f., 246f., 250
Dibond 297
Digital
 Camera 71, 295f.
 Image 284, 296
 Photography 280, 295, 299
Digitalization 266, 278, 280
Diffusion Filter 224
Disturbance 34
Documentary Photography 22, 28, 265
Double Exposure 142
Druid 120
Drypoint Engraving 292
Duality 105
Duraflex Print® 297
Dust 34
Dye Diffusion Transfer Process 291, 299
Dye Imbibition Transfer Process/Dye
 Transfer® 292, 299

Eddy 168
Edge Effect 197
Emotive Photography 148
Electron Ray 196
Electrophotography 295, 298
Electroworks 295, 299
Elemental Photography 299
Equidensity Photography
Equivalents 21, 44f., 298
Esoteric 103
Essay, photographic 30
Exact Aesthetics 27
Experimental
 Media Reflection 16, 28, 299
 Photography 19, 25, 298
Expressionism 224, 279f.
Extended Photography 30, 299

Factura 227
Fax Machine 187
Film Animation 296
Fine Art Print 32, 290, 292
Flickering 34
Fluid
 Emulsion 20
 Picture 81
Fluidal Photography 93, 108
Flux Picture 81
Formalism 22
Fotodinamismo Futurista 131, 298
fotoform 24f., 299
fotografia buffa 295
fotografie elementar 28
Fourth Dimension 103, 128f.
Freemasonry 103, 120
Futurism 18, 144, 164, 169, 178, 279f.

Gelatin Silver
 Baryta Paper 4ff., 288
 Painting 263f., 271f.
 Print 4ff.
Generative
 Aestethics 226
 Computergraphic 27
 Photography 16, 26f., 34, 91, 96, 170,
 265, 299
 System 28
 Tendency 16, 26f.
Gray Scale 96, 100f.
Gum Bichromate Print 110, 294, 298
Gum Platinum Print 15, 294

Haiku 175
Heliogravure 271, 298
High-
 Frequency Photography 33, 288
 Speed Photography 18, 33
 Voltage Photography 19
Hybrid Techniques 20, 195
Hyper Media 299

Icon 34
Ideogramm 177
Ilfochrome® 292
Image 175ff.

Image, digital 284
Image-
 giving 13
 making 195
 taking 13
Imaginism 175
Imago 196
Imprint 277
Indexical Sign 34
Indice 34
Information Aestetics 27
Intermittent Exposure 36, 288
Internal Dye Diffusion Transfer Process
 291f.
Inkjet Print 4, 68
Introspection 222
Impressionism 143, 169
Information Aesthetics 27
Iris-(Giclée-) Print® 224, 244f., 296

Kaleidoscope 124
Kirlian-Photography 295
Kunsthalle Bielefeld 7

Lambda Print® 286, 297
Laser Light 19
Latent Image 286f.
Light-
 Box 298
 Composition 269f.
 Design 223, 227, 286
 Drawing 293, 298
 Diffraction 223
 Graphics 25, 87, 223, 293
 Microscope 196, 288
 Modulator 298
 Painting 69, 293, 298
 Pen 270, 293
 Pendulum 274
 Pure 270
 Reflection 223, 294
 Refraction 223
 Sensitive Textiles 20
 Sculpture 294
 Space 271
Liquid Light® 20
Left Front (Group) 149

Fotoräumliche Gestaltung 294
Freimaurertum 103, 121
Froschperspektive 141
Futurismus 18, 34, 145, 169, 179f.

Gedankenfotografie 107
Gegenstandslose Kunst 120
Gegenstandslosigkeit 103, 122, 128
Gelatine 288f., 293
Generative
 Ästhetik 27
 Comptergrafik 27
 Fotografie 16, 26, 34, 91, 96, 171, 265,
 274
 Tendenzen 16, 25
Generatives System 28
Geometrie, heilige 105
Gestaltende Fotografie 33
Graukeil 96f., 100f.
Gummidruck 110, 113, 294, 298

Heilige Geometrie 105
Heliografie 274, 298
Hermetik 103
Hochspannungs-Fotogramm 19
Hochfrequenzfotografie 33, 288
Hybridverfahren 195

Ikon 34
Ilfochrome® 292
Indiz 16, 34
Informationsästhetik 26
Inkjet-Print 296
Intermittierende Belichtung 36, 288
Introspektion 222
Image 177
Imago 196
Imaginismus 176
Impressionismus 144, 169
Iris (Giclée) Print® 224, 244f., 296

Jugendstil 144

Kabbala 103
Kaleidoskop 124
Kaliumbichromat 114
Kalotypie 290

Kamera, virtuelle 32, 71
Kamerafotografie 20, 67, 280
Kameralose
 Fotografie 20, 282, 286
 Lichtbilder 214
Kanteneffekt 197
Kieselalgen 202
Kinematografie 18, 20, 287
Kirlianfotografie 295
Kollodiumverfahren 289
Kombinationsgummidruck 114
Konkrete
 Fotografie 13, 25, 34, 96, 298
 Kunst 226f., 266
 Malerei 229
Konstruktion 222
Konstruktive Fotografie 33, 298
Konstruktivismus 34, 145, 148f., 217
Kontinuierliche Belichtung 71, 287
Kontravision 16
Konventionelle Fotografie 30
Konzeptfotografie 29, 299
Koronafotografie 295
Kreativität 7
Kubismus 145f., 165, 179, 185, 259, 280
Kunst
 absolute 116f.
 abstrakte 7, 95
 entartete 25
 fotogene 13
 gegenstandslose 120
 konkrete 226f., 266
 kybernetische 226
 moderne 103
 verfemte 25
Kunstfotografie 12, 170
Künstlerische Fotografie 75, 260, 298
Kurzzeitfotografie 18, 33
Kybernetische
 Ästhetik 26
 Kunst 226

Lambda Print® 297
Langzeitaufnahme 225
Laserlicht 19
Latentes Bild 286, 288

Licht-
 aggregat 293
 beugung 223
 energie 270
 gestaltung 223, 227, 286
 grafik 13, 25, 87, 223, 293
 komposition 269ff.
 malerei 13, 69, 293, 298
 modulation 223, 298
 mikroskop 196, 288
 pendel 274
 raum 270
 reflex 223
 schrift 270
 spur 18, 33, 81
 zeichnung 293, 298
Lichtbildkunst 110, 116
Liquid Light® 20
Lochblendenstruktur 28, 57, 78, 82
Lochkamera 225, 287, 299
Lomografie 30, 299
Luminogramm 4, 34, 50ff., 86, 94, 98,
 286, 289, 291f., 299
Luzidogramm 292, 299

Magische Kanäle 184
Makro-
 fotografie 20, 268
 kosmos 175, 198
Malerei
 abstrakte 7, 216, 270, 276
 absolute 270
 konkrete 229
 philosophische 277
Mandala 134, 136
Materialismus 103, 222
Medien-
 analyse 29
 reflexion 16, 28f.
Medium Fotografie 21, 29f, 91, 145, 282
Mehrfachbelichtung 20, 33, 56, 128, 133
Metaphorik 105
Mikro-
 fotografie 18, 33, 195ff., 268, 288
 kosmos 21, 195ff., 287
 motor 195
 turbine 195f.

Lensless Photography 19f.
Lomography 30, 299
Longtime Exposure 225
Lucidogram 292
Luminogram 4, 28, 34, 50ff., 86, 286,
 289, 291f.

Mandala 133f.
Macro Cosmos 198
Macro Photography 268, 268
Materialism 103, 222
Medium
 Analysis 29
 Photography 29f., 91, 281
 Reflection 29
Micro-
 cosmos 21, 195ff.
 motor 195
 photography 33, 195ff., 268, 287f.
 scope 199, 288, 298
 turbine 195
Mimesis 220
Mixed Media 299
Modernity 103
Monism 115
Monochromy 229
Motography 287
Moving-Image 177
Multimedia Performance 71
Multiple Exposure 20, 33, 56, 125, 132
Mysticism 222

Naturalism 169
Negativ-Montage 20, 75
Neo-Plasticism 144, 294
New
 Bauhaus 21, 298
 Objectivity 146
 Photography 22
Non-Objective
 Art 119
 Photography 12, 22, 121
Numerical Aesthetics 27

Objective
 Art 81
 Photography 281

Objet trouvé 149
Objective Photography 12
Octopus 102, 122
Occultism 103
Oil Print 294
One-Image-Poem 176
Ornamenting Technique 114
Ornamentation 103

Painting, Abstract 7, 216
Palladiotype 290
Panoramic Photography 70
Performance 20
Perspective 11
Phantom Picture 221
Phase Photography 288
Philosophy of Photography 16, 35
Photo-
 action 4, 32, 92, 294, 299
 aesthetic 91
 animation 296, 299
 assemblage 20, 32
 composition
 collage 12f., 147, 187, 293, 298
 copy 295
 galvano 295
 genic 13, 63, 286
 graphics 33, 292f.
 gram 19, 34, 39, 112, 144, 146, 219,
 277, 269ff., 286, 289, 291, 298
 gravure 42, 295, 298
 installation 4, 32, 50, 58, 93, 294,
 299
 laser 299
 media 299
 micrography 18
 montage 29, 147, 185, 292f., 298
 multiplier 197
 object 294
 plastic 19f., 294, 298
 performance 93, 294f., 299
 relief 20
 sculpture 20
 sequence 29
 sgraffito 66
 simulation 296, 299
 tableau 58

 typography 147
Photochemical Design 288
Photoelectric Design 295
Photoelectronic Design 295
Photogenic Drawing 14, 19, 286
Photographic
 Abstraction 22
 Essay 30
Photo-Graphic Design 292
Photography
 Absolute 13
 Abstract 1ff.
 Advertising 146ff.
 Aesthetic 75
 Analytical 28, 299
 Applied 148
 Cameraless 20, 82, 281, 286, 289
 Conceptual 29
 Concrete 13, 34, 96, 298
 Constructive 34, 298
 Conventional 30
 Creative 75
 Digital 280, 295, 299
 Documentary 22, 28, 265
 Emotive 148
 Experimental 18ff., 25, 298
 Extended 30, 299
 Generative 16, 26f., 34, 96, 265, 271,
 299
 Journalistic 275
 Lensless 19f.
 New 25, 298
 Non-Objective 12, 22, 121
 Pictorial 12, 95, 123
 Presentational 22
 Realistic 275
 Serial 299
 Subjective 12, 25, 299
 Structural 274
 Surrealistic 16, 298
 Virtual 299
photokina® 30
Photo-Mechanical Transformation 28, 56
Photo-Optical Design 287
Photoshop® 20, 224, 293
Photospacial Design 294f.
Pictogram 169

Mikroskop 199, 298
Mimesis 220
Moderne, Die 103, 163
Moderne Kunst 103
Monismus 115
Monochromie 229
Motografie 287
Multimedia Performance 71
Mystik 103
Mystizismus 222

Nahaufnahme 33
Naturalismus 169
Naturwissenschaftliche Fotografie 268
Negativ 79
Negativmontage 20
Neoplastizismus 145, 294
Neue
 Fotografie 24
 Sachlichkeit 21, 147
Neues Sehen 24, 298
Neusachliche Fotografie 35, 298
New Bauhaus 21, 298
Numerische Ästhetik 26

Objekt Fotografie 282
Objektive Fotografie 12
Objektkunst 81, 96f.
Objet trouvé 149
Octopus 102, 122
Okkultismus 103
Öldruck 294
Ornamentierverfahren 114
Ornamentik 103

Palladiotypie 290
Panoramafotografie 70
PE-Papier 290
Performance 20
Perspektive 11, 287
Phantombild 35, 221
Phasenfotografie
Philosophie der Fotografie 16, 35
Philosophische Malerei 277
Photo Secession 21
Photoshop® 20, 224, 293
Photo League 150

Pigmentdruck 158, 294
Piktogramm 169
Piktoralismus 12, 144, 298
Platindruck/Platinotypie 290, 294, 298
Plexiglas® 297
Pluralismus 214
Pointillismus 18
Polaroid® 184, 188, 292, 299
Politische Fotografie 75
Positivismus 103
Postfotografische Entwicklung 16, 29
Postmoderne 214, 222
Präsentat 16
Präsentationstechnik 297
Prisma 123, 174, 189, 223
Programmierung des Schönen 27

Quantentheorie 185

Radiolarien 201
Rapportier-
 apparat 113
 kassette 114
Raster-
 elektronenmikroskop (REM) 21,
 194ff., 288, 299
 projektion 226
Rauschen 34
Rayografie 19, 142, 277, 298
Realismus 181, 198, 215, 274
Realismus, sozialistischer 22, 25
Realistische Fotografie 29
Ready-made 283
Reflektorische Lichtspiele 111, 132
Reine Fotografie 35
Relativitätstheorie 131
Renaissance 170
Repräsentat 16
Röntgen-
 fotografie 33, 268, 279, 298
 strahlung 19, 165
Rosenkreuzertum 103, 121

Salzpapier 289
Scanachrome® 296
Scannen 296
Schadografie 19, 298

Schärfentiefe 197, 199
Schicht, lichtempfindiche 286
Schlierenfotografie 18, 33
Schlitzblende 225
Schnappschuß 29
Schönheit 13
Seismogramm 224
Selbst-
 bild 16
 darstellung, -erkundung 16
 referenz 270
 reflexion 84, 265
Sichtbarkeit 8, 16, 33, 90ff., 195
Silber-
 farbausbleich-Verfahren 291, 299
 farbdiffusions-Verfahren 291f.
 gelatine-Barytpapier 4ff. 290
 gelatine-Malerei 263f, 274
 halogenide/s Salz/e 288f., 293
Sinnbild 12, 34
Skeptizismus 103
Skulptur, abstrakte 7
Solarisation 20, 33, 197, 293, 298
Songs of the Sky 21
Sozialfotografie 141, 150f.
Sozialistischer Realismus 22, 25
Spermologischer Stil 168
Spiritismus 103, 269
Spur(-fotografie) 221, 287
Stereo-
 mikroskop 198
 skop 189
Stilpsychologie 13
Straight Photography 21, 259, 298
Strobo-
 blitz 288, 298
 fotografie 18, 288
 kamera 288
Strömungbild 81
Strukturbild 12, 34
Strukturelle Fotografie 274
Subjektive Fotografie 12, 25, 299
Suprematismus 280
Surrealismus 34, 147ff.
Surrealistische Fotografie 19, 298
Symbol 34, 176, 136, 201
Symbolik 222

Pictoralism 12, 143
Pictorial
 Photography 12, 95, 123, 298
 Reality 7
 Terminology 7
Pigment Print 158, 294
Pinhole Structure 28, 57, 78, 82
Pinhole
 Camera 225, 287, 299
 Diaphragm 287
Platinotype/Platinum Print 42
Plexiglass® 297
Plurality 214
Pointillism 18
Polaroid® 183ff., 292, 299
Political Photography
Polyethylene-coated (PE-)Paper 290
Positivism 103
Postmodernism 214ff., 222
Post-Photographic Development 16f., 29
Potassium Bichromate 114, 290
Presentational Photography 22
Print 291
Print(ing)-Out Emulsion
Prism 122, 171, 187, 223

Radiolaria 201
Raster Projection 226
Rayograph 19, 38, 277, 298
Resin-coated (RC-)Paper 290
Ready-made 283
Realism 179, 198, 215
Realism, socialist 24
Relativity, Theory of 129, 189
Renaissance 170, 287
Rosicrucianism 103

Sacred Geometry 105
Scanachrome® 296
Scanning Electron Microscope (SEM) 21,
 194ff., 288, 299
Schadograph 19, 298
Schlieren Photography 18, 33
Scintillator 197
Scepticism 103
Scrolls, Chinese 189
Seismogramm 224

Self-
 Introspection 16
 Production 12
 Referenciality 270, 281
 Reflection 84, 265
 Representation 286
Serial Photography 299
Sign 175
Silver
 Dye Bleach Process 291, 299
 Halide/Salts 288, 290
Similarity 76
Slit Photography 225, 288
Snap Shot 29
Songs of the Sky 21
Social Photography 141, 149f.
Socialist Realism 24
Solarization 20, 33, 197, 293, 298
Solar Photogram 10
Spiritualism 103, 268
Stage Photography 295
Stereo-
 microscope 198
 scope/camera 188
Straight Photography 21, 259, 298
Strobo-
 flash Photography 288
 scope 18, 288, 298
Structural Photography 274
Structure 34
Subjective Photography 12, 25, 299
Suprematism 279f.
Surrealism 148ff.
Surrealistic Method Photography 16, 298
Symbol 34, 134, 175, 202, 222
Symbolism 12, 145, 298
Symptom 34
Synaesthesia 105
Syntax 34
System, generative 28

Talbotype 290
Taoism 103, 125
Telepathy 118
Tendency
 Analytical 16
 Generative 16, 27

Theosophy 103, 116, 268
Thermo Photography 18, 33, 221
Time Exposure 130, 298
Tone
 Reversal 20, 33
 Separation 20, 293, 298
Total Abstraction 117, 124
Transcendence 268
Two Cultures 26
Typography 169
Typophoto 293, 298

Ultrasound 201
Uncertainty
 Principle 183, 185
 Relation 185, 189
Understanding Media 183
Unique Print 286, 291
Upanishad 115, 120, 125

Vanishing Presence 31, 299
Verifiches/Verifications 29
Vibration 105f., 116, 119
Videogram 226
Virtual Camera Photography 32, 71, 299
Visibility 34, 195
Visualistic 8
Visualistic Photography 28f.
Visualism 28, 299
Visualization 8, 34
Vortex 168, 188
Vorticism 18, 123f., 163ff.
Vortograph 17, 123f., 127f. 162ff., 298
Vortoscope 123

Whirl 168
Worm's-Eye View 140

Xerocopy 295, 299
X-Ray 33, 164, 268, 279, 298

Zen-Buddhism 103
Život 139, 143, 152

Symbolismus 12, 146, 298
Symptom 16, 34
Synästhesie 105f.
Syntax 34
System, generatives 28
Szintillator 196

Talbotypie 290
Taoismus 103, 128
Telepathie 119
Tendenzen
 abstrakte 142
 analytische 16
 generative 16
Theosophie 103, 116, 269
Thermofotografie 18, 33
Tintenstrahldruck 4
Tontrennung 20, 293, 298
Tonwertumkehrung 20, 33
Totale Abstraktion 125
Transzendenz 269
Trickfilm 296
Typo-
 foto 293, 298
 grafie 169

Ultraschall 198, 201
Ungegenständliche Fotografie 22, 299
Ungegenständliches Lichtbild 214
Unikat 286, 291
Unschärfe 189
Unschärferelation 185, 187ff.
Upanishaden 114, 120

Vanishing/Presence 30
Verfahren, bildgebende 33
Verfemte Kunst 25
Verifiches/Verifications 29
Vibration 103, 106, 116, 119f.
Videogramm 226
Vierte Dimension 103, 129, 131f.
Virtuelle
 Fotografie 71, 299
 Kamera 32, 71
Visualisierung 8, 33
Visualismus 28
Visualistik 8

Vogelperspektive 202
Vortex 168, 192
Vortizismus 18, 34, 124, 163ff.
Vortografie 17, 124, 163ff., 260, 298
Vortoskop 124

Weichzeichner 224
Werbefotografie 140, 147f.
Wirbel 168, 182

Xerokopie 295, 299

Zeichen 89ff., 176, 183
Zeichnung, fotogenische 286
Zen-Buddhismus 103
Zentrale Kommission Fotografie (DDR)
 25
Zielfotografie 288
Život 139, 143, 152
Zwei Kulturen 26

Personenregister Index of Names

Fett gedruckte Seitenzahlen verweisen
auf Abbildungen Page references in **bold
face** refer to illustrations

Ades, Dawn 293
Aigner, Carl 32
Altschul, Pavel 141
Amelunxen, Hubertus von 29, 31
Anděl, Jaroslav 141
Animato (Group) **71**
Arbuthnot, Malcolm 122
Aristoteles 287
Arnold, Burkhard 249
Arnow, Jan 290
Atget, Eugène 148f.
Atkins, Anna 19
Auer, Anna 19, 30, 299
Aventin (Trio) 141

Baier, Wolfgang 11, 286f.
Balla, Giacomo 17
Bally, Théodore 22, **23**
Baraduc, Hippolyt 107, **109**
Bartuška, Josef 141
Baudelaire, Charles 11
Bayer, Herbert 145f.
Becher, Bernd and Hilla 198, 264f.
Beiler, Berthold 22
Benjamin, Walter 188, 192
Bense, Max 27, 226
Berka, Ladislav Emil 141
Besant, Anni 105, 107f.
BIKLA (School) 264
Bill, Max 105, 226
Binder, Walter 216
Birgus, Darina 161
Birgus, Vladimír 3, 139, 161, 259
Bleckner, Ross 216
Blossfeldt, Karl 20f., 201, **206f.**, 265
Boccioni, Umberto 164f.
Bogner, Manfred **66**
Boleslav, Mladá 141
Bollans, Susan 4

Bragaglia, Arturo **130**, 131ff.
Bragaglia, Antonio Guilio 131ff., 298
Brand, Bill (and Noya) 149f., 184, 186
Brassaï 263
Braun, Marta 133
Breier, Kilian 27f., **54**
Breton, André 148f.
Breuer, Marco 220, **236f.**
Brudna, Denis 202
Bruguière, Francis Joseph 103, 124ff., 125,
 128, **130**, 131ff., 134, **135**, 137, 142f., 144f.
Bry, Doris 21
Buddha 120
Bunnell, Peter C. 259
Busoni, Ferruccio 165

Callahan, Harry 21, **47**
Calvesi, Maurizio 18
Carlsson, Chester F. 295
Cartier-Bresson, Henri 29, 263
Carpenter, Edward 118ff.
Cézanne, Paul 259
Chalupa, Resl 141
Chargesheimer (Karl Heinz Hargesheimer)
 261, **262**, 271f.
Cheney, Sheldon 132
Chochola, Václav 149f.
Chopin, Frédéric 169
Clausberg, Karl 189
Coburn, Alvin Langdon 7, 17f., 73, 78, 80,
 94f., **102f.**, 117ff., 125, **126f.**, 142, **162ff.**,
 166f., **172f.**, 259f., 298
Cohen, Alfred 142ff.
Compton, Susan 168
Cordier, Pierre 27f. **55**, **72**, 289
Cork, Richard 124, 163
Cremer Wolfgang 29

Darget, Louis 107, **108**
Dašek, Josef 141
Davies, Thomas Landon 20
Dawid (Björn Dawidsson) 31f.
Delaunay, Sonja 17, 144f.
Delaunay, Robert 17, 144f.
Deleuze, Gilles 181, 192
Deppner, Martin Roman 3, 163
Devětsil (Group) 139

Dibbets, Jan **58**
Dick, Inge 228, **252f.**, 283, **284**
DiFederico, Frank 125
Dolezal, Stanislav 146
Doesburg, Theo van 144f., 294
Dress, Andreas 11, 88
Drost, Wolfgang 294
Drtikol, František 139, 144ff., **158**
Družstevni (publ. house) 147
Dubreuil, Pierre 143
Dufek, Antonín 139, 141
Dürer, Albrecht 287

Edgerton, Harold E. 288
Edwards, Paul 169
Ehm, Josef 140f., 147f.
Einstein, Albert 129, 131
Eisenstein, Sergej 177f.
Eliot, Thomas Stearns (T. S.) 163f., 176,
 183f., 185, 187f.
Elkins, James 221
Enyart, James 125, 128f., 131ff., 134
Epstein, Jacob 123f., 165
Ernst, Max 148f.
Eskildsen, Ute 139
Evers, Winfried 222, **240f.**

Faber, Monika 31, 216
Fährenkemper, Claudia 3, **194**, 195, 200,
 205, 212f.
Fárová, Anna 140, 146
Fenollosa, Ernest 177f., 179
Fetscher, Iring 115
Feuerstein, Bedrich **152**
Fideli, Deborah 4
Filges, Ralf **2**, 4, 81, **92f.**
Fischer, Roland 31f., **67**
Fischer, Walter 178
Fleischmann, Gerd 4, 9
Fleischmann, Karel 141
Flusser, Vilém 16, 35
Fontcuberta, Joan 16
Francesca, Pierro della 179, 181
Frank, Helmar 26
Franke, Herbert W. 26, 28
Freeman, Judi 131

Funke, Jaromír 111, 139 ff., 145 ff., 149 f.,
 152, 159 f.
Fuller, Rosalinde 135
Fuss, Adam 22, 31 f., **51**
f 5 (group) 146 f.

Gabrielová, Vera 140
Gaßner, Hubertus 168
Gerke, Hans 16, 29
Gernsheim, Helmut and Alison 117, 163
Giacometti, Alberto 187
Gilbert & George 29 f.
Glassman, Elizabeth 20, 292
Gogh, Vincent van 175 f.
Gourmonts, Remy de 169
Gravenhorst, Hein 24, **26**, 28, **56**
Green, Jonathan 132
Greco, El 111
Groebli, René 22
Gruber, L. Fritz 102
Gruppe 42 (group) 149
Guilbaut, Serge 182
Gundlach, F. C. 52

Hackenschmied, Alexander 140 f.
Haeckel, Ernst 115 f., 119, 201 f., **204**, 288
Hahn, Peter 21
Hájek, Karel 141, 150 f.
Hajek-Halke, Heinz 25, **53**, **87**, 261, 264
Haftmann, Werner 187
Hák, Miroslav 146 f., 148 f.
Halley, Peter 216
Hammond, John H. 287
Hansen, Miriam 163, 168, 170, 176
Hardy, Bert 149 f.
Harten, Jürgen 164 f.
Hartmann, Sadakichi 259, 298
Hartung, Hans 187, 189, **190**
Hatlák, Jindřich 141
Hatláková, Jaroslava 140
Haus, Andreas 21
Heartfield, John 293
Hegel, Georg Wilhelm Friedrich 76, 120
Heidtmann, Frank 294
Heisenberg, Werner 185
Heiting, Manfred 166
Helbing, Anja 239

Henderson, Linda Dalrymple 131 f.
Hernandez, Antonio 22, 299
Herneck, Friedrich 22, 25
Herschel, John F. J. 286
Herzfelde, Wieland 293
Herzogenrath, Wulf 30
Hesper, Stefan 181
Hesse, Eva 163, 169 f., 174 ff., 178 f., 181, 183
Hiepe, Richard 293
Hilliard, John 28 f., 30, **61**
Hiroshige, Ando **172**
Hirschfeld-Mack, Ludwig 111, **112**, 114, 131 f.,
 133, 294
Hnízdo, Vladimír 141, 150 f.
Hockney, David 29 f., 175 f., 178 ff., **180**,
 183 ff., **186, 190 f.**, 299
Hokusai, Katsushika **173**, 189, 193
Holz, Hans Heinz 192
Hölzel, Adolf 111
Holzhäuser, Karl Martin 16, 31 f., **50, 69**, 91
Hornes, Bernard Shea 143
Honty, Tibor 149 f.
Hopper, Edward 179, 181
Horowitz, Roth 236 f.
Hülsewig-Johnen, Jutta 13
Humbert, Roger 22, **23**
Humphreys, Richard 170, 174 f.

Iglhaut, Stefan 31
Inboden, Gudrun 31
Ingarden, Roman 85, 88
Iser, Wolfgang 163, 176 f., 188
Istler, Josef 146 f.

Jäger, Gottfried 1, 3, **26, 57**, 78, 80, 82,
 88, 91 ff., **100 f.**, 201, 259 ff., 265 f., **267**,
 297, 299
Jaguer, Edouard 19
James, Henry 165
Jauß, Hans Robert 188
Jeníček, Jiří 141
Jeon, Dai-yong 31 f., **68**
Jessen, Peter 115
Jesus 120
Jílovská, Stanislava 140
Jíru, Václav 150 f.
Josephson, Kenneth 16, 29

Jung, Carl Gustav (C. G.) 125, 128, 133 f.
Jussim, Estelle 122

Kage, Manfred **210 f.**
Kalivoda, František 149 f.
Kämper, Dietrich 165
Kandinsky, Wassily 17, 103, 105 f., 116 f., 120,
 125, 128, 222
Kant, Immanuel 120
Kapaík, Karel 140 f.
Kassák, Lajos 144 f.
Kašpařík, Karel 141, 149, 151
Kaufhold, Enno 12, 293
Kawara, On 184 f.
Keetman, Peter 25 f., **52**, 94, **98**, 261
Kellein, Thomas 17, 21, 31, 163, 171, 259 ff.
Kelly, Ellsworth 227
Kemp, Wolfgang 11, 17, 73, 80, 163
Kempinger, Herwig 230, **256 f.**
Kepes, György 21, **46, 86**
Kirlian, Semjon D. 290, 295
Kitaj, R. B. 178 f.
Klein, Ferry 141
Klappert, H. 6
Klar, Willi **40**
Klee, Paul 103
Klink, Stefan 4, 9
Kluge, Steffen 223, **242 f.**
Knodt, Robert 290, 294
Koch, Jindřich 140 f.
Köhler, Michael 3, 214
Kohn, Rudolf 150 f.
Koliusis, Nikolaus 31 f.
König, Alexander 203
König, Traugott 91
Koo, Bohn-Chang 31 f.
Koreček, Miloš 146 f.
Koshofer, Gert 18
Kossack, Ariane 4
Kracauer, Siegfried 30
Krauss, Rolf H. 3, 103, 109, 264, 292
Krejcar, Jaromír **152**
Kretschmer, Hubert 224, **244 f.**
Kreuzer, H. 26
Kreyenkamp, August 202, **206**
Krippner, Stanley 295
Kuball, Mischa **50**

Kupka, František 17, 103, 144f.
Kuspit, Donald 198

Lampe, Angela 17, 21, 31, 163, 171, 259
Lange, G. A. 107
Lankheit, Klaus 105
Lauschmann, Jan 140f.
Lauterwasser, Siegfried 25
Leadbeater, C. W. 106ff.
Lehovec, Jiří 141, 150f.
Leonardo da Vinci 287
Lerner, Nathan 21
Léger, Fernand 17, 164
Lewis, Wyndham 123f., 165, 169, **172**, 183f.
Linhard, Lubomír 139
Linie (group) 141
Linke Front (group) 150
Lintermann, Bernd 266, **267**, 287f.
Lissitzky, El 145f., 261, 264
Livingstone, Marco 181
Lloyd, Engelbrecht 21
Loers, Veit 32
Lombardi, Ines 31f.
Loos, Adolf 104
Lukas, Jan 141
Lusk, Irene-Charlotte 294

Maar, Dora 86
Mach, Ernst 188f.
Mächler, René 4, 22, 226, **248f.**
Madigan, Martha **10**, 21f.
Maddox, Richard Leach 289
Magritte, René 188f.
Malewitsch, Kasimir 103, 144f., 222, **273**
Manet, Edouard 175f.
Marc, Franz 105, 165
Marey, Etienne-Jules **36**, 164, **166**, 268, 287
Marinetti, Filippo T. 165, 168, 189, 192
Maser, Siegfried 27
Matisse, Henri 104, 259
Mattner, Jacob **6, 15**
McLuhan, Marshall 183f., 229
Meier, Norbert 31f., **70**
Menz, Wolfgang 203
Meyer zu Eissen, Annette 30
Metzger, Rainer 176

Metzker, Ray K. 21f.
Mißelbeck, Reinhold 189, 259ff.
Mlcoch, Jan 146
Moeller, Magdalene M. 164
Moholy-Nagy, Hattula 39f., 112
Moholy-Nagy, László 7, 19, 21, 25, 27, **39f.**, 49f., 71, 111, **112**, 144f., 223, 227, 260f., 264, 269ff., **273**, 286, 293f., 298
Molderings, Herbert 259ff.
Mondrian, Piet 103, 222, 229, 294
Moritz, William 114
Mrázková, Daniela 139
Müller, Elke and Herbert 114ff.
Müller-Pohle, Andreas 28f., **64**, 299
Müller-Schorp, Hansi **40**
Mulas, Ugo 29, **58**
Mumler, William H. 128
Münzberg, Diether 294
Mutter, Edwin 290
Muybridge, Eadweard **36**, 287
Nake, Frieder 27
Nees, Georg 27
Neumann, Jan A. 293
Neusüss, Floris M. 16, 19, 29, 73, 219, **234f.**, 286, 299
Newhall, Nancy 122
Newman, Barnett 225, 227, 229
Nierendorf, Karl 201
Nixdorf, Peter 49f., 250, 251
Nouza, Oldřich 141
Novák, Ada 141

Orchard, Karin 18, 163f.
Orlopp, Detlef 218, **232f.**
Osterwold, Tillman 30
Outerbridge, Paul 143

Paech, Joachim 164
Paul(us) 120
Pennick, Nigel 105
Petr, Nedoma 146
Photo League (group) 149
Picasso, Pablo Ruiz 17, **86**, **166**, 187, 189, 259
Pikart, Arnošt 140f.
Plato 120
Plotin 115, 120

Policansky, Karel 150f.
Pollmeier, Klaus 290, 294
Pollock, Jackson 184ff., **186**
Polke, Sigmar 216, 264
Pospšil, M. 140
Pound, Ezra 123ff., 128, 162ff., 168ff., 173ff., 178ff., 185, 188, 192, 260
Povolný, František 146f., 150f.
Proust, Marcel 185, 188
Puttnies, Georg 25f.

Quedenfeldt, Erwin Theodor 103, 107ff., **113**, 123, 125, 128, 292

Ra (group) 146f.
Rautert, Timm 28f.
Ray, Man 19, **38**, 78, 111, **112**, 141ff., 146, 148f., **258**, 260, 264, 271, 298
Redlin (family) 264
Reilly, James M. 290
Reisewitz, Wolfgang 25
Remeš, Vladimír 139
Renger-Patzsch, Albert 35, 198
Renner, Eric 287, 299
Reumuth, Horst 288
Reusse, Stephan 221, **238f.**
Richter, Christiane 227, **250f.**
Richter, Gerhard 216, 266
Riethmüller, Albrecht 165
Ringbom, Sixten 106f.
Robertson, Helen 31f., **65**
Robinson, Henry Peach 12, **14**
Rodin, Auguste 259
Rodtschenko, Alexander M. 144f.
Roh, Franz 25, 261, 298
Rössler, Jaroslav **138**, 139ff., 144ff., **153ff.**
Rossmannová, Marie 140
Rothko, Mark 227
Rötzer, Florian 31
Rotzler, Willy 26
Rubin, Daniel 295
Rupesová, Miloslava 160
Růžička, Drahomír Josef 140

Sabau, Luminita 31
Säfken, Jean 4

Sal, Jack 21f., **49**
Sana, Jimmy 31
Sartre, Paul 91
Saussure, Ferdinand de 182f.
Sayag, Alain 139
Schad, Christian 19, **37**, 78, 142f., 259f.,
 298
Schiff, Gert 189
Schmalriede, Manfred 28
Schmidt, Hartmut 93
Schmidt, Marjen 298
Schmitt, Michael 203
Schmoll gen. Eisenwerth, J. A. 12f., 25,
 299
Schneeberger, Adolf 146f.
Schneiders, Toni 25
Schnelle-Schneyder, Marlene 20, 164, 287
Schöffer, Nicolas 263
Schopenhauer, Arthur 120
Schroeter, Rolf 22
Schüler, Gerhard 203
Schulz, Lucia 260
Schuré, Edouard 103
Schwarz, Hartwig 92
Schwerdtfeger, Kurt 111
Seeley, George H. **15**
Selichar, Günther 229, **254f.**
Serocka, Peter 71
Serrano, Andres 31f., **62**
Sever, Jirí 149f.
Shaw, Bernhard 165
Sheridan, Sonja Landy 28
Sieverding, Katharina 31, **60**
Síma, Josef **152**
Siskind, Aaron 21, **48**
Slánský, Josef 141
Smith, Lauren 287
Snow, Charles P. 26
Sobi, James Thrall 38
Sociofotó (group) 150
Souček, Ludvík 139
Spies, Werner 179, 181
Spinoza, Baruch de 120
Stahel, Urs 32
Stamm, Rainer 65
Starn, Douglas and Mike 21f., 31f., **59f.**
Šťastný, Bohumil 140

Steichen, Edward **43**, 260
Stein, Gertrude 165
Steiner, Rudolf 103
Steinert, Otto 25f., **52**, 261
Steinert, Stefan **52**, 299
Steinorth, Karl 18
Stevenson, Anders 185
Stieglitz, Alfred 21, **44f.**, 170f., 259, 298
Still, Clifford 225
Stöhr, Jürgen 192
Straka, Oldřich 141, 150f.
Strand, Paul 21, **42**, 142f., 259f., 298
Strüwe, Carl 21, 88, 201, **208f.**, 261, 288
Štyrský, Jindrích 148f.
Sudek, Josef 140f., 146f., **161**
Sugimoto, Hiroshi 31f.
Sutnar, Ladislav 147
Symmes, Marilyn F. 20, 292

Taaffe, Philip 216
Tabard, Maurice 148f.
Talbot, William Henry Fox **14**, 19
Teige, Karel 139, 145ff., **152**
Thierkopf, Dietrich 192
Thomas, Ann 202
Thorn-Prikker, Jan 26
Tillmans, Wolfgang 31f., **63**
Tuchman, Maurice 105f., 131
Toles, Mary Jo **41**
Trio Aventin 141
Tschichold, Jan 261

Ulmen, Karin 203
Ulrichs, Timm **99**
Umbro, Apollonio 18
Urbons, Klaus 295

Valter, Karel 141
Vepřek, Emil 141
Verspohl, Franz-Joachim 187
Vobecký, František 148f.
Voříšek, Josef 141

Wadsworth, Edward 123f.
Wagner, Monika 165
Walser, Rupert 252
Walter, Ingo 176

Watkins, Margret 143
Weaver, Mike 122, 168f., 171, 174f., 193
Weber, Max 129, 131f.
Wedewer, Rolf 29
Weibel, Peter 30, 299
Weizman, Fred and Marcia 180
Weiermair, Peter 30
Weinberg, Adam 31
Welling, James 21f., 31f., **64**
Weschler, Lawrence 193
Wesely, Michael 225, **246f.**
Wicpalek, Heinrich 141
Wiesing, Lambert 3, 9, 16f., 73
Wilfred, Thomas 114, 128f., 129
Wilhelm, Richard 133f.
Willème, François 294
Windstoßer, Ludwig 25
Wiškowský, Eugen 140f., **156f.**
Wittgenstein, Ludwig 182f.
Wolf, Herta 28
Wols 187
Worringer, Wilhelm 13, 110
Wyss, Beat 107

Yeats, William Butler 165f.
Young, Stark 128f.

Zikánová, Josefa 140
Život (revue) 139, 141f.
Zuckriegel, Margit 22, 139

Vitae Notes on Authors and Podium Discussion Participants

Vladimír Birgus * 1954 in Frydek-Mísdek, today Czech Republic. Professor in the Faculty of Film and Television at the Academy for the Performing Arts, Prague, and director of the Institute of Creative Photography at the Silesian University, Opava. Special research areas and publications: *Encyclopaedia of Czech and Slovak Photographers* (published Prague, 1993); *Czech Avant-garde Photography 1918–1948* (Stuttgart 1999); *The Nude in Czech Photography; František Drtikol* (Prague, 2000), and at last *Jaroslav Rössler* (Prague 2001).

Martin Roman Deppner * 1946 in Westermoor, Germany. Studied Visual Communication in Bielefeld (diploma 1973), Aesthetics (MA 1982), Literature and History of Art in Hamburg (PhD 1987). Several stand-in and visiting professorships. Special research areas: Media aspects of art and their interrelationship with other, newer media; Jewish thought in the context of Media Theory and Art Modernity.

Claudia Fährenkemper * 1959 in Castrop-Rauxel, Germany. Studied Art and Geography in Dusseldorf for secondary school teaching (second state examination 1986). Studied Photography in Cologne with Arno Jansen, in Dusseldorf with Bernd Becher and Nan Hoover. 1995, master student. As of 1993, solo and group exhibitions in Germany and abroad. Collections: Musée de l'Elysée, Lausanne; National Gallery of Canada, Ottawa.

Gottfried Jäger * 1937 in Burg near Magdeburg, Germany. Trained as photographer. Studied Photo-Engineering in Cologne (diploma 1960). Since 1972, professor for Photography at the *Fachhochschule Bielefeld* (University of Applied Sciences). Activities in aesthetic theory and practice of *Apparative Art* (Cologne, 1973), *Generative Photography* (Ravensburg, 1975), multimedia-projects. Initiated in 1979 the Center of Research for Photography and Media with *The Bielefeld Symposia on Photography and Media and their History* with publications on *László Moholy-Nagy* (Bielefeld, 1997, with Gudrun Wessing) and *Vilém Flusser* (Bielefeld, 2001).

Thomas Kellein * 1955 in Nuremberg, Germany. Since 1996, director of the Kunsthalle Bielefeld. Special areas and publications on *Ad Reinhardt: Schriften und Gespräche* (Munich, 1985, 1998);

Walter de Maria: Fünf Kontinente Skulptur (Stuttgart, 1987); *Künstlerische Großprojekte von Yves Klein zu Christo* (Stuttgart, 1988); *Hiroshi Sugimoto: Time Exposed* (Stuttgart, 1995); *Caspar David Friedrich: Der künstlerische Weg* (Munich, 1998); *Abstrakte Fotografie* (Bielefeld, Ostfildern, 2000, with Angela Lampe).

Rolf H. Krauss * 1930 in Stuttgart, Germany. Studied Economics in Munich (PhD 1956). Retail trade entrepreneur. Long-standing president of the history branch of the German Photographic Society (DGPh). Studied German Literature and History of Art in Stuttgart (MA 1997, PhD 1999). Publications: *Fotografie als Medium: 10 Thesen zur konventionellen und konzeptionellen Photographie* (Berlin, 1979; Ostfildern, 1996); *Kunst mit Photographie: Die Sammlung Dr. Rolf H. Krauss* (Berlin, 1983); on: *Photographie und Paranormale Phänomene* (Marburg, 1992), *Walter Benjamin und der neue Blick auf die Photographie* (Ostfildern, 1998), *Photographie und Literatur* (Ostfildern, 2000).

Michael Köhler * 1946 in Siegen/Westphalia, Germany. Studied Philology in Munich and Yale, USA. Since 1995, curator of exhibitions; writer and publisher with special research areas in photographic art and avant-garde literature. Activities as curator and publisher: *Das Aktfoto: Ansichten vom Körper im technischen Zeitalter* (Munich, 1985, Schaffhausen, 1987); *Allen Ginsberg* (Berlin, 1989); *Das konstruierte Bild: Fotokunst arrangiert und inszeniert* (Schaffhausen, 1989); *Burroughs: Eine Bildbiografie* (Berlin, 1993).

Reinhold Mißelbeck * 1948 in Regensburg, Germany, died 2001 in Cologne; Studied History of Art, Philosophy, Sociology and Painting. 1980–2001, director of the section Photography and Video, Museum Ludwig, Cologne. President of *International Photoscene, Cologne*. Since 1993 he was lecturer at the History of Art Institute at the University of Cologne.

Herbert Molderings * 1948 in Witterschlick near Bonn, Germany. Studied History of Art, Archeology, Philosophy, Sociology in Bonn and Bochum (PhD 1973). 1975–1978, director of the Westphalian Society of Art, Munster. 1978–1982, freelance academic author and exhibition organizer in Paris. Since 1995, outside lecturer in Early-Modern and Modern History of Art, Ruhr University, Bochum. Special research areas: 20th-century Art; the œuvres of Marcel Duchamp, Man Ray, Umbo and László Moholy-Nagy; the history of European photography of the 1920s and 1930s.

Künstler/in Artist	Veröffentlichungsrechte Copyright
Animato, Gruppe	© Gruppe Animato / Prof. Gottfried Jäger, Bielefeld (D)
Bally, Théodore	© Aargauer Kunsthaus, Aarau (CH)
Blossfeldt, Karl	© Karl Blossfeldt Archiv, Ann und Jürgen Wilde, Zülpich (D) / VG Bild-Kunst, Bonn (D) 2002
Bogner, Manfred	© Manfred Bogner, Bad Honnef (D)
Bragaglia, Anton Giulio	© VG Bild-Kunst, Bonn (D), 2002
Breier, Kilian	© Prof. Kilian Breier, Hamburg (D)
Breuer, Marco	© Roth Horowitz, New York, NY (USA)
Bruguière, Francis Joseph	© George Eastman House – International Museum of Photography and Film, Rochester, NY (USA)
Callahan, Harry	© The Estate of Harry Callahan / Pace / MacGill Gallery, New York, NY (USA)
Coburn, Alvin Langdon	© George Eastman House – International Museum of Photography and Film, Rochester, NY (USA)
Cordier, Pierre	© Pierre Cordier, St.-Saturnin-lès-Apt (F) / VG Bild-Kunst, Bonn (D), 2002
Darget, Louis	© Institut für die Grenzgebiete der Psychologie und Psychohygiene e. V., Freiburg im Breisgau (D)
Dibbets, Jan	© VG Bild-Kunst, Bonn (D), 2002
Dick, Inge	© Inge Dick, Loibichl (A)
Drtikol, František	© Ervina Boková-Drtikolová, Podebrady (CZ)
Evers, Winfried	© Winfried Evers, Amsterdam (NL)
Fährenkemper, Claudia	© Claudia Fährenkemper, Lünen (D)
Filges, Ralf	© Ralf Filges, Bielefeld, (D)
Fischer, Roland	© Galerie von Lintel & Nusser, New York NY (USA) / Munich (D) / VG Bild-Kunst, Bonn (D), 2002
Funke, Jaromír	© Dr. Miloslava Rupesová-Funková, Prague (CZ)
Fuss, Adam	© Cheim & Read Gallery, New York, NY (USA)
Gravenhorst, Hein	© Hein Gravenhorst, Berlin (D)
Hajek-Halke, Heinz	© Sammlung Michael Ruetz / Nachlaß Heinz Hayek-Halke / Agentur Focus, Hamburg (D)
Hartung, Hans	© VG Bild-Kunst, Bonn (D), 2002
Hilliard, John	© John Hilliard, London (GB)
Hirschfeld-Mack, Ludwig	© Bauhaus-Archiv, Berlin (D)
Hockney, David	© David Hockney, Los Angeles, CA (USA)
Holzhäuser, Karl Martin	© Prof. Karl Martin Holzhäuser, Bielefeld (D)
Humbert, Roger	© Roger Humbert, Basel (CH)
Jäger, Gottfried	© Prof. Gottfried Jäger, Bielefeld (D)
Jeon, Dai-Yong	© Dai-Yong Jeon, Seoul (ROK)
Kage, Manfred P.	© Manfred P. Kage, Lauterstein (D)
Keetman, Peter	© Peter Keetman, Marquartstein (D)
Kempinger, Herwig	© Herwig Kempinger, Vienna (A)
Kepes, György	© Juliet K. Stone, Watertown, MA (USA)
Klappert, H.	© H. Klappert / Jakob Mattner, Berlin (D)
Kluge, Steffen	© Steffen Kluge, Wolfsburg (D)
Kretschmer, Hubert	© Hubert Kretschmer, Munich (D)
Kreyenkamp, August	© Rheinisches Bildarchiv der Stadt Köln, Cologne (D)
Kuball, Mischa	© Mischa Kuball, Düsseldorf (D) / VG Bild-Kunst, Bonn (D), 2002
Lintermann, Bernd	© Bernd Lintermann, Karlsruhe (D)
Mächler, René	© René Mächler, Zuzgen (CH)
Madigan, Martha	© Michael Rosenfeld Gallery, New York, NY (USA)
Malewitsch, Kasimir	© VG Bild-Kunst, Bonn (D), 2002
Marey, Etienne-Jules	© Deutsches Filmmuseum, Frankfurt am Main (D)